Roland Barthes//Joseph Beuys//Nicolas Bourriaud//
Peter Bürger//Graciela Carnevale//Lygia Clark//
Collective Actions//Eda Cufer//Guy Debord//Jeremy
Deller//Umberto Eco//Hal Foster//Édouard Glissant//
Group Material//Félix Guattari//Thomas Hirschhorn//
Carsten Höller//Allan Kaprow//Lars Bang Larsen//
Jean-Luc Nancy//Molly Nesbit//Hans Ulrich Obrist//
Hélio Oiticica//Adrian Piper//Jacques Rancière//
Dirk Schwarze//Rirkrit Tiravanija

D1449498

Participation

Whitechapel
London
The MIT Press
Cambridge, Massachusetts

Edited by Claire Bishop

PARTICIPATION

Documents of Contemporary Art

Co-published by Whitechapel Gallery
and The MIT Press

First published 2006
© 2006 Whitechapel Gallery Ventures Limited
Texts © the authors, unless otherwise stated

Whitechapel Gallery is the imprint of Whitechapel
Gallery Ventures Limited

ISBN 978-0-85488-147-5 (Whitechapel Gallery)
ISBN 978-0-262-52464-3 (The MIT Press)

A catalogue record for this book is available from
the British Library

Library of Congress Cataloguing-in-Publication Data

Participation / edited by Claire Bishop
 p. cm. – (Documents of contemporary art series)
Includes bibliographical references and index
ISBN-13: 978-0-262-52464-3 (pbk. :alk. paper)
ISBN-10: 0-262-52464-3 (pbk. :alk. paper)
1. Interactive art. 2. Arts audiences.
3. Authorship–Sociological aspects
I. Bishop, Claire. II. Series
NX46.5.157P37 2006
700.1–dc22
 2006044940

10 9 8 7 6 5 4 3

Series Editor: Iwona Blazwick
Executive Director: Tom Wilcox
Commissioning Editor: Ian Farr
Project Editor: Hannah Vaughan
Designed by SMITH
Printed in Italy

Cover: Lygia Clark, *Baba antropofága* (1973),
from the series *Collective Body*. © The World of
Lygia Clark Cultural Association, Rio de Janeiro

Whitechapel Gallery Ventures Limited
80-82 Whitechapel High Street
London E1 7QZ
www.whitechapelgallery.org
To order (UK and Europe) call +44 (0)207 522 7888
or email MailOrder@whitechapelgallery.org
Distributed to the book trade (UK and Europe only)
by Central Books
www.centralbooks.com

The MIT Press
55 Hayward Street
Cambridge, MA 02142
For information on quantity discounts,
please email special_sales@mitpress.mit.edu

Whitechapel Gallery

Documents of Contemporary Art

In recent decades artists have progressively expanded the boundaries of art as they have sought to engage with an increasingly pluralistic environment. Teaching, curating and understanding of art and visual culture are likewise no longer grounded in traditional aesthetics but centred on significant ideas, topics and themes ranging from the everyday to the uncanny, the psychoanalytical to the political.

The Documents of Contemporary Art series emerges from this context. Each volume focuses on a specific subject or body of writing that has been of key influence in contemporary art internationally. Edited and introduced by a scholar, artist, critic or curator, each of these source books provides access to a plurality of voices and perspectives defining a significant theme or tendency.

For over a century the Whitechapel Gallery has offered a public platform for art and ideas. In the same spirit, each guest editor represents a distinct yet diverse approach – rather than one institutional position or school of thought – and has conceived each volume to address not only a professional audience but all interested readers.

Series Editor: Iwona Blazwick; Commissioning Editor: Ian Farr; Project Editor: Hannah Vaughan; Executive Director: Tom Wilcox; Editorial Advisory Board: Roger Conover, Neil Cummings, Mark Francis, David Jenkins, Gilane Tawadros

I WANT THE PUBLIC TO BE IN SIDE A BRAIN IN ACTION

Claire Bishop
Introduction//Viewers as Producers

The point of departure for the selection of texts in this reader is the *social* dimension of participation – rather than activation of the individual viewer in so-called 'interactive' art and installation. The latter trajectory has been well rehearsed elsewhere: the explosion of new technologies and the breakdown of medium-specific art in the 1960s provided myriad opportunities for physically engaging the viewer in a work of art.[1] Less familiar is the history of those artistic practices since the 1960s that appropriate *social* forms as a way to bring art closer to everyday life: intangible experiences such as dancing samba (Hélio Oiticica) or funk (Adrian Piper); drinking beer (Tom Marioni); discussing philosophy (Ian Wilson) or politics (Joseph Beuys); organizing a garage sale (Martha Rosler); running a café (Allen Ruppersberg; Daniel Spoerri; Gordon Matta-Clark), a hotel (Alighiero Boetti; Ruppersberg) or a travel agency (Christo and Jeanne-Claude). Although the photographic documentation of these projects implies a relationship to performance art, they differ in striving to collapse the distinction between performer and audience, professional and amateur, production and reception. Their emphasis is on collaboration, and the collective dimension of social experience.

These socially-oriented projects anticipate many artistic developments that proliferated since the 1990s, but they also form part of a longer historical trajectory. The most important precursors for participatory art took place around 1920. The Paris 'Dada-Season' of April 1921 was a series of manifestations that sought to involve the city's public, the most salient being an excursion to the church of Saint Julien le Pauvre which drew more than one hundred people despite the pouring rain. A month later, Dada artists and writers held a mock trial of the anarchist author turned nationalist Maurice Barrès, in which members of the public were invited to sit on the jury. André Breton coined the phrase 'Artificial Hells' to describe this new conception of Dada events that moved out of the cabaret halls and took to the streets.[2] At the other extreme from these collaborative (yet highly authored) experiences were the Soviet mass spectacles that sublated individualism into propagandistic displays of collectivity. The Storming of the Winter Palace (1920), for example, was held on the third anniversary of the October Revolution and involved over 8,000 performers in restaging the momentous events that had led to the Bolshevik victory.[3] The collective fervour of these theatrical spectacles was paralleled by new proletarian music such as the Hooter Symphonies: celebrations of machinic

noise (factory sirens, motors, turbines, hooters, etc.) performed by hundreds of participants, directed by conductors signalling from the rooftops.[4] These two approaches continue to be seen throughout the multiple instances of participatory art that develop in their wake: an authored tradition that seeks to provoke participants, and a de-authored lineage that aims to embrace collective creativity; one is disruptive and interventionist, the other constructive and ameliorative. In both instances, the issue of participation becomes increasingly inextricable from the question of political commitment.

One of the first texts to elaborate theoretically the political status of participation dates from 1934, by the left-wing German theorist Walter Benjamin. He argued that when judging a work's politics, we should not look at the artist's declared sympathies, but at the position that the work occupies in the production relations of its time. Referring directly to the example of Soviet Russia, Benjamin maintained that the work of art should actively intervene in and provide a model for allowing viewers to be involved in the processes of production: 'this apparatus is better, the more consumers it is able to turn into producers – that is, the more readers or spectators into collaborators'.[5] By way of example he cites the letters page of a newspaper, but his ideal lies in the plays of his contemporary, the German dramatist Bertolt Brecht. As Benjamin explains, Brechtian theatre abandons long complex plots in favour of 'situations' that interrupt the narrative through a disruptive element, such as song. Through this technique of montage and juxtaposition, audiences were led to break their identification with the protagonists on stage and be incited to critical distance. Rather than presenting the illusion of action on stage and filling the audiences with sentiment, Brechtian theatre compels the spectator to take up a position towards this action.

By today's standards, many would argue that the Brechtian model offers a relatively passive mode of spectatorship, since it relies on raising consciousness through the distance of critical *thinking*. By contrast, a paradigm of *physical* involvement – taking its lead from Antonin Artaud's Theatre of Cruelty among others – sought to reduce the distance between actors and spectators.[6] This emphasis on proximity was crucial to myriad developments in avant-garde theatre of the 1960s, and was paralleled by upheavals in visual art and pedagogy. In this framework, physical involvement is considered an essential precursor to social change. Today this equation is no less persistent, but its terms are perhaps less convincing. The idea of collective presence has (for better or worse) been scrutinized and dissected by numerous philosophers; on a technical level, most contemporary art is collectively produced (even if authorship often remains resolutely individual); participation is used by business as a tool for improving efficiency and workforce morale, as well as being all-pervasive in the mass-

media in the form of reality television.[7] As an artistic medium, then, participation is arguably no more intrinsically political or oppositional than any other.

Despite this changing context, we can nevertheless draw attention to continuities between the participatory impulse of the 1960s and today. Recurrently, calls for an art of participation tend to be allied to one or all of the following agendas. The first concerns the desire to create an active subject, one who will be empowered by the experience of physical or symbolic participation. The hope is that the newly-emancipated subjects of participation will find themselves able to determine their own social and political reality. An aesthetic of participation therefore derives legitimacy from a (desired) causal relationship between the experience of a work of art and individual/collective agency. The second argument concerns authorship. The gesture of ceding some or all authorial control is conventionally regarded as more egalitarian and democratic than the creation of a work by a single artist, while shared production is also seen to entail the aesthetic benefits of greater risk and unpredictability. Collaborative creativity is therefore understood both to emerge from, and to produce, a more positive and non-hierarchical social model. The third issue involves a perceived crisis in community and collective responsibility. This concern has become more acute since the fall of Communism, although it takes its lead from a tradition of Marxist thought that indicts the alienating and isolating effects of capitalism. One of the main impetuses behind participatory art has therefore been a restoration of the social bond through a collective elaboration of meaning.

These three concerns – activation; authorship; community – are the most frequently cited motivations for almost all artistic attempts to encourage participation in art since the 1960s. It is significant that all three appear in the writing of Guy Debord, co-founder of the Situationist International, since it is invariably against the backdrop of his critique of capitalist 'spectacle' that debates on participation come to be staged. The spectacle – as a social relationship between people mediated by images – is pacifying and divisive, uniting us only through our separation from one another:

> The specialization of the mass spectacle constitutes [...] the epicentre of separation and noncommunication.[8]

> The spectacle is by definition immune from human activity, inaccessible to any projected review or correction. It is the opposite of dialogue. [...] It is the sun that never sets on the empire of modern passivity.[9]

If spectacle denotes a mode of passivity and subjugation that arrests thought

and prevents determination of one's reality, then it is precisely as an injunction to *activity* that Debord advocated the construction of 'situations'. These, he argued, were a logical development of Brechtian theatre, but with one important difference: they would involve the audience function disappearing altogether in the new category of *viveur* (one who lives). Rather than simply awakening critical consciousness, as in the Brechtian model, 'constructed situations' aimed to produce new social relationships and thus new social realities.

The idea of constructed situations remains an important point of reference for contemporary artists working with live events and people as privileged materials. It is, for example, frequently cited by Nicolas Bourriaud in his *Relational Aesthetics* (1998), a collection of theoretical essays that has catalyzed much debate around the status of contemporary participation. In parallel with this debate, and perhaps addressing the sense of unrealized political potential in the work that Bourriaud describes, a subsequent generation of artists have begun to engage more directly with specific social constituencies, and to intervene critically in participatory forms of mass media entertainment.[10] The texts in this reader have been selected with the development of this work in mind. The aim has been to provide a historical and theoretical lineage for recent socially-collaborative art, presenting a variety of positions that will allow students and researchers to think more widely about the claims and implications of the artistic injunction to participate.

The book is divided into three sections. The first offers a selection of theoretical frameworks through which to consider participation. It begins with key structuralist texts by Umberto Eco and Roland Barthes, which concern the new role of the viewer in relation to modern art, music and literature. It is followed by Peter Bürger's classic Marxist critique of bourgeois art as a failure to fuse art and social praxis. Jean-Luc Nancy, addressing the impasse of Marxist theory in the 1980s, attempts to rethink political subjectivity outside the conventional framework of activation. He posits a community that is 'inoperative' or 'unworked' (*désoeuvrée*), founded not on the absolute immanence of man to man (for example, the 'being-in-common' of nations, communities or lovers), but on the presence of that which impedes such immanence, that is, our consciousness of death. Gilles Deleuze and Félix Guattari have provided the foundation for several contemporary theories of political action, most notably Michael Hardt and Antonio Negri's influential *Empire* (2000), one of the key texts of the anti-globalization movement. (*Empire* is available online, and therefore has not been included in this reader; the most relevant passage is section 4.3 on the multitude.) Ten years prior to *Empire*, Édouard Glissant used Deleuze and Guattari as the theoretical basis of his 'poetics of relation', an argument for the creative subversion of colonialist

ART

NO

LONGER WANTS TO RESPOND TO THE
EXCESS OF COMMODITIES AND SIGNS

BUT

TO A LACK OF CONNECTIONS

Jacques Rancière, 'Problems and Transformations in Critical Art', 2004

culture by those subjugated to its language. Guattari's *Chaosmosis* (1992) and Rancière's *Malaise dans l'esthétique* (2004) both offer a tripartite history of art's development, and both argue for a culminating phase in which art has an integral relation to other spheres: for Guattari the ethical, for Rancière the political.

Section two comprises artist's writings, the selection of which has been partially determined by the desire to present informative texts relating to substantial works of art. Another desire was to show a range of different approaches to the documentation and analysis of these often elusive and ephemeral projects. The chosen texts represent a variety of proposals for recording process-based participation on the page: the manifesto format (Debord, Kaprow, Beuys), the project description (Carnevale, Höller, Hirschhorn), the detailed log of events (Schwarze on Beuys), reflections after the event (Piper, Cufer, Deller), dialogues in the form of correspondence (Oiticica and Clark), and a retrospective survey in the form of a third-person narrative (Tiravanija). Limitations of space have prevented a fuller presentation of the Collective Actions group, whose methodical approach to documentation erased the boundary between collaboration, event and reflection: the participants in each work were invited to document their response to it. *Ten Appearances*, for example, is accompanied by long, detailed texts by the artist Ilya Kabakov and the poet Vsevolod Nekrasov.

The final section presents a selection of recent curatorial and critical positions. It begins with excerpts from Bourriaud's *Relational Aesthetics*, part of which formed the catalogue essay for his group exhibition *Traffic* (1995). Lars Bang Larsen's 'Social Aesthetics' (1999) is an attempt to present connections between today's participatory practice and historical precursors of the 1960s, here with a focus on Scandinavia. One of the most memorable curatorial gestures of the present decade was *Utopia Station* (Venice Biennale, 2003), a collaborative exhibition whose project description draws a connection between activated spectatorship and activism. The final essay in the book, by Hal Foster, is more cautious, and reflects on the limitations of the participatory impulse. The scope of this reader therefore ranges from the 1950s to the present day; although there are important examples of social participation in the historic avant-garde, it is not until the eve of the sixties that a coherent and well-theorized body of work emerges: Situationism in France, Happenings in the United States, and Neo-Concretism in Brazil.

Many writings outside the discipline of art history could have been added to this anthology, particularly texts that draw attention to the history of participation in theatre, architecture and pedagogy.[11] Important work remains to be done in connecting these histories to participation in visual art. Rancière's

unpublished essay 'The Emancipated Spectator' (2004) has begun to do precisely this task, drawing links between the history of theatre and education, and questioning theories that equate spectacle with passivity.[12] He argues that the opposition of 'active' and 'passive' is riddled with presuppositions about looking and knowing, watching and acting, appearance and reality. This is because the binary of active/passive always ends up dividing a population into those with capacity on one side, and those with incapacity on the other.[13] As such, it is an allegory of inequality. Drawing analogies with the history of education, Rancière argues that emancipation should rather be the presupposition of *equality*: the assumption that everyone has the same capacity for intelligent response to a book, a play or a work of art. Rather than suppressing this mediating object in favour of communitarian immediacy, Rancière argues that it should be a crucial third term which both parts refer to and interpret. The distance that this imposes, he writes, is not an evil that should be abolished, since it is the precondition of any communication:

> Spectatorship is not the passivity that has to be turned into activity. It is our normal situation. We learn and teach, we act and know as spectators who link what they see with what they have seen and told, done and dreamt. There is no privileged medium as there is no privileged starting point.

In calling for spectators who are active *as interpreters*, Rancière implies that the politics of participation might best lie, not in anti-spectacular stagings of community or in the claim that mere physical activity would correspond to emancipation, but in putting to work the idea that we are all equally capable of inventing our own translations.[14] Unattached to a privileged artistic medium, this principle would not divide audiences into active and passive, capable and incapable, but instead would invite us all to appropriate works for ourselves and make use of these in ways that their authors might never have dreamed possible.

1 See for example Germano Celant, *Ambiente/Arte: dal Futurismo alla Body Art* (Venice: Edizioni La Biennale di Venezia, 1977. Based on *Ambiente/Arte* exhibition, 1976 Venice Biennale); Nicholas de Oliviera, *et al., Installation Art in the New Millenium* (London: Thames and Hudson, 2003); Claire Bishop, *Installation Art: A Critical History* (London: Tate Publishing, 2005).

2 See André Breton, 'Artificial Hells, Inauguration of the "1921 Dada Season"' (1921), trans. Matthew S. Witkovsky in *October*, 105, Summer 2003, 139: 'Dada events certainly involve a desire other than to scandalize. Scandal, for all its force (one may easily trace it from Baudelaire to the present), would be insufficient to elicit the delight that one might expect from an artificial hell. One should also keep in mind the odd pleasure obtained in "taking to the street" or "keeping one's footing", so to speak [...] By conjoining thought with gesture, Dada has left the realm of shadows to venture

onto solid ground.'

3 For a detailed critical commentary see Frantisek Deak, 'Russian Mass Spectacles', *Drama Review*, vol. 19, no. 2, June 1975, 7–22.

4 For a first-hand account of these events see René Fülöp-Miller, *The Mind and Face of Bolshevism* (London and New York: Putnams and Sons Ltd, 1929) 184.

5 Walter Benjamin, 'The Author as Producer', in Benjamin, *Selected Writings*, vol. 2, part 2, 1931–34 (Cambridge, Massachusetts: Harvard University Press, 2003) 777.

6 The French playwright and director Antonin Artaud developed the term 'Theatre of Cruelty' in the late 1930s. He used it to denote a type of ritualistic drama that aimed, through technical methods (sound, lighting, gesture), to express stark emotions and thereby desensitize the audience, allowing them to confront themselves. See Artaud, *Theatre and Its Double* (London: Calder and Boyars, 1970).

7 On a political level, participation is increasingly considered a privileged medium for British and EU government cultural funding policies seeking to create the impression of social inclusion. See François Matarasso, *Use or Ornament? The Social Impact of Participation in the Arts* (London: Comedia, 1997). In Britain, Matarasso's report has been key to the formulation of New Labour's funding for the arts; for a cogent critique of its claims, see Paola Merli, 'Evaluating the Social Impact of Participation in Arts Activities: A Critical Review of François Matarasso's *Use or Ornament?*', *International Journal of Cultural Policy*, vol. 8, no. 1, 2002, 107–18.

8 Guy Debord, cited in Tom McDonough, ed., *Guy Debord and the Situationist International* (Cambridge, Massachusetts: The MIT Press, 2002) 143.

9 Guy Debord, *Society of the Spectacle* (1967) (New York: Zone Books, 1997) 17.

10 See for example Matthieu Laurette's *The Great Exchange* (2000), a television programme in which the public exchange goods of progressively less value week by week, and Phil Collins, *The Return of the Real* (2005), which involved a press conference for former stars of Turkish reality television.

11 See for example Paolo Freire, *Pedagogy of the Oppressed* (London: Penguin, 1970), Augusto Boal, *Theatre of the Oppressed* (London: Pluto Press, 1979), Oskar Hansen, *Towards Open Form* (Warsaw: Foksal Gallery Foundation/Warsaw Academy of Fine Arts Museum, 2005).

12 Jacques Rancière, 'The Emancipated Spectator', unpublished conference paper, Frankfurt, August 2004, http://theater.kein.org/

13 Be this a disparagement of the spectator because he does nothing, while the performers on stage do something – or the converse claim that those who act are inferior to those who are able to look, contemplate ideas, and have critical distance on the world. The two positions can be switched but the structure remains the same. See Rancière, 'The Emancipated Spectator'.

14 A similar argument for consumption as creative is put forward by Michel de Certeau in *The Practice of Everyday Life* (1980). Literary variants of this idea can be found in Roland Barthes' 'Death of the Author' (1968) and 'From Work to Text' (1971), and in Jacques Derrida's idea of the 'Countersignature', *Paragraph*, vol. 27, no. 2, July 2004, 7–42.

TRUE PARTICIPATION IS OPEN

WE WILL NEVER BE ABLE TO KNOW WHAT WE GIVE TO THE SPECTATOR AUTHOR

Lygia Clark, Letter to Hélio Oiticica, 14 November 1968

Umberto Eco
The Poetics of the Open Work//1962

Italian semiotician Umberto Eco is one of the pioneers of reader response theory. The Open Work (1962) addresses the open-ended and aleatory nature of modern music, literature and art, pointing to the wider implications of this new mode of aesthetic reception for sociology and pedagogy, and for new forms of communication.

A number of recent pieces of instrumental music are linked by a common feature: the considerable autonomy left to the individual performer in the way he chooses to play the work. Thus, he is not merely free to interpret the composer's instructions following his own discretion (which in fact happens in traditional music), but he must impose his judgment on the form of the piece, as when he decides how long to hold a note or in what order to group the sounds: all this amounts to an act of improvised creation. Here are some of the best-known examples of the process.

1. In *Klavierstück XI*, by Karlheinz Stockhausen, the composer presents the performer a single large sheet of music paper with a series of note groupings. The performer then has to choose among these groupings, first for the one to start the piece and, next, for the successive units in the order in which he elects to weld them together. In this type of performance, the instrumentalist's freedom is a function of the 'narrative' structure of the piece, which allows him to 'mount' the sequence of musical units in the order he chooses.

2. In Luciano Berio's *Sequence for Solo Flute*, the composer presents the performer a text which predetermines the sequence and intensity of the sounds to be played. But the performer is free to choose how long to hold a note inside the fixed framework imposed on him, which in turn is established by the fixed pattern of the metronome's beat.

3. Henri Pousseur has offered the following description of his piece *Scambi*:

> *Scambi* is not so much a musical composition as a field of possibilities, an explicit invitation to exercise choice. It is made up of sixteen sections. Each of these can be linked to any two others, without weakening the logical continuity of the musical process. Two of its sections, for example, are introduced by similar motifs (after which they evolve in divergent patterns); another pair of sections, on the

contrary, tends to develop towards the same climax. Since the performer can start or finish with any one section, a considerable number of sequential permutations are made available to him. Furthermore, the two sections which begin on the same motif can be played simultaneously, so as to present a more complex structural polyphony. It is not out of the question that we conceive these formal notations as a marketable product: if they were tape-recorded and the purchaser had a sufficiently sophisticated reception apparatus, then the general public would be in a position to develop a private musical construct of its own and a new collective sensibility in matters of musical presentation and duration could emerge.

4. In Pierre Boulez's *Third Sonata for Piano*, the first section (*Antiphonie, Formant 1*) is made up of ten different pieces on ten corresponding sheets of music paper. These can be arranged in different sequences like a stack of filing cards, though not all possible permutations are permissible. The second part (*Formant 2, Thrope*) is made up of four parts with an internal circularity, so that the performer can commence with any one of them, linking it successively to the others until he comes round full circle. No major interpretative variants are permitted inside the various sections, but one of them, *Parenthèse*, opens with a prescribed time beat, which is followed by extensive pauses in which the beat is left to the player's discretion. A further prescriptive note is evinced by the composer's instructions on the manner of linking one piece to the next (for example, *sans retenir, enchaîner sans interruption*, and so on).

What is immediately striking in such cases is the macroscopic divergence between these forms of musical communication and the time-honoured tradition of the classics. This difference can be formulated in elementary terms as follows: a classical composition, whether it be a Bach fugue, Verdi's *Aïda*, or Stravinsky's *Rite of Spring*, posits an assemblage of sound units which the composer arranged in a closed, well-defined manner before presenting it to the listener. He converted his idea into conventional symbols which more or less obliged the eventual performer to reproduce the format devised by the composer himself, whereas the new musical works referred to above reject the definitive, concluded message and multiply the formal possibilities of the distribution of their elements. They appeal to the initiative of the individual performer, and hence they offer themselves not as finite works which prescribe specific repetition along given structural coordinates but as 'open' works, which are brought to their conclusion by the performer at the same time as he experiences them on an aesthetic plane.[1]

To avoid any confusion in terminology, it is important to specify that here the definition of the 'open work', despite its relevance in formulating a fresh

dialectics between the work of art and its performer, still requires to be separated from other conventional applications of this term. Aesthetic theorists, for example, often have recourse to the notions of 'completeness' and 'openness' in connection with a given work of art. These two expressions refer to a standard situation of which we are all aware in our reception of a work of art: we see it as the end product of an author's effort to arrange a sequence of communicative effects in such a way that each individual addressee can refashion the original composition devised by the author. The addressee is bound to enter into an interplay of stimulus and response which depends on his unique capacity for sensitive reception of the piece. In this sense the author presents a finished product with the intention that this particular composition should be appreciated and received in the same form as he devised it. As he reacts to the play of stimuli and his own response to their patterning, the individual addressee is bound to supply his own existential credentials, the sense conditioning which is peculiarly his own, a defined culture, a set of tastes, personal inclinations and prejudices. Thus, his comprehension of the original artefact is always modified by his particular and individual perspective. In fact, the form of the work of art gains its aesthetic validity precisely in proportion to the number of different perspectives from which it can be viewed and understood. These give it a wealth of different resonances and echoes without impairing its original essence; a road traffic sign, on the other hand, can be viewed in only one sense, and, if it is transfigured into some fantastic meaning by an imaginative driver, it merely ceases to be *that* particular traffic sign with that particular meaning. A work of art, therefore, is a complete and *closed* form in its uniqueness as a balanced organic whole, while at the same time constituting an *open* product on account of its susceptibility to countless different interpretations which do not impinge on its unadulterable specificity. Hence, every reception of a work of art is both an *interpretation* and a *performance* of it, because in every reception the work takes on a fresh perspective for itself.

Nonetheless, it is obvious that works like those of Berio and Stockhausen are 'open' in a far more tangible sense. In primitive terms we can say that they are quite literally 'unfinished': the author seems to hand them on to the performer more or less like the components of a construction kit. He seems to be unconcerned about the manner of their eventual deployment. This is a loose and paradoxical interpretation of the phenomenon, but the most immediately striking aspect of these musical forms can lead to this kind of uncertainty, although the very fact of our uncertainty is itself a positive feature: it invites us to consider *why* the contemporary artist feels the need to work in this kind of direction, to try to work out what historical evolution of aesthetic sensibility led

up to it and which factors in modern culture reinforced it. We are then in a position to surmise how these experiences should be viewed in the spectrum of a theoretical aesthetics.

Pousseur has observed that the poetics of the 'open' work tends to encourage 'acts of conscious freedom' on the part of the performer and place him at the focal point of a network of limitless interrelations, among which he chooses to set up his own form without being influenced by an external *necessity* which definitively prescribes the organization of the work in hand.[2] At this point one could object (with reference to the wider meaning of 'openness' already introduced in this essay) that any work of art, even if it is not passed on to the addressee in an unfinished state, demands a free, inventive response, if only because it cannot really be appreciated unless the performer somehow reinvents it in psychological collaboration with the author himself. Yet this remark represents the theoretical perception of contemporary aesthetics, achieved only after painstaking consideration of the function of artistic performance; certainly an artist of a few centuries ago was far from being aware of these issues. Instead nowadays it is primarily the artist who is aware of its implications. In fact, rather than submit to the 'openness' as an inescapable element of artistic interpretation, he subsumes it into a positive aspect of his production, recasting the work so as to expose it to the maximum possible 'opening'.

The force of the subjective element in the interpretation of a work of art (any interpretation implies an interplay between the addressee and the work as an objective fact) was noticed by classical writers, especially when they set themselves to consider the figurative arts. In the *Sophist* Plato observes that painters suggest proportions not by following some objective canon but by judging 'them in relation to the angle from which they are seen by the observer'. Vitruvius makes a distinction between 'symmetry' and 'eurhythmy', meaning by this latter term an adjustment of objective proportions to the requirements of a subjective vision. The scientific and practical development of the technique of perspective bears witness to the gradual maturation of this awareness of an interpretative subjectivity pitted against the work of art. Yet it is equally certain that this awareness has led to a tendency to operate against the 'openness' of the work, to favour its 'closing out'. The various devices of perspective were just so many different concessions to the actual location of the observer in order to ensure that he looked at the figure in *the only possible right way* – that is, the way the author of the work had prescribed, by providing various visual devices for the observer's attention to focus on.

Let us consider another example. In the Middle Ages there grew up a theory of allegory which posited the possibility of reading the Scriptures (and

THE POETICS OF THE 'OPEN' WORK TENDS TO
ENCOURAGE 'ACTS OF
CONSCIOUS FREEDOM'
ON THE PART OF THE
PERFORMER AND
PLACE HIM AT
THE FOCAL
POINT OF A
NETWORK OF
LIMITLESS
INTERRELA
TIONS

Henri Pousseur cited by Umberto Eco in *The Open Work*, 1962

eventually poetry, figurative arts) not just in the literal sense but also in three other senses: the moral, the allegorical and the anagogical. This theory is well known from a passage in Dante, but its roots go back to Saint Paul (*'videmus nunc per speculum in aenigmate, tunc autem facie ad faciem'*) ['For now we see through a glass, darkly; but then face to face'], and it was developed by Saint Jerome, Augustine, Bede, Scotus Erigena, Hugh and Richard of Saint Victor, Alain of Lille, Bonaventure, Aquinas and others in such a way as to represent a cardinal point of medieval poetics. A work in this sense is undoubtedly endowed with a measure of 'openness'. The reader of the text knows that every sentence and every trope is 'open' to a multiplicity of meanings which he must hunt for and find. Indeed, according to how he feels at one particular moment, the reader might choose a possible interpretative key which strikes him as exemplary of this spiritual state. He will *use* the work according to the desired meaning (causing it to come alive again, somehow different from the way he viewed it at an earlier reading). However, in this type of operation, 'openness' is far removed from meaning 'indefiniteness' of communication, 'infinite' possibilities of form, and complete freedom of reception. What in fact is made available is a range of rigidly pre-established and ordained interpretative solutions, and these never allow the reader to move outside the strict control of the author. Dante sums up the issue in his thirteenth Letter:

> We shall consider the following lines in order to make this type of treatment clearer: *In exitu Israel de Egypto, domus Jacob de populo barbaro, facta est judea sanctificatio eius, Israel potestas eius.* [When Israel went out of Egypt, the house of Jacob from a people of strange language; Judah was his sanctuary, and Israel his dominion.] Now if we just consider the literal meaning, what is meant here is the departure of the children of Israel from Egypt at the time of Moses. If we consider the allegory, what is meant is our human redemption through Christ. If we consider the moral sense, what is meant is the conversion of the soul from the torment and agony of sin to a state of grace. Finally, if we consider the anagogical sense, what is meant is the release of the spirit from the bondage of this corruption to the freedom of eternal glory.

It is obvious at this point that all available possibilities of interpretation have been exhausted. The reader can concentrate his attention on one sense rather than on another, in the limited space of this four-tiered sentence, but he must always follow rules that entail a rigid univocality. The meaning of allegorical figures and emblems which the medieval reader is likely to encounter is already prescribed by his encyclopaedias, bestiaries and lapidaries. Any symbolism is objectively defined and organized into a system. Underpinning this poetics of

the necessary and the univocal is an ordered cosmos, a hierarchy of essences and laws which poetic discourse can clarify at several levels, but which each individual must understand in the only possible way, the one determined by the creative *logos*. The order of a work of art in this period is a mirror of imperial and theocratic society. The laws governing textual interpretation are the laws of an authoritarian regime which guide the individual in his every action, prescribing the ends for him and offering him the means to attain them.

It is not that the *four* solutions of the allegorical passage are quantitatively more limited than the *many* possible solutions of a contemporary 'open' work. As I shall try to show, it is a different vision of the world which lies under these different aesthetic experiences.

If we limit ourselves to a number of cursory historical glimpses, we can find one striking aspect of 'openness' in the 'open form' of Baroque. Here it is precisely the static and unquestionable definitiveness of the classical Renaissance form which is denied: the canons of space extended round a central axis, closed in by symmetrical lines and shut angles which cajole the eye toward the centre in such a way as to suggest an idea of 'essential' eternity rather than movement. Baroque form is dynamic; it tends to an indeterminacy of effect (in its play of solid and void, light and darkness, with its curvature, its broken surfaces, its widely diversified angles of inclination); it conveys the idea of space being progressively dilated. Its search for kinetic excitement and illusory effect leads to a situation where the plastic mass in the Baroque work of art never allows a privileged, definitive, frontal view; rather, it induces the spectator to shift his position continuously in order to see the work in constantly new aspects, as if it were in a state of perpetual transformation. Now if Baroque spirituality is to be seen as the first clear manifestation of modern culture and sensitivity, it is because here, for the first time, man opts out of the canon of authorized responses and finds that he is faced (both in art and in science) by a world in a fluid state which requires corresponding creativity on his part. The poetic treatises concerning '*maraviglia*', 'wit', '*agudezas*', and so on really strain to go further than their apparently Byzantine appearance: they seek to establish the new man's inventive role. He is no longer to see the work of art as an object which draws on given links with experience and which demands to be enjoyed; now he sees it as a potential mystery to be solved, a role to fulfil, a stimulus to quicken his imagination. Nonetheless, even these conclusions have been codified by modern criticism and organized into aesthetic canons. In fact, it would be rash to interpret Baroque poetics as a conscious theory of the 'open work'.

Between classicism and the Enlightenment, there developed a further concept which is of interest to us in the present context. The concept of 'pure poetry' gained currency for the very reason that general notions and abstract

canons fell out out fashion, while the tradition of English empiricism increasingly argued in favour of the 'freedom' of the poet and set the stage for the coming theories of creativity. From Burke's declarations about the emotional power of words, it was a short step to Novalis' view of the pure evocative power of poetry as an art of blurred sense and vague outlines. An idea is now held to be all the more original and stimulating in so far as it 'allows for a greater interplay and mutual convergence of concepts, life-views and attitudes. When a work offers a multitude of intentions, a plurality of meaning, and above all a wide variety of different ways of being understood and appreciated, then under these conditions we can only conclude that it is of vital interest and that it is a pure expression of personality.'[3]

To close our consideration of the Romantic period, it will be useful to refer to the first occasion when a conscious poetics of the open work appears. The moment is late-nineteenth-century Symbolism; the text is Verlaine's *Art Poétique:*

> *De la musique avant toute chose,*
> *et pour cela préfère l'impair*
> *plus vague et plus soluble dans l'air*
> *sans rien en lui qui pèse et qui pose.*

> Music before everything else,
> and, to that end, prefer the uneven
> more vague and more soluble in air
> with nothing in it that is heavy or still.

Mallarmé's programmatic statement is even more explicit and pronounced in this context: '*Nommer un objet c'est supprimer les trois quarts de la jouissance du poème, qui est faite du bonheur de deviner peu a peu: le suggérer ... voila le rêve'* ('To name an object is to suppress three-fourths of the enjoyment of the poem, which is composed of the pleasure of guessing little by little: to suggest ... there is the dream'). The important thing is to prevent a single sense from imposing itself at the very outset of the receptive process. Blank space surrounding a word, typographical adjustments, and spatial composition in the page setting of the poetic text – all contribute to create a halo of indefiniteness and to make the text pregnant with infinite suggestive possibilities.

This search for *suggestiveness* is a deliberate move to 'open' the work to the free response of the addressee. An artistic work that suggests is also one that can be performed with the full emotional and imaginative resources of the interpreter. Whenever we read poetry there is a process by which we try to adapt our personal world to the emotional world proposed by the text. This is all

the more true of poetic works that are deliberately based on suggestiveness, since the text sets out to stimulate the private world of the addressee so that he can draw from inside himself some deeper response that mirrors the subtler resonances underlying the text.

A strong current in contemporary literature follows this use of symbol as a communicative channel for the indefinite, open to constantly shifting responses and interpretative stances. It is easy to think of Kafka's work as 'open': trial, castle, waiting, passing sentence, sickness, metamorphosis and torture – none of these narrative situations is to be understood in the immediate literal sense. But, unlike the constructions of medieval allegory, where the superimposed layers of meaning are rigidly prescribed, in Kafka there is no confirmation in an encyclopaedia, no matching paradigm in the cosmos, to provide a key to the symbolism. The various existentialist, theological, clinical and psychoanalytic interpretations of Kafka's symbols cannot exhaust all the possibilities of his works. The work remains inexhaustible in so far as it is 'open', because in it an ordered world based on universally acknowledged laws is being replaced by a world based on ambiguity, both in the negative sense that directional centres are missing and in a positive sense, because values and dogma are constantly being placed in question.

Even when it is difficult to determine whether a given author had symbolist intentions or was aiming at effects of ambivalence or indeterminacy, there is a school of criticism nowadays which tends to view all modern literature as built upon symbolic patterns. W.Y. Tindall, in his book on the literary symbol, offers an analysis of some of the greatest modern literary works in order to test Valéry's declaration that *'il n'y a pas de vrai sens d'un texte'* ('there is no true meaning of a text'). Tindall eventually concludes that a work of art is a construct which anyone at all, including its author, can put to any use whatsoever, as he chooses. This type of criticism views the literary work as a continuous potentiality of 'openness' – in other words, an indefinite reserve of meanings. This is the scope of the wave of American studies on the structure of metaphor, or of modern work on 'types of ambiguity' offered by poetic discourse.[4]

Clearly, the work of James Joyce is a major example of an 'open' mode, since it deliberately seeks to offer an image of the ontological and existential situation of the contemporary world. The 'Wandering Rocks' chapter in *Ulysses* amounts to a tiny universe that can be viewed from different perspectives: the last residue of Aristotelian categories has now disappeared. Joyce is not concerned with a consistent unfolding of time or a plausible spatial continuum in which to stage his characters' movements. Edmund Wilson has observed that, like Proust's or Whitehead's or Einstein's world, 'Joyce's world is always changing as it is perceived by different observers and by them at different times.'[5]

In *Finnegans Wake* we are faced with an even more startling process of 'openness': the book is moulded into a curve that bends back on itself, like the Einsteinian universe. The opening word of the first page is the same as the closing word of the last page of the novel. Thus, the work is *finite* in one sense, but in another sense it is *unlimited*. Each occurrence, each word stands in a series of possible relations with all the others in the text. According to the semantic choice which we make in the case of one unit, so goes the way we interpret all the other units in the text. This does not mean that the book lacks specific sense. If Joyce does introduce some keys into the text, it is precisely because he wants the work to be read in a certain sense. But this particular 'sense' has all the richness of the cosmos itself. Ambitiously, the author intends his book to imply the totality of space and time, of all spaces and all times that are possible. The principal tool for this all-pervading ambiguity is the pun, the *calembour*, by which two, three or even ten different etymological roots are combined in such a way that a single word can set up a knot of different sub-meanings, each of which in turn coincides and interrelates with other local allusions, which are themselves 'open' to new configurations and probabilities of interpretation. The reader of *Finnegans Wake* is in a position similar to that of the person listening to post-dodecaphonic serial composition as he appears in a striking definition by Pousseur: 'Since the phenomena are no longer tied to one another by a term-to-term determination, it is up to the listener to place himself deliberately in the midst of an inexhaustible network of relationships and to choose for himself, so to speak, his own modes of approach, his reference points and his scale, and to endeavour to use as many dimensions as he possibly can at the same time and thus dynamize, multiply and extend to the utmost degree his perceptual faculties.'[6]

Nor should we imagine that the tendency toward openness operates only at the level of indefinite suggestion and stimulation of emotional response. In Brecht's theoretical work on drama, we shall see that dramatic action is conceived as the problematic exposition of specific points of tension. Having presented these tension points (by following the well-known technique of epic recitation, which does not seek to influence the audience, but rather to offer a series of facts to be observed, employing the device of 'defamiliarization'), Brecht's plays do not, in the strict sense, devise solutions at all. It is up to the audience to draw its own conclusions from what it has seen on stage. Brecht's plays also end in a situation of ambiguity (typically, and more than any other, his *Galileo*), although it is no longer the morbid ambiguousness of a half-perceived infinitude or an anguish-laden mystery, but the specific concreteness of an ambiguity in social intercourse, a conflict of unresolved problems taxing the ingenuity of playwright, actors and audience alike. Here the work is 'open' in the

same sense that a debate is 'open'. A solution is seen as desirable and is actually anticipated, but it must come from the collective enterprise of the audience. In this case the 'openness' is converted into an instrument of revolutionary pedagogics.

In all the phenomena we have so far examined, I have employed the category of 'openness' to define widely differing situations, but on the whole the sorts of works taken into consideration are substantially different from the post-Webernian musical composers whom I considered at the opening of this essay. From the Baroque to modern Symbolist poetics, there has been an ever-sharpening awareness of the concept of the work susceptible to many different interpretations. However, the examples considered in the preceding section propose an 'openness' based on the *theoretical, mental* collaboration of the consumer, who must freely interpret an artistic datum, a product which has already been organized in its structural entirety (even if this structure allows for an indefinite plurality of interpretations). On the other hand, a composition like *Scambi*, by Pousseur, represents a fresh advance. Somebody listening to a work by Webern freely reorganizes and enjoys a series of interrelations inside the context of the sound system offered to him in that particular (already fully produced) composition. But in listening to *Scambi* the auditor is required to do some of this organizing and structuring of the musical discourse. He collaborates with the composer in *making* the composition.

None of this argument should be conceived as passing an aesthetic judgment on the relative validity of the various types of works under consideration. However, it is clear that a composition such as *Scambi* poses a completely new problem. It invites us to identify inside the category of 'open' works a further, more restricted classification of works which can be defined as 'works in movement', because they characteristically consist of unplanned or physically incomplete structural units.

In the present cultural context, the phenomenon of the 'work in movement' is certainly not limited to music. There are, for example, artistic products which display an intrinsic mobility, a kaleidoscopic capacity to suggest themselves in constantly renewed aspects to the consumer. A simple example is provided by Calder's mobiles or by mobile compositions by other artists: elementary structures which can move in the air and assume different spatial dispositions. They continuously create their own space and the shapes to fill it.

If we turn to literary production to try to isolate an example of a 'work in movement', we are immediately obliged to take into consideration Mallarmé's *Livre*, a colossal and far-reaching work, the quintessence of the poet's production. He conceived it as the work which would constitute not only the

goal of his activities but also the end goal of the world: '*Le monde existe pour aboutir à un livre.*' ['The world exists to end up in a book'.] Mallarmé never finished the book, although he worked on it at different periods throughout his life. But there are sketches for the ending which have recently been brought to light by the acute philological research of Jacques Schérer.[7]

The metaphysical premises for Mallarmé's *Livre* are enormous and possibly questionable. I would prefer to leave them aside in order to concentrate on the dynamic structure of this artistic object which deliberately sets out to validate a specific poetic principle: '*Un livre ne commence ni ne finit; tout au plus fait-il semblant.*' ['A book neither begins nor ends; it only pretends to do so.'] The *Livre* was conceived as a mobile apparatus, not just in the mobile and 'open' sense of a composition such as *Un coup de dès ...* [*A Throw of the Dice ...*], where grammar, syntax and typesetting introduced a plurality of elements, polymorphous in their indeterminate relation to each other.

However, Mallarmé's immense enterprise was utopian: it was embroidered with ever more disconcerting aspirations and ingenuities, and it is not surprising that it was never brought to completion. We do not know whether, had the work been completed, the whole project would have had any real value. It might well have turned out to be a dubious mystical and esoteric incarnation of a decadent sensitivity that had reached the extreme point of its creative parabola. I am inclined to this second view, but it is certainly interesting to find at the very threshold of the modern period such a vigorous programme for a *work in movement*, and this is a sign that certain intellectual currents circulate imperceptibly until they are adopted and justified as cultural data which have to be integrated organically into the panorama of a whole period.

In every century, the way that artistic forms are structured reflects the way in which science or contemporary culture views reality. The closed, single conception in a work by a medieval artist reflected the conception of the cosmos as a hierarchy of fixed, pre-ordained orders. The work as a pedagogical vehicle, as a monocentric and necessary apparatus (incorporating a rigid internal pattern of metre and rhymes) simply reflects the syllogistic system, a logic of necessity, a deductive consciousness by means of which reality could be made manifest step by step without unforeseen interruptions, moving forward in a single direction, proceeding from first principles of science which were seen as one and the same with the first principles of reality. The openness and dynamism of the Baroque mark, in fact, the advent of a new scientific awareness: the *tactile* is replaced by the *visual* (meaning that the subjective element comes to prevail) and attention is shifted from the *essence* to the *appearance* of architectural and pictorial products. It reflects the rising interest in a psychology of impression

and sensation – in short, an empiricism which converts the Aristotelian concept of real substance into a series of perceptions by the viewer. On the other hand, by giving up the essential focus of the composition and the prescribed point of view for its viewer, aesthetic innovations were in fact mirroring the Copernican vision of the universe. This definitively eliminated the notion of geocentricity and its allied metaphysical constructs. In the modern scientific universe, as in architecture and in Baroque pictorial production, the various component parts are all endowed with equal value and dignity, and the whole construct expands toward a totality which is close to the infinite. It refuses to be hemmed in by any ideal normative conception of the world. It shares in a general urge toward discovery and constantly renewed contact with reality.

In its own way, the 'openness' that we meet in the decadent strain of Symbolism reflects a cultural striving to unfold new vistas. For example, one of Mallarmé's projects for a multidimensional, deconstructible book envisaged the breaking down of the initial unit into sections which could be reformulated and which could express new perspectives by being deconstructed into correspondingly smaller units which were also mobile and reducible. This project obviously suggests the universe as it is conceived by modern, non-Euclidean geometries.

Hence, it is not overambitious to detect in the poetics of the 'open' work – and even less so in the 'work in movement' – more or less specific overtones of trends in contemporary scientific thought. For example, it is a critical commonplace to refer to the spatio-temporal continuum in order to account for the structure of the universe in Joyce's works. Pousseur has offered a tentative definition of his musical work which involves the term 'field of possibilities'. In fact, this shows that he is prepared to borrow two extremely revealing technical terms from contemporary culture. The notion of 'field' is provided by physics and implies a revised vision of the classic relationship posited between cause and effect as a rigid, one-directional system: now a complex interplay of motive forces is envisaged, a configuration of possible events, a complete dynamism of structure. The notion of 'possibility' is a philosophical canon which reflects a widespread tendency in contemporary science; the discarding of a static, syllogistic view of order, and a corresponding devolution of intellectual authority to personal decision, choice and social context.

If a musical pattern no longer necessarily determines the immediately following one, if there is no tonal basis which allows the listener to infer the next steps in the arrangement of the musical discourse from what has physically preceded them, this is just part of a general breakdown in the concept of causation. The two-value truth logic which follows the classical *aut-aut*, the disjunctive dilemma between *true* and *false*, a fact and its contradictory, is no

longer the only instrument of philosophical experiment. Multi-value logics are now gaining currency, and these are quite capable of incorporating *indeterminacy* as a valid stepping-stone in the cognitive process. In this general intellectual atmosphere, the poetics of the open work is peculiarly relevant: it posits the work of art stripped of necessary and foreseeable conclusions, works in which the performer's freedom functions as part of the *discontinuity* which contemporary physics recognizes, not as an element of disorientation, but as an essential stage in all scientific verification procedures and also as the verifiable pattern of events in the subatomic world.

From Mallarmé's *Livre* to the musical compositions which we have considered, there is a tendency to see every execution of the work of art as divorced from its ultimate definition. Every performance *explains* the composition but does not *exhaust* it. Every performance makes the work an actuality, but is itself only complementary to all possible other performances of the work. In short, we can say that every performance offers us a complete and satisfying version of the work, but at the same time makes it incomplete for us, because it cannot simultaneously give all the other artistic solutions which the work may admit.

Perhaps it is no accident that these poetic systems emerge at the same period as the physicists' principle of *complementarity*, which rules that it is not possible to indicate the different behaviour patterns of an elementary particle simultaneously. To describe these different behaviour patterns, different *models*, which Heisenberg has defined as adequate when properly utilized, are put to use, but, since they contradict one another, they are therefore also complementary.[8] Perhaps we are in a position to state that for these works of art an incomplete knowledge of the system is in fact an essential feature in its formulation. Hence one could argue, with Bohr, that the data collected in the course of experimental situations cannot be gathered in one image but should be considered as complementary, since only the sum of all the phenomena could exhaust the possibilities of information.[9]

Above I discussed the principle of ambiguity as moral disposition and problematic construct. Again, modern psychology and phenomenology use the term 'perceptive ambiguities', which indicates the availability of new cognitive positions that fall short of conventional epistemological stances and that allow the observer to conceive the world in a fresh dynamics of potentiality before the fixative process of habit and familiarity comes into play. Husserl observed that

> each state of consciousness implies the existence of a horizon which varies with the modification of its connections together with other states, and also with its own phases of duration... In each external perception, for instance, the sides of

the objects which are actually *perceived* suggest to the viewer's attention the unperceived sides which, at the present, are viewed only in a non-intuitive manner and are expected to become elements of the succeeding perception. This process is similar to a continuous projection which takes on a new meaning with each phase of the perceptive process. Moreover, perception itself includes horizons which encompass other perceptive possibilities, such as a person might experience by changing deliberately the direction of his perception, by turning his eyes one way instead of another, or by taking a step forward or sideways, and so forth.[10]

Sartre notes that the existent object can never be reduced to a given series of manifestations, because each of these is bound to stand in relationship with a continuously altering subject. Not only does an object present different *Abschattungen* (or profiles), but also different points of view are available by way of the same *Abschattung*. In order to be defined, the object must be related back to the total series of which, by virtue of being one possible apparition, it is a member. In this way the traditional dualism between being and appearance is replaced by a straight polarity of finite and infinite, which locates the infinite at the very core of the finite. This sort of 'openness' is at the heart of every act of perception. It characterizes every moment of our cognitive experience. It means that each phenomenon seems to be 'inhabited' by a certain *power* – in other words, 'the ability to manifest itself by a series of real or likely manifestations.' The problem of the relationship of a phenomenon to its ontological basis is altered by the perspective of perceptive 'openness' to the problem of its relationship to the multiplicity of different-order perceptions which we can derive from it.[11]

This intellectual position is further accentuated in Merleau-Ponty:

How can anything ever present itself truly to us since its synthesis is never completed? How could I gain the experience of the world, as I would of an individual actuating his own existence, since none of the views or perceptions I have of it can exhaust it and the horizons remain forever open? ... The belief in things and in the world can only express the assumption of a complete synthesis. Its completion, however, is made impossible by the very nature of the perspectives to be connected, since each of them sends back to other perspectives through its own horizons ... The contradiction which we feel exists between the world's reality and its incompleteness is identical to the one that exists between the ubiquity of consciousness and its commitment to a field of presence. This ambiguousness does not represent an imperfection in the nature of existence or

in that of consciousness; it is its very definition ... Consciousness, which is commonly taken as an extremely enlightened region, is, on the contrary, the very region of indetermination.'[12]

These are the sorts of problems which phenomenology picks out at the very heart of our existential situation. It proposes to the artist, as well as to the philosopher and the psychologist, a series of declarations which are bound to act as a stimulus to his creative activity in the world of forms: 'It is therefore essential for an object and also for the world to present themselves to us as "open" ... and as always promising future perceptions.'[13]

It would be quite natural for us to think that this flight away from the old, solid concept of necessity and the tendency toward the ambiguous and the indeterminate reflect a crisis of contemporary civilization. On the other hand, we might see these poetical systems, in harmony with modern science, as expressing the positive possibility of thought and action made available to an individual who is open to the continuous renewal of his life patterns and cognitive processes. Such an individual is productively committed to the development of his own mental faculties and experiential horizons. This contrast is too facile and Manichaean. Our main intent has been to pick out a number of analogies which reveal a reciprocal play of problems in the most disparate areas of contemporary culture and which point to the common elements in a new way of looking at the world.

What is at stake is a convergence of new canons and requirements which the forms of art reflect by way of what we could term *structural homologies*. This need not commit us to assembling a rigorous parallelism – it is simply a case of phenomena like the 'work in movement' simultaneously reflecting mutually contrasted epistemological situations, as yet contradictory and not satisfactorily reconciled. Thus, the concepts of 'openness' and dynamism may recall the terminology of quantum physics: indeterminacy and discontinuity. But at the same time they also exemplify a number of situations in Einsteinian physics.

The multiple polarity of a serial composition in music, where the listener is not faced by an absolute conditioning centre of reference, requires him to constitute his own system of auditory relationships.[14] He must allow such a centre to emerge from the sound continuum. Here are no privileged points of view, and all available perspectives are equally valid and rich in potential. Now, this multiple polarity is extremely close to the spatio-temporal conception of the universe which we owe to Einstein. The thing which distinguishes the Einsteinian concept of the universe from quantum epistemology is precisely this faith in the totality of the universe, a universe in which discontinuity and indeterminacy can admittedly upset us with their surprise apparitions, but in

fact, to use Einstein's words, presuppose not a God playing random games with dice but the Divinity of Spinoza, who rules the world according to perfectly regulated laws. In this kind of universe, relativity means the infinite variability of experience as well as the infinite multiplication of possible ways of measuring things and viewing their position. But the objective side of the whole system can be found in the invariance of the simple formal descriptions (of the differential equations) which establish once and for all the relativity of empirical measurement.

This is not the place to pass judgment on the scientific validity of the metaphysical construct implied by Einstein's system. But there is a striking analogy between his universe and the universe of the work in movement. The God in Spinoza, who is made into an untestable hypothesis by Einsteinian metaphysics, becomes a cogent reality for the work of art and matches the organizing impulse of its creator.

The *possibilities* which the work's openness makes available always work within a given *field of relations*. As in the Einsteinian universe, in the 'work in movement' we may well deny that there is a single prescribed point of view. But this does not mean complete chaos in its internal relations. What it does imply is an organizing rule which governs these relations. Therefore, to sum up, we can say that the 'work in movement' is the possibility of numerous different personal interventions, but it is not an amorphous invitation to indiscriminate participation. The invitation offers the performer the opportunity for an oriented insertion into something which always remains the world intended by the author.

In other words, the author offers the interpreter, the performer, the addressee, a work *to be completed*. He does not know the exact fashion in which his work will be concluded, but he is aware that once completed the work in question will still be his own. It will not be a different work, and, at the end of the interpretative dialogue, a form which is *his* form will have been organized, even though it may have been assembled by an outside party in a particular way that he could not have foreseen. The author is the one who proposed a number of possibilities which had already been rationally organized, oriented and endowed with specifications for proper development.

Berio's *Sequence*, which is played by different flutists, Stockhausen's *Klavierstück XI*, or Pousseur's *Mobiles*, which are played by different pianists (or performed twice over by the same pianists), will never be quite the same on different occasions. Yet they will never be gratuitously different. They are to be seen as the actualization of a series of consequences whose premises are firmly rooted in the original data provided by the author.

This happens in the musical works which we have already examined, and it happens also in the plastic artefacts we considered. The common factor is a mutability which is always deployed within the specific limits of a given taste, or of predetermined formal tendencies, and is authorized by the concrete pliability of the material offered for the performer's manipulation. Brecht's plays appear to elicit free and arbitrary response on the part of the audience. Yet they are also rhetorically constructed in such a way as to elicit a reaction oriented toward, and ultimately anticipating, a Marxist dialectic logic as the basis for the whole field of possible responses.

All these examples of 'open' works and 'works in movement' have this latent characteristic, which guarantees that they will always be seen as 'works' and not just as a conglomeration of random components, ready to emerge from the chaos in which they previously stood and permitted to assume any form whatsoever.

Now, a dictionary clearly presents us with thousands upon thousands of words which we could freely use to compose poetry, essays on physics, anonymous letters or grocery lists. In this sense the dictionary is clearly open to the reconstitution of its raw material in any way that the manipulator wishes. But this does not make it a 'work'. The 'openness' and dynamism of an artistic work consist in factors which make it susceptible to a whole range of integrations. They provide it with organic complements which they graft into the structural vitality which the work already possesses, even if it is incomplete. This structural vitality is still seen as a positive property of the work, even though it admits of all kinds of different conclusions and solutions for it.

The preceding observations are necessary because, when we speak of a work of art, our Western aesthetic tradition forces us to take 'work' in the sense of a personal production which may well vary in the ways it can be received but which always maintains a coherent identity of its own and which displays the personal imprint that makes it a specific, vital and significant act of communication. Aesthetic theory is quite content to conceive of a variety of different poetics, but ultimately it aspires to general definitions, not necessarily dogmatic or *sub specie aeternitatis*, which are capable of applying the category of the 'work of art' broadly speaking to a whole variety of experiences, which can range from the *Divine Comedy* to, say, electronic composition based on the different permutations of sonic components.

We have, therefore, seen that (i) 'open' works, in so far as they are *in movement*, are characterized by the invitation to *make the work* together with the author and that (ii) on a wider level (as a *subgenus* in the *species* 'work in movement') there exist works which, though organically completed, are 'open'

to a continuous generation of internal relations which the addressee must uncover and select in his act of perceiving the totality of incoming stimuli. (iii) *Every* work of art, even though it is produced by following an explicit or implicit poetics of necessity, is effectively open to a virtually unlimited range of possible readings, each of which causes the work to acquire new vitality in terms of one particular taste, or perspective, or personal *performance.*

Contemporary aesthetics has frequently pointed out this last characteristic *of every* work of art. According to Luigi Pareyson:

> The work of art ... is a form, namely of movement, that has been concluded; or we can see it as an infinite contained within finiteness ... The work therefore has infinite aspects, which are not just 'parts' or fragments of it, because each of them contains the totality of the work, and reveals it according to a given perspective. So the variety of performances is founded both in the complex factor of the performer's individuality and in that of the work to be performed ... The infinite points of view of the performers and the infinite aspects of the work interact with each other, come into juxtaposition and clarify each other by a reciprocal process, in such a way that a given point of view is capable of revealing the whole work only if it grasps it in the relevant, highly personalized aspect. Analogously, a single aspect of the work can only reveal the totality of the work in a new light if it is prepared to wait for the right point of view, capable of grasping and proposing the work in all its vitality.

The foregoing allows Pareyson to move on to the assertion that

> all performances are definitive in the sense that each one is for the performer, tantamount to the work itself; equally, all performances are bound to be provisional in the sense that each performer knows that he must always try to deepen his own interpretation of the work. In so far as they are definitive, these interpretations are parallel, and each of them is such as to exclude the others without in any way negating them.[15]

This doctrine can be applied to all artistic phenomena and to artworks throughout the ages. But it is useful to have underlined that now is the period when aesthetics has paid especial attention to the whole notion of 'openness' and sought to expand it. In a sense these requirements, which aesthetics has referred widely to every type of artistic production, are the same as those posed by the poetics of the 'open work' in a more decisive and explicit fashion. Yet this does not mean that the existence of 'open' works and of 'works in movement' adds absolutely nothing to our experience, because everything in the world is

already implied and subsumed by everything else, from the beginning of time, in the same way that it now appears that every discovery has already been made by the Chinese. Here we have to distinguish between the theoretical level of aesthetics as a philosophical discipline which attempts to formulate definitions and the practical level of poetics as programmatic projects for creation. While aesthetics brings to light one of the fundamental demands of contemporary culture, it also reveals the latent possibilities of a certain type of experience in every artistic product, independently of the operative criteria which presided over its moment of inception.

The poetic theory or practice of the 'work in movement' senses this possibility as a specific vocation. It allies itself openly and selfconsciously to current trends in scientific method and puts into action and tangible form the very trend which aesthetics has already acknowledged as the general background to performance. These poetic systems recognize 'openness' as *the* fundamental possibility of the contemporary artist or consumer. The aesthetic theoretician, in his turn, will see a confirmation of his own intuitions in these practical manifestations; they constitute the ultimate realization of a receptive mode which can function at many different levels of intensity.

Certainly this new receptive mode vis-a-vis the work of art opens up a much vaster phase in culture and in this sense is not intellectually confined to the problems of aesthetics. The poetics of the 'work in movement' (and partly that of the 'open' work) sets in motion a new cycle of relations between the artist and his audience, a new mechanics of aesthetic perception, a different status for the artistic product in contemporary society. It opens a new page in sociology and in pedagogy, as well as a new chapter in the history of art. It poses new practical problems by organizing new communicative situations. In short, it installs a new relationship between the *contemplation* and the *utilization* of a work of art.

Seen in these terms and against the background of historical influences and cultural interplay which links art by analogy to widely diversified aspects of the contemporary world view, the situation of art has now become a situation in the process of development. Far from being fully accounted for and catalogued, it deploys and poses problems in several dimensions. In short, it is an 'open' situation, *in movement.* A work in progress.

1 Here we must eliminate a possible misunderstanding straight away: the practical intervention of a 'performer' (the instrumentalist who plays a piece of music or the actor who recites a passage) is different from that of an interpreter in the sense of consumer (somebody who looks at a picture, silently reads a poem, or listens to a musical composition performed by somebody else). For the purposes of aesthetic analysis, however, both cases can be seen as different manifestations of the same interpretative attitude. Every 'reading', 'contemplation' or

'enjoyment' of a work of art represents a tacit or private form of 'performance'.

2 Henri Pousseur, 'La nuova sensibilita musicale', *Incontri musicali*, 2 (May 1958) 25.

3 For the evolution of pre-Romantic and Romantic poets in this sense, see L. Anceschi, *Autonomia ed eteronomia dell'arte*, 2nd ed. (Florence: Vallecchi, 1959).

4 See W.Y. Tindall, *The Literary Symbol* (New York: Columbia University Press, 1955). For an analysis of the aesthetic importance of the notion of ambiguity, see the useful observations and bibliographical references in Gillo Dorfles, *Il divenire delle arti* (Turin: Einaudi, 1959) 51 ff.

5 Edmund Wilson, *Axel's Castle* (London: Collins, Fontana Library, 1961) 178.

6 Pousseur, 'La nuova sensibilita musicale', 25.

7 J. Schérer, *Le 'Livre' de Mallarmé Premières recherches sur des documents inédits* (Paris: Gallimard, 1957). See in particular the third chapter, 'Physique du livre'.

8 Werner Heisenberg, *Physics and Philosophy* (London: Allen and Unwin, 1959) ch. 3.

9 Niels Bohr, in his epistemological debate with Einstein; see P.A. Schlipp, ed., *Albert Einstein: Philosopher-Scientist* (Evanston, 111: Library of Living Philosophers, 1949). Epistemological thinkers connected with quantum methodology have rightly warned against an ingenuous transposition of physical categories into the fields of ethics and psychology (for example, the identification of indeterminacy with moral freedom; see P. Frank, *Present Role of Science*, Opening Address to the Seventh International Congress of Philosophy, Venice, September 1958). Hence, it would not be justified to understand my formulation as making an analogy between the structures of the work of art and the supposed structures of the world. Indeterminacy, complementarity, noncausality are not *modes of being* in the physical world, but *systems for describing* it in a convenient way. The relationship which concerns my exposition is not the supposed nexus between an 'ontological' situation and a morphological feature in the work of art, but the relation between an operative procedure for explaining physical processes and an operative procedure for explaining the processes of artistic production and reception. In other words, the relationship between a *scientific methodology* and a *poetics*.

10 Edmund Husserl, *Méditations cartésiennes*, Med. 2, par. 19 (Paris: Vrin, 1953) 39. The translation of this passage is by Anne Fabre-Luce.

11 Jean-Paul Sartre, *L'Être et le néant* (Paris: Gallimard, 1943) ch. i.

12 Maurice Merleau-Ponty, *Phénomenologie de la perception* (Paris: Gallimard, 1945) 381–3.

13 *Ibid.*, 384.

14 On this 'éclatement multidirectionnel des structures', see A. Boucourechliev, 'Problèmes de la musique moderne', *Nouvelle revue française* (December–January 1960–61).

15 Luigi Pareyson, *Estetica: teoria della formatività*, 2nd ed. (Bologna: Zanichelli, 1960) 194 ff., and in general the whole of chapter 8, 'Lettura, interpretazione e critica'.

Umberto Eco, *Opera aperta* (Milan: Bompiano, 1962); trans. Anna Cancogni, *The Open Work* (Cambridge, Massachusetts: Harvard University Press, 1989) 1–23.

Roland Barthes
The Death of the Author//1968

Roland Barthes' short essay 'The Death of the Author' (1968) should ideally be read alongside 'From Work to Text' (1971) as his key statement on the idea that a work's meaning is not dependent on authorial intention but on the individual point of active reception. Barthes was concerned primarily with literature but his insights are analogous to much contemporary art of this period, particularly works that emphasize the viewer's role in their completion.

In his story *Sarrasine* Balzac, describing a castrato disguised as a woman, writes the following sentence: 'This was woman herself, with her sudden fears, her irrational whims, her instinctive worries, her impetuous boldness, her fussings, and her delicious sensibility.' Who is speaking thus? Is it the hero of the story bent on remaining ignorant of the castrato hidden beneath the woman? Is it Balzac the individual, furnished by his personal experience with a philosophy of Woman? Is it Balzac the author professing 'literary' ideas on femininity? Is it universal wisdom? Romantic psychology? We shall never know, for the good reason that writing is the destruction of every voice, of every point of origin. Writing is that neutral, composite, oblique space where our subject slips away; the negative where all identity is lost, starting with the very identity of the body writing.

No doubt it has always been that way. As soon as a fact is *narrated* no longer with a view to acting directly on reality but intransitively, that is to say, finally outside of any function other than that of the very practice of the symbol itself, this disconnection occurs, the voice loses its origin, the author enters into his own death, writing begins. The sense of this phenomenon, however, has varied; in ethnographic societies the responsibility for a narrative is never assumed by a person but by a mediator, shaman or relator whose 'performance' – the mastery of the narrative code – may possibly be admired but never his 'genius'. The author is a modern figure, a product of our society in so far as, emerging from the Middle Ages with English empiricism, French rationalism and the personal faith of the Reformation, it discovered the prestige of the individual, of, as it is more nobly put, the 'human person'. It is thus logical that in literature it should be this positivism, the epitome and culmination of capitalist ideology, which has attached the greatest importance to the 'person' of the author. The *author* still reigns, in histories of literature, biographies of writers, interviews, magazines, as in the very consciousness of men of letters anxious to unite their person and their work through diaries and memoirs. The image of literature to

be found in ordinary culture is tyrannically centred on the author, his person, his life, his tastes, his passions, while criticism still consists for the most part in saying that Baudelaire's work is the failure of Baudelaire the man, Van Gogh's his madness, Tchaikovsky's his vice. The *explanation* of a work is always sought in the man or woman who produced it, as if it were always in the end, through the more or less transparent allegory of the fiction, the voice of a single person, the *author* 'confiding' in us.

Though the sway of the Author remains powerful (the new criticism has often done no more than consolidate it), it goes without saying that certain writers have long since attempted to loosen it. In France, Mallarmé was doubtless the first to see and to foresee in its full extent the necessity to substitute language itself for the person who until then had been supposed to be its owner. For him, for us too, it is language which speaks, not the author; to write is, through a prerequisite impersonality (not at all to be confused with the castrating objectivity of the realist novelist), to reach that point where only language acts, 'performs', and not 'me'. Mallarmé's entire poetics consists in suppressing the author in the interests of writing (which is, as will be seen, to restore the place of the reader). Valéry, encumbered by a psychology of the Ego, considerably diluted Mallarmé's theory but, his taste for classicism leading him to turn to the lessons of rhetoric, he never stopped calling into question and deriding the Author; he stressed the linguistic and, as it were, 'hazardous' nature of his activity, and throughout his prose works he militated in favour of the essentially verbal condition of literature, in the face of which all recourse to the writer's interiority seemed to him pure superstition. Proust himself, despite the apparently psychological character of what are called his *analyses*, was visibly concerned with the task of inexorably blurring, by an extreme subtilization, the relation between the writer and his characters; by making of the narrator not he who has seen and felt nor even he who is writing, but he who *is going to write* (the young man in the novel – but, in fact, how old is he and who is he? – wants to write but cannot; the novel ends when writing at last becomes possible), Proust gave modern writing its epic. By a radical reversal, instead of putting his life into his novel, as is so often maintained, he made of his very life a work for which his own book was the model; so that it is clear to us that Charlus does not imitate Montesquieu but that Montesquieu – in his anecdotal, historical reality – is no more than a secondary fragment, derived from Charlus. Lastly, to go no further than this prehistory of modernity, Surrealism, though unable to accord language a supreme place (language being system and the aim of the movement being, romantically, a direct subversion of codes – itself moreover illusory: a code cannot be destroyed, only 'played off'), contributed to the desacrilization of the image of the Author by ceaselessly recommending the abrupt

disappointment of expectations of meaning (the famous surrealist 'jolt'), by entrusting the hand with the task of writing as quickly as possible what the head itself is unaware of (automatic writing), by accepting the principle and the experience of several people writing together. Leaving aside literature itself (such distinctions really becoming invalid), linguistics has recently provided the destruction of the Author with a valuable analytical tool by showing that the whole of the enunciation is an empty process, functioning perfectly without there being any need for it to be filled with the person of the interlocutors. Linguistically, the author is never more than the instance writing, just as *I* is nothing other than the instance saying *I*: language knows a 'subject', not a 'person', and this subject, empty outside of the very enunciation which defines it, suffices to make language 'hold together', suffices, that is to say, to exhaust it.

The removal of the Author (one could talk here with Brecht of a veritable 'distancing', the Author diminishing like a figurine at the far end of the literary stage) is not merely an historical fact or an act of writing; it utterly transforms the modern text (or – which is the same thing – the text is henceforth made and read in such a way that at all its levels the author is absent). The temporality is different. The Author, when believed in, is always conceived of as the past of his own book: book and author stand automatically on a single line divided into a *before* and an *after*. The Author is thought to *nourish* the book, which is to say that he exists before it, thinks, suffers, lives for it, is in the same relation of antecedence to his work as a father to his child. In complete contrast, the modem scriptor is born simultaneously with the text, is in no way equipped with a being preceding or exceeding the writing, is not the subject with the book as predicate; there is no other time than that of the enunciation and every text is eternally written *here and now*. The fact is (or, it follows) that *writing* can no longer designate an operation of recording, notation, representation, 'depiction' (as the Classics would say); rather, it designates exactly what linguists, referring to Oxford philosophy, call a performative, a rare verbal form (exclusively given in the first person and in the present tense) in which the enunciation has no other content (contains no other proposition) than the act by which it is uttered – something like the *I declare* of kings or the *I sing* of very ancient poets. Having buried the Author, the modern scriptor can thus no longer believe, as according to the pathetic view of his predecessors, that this hand is too slow for his thought or passion and that consequently, making a law of necessity, he must emphasize this delay and indefinitely 'polish' his form. For him, on the contrary, the hand, cut off from any voice, borne by a pure gesture of inscription (and not of expression), traces a field without origin – or which, at least, has no other origin than language itself, language which ceaselessly calls into question all origins.

We know now that a text is not a line of words releasing a single 'theological'

meaning (the 'message' of the Author-God) but a multi-dimensional space in which a variety of writings, none of them original, blend and clash. The text is a tissue of quotations drawn from the innumerable centres of culture. Similar to Bouvard and Pécuchet, those eternal copyists, at once sublime and comic and whose profound ridiculousness indicates precisely the truth, of writing, the writer can only imitate a gesture that is always anterior, never original. His only power is to mix writings, to counter the ones with the others, in such a way as never to rest on any one of them. Did he wish to *express himself*, he ought at least to know that the inner 'thing' he thinks to 'translate' is itself only a ready-formed dictionary, its words only explainable through other words, and so on indefinitely; something experienced in exemplary fashion by the young Thomas de Quincey, he who was so good at Greek that in order to translate absolutely modern ideas and images into that dead language, he had, so Baudelaire tells us (in *Paradis Artificiels*), 'created for himself an unfailing dictionary, vastly more extensive and complex than those resulting from the ordinary patience of purely literary themes'. Succeeding the Author, the scriptor no longer bears within him passions, humours, feelings, impressions, but rather this immense dictionary from which he draws a writing that can know no halt: life never does more than imitate the book, and the book itself is only a tissue of signs, an imitation that is lost, infinitely deferred.

Once the Author is removed, the claim to decipher a text becomes quite futile. To give a text an Author is to impose a limit on that text, to furnish it with a final signified, to close the writing. Such a conception suits criticism very well, the latter then allotting itself the important task of discovering the Author (or its hypostases: society, history, psyche, liberty) beneath the work: when the Author has been found, the text is 'explained' – victory to the critic. Hence there is no surprise in the fact that, historically, the reign of the Author has also been that of the Critic, nor again in the fact that criticism (be it new) is today undermined along with the Author. In the multiplicity of writing, everything is to be *disentangled*, nothing *deciphered*; the structure can be followed, 'run' (like the thread of a stocking) at every point and at every level, but there is nothing beneath: the space of writing is to be ranged over, not pierced; writing ceaselessly posits meaning ceaselessly to evaporate it, carrying out a systematic exemption of meaning. In precisely this way literature (it would be better from now on to say *writing*), by refusing to assign a 'secret', an ultimate meaning, to the text (and to the world as text), liberates what may be called an anti-theological activity, an activity that is truly revolutionary since to refuse to fix meaning is, in the end, to refuse God and his hypostases – reason, science, law.

Let us come back to the Balzac sentence. No one, no 'person', says it: its source, its voice, is not the true place of the writing, which is reading. Another –

very precise – example will help to make this clear: recent research (J.-P. Vernant)[1] has demonstrated the constitutively ambiguous nature of Greek tragedy, its texts being woven from words with double meanings that each character understands unilaterally (this perpetual misunderstanding is exactly the 'tragic'); there is, however, someone who understands each word in its duplicity and who, in addition, hears the very deafness of the characters speaking in front of him – this someone being precisely the reader (or here the listener). Thus is revealed the total existence of writing: a text is made of multiple writings, drawn from many cultures and entering into mutual relations of dialogue, parody, contestation, but there is one place where this multiplicity is focused and that place is the reader, not, as was hitherto said, the author. The reader is the space on which all the quotations that make up a writing are inscribed without any of them being lost; a text's unity lies not in its origin but in its destination. Yet this destination cannot any longer be personal: the reader is without history, biography, psychology; he is simply that *someone* who holds together in a single field all the traces by which the written text is constituted. Which is why it is derisory to condemn the new writing in the name of a humanism hypocritically turned champion of the reader's rights. Classic criticism has never paid any attention to the reader; for it, the writer is the only person in literature. We are now beginning to let ourselves be fooled no longer by the arrogant antiphrastical recriminations of good society in favour of the very thing it sets aside, ignores, smothers or destroys; we know that to give writing its future, it is necessary to overthrow the myth: the birth of the reader must be at the cost of the death of the Author.

1 See Jean-Pierre Vernant, with Pierre Vidal-Naquet, *Mythe et tragédie en Grèce ancienne* (Paris 1972), especially pages 19–40; 99–131. [Translator]

Roland Barthes, 'La mort de l'auteur', *Mantéia*, V (Paris, 1968); trans. 'The Death of the Author', in Roland Barthes, *Image – Music – Text*, ed. and trans. Stephen Heath (New York: Hill & Wang/London: Fontana, 1977) 142–8.

Peter Bürger
The Negation of the Autonomy of Art by the Avant-garde//2002

Informed by the Frankfurt School of critical theory, Peter Bürger's Theory of the Avant-garde *(1974) decries a bourgeois model of art that is produced and consumed by individuals. His influential reading of the historic avant-garde (Dada, Constructivism and Surrealism) as an attempt to fuse art with social praxis, together with the chart reproduced below, provide a poignant contextualization for contemporary collaborative art.*

In scholarly discussion up to now, the category 'autonomy' has suffered from the imprecision of the various subcategories thought of as constituting a unity in the concept of the autonomous work of art. Since the development of the individual subcategories is not synchronous, it may happen that sometimes courtly art seems already autonomous, while at other times only bourgeois art appears to have that characteristic. To make clear that the contradictions between the various interpretations result from the nature of the case, we will sketch a historical typology that is deliberately reduced to three elements (purpose or function, production, reception), because the point here is to have the nonsynchronism in the development of individual categories emerge with clarity.

 A. Sacral Art (example: the art of the High Middle Ages) serves as cult object. It is wholly integrated into the social institution 'religion'. It is produced collectively, as a craft. The mode of reception also is institutionalized as collective.[1]

 B. Courtly Art (example: the art at the court of Louis XIV) also has a precisely defined function. It is representational and serves the glory of the prince and the self-portrayal of courtly society. Courtly art is part of the life praxis of courtly society, just as sacral art is part of the life praxis of the faithful. Yet the detachment from the sacral tie is a first step in the emancipation of art. ('Emancipation' is being used here as a descriptive term, as referring to the process by which art constitutes itself as a distinct social subsystem.) The difference from sacral art becomes particularly apparent in the realm of production: the artist produces as an individual and develops a consciousness of the uniqueness of his activity. Reception, on the other hand, remains collective. But the content of the collective performance is no longer sacral, it is sociability.

 C. Only to the extent that the bourgeoisie adopts concepts of value held by the aristocracy does bourgeois art have a representational function. When it is genuinely bourgeois, this art is the objectification of the self-understanding of

the bourgeois class. Production and reception of the self-understanding as articulated in art are no longer tied to the praxis of life. Habermas calls this the satisfaction of residual needs, that is, of needs that have become submerged in the life praxis of bourgeois society. Not only production but reception also are now individual acts. The solitary absorption in the work is the adequate mode of appropriation of creations removed from the life praxis of the bourgeois, even though they still claim to interpret that praxis. In Aestheticism, finally, where bourgeois art reaches the stage of self-reflection, this claim is no longer made. Apartness from the praxis of life, which had always been the condition that characterized the way art functioned in bourgeois society, now becomes its content. The typology we have sketched here can be represented in the accompanying tabulation (the vertical lines in boldface [substituted by boldface text below] refer to a decisive change in the development, the broken ones [substituted by italicized text] to a less decisive one).

	Sacral Art	Courtly Art	Bourgeois Art
Purpose or function	cult object	*representational object*	**portrayal of bourgeois self-understanding**
Production	collective craft	**individual**	*individual*
Reception	collective (sacral)	*collective (sociable)*	**individual**

The tabulation allows one to notice that the development of the categories was not synchronous. Production by the individual that characterizes art in bourgeois society has its origins as far back as courtly patronage. But courtly art still remains integral to the praxis of life, although as compared with the cult function, the representational function constitutes a step toward a mitigation of claims that art play a direct social role. The reception of courtly art also remains collective, although the content of the collective performance has changed. As regards reception, it is only with bourgeois art that a decisive change sets in: its reception is one by isolated individuals. The novel is that literary genre in which the new mode of reception finds the form appropriate to it.[2] The advent of bourgeois art is also the decisive turning point as regards use or function. Although in different ways, both sacral and courtly art are integral to the life praxis of the recipient. As cult and representational objects, works of art are put to a specific use. This requirement no longer applies to the same extent to bourgeois art. In bourgeois art, the portrayal of bourgeois self-understanding occurs in a sphere that lies outside the praxis of life. The citizen who, in everyday life, has been reduced to a partial function (means-ends activity) can be discovered in art as 'human being'. Here, one can unfold the abundance of one's

talents, though with the proviso that this sphere remain strictly separate from the praxis of life. Seen in this fashion, the separation of art from the praxis of life becomes the decisive characteristic of the autonomy of bourgeois art (a fact that the tabulation does not bring out adequately). To avoid misunderstandings, it must be emphasized once again that autonomy in this sense defines the status of art in bourgeois society but that no assertions concerning the contents of works are involved. Although art as an institution may be considered fully formed towards the end of the eighteenth century, the development of the contents of works is subject to a historical dynamics, whose terminal point is reached in Aestheticism, where art becomes the content of art.

The European avant-garde movements can be defined as an attack on the status of art in bourgeois society. What is negated is not an earlier form of art (a style) but art as an institution that is unassociated with the life praxis of men. When the avant-gardistes demand that art become practical once again, they do not mean that the contents of works of art should be socially significant. The demand is not raised at the level of the contents of individual works. Rather, it directs itself to the way art functions in society, a process that does as much to determine the effect that works have as does the particular content.

The avant-gardistes view its dissociation from the praxis of life as the dominant characteristic of art in bourgeois society. One of the reasons this dissociation was possible is that Aestheticism had made the element that defines art as an institution the essential content of works. Institution and work contents had to coincide to make it logically possible for the avant-garde to call art into question. The avant-gardistes proposed the sublation of art – sublation in the Hegelian sense of the term: art was not to be simply destroyed, but transferred to the praxis of life where it would be preserved, albeit in a changed form. The avant-gardistes thus adopted an essential element of Aestheticism. Aestheticism had made the distance from the praxis of life the content of works. The praxis of life to which Aestheticism refers and which it negates is the means-ends rationality of the bourgeois everyday. Now, it is not the aim of the avant-gardistes to integrate art into *this* praxis. On the contrary, they assent to the aestheticists' rejection of the world and its means-ends rationality. What distinguishes them from the latter is the attempt to organize a new life praxis from a basis in art. In this respect also, Aestheticism turns out to have been the necessary precondition of the avant-gardiste intent. Only an art the contents of whose individual works is wholly distinct from the (bad) praxis of the existing society can be the centre that can be the starting point for the organization of a new life praxis.

With the help of Herbert Marcuse's theoretical formulation concerning the twofold character of art in bourgeois society, the avant-gardiste intent can be

understood with particular clarity. All those needs that cannot be satisfied in everyday life, because the principle of competition pervades all spheres, can find a home in art, because art is removed from the praxis of life. Values such as humanity, joy, truth, solidarity are extruded from life, as it were, and preserved in art. In bourgeois society, art has a contradictory role: it projects the image of a better order and to that extent protests against the bad order that prevails. But by realizing the image of a better order in fiction, which is semblance (*Schein*) only, it relieves the existing society of the pressure of those forces that make for change. They are assigned to confinement in an ideal sphere. Where art accomplishes this, it is 'affirmative' in Marcuse's sense of the term. If the twofold character of art in bourgeois society consists in the fact that the distance from the social production and reproduction process contains an element of freedom and an element of the noncommittal and an absence of any consequences, it can be seen that the avant-gardistes' attempt to reintegrate art into the life process is itself a profoundly contradictory endeavour. For the (relative) freedom of art vis-a-vis the praxis of life is at the same time the condition that must be fulfilled if there is to be a critical cognition of reality. An art no longer distinct from the praxis of life but wholly absorbed in it will lose the capacity to criticize it, along with its distance. During the time of the historical avant-garde movements, the attempt to do away with the distance between art and life still had all the pathos of historical progressiveness on its side. But in the meantime, the culture industry has brought about the false elimination of the distance between art and life, and this also allows one to recognize the contradictoriness of the avant-gardiste undertaking.[3]

In what follows, we will outline how the intent to eliminate art as an institution found expression in the three areas that we used above to characterize autonomous art: purpose or function, production, reception. Instead of speaking of the avant-gardiste work, we will speak of avant-gardiste manifestation. A dadaist manifestation does not have work character but is nonetheless an authentic manifestation of the artistic avant-garde. This is not to imply that the avant-gardistes produced no works whatever and replaced them by ephemeral events. We will see that whereas they did not destroy it, the avant-gardistes profoundly modified the category of the work of art.

Of the three areas, the *intended purpose or function* of the avant-gardiste manifestation is most difficult to define. In the aestheticist work of art, the disjointure of the work and the praxis of life characteristic of the status of art in bourgeois society has become the work's essential content. It is only as a consequence of this fact that the work of art becomes its own end in the full meaning of the term. In Aestheticism, the social functionlessness of art becomes manifest. The avant-gardiste artists counter such functionlessness not by an art

that would have consequences within the existing society, but rather by the principle of the sublation of art in the praxis of life. But such a conception makes it impossible to define the intended purpose of art. For an art that has been reintegrated into the praxis of life, not even the absence of a social purpose can be indicated, as was still possible in Aestheticism. When art and the praxis of life are one, when the praxis is aesthetic and art is practical, art's purpose can no longer be discovered, because the existence of two distinct spheres (art and the praxis of life) that is constitutive of the concept of purpose or intended use has come to an end.

We have seen that the *production* of the autonomous work of art is the act of an individual. The artist produces as individual, individuality not being understood as the expression of something but as radically different. The concept of genius testifies to this. The quasi-technical consciousness of the makeability of works of art that Aestheticism attains seems only to contradict this. Valéry, for example, demystifies artistic genius by reducing it to psychological motivations on the one hand, and the availability to it of artistic means on the other. While pseudo-romantic doctrines of inspiration thus come to be seen as the self-deception of producers, the view of art for which the individual is the creative subject is let stand. Indeed, Valéry's theorem concerning the force of pride (*orgueil*) that sets off and propels the creative process renews once again the notion of the individual character of artistic production central to art in bourgeois society.[4] In its most extreme manifestations, the avant-garde's reply to this is not the collective as the subject of production but the radical negation of the category of individual creation. When Duchamp signs mass-produced objects (a urinal, a bottle drier) and sends them to art exhibits, he negates the category of individual production. The signature, whose very purpose it is to mark what is individual in the work, that it owes its existence to this particular artist, is inscribed on an arbitrarily chosen mass product, because all claims to individual creativity are to be mocked. Duchamp's provocation not only unmasks the art market where the signature means more than the quality of the work; it radically questions the very principle of art in bourgeois society according to which the individual is considered the creator of the work of art. Duchamp's Readymades are not works of art but manifestations. Not from the form-content totality of the individual object Duchamp signs can one infer the meaning, but only from the contrast between mass-produced object on the one hand, and signature and art exhibit on the other. It is obvious that this kind of provocation cannot be repeated indefinitely. The provocation depends on what it turns against: here, it is the idea that the individual is the subject of artistic creation. Once the signed bottle drier has been accepted as an object that deserves a place in a museum, the

provocation no longer provokes; it turns into its opposite. If an artist today signs a stove pipe and exhibits it, that artist certainly does not denounce the art market but adapts to it. Such adaptation does not eradicate the idea of individual creativity, it affirms it, and the reason is the failure of the avant-gardiste intent to sublate art. Since now the protest of the historical avant-garde against art as institution is accepted as *art*, the gesture of protest of the neo-avant-garde becomes inauthentic. Having been shown to be irredeemable, the claim to be protest can no longer be maintained. This fact accounts for the arts-and-crafts impression that works of the avant-garde not infrequently convey.[5]

The avant-garde not only negates the category of individual production but also that of individual *reception*. The reactions of the public during a dada manifestation where it has been mobilized by provocation, and which can range from shouting to fisticuffs, are certainly collective in nature. True, these remain reactions, responses to a preceding provocation. Producer and recipient remain clearly distinct, however active the public may become. Given the avant-gardiste intention to do away with art as a sphere that is separate from the praxis of life, it is logical to eliminate the antithesis between producer and recipient. It is no accident that both Tzara's instructions for the making of a Dadaist poem and Breton's for the writing of automatic texts have the character of recipes.[6] This represents not only a polemical attack on the individual creativity of the artist; the recipe is to be taken quite literally as suggesting a possible activity on the part of the recipient. The automatic texts also should be read as guides to individual production. But such production is not to be understood as artistic production, but as part of a liberating life praxis. This is what is meant by Breton's demand that poetry be practiced (*pratiquer la poésie*). Beyond the coincidence of producer and recipient that this demand implies, there is the fact that these concepts lose their meaning: producers and recipients no longer exist. All that remains is the individual who uses poetry as an instrument for living one's life as best one can. There is also a danger here to which Surrealism at least partly succumbed, and that is solipsism, the retreat to the problems of the isolated subject. Breton himself saw this danger and envisaged different ways of dealing with it. One of them was the glorification of the spontaneity of the erotic relationship. Perhaps the strict group discipline was also an attempt to exorcise the danger of solipsism that surrealism harbours.[7]

In summary, we note that the historical avant-garde movements negate those determinations that are essential in autonomous art: the disjunction of art and the praxis of life, individual production, and individual reception as distinct from the former. The avant-garde intends the abolition of autonomous art, by which it means that art is to be integrated into the praxis of life. This has not occurred, and presumably cannot occur, in bourgeois society unless it be as a

false sublation of autonomous art.[8] Pulp fiction and commodity aesthetics prove that such a false sublation exists. A literature whose primary aim it is to impose a particular kind of consumer behaviour on the reader is in fact practical, though not in the sense the avant-gardistes intended. Here, literature ceases to be an instrument of emancipation and becomes one of subjection.[9] Similar comments could be made about commodity aesthetics that treat form as mere enticement, designed to prompt purchasers to buy what they do not need. Here also, art becomes practical but it is an art that enthralls.[10] This brief allusion will show that the theory of the avant-garde can also serve to make us understand popular literature and commodity aesthetics as forms of a false sublation of art as institution. In late capitalist society, intentions of the historical avant-garde are being realized but the result has been a disvalue. Given the experience of the false sublation of autonomy, one will need to ask whether a sublation of the autonomy status can be desirable at all, whether the distance between art and the praxis of life is not requisite for that free space within which alternatives to what exists become conceivable.

1 [footnote 14 in source] On this, see the essay by R. Warning, 'Ritus, Mythos und geistliches Spiel', in *Terror und Spiel. Probleme der Mythenrezeption*, ed. Fuhrmann (Munich: Wilhelm Fink Verlag, 1971) 211–39.

2 [15] Hegel already referred to the novel as 'the modern middle-class epic' (*Asthetik*, ed. F. Bassenge, vol. II [Berlin/Weimar, 1965] 452.)

3 [16] On the problem of the false sublation of art in the praxis of life, see J. Habermas, *Strukturwandel der Offentlichkeit. Untersuchungen zu einer Kategorie der bürgerlichen Gesellschaft* (Neuwied/Berlin, 1968) § 18, 176 ff.

4 [17] See P. Bürger, 'Funktion und Bedeutung des *orgueil* bei Paul Valéry', in *Romanistisches Jahrbuch*, 16 (1965) 149–68.

5 [18] Examples of neo-avant-gardiste paintings and sculptures to be found in the catalogue of the exhibit *Sammlung Cremer. Europäische Avantgarde 1950–1970*, ed. G. Adriani (Tubingen, 1973).

6 [19] Tristan Tzara, 'Pour faire un poème dadaiste', in Tzara, *Lampisteries précédées des sept manifestos dada* (place of publication not given, 1963) 64. André Breton, 'Manifeste du surréalisme' (1924), in Breton, *Manifestos du surréalisme* (Paris: Coll. Idées 23, 1963) 42 f.

7 [20] On the Surrealists' conception of groups and the collective experiences they sought and partially realized, see Elisabeth Lenk, *Der springende Narziss. André Breton's poetischer Materialismus* (Munich, 1971) 57 ff., 73 f.

8 [21] One would have to investigate to what extent, after the October revolution, the Russian avant-gardistes succeeded to a degree, because social conditions had changed, in realizing their intent to reintegrate art in the praxis of life. Both B. Arvatov and S. Tretjakov turn the concept of art as developed in bourgeois society around and define art quite straightforwardly as socially useful activity: 'The pleasure of transforming the raw material into a particular, socially useful

form, connected to the skill and the intensive search for the suitable form – those are the things the slogan "art for all" should mean.' (S. Tretjakov, 'Die Kunst in der Revolution and die Revolution in der Kunst', in Tretjakov, *Die Arbeit des Schriftstellers*, ed. H. Boehncke (Reinbek bei Hamburg: Rowohit, 1971) 13. 'Basing himself on the technique which is common to all spheres of life, the artist is imbued with the idea of suitability. It is not by subjective taste that he will allow himself to be guided as he works on his material but by the objective tasks of production' (B. Arvatov, 'Die Kunst im System der proletarischen Kultur', in Arvatov, *Kunst und Produktion*, 15). With the theory of the avant-garde as a point of departure, and with concrete investigations as guide, one should also discuss the problem of the extent (and of the kinds of consequences for the artistic subjects) to which art as an institution occupies a place in the society of the socialist countries that differs from its place in bourgeois society.

9 [22] See Christa Bürger, *Textanalyse als Ideologiekritik. Zur Rezeption witgen ossischer Unterhaltungsliteratur* (Frankfurt: Athenaum, 1973).

10 [23] See W.F. Haug, *Kritik der Warendsthetik* (Frankfurt: Suhrkamp, 1971).

Peter Bürger, *Theorie der Avantgarde* (Frankfurt am Main: Suhrkamp Verlag, 1974); trans. Michael Shaw, *Theory of the Avant-garde* (Minneapolis: University of Minnesota Press, 1984) 47–54.

Jean-Luc Nancy
The Inoperative Community//1986

A number of post-Marxist theories of community emerged in the 1980s. French philosopher Jean-Luc Nancy, writing in a Heideggerian and Derridean tradition, argues for an understanding of community founded not on the immanence of individuals being-in-common, but on an 'unworking' (désoeuvrement) of togetherness brought about by that which presents a limit to community – that is, death. Nancy's complex text has been referenced by a number of writers on participatory art (George Baker, Miwon Kwon, Pamela M. Lee, Jessica Morgan).

The gravest and most painful testimony of the modern world, the one that possibly involves all other testimonies to which this epoch must answer (by virtue of some unknown decree or necessity, for we bear witness also to the exhaustion of thinking through History), is the testimony of the dissolution, the dislocation, or the conflagration of community. Communism, as Sartre said, is 'the unsurpassable horizon of our time', and it is so in many senses – political, ideological and strategic. But not least important among these senses is the following consideration, quite foreign to Sartre's intentions: the word 'communism' stands as an emblem of the desire to discover or rediscover a place of community at once beyond social divisions and beyond subordination to technopolitical dominion, and thereby beyond such wasting away of liberty, of speech or of simple happiness as comes about whenever these become subjugated to the exclusive order of privatization; and finally, more simply and even more decisively, a place from which to surmount the unravelling that occurs with the death of each one of us – that death that, when no longer anything more than the death of the individual, carries an unbearable burden and collapses into insignificance.

More or less consciously, more or less deliberately, and more or less politically, the word 'communism' has constituted such an emblem – which no doubt amounted to something other than a concept, and even something other than the *meaning* of a word. This emblem is no longer in circulation, except in a belated way for a few; for still others, though very rare nowadays, it is an emblem capable of inferring a fierce but impotent resistance to the visible collapse of what it promised. If it is no longer in circulation, this is not only because the States that acclaimed it have appeared, for some time now, as the agents of its betrayal. (Bataille in 1933: 'The Revolution's minimal hope has been described as the decline of the State: but it is in fact the revolutionary forces that

the present world is seeing perish and, at the same time, every vital force today has assumed the form of the totalitarian State')[1] The schema of betrayal, aimed at preserving an originary communist purity of doctrine or intention, has come to be seen as less and less tenable. Not that totalitarianism was already present, as such, in Marx: this would be a crude proposition, one that remains ignorant of the strident protest against the destruction of community that in Marx continuously parallels the Hegelian attempt to bring about a totality, and that thwarts or displaces this attempt.

But the schema of betrayal is seen to be untenable in that it was the very basis of the communist ideal that ended up appearing most problematic: namely, human beings defined as producers (one might even add: human beings *defined* at all), and fundamentally as the producers of their own essence in the form of their labour or their work.

That the justice and freedom – and the equality – included in the communist idea or ideal have in effect been betrayed in so-called real communism is something at once laden with the burden of an intolerable suffering (along with other, no less intolerable forms of suffering inflicted by our liberal societies) and at the same time politically decisive (not only in that a political strategy must favour resistance to this betrayal, but because this strategy, as well as our thought in general, must reckon with the possibility that an entire society has been forged, docilely and despite more than one forum of revolt, in the mould of this betrayal – or more plainly, at the mercy of this abandonment: this would be Zinoviev's question, rather than, Solzhenitsyn's). But these burdens are still perhaps only relative compared with the absolute weight that crushes or blocks all our 'horizons': there is, namely, no form of communist opposition – or let us say rather 'communitarian' opposition, in order to emphasize that the word should not be restricted in this context to strictly political references – that has not been or is not still profoundly subjugated to the goal of a *human* community, that is, to the goal of achieving a community of beings producing in essence their own essence as their work, and furthermore producing precisely this essence *as community*. An absolute immanence of man to man – a humanism – and of community to community – a communism – obstinately subtends, whatever be their merits or strengths, all forms of oppositional communism, all leftist and ultraleftist models, and all models based on the workers' council.[2] In a sense, all ventures adopting a communitarian opposition to 'real communism' have by now run their course or been abandoned, but everything continues along its way as though, beyond these ventures, it were no longer even a question of thinking about community.

Yet it is precisely the immanence of man to man, or it is *man*, taken absolutely, considered as the immanent being par excellence, that constitutes

the stumbling block to thinking of community. A community presupposed as having to be one *of human beings* presupposes that it effect, or that it must effect, as such and integrally, its own essence, which is itself the accomplishment of the essence of humanness. ('What can be fashioned by man? Everything. Nature, human society, humanity', wrote Herder. We are stubbornly bound to this regulative idea, even when we consider that this 'fashioning' is itself only a 'regulative idea'.) Consequently, economic ties, technological operations and political fusion (into a *body* or under a *leader*) represent or rather present, expose and realize this essence necessarily in themselves. Essence is set to work in them; through them, it becomes its own work. This is what we have called 'totalitarianism', but it might be better named 'immanentism', as long as we do not restrict the term to 'designating certain types of societies or regimes but rather see in it the general horizon of our time, encompassing both democracies and their fragile juridical parapets.

Is it really necessary to say something about the individual here? Some see in its invention and in the culture, if not in the cult built around the individual, Europe's incontrovertible merit of having shown the world the sole path to emancipation from tyranny, and the norm by which to measure all our collective or communitarian undertakings. But the individual is merely the residue of the experience of the dissolution of community. By its nature – as its name indicates, it is the atom, the indivisible – the individual reveals that it is the abstract result of a decomposition. It is another, and symmetrical, figure of immanence: the absolutely detached for-itself, taken as origin and as certainty.

But the experience through which this individual has passed, since Hegel at least, (and through which he passes, it must be confessed, with staggering opinionatedness) is simply the experience of this: that the individual can be the origin and the certainty of nothing but its own death. And once immortality has passed into its works, an *operative* immortality remains its own alienation and renders its death still more strange than the irremediable strangeness that it already 'is'.

Still, one cannot make a world with simple atoms. There has to be a *clinamen*. There has to be an inclination or an inclining from one towards the other, of one by the other, or from one to the other. Community is at least the *clinamen* of the 'individual'. Yet there is no theory, ethics, politics or metaphysics of the individual that is capable 'of envisaging this *clinamen*, this declination or decline of the individual within community. Neither 'Personalism' nor Sartre ever managed to do anything more than coat the most classical individual-subject with a moral or sociological paste: they never *inclined* it, outside itself, over that edge that opens up its being-in-common.

An inconsequential atomism, individualism tends to forget that the atom is a world. This is why the question of community is so markedly absent from the metaphysics of the subject, that is to say, from the metaphysics of the absolute for-itself – be it in the form of the individual or the total State – which means also the metaphysics of the *absolute* in general, of being as absolute, as perfectly detached, distinct and closed: being without relation. This absolute can appear in the form of the Idea, History, the Individual, the State, Science, the Work of Art, and so on. Its logic will always be the same in as much as it is without relation. A simple and redoubtable logic will always imply that within its very separation the absolutely separate encloses, if we can say this, more than what is simply separated. Which is to say that the separation itself must be enclosed, that the closure must not only close around a territory (while still remaining exposed, at its outer edge, to another territory, with which it thereby communicates), but also, in order to complete the absoluteness of its separation, around the enclosure itself. The absolute must be the absolute of its own absoluteness, or not be at all. In other words: to be absolutely alone, it is not enough that I be so; I must also be alone being alone – and this of course is contradictory. The logic of the absolute violates the absolute. It implicates it in a relation that it refuses and precludes by its essence. This relation tears and forces open, from within and from without at the same time, and from an outside that is nothing other than the rejection of an impossible interiority, the 'without relation' from which the absolute would constitute itself.

Excluded by the logic of the absolute subject of metaphysics (Self, Will, Life, Spirit, etc.), community comes perforce *to cut into* this subject by virtue of this same logic. The logic of the absolute *sets it in relation:* but this, obviously, cannot make for a relation between two or several absolutes, no more than it can make an absolute of the relation. It undoes the absoluteness of the absolute. The relation (the community) is, if it *is*, nothing other than what undoes, in its very principle – and at its closure or on its limit – the autarchy of absolute immanence. [...]

The solidarity of the individual with communism at the heart of a thinking of immanence, while neglecting ecstasy, does not however entail a simple symmetry. Communism – as, for example, in the generous exuberance that will not let Marx conclude without pointing to a reign of freedom, one beyond the collective regulation of necessity, in which surplus work would no longer be an exploitative *work*, but rather art and invention – communicates with an extremity of play, of sovereignty, even of ecstasy from which the individual as such remains definitively removed. But this link has remained distant, secret, and most often unknown to communism itself (let us say, to lend concreteness,

unknown to Lenin, Stalin and Trotsky), except in the fulgurating bursts of poetry, painting and cinema at the very beginning of the Soviet revolution, or the motifs that Benjamin allowed as reasons for calling oneself a Marxist, or what Blanchot tried to bring across or propose (rather than signify) with the word 'communism' ('Communism: that which excludes [and excludes itself from] every community already constituted').[3] But again even this proposal in the final analysis went unrecognized, not only by 'real' communism, but also, on close inspection, by those singular 'communists' themselves, who were perhaps never able to recognize (until now at least) either where the metaphor (or the hyperbole) began and ended in the usage they made of the word, or, especially, what other trope – supposing it were necessary to change words – or what effacement of tropes might have been appropriate to reveal what haunted their use of the word 'communism'.

By the usage to which this word was put, they were able to communicate with a thinking of art, of literature, and of thought itself – other figures or other exigencies of ecstasy – but they were not truly able to communicate, explicitly and thematically (even if 'explicit' and 'thematic' are only very fragile categories here), with a thinking of community. Or rather, their communication with such a thinking has remained secret, or suspended.

The ethics, the politics, the philosophies of community, when there were any (and there always are, even if they are reduced to chatter about fraternity or to laborious constructions around 'intersubjectivity'), have pursued their paths or their humanist dead ends without suspecting for an instant that these singular voices were speaking about community and were perhaps speaking about nothing else, without suspecting that what was taken for a 'literary' or 'aesthetic' experience was entrenched *in* the ordeal of community, was at grips with it. (Do we need to be reminded, to take a further example, what Barthes' first writings were about, and some of the later ones as well?)

Subsequently, these same voices that were unable to communicate what, perhaps without knowing it, they were saying, were exploited – and covered up again – by clamorous declarations brandishing the flag of the 'cultural revolutions' and by all kinds of 'communist writing' or 'proletarian inscriptions'. The professionals of society saw in them (and not without reason, even if their view was shortsighted) nothing more than a bourgeois Parisian or Berliner form of *Proletkult*, or else merely the unconscious return of a 'republic of artists', the concept of which had been inaugurated two hundred years earlier by the Jena romantics. In one way or another, it was a matter of a simple, classical and dogmatic system of truth: an art: (or a thought) adequate to politics (to the form or the description of community), a politics adequate to art. The basic presupposition remained that of a community effectuating itself in the absolute

of the work, or effectuating itself as work. For this reason, and whatever it may have claimed for itself, this 'modernity' remained in its principle a humanism.

We will have to return to the question of what brought about – albeit at the cost of a certain naïveté or misconception – the exigency of a literary[4] experience of community or communism. This is even, in a sense, the only question. But the terms of this question all need to be transformed, to be put back into play in a space that would be distributed quite differently from one composed of all-too-facile relations (for example, solitude of the writer/collectivity, or culture/society, or elite/masses – whether these relations be proposed as oppositions, or, in the spirit of the 'cultural revolutions', as equations). And for this to happen, the question of community must first of all be put back into play, for the necessary redistribution of space depends upon it. Before getting to this, and without rescinding any of the resistant generosity or the active restlessness of the word 'communism' and without denying anything of the excesses to which it can lead, but also without forgetting either the burdensome mortgage that comes along with it or the usury it has (not accidentally) suffered, we must allow that *communism* can no longer be the unsurpassable horizon of our time. And if in fact it no longer is such a horizon, this is not because we have passed beyond any horizon. Rather, everything is inflected by resignation, as if the new unsurpassable horizon took form around the disappearance, the impossibility, or the condemnation of communism. Such reversals are customary; they have never altered anything. It is the *horizons* themselves that must be challenged. The ultimate limit of community, or the limit that is formed by community, as such, traces an entirely different line. This is why, even as we establish that communism is no longer our unsurpassable horizon, we must also establish, just as forcefully, that a communist exigency or demand communicates with the gesture by means of which we must go farther than all possible horizons.

The first task in understanding what is at stake here consists in focusing on the horizon *behind* us. This means questioning the breakdown in community that supposedly engendered the modern era. The consciousness of this ordeal belongs to Rousseau, who figured a *society* that experienced or acknowledged the loss or degradation of a communitarian (and communicative) intimacy – a society producing, of necessity, the solitary figure, but one whose desire and intention was to produce the citizen of a free sovereign community. Whereas political theoreticians preceding him had thought mainly in terms of the institution of a State, or the regulation of a society, Rousseau, although he borrowed a great deal from them, was perhaps the first thinker of community, or more exactly, the first to experience the question of society as an uneasiness directed towards the community, and as the consciousness of a (perhaps

irreparable) rupture in this community. This consciousness would subsequently be inherited by the Romantics, and by Hegel in *The Phenomenology of Spirit*: the last figure of spirit, before the assumption of all the figures and of history into absolute knowledge, is that which cleaves community (which for Hegel figures the split in religion). Until this day history has been thought on the basis of a lost community – one to be regained or reconstituted.

The lost, or broken, community can be exemplified in all kinds of ways, by all kinds of paradigms: the natural family, the Athenian city, the Roman Republic, the first Christian community, corporations, communes or brotherhoods – always it is a matter of a lost age in which community was woven of tight, harmonious and infrangible bonds and in which above all it played back to itself, through its institutions, its rituals and its symbols, the representation, indeed the living offering, of its own immanent unity, intimacy and autonomy. Distinct from society (which is a simple association and division of forces and needs) and opposed to empire (which dissolves community by submitting its peoples to its arms and to its glory), community is not only intimate communication between its members, but also its organic communion with its own essence. It is constituted not only by a fair distribution of tasks and goods, or by a happy equilibrium of forces and authorities: it is made up principally of the sharing, diffusion or impregnation of an identity by a plurality wherein each member identifies himself only through the supplementary mediation of his identification with the living body of the community. In the motto of the Republic, *fraternity* designates community: the model of the family and of love.

But it is here that we should become suspicious of the retrospective consciousness of the lost community and its identity (whether this consciousness conceives of itself as effectively retrospective or whether, disregarding the realities of the past, it constructs images of this past for the sake of an ideal or a prospective vision). We should be suspicious of this consciousness first of all because it seems to have accompanied the Western world from its very beginnings: at every moment in its history, the Occident has given itself over to the nostalgia for a more archaic community that has disappeared, and to deploring a loss of familiarity, fraternity and conviviality. Our history begins with the departure of Ulysses and with the onset of rivalry, dissension and conspiracy in his palace. Around Penelope, who reweaves the fabric of intimacy without ever managing to complete it, pretenders set up the warring and political scene of society – pure exteriority.

But the true consciousnesss of the loss of community is Christian: the community desired or pined for by Rousseau, Schlegel, Hegel, then Bakunin, Marx, Wagner or Mallarmé is understood as communion, and communion takes place, in its principle as in its ends, at the heart of the mystical body of Christ. At

the same time as it is the most ancient myth of the Western world, community might well be the altogether modern thought of humanity's partaking of divine life: the thought of a human being penetrating into pure immanence. (Christianity has had only two dimensions, antinomical to one another; that of the *deus absconditus*, in which the Western disappearance of the divine is still engulfed, and that of the god-man, *deus communis*, brother of humankind, invention of a familial immanence of humanity, then of history as the immanence of salvation.)

Thus, the thought of community or the desire for it might well be nothing other than a belated invention that tried to respond to the harsh reality of modern experience: namely, that divinity was withdrawing infinitely from immanence, that the god-brother was at bottom *himself* the *deus absconditus* (this was Hölderlin's insight), and that the divine essence of community – or community as the existence of a divine essence – was the impossible itself. One name for this has been the death of God: this expression remains pregnant with the possibility if not the necessity of a resurrection that restores both man and God to a common immanence. (Not only Hegel, but also Nietzsche himself, at least in part, bear witness to this.) The discourse of the 'death of God' also misses the point that the 'divine' is what it is (if it 'is') only in as much as it is removed from immanence, or withdrawn from it – within it, one might say, yet withdrawn from it: And this, moreover, occurs in the very precise sense that it is not because there is a 'divine' that its share would be subtracted from immanence, but on the contrary, it is only to the extent that immanence itself, here or there (but is it localizable? Is it not rather this that localizes, that spaces?), is subtracted from immanence that there can be something like the 'divine'. (And perhaps, in the end, it will no longer be necessary to speak of the 'divine'. Perhaps we will come to see that community, death, love, freedom, singularity are names for the 'divine' not just because they substitute for it – and neither sublate nor resuscitate it under another form – but equally because this substitution is in no way anthropomorphic or anthropocentric and gives way to no becoming-human of the 'divine'. Community henceforth constitutes the limit of the human as well as of the divine. Through God or the gods communion – as substance and act, the act of communicated immanent substance – has been definitively withdrawn from community.)

The modern, humanist Christian consciousness of the loss of community therefore gives every apearance of recuperating the transcendental illusion of reason when reason exceeds the bounds of all possible experience, which is basically the experience of concealed immanence. *Community has not taken place*, or rather, if it is indeed certain that humanity has known (or still knows, outside of the industrial world) social ties quite different from those familiar to

us, community has never taken place along the lines of our projections of it according to these different social forms. It did not take place for the Guayaqui Indians, it did not take place in an age of huts; nor did it take place in the Hegelian 'spirit of a people' or in the Christian *agape*. No *Gesellschaft* has come along to help the State, industry and capital dissolve a prior *Gemeinschaft*. It would undoubtedly be more accurate to say, bypassing all the twists and turns taken by ethnological interpretation and all the mirages of an origin or of 'bygone days', that *Gesellschaft* – 'society', the dissociating association of forces, needs and signs – has taken the place of something for which we have no name or concept, something that issued at once from a much more extensive communication than that of a mere social bond (a communication with the gods, the cosmos, animals, the dead, the unknown) *and* from much more piercing and dispersed segmentation of this same bond, often involving much harsher effects (solitude, rejection, admonition, helplessness) than what we expect from a communitarian minimum in the social bond. *Society* was not built on the ruins of a *community*. It emerged from the disappearance or the conservation of something – tribes or empires – perhaps just as unrelated to what we call 'community' as to what we call 'society'. So that community, far from being what society has crushed or lost, is *what happens to us* – question, waiting, event, imperative – *in the wake of society*.

Nothing, therefore, has been lost, and for this reason nothing is lost. We alone are lost, we upon whom the 'social bond' (relations, communication), our own invention, now descends heavily like the net of an economic, technical, political and cultural snare. Entangled in its meshes, we have wrung for ourselves the phantasm of the lost community.

What this community has 'lost' – the immanence and the intimacy of a communion – is lost only in the sense that such a 'loss' is constitutive of 'community' itself.

It is not a loss: on the contrary, immanence, if it were to come about, would instantly suppress community, or communication, as such. Death is not only the example of this, it is its truth. In death, at least if one considers in it what brings about immanence (decomposition leading back to nature – 'everything returns to the ground and becomes part of the cycle' – or else the paradisal versions of the same 'cycle') and if one forgets what makes it always irreducibly *singular*, there is no longer any community or communication: there is only the continuous identity of atoms.

This is why political or collective enterprises dominated by a will to absolute immanence have as their truth the truth of death. Immanence, communal fusion, contains no other logic than that of the suicide of the community that is

governed by it. Thus the logic of Nazi Germany was not only that of the extermination of the other, of the subhuman deemed exterior to the communion of blood and soil, but also, effectively, the logic of sacrifice aimed at all those in the 'Aryan' community who did not satisfy the criteria of *pure* immanence, so much so that – it being obviously impossible to set a limit on such criteria – the suicide of the German nation itself might have represented a plausible extrapolation of the process: moreover, it would not be false to say that this really took place, with regard to certain aspects of the spiritual reality of this nation.

The joint suicide or death of lovers is one of the mythico-literary figures of this logic of communion in immanence. Faced with this figure, one cannot tell which – the communion or the love – serves as a model for the other in death. In reality, with the immanence of the two lovers, death accomplishes the infinite reciprocity of two agencies: impassioned love conceived on the basis of Christian communion, and community thought according to the principle of love. The Hegelian State in its turn bears witness to this, for although it certainly is not established on the basis of love – for it belongs to the sphere of so-called objective spirit – it nonetheless has as its *principle* the reality of love, that is to say the fact 'of having in another the moment of one's own subsistence'. In this State, each member has his truth in the other, which is the State itself, whose reality is never more present than when its members give their lives in a war that the monarch – the effective presence-to-self of the Subject-State – has alone and freely decided to wage.[5]

Doubtless such immolation for the sake of community – and by it, therefore – could and can be full of meaning, on the condition that this 'meaning' be that of a community, and on the further condition that this community not be a 'community of death' (as has been the case since at least the First World War, thereby justifying all refusals to 'die for one's country'). Now the community of human immanence, man made equal to himself or to God, to nature, and to his own works, is one such community of deaths – or of the dead. The fully realized person of individualistic or communistic humanism is the dead person. In other words, death, in such a community, is not the unmasterable excess of finitude, but the infinite fulfilment of an immanent life: it is death itself consigned to immanence; it is in the end that resorption of death that the Christian civilization, as though devouring its own transcendence, has come to minister to itself in the guise of a supreme work. Since Leibniz there has been no death in our universe: in one way or another an absolute circulation of meaning (of values, of ends, of History) fills or reabsorbs all finite negativity, draws from each finite singular destiny a surplus value of humanity or an infinite superhumanity. But this presupposes, precisely, the death of each and all in the life of the infinite.

Generations of citizens and militants, of workers and servants of the States,

have imagined their death reabsorbed or sublated in a community, yet to come, that would attain immanence. But by now we have nothing more than the bitter consciousness of the increasing remoteness of such a community, be it the people, the nation or the society of producers. However, this consciousness, like that of the 'loss' of community, is superficial. In truth, death is not sublated. The communion to come does not grow distant, it is not deferred: it was never to come; it would be incapable of coming about or forming a future. What forms a future, and consequently what truly comes about, is always the singular death – which does not mean that death does not come about in the community: on the contrary, I shall come to this. But communion is not what comes of death, no more than death is the simple perpetual past of community.

Millions of deaths, of course, are *justified* by the revolt of those who die: they are justified as a rejoinder to the intolerable, as insurrections against social, political, technical, military, religious oppression. But these deaths are not *sublated*: no dialectic, no salvation leads these deaths to any other immanence than that of … death (cessation, or decomposition, which forms only the parody or reverse of immanence). Yet the modern age has conceived the justification of death only in the guise of salvation or the dialectical sublation of history. The modern age has struggled to *close the circle* of the time of men and their communities in an immortal communion in which death, finally, loses the senseless meaning that it ought to have – and that it has, obstinately.

We are condemned, or rather reduced, to search for this meaning beyond meaning of death elsewhere than in community. But the enterprise is absurd (it is the absurdity of a thought derived from the individual). Death is indissociable from community, for it is through death that the community reveals itself – and reciprocally. It is not by chance that this motif of a reciprocal revelation has preoccupied thought informed by ethnology as well as the thinking of Freud and Heidegger, and at the same time Bataille, that is to say in the time leading from the First to the Second World War.

The motif of the revelation, through death, of being-together or being-with, and of the crystallization of the community around the death of its members, *that is to say, around the 'loss' (the impossibility) of their immanence* and not around their fusional assumption in some collective hypostasis, leads to a space of thinking incommensurable with the problematics of sociality or intersubjectivity (including the Husserlian problematic of the alter ego) within which philosophy, despite its resistance, has remained captive. Death irremediably exceeds the resources of a metaphysics of the subject. The phantasm of this metaphysics, the phantasm that Descartes (almost) did not dare have but that was already proposed in Christian theology, is the phantasm of a dead man who says, like Villiers' Monsieur Waldemar, 'I am dead' – ego *sum*

... *mortuus*. If the *I* cannot say that it is dead, if the *I* disappears, in effect in *its* death, in that death that is precisely what is most proper to it and most inalienably its own, it is because the *I* is something other than a subject. All of Heidegger's research into 'being-for (or toward)-death' was nothing other than an attempt to state this: *I* is not – *am* not – a subject. (Although, when it came to the question of community as such, the same Heidegger also went astray with his vision of a people and a destiny conceived at least in part as a subject,[6] which proves no doubt that Dasein's 'being-toward-death' was never radically implicated in its being-with – in *Mitsein* – and that it is this implication that remains to be thought.)

That which is not a subject opens up and opens onto a community whose conception, in turn, exceeds the resources of a metaphysics of the subject. Community does not weave a superior, immortal or transmortal life between subjects (no more than it is itself woven of the inferior bonds of a consubstantiality of blood or of an association of needs), but it is constitutively, to the extent that it is a matter of a 'constitution' here, calibrated on the death of those whom we call, perhaps wrongly, its 'members' (in as much as it is not a question of an organism). But it does not make a work of this calibration. Community no more makes a work out of death than it is itself a work. The death upon which community is calibrated does not *operate* the dead being's passage into some communal intimacy, nor does community, for its part, *operate* the transfiguration of its dead into some substance or subject – be these homeland, native soil or blood, nation, a delivered or fulfilled humanity, absolute phalanstery, family, or mystical body. Community is calibrated on death as on that of which it is precisely impossible to *make a work* (other than a work of death, as soon as one tries to make a work of it). Community occurs in order to acknowledge this impossibility, or more exactly – for there is neither function nor finality here – the impossibility of making a work out of death is inscribed and acknowledged as 'community'.

Community is revealed in the death of others; hence it is always revealed to others. Community is what takes place always through others and for others. It is not the space of the *egos* – subjects and substances that are at bottom immortal – but of the *I*'s, who are always *others* (or else are nothing). If community is revealed in the death of others it is because death itself is the true community of *I*'s that are not *egos*. It is not a communion that fuses the *egos* into an *Ego* or a higher *We*. It is the community of *others*. The genuine community of mortal beings, or death as community, establishes their impossible communion. Community therefore occupies a singular place: it assumes the impossibility of its own immanence, the impossibility of a communitarian being in the form of a subject. In a certain sense community acknowledges and inscribes – this is its

peculiar gesture – the impossibility of community. A community is not a project of fusion, or in some general way a productive or operative project – nor is it a *project* at all (once again, this is its radical difference from 'the spirit of a people', which from Hegel to Heidegger has figured the collectivity as project, and figured the project, reciprocally, as collective – which does not mean that we can ignore the question of the singularity of a 'people').

A community is the presentation to its members of their mortal truth (which amounts to saying that there is no community of immortal beings: one can imagine either a society or a communion of immortal beings, but not a community). It is the presentation of the finitude and the irredeemable excess that make up finite being: its death, but also its birth, and only the community can present me my birth, and along with it the impossibility of my reliving it, as well as the impossibility of my crossing over into my death. [...]

Community means, consequently, that there is no singular being without another singular being, and that there is, therefore, what might be called, in a rather inappropriate idiom, an originary or ontological 'sociality' that in its principle extends far beyond the simple theme of man as a social being (the *zoon politikon* is secondary to this community). For, on the one hand, it is not obvious that the community of singularities is limited to 'man' and excludes, for example, the 'animal' (even in the case of 'man' it is not *a fortiori* certain that this community concerns only 'man' and not also the 'inhuman' or the 'superhuman', or, for example, if I may say so with and without a certain *Witz*, 'woman': after all, the difference befween the sexes is itself a singularity in the difference of singularities). On the other hand, if social being is always posited as a predicate of man, community would signify on the contrary the basis for thinking only something like 'man'. But this thinking would at the same time remain dependent upon a principal determination of community, namely, that there is no communion of singularities in a totality superior to them and immanent to their common being.

In place of such a communion, there is communication. Which is to say, in very precise terms, that finitude itself *is* nothing; it is neither a ground, nor an essence, nor a substance. But it appears, it presents itself, it exposes itself, and thus it *exists* as communication. In order to designate this singular mode of appearing, this specific phenomenality, which is no doubt more originary than any other (for it could be that the world appears to the community, not to the individual), we would need to be able to say that finitude *co-appears* or *compears, (com-paraît)* and can only *compear*: in this formulation we would need to hear that finite being always presents itself 'together', hence severally; for finitude always presents itself in being-in-common and as this being itself, and

it always presents itself at a *hearing* and before the judgment of the law of community, or, more originarily, before the judgment of community as law.

Communication consists before all else in this sharing and in this compearance (*com-parution*) of finitude: that is, in the dislocation and in the interpellation that reveal themselves to be constitutive of being-in-common – precisely in as much as being-in-common is not a common being. The finite-being exists first of all according to a division of sites, according to an extension – *partes extra partes* – such that each singularity is extended (in the sense that Freud says: 'The psyche is extended'). It is not enclosed in a form – although its whole being touches against its singular limit – but it is what it is, singular being (singularity of being), only through its extension, through the areality that above all extroverts it in its very being – whatever the degree or the desire of its 'egoism' – and that makes it exist only by *exposing it to an outside*. This outside is in its turn nothing other than the exposition of another areality, of another singularity – the same other. This exposure, or this exposing-sharing, gives rise, from the outset, to a mutual interpellation of singularities prior to any address in language (though it gives to this latter its first condition of possibility).[7] Finitude compears, that is to say it is exposed: such is the essence of community.

Under these conditions, communication is not a bond. The metaphor of the 'social bond' unhappily superimposes upon 'subjects' (that is to say, objects) a hypothetical reality (that of the 'bond') upon which some have attempted to confer a dubious 'intersubjective' nature that would have the virtue of attaching these objects to one another. This would be the economic link or the bond of recognition. But compearance is of a more originary order than that of the bond. It does not set itself up, it does not establish itself, it does not emerge among already given subjects (objects). It consists in the appearance of the *between* as such: you *and* I (between us) – a formula in which the *and* does not imply juxtaposition but exposition. What is exposed in compearance is the following, and we must learn to read it in all its possible combinations: 'you (are/and/is) (entirely other than) I' ('*toi [e(s)t] [tout autre que] moi*'). Or again, more simply: *you shares me* ('*toi portage moi*').

Only in this communication are singular beings given – without a bond *and* without communion, equally distant from any notion of connection or joining from the outside and from any notion of a common and fusional interiority. Communication is the constitutive fact of an exposition to the outside that defines singularity. In its being, as its very being, singularity is exposed to the outside. By virtue of this position or this primordial structure, it is at once detached, distinguished and communitarian. Community is the presentation of the detachment (or retrenchment) of this distinction that is not individuation, but finitude compearing. [...]

This is why community cannot arise from the domain of *work*. One does not produce it, one experiences or one is constituted by it as the experience of finitude. Community understood as a work or through its works would presuppose that the common being, as such, be objectifiable and producible (in sites, persons, buildings, discourses, institutions, symbols: in short, in subjects). Products derived from operations of this kind, however grandiose they might seek to be and sometimes manage to be, have no more communitarian existence than the plaster busts of Marianne.

Community necessarily takes place in what Blanchot has called 'unworking', referring to that which, before or beyond the work, withdraws from the work, and which, no longer having to do either with production or with completion, encounters interruption, fragmentation, suspension. Community is made of the interruption of singularities, or of the suspension that singular beings *are*. Community is not the work of singular beings, nor can it claim them as its works, just as communication is not a work or even an operation of singular beings, for community is simply their being – their being suspended upon its limit. Communication is the unworking of work that is social, economic, technical and institutional.[8] [...]

The political, if this word may serve to designate not the organization of society but the disposition of community as such, the destination of its sharing, must not be the assumption or the work of love or of death. It need neither find, nor regain, nor effect a communion taken to be lost or still to come. If the political is not dissolved in the sociotechnical element of forces and needs (in which, in effect, it seems to be dissolving under our eyes), it must inscribe the sharing of community. The outline of singularity would be 'political' – as would be the outline of its communication and its ecstasy. 'Political' would mean a community ordering itself to the unworking of its communication, or destined to this unworking: a community consciously undergoing the experience of its sharing. To attain such a signification of the 'political' does not depend, or in any case not simply, on what is called a 'political will'. It implies being already engaged in the community, that is to say, undergoing, in whatever manner, the experience of community as communication: it implies writing. We must not stop writing, or letting the singular outline of our being-in-common expose itself.

Not only will this have been written after Bataille, but also to him, just as he wrote to us – because one always writes *to* – communicating to us the anguish of community, writing from a solitude prior to any isolation, invoking a community that no society contains or precedes, even though every society is implied in it:

The reasons for writing a book can be brought back to the desire to modify the existing relations between a man and his fellow beings. These relations are judged unacceptable and are perceived as an atrocious misery. (Georges Bataille, *Oeuvres Complètes*, vol. 2, 143)

Or else, it is community itself – though it *is* nothing, *it* is not a collective subject – that never stops, in writing, sharing itself.

The anguish which you do not communicate to your fellow being is in some way scorned and mistreated. It has only to the weakest extent the power to reflect the glory that comes from the depth of the heavens. (*O.C.* 5: 444)

In *My Mother*, Hélène, the mother, writes to her son:

I admire myself for writing to you like this, and I marvel to think that my letter is worthy of you. (*O.C.* 4: 260)

But this hand that writes is *dying*, and through this death promised to it, it escapes accepted limits by writing. (*O.C.* 3: 12)

I would say, rather: it exposes these limits, it never passes beyond them, nor passes beyond community. But at every instant singular beings share their limits, share each other on their limits. They escape the relationships of society ('mother' and 'son', 'author' and 'reader', 'public figure' and 'private figure', 'producer' and 'consumer'), but they are in community, and are unworked.

I have spoken of a community as existing: Nietzsche brought his affirmations to this, but remained alone ... The desire to communicate is born in me out of a feeling of community binding me to Nietzsche, and not out of an isolated originality. (*O.C.* 5: 39)

We can only go farther.

1 Georges Bataille, *Oeuvres Complètes*, vol. 1 (Paris: Gallimard, 1970) 332; hereafter '*O.C.*'

2 Considered in detail, taking into account the precise historical conjuncture of each instance, this is not rigorously exact as regards, for example, the Hungarian Council of 1956, and even more so the left of Solidarity in Poland. Nor is it absolutely exact as regards all of the discourses held today: one might, in this respect alone, juxtapose the situationists of not so long ago with certain aspects of Hannah Arendt's thought and also, as strange or provocative as the mixture might appear, certain propositions advanced by Lyotard, Badiou, Ellul, Deleuze, Pasolini and Rancière. These thoughts occur, although each one engages it in its own particular way (and sometimes whether they know it or not), in the wake of a Marxist event that I will try to characterize below and that signifies for us the bringing into question of communist or communitarian humanism (quite different from the questioning once undertaken by Althusser in the name of a Marxist science). This is also why such propositions communicate with what I shall name, tentatively and in spite of everything, 'literary communism'.

3 [footnote 5 in source] 'Le communisme sans heritage', *revue Comité*, 1968, *Gramma*, 3/4 (1976) 32.

4 [6] For the moment, let us retain simply that 'literature', here, must above all not be taken in the sense Bataille gave to the word when he wrote, for example (in his critique of *Inner Experience* and *Guilty*): 'I have come to realize through experience that these books lead those who read them into complacency. They please most often those vague and impotent minds who want to flee and sleep and *satisfy* themselves with the escape provided by literature' (*O.C.* 8: 583). He also spoke of the 'sliding into impotence of thought that turns to literature' (ibid.).

5 [8] See Jean-Luc Nancy, 'La juridiction du monarque hégélien', in *Rejouer le politique* (Paris: Galilée, 1981). Translated in *The Birth to Presence* (Stanford: Stanford University Press, 1993).

6 [9] See Philippe Lacoue-Labarthe, 'Transcendence Ends in Politics', trans. P. Caws, in *Typography: Mimesis, Philosophy, Politics*, ed. C. Fynsk (Harvard University Press, 1989) 267–300, and G. Granel, 'Pourquoi avoir public cela?' in *De l'université* (Toulouse: T.E.R., 1982).

7 [24] In this sense, the compearance of singular beings is anterior even to the preliminary condition of language that Heidegger understands as prelinguistic 'interpretation' (*Auslegung*), to which I referred the singularity of voices in 'Sharing Voices', in *Transforming the Hermeneutic Context*, ed. Gayle L. Ormiston and Alan D. Schrift (Albany: SUNY Press, 1989). Contrary to what this essay might lead one to think, the sharing of voices does not lead to community; on the contrary, it depends on this originary sharing that community 'is'. Or rather, this 'originary' sharing itself is nothing other than a 'sharing of voices', but the 'voice' should be understood not as linguistic or even prelinguistic, but as communitarian.

8 [26] I do not include the political here. In the form of the State, or the Party (if not the State-Party), it indeed seems to be of the order of a work. But it is perhaps at the heart of the political that communitarian unworking resists.

Jean-Luc Nancy, *La Communauté désoeuvrée* (Paris: Christian Bourgois, 1986); ed. and trans. Peter Connor, *The Inoperative Community* (Minneapolis: University of Minnesota Press, 1991) 1–4; 7–15; 28–9; 31; 40–1.

Édouard Glissant
Poetics of Relation//1990

Influenced by Deleuze and Guattari's A Thousand Plateaux *(1980), which advocates an incessant subversion of power via 'deterritorializing' gestures, the French-Caribbean author Édouard Glissant poetically argues for the active appropriation of colonial culture by the colonized, particularly on the level of language. In contrast to the culturally unifying concept of négritude, Glissant's* Poetics of Relation *(1990) advocates a unity understood as diverse and fluctuating.*

Errantry, Exile

Roots make the commonality of errantry and exile, for in both instances roots are lacking. We must begin with that.

Gilles Deleuze and Félix Guattari criticized notions of the root and even, perhaps, notions of being rooted. The root is unique, a stock taking all upon itself and killing all around it. In opposition to this they propose the rhizome, an enmeshed root system, a network spreading either in the ground or in the air, with no predatory rootstock taking over permanently. The notion of the rhizome maintains, therefore, the idea of rootedness but challenges that of a totalitarian root. Rhizomatic thought is the principle behind what I call the Poetics of Relation, in which each and every identity is extended through a relationship with the Other.

These authors extol nomadism, which supposedly liberates Being, in contrast, perhaps, to a settled way of life, with its law based upon the intolerant root. Already Kant, at the beginning of *Critique of Pure Reason*, had seen similarities between skeptics and nomads, remarking also that, from time to time, 'they break the social bond'. He seems thus to establish correlations between, on the one hand, a settled way of life, truth and society and, on the other, nomadism, skepticism and anarchy. This parallel with Kant suggests that the rhizome concept appears interesting for its anti-conformism, but one cannot infer from this that it is subversive or that rhizomatic thought has the capacity to overturn the order of the world – because, by so doing, one reverts to ideological claims presumably challenged by this thought.

But is the nomad not overdetermined by the conditions of his existence? Rather than the enjoyment of freedom, is nomadism not a form of obedience to contingencies that are restrictive? Take, for example, circular nomadism: each time a portion of the territory is exhausted, the group moves around. Its function is to ensure the survival of the group by means of this circularity. This is the

nomadism practised by populations that move from one part of the forest to another, by the Arawak communities who navigated from island to island in the Caribbean, by hired labourers in their pilgrimage from farm to farm, by circus people in their peregrinations from village to village, all of whom are driven by some specific need to move, in which daring or aggression play no part. Circular nomadism is a not-intolerant form of an impossible settlement.

Contrast this with invading nomadism, that of the Huns, for example, or the Conquistadors, whose goal was to conquer lands by exterminating their occupants. Neither prudent nor circular nomadism, it spares no effect. It is an absolute forward projection: an arrowlike nomadism. But the descendants of the Huns, Vandals or Visigoths, as indeed those of the Conquistadors, who established their clans, settled down bit by bit, melting into their conquests. Arrowlike nomadism is a devastating desire for settlement.

Neither in arrowlike nomadism nor in circular nomadism are roots valid. Before it is won through conquest, what 'holds' the invader is what lies ahead; moreover, one could almost say that being compelled to lead a settled way of life would constitute the real uprooting of a circular nomad. There is, furthermore, no pain of exile bearing down, nor is there the wanderlust of errantry growing keener. Relation to the earth is too immediate or too plundering to be linked with any preoccupation with identity – this claim to or consciousness of a lineage inscribed in a territory. Identity will be achieved when communities attempt to legitimate their right to possession of a territory through myth or the revealed word. Such an assertion can predate its actual accomplishment by quite some time. Thus, an often and long contested legitimacy will have multiple forms that later will delineate the afflicted or soothing dimensions of exile or errantry.

In Western antiquity a man in exile does not feel he is helpless or inferior, because he does not feel burdened with deprivation – of a nation that for him does not yet exist. It even seems, if one is to believe the biographies of numerous Greek thinkers including Plato and Aristotle, that some experience of voyaging and exile is considered necessary for a being's complete fulfilment. Plato was the first to attempt to base legitimacy not on community within territory (as it was before and would be later) but on the City in the rationality of its laws. This at a time when his city, Athens, was already threatened by a 'final' deregulation.

In this period identification is with a culture (conceived of as civilization), not yet with a nation. The pre-Christian West along with pre-Columbian America, Africa of the time of the great conquerors, and the Asian kingdoms all shared this mode of seeing and feeling. The relay of actions exerted by arrowlike nomadism and the settled way of life were first directed against generalization (the drive for an identifying universal as practised by the Roman Empire). Thus, the particular resists a generalizing universal and soon begets specific and local

senses of identity, in concentric circles (provinces then nations). The idea of civilization, bit by bit, helps hold together opposites, whose only former identity existed in their opposition to the Other.

During this period of invading nomads the passion for self-definition first appears in the guise of personal adventure. Along the route of their voyages conquerors established empires that collapsed at their death. Their capitals went where they went. 'Rome is no longer in Rome, it is wherever I am.' The root is not important. Movement is. The idea of errantry, still inhibited in the face of this mad reality, this too-functional nomadism, whose ends it could not know, does not yet make an appearance. Centre and periphery are equivalent. Conquerors are the moving, transient root of their people.

The West, therefore, is where this movement becomes fixed and nations declare themselves in preparation for their repercussions in the world. This fixing, this declaration, this expansion, all require that the idea of the root gradually take on the intolerant sense that Deleuze and Guattari, no doubt, meant to challenge. The reason for our return to this episode in Western history is that it spread throughout the world. The model came in handy. Most of the nations that gained freedom from colonization have tended to form around an idea of power – the totalitarian drive of a single, unique root – rather than around a fundamental relationship with the Other. Culture's self-conception was dualistic, pitting citizen against barbarian. Nothing has ever more solidly opposed the thought of errantry than this period in human history when Western nations were established and then made their impact on the world.

At first this thought of errantry, bucking the current of nationalist expansion, was disguised 'within' very personalized adventures – just as the appearance of Western nations had been preceded by the ventures of empire builders. The errantry of a troubadour or that of Rimbaud is not yet a thorough, thick (opaque) experience of the world, but it is already an arrant, passionate desire to go against a root. The reality of exile during this period is felt as a (temporary) lack that primarily concerns, interestingly enough, language. Western nations were established on the basis of linguistic intransigence, and the exile readily admits that he suffers most from the impossibility of communicating in his language. The root is monolingual. For the troubadour and for Rimbaud errantry is a vocation only told via detour. The call of Relation is heard, but it is not yet a fully present experience.

However, and this is an immense paradox, the great founding books of communities, the Old Testament, the *Iliad*, the *Odyssey*, the *Chansons de Geste*, the Islandic *Sagas*, the *Aeneid* or the African epics, were all books about exile and often about errantry. This epic literature is amazingly prophetic. It tells of the community but, through relating the community's apparent failure or in any

case its being surpassed, it tells of errantry as a temptation (the desire to go against the root) and, frequently, actually experienced. Within the collective books concerning the sacred and the notion of history lies the germ of the exact opposite of what they so loudly proclaim. When the very idea of territory becomes relative, nuances appear in the legitimacy of territorial possession. These are books about the birth of collective consciousness, but they also introduce the unrest and suspense that allow the individual to discover himself there, whenever he himself becomes the issue. The Greek victory in the *Iliad* depends on trickery; Ulysses returns from his Odyssey and is recognized only by his dog; the Old Testament David bears the stain of adultery and murder; the *Chanson de Roland* is the chronicle of a defeat; the characters in the *Sagas* are branded by an unstemmable fate, and so forth. These books are the beginning of something entirely different from massive, dogmatic and totalitarian certainty (despite the religious uses to which they will be put). These are books of errantry, going beyond the pursuits and triumphs of rootedness required by the evolution of history.

Some of these books are devoted entirely to the supreme errantry, as in the Egyptian Book of the Dead. The very book whose function is to consecrate an intransigent community is already a compromise, qualifying its triumph with revelatory wanderings.

In both *L'Intention poétique* (*Poetic Intention*) and *Le Discours antillais* (*Caribbean Discourse*) – of which the present work is a reconstituted echo or a spiral retelling – I approached this dimension of epic literature. I began wondering if we did not still need such founding works today, ones that would use a similar dialectics of rerouting, asserting, for example, political strength but, simultaneously, the rhizome of a multiple relationship with the Other and basing every community's reasons for existence on a modern form of the sacred, which would be, all in all, a Poetics of Relation.

This movement, therefore (one among others, equally important, in other parts of the world), has led from a primordial nomadism to the settled way of life of Western nations, then to Discovery and Conquest, which achieved a final, almost mystical perfection in the Voyage.

In the course of this journey, identity, at least as far as the Western peoples who made up the great majority of voyagers, discoverers and conquerors were concerned, consolidates itself implicitly at first ('my root is the strongest') and then is explicitly exported as a value ('a person's worth is determined by his root'). The conquered or visited peoples are thus forced into a long and painful quest after an identity whose first task will be opposition to the denaturing process introduced by the conqueror. A tragic variation of a search for identity. For more than two centuries whole populations have had to assert their identity

in opposition to the processes of identification or annihilation triggered by these invaders. Whereas the Western nation is first of all an 'opposite,' for colonized peoples identity will be primarily 'opposed to' – that is, a limitation from the beginning. Decolonization will have done its real work when it goes beyond this limit.

The duality of self-perception (one is citizen or foreigner) has repercussions on one's idea of the Other (one is visitor or visited; one goes or stays; one conquers or is conquered). Thought of the Other cannot escape its own dualism until the time when differences become acknowledged. From that point on thought of the Other 'comprehends' multiplicity, but mechanically and still taking the subtle hierarchies of a generalizing universal as its basis. Acknowledging differences does not compel one to be involved in the dialectics of their totality. One could get away with: 'I can acknowledge your difference and continue to think it is harmful to you. I can think that my strength lies in the Voyage (I am making History) and that your difference is motionless and silent.' Another step remains to be taken before one really enters the dialectic of totality. And, contrary to the mechanics of the Voyage, this dialectic turns out to be driven by the thought of errantry.

Let us suppose that the quest for totality, starting from a non-universal context of histories of the West, has passed through the following stages:

– the thinking of territory and self (ontological, dual)
– the thinking of voyage and other (mechanical, multiple)
– the thinking of errantry and totality (relational, dialectical).

We will agree that this thinking of errantry, this errant thought, silently emerges from the destructuring of compact national entities that yesterday were still triumphant and, at the same time, from difficult, uncertain births of new forms of identity that call to us.

In this context uprooting can work towards identity, and exile can be seen as beneficial, when these are experienced as a search for the Other (through circular nomadism) rather than as an expansion of territory (an arrowlike nomadism). Totality's imaginary allows the detours that lead away from anything totalitarian.

Errantry, therefore, does not proceed from renunciation nor from frustration regarding a supposedly deteriorated (deterritorialized) situation of origin; it is not a resolute act of rejection or an uncontrolled impulse of abandonment. Sometimes, by taking up the problems of the Other, it is possible to find oneself. Contemporary history provides several striking examples of this, among them Frantz Fanon, whose path led from Martinique to Algeria. That is very much the image of the rhizome, prompting the knowledge that identity is no longer completely within the root but also in Relation. Because the thought of errantry

is also the thought of what is relative, the thing relayed as well as the thing related. The thought of errantry is a poetics, which always infers that at some moment it is told. The tale of errantry is the tale of Relation.

In contrast to arrowlike nomadism (discovery or conquest), in contrast to the situation of exile, errantry gives-on-and-with the negation of every pole and every metropolis, whether connected or not to a conqueror's voyaging act. We have repeatedly mentioned that the first thing exported by the conqueror was his language. Moreover, the great Western languages were supposedly vehicular languages, which often took the place of an actual metropolis. Relation, in contrast, is spoken multilingually. Going beyond the impositions of economic forces and cultural pressures, Relation rightfully opposes the totalitarianism of any monolingual intent.

At this point we seem to be far removed from the sufferings and preoccupations of those who must bear the world's injustice. Their errantry is, in effect, immobile. They have never experienced the melancholy and extroverted luxury of uprooting. They do not travel. But one of the constants of our world is that a knowledge of roots will be conveyed to them from within intuitions of Relation from now on. Travelling is no longer the locus of power but rather a pleasurable, if privileged time. The ontological obsession with knowledge gives way here to the enjoyment of a relation; in its elementary and often caricatural form this is tourism. Those who stay behind thrill to this passion for the world shared by all. Or indeed they may suffer the torments of internal exile.

I would not describe the physical situation of those who suffer the oppression of an Other within their own country, such as the blacks in South Africa, as internal exile. Because the solution here is visible and the outcome determined; force alone can oppose this. Internal exile strikes individuals living where solutions concerning the relationship of a community to its surroundings are not, or at least not yet, consented to by this community as a whole. These solutions, precariously outlined as decisions, are still the prerogative of only a few who as a result are marginalized. Internal exile is the voyage out of this enclosure. It is a motionless and exacerbated introduction to the thought of errantry. Most often it is diverted into partial, pleasurable compensations in which the individual is consumed. Internal exile tends toward material comfort, which cannot really distract from anguish.

Whereas exile may erode one's sense of identity, the thought of errantry – the thought of that which relates – usually reinforces this sense of identity. It seems possible, at least to one observer, that the persecuted errantry, the wandering of the Jews, may have reinforced their sense of identity far more than their present settling in the land of Palestine. Being exiled Jews turned into a

vocation of errantry, their point of reference an ideal land whose power may, in fact, have been undermined by concrete land (a territory), chosen and conquered. This, however, is mere conjecture. Because, while one can communicate through errantry's imaginary vision, the experiences of exiles are incommunicable.

The thought of errantry is not apolitical nor is it inconsistent with the will to identity, which is, after all, nothing other than the search for a freedom within particular surroundings. If it is at variance with territorial intolerance, or the predatory effects of the unique root (which makes processes of identification so difficult today), this is because, in the Poetics of Relation, one who is errant (who is no longer traveller, discoverer or conqueror) strives to know the totality of the world yet already knows he will never accomplish this – and knows that is precisely where the threatened beauty of the world resides.

Errant, he challenges and discards the universal – this generalizing edict that summarized the world as something obvious and transparent, claiming for it one presupposed sense and one destiny. He plunges into the opacities of that part of the world to which he has access. Generalization is totalitarian: from the world it chooses one side of the reports, one set of ideas, which it sets apart from others and tries to impose by exporting as a model. The thinking of errantry conceives of totality but willingly renounces any claims to sum it up or to possess it.

The founding books have taught us that the sacred dimension consists always of going deeper into the mystery of the root, shaded with variations of errantry. In reality errant thinking is the postulation of an unyielding and unfading sacred. We remember that Plato, who understood the power of Myth, had hoped to banish the poets, those who force obscurity, far from the Republic. He distrusted the fathomless word. Are we not returning here, in the unforeseeable meanders of Relation, to this abyssal word? Nowhere is it stated that now, in this thought of errantry, humanity will not succeed in transmuting Myth's opacities (which were formerly the occasion for setting roots) and the diffracted insights of political philosophy, thereby reconciling Homer and Plato, Hegel and the African griot.

But we need to figure out whether or not there are other succulencies of Relation in other parts of the world (and already at work in an underground manner) that will suddenly open up other avenues and soon help to correct whatever simplifying, ethnocentric exclusions may have arisen from such a perspective. [...]

Dictate, Decree
[...] Summarizing what we know concerning the varieties of identity, we arrive at the following:

Root identity
– is founded in the distant past in a vision, a myth of the creation of the world;
– is sanctified by the hidden violence of a filiation that strictly follows from this founding episode;
– is ratified by a claim to legitimacy that allows a community to proclaim its entitlement to the possession of a land, which thus becomes a territory;
– is preserved by being projected onto other territories, making their conquest legitimate – and through the project of a discursive knowledge. Root identity therefore rooted the thought of self and of territory and set in motion the thought of the other and of voyage.

Relation identity
– is linked not to a creation of the world but to the conscious and contradictory experience of contacts among cultures;
– is produced in the chaotic network of Relation and not in the hidden violence of filiation;
– does not devise any legitimacy as its guarantee of entitlement, but circulates, newly extended;
– does not think of a land as a territory from which to project toward other territories but as a place where one gives-on-and-with rather than grasps.

Relation identity exults the thought of errantry and of totality. The shock of relating, hence, has repercussions on several levels. When secular cultures come into contact through their intolerances, the ensuing violence triggers mutual exclusions that are of a sacred nature and for which any future reconciliation is hard to foresee. When a culture that is expressly composite, such as the culture of Martinique, is touched by another (French) that 'entered into' its composition and continues to determine it, not radically but through the erosion of assimilation, the violence of reaction is intermittent and unsure of itself. For the Martinican it has no solid rootstock in any sacred territory or filiation. This, indeed, is a case in which specificity is a strict requirement and must be defined as closely as possible. For this composite culture is fragile in the extreme, wearing down through contact with a masked colonization. [...]

Édouard Glissant, *Poétique de la Relation* (Paris: Éditions Gallimard, 1990); trans. Betsy Wing, *Poetics of Relation* [footnotes not included] (Ann Arbor: University of Michigan Press, 1997) 11–21; 143–4.

Félix Guattari
Chaosmosis: An Ethico-Aesthetic Paradigm//1992

Chaosmosis: An Ethico-Aesthetic Paradigm (1992) is the last book written by French psychoanalyst and philosopher Félix Guattari. In it he turns to aesthetics as the model for a new ethical behaviour opposed to capitalist rationality. For Guattari, art is a process of 'becoming': a fluid and partially autonomous zone of activity that works against disciplinary boundaries, yet which is inseparable from its integration in the social field. Chaosmosis is an important reference for the final essay in Nicolas Bourriaud's Relational Aesthetics.

[...] Artistic cartographies have always been an essential element of the framework of every society. But since becoming the work of specialized corporate bodies, they may have appeared to be side issues, a supplement of the soul, a fragile superstructure whose death is regularly announced. And yet from the grottoes of Lascaux to Soho, taking in the dawn of the cathedrals, they have never stopped being a vital element in the crystallization of individual and collective subjectivities.

Fabricated in the socius, art, however, is only sustained by itself. This is because each work produced possesses a double finality: to insert itself into a social network which will either appropriate or reject it, and to celebrate, once again, the Universe of art as such, precisely because it is always in danger of collapsing.

What confers it with this perennial possibility of eclipse is its function of rupturing with forms and significations circulating trivially in the social field. The artist and, more generally, aesthetic perception, detach and deterritorialize a segment of the real in such a way as to make it play the role of a partial enunciator. Art confers a function of sense and alterity to a subset of the perceived world. The consequence of this quasi-animistic speech effect of a work of art is that the subjectivity of the artist and the 'consumer' is reshaped. In short, it is a matter of rarefying an enunciation which has too great a tendency to become entangled in an identificatory seriality which infantilizes and annihilates it. The work of art, for those who use it, is an activity of unframing, of rupturing sense, of baroque proliferation or extreme impoverishment, which leads to a recreation and a reinvention of the subject itself. A new existential support will oscillate on the work of art, based on a double register of reterritorialization (refrain function) and resingularization. The event of its encounter can irreversibly date the course of an existence and generate fields of

the possible 'far from the equilibria' of everyday life.

Viewed from the angle of this existential function – namely, in rupture with signification and denotation – ordinary aesthetic categorizations lose a large part of their relevance. Reference to 'free figuration', 'abstraction' or 'conceptualism' hardly matters! What is important is to know if a work leads effectively to a mutant production of enunciation. The focus of artistic activity always remains a surplus-value of subjectivity or, in other terms, the bringing to light of a negentropy at the heart of the banality of the environment – the consistency of subjectivity only being maintained by self-renewal through a minimal, individual or collective, resingularization.

The growth in artistic consumption we have witnessed in recent years should be placed, nevertheless, in relation to the increasing uniformity of the life of individuals in the urban context. It should be emphasized that the quasi-vitaminic function of this artistic consumption is not univocal. It can move in a direction parallel to uniformization, or play the role of an operator in the bifurcation of subjectivity (this ambivalence is particularly evident in the influence of rock culture). This is the dilemma every artist has to confront: 'to go with the flow', as advocated, for example, by the Transavantgarde and the apostles of postmodernism, or to work for the renewal of aesthetic practices relayed by other innovative segments of the Socius, at the risk of encountering incomprehension and of being isolated by the majority of people.

Of course, it's not at all clear how one can claim to hold creative singularity and potential social mutations together. And it has to be admitted that the contemporary Socius hardly lends itself to experimentation with this kind of aesthetic and ethico-political transversality. It nonetheless remains the case that the immense crisis sweeping the planet – chronic unemployment, ecological devastation, deregulation of modes of valorization, uniquely based on profit or State assistance – open the field up to a different deployment of aesthetic components. It doesn't simply involve occupying the free time of the unemployed and 'marginalized' in community centres! In fact it is the very productions of science, technology and social relations which will drift towards aesthetic paradigms. It's enough to refer to the latest book by Ilya Prigogine and Isabelle Stengers, where they evoke the necessity of introducing into physics a 'narrative element' as indispensable to a genuine conception of evolution.[1]

Today our societies have their backs up against the wall; to survive they will have to develop research, innovation and creation still further – the very dimensions which imply an awareness of the strictly aesthetic techniques of rupture and suture. Something is detached and starts to work for itself, just as it can work for you if you can 'agglomerate' yourself to such a process. Such requestioning concerns every institutional domain; for example, the school.

How do you make a class operate like a work of art? What are the possible paths to its singularization, the source of a 'purchase on existence' for the children who compose it?[2] And on the register of what I once called 'molecular revolutions', the Third World conceals treasures which deserve to be explored.[3]

A systematic rejection of subjectivity in the name of a mythical scientific objectivity continues to reign in the University. In the heyday of structuralism the subject was methodically excluded from its own multiple and heterogeneous material of expression. It is time to re-examine machinic productions of images, signs of artificial intelligence, etc., as new materials of subjectivity. In the Middle Ages, art and technique found refuge in the monasteries and convents which had managed to survive. Perhaps artists today constitute the final lines along which primordial existential questions are folded. How are the new fields of the possible going to be fitted out? How are sounds and forms going to be arranged so that the subjectivity adjacent to them remains in movement, and really alive?

The future of contemporary subjectivity is not to live indefinitely under the regime of self-withdrawal, of mass-mediatic infantilization, of ignorance of difference and alterity – both on the human and the cosmic register. Its modes of subjectivation will get out of their homogenetic 'entrapment' only if creative objectives appear within their reach. What is at stake here is the finality of the ensemble of human activities. Beyond material and political demands, what emerges is an aspiration for individual and collective reappropriation of the production of subjectivity. In this way the ontological heterogenesis of value becomes the focus of political concerns which at present lack the site, the immediate relation, the environment, the reconstitution of the social fabric and existential impact of art ... And at the end of a slow recomposition of assemblages of subjectivation, the chaosmic explorations of an ecosophy – articulating between them scientific, political, environmental and mental ecologies – ought to be able to claim to replace the old ideologies which abusively sectorized the social, the private and the civil, and which were fundamentally incapable of establishing transversal junctions between the political, the ethical and the aesthetic.

It should, however, be clear that we are in no way advocating an aestheticization of the Socius, for, after all, promoting a new aesthetic paradigm involves overthrowing current forms of art as much as those of social life! I hold out my hand to the future. My approach will be marked by mechanical confidence or creative uncertainty, according to whether I consider everything to be worked out in advance or everything to be there for the taking – that the world can be rebuilt from other Universes of value and that other existential Territories should be constructed towards this end. The immense ordeals which

the planet is going through – such as the suffocation of its atmosphere – involve changes in production, ways of living and axes of value. The demographic explosion which will, in a few decades, see the population of Latin America multiply by three and that of Africa by five[4] does not proceed from an inexorable biological malediction. The key factors in it are economic (that is, they relate to power) and in the final analysis are subjective – cultural, social and mass-mediatic. The future of the Third World rests primarily on its capacity to recapture its own processes of subjectivation in the context of a social fabric in the process of desertification. (In Brazil, for example, Wild West capitalism, savage gang and police violence coexist with interesting attempts by the Workers' Party movement at recomposing social and urbanistic practices.)

Among the fogs and miasmas which obscure our *fin de millénaire*, the question of subjectivity is now returning as a leitmotiv. It is not a natural given any more than air or water. How do we produce it, capture it, enrich it, and permanently reinvent it in a way that renders it compatible with Universes of mutant value? How do we work for its liberation, that is, for its resingularization? Psychoanalysis, institutional analysis, film, literature, poetry, innovative pedagogies, town planning and architecture – all the disciplines will have to combine their creativity to ward off the ordeals of barbarism, the mental implosion and chaosmic spasms looming on the horizon, and transform them into riches and unforeseen pleasures, the promises of which, for all that, are all too tangible.

1 [footnote 2 in source] 'For mankind today, the "Big Bang" and the evolution of the Universe are part of the world in the same way as, in prior times, the myths of origin.' *Entre le temps et l'éternité* (Paris: Fayard, 1988) 65.

2 [3] Among the many works on institutional pedagogy, see René Lafitte, *Une journée dans une classe coopérative: le désir retrouvé* (Paris: Syros, 1985).

3 [4] On the networks of solidarity subsisting amongst those 'defeated' by modernity in the Third World: Serge Latouche, *La Planète des naufragés. Essai sur l'après-développement* (Paris: La Découverte, 1991).

4 [5] Jacques Vallin (de l'INED), *Transversales Science/Culture*, no. 9, June 1991 (29, rue Marsoulin, 75012 Paris). *La population mondiale, la population française* (Paris: La Découverte, 1991).

Félix Guattari, *Chaosmose* (Paris: Éditions Galilée, 1992); trans. Paul Bains and Julian Pefanis, *Chaosmosis: An Ethico-Aesthetic Paradigm* (Indianapolis: Indiana University Press, 1995) 130–5.

Jacques Rancière
Problems and Transformations in Critical Art//2004

The French philosopher Jacques Rancière has written extensively on the relationship between aesthetics and politics as a partage du sensible *– the sharing/division of what is visible, sayable and thinkable. In this extract from* Malaise dans l'esthétique *(2004), Rancière addresses the limitations of didactic critical art, as well as the spectacularization of relational art that seeks to repair the social bond.*

In its most general formula, critical art intends to raise consciousness of the mechanisms of domination in order to turn the spectator into a conscious agent in the transformation of the world. We know the dilemma that weighs upon this project. On the one hand, understanding alone can do little to transform consciousness and situations. The exploited have rarely had the need to have the laws of exploitation explained to them. Because it's not a misunderstanding of the existing state of affairs that nurtures the submission of the oppressed, but a lack of confidence in their own capacity to transform it. Now, the feeling of such a capacity assumes that they are already engaged in a political process that changes the configuration of a given situation (*données sensibles*), and which constructs the forms of a world to come within the existing world. On the other hand, the work of art that 'makes you understand', and that breaks up appearances, thereby kills the strangeness of an appearance of resistance that bears witness to the non-necessary or intolerable character of a world. Critical art that invites you to see the signs of Capital behind everyday objects and behaviours risks inscribing itself into the perpetuation of a world where the transformation of things into signs redoubles the very excess of interpretative signs that make all resistance disappear.

In this vicious circle of critical art we generally see proof that aesthetics and politics can't go together. It would be more fair, however, to recognize the plurality of ways in which they are linked. On the one hand, politics is not a simple sphere of action that comes after the 'aesthetic' revelation of the state of things. It has its own aesthetic: its ways of dissensually inventing scenes and characters, of manifestations and statements different from the inventions of art and sometimes even opposed to them. On the other hand, aesthetics has its own politics, or rather its own tension between two opposed politics: between the logic of art that becomes life at the price of abolishing itself as art, and the logic of art that does politics on the explicit condition of not doing it at all. The difficulty of critical art is not that of having to negotiate between politics and art.

It is having to negotiate the relation between the two aesthetic logics that exist independently of it, because they belong to the logic of the aesthetic regime itself. Critical art must negotiate the tension that pushes art towards 'life' and which, conversely, separates aesthetic sensoriality from other forms of sensible experience. It must borrow the connections that provoke political intelligibility from the blurry zone between art and other spheres. And it must borrow the sense of sensible heterogeneity that feeds the political energies of refusal from the isolation of the work of art. It's this negotiation between the forms of art and those of non-art that permits the formation of combinations of elements capable of speaking twice: from their readability and from their unreadability.

Therefore, the combination of these two forces necessarily takes the form of a realignment of heterogeneous logics. If collage has been one of the great techniques of modern art, it is because its technical forms obey a more fundamental aesthetico-political logic. Collage, in the most general sense of the term, is the principle of a 'third' aesthetic politics. Prior to mixing paintings, newspapers, oilcloth or clock parts, it mixes the strangeness of the aesthetic experience with the becoming-life of art and the becoming-art of ordinary life. Collage can be carried out as a pure encounter of heterogeneities, testifying wholesale to the incompatibility of two worlds. It's the surrealist encounter of the umbrella and the sewing machine, showing the absolute power of desire and dreams against the reality of the everyday world, but using its objects. Conversely, collage can be seen as evidence of the hidden link between two apparently opposed worlds: thus do the photomontages of John Heartfield, revealing the reality of capitalist gold in the throat of Adolf Hitler, or those of Martha Rosler, mixing photographs of the horror of Vietnam with advertising images of American comfort. In this case, it's not any longer the heterogeneity of the two worlds that should nourish a sense of the intolerable but, on the contrary, the making evident of the causal connection that links one to the other.

But the politics of collage finds its balancing point where it can combine the two relations and play on the line of indiscernability between the force of readability of sense and the force of strangeness of non-sense. So do, for example, the stories of cauliflowers in Brecht's *Arturo Ui*. They play an exemplary double game between denouncing the law of the market and using ways of deriding high art borrowed from the market debasement of culture. They simultaneously play on the readability of an allegory of Nazi power as the power of capital, and on a buffoonery that reduces all grand ideals, political or otherwise, to the insignificant business of vegetables. Behind this grand discourse, the secret of the market is thus equated with its absence of secret, with its triviality or radical non-meaning or non-sense. But this possibility of playing simultaneously on sense and on non-sense assumes another, which is

that one may play at once on the radical separation between the world of art and that of cauliflowers *and* on the permeability of the border that separates them. It's necessary that the cauliflowers be without any relation to art or politics and that they be already linked, that the border be always there yet already crossed.

In fact, when Brecht tries to put vegetables in the service of critical distanciation, they already have a long artistic history. Think of their role in impressionist still lifes. Think also of the way in which a novelist, Émile Zola, in *Le Ventre de Paris* (*The Belly of Paris*, also trans. *The Fat and the Thin*, 1874), elevated vegetables in general – and cabbages in particular – to the dignity of artistic and political symbols. This novel, written just after the fall of the Paris Commune, is in effect constructed on the polarity of two characters: on the one hand, the revolutionary who returns from deportation to the new Paris des Halles and finds himself crushed by the accumulation of commodities that materializes a new world of mass consumption; on the other hand, the impressionist painter who sings an epic of cabbages, of the new beauty, opposing the iron architecture of Les Halles and the piles of vegetables that it shelters to the old beauty henceforth deprived of life, symbolized by the neighbouring gothic church.

This Brechtian double game with the political and the apolitical character of cauliflowers is possible because there already exists a relationship between politics, the new beauty and market displays. We can generalize the meaning of this vegetable allegory. Critical art – art which plays on the union and tension of different aesthetic politics – is possible thanks to a movement of translation that has, for a long time now, crossed the border in both directions between the world of art and the prosaic world of the commodity. There's no need to imagine a 'postmodern' rupture blurring the border that separated high art from the forms of popular culture. The blurring of boundaries is as old as 'modernity' itself. Brechtian distanciation is clearly indebted to surrealist collages that brought into the domain of art the obsolete consumer goods from the arcades, the magazine illustrations, or the outmoded catalogues. But the process goes back much further. The moment when high art is constituted – by declaring its own end, according to Hegel – is also the moment when it started to be banalized in magazine reproductions and be corrupted in the bookshop trade and in the 'industrial' literature of newspapers. But this is also the time when commodities started to travel in the opposite direction, to cross the border that separates it from the world of art, to repopulate and re-materialize this art that Hegel believed to have exhausted its forms.

This is what Balzac shows us in *Illusions perdues* (*Lost Illusions*, 1837). The dilapidated and muddy stalls of the Galeries du bois, where the fallen poet Lucien de Rubempré goes to sell his prose and his soul among the trade of the Stock Exchange and of prostitution, instantly become the place of a new poetry:

a fantastical poetry made from the abolition of frontiers between the ordinary of the market and the extraordinary of art. The heterogeneous sensible from which art of the aesthetic age feeds can be found anywhere, and especially on the very terrain from which the purists wanted to eliminate it. Any commodity or useful object can, by becoming obsolete and unfit for consumption, become available to art in different ways, separate or linked: as an object of disinterested pleasure, a body encoded with a story, or as witness to a strangeness impossible to assimilate.

While some dedicated art-life to the creation of furniture for a new world, and others denounced the transformation of art products into the décor of aestheticized commodities, others seized this double movement that blurred the simple opposition of two great aesthetic politics: if art products do not cease to cross into the domain of commodities, then commodities and functional goods do not stop crossing the border in the other direction, leaving the sphere of utility and value to become hieroglyphs carrying their history on their body, or mute disaffected objects carrying the splendour of what no longer bears any project or will. This is what the idleness of the *Juno Ludovisi* could communicate to all obsolete functional objects and advertising imagery.[1] This 'dialectical work in things' that renders them available to art and for subversion – by breaking the uniform run of time, by introducing a temporality within another, by changing the status of objects and the relationship between exchange signs and art forms – is what Walter Benjamin discovered in his reading of Aragon's *Le Paysan de Paris* (*Paris Peasant*, 1926) which transformed a shop of old walking sticks in the Passage de l'Opera into a mythological landscape and legendary poem. And 'allegorical' art, which so many contemporary artists claim, inscribes itself in this long-term filiation.

It is because of this crossing of the borders and status changes between art and non-art that the radical strangeness of the aesthetic object and the active appropriation of the common world have been able to come together and constitute the 'third way' of a micro-politics of art, between the opposed paradigms of art becoming life and art as resistant form. This process underpins the performances of critical art, and can help us to understand its contemporary transformations and ambiguities. If there is a political question about contemporary art, it is not to be grasped in the grid of the opposition modern/postmodern. It is in the analysis of the changes affecting this 'third' politics, the politics founded on a game of exchanges and displacements between the world of art and that of non-art.

The politics of the mix of heterogeneous elements took a dominant form, from dadaism up to the diverse forms of anti-establishment art in the 1960s: the polemical form. The game of exchanges between art and non-art served to construct collisions between heterogeneous elements, dialectical oppositions

between form and content, that themselves denounced social relations and the place was allocated for art there. The stichomythic form that Brecht gave to a discussion in verse on the matter of cauliflowers denounced the hidden interests behind fine words.[2] Dadaist canvases glued with bus tickets, clock parts and other accessories ridiculed the pretensions of an art cut off from life. Warhol's introduction of soup cans and Brillo boxes into the museum denounced high art's pretensions to isolation. Wolf Vostell's blending of celebrity images and war images showed the dark side of the American dream; Krzysztof Wodiczko's projections of homeless figures onto American monuments denounced the expulsion of the poor from public space; Hans Haacke's little labels placed alongside museum works revealed them to be objects of financial investment, and so on. Heterogeneous collage generally takes the form of a shock, which reveals one world hidden beneath another: capitalist violence behind the happiness of consumption; market interests and violent class struggle behind the apparent serenity of art. Art's self-criticism thus blended with criticism of the mechanisms of state and market domination.

This polemical function of the shock of the heterogeneous is always mentioned in the legitimation of works, installations and exhibitions. However, the continuity of this discourse conceals significant transformations that a simple example can allow us to grasp. In 2000, in Paris, an exhibition called *Bruit de fond* (*Background Noise*) put 1970s and contemporary works on view. Amongst the former were Martha Rosler's photomontages from the series *Bringing the War Home* (1967–72), juxtaposing advertising images of domestic American happiness with images of the war in Vietnam. Nearby was another work devoted to the hidden side of American happiness. Made by Wang Du, it comprised two elements: on the left, the Clinton couple, represented as two mannequins from a wax museum; on the other, another kind of wax figure: a sculpture of Courbet's *L'Origine du monde* (*The Origin of the World*, 1866), which, as we know, explicitly presents the female sexual organs. The two works played on the relationship between an image of happiness or greatness and its hidden side of violence or profanity. But the currency of the Lewinsky affair was not enough to confer political stakes to the representation of the Clinton couple. To be precise, currency was of little importance. We were witnessing the automatic functioning of canonical procedures of delegitimation: the wax figure that turns the politician into a puppet; sexual profanation that is the little dirty hidden/exposed secret of all forms of sublimity. These procedures always work. But they work by turning on themselves, like the denigration of power in general taking the place of political denunciation. Or rather, their function is to make us sensitive towards this automatic-ness itself, of delegitimizing the procedures of delegitimation at the same time as delegitimizing their object. Humorous

distance then replaces provocative shock.

I've chosen this significant example, but you could cite many others that witness, beneath the apparent continuity of mechanisms and of their textual legitimations, the same slide of yesterday's dialectical provocations towards new figures of the composition of the heterogeneous. And you could range these multiple slidings under four major types of contemporary exhibitions: the game, the inventory, the encounter and the mystery.

First of all the *game*, which is to say a double-game. Elsewhere I have mentioned an exhibition presented at Minneapolis under the title *Let's Entertain*, and renamed, in Paris, *Au-delà du spectacle*.[3] The American title already played a double game, winking towards a criticism of the *entertainment* industry, and also towards *pop*'s denunciation of the separation between high art and a popular culture of consumption. The Parisian title introduced a further turn. On the one hand, the reference to Guy Debord's book [*La Société du spectacle*] reinforced the rigour of the critique of *entertainment*. But on the other hand, it recalled that his antidote to spectacle's passivity is the free activity of the game. This play on the titles brings us back, of course, to the undecidability of the works themselves. The menagerie of Charles Ray or the huge football-table of Maurizio Cattelan could indifferently symbolize *pop* derision, a critique of market *entertainment*, or the positive power of games. And all the conviction of the exhibition curators was needed in order to prove to us that manga, adverts and disco sounds as reprocessed by the other artists offered us a radical critique of the alienated consumption of leisure by their very reduplication. Rather than a Schillerian suspension of the relations of domination, the games invoked here mark the suspension of meaning in the collages presented. Their value as polemic revelations has become undecidable. And it's the production of this undecidability that is at the heart of the work of many artists and exhibitions. Where the critical artist once painted clashing images of market domination or imperialist war, the contemporary video artist lightly *détournes* video-clips and manga; where giant puppets once made contemporary history into an epic spectacle, balls and toys now 'interrogate' our ways of life. A redoubling of the spectacles, props and icons of ordinary life, flimsily displaced, no longer invites us to read signs in objects in order to understand the jurisdictions of our world. They claim both to sharpen our perception of the play of signs, our consciousness of the fragility of the procedures for the reading of those signs, and our pleasure at playing with the undecidable. The virtue that these artists most willingly reclaim for themselves today is humour: well, humour as a flimsy displacement that it's possible not even to notice in their way of presenting a sequence of signs or an assemblage of objects.

These procedures of delegitimation, passed from a critical to a ludic register,

become, if pushed, indistinguishable from those produced by power and the media, or by the market's own forms of presentation. Humour itself becomes the dominant mode of exhibiting commodities, and advertising increasingly plays on the undecidability of a product's use value and its value as a support for images or signs. The only remaining subversion is, then, to play on this undecidability; to suspend, in a society working towards the accelerated consumption of signs, the meaning of the protocols of reading those signs.

Consciousness of this undecidability favours a displacement of artistic propositions towards the second form, that of the *inventory*. The meeting of heterogeneous objects no longer aims to provoke a critical shock, nor to play on the undecidability of this shock. The same materials, images and messages that were interrogated according to the rules of an art of suspicion are now summoned to the reverse operation: to repopulate the world of things, to re-seize their collective historical potential that critical art dissolved into manipulable signs. Assembling heterogeneous materials becomes a positive memory, in a double form. Primarily it's an inventory of historical traces: objects, photographs or simply lists of names that witness a shared history or a shared world. Four years ago in Paris, an exhibition called *Voilà – Le monde dans la tête* thus set out to recapitulate the twentieth century. Through photographic displays and diverse installations, it was about gathering experiences, about making displays of any old objects, names or anonymous faces speak, about being introduced into these welcoming mechanisms. The visitor was first welcomed by the sign of a game (Robert Filliou's pattern of multicoloured dice), then walked through a Christian Boltanski installation, *Les Abonnés du téléphone*, comprising directories from different years and countries that you could, if you liked, take off the shelves and browse on the tables placed at your disposal. Then a sound installation by On Kawara that evoked, for him, some of 'the last forty thousand years gone by'. Hans-Peter Feldmann then presented photographs of one hundred people aged from one to one hundred years old. Peter Fischli and David Weiss's display of photographs under vitrines exposed a *Visible World* resembling holiday photos from family albums, while Fabrice Hybert showed a collection of bottles of mineral water, etc.

In this logic, the artist is at once an archivist of collective life and the collector, witness to a shared ability. Because the inventory, which evidences the potential of objects' and images' collective history, by bringing closer the art of the sculptor and that of the rag-and-bone man, shows in this way the relationship between the inventive gestures of art and the multiplicity of inventions of the arts of doing and arts of living that constitute a shared world: DIY, collecting, language games, props for manifestations, etc. The artist takes it upon himself to make visible, in art's reserved space, these arts of doing that exist

throughout society.[4] Through this double vocation of the inventory, critical art's political/polemical vocation tends to become a social/communitarian vocation.

This slippage is shown by the third form. I've called it the *encounter*. You could also call it the *invitation*. The artist-collector institutes a space of reception to engage the passer-by in an unexpected relationship. Thus Boltanski's installation invites the visitor to take a directory from the shelves and sit at a table to consult it. A little further along in the same exhibition, Dominique Gonzalez-Foerster invited us to take a volume from a pile of pocket books and to sit down and read them on a carpet depicting a desert island typical of children's dreams. In another exhibition, Rirkrit Tiravanija put at the visitor's disposal packets of food, camping gas and cooking pans so that he could prepare a Chinese soup for himself, sit down and engage in discussion with the artist or with other visitors. Parallel to these transformations in the exhibition space are many forms of intervention in urban space: a modified sign in a bus shelter transforms the necessity of everyday life into an adventure (Pierre Huyghe); an illuminated text in Arabic or a loudspeaker in Turkish reverses the relations between the local and the foreign (Jens Haaning); an empty pavilion is offered to the social desires of the residents of a neigbourhood (Group A12). Relational art thus intends to create not only objects but situations and encounters. But this too simple opposition between objects and situations operates a short-circuit. What is at stake is the transformation of these problematic spaces that conceptual art had opposed to art's objects/commodities. Yesterday's distance towards commodities is now inverted to propose a new proximity between entities, the institution of new forms of social relations. Art no longer wants to respond to the excess of commodities and signs, but to a lack of connections. As the principle theorist of this school writes: 'by offering small services, the artist repairs the weaknesses in the social bond'.[5]

The loss of the 'social bond', and the duty incumbent on artists to work to repair it, are the words on the agenda. But an acknowledgement of this loss can be more ambitious. It's not only the forms of civility that we will have lost, but the very sense of the co-presence of beings and things that constitutes a world. This is what the fourth type proposes to mend, the *mystery*. Applying it to cinema, Jean-Luc Godard honoured this category that, since Mallarmé, designates a certain way of linking heterogeneous elements: in the latter, for example, the poet's thought, the steps of a dancer, the unfolding of a fan, the foam of a wave or the movement of a curtain lifted by the wind; in Godard, the rose of *Carmen*, a Beethoven quartet, the foam of waves on the beach evoking *The Waves* by Virginia Woolf, and the surge of bodies in love. This sequence of *Prénom Carmen* that I'm summarizing really shows the passage from one logic to another. The choice of elements put into relation in effect restores a tradition of

détournement: the Andalusian mountains become a weekend beach; romantic smugglers become crazy terrorists; the discarded flower of which Don José sings is only a plastic rose, and Micaela massacres Beethoven instead of singing Bizet arias. But the *détournement* no longer has the function of a political critique of high art. On the contrary, it effaces the picturesque imagery to which the critique appeals in order to let the Bizet characters be reborn as the pure abstraction of a Beethoven quartet. It makes gypsies and toreadors disappear in the melting music of images that unites, in the same breath, the sound of strings, of waves and of bodies. In opposition to the dialectical practice that accentuates the heterogeneity of elements to provoke a shock, bearing witness to a reality marked by antagonisms, mystery emphasises the kinship of the heterogeneous. It constructs a game of analogies in which they witness a common world, where the most distant realities appear as if cut from the same sensible fabric and can always be linked by what Godard calls the 'fraternity of metaphors'.

'Mystery' was the central concept of symbolism. And certainly, symbolism is once again on the agenda. By that I'm not referring to certain spectacular and slightly nauseous forms, like the resurrection of symbolist mythology and Wagnerian fantasies of the total work of art in Matthew Barney's *Cremaster* cycle (1997–99). I'm thinking of the more modest, sometimes imperceptible way in which assemblages of objects, images and signs presented by contemporary installations have, over the last few years, slid the logic of provocative dissensus into that of a mystery that bears witness to a co-presence. Elsewhere I have mentioned the photographs, videos and installations of the exhibition 'Moving Pictures', presented at the Guggenheim Museum in New York in 2002.[6] It affirmed contemporary art's continuity with an artistic radicality born in the 1970s as a critique of both artistic autonomy and dominant representations. But – in the image of Vanessa Beecroft's videos presenting nude and inexpressive female bodies in the museum space, in the photographs of Sam Taylor-Wood, Rineke Dijkstra or Gregory Crewdson showing bodies of ambiguous identity in undefined spaces, or in Christian Boltanski's dark room with lightbulbs illuminating walls covered in anonymous photographs – the interrogation of perceptual stereotypes, which was always invoked, slid towards a completely different interest in the vague borders between the familiar and the strange, the real and the symbolic, that fascinated painters at the time of symbolism, metaphysical painting and magic realism. However, on the upper level of the museum, a video installation by Bill Viola was projected onto four walls of a dark room: flames and deluges, slow processions, urban wanderings, a wake, or casting off a ship, simultaneously symbolizing the four elements and the whole cycle of birth, life, death and resurrection. The experimental art of video thus came to manifest the latent tendency of many mechanisms of today that mimic,

in their own ways, the great frescoes of human destiny that the symbolist and expressionist period had a liking for.

Of course these categorizations are schematic. Contemporary exhibitions and installations confer on the couple 'to exhibit/to install' several roles at once; they play on the fluctuating border between critical provocation and the undecidability of its meaning, between the form of an exhibited work and that of the appointed space of interaction. The mechanisms of contemporary exhibitions often cultivate this polyvalence or submit to its effect. The exhibition *Voilà* thus presented an installation by Bertrand Lavier, *Salle des Martin*, which gathered together about fifty paintings, from the collections of provincial museums, that had as their only shared element the name of their author, Martin – the most common surname in France. The initial idea set this installation in relation to a questioning of the meanings of a work and of the signature that is characteristic of conceptual art. But in this new memorial context it took on a new meaning, attesting to the multiplicity of more or less ignored pictorial abilities, and inscribing a lost world of painting in the memory of the century. This multiplicity of meanings attributed to the same mechanisms is sometimes presented as bearing witness to art's democracy, refusing to disentangle a complexity of standpoints and a fluidity of borders that themselves reflect the complexity of a world.

The contradictory attitudes shown by the main aesthetic paradigms today express a more fundamental undecidability about the politics of art. This undecidability is not the effect of a postmodern turn. It is constitutive: aesthetic suspension lets itself be interpreted in two ways. The singularity of art is linked to the identification of its autonomous forms with the forms of life and with possible politics. These possible politics are only ever realized in full at the price of abolishing the singularity of art, the singularity of politics, or the two together. Being conscious of this undecidability today leads to opposed feelings: in some, a melancholy with regard to the shared world that art carried within itself, if this had not been betrayed by political enrolment or commercial compromises; in others, an awareness of its limits, the tendency to play on the limitation of its powers and the very uncertainty of its effects. But the paradox of our present is perhaps that this art, so uncertain of its politics, might be invited to a higher degree of intervention by the very deficit of politics proper. It's as if the shrinking of public space and the effacement of political inventiveness in a time of consensus gave a substitutive political function to the mini-demonstrations of artists, to their collections of objects and traces, to their mechanisms of interaction, to their provocations *in situ* or elsewhere. Knowing if these 'substitutions' can recompose political spaces, or if they must be content to parody them, is certainly one of the questions of today.

1 The *Junon Ludovisi* is a statue described by Schiller in the fifteenth of his *Letters on the Aesthetic Education of Man* (1794), and which is key to Rancière's elucidation of the aesthetic regime of art. For a fuller discussion see Jacques Rancière, 'The Aesthetic Revolution and its Outcomes', *New Left Review*, March/April 2002. [Translator]

2 Stichomythic, from *stychomathia* – dialogue in alternate lines of verse, usually in disputation. From Greek drama. [Translator]

3 Cf. Jacques Rancière, *Le Destin des images* (Paris: La Fabrique, 2003) 33.

4 Reference is made here to Michel de Certeau's book *Les Arts de faire* (Paris: UGE, 1980).

5 Nicolas Bourriaud, *Esthétique rélationnelle* (Dijon: Les presses du réel, 1998) 37.

6 Jacques Rancière, *Le Destin des images, op cit.*, 74–5.

Jacques Rancière, 'Problems and Transformations in Critical Art', *Malaise dans l'esthétique* (Paris: Editions Galilée, 2004) 65–84. Translated by Claire Bishop, assisted by Pablo Lafuente, 2006.

IT
IS
NOT
A
QUESTION
OF
KNOWING WHETHER
THIS
INTERESTS YOU
BUT
RATHER
OF
WHETHER YOU YOURSELF
COULD BECOME INTERESTING
UNDER NEW CONDITIONS
OF
CULTURAL CREATION

Guy Debord, *Towards a Situationist International*, 1957

Guy Debord
Towards a Situationist International//1957

Shortly before abandoning visual art for film and literature, Guy Debord outlined his theory of 'constructed situations' – participatory events using experimental behaviour to break the spectacular bind of capitalism. Constructed situations, in which the audience is an active participant, have been an ongoing point of reference for contemporary artists working with live events.

Our central purpose is the construction of situations, that is, the concrete construction of temporary settings of life and their transformation into a higher, passionate nature. We must develop an intervention directed by the complicated factors of two great components in perpetual interaction: the material setting of life and the behaviours that it incites and that overturn it.

Our prospects for action on the environment lead, in their latest development, to the idea of a unitary urbanism. Unitary urbanism first becomes clear in the use of the whole of arts and techniques as means cooperating in an integral composition of the environment. This whole must be considered infinitely more extensive than the old influence of architecture on the traditional arts, or the current occasional application to anarchic urbanism of specialized techniques or of scientific investigations such as ecology. Unitary urbanism must control, for example, the acoustic environment as well as the distribution of different varieties of drink or food. It must take up the creation of new forms and the *détournement* of known forms of architecture and urbanism – as well as the *détournement* of the old poetry and cinema. Integral art, about which so much has been said, can only materialize at the level of urbanism. But it can no longer correspond with any traditional definitions of the aesthetic. In each of its experimental cities, unitary urbanism will work through a certain number of force fields, which we can temporarily designate by the standard expression *district*. Each district will be able to lead to a precise harmony, broken off from neighbouring harmonies; or rather will be able to play on a maximum breaking up of internal harmony.

Secondly, unitary urbanism is dynamic, i.e., in close touch with styles of behaviour. The most reduced element of unitary urbanism is not the house but the architectural complex, which is the union of all the factors conditioning an environment, or a sequence of environments colliding at the scale of the constructed situation. Spatial development must take the affective realities that the experimental city will determine into account. One of our comrades has promoted a theory of states-of-mind districts, according to which each quarter of

a city would tend to induce a single emotion, to which the subject will consciously expose herself or himself. It seems that such a project draws timely conclusions from an increasing depreciation of accidental primary emotions, and that its realization could contribute to accelerating this change. Comrades who call for a new architecture, a free architecture, must understand that this new architecture will not play at first on free, poetic lines and forms – in the sense that today's 'lyrical abstract' painting uses these words – but rather on the atmospheric effects of rooms, corridors, streets, atmospheres linked to the behaviours they contain. Architecture must advance by taking as its subject emotionally moving situations, more than emotionally moving forms, as the material it works with. And the experiments drawn from this subject will lead to unknown forms. Psychogeographical research, 'study of the exact laws and precise effects of the geographical environment, consciously organized or not, acting directly on the affective deportment of individuals', thus takes on its double meaning of active observation of today's urban areas and the establishment of hypotheses on the structure of a situationist city. Psychogeography's progress depends to a great extent on the statistical extension of its methods of observation, but principally on experimentation through concrete interventions in urbanism. Until this stage, the objective truth of even the first psychogeographical data cannot be ensured. But even if these data should turn out to be false, they would certainly be false solutions to a genuine problem.

Our action on deportment, in connection with other desirable aspects of a revolution in customs, can be defined summarily as the invention of a new species of games. The most general aim must be to broaden the non-mediocre portion of life, to reduce its empty moments as much as possible. It may thus be spoken of as an enterprise of human life's quantitative increase, more serious than the biological processes currently being studied. Even there, it implies a qualitative increase whose developments are unforeseeable. The situationist game stands out from the standard conception of the game by the radical negation of the ludic features of competition and of its separation from the stream of life. In contrast, the situationist game does not appear distinct from a moral choice, deciding what ensures the future reign of freedom and play. This is obviously linked to the certainty of the continual and rapid increase of leisure, at a level corresponding to that of our era's productive forces. It is equally linked to the recognition of the fact that a battle over leisure is taking place before our eyes whose importance in the class struggle has not been sufficiently analyzed. To this day, the ruling class is succeeding in making use of the leisure that the revolutionary proletariat extracted from it by developing a vast industrial sector of leisure that is an unrivaled instrument for bestializing the proletariat through by-products of mystifying ideology and bourgeois tastes. One of the reasons for the American

working class's incapacity to become politicized should likely be sought amidst this abundance of televised baseness. By obtaining through collective pressure a slight rise in the price of its labour above the minimum necessary for the production of that labour, the proletariat not only enlarges its power of struggle but also widens the terrain of the struggle. New forms of this struggle then occur parallel with directly economic and political conflicts. Revolutionary propaganda can be said until now to have been constantly dominated in these forms of struggle in all countries where advanced industrial development has introduced them. That the necessary transformation of the base could be delayed by errors and weaknesses at the level of superstructures has unfortunately been proven by some of the twentieth century's experiences. New forces must be hurled into the battle over leisure, and we will take up our position there.

A first attempt at a new manner of deportment has already been achieved with what we have designated the *dérive*, which is the practice of a passionate uprooting through the hurried change of environments, as well as a means of studying psychogeography and situationist psychology. But the application of this will to ludic creation must be extended to all known forms of human relationships, and must, for example, influence the historical evolution of emotions like friendship and love. Everything leads to the belief that the main insight of our research lies in the hypothesis of constructions of situations.

A man's life is a sequence of chance situations, and if none of them is exactly similar to another, at the least these situations are, in their immense majority, so undifferentiated and so dull that they perfectly present the impression of similitude. The corollary of this state of affairs is that the singular, enchanting situations experienced in life strictly restrain and limit this life. We must try to construct situations, i.e., collective environments, ensembles of impressions determining the quality of a moment. If we take the simple example of a gathering of a group of individuals for a given time, and taking into account acquaintances and material means at our disposal, we must study which arrangement of the site, which selection of participants, and which incitement of events suit the desired environment. Surely the powers of a situation will broaden considerably in time and in space with the realizations of unitary urbanism or the education of a situationist generation. The construction of situations begins on the other side of the modern collapse of the idea of the theatre. It is easy to see to what extent the very principle of the theatre – non-intervention – is attached to the alienation of the old world. Inversely, we see how the most valid of revolutionary cultural explorations have sought to break the spectator's psychological identification with the hero, so as to incite this spectator into activity by provoking his capacities to revolutionize his own life. The situation is thus made to be lived by its constructors. The role of the 'public', if not passive at least a walk-on, must ever

diminish, while the share of those who cannot be called actors but, in a new meaning of the term, 'livers',[1] will increase.

Let us say that we have to multiply poetic objects and subjects (unfortunately so rare at present that the most trifling of them assumes an exaggerated emotional importance) and that we have to organize games of these poetic subjects among these poetic objects. There is our entire programme, which is essentially ephemeral. Our situations will be without a future; they will be places where people are constantly coming and going. The unchanging nature of art, or of anything else, does not enter into our considerations, which are in earnest. The idea of eternity is the basest one a man could conceive of regarding his acts.

Situationist techniques have yet to be invented, but we know that a task presents itself only where the material conditions necessary for its realization already exist, or are at least in the process of formation. We must begin with a small-scale, experimental phase. Undoubtedly we must draw up blueprints for situations, like scripts, despite their unavoidable inadequacy at the beginning. Therefore, we will have to introduce a system of notation whose accuracy will increase as experiments in construction teach us more. We will have to find or confirm laws, like those that make situationist emotion dependent upon an extreme concentration or an extreme dispersion of acts (classical tragedy providing an approximate image of the first case, and the *dérive* of the second). Besides the direct means that will be used toward precise ends, the construction of situations will require, in its affirmative phase, a new implementation of reproductive tech-nologies. We could imagine, for example, live televisual projections of some aspects of one situation into another, bringing about modifications and interfer-ences. But, more simply, cinematic 'news' reels might finally deserve their name if we establish a new documentary school dedicated to fixing the most meaningful moments of a situation for our archives, before the development of these elements has led to a different situation. The systematic construction of situations having to generate previously non-existent feelings, the cinema will discover its greatest pedagogical role in the diffusion of these new passions.

Situationist theory resolutely asserts a non-continuous conception of life. The idea of consistency must be transferred from the perspective of the whole of a life – where it is a reactionary mystification founded on the belief in an immortal soul and, in the last analysis, on the division of labour – to the viewpoint of moments isolated from life, and of the construction of each moment by a unitary use of situationist means. In a classless society, it might be said, there will be no more painters, only situationists who, among other things, make paintings.

Life's chief emotional drama, after the never-ending conflict between desire and reality hostile to that desire, certainly appears to be the sensation of time's passage. The situationist attitude consists in counting on time's swift passing,

unlike aesthetic processes which aim at the fixing of emotion. The situationist challenge to the passage of emotions and of time will be its wager on always gaining ground on change, on always going further in play and in the multiplication of moving periods. Obviously, it is not easy for us at this time to make such a wager; however, even were we to lose it a thousand times, there is no other progressive attitude to adopt.

The situationist minority was first formed as a trend within the lettrist left wing, then within the Lettrist International, which it eventually controlled. The same objective impulse is leading several contemporary avant-garde groups to similar conclusions. Together we must discard all the relics of the recent past. We deem that today an agreement on a unified action among the revolutionary cultural avant-garde must implement such a programme. We do not have formulas nor final results in mind. We are merely proposing an experimental research that will collectively lead in a few directions that we are in the process of defining, and in others that have yet to be defined. The very difficulty of arriving at the first situationist achievements is proof of the newness of the realm we are entering. What alters the way we see the streets is more important than what alters the way we see painting. Our working hypotheses will be reconsidered at each future upheaval, wherever it may come from.

We will be told, chiefly by revolutionary intellectuals and artists who for reasons of taste put up with a certain powerlessness, that this 'situationism' is quite disagreeable, that we have made nothing of beauty, that we would be better off speaking of Gide, and that no one sees any clear reason to be interested in us. People will shy away by reproaching us for repeating a number of viewpoints that have already caused too much scandal, and that express the simple desire to be noticed. They will become indignant about the conduct we have believed necessary to adopt on a few occasions in order to keep or to recover our distances. We reply: it is not a question of knowing whether this interests you, but rather of whether you yourself could become interesting under new conditions of cultural creation. Revolutionary artists and intellectuals, your role is not to shout that freedom is abused when we refuse to march with the enemies of freedom. You do not have to imitate bourgeois aesthetes who try to bring everything back to what has already been done, because the already-done does not make them uncomfortable. You know that creation is never pure. Your role is to search for what will give rise to the international avant-garde, to join in the constructive critique of its programme, and to call for its support.

Our Immediate Tasks
We must support, alongside the workers' parties or extremist tendencies existing within these parties, the necessity of considering a consistent ideological action

for fighting, on the level of the passions, the influence of the propaganda methods of late capitalism: to concretely contrast, at every opportunity, other desirable ways of life with the reflections of the capitalist way of life; to destroy, by all hyperpolitical means, the bourgeois idea of happiness. At the same time, taking into account the existence among the ruling social class of elements who have always cooperated, through boredom and need of novelty, in that which finally entails the disappearance of these societies, we must urge persons who hold certain of the vast resources that we lack to give us the means to carry out our experiments, through an account analogous to what might be employed in scientific research and might be quite profitable as well.

We must introduce everywhere a revolutionary alternative to the ruling culture; coordinate all the enquiries that are happening at this moment without a general perspective; orchestrate, through criticism and propaganda, the most progressive artists and intellectuals of all countries to make contact with us with a view to a joint action.

We must declare ourselves ready to resume discussion on the basis of this platform with all those who, having taken part in a prior phase of our action, are again capable of rejoining us.

We must advance the keywords of unitary urbanism, of experimental behaviour, of hyperpolitical propaganda, and of the construction of environments. The passions have been interpreted enough: the point now is to discover others.

1 In French, *viveurs*, a theatrical pun. Typically, the word means 'rake' or 'playboy', and was thus commonly linked with the dubious morality of the theatrical world; here, Debord assigns it a new meaning that recalls its roots in *vivre*, to live. [Translator]

Guy Debord, *Rapport sur la construction des situations et sur les conditions de l'organisation et de l'action de la tendence situationniste internationale* (Paris: Internationale lettriste, July 1957), first presented by Guy Debord to the founding conference of the Situationist International at Cosio d'Arroscia, July 1957; translated in *Guy Debord and the Situationist International: Texts and Documents*, ed. Tom McDonough (Cambridge, Massachusetts: The MIT Press, 2002) 44–50.

Allan Kaprow
Notes on the Elimination of the Audience//1966

The emergence of Happenings in New York in the late 1950s was in part a response to the gestural expressionism of Jackson Pollock's paintings. Allan Kaprow sought from the Happenings a heightened experience of the everyday, in which viewers were formally fused with the space-time of the performance and thereby lost their identity as 'audience'.

Although the Assemblages' and Environments' free style was directly carried into the Happenings, the use of standard performance conventions from the very start tended to truncate the implications of the art. The Happenings were presented to small, intimate gatherings of people in lofts, classrooms, gymnasiums and some of the offbeat galleries, where a clearing was made for the activities. The watchers sat very close to what took place, with the artists and their friends acting along with assembled environmental constructions. The audience occasionally changed seats as in a game of musical chairs, turned around to see something behind it, or stood without seats in tight but informal clusters. Sometimes, too, the event moved in and amongst the crowd, which produced some movement on the latter's part. But, however flexible these techniques were in practice, there was always an audience in one (usually static) space and a show given in another.

This proved to be a serious drawback, in my opinion, to the plastic morphology of the works, for reasons parallel to those which make galleries inappropriate for Assemblages and Environments. But it was more dramatically evident. The rooms enframed the events, and the immemorial history of cultural expectations attached to theatrical productions crippled them. It was repeatedly clear with each Happening that in spite of the unique imagery and vitality of its impulse, the traditional staging, if it did not suggest a 'crude' version of the avant-garde Theatre of the Absurd, at least smacked of night club acts, side shows, cock fights and bunkhouse skits. Audiences seemed to catch these probably unintended allusions and so took the Happenings for charming diversions, but hardly for art or even purposive activity. Night club acts can of course be more than merely diverting, but their structure of 'grammar' is unusually hackneyed and, as such, is detrimental to experimentation and change.

Unfortunately, the fact that there was a tough nut to crack in the Happenings seems to have struck very few of its practitioners. Even today, the majority continues to popularize an art of 'acts' which often is well-done enough but

fulfils neither its implications nor strikes out in uncharted territory.

But for those who sensed what was at stake, the issues began to appear. It would take a number of years to work them out by trial and error, for there is sometimes, though not always, a great gap between theory and production. But gradually a number of rules-of-thumb could be listed: [...]

(F) *It follows that audiences should be eliminated entirely.* All the elements – people, space, the particular materials and character of the environment, time – can in this way be integrated. And the last shred of theatrical convention disappears. For anyone once involved in the painter's problem of unifying a field of divergent phenomena, a group of inactive people in the space of a Happening is just dead space. It is no different from a dead area of red paint on a canvas. Movements call up movements in response, whether on a canvas or in a Happening. A Happening with only an empathic response on the part of a seated audience is not a Happening but stage theatre.

Then, on a human plane, to assemble people unprepared for an event and say that they are 'participating' if apples are thrown at them or they are herded about is to ask very little of the whole notion of participation. Most of the time the response of such an audience is half-hearted or even reluctant, and sometimes the reaction is vicious and therefore destructive to the work (though I suspect that in numerous instances of violent reaction to such treatment it was caused by the latent sadism in the action, which they quite rightly resented). After a few years, in any case, 'audience response' proves to be so predictably pure cliché that anyone serious about the problem should not tolerate it, any more than the painter should continue the use of dripped paint as a stamp of modernity when it has been adopted by every lampshade and Formica manufacturer in the country.

I think that it is a mark of mutual respect that all persons involved in a Happening be willing and committed participants who have a clear idea what they are to do. This is simply accomplished by writing out the scenario or score for all and discussing it thoroughly with them beforehand. In this respect it is not different from the preparations for a parade, a football match, a wedding or religious service. It is not even different from a play. The one big difference is that while knowledge of the scheme is necessary, professional talent is not; the situations in a Happening are lifelike or, if they are unusual, are so rudimentary that professionalism is actually uncalled for. Actors are stage-trained and bring over habits from their art that are hard to shake off; the same is true of any other kind of showman or trained athlete. The best participants have been persons not normally engaged in art or performance, but who are moved to take part in an activity that is at once meaningful to them in its ideas yet natural in its methods.

There is an exception, however, to restricting the Happenings to participants only. When a work is performed on a busy avenue, passers-by will ordinarily stop and watch, just as they might watch the demolition of a building. These are not theatre-goers and their attention is only temporarily caught in the course of their normal affairs. They might stay, perhaps become involved in some unexpected way, or they will more likely move on after a few minutes. Such persons are authentic parts of the environment.

A variant of this is the person who is engaged unwittingly with a performer in some planned action: a butcher will sell certain meats to a customer-performer without realizing that he is a part of a piece having to do with purchasing, cooking, and eating meat.

Finally, there is this additional exception to the rule. A Happening may be scored for *just watching*. Persons will do nothing else. They will watch things, each other, possibly actions not performed by themselves, such as a bus stopping to pick up commuters. This would not take place in a theatre or arena, but anywhere else. It could be an extremely meditative occupation when done devotedly; just 'cute' when done indifferently. In a more physical mood, the idea of called-for watching could be contrasted with periods of action. Both normal tendencies to observe and act would now be engaged in a responsible way. At those moments of relative quiet the observer would hardly be a passive member of an audience; he would be closer to the role of a Greek chorus, without its specific meaning necessarily, but with its required place in the overall scheme. At other moments the active and observing roles would be exchanged, so that by reciprocation the whole meaning of watching would be altered, away from something like spoon-feeding, towards something purposive, possibly intense [...]

Allan Kaprow, *Assemblages, Environments and Happenings* (New York: Harry N. Abrams, 1966) 187–8; 195–8.

Hélio Oiticica
Dance in My Experience (Diary Entries)//1965-66

No account of collective production and reception in art is complete without reference to the work and writings of the Brazilian artist Hélio Oiticica. By the mid-1960s, Oiticica was collaborating with participants from the samba schools of the Rio favelas to produce disruptive events based around dancing in parangolé *capes (see footnote below). The emphasis was on a Dionysian loss of self in social fusion.*

Before anything else I need to clarify my interest in dance, in rhythm, which in my particular case came from a vital necessity for disintellectualization. Such intellectual disinhibition, a necessary free expression, was required since I felt threatened by an excessively intellectual expression. This was the definite step towards the search for myth, for a reappraisal of this myth and a new foundation in my art. Personally, it was therefore an experience of the greatest vitality – indispensable, particularly in the demolition of preconceived ideas and stereotypification, etc. As we will see later, there was a convergence of this experience with the form that my art took in the *Parangolé*[1] and all that relates to this (since the *Parangolé* influenced and changed the trajectory of the *Nuclei, Penetrables* and *Bólides*).[2] Moreover, it was the beginning of a definitive social experience; I am still unaware of the direction which this will take.

Dance is *par excellence* the search for a direct expressive act; it is the immanence of the act. Ballet dance, on the contrary, is excessively intellectualized through the presence of choreography that searches to transcend this act. However, the 'Dionysian' dance, which is born out of the interior rhythm of the collective, exteriorizes itself as a characteristic of popular groupings, nations, etc. In these, improvisation reigns, as opposed to organized choreography; in fact the freer the improvisation the better. It is as if an immersion into rhythm takes place, a flux where the intellect remains obscured by an internal mythical force that operates at an individual and collective level (in fact, in this instance one cannot establish a distinction between the collective and the individual). The images are mobile, rapid, inapprehensible – they are the opposite of the static icon that is characteristic of the so-called fine arts. In reality, dance, rhythm, is the actual aesthetic act in its essential raw state – implied here is the direction towards the discovery of immanence. Such an act, the immersion into rhythm, is a pure creative act, it is an art. It is the creation of the actual act, of continuity, and also, like all acts of creative expression, it is a producer of images. Actually, for me it provided a new discovery of the image, a

recreation of the image, encompassing unavoidably the aesthetic expression in my work.

The collapse of social preconceived ideas, of separations of groups, social classes etc., would be inevitable and essential in the realization of this vital experience. I discovered here the connection between the collective and individual expression – the most important step towards this – which is the ability not to acknowledge abstract levels, such as social 'layers', in order to establish a comprehension of a totality. The bourgeois conditioning which I had been submitted to since I was born undid itself as if by magic – I should mention, in fact, that the process was already under way even before I was aware of it. The unbalance that was entailed by this social dislocation, from the continuous discrediting of the structures that rule our life in this society, specifically here in Brazil, was both inevitable and charged with problems. These, far from being overcome, renew themselves every day. I believe that the dynamics of the social structures were at this moment revealed to me in all their crudity, in their most immediate expression, precisely due to my process of discrediting the so-called social layers. Not that I consider their existence but that, for me, they have become schematic, artificial, as if all of a sudden I gazed from a vantage point onto their map, their scheme, being 'external' to them. Marginalization, naturally an already present characteristic of the artist, has become fundamental for me. This position represents a total 'lack of social place', at the same time as being the discovery of my own 'individual place' as a total man in the world, as a 'social being' in the total sense, as opposed to being included in a particular social layer or 'elite' – not even in the artistic marginal elite, but that exists (I speak of the true artists, and not of the *habitués* of art). No, the process here is more profound: it is a process in society as a whole, in practical life, in the objective world of being, in the subjective lived experience – it would be the will for an integral position, social in its most noble meaning, free, total. What interests me is the 'total act of being', which is what I experiment with here – not partial total acts, but a 'total act of life', irreversible, an unbalance for the equilibrium of being.

The old position with regards to the work of art has stagnated – even in those works that today do not demand spectator participation, what they propose is not a transcendental contemplation but a 'being' in the world. Dance too does not propose an 'escape' from this immanent world, but reveals it in all its plenitude – what for Nietzsche would be the 'Dionysian drunkenness' is in reality the 'expressive lucidity of the act's immanence', an act itself not characterized by any partiality but by its totality as such – a total expression of the self. Would this not be the philosopher's stone of art? The *Parangolé* for instance, when it demands participation through dance, is a mere adaptation of

this structure and vice-versa with regard to this structure in dance – this is simply a transformation of this 'total act of the self'. The gesture, the rhythm, take on a new form which is determined by the demands of the *Parangolé*'s structure, being that pure dance is a trace of this structural participation – it is not a question of determining value levels in terms of one or another expression, since they are both (pure dance and dance in the *Parangolé*) total expressions.

What has been conventionally described as 'interpretation' also suffers a transformation today – it is not a question of repeating, in some cases, of course, a creation (a song for example), giving it greater or lesser expression according to the interpreter.[3] Today an interpreter can reach such an important level that the actual song (or any other form) is surpassed. It is not a case of individual 'celebrity', although this also occurs, but of a real expressive valorization. In the old days 'celebrity status' served the purpose of immortalizing interpreters according to their creation based upon famous works (in opera and theatre). Today the issue is different: even if the works that are interpreted are not great creations, fantastic musicals (in the field of popular music for example) the interpreter reaches a high expressive level – a singer such as Nat King Cole for example, creates a 'vocal expressive structure' that is independent from the songs he interprets. This is a creation that is not simply interpretative but pertains to a highly expressive vocalist. An actor such as Marilyn Monroe for example, due to her all-encompassing interpretative presence, possesses above all else a creative quality, which is structurally expressive. Her presence in certain mediocre films makes these films uncommonly interesting, a fact that is due to her action as interpreter. What is interesting here is the vocalization of Nat and the interpretative act of Marilyn, independent of the quality of the interpreted score or script, even if these possess, of course, a value that is relative and not absolute as before.

10 April 1966 (continuation)
The experience of dance (of samba) therefore gave me the exact idea of what creation through the corporal act may be, a continuous transformability. On the other hand however, it revealed what I call the 'being' of things, that is, the static expression of objects, their expressive immanence, which in this case is the immanence of the corporal expressive act, which transforms itself continuously. The opposite, the non-transformability, is not exactly the fact of 'not transforming oneself in time and space' but in the immanence that is revealed in its structure, founding within the world, in the objective space that it occupies, its unique place, and this too is a *Parangolé*-structure. I cannot consider today the *Parangolé* as a structure that is kinetically-transformable by the

spectator but neither can I consider it as its opposite; that is, the things or, better still, the objects that *are* create a different relation with objective space: they 'dislocate' the environmental space away from obvious, already known, relations. Here is the key to what I will call 'environmental art': the eternally mobile, the transformable, which is structured by both the action of the spectator and that which is static. The latter is also transformable in its own way, depending on the environment in which it is participating as a structure. It will be necessary to create 'environments' for these works – the actual concept of 'exhibition' in its traditional sense, is changed, since to 'exhibit' such work does not make sense (this would be a lesser partial interest) – structural spaces that are free both to the participation and to the creative inventions of spectators. A pavilion, one of those used these days for industrial exhibitions (how more interesting they are than anaemic little art shows!), would be ideal for such a purpose – it would be an opportunity for a truly efficient experience with the people, throwing them into the creative participatory notion, away from the 'elite exhibitions' so fashionable today. This experience should range from the 'givens' that have already been produced, the 'livings' that structure as if architecturally the routes to be traced, to the 'transformable givens' that demand whatever inventive participation from the spectator (be it to dress and unfold or dance) and the 'givens to be made', that is, the raw material that would be supplied so that each person can construct or create whatever they like, since motivation, the stimulus, is born from the simple fact of 'being there for that'.

The execution of such a plan is complex, demanding rigorous prior organization, and obviously a team. The varied and multiple categories to be explored (elsewhere I will explain what I consider to be the structural categories in this new concept of mine, 'environmental art') in fact being and indeed requiring the collaboration of various artists with differing ideas, solely concentrated on this general idea of a 'total participatory creation' – to which would be added works created through the anonymous participation of the spectators, who actually would be better described as 'participants'.

1 The *Parangolés* (a slang term meaning 'an animated situation and sudden confusion and/or agitation between people') were strangely weighted capes made from unusual fabrics that encouraged wearers to move and dance, and forged a circular relationship between watcher and wearer.

2 Hélio Oiticica used generic terms that defined groups of works such as the *Parangolés*. His *Núcleus* installations comprised 'floating panels' (acrylic on wood) that hung from latticed structures. Each panel would contain a particular variation in colour, yellow or orange being the predominant tones. With *Núcleo NC1* (1960) the viewer gazes through the structure, directly or indirectly through the mirror placed on the floor. With *Grande Núcleo* (1960) the viewer is

invited to walk through the tonal differentiations stepping on the gravel that surrounds the structure. The first in the series of *Penetrables* that Oiticica would develop was *PN1* (1960). Here the viewer enters an orange/yellow cabin with sliding walls, literally entering into colour. The *Penetrables* vary in material and complexity. They remain in the artist's repertoire throughout his transition from concerns with colour into his late 1960s experiments, which he would define environmental art. *Bólides* could be loosely translated as 'fireballs'; they are generally vessels that vary greatly in dimensions, materials and functions. Oiticica's early *Bólides* were boxes made of wood, and/or glass containing pigment or fabric that would be manipulated by the viewer such as *Box-Bólide 9* (1964) and *Glass Bólide 1* (1963). *Bólides* soon acquired a readymade element such as in *Glass Bólide 10. Homage to Malevich* (1965) in which two bottles (one opaque yellow, the other translucent) would be placed side by side. [Translator]

3 Interpreter is here used as the term for a musician who plays or sings a song composed by someone else. [Translator]

Hélio Oiticica, 'Dance in my Experience', Diary entry, 12 November 1965; reprinted in Figueiredo, L., Pape, L., Salomao, W., eds, *Hélio Oiticica: Aspiro ao Grande Labirinto* (Rio de Janeiro: Rocco, 1986) 72–5; and 'continuation 10 April 1966' (*ibid.*) 75–6. Translated by Michael Asbury, 2006.

Lygia Clark and Hélio Oiticica
Letters//1968–69

Hélio Oiticica and Lygia Clark shared an intense artistic dialogue throughout their careers. Excerpts of their correspondence below trace the evolution of their thinking, from interactive sculptural objects to group events that addressed external relations (Oiticica) and interior psychological states (Clark). For both artists, a key term was vivências, *or lived experience: the body's heightened sensory presence as authentic, immediate, and resistant to ideological capture.*

26 October 1968

Dearest HéliCaetaGério,[1]
[...]
Since *Caminhando* [*Walking*, 1963], the object for me has lost its significance, and if I still use it, it is so that it becomes a mediator for participation. With the sensorial gloves, for example, it gives the measure of the act and the miraculous character of the gesture, with its spontaneity, which seems to have been forgotten. In all that I do, there really is the necessity of the human body, so that it expresses itself or is revealed as in a first [primary] experience. For me it doesn't matter whether I am avant-garde or placed within new theories. I can only be what I am and I still intend to produce those films in which man is at the centre of the event. For me, the stones that I come across, or the plastic bags, are one and the same: they are there only to express a proposition. I don't see why we should negate the object simply because we have constructed it. It is important that it should be expressive. If I feel in my life today the state that you feel and define as hallucinatory, it is because through these propositions I have learnt to feel these same moments, and if I had not done so, perhaps I would have never discovered these same moments that are fantastic. What I want is to avoid schematizing anything, and each day eat a new 'pear', to see if it's good or not. Mario's [Pedrosa] term, as always is excellent, but for me it is not about the moment of chance but the 'fruit' of the moment. Fruit in the fruit sense, such is the flavour and the sensuality of eating, of living this moment. I also found it very good when you said that already in the rudimentary element the open structures are liberated despite the fact that we use it precisely because we no longer believe in the aesthetic concept. At the end your text is splendid with regard to the poetic lived experience [*vivência poética*] and the subjective charge, only I do not believe, as I mentioned above, in the marginality of who proposes;

what's great is this diversity of positions, since as long as there is contradiction and negation there is also confirmation of a reality.
[...]
Thousand of kisses to this new HélioCaetaGério!
Clark

8 November 1968

Lygia, my Dear
[...]
Your letter, as always, was fantastic. This issue of being deflowered by the spectator is the most dramatic thing: in fact everyone is, since beyond the action there is the moment-consciousness of each action, even if this consciousness is modified later on, or incorporates other lived experiences [*vivências*]. This business of participation is really terrible since it is what is actually inconceivable that manifests itself in each person, at each moment, as if taking possession: like you, I also felt this necessity of killing the spectator or participator, which is a good thing since it creates an interior dynamic with regard to the relation. Contrary to what has been happening a lot lately, it shows that there is no aestheticization of participation: the majority creates an academicism of the relation or of the idea of spectator participation, to such an extent that it has left me with doubts about the idea itself. The other day with [Mário] Schemberg I discussed this issue a lot over here: he thinks in fact that there is no participation, or this issue, which is perhaps due to his exaggerated generalization with regard to this. What I think is that the formal aspect of this issue was overcome some time ago, by the 'relation in itself', its dynamic, by the incorporation of all the lived experiences of precariousness, by the non-formulated; and sometimes what appears to be participation is a mere detail of it, because the artist cannot in fact measure this participation, since each person experiences it differently. This is why there is this unbearable experience [*vivência*] of ours, of being deflowered, of possession, as if he, the spectator, would say: 'Who are you? What do I care if you created this or not? Well, I am here to modify everything, this unbearable shit that proposes dull experiences, or good ones, libidinous, fuck you, and all of this because I devour you, and then I shit you out; what is of interest only I can experience and you will never evaluate what I feel and think, the lust that devours me.' And the artist comes out of it in tatters. But it is good. It is not, as one could imagine, a question of masochism, it's just the true nature of the business. It's funny, something I experienced the other day has, to a certain extent, a relation to all of this, I'm not sure if you'll agree: the idol, the artist person who uses himself in order to

express. Caetano [Veloso] for example, when he sings and does all of that, is totally devoured, in an almost physical sense: once coming out from Chacrinha [music show recorded for TV], I saw in the corridors millions of students, adolescents, in an incredible fury, grabbing him to ask for autographs, but in reality it was not only that. The true, profound meaning of all of that was of a veritable coitus – Caetano reacted passively, *relax* [originally in English], as you would say, but the whole thing scared me profoundly, such a collective fury in contrast with the noble and delicate intentions of Caetano: a poet, ultra-sensitive, all of a sudden is thrown into an arena of wild beasts, but beasts not in the sense of animals from which you have to defend yourself physically more than psychologically, but human-beasts, like me and you, children almost, each one projecting their own psychological charge in a terrible manner. Something worse happened: at that crap song festival, during the São Paulo preliminaries that I watched on TV, the fury of the organized fan-clubs in the audience functioned as acclamation, equal but in reverse, but ultimately booing and applause become identified with devouring. The audience screamed, booed like I have never seen before, to the point that it was no longer possible to sing. When the song was selected to go on to the next stage, then it was even worse: it was as if the intellectual intention of destruction became conscious of itself. If Caetano had been at people's reach he would have been destroyed in a horrendous manner: everyone shouted queer, queer, queer, and threw objects, bits of wood at him and the Mutantes [pop/rock band inspired by the Beatles and psychedelia] and then they turned their backs to the stage. Then the Mutantes also turned their backs to the audience and Caetano stopped singing and said the most dramatic and profound things I have ever seen, not due to the words themselves but in the sense of their closure and what they represented at that moment. It was incredible, and do you know what it reminded me of? The scene with Abel Gance's Napoleon in front of the tribunal with that *travelling* that Gance made, imitating the movement of the sea, remember? This is what is terrible: the disjunction between the always noble, etc., intentions of the artist and the fury of the participatory relation. I believe that that moment revealed many things for me, especially the 'well nourished' appearance of people, of the destructive fury, as if that moment of lack of repression was a chance for destruction, which to an extent it always is. But it is a good test of the validity of the proposition: to not accept passively is more important than to accept everything, and in this dynamic of the relation new possibilities arise which, even if painful, are essential. I believe that perhaps in Venice you experienced this in relation to the work-spectator-creator, and the will to kill him, to push aside people's unbearable lust; this is important within the dialectics of the issue: because giving does not push aside the taking; on the contrary, it

stimulates it, in an erotic way too. As Marcuse would say, it liberates the Eros that is repressed by repressive activities: the *relax* in participation is a non-repressive activity, which confuses and liberates truly unpredictable forces, and in this, I believe, you base yourself on your own experience, which is also highly revolutionary; this is the great current issue.

I believe that our great innovation is precisely the form of participation, that is, its meaning, which is where we differ from what is proposed in super-civilized Europe or in the USA: we have here a far rougher scene, perhaps, because we have reached these issues in a more violent manner. For example, your black with white line phase, or even the one before that, even the breaking of the frame, this type of painting contains a *sui generis* dramaticality that did not occur even in Argentina, since the Argentines, to a certain extent, are more civilized, more European than us: Brazil is a form of synthesis of the peoples, races, habits, where the European speaks but does not speak so loudly, except in the universalist, academic fields, which are not those of 'cultural creation' but those of closure. Creation, even in Tarsila [do Amaral] and especially in Oswaldo de Andrade,[2] possesses a subjective charge that differs extremely from the rationalism of the European, this is our 'thing',[3] that Guy Brett was able to understand so well and that the Europeans will have to swallow, in fact with appetite since they are fed up with everything and it looks as if that saturated civilization is drying their imagination.

[...]

Kiiiisses,

Hélio

14 November 1968

Dear Hélio

[...]

As far as the idea of participation is concerned, as always there are *weak artists* who cannot really express themselves through thought, so instead they illustrate the issue. For me this issue does indeed exist and is very important. As you say, it is exactly the 'relation in itself' that makes it alive and important. For example, this has been the issue in my work since the sixties; if we go back even further to 1955, I produced the maquette for the house: 'build your own living space'. But it is not participation for participation's sake and it is not a fact of saying, like [Julio] Le Parc's group [GRAV: Groupe de recherche d'art visuel] does, that art is an issue for the bourgeoisie. It would be too simple and linear. There is no depth in this simplicity and nothing is truly linear. They negate precisely

what is important: thought. I think that now we are those who propose, and through the proposition there should be thought, and when the spectator expresses this proposition, he is in reality gathering the characteristic of a work of art of all times: thought and expression. And for me all of this is connected. From the option, the act, to immanence as a means of communication, and the lack of any myth exterior to man and more so, in my fantasy, it connects itself with the anti-universe where things are there because it happens *now*. It would be perhaps the first occasion in which consciousness of the actual absolute is achieved in the now. Another thing that I am very impressed with is today's youth who, like us, want to give themselves meaning from the inside towards the outside as opposed to, as it has always been, from the outside towards the inside. True participation is open and we will never be able to know what we give to the spectator-author. It is precisely because of this that I speak of a well, from inside which a sound would be taken, not by the you-well but by the other, in the sense that he throws his own stone... My experience of deflowering is not quite the same as yours. It is not myself who is deflowered but the proposal itself. And when I cry about this phenomenon it is not because I feel wounded in my personal integrity, but because they ruin everything and I have to start constructing the work all over again. On the contrary, I don't even put on my masks and clothes, but I hope someone will come along and give meaning to the formulation. And the more diverse the lived experiences are, the *more open is the proposition* and it is therefore more important. In fact, I think that now I am proposing the same type of issue that before was still achieved via the object: the empty-full, the form and its own space, the organicity... Only now, with these new sensorial masks, it is man who discovers himself in all his plenitude, and even when he fills the plastic bags (what is important now is also to make the mask) he feels that he is casting himself (in the sense that he exhales the air and the bag takes shape). This same space that comes out of him, as he becomes conscious of his own bodily space that goes beyond him, takes a form that would fill the actual space around him. I for instance, feel that after formulating these large plastic bags with my own lungs, when lying down on the floor in my flat I could touch, with a simple gesture, the ceiling, which is no less than 6 metres high... It is as if I had created an egg of space that belongs to me and that embraces me. It would be the most organic *Breathe with me* [1966] yet less illustrative! Man when putting on these masks turns himself into an authentic beast, since the mask is his appendix, not like the first ones where there was in fact a *real mask*. They turn themselves into monsters like elephants or enormous birds with great crops. More and more [Mário] Pedrosa's sentence functions for my work: 'man as the object of himself'. As you see, participation is increasingly greater. There no longer is the object to express any concept but the spectator

who reaches, more and more profoundly, his own self. He, man, is now a 'beast' and the dialogue is now with himself, to the extent of the organicity and also the magic that he is able to borrow from within himself. As far as Caetano's problem is concerned, it is different since he is affected as a person but is *an idol*; he is the opposite of myself, who no longer possesses anything, not even as a creative artist who provides what is still a total oeuvre that in the end is my self. Each day I loose more of my apparent personality, entering into the collective in search of a dialogue and accomplishing myself through the spectator. And the crises, when they arrive, appear in a more brutal manner, much more painful, yet they pass by quicker than before...

[...]

Thousand of kisses and do write!

Clark

27 June 1969

Lygia, my love

[...]

Your letter:

I very much liked the ideas and incredible relations concerning you, that I wrote about in another part of the enormous text that I prepared for the symposium I mentioned. I'll translate a section and I am sure you will love it, since, in fact after I wrote it, I discovered in Marcuse's most recent book a chapter in which he proposes a 'biological society' that would be unrepressed and based upon a direct chain of communication, the same thing I had thought about when writing about your issues; see below in a certain passage of the text:

'... the most recent experiences of Lygia Clark have led her to fascinating proposals as she discovered that certainly her communication will have to be more of an *introduction* to a practice that she calls *cellular*: From person to person, this is an improvised corporal dialogue that can expand into a total *chain* creating something of an *all encompassing biological entity* or what I would call a *crepractice*.[4] The idea of creating such relations goes beyond that of a facile participation, such as in the manipulation of objects: there is the search for what could be described as a *biological ritual*, where interpersonal relations are enriched and establish a *communication of growth* at an open level. I say open level, because it does not relate to an object-based communication, of subject-object, but to an interpersonal practice that leads towards a truly open communication: a me-you relation, rapid, brief as the actual act; no corrupted benefit, of interest, should be expected – observations such as "this is nothing" or "what is it about?", etc., should be expected; an introduction as initiation is

necessary. The elements that are used in all of these process-based experiences, a vital process, are those that are a part of it instead of being isolated objects: they are *orders in a totality...*'

[...]

A Kiss for you,

Hélio

1 *HéliCaetaGério* – composite name for Hélio Oiticica, Caetano Veloso and Rogério Duarte, suggesting that Hélio was at that moment immersed in his ideas and activities respectively with the singer/composer and the graphic designer/poet/composer [Translator]. For further reading on the collaboration between Oiticica, Veloso, Duarte and others see *Tropicália: A Revolution in Brazilian Culture*, ed. Carlos Basualdo (Chicago: Museum of Contemporary Art/São Paulo: Cosac Naify, 2005).

2 The modernist poet Oswaldo de Andrade (1890–1954) was the author of polemical texts on Brazilian cultural identity which influenced these artists, particularly his notion of 'cultural cannibalism' in the 'Anthropophagite Manifesto' published in *Revista de Antropofagia*, No. 1 (São Paulo, May 1928), translated in Dawn Adès, *Art in Latin America: The Modern Era, 1820–1980* (New Haven: Yale University Press, 1989).

3 'Pla': slang meaning approximately 'context'. [Translator]

4 'Cre' from create, see: Oiticica's concept of Creleisure. [Translator]

Letters between Lygia Clark and Hélio Oiticica, reprinted in Luciano Figueiredo (ed), *Lygia Clark -Hélio Oiticica: Cartas (1964-74)* (Rio de Janeiro: Editora UFRJ, 1996) 61–2, 69–73, 83–6, 121–2. Translated by Michael Asbury, 2006.

Graciela Carnevale
Project for the Experimental Art Series, Rosario//1968

1968 saw an irruption of politicized participatory practice in many countries, and took a particularly dramatic form in Argentina. The Experimental Art Cycle was a series of actions in Rosario, many of which worked on the audience as a privileged artistic material. Graciela Carnevale's project represents the most extreme example of this approach. In the years that followed, Carnevale, like many of the artists involved in the Cycle, abandoned art for teaching.

The work consists of first preparing a totally empty room, with totally empty walls; one of the walls, which was made of glass, had to be covered in order to achieve a suitably neutral space for the work to take place. In this room the participating audience, which has come together by chance for the opening, has been locked in. The door has been hermetically closed without the audience being aware of it. I have taken prisoners. The point is to allow people to enter and to prevent them from leaving. Here the work comes into being and these people are the actors. There is no possibility of escape, in fact the spectators have no choice; they are obliged, violently, to participate. Their positive or negative reaction is always a form of participation. The end of the work, as unpredictable for the viewer as it is for me, is nevertheless intentioned: will the spectator tolerate the situation passively? Will an unexpected event – help from the outside – rescue him from being locked in? Or will he proceed violently and break the glass?

Through an act of aggression, the work intends to provoke the viewer into awareness of the power with which violence is enacted in everyday life. Daily we submit ourselves, passively, out of fear, or habit, or complicity, to all degrees of violence, from the most subtle and degrading mental coercion from the information media and their false reporting, to the most outrageous and scandalous violence exercised over the life of a student.

The reality of the daily violence in which we are immersed obliges me to be aggressive, to also exercise a degree of violence – just enough to be effective – in the work. To that end, I also had to do violence myself. I wanted each audience member to have the experience of being locked in, of discomfort, anxiety, and ultimately the sensations of asphyxiation and oppression that go with any act of unexpected violence. I made every effort to foresee the reactions, risks and dangers that might attend this work, and I consciously assumed responsibility for the consequences and implications. I think an important element in the

conception of the work is the consideration of the natural impulses that get repressed by a social system designed to create passive beings, to generate resistance to action, to deny, in sum, the possibility of change.

The 'lock up' has already been incorporated in the verbal image (literature) and in the visual image (film). Here the gambit is not filtered through anything imaginary; rather it is experienced, at once vitally and artistically. I consider that materializing an aggressive act on the aesthetic level as an artistic event necessarily implies great risk. But it is precisely this risk that clarifies the art in the work, that gives a clear sense of art, relegating to other levels of meaning whatever psychological or sociological sense the work might have.

Graciela Carnevale, statement originally published as part of a series of brochures accompanying the 'Cido de Me Experimental'. Carnevale's exhibition took place in Rosario, 7–19 October 1968; trans. Marguerite Feitlowitz, in Andrea Jiunta and Ines Katzenstein, eds, *Listen, Here, Now! Argentine Art of the 1960s* (New York: The Museum of Modern Art, 2004) 299–301.

These people
are the actors.
There is no
possibility
of escape.
In fact the
spectators
have no
choice. They
are obliged
violently
to participate.

Graciela Carnevale, *Project for the Experimental Art Series, Rosario,* 1968

Joseph Beuys and Dirk Schwarze
Report on a Day's Proceedings at the *Bureau for Direct Democracy*//1972

Joseph Beuys' concept of 'Social Sculpture' remains an important reference for contemporary artists such as Thomas Hirschhorn. The following report on Beuys' Bureau for Direct Democracy *(1972), a 100-day live installation at Documenta 5, records in candid detail the type of relational encounters generated by his activist approach. It is followed by 'I am searching for field character' (1973), Beuys' most concise statement on Social Sculpture.*

30 June to 8 October 1972: Joseph Beuys runs an office of information for the 'Organization for Direct Democracy through Referendum' at Documenta 5.

Beuys' participation in the Documenta was instituted with the intention of representing and making known his expanding art concept through an office of information at this internationally respected and visited art forum. During the 100 days of the Documenta, Beuys was present daily at this information office and discussed with visitors the idea of direct democracy through referendum and its possibilities for realization.

Report of a day's proceedings in the office of Joseph Beuys, Fridericianum, written by Dirk Schwarze:

10:00 a.m. The Documenta opens; Beuys, in a red fishing vest and felt hat, is in his office. He has two co-workers. On the desk is a long-stemmed rose, next to it are piles of handbills. On the wall with the window is a blue neon sign that says 'Office of the Organization for Direct Democracy through Referendum'. Besides this, there are several blackboards on the walls. On each is written the word 'man'.

11:00 a.m. Until now about 80 visitors in the office. Half, however, remain standing in the doorway and look around, others walk past the blackboards and then remain longer in the office. Some only come to the door and leave in fright, as if they had come into the wrong restroom.

11:07 a.m. The room fills up. Beuys offers a young man material and initiates the first discussion. A young man asks about Beuys' goal and thinks that at a referendum 90 per cent would declare themselves in favour of the present system. Beuys explains the present party structure, which is ruled from top to bottom. He wants a system that is ruled from bottom to top. Still, if 60 per cent voted for the present system in a referendum, it would be a success because through it a new awareness could be created.

11:20 a.m. The discussion expands: five listeners. A man who says he is a member of a party takes part in the talk. Beuys explains his concept: 'We do not want to be a power factor, but an independent free school.' The goal would be to establish a whole network of offices as schooling places which would contribute to consciousness formation. One must start with the present possibilities. Referendum is provided for in the constitution of North Rhine-Westphalia. For a vote of the Federal Diet Beuys recommends a vote of abstinence, linked to a 'counter-demonstration', to make clear why one is not voting. The party member accepts the material: 'This is very interesting to me.'

11:45 a.m. Up to now 130 visitors. The discussion continues, with eight listeners. A young Swiss asks whether Beuys wants nationalization of industry. The answer: 'No, I have no use for nationalization, but I do want socialization.' The state, whether east or west, appears to him as evil. He quotes Bishop Dibelius, who describes the state as 'the animal from underground'.

12:20 a.m. Up to now 210 visitors. A vigorous argument begins between Beuys and a young man who designates himself a member of the German Communist Party. Sixteen listeners. The young man calls Beuys' activities 'nonsense', a waste of energy. 'What have you accomplished?' he asks, and invites Beuys to join the workers' movement rather than to lead an organization that is financed by industrialists. Beuys replies: 'You cannot think straight. I cannot work with the concept of class. What is important is the concept of man. One must straightforwardly realize what has not yet appeared in history, namely, democracy.'

12:35 a.m. In the meantime 22 listeners. An elderly man joins in: 'Can we talk about the Documenta here and not just about politics?' Beuys: 'Politics and the creativity of all are dealt with here.' When the man speaks of the failure of the exhibition because no one here is directly interested, Beuys asserts, 'It is also a failure on the part of the visitors, because they are not more capable of giving of themselves.'

1:00 p.m. Until now 360 visitors. The vigorous talk with the Communist Party member continues, 22 listeners. Beuys energetically defends himself against the reproach that he indulges in a utopia, replying: 'I am against a revolution in which one drop of blood flows.' Marxists, he says, are, for him, devout fetishists in this connection.

1:05 p.m. A young woman: 'Mr Beuys, your artworks are an ingredient in the system – they can be bought.' Beuys: 'Everyone who lives in the system participates in it. I make use of it through the sale of my work.'

1:30 p.m. Until now 450 visitors. At present thirty listeners. A middle-aged man addresses Beuys regarding the possibilities of change through art. Beuys wards it off: 'Art is not there to overthrow the state. According to my concept of

art, I want to affect all areas of life. What I practice here is my concept of art.' He admits, 'I believe in man.'

2:00 p.m. Until now 535 visitors. After the distribution of materials a quiet period sets in. Beuys fortifies himself: coffee and yogurt. He explains his models to a young girl: Rudolph Steiner, Schiller, and Jean Paul.

2:30 p.m. A young man: 'I don't see the connection between your theories and your felt objects.' Beuys: 'Many have seen only my objects, but not my concepts, which belong to them.'

3:00 p.m. Until now 560 visitors. A young girl comes to Beuys and asks: 'Is this art?' Answer: 'A special type of art. One can think with it, think with it.'

4:05 p.m. Until now 625 visitors. Two Italians want to know whether Beuys could be called a non-violent anarchist. Beuys says 'yes.'

4:15 p.m. The office fills up again. A teacher asks: 'Whom do you represent? Democracy, what does that mean? What models do you have?' Beuys: 'I have no historical model apart from reality and want to better these realities for the well-being of all.' An argument starts over whether direct or only representative government is possible.

4:30 p.m. Until now 670 visitors. At present twenty listeners. An elderly man: 'One is entertained too little here, there is so much at the Documenta that is boring. Documenta is still too elite.' Beuys: 'Art is experiencing a crisis. All fields are in a state of crisis.'

4:40 p.m. A young man: 'You are a big earner on the German art market. What do you do with the money?' Beuys: 'The money goes into this organization.'

4:45 p.m. Eighteen listeners. Beuys suggests to a teacher that he resign his civil service status; a lively discussion beings. The teacher argues that only Beuys could accomplish such a thing, because he is a famous artist. The teacher: 'My situation is fairly bad. It's easy for you to stand there with your moral declarations.'

5:15 p.m. Until now 720 visitors. After a discussion of the role of the art market as a middle market, another quiet period. The sale of the bags with the schematic representation of 'direct democracy' is flourishing. For the first time today a visitor asks for Beuys' autograph on the bag.

6:00 p.m. Visitors slacken noticeably. Until now about 780 visitors.

7:40 p.m. A total of 811 visitors, of which 35 asked questions or discussed.

8:00 p.m. Beuys' office closes.

Question To what extent do you believe an exhibition can be the most suitable forum for passing on to the public the impulses which you hope to attain?
Beuys The place is relatively unimportant. I have thought this over for a long

Beuys, in a red
fishing vest and
felt hat, is in his
office. He has two
co-workers. On the
desk is a long-stemmed
rose, next to it are
piles of handbills.
On the wall with the
window is a blue neon
sign that says 'Office
of the Organization
for Direct Democracy
through Referendum'.
Besides this, there
are several blackboards
on the walls.
On each is written
the word 'man'.

Joseph Beuys and Dirk Schwarze, *Report on a Day's Proceedings at the* Bureau for Direct Democracy, 1972

time. For example, I have the office here; it is a copy of my office in Düsseldorf, which gives onto the street. This is so that people can come in right off the street. It looks exactly like our office, exactly. And there anyone can come in. I have thought about which is more effective: if I remain in Düsseldorf or if I climb onto this platform and reach men here. I came very simply to the conclusion that it is vacation time now in Düsseldorf; there we would have perhaps one visitor a day, and here we can reach more people. Here I can reach people from all over the world. Here I can establish international contacts. This is very important.

Question Do you see yourself as an individualist and do you see your office here as an isolated department?

Beuys No, in no way. I do not see myself as being isolated here. I have all kinds of possibilities here. I can speak freely with everyone. No one has prevented me yet. Whether someone will try to in the future, that we will find out. (Laughing) Yes, that we will find out, won't we?

Question You have set up your office here at the fifth Documenta, and with it you pursue not only political intentions but also artistic ones …

Beuys Because real future political intentions must be artistic. This means that they must originate from human creativity, from the individual freedom of man. For this reason here I deal mostly with the problem of education, with the pedagogical aspect. This is a model of freedom, a revolutionary model of freedom. It begins with human thought and with the education of man in this area of freedom. And there must also be free press, free television, and so on, independent of state influence. Just as there must be an educational system independent of state influence. From this I attempt to develop a revolutionary model which formulates the basic democratic order as people would like it, according to the will of the people, for we want a democracy. It is part of the fundamental law: all state power comes from the people.

The area of freedom – not a free area – I want to emphasize this, because they are always being interchanged; people say Beuys wants a free area. I do not want a free area, an extra area, but I want an area of freedom that will become known as the place where revolution originates, changed by stepping through the basic democratic structure and then restructuring the economy in such a way that it would serve the needs of man and not merely the needs of a minority for their own profit. That is the connection. And that I understand as art.

Joseph Beuys/Dirk Schwarze, report on a day's proceedings at the *Informationsbüros der Organisation für direkte Demokratie durch Volksabstimmung*, Documenta 5 (Kassel, 1972); translated in Adriani Götz, et al., *Joseph Beuys: Life and Work* (New York: Barron's, 1979) 244–9.

Joseph Beuys
I Am Searching for Field Character//1973

Only on condition of a radical widening of definition will it be possible for art and activities related to art to provide evidence that art is now the only evolutionary-revolutionary power. Only art is capable of dismantling the repressive effects of a senile social system that continues to totter along the deathline: to dismantle in order to build A SOCIAL ORGANISM AS A WORK OF ART.

This most modern art discipline – Social Sculpture/Social Architecture – will only reach fruition when every living person becomes a creator, a sculptor or architect of the social organism. Only then would the insistence on participation of the action art of Fluxus and Happening be fulfilled; only then would democracy be fully realized. Only a conception of art revolutionized to this degree can turn into a politically productive force, coursing through each person and shaping history,

But all this, and much that is as yet unexplored, has first to form part of our consciousness: insight is needed into objective connections. We must probe (theory of knowledge) the moment of origin of free individual productive potency (creativity). We then reach the threshold where the human being experiences himself primarily as a spiritual being, where his supreme achievements (work of art), his active thinking, his active feeling, his active will, and their higher forms, can be apprehended as sculptural generative means, corresponding to the exploded concepts of sculpture divided into its elements – indefinite – movement – definite (see theory of sculpture), and are then recognized as flowing in the direction that is shaping the content of the world right through into the future.

This is the concept of art that carries within itself not only the revolutionizing of the historic bourgeois concept of knowledge (materialism, positivism), but also of religious activity.

EVERY HUMAN BEING IS AN ARTIST who – from his state of freedom – the position of freedom that he experiences at first hand – learns to determine the other positions in the TOTAL ARTWORK OF THE FUTURE SOCIAL ORDER. Self-determination and participation in the cultural sphere (freedom); in the structuring of laws (democracy); and in the sphere of economics (socialism). Self-administration and decentralization (threefold structure) occurs: FREE DEMOCRATIC SOCIALISM.

THE FIFTH INTERNATIONAL is born

Communication occurs in reciprocity: it must never be a one-way flow from the teacher to the taught. The teacher takes equally from the taught. So oscillates – at all times and everywhere, in any conceivable internal and external circumstance, between all degrees of ability, in the work place, institutions, the street, work circles, research groups, schools – the master/pupil, transmitter/receiver, relationship. The ways of achieving this are manifold, corresponding to the varying gifts of individuals and groups. THE ORGANIZATION FOR DIRECT DEMOCRACY THROUGH REFERENDUM is one such group. It seeks to launch many similar work groups or information centres, and strives towards worldwide cooperation.

Joseph Beuys, 'I am Searching for Field Character' (1973), in Carin Kuoni, ed., *Energy Plan for the Western Man: Joseph Beuys in America* (New York: Four Walls Eight Windows, 1990) 21–3.

Collective Actions
Ten Appearances//1981

The five-person Collective Actions group, working in Moscow from the mid-1970s to the mid-1980s, represent a particularly poetic and cerebral approach to participation. Ten Appearances *is typical of their work in taking place in fields outside the city, with a small number of participants who took an active part in the action and then contributed to its analysis. These gestures differ from Western equivalents of this period in being preoccupied with art's internal reception and circulation, rather than in its relationship to social institutions.*

In the middle of a large, snowed-over field surrounded by a forest, together with the action's organizers strode ten participants, knowing neither the name of that in which they were about to participate, nor what was to happen.

Ten spools on vertical nails were affixed to a board (60 x 90 cm) which was laid upon the snow. Each of the spools was wound with two to three hundred metres of strong, white thread. Each of the participants was required to take the end of a thread from one of the spools and, unravelling the thread from the spool, move in a straight line into the forest surrounding the field. Thus the ten participants were to have dispersed from the centre of the field in the following directions:

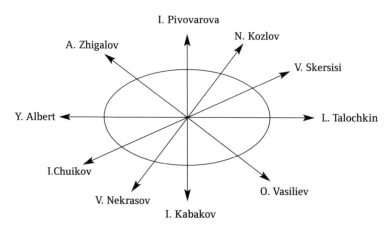

The participants were instructed to move in a straight line as far as the forest and then, entering the forest, to continue on into the depths of the forest for about another fifty to one hundred metres, or to the point where the field could no

longer be seen. Each of the participants travelled three to four hundred metres. Walking in the field and forest entailed a considerable physical effort, as the snow ranged from half a metre to a metre in depth. Having completed his trek, each participant (also according to prior instructions) was to pull to himself the other end of the thread (which was not attached to the spool), to which a piece of paper with factographic text (the last names of the organizers, time and place of the action) was affixed.

In so far as no further instructions had been given, each participant, having extracted his factography, was left to his own discretion as to further action; they could return to the field's centre, where the organizers remained, or, not returning, leave this place behind, moving on further through the forest.

Eight participants came back to the centre of the field within an hour; moreover, seven of them returned along their own paths, and one (N. Kozlov) along a neighbour's path. Two participants – V. Nekrasov and A. Zhigalov – did not return.

The returning participants received photographs (30 x 40 cm), glued to cardboard, from the organizers. Each photograph depicted the portion of the forest into which the participant receiving that photo had walked at the beginning of the action, and the scarcely distinguishable figure of a man emerging from the forest. The photographs were outfitted with label/signatures upon which were written the last names of the action's authors, the action's name *Ten Appearances*, and the event 'represented' in the photograph; for example, 'The appearance of I. Chuikov on the first of February, 1981', and so on. These photographs were taken within the week before the action: the action's organizers photographed in a 'zone of indifferentiation' in the very same directions in which the participants had been directed and from whence they had returned.

Thus the name of the action and its full significance became clear to the participants only at the moment when they received the photographs, and not when they pulled the factographic documents, which signified only the completion of the first stage of the action – the distancing of the participants into portions of the forest visually isolated one from another (at the terminal points of their paths out from the centre of the field, in the depths of the forest, the participants could not see each other, as the interstices between these points measured no less than four hundred metres). During the action, photographs were taken of the actual appearances from the forest. These photographs could be distinguished from those handed to the participants at the conclusion of the action by the differing conditions of the forest (snow which had covered the branches of the trees a week before the action had melted away), and by the absence of the quotation marks, which on the first photographs had been placed

around the names of the events depicted on them, i.e., in the given circumstances the simple appearance of I. Chuikov, I. Kabakov, I. Pivovarova and so on. The figures of the participants emerging from the forest were practically indistinguishable from the figures in the first 'metaphorical' photographs, owing to the fact that they were taken from equal distances (in the 'zone of indifferentiation'). The function of these 'metaphorical' photographs was, in the case of the participants' return, to indicate only the fact of their return (which was utterly volitional, as no instruction to return had been given), without adding any supplementary meaning to their prior acts of walking off and dispersing into the depths of the forest. At the same time these 'metaphorical' photographs were signs of time extrademonstrational (for the participants) to the event and were included in the structure of the action and served as its 'empty act'. In other words, they were signs of the time between the 'end' of the action and the moment when they were handed the photographs indicating their appearance (or return) from the forest, which the participants did not recognize and could not have recognized as the signified and culminating event in the structure of the action.

The fact that of the ten possible appearances only eight, and not all ten, came to pass, represents in our view not a failing of the action but, on the contrary, underscores the realization of zones of psychic experience of the action as aesthetically sufficient on the plane of the demonstrational field of the action as a whole. This is to say that the planned appearance in reality turned out to lie entirely in the extrademonstrational time of the event – the participant appeared from a non-artistic, non-artificially-constructed space.

Collective Actions (Andrei Monastyrsky, Georgii Kizevalter, Sergei Romashko, Nikita Alekseev, Igor Makarevich, Elena Elagina, Nikolai Panitkov), *Ten Appearances* ('Kievi-Gorky', Savel, Moscow Province, February 1981); translated in David A. Ross, et al., eds, *Between Spring and Summer – Soviet Conceptual Art in the Era of Late Communism* (Boston: Institute of Contemporary Art/Cambridge, Massachusetts: The MIT Press, 1990) 157-8.

Adrian Piper
Notes on Funk, I–II//1985/83

Adrian Piper's Funk Lessons *(1982–84), were a series of participatory social events in which the artist taught white participants about black funk music and how to dance to it. Her four essays entitled 'Notes on Funk' present a thoughtful analysis of her intentions, experiences and of feedback from her collaborators.*

Notes on Funk I
From 1982 to 1984, I staged collaborative performances with large or small groups of people, entitled *Funk Lessons*. The first word in the title refers to a certain branch of black popular music and dance known as 'funk' (in contrast, for example, to 'punk', 'rap' or 'rock'). Its recent ancestor is called 'rhythm and blues' or 'soul', and it has been developing as a distinctive cultural idiom, within black culture since the early 1970s. Funk constitutes a language of interpersonal communication and collective self-expression that has its origins in African tribal music and dance and is the result of the increasing interest of contemporary black musicians and the populace in those sources elicited by the civil rights movement of the 1960s and early 1970s (African tribal drumming by slaves was banned in the United States during the nineteenth century, so it makes sense to describe this increasing interest as a 'rediscovery').

This medium of expression has been largely inaccessible to white culture, in part because of the different roles of social dance in white as opposed to black culture. For example, whereas social dance in white culture is often viewed in terms of achievement, social grace or competence, or spectator-oriented entertainment, it is a collective and participatory means of self-transcendence and social union in black culture along many dimensions, and so is often much more fully integrated into daily life. Thus it is based on a system of symbols, cultural meanings, attitudes and patterns of movement that one must directly experience in order to understand fully. This is particularly true in funk, where the concern is not how spectacular anyone looks but rather how completely everyone participates in a collectively shared, enjoyable experience.

My immediate aim in staging the large-scale performance (preferably with sixty people or more) was to enable everyone present to
GET DOWN AND PARTY. TOGETHER.
This helps explain the second word in the title, that is, 'Lessons'. I began by introducing some of the basic dance movements to the audience, and discussing their cultural and historical background, meanings, and the roles they play in

black culture. This first part of the performance included demonstrating some basic moves and then, with the audience, rehearsing, internalizing, re-rehearsing, and improvising on them. The aim was to transmit and share a physical language that everyone was then empowered to use. By breaking down the basic movements into their essentials, these apparently difficult or complex patterns became easily accessible to everyone. Needless to say, no prior training in or acquaintance with dance was necessary. Because both repetition and individual self-expression are both important aspects of this kind of dance, it was only a matter of a relatively short time before these patterns became second nature. However, sometimes this worked more successfully than others, depending on the environment and the number and composition of the audience-participants. (See my videotape, *Funk Lessons with Adrian Piper*, produced by Sam Samore and distributed by The Kitchen, for a record of one of the more successful performances.) Also, the large-scale performance compressed a series of lessons that might normally extend over a period of weeks or months.

As we explored the experience of the dance more fully, I would gradually introduce and discuss the music (which had, up to this point, functioned primarily as a rhythmic background) and the relation between the dance and the music: Because of the participatory and collective aspects of this medium, it is often much easier to discern the rhythmic and melodic complexities of the music if one is physically equipped to respond to it by dancing. Thus the first part of the performance prepared the audience for the second. Here I concentrated on the structural features that define funk music, and on some of its major themes and subject matter, using representative examples. I would discuss the relation of funk to disco, rap, rock, punk and new wave, and illustrate my points with different selections of each. During this segment, except for brief pauses for questions, dialogue and my (short) commentaries, everyone was refining their individual techniques, that is, they were LISTENING by DANCING. We were all engaged in the pleasurable process of self-transcendence and creative expression within a highly structured and controlled cultural idiom, in a way that attempted to overcome cultural and racial barriers. I hoped that it also overcame some of our culturally and racially influenced biases about what 'High Culture' is or ought to be. Again, this didn't always work out (see 'Notes on Funk III').

The 'Lessons' format during this process became ever more clearly a kind of didactic foil for collaboration: Dialogue quickly replaced pseudo-academic lecture/demonstration, and social union replaced the audience-performer separation. What I purported to 'teach' my audience was revealed to be a kind of fundamental sensory 'knowledge' that everyone has and can use.

The small-scale, usually unannounced and unidentified spontaneous performances consisted in one intensive dialogue or a series of intensive

GET

DOWN AND

PARTY

TOGETHER

Adrian Piper, *Notes on Funk I*, 1985

dialogues with anywhere from one to seven other people (more than eight people tend to constitute a party, the interpersonal dynamics of which are very different). I would have people over to dinner, or for a drink, and, as is standard middle-class behaviour, initially select my background music from the Usual Gang of Idiots (Bach, Mozart, Beethoven, Brahms, etc.). I would then interpose some funk and watch people become puzzled, agitated or annoyed, and then I would attempt to initiate systematic discussion of the source of their dismay (in fact these reactions to my unreflective introduction of the music into this social context were what initially alerted me to the need to confront the issues systematically and collaboratively in the performance context). This usually included listening to samples of funk music and analyzing their structures, content and personal connotations for each listener, in a sympathetic and supportive atmosphere. Occasionally, it also included dance lessons of the kind described previously, though this usually worked better with party-size or larger groups.

The intimate scale of the dialogue permitted a more extensive exploration of individual reactions to funk music and dance, which are usually fairly intense and complex. For example, it sometimes elicited anxiety, anger or contempt from middle-class, college-educated whites: anxiety, because its association with black, working-class culture engenders unresolved racist feelings that are then repressed or denied rather than examined; anger; because it is both sexually threatening and culturally intrusive to individuals schooled exclusively in the idiom of the European-descended tradition of classical, folk, and/or popular music; contempt, because it sounds 'mindless' or 'monotonous' to individuals who, through lack of exposure or musicological training, are unable to discern its rhythmic, melodic and topical complexity.

Alternately, funk sometimes elicited condescension or embarrassment from middle-class, college-educated blacks: condescension, because it is perceived as black *popular* culture, that is, relatively unsophisticated or undeveloped by comparison with jazz as black high culture; embarrassment, because funk's explicit and aggressive sexuality and use of Gospel-derived vocal techniques sometimes seem excessive by comparison with the more restrained, subdued, white- or European-influenced middle-class lifestyle. Often this music is also associated with adolescent popularity traumas concerning dancing, dating or sexual competence. These negative associations linger into adulthood and inhibit one's ability even to listen to this genre of music without painful personal feelings.

These and other intense responses were sympathetically confronted, articulated and sometimes exorcised in the course of discussing and listening to the music. The result was often cathartic, therapeutic and intellectually stimulating: to engage consciously with these and related issues can liberate one to listen to and understand this art form of black, working-class culture without

fear or shame, and so to gain a deeper understanding of the cultural and political dimensions of one's social identity. What follows are notes I took after having staged the performance at different times. They are the fruit of my dialogues with participants and of my observations of their responses to the performance.

Notes on Funk II

[...] I suppose that what finally vindicates the performances in my own eyes (as well as the effort to continue engaging with very different kinds of people in doing them) is the undeniable *experience* people seem to get, almost invariably, from participating in them, including me: It just seems to be true that most of my white friends feel less alienated from this aesthetic idiom after having participated in it directly, and discussed their feelings about it in a receptive context, regardless of their reservations about whether what I'm doing is 'art' or not, whether funk deserves the legitimation of 'high culture' or not, and so on. For me what it means is that the experiences of sharing, commonality and self-transcendence turn out to be more intense and significant, in some ways, than the postmodernist categories most of us art-types bring to aesthetic experience. This is important to me because I don't believe those categories should be the sole arbiters of aesthetic evaluation.

But perhaps the real point of it for me has to do with the ways in which it enables me to overcome my own sense of alienation, both from white and black culture. As a Woman of Colour (I think that's the going phrase these days; as my parents often complain, 'What's the matter with 'coloured'? Or 'coloured woman'? That was a good, serviceable, accurate description forty years ago!') who is often put in the moral dilemma of being identified as white and hence subject to the accusation of 'passing', it gives me the chance to affirm and explore the cultural dimensions of my identity as a black in ways that illuminate my personal and political connection to other (more identifiably) black people, and celebrate our common cultural heritage. At the same time, the piece enables me to affirm and utilize the conventions and idioms of communications I've learned in the process of my acculturation into white culture: the analytical mode, the formal and structural analysis, the process of considered and constructive rational dialogue, the pseudo-academic lecture/demonstration/group participation style, and so on. These modes of fluency reinforce my sense of identification with my audience and ultimately empower all of us to move with greater ease and fluidity from one such mode to another. It also reinforces my sense of optimism that eventually the twain *shall* meet!

Adrian Piper, 'Notes on Funk I (1985)', 'Notes on Funk II' (1983), *Out of Order, Out of Sight, Volume 1: Selected Writings in Meta-Art, 1968–1992* (Cambridge, Massachusetts: The MIT Press, 1996) 195–8; 204.

Group Material
On Democracy//1990

The US collective Group Material began working in the late 1970s, producing collaborative exhibitions with residents of their neighbourhood in Manhattan. Throughout the 1980s their projects grew more critical of the Republican government, particularly its policy on AIDS. The following text introduces Democracy, *a conference and installation project they organized at the Dia Arts Foundation, New York, in 1988.*

> Participating in the system doesn't mean that we must identify with it, stop criticizing it, or stop improving the little piece of turf on which we operate.
> – Judge Bruce Wright, Justice, New York State Supreme Court.

Ideally, democracy is a system in which political power rests with the people: all citizens actively participate in the process of self-representation and self-governing, an ongoing discussion in which a multitude of diverse voices converge. But in 1987, after almost two terms of the Reagan presidency and with another election year at hand, it was clear that the state of American democracy was in no way ideal. Access to political power was obstructed in complex ways, participation in politics had degenerated into passive and symbolic involvement, and the current of 'official' politics precluded a diversity of viewpoints. When the Dia Art Foundation approached us with the idea of doing a project, it was immediately apparent to us that democracy should serve as the theme.

The subject of democracy not only became our content but influenced our method of working. This theme prompted a greater awareness of our own process. One of the first questions we asked was: 'Why are they asking us?' To us, the Dia Art Foundation signified 'exclusive', 'white', 'esoteric', and 'male', whereas we had always attempted to redefine culture around an opposing set of terms: 'inclusive', 'multicultural', 'nonsexist', and 'socially relevant'. In general, we see ourselves as the outspoken distant relative at the annual reunion who can be counted on to bring up the one subject no one wants to talk about.

The subject that no one in the art world wants to talk about is usually politics. Yet, because every social or cultural relationship is a political one, we regard an understanding of the link between politics and culture as essential. 'Politics' cannot be restricted to those arenas stipulated as such by professional politicians. Indeed, it is fundamental to our methodology to question every aspect of our cultural situation from a political point of view, to ask, 'What politics inform

accepted understandings of art and culture? Whose interests are served by such cultural conventions? How is culture made, and for whom is it made?'

In conceptualizing this project, therefore, we proposed a structure that differed from the conventional art exhibitions, lectures and panels that Dia had previously sponsored. We identified four significant areas of the crisis in democracy: education, electoral politics, cultural participation and AIDS. For each topic, we collaboratively organized a round table discussion, an exhibition and a town meeting. For each round table we invited individual speakers from diverse professions and perspectives to participate in an informal conversation. These discussions helped us to prepare the installations and provided important information for planning the agendas for the town meetings.

Each of the four exhibitions that we installed at 77 Wooster Street reiterated the interrelatedness of our subjects and the necessity of our collaborative process. Our working method might best be described as painfully democratic: because so much of our process depends on the review, selection and critical juxtaposition of innumerable cultural objects, adhering to a collective process is extremely time-consuming and difficult. However, the shared learning and ideas produce results that are often inaccessible to those who work alone.

Our exhibitions and projects are intended to be forums in which multiple points of view are represented in a variety of styles and methods. We believe, as the feminist writer bell hooks has said, that 'we must focus on a policy of inclusion so as not to mirror oppressive structures'. As a result, each exhibition is a veritable model of democracy. Mirroring the various forms of representation that structure our understanding of culture, our exhibitions bring together so-called fine art with products from supermarkets, mass-cultural artefacts with historical objects, actual documentation with homemade projects. We are not interested in making definitive evaluations or declarative statements, but in creating situations that offer our chosen subject as a complex and open-ended issue. We encourage greater audience participation through interpretation.

One form of participation was the town meeting held for each exhibition. These meetings were well publicized and were open to the public at large. In selecting the town meeting format, we meant not only to allude to the prototypical democratic experience but also to eliminate the demarcation between experts and the public so evident at most public lectures. For the town meetings all audience members were potential participants. Beyond the desire to erode such traditional categories, our expectations for these discussions were somewhat undefined. In the end, each town meeting had a life of its own, determined not only by the moderator, but by who was in the audience and who among them had the courage to speak up. Much of the public discussion built on issues raised in the round table meetings, and it was gratifying to hear different

people discussing their relation to those issues.

The final part of 'Democracy', and perhaps the most important, is this book. Through this book we tried to encapsulate many of the ideas that went into and came out of the Democracy Project in order to make them available to a far wider public than could attend the events. We organized this publication very much as we organize our exhibitions, bringing together a variety of voices and points of view to address the issues. In this case, we hope that the results provide a strong analysis of the current situation of democracy in America and suggest possible means for responding to its challenges. [...]

Group Material (Doug Ashford, Julie Ault, Felix Gonzalez-Torres), *Democracy: A Project by Group Material* (Seattle: Bay Press, 1990) 1–3.

Eda Cufer
Transnacionala/A Journey from the East to the West//1996

The five-man Slovenian collective IRWIN are arguably the relational artists par excellence of Eastern Europe. Their live installation NSK Embassy Moscow *(1992) addressed social and political relations in the post-Communist period, and the construction of Eastern European identity. The following text by their frequent collaborator, the artist Eda Cufer, is typical of their approach: a wry self-interrogation and poignant analysis of the limitations of a discussion-based road trip across the US, which the group undertook in 1996.*

How to conceptualize *post festum*, an artistic event which, as such, took place within individual and collective thought, in a flow of thoughts and emotions largely determined by the very corporeity and directness of events, vanishing in time as the journey progressed from mile to mile, from city to city, from meeting to meeting?

The non-differentiated, subjective material of *Transnacionala* which the journey's participants brought home from this experience is a kind of amalgam of images, impressions, memories and realizations. The banalities of everyday life, which range from sleeping, eating, the cleaning of the crowded living environment and self, to psychological tensions and attempts to relax – all intertwine with more sublime impressions of unforgettable landscapes, wide expanses and people; with reflections physically linked to these different banal or exhaled states; with memories of conversations and memories of towns and the atmospheres in which they took place; as well as with tentative syntheses occasioned by thought-shifts between different time-space and existential zones – between America, Europe and the world, between memories of local life situations in Ljubljana, Moscow, New York and Chicago – all caught up in the dull gaze and the monotonous image that defined, for hours and hours, the content and basic situation of the motor homes.

Although it is difficult to part from this non-differentiated image, impression and experience of *Transnacionala*, the three months that have elapsed since the project ended in Seattle on 28 July 1996 provide a sufficient time-distance to produce at least a rough reckoning of what the direct experience of the project signifies, in respect to its initial conceptual points of departure.

One of these fundamental points, which specifically enabled the later physical and metaphysical framework of the journey, was the positive experience of the *Apt Art* project, more precisely, the *NSK Embassy Moscow*

project which took place in 1993. The primary motive for *Transnacionala* was to organize an international art project to take place outside the established international institutional networks, without intermediaries, without a curator-formulated concept, and without any direct responsibility towards its sponsors. In short, to organize a project as a direct network of individuals brought together by a common interest in particularly open aesthetic, ethical, social and political questions, all of whom would travel together for one month, exchange views, opinions and impressions, meet new people in their local environments, and try to expand the network based on the topicality of questions posed – spontaneously and without any predetermined, centralized aesthetic, ideological or political objective.

The second methodological point of departure, also based on the positive experience of Moscow in 1992, was to create conditions for a kind of experimental existential situation. Like the one-month stay in an apartment at 12 Leninsky Prospekt, Moscow, in 1992, the one-month cohabitation of ten individuals in two motor homes, in barely ten square metres of physical space, also should have enabled a questioning of the myth of the public and intimate aspects of artist and art – that is, of the split forming the basis of the system of representation.

The next research-oriented point of departure was to analyse the problems of the global art system; the system of values, of existential, linguistic and market models contained therein. The aesthetic and ethical point of departure was the very implementation of the project itself – an attempt to establish a complex personal and group experience, the creation of a time-space module living within the multitudes of linguistically indefinable connections.

On the surface, the *Transnacionala* project may seem yet another attempt to establish or reaffirm the myth of communication. Its mission could be defined as an attempt to bridge personal, cultural, ideological, political, racial and other differences. It was in this positive, optimistic spirit that the first letters to prospective participants and hosts were composed, and quite frequently such an agit-prop discourse was also used in the process of establishing communication with the public in the five US cities we visited. It's more difficult, however, to define how and with what complications this communication really took place. The success of communication by individuals largely coming from spaces and times separate, as to both culture and experience, depends primarily on the skill of the individuals and groups wishing to communicate – their skill at playing a role within the structure of the dialogue. In the context of contemporary art and theory, the role of the engineers of such a communication structure is largely played by various international institutions, intermediaries who have successfully maintained, for the entire century, the illusion that despite cultural,

political, economic and individual differences the contemporary art community speaks the same language. Since the collapse in the seventies of what could be termed the option of the left, an option which determined the system of values and the consistency of language on which the above illusion was based, this institutionalized communication framework has been showing its cracks and fissures. It has shown itself inadequate, yet at the same time it remains the only model linking separate individuals and groups. It protects them from sinking back into more or less primitive national and local communities.

By trying to circumvent the institutional framework, and to ignore the potential of skilful professionals who would inevitably try to place the event within an established context of reception, the *Transnacionala* project deliberately provoked what could be called a communication noise. It placed the event in a certain margin – a margin that was constantly bringing up questions about the point of the participants' own activity, about what makes the project different from a tourist trip abusing art as an excuse for stealing national and international funds in the interest of structuring pleasure, as well as various self-accusatory images in which the participants saw themselves as a bunch of demoralized, neurotic individuals in pursuit of some abstract private utopias, non-existent relations, and deficiencies that cannot be compensated for. These feelings gradually took on the status of a unique experience, of a state we had deliberately provoked. They became the subject and theme of the journey.

The problem of the structure and dominion of the public is specifically that power which decides whether a particular individual or collective art production is a real part of the public exchange of values – or merely what could be termed the hyper-production of an alienated subject, to be stuck in the cellar or attic of a private house, in the inventory of a bankrupt gallery, in a collection that has lost its value overnight, or in some other of history's many dumping grounds.

In view of the prevailing East European provenance of the artists who had embarked on the adventure of discovering America – the central myth of the West – we repeatedly posed a basic question to the American public present at our public events: what does the American cultural public understand by the notions of the East – of Eastern art, of Eastern societies? What already exists in the minds of our interlocutors? On the other hand, we were faced with the question of how to present our real historical, existential and aesthetic experience in such a way as to transcend the cultural, ideological and political headlines linked to the collapse of the Eastern political systems and the wars in ex-Yugoslavia and the ex-Soviet Union. How to define historical, cultural and existential differences in the context of global, transnational capitalism? And finally, how to transcend sociological discourse and establish conditions for aesthetic discourse? Communicating and associating with various American art

and intellectual communities revealed a certain similarity between the psychological relation or attitude – even frustration – of various American minority groups (national, cultural, racial, sexual, religious, ideological) towards the activity of central social institutions, and the frustration of East European cultures in relation to their economically stronger West European and North American counterparts. In other words, the relation of the margin to the centre.

When mentioning this psychological relationship or attitude, or simply frustration, towards the constant of the world order as a point of potential identification within the context of difference, I have in mind primarily the semi-conscious, ambivalent and non-structured nature of the languages used in the structure of public dialogue in connection with this question. Who are we, whom and what do we represent? Who am I, whom and what do I represent? Being the *fil rouge* of private conversations among the participants in the trip, this question was gradually gaining in importance, giving the project a kind of ontological stamp precisely because of its ambivalence and insolubility, which grew with time. None of the so-called East European artists identified themselves with the East in the sense of representing its political or even cultural, messianic role. Our common attitude to this question could be defined as an attempt to take a different view, to formulate a different question: 'How does the East see itself from the outside, from the point of view of another continent, and what consumed its role and place in the structure of the global world order?' What remains of ourselves and our conceptual and aesthetic points of departure, once we are transposed into a foreign cultural and historical context? Who are we by ourselves? Can art really conceptualize and interpret itself through itself? From where do form and content derive? Does autonomy – freedom of art and the individual – exist? If it does, on what values it is based? These seemingly clear, even worn-out and abused questions, brought about numerous conflicts, deadlocked discussions, retreats into silence and reflection, depressions, exalted visions of solutions, utopian impulses, feelings of absurdity, emptiness and exposure to the mechanisms of life, which in the desert between Chicago and San Francisco looked wonderful, yet totally incomprehensible and indifferent to the symbolical and value games playing themselves out in our mental spaces. In the middle of the desert, where all points of the universe seem equally close to, and equally distant from, man as its centre, we were discovering that as East European artists we were not defined so much by the form and content of our mental spaces as by their symbolical exchange value. The previously mentioned frustration of Eastern cultures and societies vis à vis Western ones, which grew even bigger after the collapse of socialism, is manifest in the field of art primarily as the problem of the non-existence of a system of contemporary art in the territory of the East – that is, of a system of symbolic

and economic exchange which would take place in countries sharing the common historical experience of socialism, paving the way to integration into the global contemporary art system. But why would we regret the non-existence of something suppressing the individual and their artistic freedom, at least according to the romantic, utopian definition of art? Which even today is still formally advocated by a great number of ideologues and users of the existing (and virtually the only) West European and North American system of contemporary art? In fact, this is not a regret but a realization that – without a system of institutions which by definition represents the field of contemporary art – there is no broader intellectual and creative production; without a broader intellectual and creative production there are no differences; without differences there is no hierarchy of values; without a hierarchy of values there is no critical reflection; without critical reflection there is no theory; and without theory there is no universally-understood referential language, capable of communicating on an equal footing with other referential languages in other places and times of the existing world.

Despite bringing up problems that promise no imminent solutions, and despite a communication that lacked colloquial smoothness (and which was in fact at times full of clashes and thorns), the *Transnacionala* project achieved its conceptual objective precisely by objectivizing itself in the sphere of intimacy and closeness, which in the process in the journey took on the form of a micro volume of public space. A public space, furthermore, in which views that are still considered taboo in most public contexts of contemporary art could be expressed.

Among the participants in the journey, and among some other individuals met along the way, relationships were established forming a direct, living network. A network in which a sum of problems and realizations constituting the germ of a referential language were caught up and articulated, in order to be further developed.

1 *Transnacionala: A Journey from the East to the West* was an art project initiated by the Ljubljana-based visual art group IRWIN in the summer of 1996. The project took the form of a journey in real time from the East to the West Coast of the USA. The participants, an international group of artists comprising Alexander Brener, Vadim Fishkin, Yuri Leiderman, Goran Dordevic, Michael Benson, Eda Cufer and the five-member IRWIN group set out on a one-month journey across the United States in two recreational vehicles. The aim, quite simply, was for citizens of Eastern Europe to experience the mythology of the American highway Route 66, and to engage each other and the people they would meet along the way in informal and formal discussions about art, theory, politics and life itself. During organized stops in Atlanta, Richmond, Chicago, San Francisco and Seattle, a number of artistic events, presentations and discussions with local art communities took place. The Transnacionala journey – its talks, discussions and atmospheres –

is documented in the book *Transnacionala: Highway Collisions Between East and West at the Crossroads of Art*, edited by Eda Cufer (Ljubljlana: Koda, 1999).

Eda Cufer, edited version of text written in Ljubljlana, October 1996; first published in *IRWIN Transnacionala Barcelona* (Barcelona: Fundacio la Caixa, 1997). Translated from Slovenian by Jasna Hrastnik.

Carsten Höller
The Baudouin/Boudewijn Experiment.
A Deliberate, Non-Fatalistic Large Scale Group Experiment in Deviation//2000

Originally trained as a phytopathologist, Carsten Höller often creates experiments in which human participants are subject to behavioural situations. The Baudouin/Boudewijn Experiment: A Deliberate, Non-Fatalistic, Large-Scale Group Experiment in Deviation *was originally planned for the Brussels City of Culture 2000, but was banned after the Queen of Belgium (Baudouin's widow) objected to Höller's proposal. The project finally took place the following year, and proposes collective action as a form of radical inactivity. It has no visual documentation.*

The late king of Belgium, Baudouin or Boudewijn, found a remarkable solution to a personal dilemma. As a king, he was supposed to sign every new law established by the parliament. His contribution to the actual formulation of the law, however, was null, thus producing a purely formalistic act in signing the document. At a certain time, the parliament was working out a law which would liberalize abortion. Baudouin/Boudewijn, being a confessed catholic, had moral problems signing the paper; on the other hand, he did not want to obstruct the implementation of a new law. When the time came and his signature was requested, he resigned from being a king for one day. Another king was elected for this one day, who signed the new law. The following day, Baudouin/Boudewijn was king again.

The solution to this dilemma is ingeniously simple. It is a short-term deviation from your usual behaviour, a shift in character for the sake of avoiding producing something you don't want to produce, a refusal in time to be the professional you usually are. It is as if you would cut off a continuous line of being. Stop, and start again? Not a change in what you do, but to include an alien moment of not doing. A deviation, a negative deviation even, since the way is shortened by including a moment of motionlessness.

The experiment planned here will be as follows: a space is provided to accommodate 200 people, willing to step out of their 'usual life' for 24 hours (the amount of time during which the king was not king). The space will be closed from the outside world and mobile phones, radios or TVs will not be allowed. This is to emphasize the group aspect of the experiment and to create a structure in which the 'step-out' can be done commonly. The necessary infrastructure (furniture, food, sanitary installations, safety) will be provided, but it is refrained

from providing a programme or methods to entertain (people are free to bring what they like). Basically, the experiment will be to see what happens under these conditions; people are freed from their usual constraints, and yet confined to a space and a time.

The Baudouin/Boudewijn Experiment will not be recorded by means of film, video or otherwise (and thus is contrary to any Big-Brother-like set up); the only 'recordings' will be the memories of the participants, and they will be 'broadcast' by the stories they are willing to tell. The experiment will thus be a very unscientific one, as objectivity is not the aim. It will rather be a unique opportunity to experience with others the possibility of getting away from what you usually are.

Carsten Höller, 'The Baudouin/Boudewijn Experiment. A Deliberate, Non-Fatalistic, Large-Scale Group Experiment in Deviation' (2000), De Witte Raaf, No. 9 (Brussels, May–June, 2001).

Jeremy Deller
The Battle of Orgreave//2002

The British artist Jeremy Deller often collaborates with specific social constituencies to realize event-based projects. In 2001 he organized the reenactment of a key event from the English miners' strike of 1984, a violent clash between miners and police in the town of Orgreave. The event was undertaken with former participants in the strike and a number of historical reenactment societies. Documentation of Deller's work became the premise for Mike Figgis' political documentary The Battle of Orgreave *(Channel 4/Artangel, 2001).*

On 18 June 1984 I was watching the evening news and saw footage of a picket at the Orgreave coking plant in South Yorkshire in which thousands of men were chased up a field by mounted police. It seemed a civil war between the north and south of the country was taking place in all but name. The image of this pursuit up the hill stuck in my mind, and for years I have wanted to find out what exactly happened on that day with a view to reenacting or commemorating it in some way.

When I started to do proper research, the consequences of that day took on a much larger historic perspective. After over a year of archive reading, listening and interviewing many of those involved - the reenactment finally did take place on, or as close to as possible, the original site, with over 800 participants. Many of these participants were former miners (and a few former policemen) who were reliving events from 1984 that they themselves took part in. The rest were members of Battle reenactment societies from all over the country.

I wanted to involve members of these societies for mainly two reasons: first of all, they are well trained in recreating combat and in obeying orders. More importantly, I wanted the reenactment of The Battle of Orgreave to become part of the lineage of decisive battles in English history.

I was also interested in the term 'living history' that is frequently used in relation to reenactments, and I thought it would be interesting for reenactors to work alongside veterans of a battle from recent history, who are a personification of the term.

Also, as an artist I was interested in how far an idea could be taken, especially an idea that is on the face of it a contradiction in terms 'a recreation of something that was essentially chaos'.

Of course I would never have undertaken the project if people locally felt it was unnecessary or in poor taste. As it was, we encountered a lot of support

from the outset because there seemed to be an instinctive understanding of what the reenactment was about.

Jeremy Deller, 'The Battle of Orgreave', in James Lingwood, Michael Morris, eds, *Off Limits: 40 Artangel Projects*, (London: Merrell Publishers Limited, 2002) 90–95.

We can smell the scent of a steaming pot of jasmine rice...

Sunlight pours in from an October afternoon, and already we feel the compression of the gallery lifted from our shoulders...

As one sits down for the bowl (white enamel with blue rims) of food, one begins to realize that this is a distinctively different experience from others we have had in an art gallery or with art.

Rirkrit Tiravanija, *No Ghosts in the Wall*, 2004

Rirkrit Tiravanija
No Ghosts in the Wall//2004

Rirkrit Tiravanija has been at the centre of debates about relational art. In the following text, used as the script for an audioguide to accompany his retrospective at the Museum Boijmans Van Beuningen (2004), Tiravanija presents a discussion of his work in the third person. The narrative offers insights into his motivations for working with 'lots of people', and represents an innovative solution to the problem of presenting a retrospective of participatory art. The museum did not show any of his past works, just empty spaces that related to the original venues.

[*The Docent turns away from the window and leads the group into the partitioned room to the left of the space... it is the replicated approximation of a space which is the project room of the Paula Allen gallery... the Docent lines everyone up against the wall as if there was an installation in the middle of the room and proceeds to talk...*] Docent: The relative success of *pad thai* from nineteen ninety and the perplexed confusion following his first one man exhibition *untitled blind*, put Tiravanija on the radar of the New York art world, where one exhibition can make or break an artist overnight. We now move forward to the year nineteen ninety two and Tiravanija's second solo exhibition in New York, with the work *untitled in parenthesis free*. Once again the reintroduction of food as the key element in the approach of the work is central. In tandem with this element Tiravanija makes references to the core ideas of conceptual art that question the idealism behind the relevance of authorship and authenticity. There are two parts to the exhibition; we enter to find an exhibition space which is full to the brim with an eclectic mix of objects. The overall view is that of the overpacked storage space of a gallery. It is full of artworks in frames (many are photographs, since the gallery, 303, concentrated very strongly on photography), some paintings and parts and pieces of sculptures. When you enter from the elevator you can see a painted black cartwheel belonging to a Karen Kilimnik installation. Behind this is a curiously tall woodchip crate standing upright forming a column but not quite reaching the ceiling; there are drawers for drawings, cardboard boxes full of unknown contents and some boxes with tennis shoes and a toothbrush – all have been dragged out from all corners of the gallery and put on display, as if to make an exhibition of the entire contents of the gallery.

There is an aisle running around and through the room and we can make our way though the storage and behind the pile of art etc. Once we make our way to the back of the gallery we are surprised to discover the desk of the gallery owner,

and her assistants sitting there amongst this pile. They are working as if it was just another day. Here the intimacy of the gallery has been exposed: walls, cupboards, storage racks of art and even the toilet were stripped bare, without doors to hinder the view of all possible corners of the rooms in the gallery.

We can smell the scent of a steaming pot of jasmine rice, with its very distinct combination of water and the perfume of jasmine. It's enough to make one curious with hunger, and as we make our way though the space we come to the room at the end of the hallway, well lit, with windows at the corner of the building. Sunlight pours in from an October afternoon, and already we feel the compression of the gallery lifted from our shoulders. There are people sitting around round tables and on stools; they are talking, reading the guide for galleries, weighing their next move. The 303 Gallery is at the corner of Spring and Greene Streets in Soho, New York, formerly the main art district of the city.

There is a mess of doors leaning against the walls in this room; doors presumably of the gallery. They are unhinged and stacked. To the right as we enter is a makeshift table made from sawhorses, and yet another door from the space. A couple of people seem to busying themselves with the preparation of some vegetables – the chopping and cutting; opening gallon cans of bamboo shoots. In the middle of the room there are two pots cooking on camping rings. One seems to have been prepared already, the other is on its way. People are helping themselves to the rice from a cooker large enough to feed the whole Island of Manhattan. Right next to the low gas cookers is an old used refrigerator, white, with hints of age around the edges. As one sits down for the bowl (white enamel with blue rims) of food, one begins to realize that this is a distinctively different experience from others we have had in an art gallery or with art. There are also many milky white cylindrical buckets which seem to be sloshing with waste food, all that is left over. In the refrigerator there are Thai long beans, Thai roundish green eggplants, as well as the mini pea eggplants, looking rather green, with a strong bitterness to their taste. Bitter and stronger. And some packets of green curry.

This exhibition came at an economically depressed moment in New York that provided fertile grounds to establish it as the cornerstone of Tiravanija's practice. We don't use the word 'practice' lightly – it's as if the artist were a doctor administering the viewer with a dose of opiate to cure all maladies.

Tiravanija described his work at this time as comparable to reaching out, removing Marcel Duchamp's 'Urinal' from its pedestal, reinstalling it back on the wall, and then, in an act of return to its original use, pissing into it.

Interest in the identity of the artistic has now fully recovered to the point that the work simply is the artist or simply by the artist. Yet there is a prevalent sensibility to his endeavour, one of which a) resists artifice, b) resists the time

and space continuum which has been imposed on the ontological structure of art making, c) resists unnecessary staging of a reality which does not exist. [*The ghost has been shifting around now... we can hear him going on and on about works which do not necessarily correlate to what the Docent has been speaking about.*]

[*The Docent leads the group over to the windows of* untitled free, *and crosses the hall into the space of the Kölnischer Kunstverein.*] Docent: In nineteen ninety-six Tiravanija, having won the prize from the Köln-based Central Insurance Company (which is comprised of a six month stay in the city of Cologne, Germany), was commissioned by the company to produce a work for an exhibition at the Kölnischer Kunstverein. What we are looking at is a structural replica in full scale of Tiravanija's apartment in New York. Tiravanija had lived in this apartment for almost twenty years up to that point. It is a four-flight walkup in a tenement building. The original apartment is very old. The apartment number is twenty-one, actually a lucky number for Tiravanija, as he was also born on the twenty-first day. The actual title of the exhibition is *untitled in parenthesis tomorrow is another day*. The phrase 'tomorrow is another day' came from the director of the Kunstverein himself, Udo Kittelmann – an utterance often used as an expression of relief and resignation. But for Tiravanija it was about the inevitability of daily life. *tomorrow is another day* was for Tiravanija a work where all his essential ideas came together. Tiravanija has often said that his work was 'about use, and through this use meaning is constructed'. Here we see the apartment which was opened for three months and was open twenty-four hours a day, six days a week (it would have been seven days but German labour laws prohibited the work being open on Sundays). This was perhaps the first and only time an exhibition space was left open with full access. For the three months it was open people came and stayed in the apartment; they cooked, they ate, they bathed (everything functioned in the apartment replica as in a normal habitat), they slept, got married, had birthdays, many, many performances of music and otherwise; the space surrounding the apartment became a garden. Many, many people spent a lot of time in and around the apartment, and they shared their time and space together. They drew and wrote notes, comments, drawings, young and old. It was an open house and, against expectations, nothing terrible happened. Tiravanija left Köln soon after the apartment opened. He left everything he had brought (house-wares, TV, stereo, kitchenware... etc.) for his stay at the residency... nothing went missing and in fact people left more things behind, things of value and useful things. [*The Docent takes the group through to the next and last space... while walking the Docent continues with the dialogue...*] Docent: Similarly to *untitled in parenthesis tomorrow is another day*... now at this point you may have all noticed that

Tiravanija most often if not always leaves both his exhibitions and works untitled... however, also always within the parenthesis, from the very first work, we can see that Tiravanija wants to direct our attention to the subtext, or subtitle, of how we can direct our thoughts and ideas towards the experience we are having with his works ...

Yes, *untitled in parenthesis he promised* from two thousand and two. It is the last work we will focus on. As I was saying: similarly to *tomorrow..., he promised* is another full-scale architectural representation. In this case it is the house of an Austrian architect who lived in exile in Los Angeles by the name of Rudolph Schindler. Perhaps little known to the lay world, Schindler was a very inspirational figure for a lot of architects and artists due to his quiet but studied ideas concerning the philosophical conditions of living and architecture. Obviously Tiravanija found him so, and in this work, which was made for Vienna at the Secession exhibition space... he made a replica of part of the house which Schindler had designed and built for himself. (This is very similar to Philip Johnson's Glass House, which was also designed and built as the residence of the architect himself.)

This house was in Los Angeles on King's Road (hence it is known as the King's Road House). Tiravanija has replicated in full scale Schindler's own studio, which is one of five sections of the house. We are not looking at the complete representation of the house, as Tiravanija wanted us to focus on this particular space as an idea, as an ideal space. We can sense what life in the structure was like, and is, as we pass through this building. Schindler was highly influenced by Frank Lloyd Wright (having worked for him), as well as by the natural environment, vegetation and climate of Southern Califorma. The house was very open, with a great deal of Eastern, Oriental feel, blurring of the interior and exterior – merging also the functions of life inside and out. In this replication, however, all parts of the architecture are made from chromed and mirrored stainless steel. The entire structure is cloaked in the reflection of its environment. It shimmers as if to disappear, camouflaged by the white of the space... and unlike *tomorrow..., he promised...* was not open-ended – it was only open all day and night one day of the week. It was not meant to function twenty-four hours a day. However, time and space would be an important aspect of the work – usage was still primal. But rather than keeping it open-ended, it was programmed. There was a series of different events in which the house acted as a platform and as a lived space, hosting different discussions, exhibitions, films and musical events, Thai massage and of course a barbecue. The process, which we say at the beginning of all Tiravanija's work, was very clear and almost extreme in this situation. The house was fabricated in Guadalajara, Mexico, and since there was not enough time and too much distance, the parts of the house

were slowly shipped to Vienna. As the parts arrived, the house was put up. During the course of the exhibition, which lasted about two and a half months, the house was only completed two days before the exhibition closed. Pictures were taken of the slow process of, amongst other things, what went on in the space, as well as that of the construction process in Mexico. Visitors in Vienna could buy one ticket and return to the space at a later date to keep up with the construction of the house as well as participate in the daily events offered. Tiravanija never did participate in the process of the exhibition or see the completion of the house itself... but, like all this work, Tiravanija was much more interested in the people and how they came and went, how they may have had different views and memories of what they had passed through.

Thank you for joining us, for walking through with us and giving your attention to this 'retrospective'. You may have wondered all this time why we are not in the presence of the work itself and are instead just given a story about or descriptions of the work or event. Tiravanija and the curators believed that this is one of the possible ways this body of work could be represented. There is no object, no picture, no moment, no space and even perhaps no time, but in this void of representation we hope you have heard and have imagined a picture of your own, a memory of your own, and that in the end it was an experience of its own making... [*The Docent shows everyone out...*]

THE END

Rirkrit Tiravanija, 'No Ghosts in the Wall', *Rirkrit Tiravanija: A Retrospective* (Rotterdam: Museum Boijmans Van Beuningen, 2004) 51–92

Thomas Hirschhorn
24h Foucault//2004

Unlike many artists who work collaboratively in order to fuse art and social praxis, Thomas Hirschhorn has always asserted the importance of art's autonomy. Projects such as the Bataille Monument *(2002) and* Musée Précaire *(2004) involved collaborations with largely working-class and immigrant communities.* 24h Foucault *transferred this collaborative approach to philosophers, poets and musicians at the Palais de Tokyo.*

24h Foucault is the *avant-garde* of the *Foucault Art Work.* The *Foucault Art Work* is the project that I have developed following meetings with Daniel Defert and Philippe Artières on the invitation of Nicolas Bourriaud at the Palais de Tokyo in October 2003. *Foucault Art Work* is a project (like other projects I have) that remains to be realized in the years to come. It depends on me finding the time, energy, places, partners and money to show the *Foucault Art Work.* This is my objective and I don't want to lose sight of it. This is why the *24h Foucault* is basically the same *Foucault Art Work* project condensed and speeded up. I want the *24h Foucault* to affirm and prove that it's necessary to work as an artist with precision and with excess. I want this project to be precise and exaggerated! For me, the *Foucault Art Work* will not change, only speed up. The *24h Foucault* comprises 1. an auditorium 2. a library/documentation centre 3. a sound library 4. a video library 5. an exhibition 6. the *Merve Verlag* archives 7. a *Toolbox* bar 8. a souvenir shop 9. a newspaper 10. a Foucault studio. *24h Foucault* is an autonomous work made collectively. *24h Foucault* is a work of art!

24h Foucault, the pre-project

I want to try here to express my wish for the *Foucault Art Work.* This is the title of the work and at the same time it's the Michel Foucault exhibition programme. It's the programme because it's not about doing an exhibition on Michel Foucault. For me it's about showing, affirming, giving form to the fact that Michel Foucault was an artist. That his life and his work were a work of art. It's also about giving form to this affirmation that I share with Marcus Steinweg: philosophy is art! Pure philosophy, true, cruel, pitiless philosophy, philosophy that affirms, acts, creates. The philosophy of Spinoza, of Nietzsche, of Deleuze, of Foucault. I don't know Foucault's philosophy, but I see his work of art. It permits me to approach it, to not understand it but to seize it, to see it, to be active with it. I don't have to be a historian, a connoisseur, a specialist to confront myself

with works of art. I can seize their energy, their urgency, their necessity, their density. Michel Foucault's work of art is charged. It's a battery. I can seize this charged battery. I want to give form to this. In the *Foucault Art Work* project, there is more than a vision: there is a singular commitment. There is the commitment to make a work of art. There is the affirmation that the work of art *is* philosophy, and that philosophy *is* a work of art. We must free ourselves from exhibitions. I hate and never use the term *show* in English; I hate and I never use the term *piece.* I never use and I hate the term *installation.* But I want to make a work, a work of art! I want to become what I am. I want to become an artist! I want to appropriate what I am. This is my work as an artist.

Foucault Art Work is not documentation. Documentation, documentary films have been overtaken by fiction and by reality of all types. Because documentation wants to place itself in the middle. I don't want to place myself in the middle. I want to overtake the document, the documentary. I want to make an experience. An experience is something from which I emerge changed. An experience transforms me. I want the public to be transformed by the experience of *Foucault Art Work.* I want the public to appropriate Michel Foucault's work of art. I want the public to be active, participate. Evidently the most important participation is activity, the participation of reflexion, questioning, making your brain work. I want the public *of Foucault Art Work* to seize the energy, the strength, the necessity of Foucault's work. I want the public to confront what is important in the work of Foucault; I want the public to seize the range and the power of Foucault's philosophy. I don't want the public to understand. I want the public to seize the power. The power of art, the power of philosophy!

Concretely:

The *Foucault Art Work* takes place from 14 October to 5 December (7 weeks) at the Palais de Tokyo. I want to make a sort of *Bataille Monument,* but on the inside, in an institution. What have been the lessons from my experience of the *Bataille Monument!* That this experience produces something: meetings, confrontation, production, thought, more work, loss, discussions, friendship. To produce that, I have understood that it's necessary for the artist to be present all the time and not to be alone. This *event* must be very well prepared. You have to work uphill on this project with contributors, participants, co-producers. *Foucault Art Work is* going to be an event that must be produced elsewhere at least once (US, Japan or elsewhere). I want the Palais de Tokyo to be only the first *event.* There must be another. Another partner must be found. *Foucault Art Work* must be an event with between 700 and 1000 square metres of space. The proposed alcove of the Palais de Tokyo is too small. I need more space! It needs a minimum of 700 square metres. In the *Foucault Art Work* event, I want to work closely with my

philosopher friend Marcus Steinweg from Berlin. He will be with me on site all the time, during the *event*. He prepares, he proposes, and he accompanies this work. He is part of the work. He will affirm. He will appropriate. He will act with love, like me, but not with respect. With the love of philosophy, not with the respect of a hommage. *Foucault Art Work* will be made with love and without respect. Every day there will be the *intervention of a philosopher, a friend, a writer who will interpret the work of Foucault. There will be a Michel Foucault exhibition.* I want the public to understand: the exhibition is only one part of the *Foucault Art Work*. The exhibition with photos, personal books, original documents, press cutttings (international). Peter Gente of the *Merve-Verlag Berlin* made a beautiful exhibition at ZKM in Karlsruhe. *There will be a sound-, book- and media-*library with all the books (in all languages), all the videos and all audio material of Foucault. I want there to be photocopiers, video material, sound material, on site, simple and efficient, so that the public can take home photocopies or video and audio copies, books, extracts of books or other documents, as they wish. I want the *Foucault Art Work* not only to be a place of production, but also of dissemination. It is important to diffuse and *give diffusion to the work of Foucault* or to parts of Foucault's works. *There will be a Michel Foucault shop.* The shop isn't a place to sell things, the shop is in fact another exhibition. It's an exhibition of souvenirs made to look at, not to buy. As in the vitrines of a big football club, where trophies are exhibited, photos of former players, the players' vests, the club's different stadiums, the celebrity visits. These are important but not decisive souvenirs. Decisive is what is made today. Today and tomorrow. *There will be a Foucault-Map.* A work that I will do with Marcus Steinweg. Like I did the *Nietzsche-Map* and the *Hannah Arendt-Map.* It's a very big plan of the philosophical position of Foucault in the galaxy of philosophy. There will also be documents and elements that put the *Foucault Archives* at your disposal. This can be integrated in the *Foucault Art Work* project. However the archives must be exposed in another (second) manifestation. Finally I want there to be a simple and condensed auditorium for lectures, concerts, speeches. *I want the public to be inside a brain in action.* There will be no narration, no discussion, no illustration. There will be affirmation. There will be ideas. There will be confrontation. When I say: there is no discussion, I mean: it's not to debate and discuss philosophy and art. It's necessary to confront yourself. It's necessary to forge a resistance. I want all the forms, all the contributions to be chosen politically, philosophically, artistically. Because it's the same thing. No element is chosen for any reason other than political. I want the *Foucault Art Work* project to be a proposition that overtakes me, that makes my capacity for responsibility explode. It's necessary to try and be responsible for something which I can take responsibility for. There must also be a *Foucault-Studio.* A place of work with

computers and space for working. Making sculpture, doing research, having experiences that you don't usually have. Learning another language, for example. I repeat: the *Foucault-Studio*, the *Foucault-Shop*, the *Auditorium*, the *book-, sound- and media-library*, the *Foucault Exhibition*, the *contributors* (every other day), the *Foucault-Map*, the *Foucault Archives*. These eight elements will be put alongside each other as in the human brain; they disrupt each other, they complete each other, they compete against each other. But they never contradict each other – they demonstrate the complexity and the infinity of thought. There will be chairs, lots of chairs, armchairs, lots of armchairs for sitting down and reflecting, reading and exchanging. There will be lots of light. *Foucault Art Work* will be very lit. In the *Foucault Art Work* there will be lots of computers, photocopiers, audio-recorders, video and DVD recorders, TV screens, but all these objects will be integrated, mastered; tools, arms, but never aesthetic effects with which to intimidate the public, or to show them new technology. The technologies serve art, they serve philosophy. They will be tools, but not necessities. To kill them, it's not necessary to have a gun. To construct a house, it's not necessary to have a hammer. You must always work firstly with your brain.

Foucault Art Work will not be a Thomas Hirschhorn exhibition. I will have contributed to this project with others, I hope lots of others. Marcus Steinweg, Manuel Joseph, Christophe Fiat, Peter Gente, not to mention those to whom I've already spoken of the project. This project will be made together, multiply, with multiple singularities, active, turned towards affirmation, the other. Turned to the other with friendship, but without compromise. Neither visual, nor of meaning, nor of space, nor of content.

Foucault Art Work is an ambitious project. It is itself an affirmation as much as a work of art.

Thomas Hirschhorn, artist's proposal, *24h Foucault Journal* (Paris: Palais de Tokyo, 2–3 October 2004). Translated by Claire Bishop, 2006.

COLLABORATION
IS THE ANSWER
BUT WHAT IS
THE QUESTION

Hans Ulrich Obrist, cited in Hal Foster, *Chat Rooms*, 2004

Nicolas Bourriaud
Relational Aesthetics//1998

Relational Aesthetics *has come to be seen as a defining text for a generation of artists who came to prominence in Europe in the early to mid 1990s. The following text is a selection of excerpts from Bourriaud's collection of seven discrete essays originally published in magazines and exhibition catalogues.*

The work of art as social interstice

The possibility of a *relational* art (an art that takes as its theoretical horizon the sphere of human interactions and its social context, rather than the assertion of an autonomous and *private* symbolic space) is testimony to the radical upheaval in aesthetic, cultural and political objectives brought about by modern art. To outline its sociology: this development stems essentially from the birth of a global urban culture and the extension of the urban model to almost all cultural phenomena. The spread of urbanization, which began to take off at the end of the Second World War, allowed an extraordinary increase in social exchanges, as well as greater individual mobility (thanks to the development of rail and road networks, telecommunications and the gradual opening up of isolated places, which went hand in hand with the opening up of minds). Because this urban world's inhabitable places are so cramped, we have also witnessed a scaling down of furniture and objects, which have become much easier to handle: for a long time, artworks looked like lordly luxury items in this urban context (the dimensions of both artworks and the apartments where they were displayed were intended to signal the *distinction* between their owners and the *hoi polloi*), but the way their function and their mode of presentation has evolved reveals a growing *urbanization* of the artistic experience. What is collapsing before our very eyes is quite simply the pseudo-aristocratic conception of how artworks should be displayed, which was bound up with the feeling of having acquired a territory. We can, in other words, no longer regard contemporary works as a space we have to walk through (we were shown around collections in the same way that we were shown around great houses). Contemporary art resembles a period of time that has to be experienced, or the opening of a dialogue that never ends. The city permits and generalizes the experience of proximity: this is the tangible symbol and historical framework of the state of society, or the 'state of encounter', that has been 'imposed' on people, as Althusser puts it,[1] as opposed to the dense and unproblematic jungle of Jean-Jacques Rousseau's state *of nature*. Rousseau's jungle was such that there could be no lasting encounters.

Once it had been elevated to the status of an absolute civilizational rule this intense encounter finally gave rise to artistic practices that were in keeping with it. It gave rise, that is, to a form of art with intersubjectivity as its substratum. Its central themes are being-together [*l'être-ensemble*], the 'encounter' between viewer and painting, and the collective elaboration of meaning. We can leave aside the problem of the phenomenon's historicity: art has always been relation to some extent. It has, in other words, always been a factor in sociability and has always been the basis for a dialogue. One of the image's potentials is its capacity for 'linkage' [*reliance*], to use Michel Maffesoli's term: flags, logos, icons and signs all produce empathy and sharing, and generate *links*.[2] Art (practices derived from painting and sculpture and displayed in the form of an exhibition) proves to be an especially appropriate expression of this civilization of proximity. It compresses relational space, whereas television and books send us all back to spaces where we consume in private; and whereas the theatre or the cinema bring small groups together to look at univocal images, there is in fact no live commentary on what a theatre or cinema audience is seeing (the time for discussion comes after the show). At an exhibition, in contrast, there is always the possibility of an immediate – in both senses of the term – discussion, even when the forms on show are inert: I see, comment and move around in one space-time. Art is a site that produces a specific sociability; what status this space has within the range of 'states of encounter' proposed by the *Polis* remains to be seen. How can an art that is centred on the production of such modes of conviviality succeed in relaunching the modern project of emancipation as we contemplate it? How does it allow us to define new cultural and political goals?

Before turning to concrete examples, it is important to take a new look at where artworks are situated within the overall system of the economy – symbolic or material – that governs contemporary society: quite apart from its commodified nature or semantic value, the artwork represents, in my view, a social *interstice*. The term *interstice* was used by Karl Marx to describe trading communities that escaped the framework of the capitalist economy: barter, selling at a loss, autarkic forms of production, and so on. An interstice is a space in social relations which, although it fits more or less harmoniously and openly into the overall system, suggests possibilities for exchanges other than those that prevail within the system. Exhibitions of contemporary art occupy precisely the same position within the field of the trade in representations. They create free spaces and periods of time whose rhythms are not the same as those that organize everyday life, and they encourage an inter-human intercourse which is different to the 'zones of communication' that are forced upon us. The contemporary social context restricts opportunities for interhuman relations in that it creates spaces designed for that purpose. Superloos were invented to

keep the streets clean. The same line of thinking governed the development communicational tools while the streets of our cities were being swept clean of all relational dross. The result is that neighbourhood relations have been impoverished. The general mechanization of social functions is gradually reducing our relational space. Until only a few years ago, the early morning call service still used human voices; the responsibility for waking us up now falls to synthesized voices... The ATM has become the transit model for the most basic social functions, and professional behaviours are modelled on the efficiency of the machines that are replacing them. The same machines now perform tasks that once represented so many opportunities for exchanges, pleasure or conflict. Contemporary art is really pursuing a political project when it attempts to move into the relational sphere by problematizing it.

When Gabriel Orozco puts an orange on the stalls of a deserted market in Brazil (*Crazy Tourist*, 1991) or sets up a hammock in the garden of New York's Museum of Modern Art (*Hamoc en el MoMa*, 1993), he is operating in the heart of the 'social infra-thin' [*inframince*], or that tiny space for everyday gestures that is determined by the superstructure constructed and determined by large-scale exchanges. Orozco's photographs are an uncaptioned documentary record of tiny revolutions in ordinary urban or semi-urban life (a sleeping bag on the grass, an empty shoebox): they bear witness to the silent life (a still life or *nature morte*) that is now painted by our relations with others. When Jens Haaning uses a loudspeaker to broadcast jokes told in Turkish on a square in Copenhagen (*Turkish Jokes*, 1994), he instantly produces a micro-community of immigrants who have been brought together by the collective laughter that inverts their situation as exiles. That community is formed in relation to and inside the work. An exhibition is a privileged place where instant communities like this can be established: depending on the degree of audience participation demanded by the artist, the nature of the works on show and the models of sociability that are represented or suggested, an exhibition can generate a particular 'domain of exchanges'. And we must judge that 'domain of exchanges' on the basis of aesthetic criteria, or in other words by analysing the coherence of its form, and then the symbolic value of the 'world' it offers us or the image of human relations that it reflects. Within this social interstice, the artist owes it to himself to take responsibility for the symbolic models he is showing: all representation refers to values that can be transposed into society (though contemporary art does not so much represent as *model*) and inserts itself into the social fabric rather than taking inspiration from it). Being a human activity that is based upon commerce, art is both the object and the subject of an ethics: all the more so in that, unlike other human activities, *its only function is to be exposed to that commerce.* Art is a state of encounter... [...]

Conviviality and encounters

A work can function as a relational device in which there is a degree of randomness. It can be a machine for provoking and managing individual or collective encounters. To cite a few examples from the last two decades, this is true of Braco Dimitrijevic's *Casual Passer-by* series, which disproportionally celebrates the names and faces of anonymous passers-by on posters the size of those used for advertisements, or on busts like those of celebrities. In the early 1970s, Stephen Willats painstakingly charted the relationships that existed between the inhabitants of a block of flats. And much of Sophie Calle's work consists of accounts of her encounters with strangers: she follows a passer-by, searches hotel rooms after getting a job as a chamber maid, asks blind people how they define beauty, and then, after the event, formalizes the biographical experiments that led her to 'collaborate' with the people she met. We could also cite, almost at random, On Kawara's *I met* series, the restaurant opened by Gordon Matta-Clark in 1971 (*Food*), the dinners organized by Daniel Spoerri or the playful shop opened by George Brecht and Robert Filliou in Villefranche (*La Cédille qui sourit*). The formalization of convivial relations has been a historical constant since the 1960s. The generation of the 1980s picked up the same problematic, but the definition of art, which was central to the 1960s and 1970s, was no longer an issue. The problem was no longer the expansion of the limits of art,[3] but testing art's capacity for resistance within the social field as a whole. A single family of practices therefore gives rise to two radically different problematics: in the 1960s, the emphasis was on relationships internal to the world of art within a modernist culture that privileged 'the new' and called for linguistic subversion; it is now placed on external relationships in the context of an eclectic culture where the work of art resists the mincer of the 'Society of the Spectacle'. Social utopias and revolutionary hopes have given way to day-to-day micro-utopias and mimetic strategies: any 'direct' critique of society is pointless if it is based upon the illusion of a marginality that is now impossible, if not regressive. Almost thirty years ago, Félix Guattari was already recommending the neighbourhood strategies on which contemporary artistic practices are based: 'Just as I think it is illusory to count on the gradual transformation of society so I believe that microscopic attempts – communities, neighbourhood committees, organizing crèches in universities – play an absolutely fundamental role.'[4]

Traditional critical philosophy (and especially the Frankfurt school) can no longer sustain art unless it takes the form of an archaic folklore, or of a splendid rattle that achieves nothing. The subversive and critical function of contemporary art is now fulfilled through the invention of individual or collective vanishing lines, and through the provisional and nomadic constructions artists use to model and distribute disturbing situations. Hence

the current enthusiasm for revisited spaces of conviviality and crucibles where heterogeneous modes of sociability can be worked out. For her exhibition at the Centre pour la Création Contemporaine, Tours (1993), Angela Bulloch installed a café: when sufficient visitors sat down on the chairs, they activated a recording of a piece by Kraftwerk. For her *Restaurant* show (Paris, October 1993), Georgina Starr described her anxiety about 'dining alone' and produced a text to be handed to diners who came alone to the restaurant. For his part, Ben Kinmont approached randomly-selected people, offered to do their washing up for them and maintained an information network about his work. On a number of occasions Lincoln Tobier set up radio stations in art galleries and invited the public to take part in broadcast discussions.

Philippe Parreno has drawn particular inspiration from the form of the party, and his exhibition project for the Consortium, Dijon, consisted in 'taking up two hours of time rather than ten square metres of space' by organizing a party. All its component elements eventually produced relational forms as clusters of individuals gathered around the installed artistic objects... Rirkrit Tiravanija, for his part, explores the socio-professional aspect of conviviality: his contribution to *Surfaces de réparation* (Dijon, 1994) was a relaxation area for the exhibiting artists, complete with a table-football game and a well-stocked fridge. To end this evocation of how such conviviality can develop in the context of a culture of 'friendship', mention should be made of the bar created by Heimo Zobernig for the *Unité* exhibition, and Franz West's *Passtücke* ['adaptives'].[5] Other artists suddenly burst into the relational fabric in more aggressive ways. The work of Douglas Gordon, for example, explores the 'wild' dimension of this interaction by intervening in social space in parasitic or paradoxical ways: he phoned customers in a café and sent multiple 'instructions' to selected individuals. The best example of how untimely communications can disrupt communications networks is probably a piece by Angus Fairhurst: with the kind of equipment used by pirate radio stations, he established a phone link between two art galleries. Each interlocutor believed that the other had called, and the discussions degenerated into an indescribable confusion. By creating or exploring relational schemata, these works established relational micro-territories that could be driven into the density of the contemporary *socius*; the experiences are either mediated by object-surfaces (Liam Gillick's 'boards', the posters created in the street by Pierre Huyghe, Eric Duyckaerts' video lectures) or experienced immediately (Andrea Fraser's exhibition tours) [...]

The Subject of the Artwork
Every artist whose work derives from relational aesthetics has his or her own world of forms, his or her problematic and his or her trajectory: there are no

stylistic, thematic or iconographic links between them. What they do have in common is much more determinant, namely the fact that they operate with the same practical and theoretical horizon: the sphere of interhuman relationships. Their works bring into play modes of social exchange, interaction with the viewer inside the aesthetic experience he or she is offered, and processes of communication in their concrete dimensions as tools that can to be used to bring together individuals and human groups.

They therefore all work within what we might call the relational sphere, which is to today's art what mass production was to Pop and Minimalism.

They all ground their artistic practice in a proximity which, whilst it does not belittle visuality, does relativize its place within exhibition protocols. The artworks of the 1990s transform the viewer into a neighbour or a direct interlocutor. It is precisely this generation's attitude towards communication that allows it to be defined in relation to previous generations: whilst most artists who emerged in the 1980s (from Richard Prince to Jeff Koons via Jenny Holzer) emphasized the visual aspect of the media, their successors place the emphasis on contact and tactility. They emphasise *immediacy* in their visual writing. This phenomenon can be explained in sociological terms if we recall that the decade that has just ended was marked by the economic crisis and did little to encourage spectacular or visionary experiments. There are also purely aesthetic reasons why this should have been the case; in the 1980s, the 'back to' pendulum stopped with the movements of the 1960s and especially Pop art, whose visual effectiveness underpinned most of the forms proposed by *simulationism.* For better or worse, our period identifies with the Arte Povera and experimental art of the 1970s, and even with the atmosphere of crisis that went with it. Superficial as it may be, this fashion effect had made it possible to re-examine the work of artists such as Gordon Matta-Clark or Robert Smithson, whilst the success of Mike Kelley has recently encouraged a new reading of the Californian 'junk art' of Paul Thek and Tetsumia Kudo. Fashion can thus create aesthetic microclimates which affect the very way we read recent history: to put it a different way, the mesh of the sieve's net can be woven in different ways. It then 'lets through' different types of work, and that influences the present in return.

Having said that, when we look at relational artists, we find ourselves in the presence of a group of artists who, for the first time since the emergence of conceptual art in the mid-1960s, simply do not take as their starting point some aesthetic movement from the past. Relational art is neither a 'revival' of some movement nor the return of a style. It is born of the observation of the present and of a reflection on the destiny of artistic activity. Its basic hypothesis – the sphere of human relations as site for the artwork – is without precedent in the history of art, even though it can of course be seen, after the event, to be the

obvious backdrop to all aesthetic practice, and the modernist theme *par excellence*. Anyone who needs to be convinced that interactivity is scarcely a new notion has only to reread Marcel Duchamp's 1957 lecture on 'the creative act'. The novelty lies elsewhere. It resides in the fact that, for this generation of artists, intersubjectivity and interaction are neither fashionable theoretical gadgets nor adjuncts to (alibis for) a traditional artistic practice. They are at once a starting point and a point of arrival, or in short the main themes that inform their work. The space in which their works are deployed is devoted entirely to interaction. It is a space for the openness (Georges Bataille would have called it a 'rent') that inaugurates all dialogue. These artists produce relational space-times, interhuman experiences that try to shake off the constraints of the ideology of mass communications; they are in a sense spaces where we can elaborate alternative forms of sociability, critical models and moments of constructed conviviality. It is, however, obvious that the day of the New Man of the future-oriented manifestos and the calls for a better world 'with vacant possession' is well and truly gone: utopia is now experienced as a day to day subjectivity, in the real time of concrete and deliberately fragmentary experiments. The artwork now looks like a *social interstice* in which these experiences and these new 'life possibilities' prove to be possible. Inventing new relations with our neighbours seems to be a matter of much greater urgency than 'making tomorrows sing'.[6] That is all, but it is still a lot. And it at least offers a welcome alternative to the depressive, authoritarian and reactionary thought that, at least in France, passes for art theory in the shape of 'common sense' rediscovered. And yet modernity is not dead, if we define as 'modern' meaning a taste for aesthetic experience and adventurous thinking, as opposed to the timid conformisms that are defended by philosophers who are paid by the line, neo-traditionalists (the ludicrous Dave Hickey's 'Beauty') and militant *passéistes* like Jean Clair. Whether fundamentalist believers in yesterday's *good taste* like it or not, contemporary art has taken up and does represent the heritage of the avant-gardes of the twentieth century, whilst at the same time rejecting their dogmatism and their teleology. I have to admit that a lot of thought when into that last sentence: it was simply time to write it. Because modernism was steeped in an 'oppositional imaginary', to borrow a phrase from Gilbert Durand, it worked with breaks and clashes, and cheerfully dishonoured the past in the name of the future. It was based on conflict, whereas the imaginary of our period is concerned with negotiations, links and coexistence. We no longer try to make progress thanks to conflict and clashes, but by discovering new assemblages, possible relations between distinct units, and by building alliances between different partners. Like social contracts, aesthetic contracts are seen for what they are: no one expects the Golden Age to be ushered in on this earth, and we

are quite happy to create *modus vivendi* that make possible fairer social relations, more dense ways of life, and multiple, fruitful combinations of existence. By the same criterion, art no longer tries to represent utopias; it is trying to construct concrete spaces [...]

The Criterion of Coexistence (Works and Individuals)

Gonzalez-Torres' art gives a central role to negotiation and to the construction of a shared habitat. It also contains an ethics of the gaze. To that extent, it belongs within a specific history: that of artworks that make the viewer conscious of the context in which he or she finds himself/herself (the happenings and 'environments' of the 1960s, site-specific installations).

At one Gonzalez-Torres exhibition, I saw visitors grabbing handfuls of sweets and cramming as many of them as they could into their pockets: they were being confronted with their own social behaviour, fetishism and acquisitive worldview... Others, in contrast, did not dare to take the sweets, or waited until those next to them took one before doing likewise. The 'candy spill' works thus raise an ethical problem in a seemingly anodyne form: our relationship with authority, the use museum attendants make of their power, our sense of proportion and the nature of our relationship with the artwork.

To the extent that the latter represents an opportunity for a sensory experience based upon exchange, it must be subject to criteria analogous with those on which we base our evaluation of any constructed social reality. The basis of today's experience of art is the *co-presence of spectators before the artwork*, be it actual or symbolic. The first question we should ask when we find ourselves in the presence of an artwork is:

Does it allow me to exist as I look at it or does it, on the contrary, deny my existence as a subject and does its structure refuse to consider the Other? Does the space-time suggested or described by this artwork, together with the laws that govern it, correspond to my real-life aspirations? Does it form a critique of what needs critique? If there was a corresponding space-time in reality, could I live in it?

These questions do not relate to an excessively anthropomorphic vision of art. They relate to a vision that is quite simply *human*; to the best of my knowledge, artists intend their work to be seen by their contemporaries, unless they regard themselves as living on borrowed time or believe in a fascist-fundamentalist version of history (time closing over its meaning and origins). On the contrary, those artworks that seem to me to be worthy of sustained interest are the ones that function as interstices, as space-times governed by an economy that goes beyond the prevailing rules for the management of the public. The first thing that strikes me about this generation of artists is that they are inspired by

a concern for *democracy*. For art does not transcend our day to day preoccupations; it brings us face to face with reality through the singularity of a relationship with the world, through a fiction. No one will convince me that an authoritarian art can refer its viewers to any real – be it a fantasy or an accepted reality – other than that of an intolerant society. In sharp contrast artists like Gonzalez-Torres, and now Angela Bulloch, Carsten Höller, Gabriel Orozco or Pierre Huyghe, bring us face to face with exhibition situations inspired by a concern to 'give everyone a chance' thanks to forms that do not give the producer any *a priori* superiority (let's call it divine-right authority) over the viewer, but which negotiate open relations that are not pre-established. The status of the viewer alternates between that of a passive consumer, and that of a witness, an associate, a client, a guest, a co-producer and a protagonist. So we need to pay attention: we know that attitudes become forms, and we now have to realize that forms induce models of sociability.

And the exhibition-form itself is not immune to these warnings: the spread of 'curiosity cabinets' that we have been seeing for some time now, to say nothing of the elitist attitudes of certain actors in the art world, which reveals their holy terror of public spaces and collective aesthetic experimentation, and their love of boudoirs that are reserved for specialists. Making things available does not necessarily make them banal. As with one of Gonzalez-Torres' piles of sweets, there can be an ideal balance between form and its programmed disappearance, between visual beauty and modest gestures, between a childlike wonder at the image and the complexity of the different levels at which it can be read. [...]

Relational Aesthetics and Constructed Situations

The Situationist concept of a 'constructed situation' was intended to replace artistic representation with the experimental realization of artistic energy in everyday environments. Whilst Guy Debord's diagnosis of the spectacular process of production seems pitiless, Situationist theory overlooks the fact that, whilst the spectacle's primary targets are forms of human relations (the spectacle is 'a social relationship between people, mediated by images'), the only way we can analyse and resist it is by producing new modes of human relations.

Now the notion of a situation does not necessarily imply coexistence with my fellows. It is possible to image situations that are 'constructed' for private use, or even situations that deliberately exclude others. The notion of a situation reintroduces the unities of time, place and action in a theatre that does not necessarily involve a relationship with the Other. Now, artistic practice always involved a relationship with the other; at the same time, it constitutes a relationship with the world. A *constructed situation* does not necessarily

correspond to a *relational world* founded on the basis of a figure of exchange. Is it just a coincidence that Debord divides the temporality of the spectacle into the 'exchangeable time' of labour, ('*the endless accumulation of equivalent intervals*') and the 'consumable time' of holidays, which imitates the cycles of nature but is at the same time no more than a spectacle '*to a more intense degree*'. The notion of exchangeable time proves here to be purely negative: the negative element is not the exchange as such – exchange is a factor in life and sociability – but the *capitalist forms of exchange* that Debord identifies, perhaps wrongly, with interhuman exchange. Those forms of exchange are born of the 'encounter' that takes place in the form of a contract between an accumulation of capital (the employer) and available labour-power (the factory or office workers). They do not represent exchange in the absolute sense, but a historical form of production (capitalism): labour time is therefore not so much 'exchangeable time' in the strong sense of the terms, as time that can be *bought* in the form of a wage. An artwork that forms a 'relational world' or a social interstice can update Situationism and reconcile it, in so far as that is possible, with the world of art. [...]

The Behavioural Economy of Contemporary Art

'How can you bring a classroom to life as though it were an artwork?' asks Guattari.[7] By asking this question, he raises the ultimate aesthetic problem. How is aesthetics to be used, and can it possibly be injected into tissues that have been rigidified by the capitalist economy? Everything suggests that modernity was, from the late nineteenth century onwards, constructed on the basis of the idea of 'life as a work of art'. As Oscar Wilde put it, modernity is the moment when 'art does not imitate life; life imitates art'. Marx was thinking along similar lines when he criticised the classical distinction between *praxis* (the act of self-transformation) and *poiêsis* (a 'necessary' but servile action designed to produce or transform matter). Marx took the view that, on the contrary, praxis constantly becomes part of *poiêsis*, and vice versa. Georges Bataille later built his work on the critique of 'the renunciation of life in exchange for a function' on which the capitalist economy is based. The three registers of 'science', 'fiction' and 'action' destroy human life by *calibrating* it on the basis of pre-given categories.[8] Guattari's ecosophy also postulates that the totalization of life is a necessary preliminary to the production of subjectivity. For Guattari, subjectivity has the central role that Marx ascribes to labour, and that Bataille gives to *inner experience* in the individual and collective attempt to reconstruct the lost totality. 'The only acceptable goal of human activities,' writes Guattari, 'is the production of a subjectivity that constantly self-enriches its relationship with the world'.[9] His definition is ideally applicable to the practices of the

contemporary artists who create and stage life-structures that include working methods and ways of life, rather than the concrete objects that once defined the field of art. They use time as a raw material. Form takes priority over things, and flows over categories: the production of gestures is more important than the production of material things. Today's viewers are invited to cross the threshold of 'catalysing temporal modules', rather than to contemplate immanent objects that do not open on to the world to which they refer. The artists go so far as to present themselves as worlds of ongoing subjectivation, or as the *models* of their own subjectivity. They become the terrain for privileged experiences and for the synthetic principle behind their work. This development prefigures the entire history of modernity. In this behavioural economy, the art object acquires a *deceptive aura*, an agent that resists its commodified distribution or becomes its mimetic parasite.

In a mental world where the ready-made is a privileged model to the extent that that it is a collective production (the mass-produced object) that has been assumed and recycled in an autopoetic visual device, Guattari's theoretical schema help us to conceptualize the mutation that is under way in contemporary art. That was not however their author's primary goal, as he believed that aesthetics must, above all, accompany societal mutations and inflect them. The poetic function, which consists in reconstructing worlds of subjectivation, might therefore be meaningless, unless it too can help us to overcome 'the ordeals by barbarism, by mental implosion and chaosmic spasm that loom on the horizon and to transform them into unforeseeable riches and *jouissances*.'[10]

1 Louis Althusser, 'The Underground Current of the Materialism of the Encounter', in *Philosophy of the Encounter. Later Writings 1978-1987*, trans. G.M. Goshgarian (London: Verso, 2006) 185.

2 Michel Maffesoli, *La Contemplation du monde* (Paris: Grasset, 1993).

3 See, *inter alia*, Rosalind Krauss, 'Sculpture in the Expanded Field', *October*, Spring 1979; Lucy Lippard, *Six Years: The Dematerialization of the Artwork from 1966 to 1972: A Cross-Reference Book of Information on Core Aesthetic Boundaries* (Berkeley and Los Angeles: University of California Press, 1997).

4 Félix Guattari, *La Révolution moléculaire* (Paris: 10/18, 1977) 22.

5 Franz West's *Passtücke*, or 'adaptives', are uncategorizable works made of papier mâché, plaster, gauze and paint, intended for participants to interact with. West compares them to 'prostheses'. [Ed.]

6 The phrase 'making tomorrows sing' alludes to the expression 'vers des lendemains qui chante': the last words written by the Communist Gabriel Peri before he was shot by the Gestapo – and the title of his posthumously published autobiography. [Translator]

7 Félix Guattari, *Chaosmose*, Paris: Editions Galilée, 1992, 183.

8 Georges Bataille, 'L'Apprenti sorcier' in Denis Hollier, ed., *Le Collège de sociologie*, Paris: Gallimard 'Idées', 1979, 36–60.

9 Guattari, *op. cit.*, 38.

10 *Ibid.*, 187.

Nicolas Bourriaud, *Esthétique relationelle* (Dijon: Les presses du réel, 1998), 14–18, 30–33, 45–8, 58–60, 88–9, 106–8. Translated by David Macey, 2006.

Lars Bang Larsen
Social Aesthetics//1999

The Danish curator Lars Bang Larsen has been at the forefront of supporting socially-engaged practices in the Nordic region. In this essay he presents a number of contemporary Scandinavian examples, and seeks to recover a historical context for this work.

What I choose to call 'social aesthetics' is an artistic attitude focusing on the world of acts. It also experiments with the transgressions of various economies. The term is coined as a common denominator, as one that simply lends itself with the least resistance to the internal and external dynamics of some recent and historic artistic and art-related examples. One could probably say that the examples below describe a recent tradition of art as activism; yet they are perhaps closer to a discussion of the uses of art-institutional space than is commonly seen in art activism. The term 'ephemeral' art is also often used in this discussion as the description of a sensibility and a practice aligned to the heritage of Fluxus and Situationism but not fitting under the artistic demarcations of these schools. Common to the understanding of the eleven examples below is that the dynamic between artistic activity and the realms that are traditionally relegated to the fabric of the social fails properly to describe a dialectic. Social and aesthetic understanding are integrated into each other. Here, some forms of social aesthetic activity have deliberately been launched within the art circuit as art projects; others qualify as art, or qualify for artistic discussion, after their actualization in other contexts.

The untenable dichotomy of art versus reality is exploded by these projects – a dichotomy that anyway usually hides the positioning of art in a privileged and aloof status in relation to other forms of cultural activity, however weak art may be when located in 'living reality'. The distinction between art and other realms of knowledge is made operative in the osmotic exchange between different capacities to do things, which opens up the creation of new subject positions and articulations of democratic equivalence. The same thing goes for the dichotomy of institutional/non-institutional space. The present examples all share the fact that art and the art institution as resource become frames for activity that is real, because social interaction and the observation of its effects are allowed without conceptual rigidity.

The social aesthetic artwork involves a utilitarian or practical aspect that gives a sense of purpose and direct involvement. In the construction of the

subject's interaction with culture it could be said that social aesthetics discusses a notion of the lasting phenomenon that substantiates a critical cultural analysis, a reason for one's existence. It is a way of involving the metaphorical value of artistic concepts and projects on other professional spheres, such as architecture, design, financial structures, etc., either as an understanding integrated in an artistic project, or as a process of decoding and actualizing art-related activity within its cultural location. In this way artistic work assumes a general focus on performance in a social perspective, either by means of its own nature as an ongoing project without closure or by the real activity it occasions. This often involves collective organization and an employment of art's capacities for going against professional specialization.

Nonetheless it would be wrong to say that the opposite of social aesthetics is a painting or a sculpture, or any other traditional form of artistic expression. Social aesthetics can't be observed alone and in this sense the term is double bound. It says that the social probably can't operate in a meaningful way without the aesthetic and vice versa, hence both the social and the sphere of art and aesthetics inform it.

The following examples are all related to the Scandinavian art scene, which may be due to a certain orientation, especially among Copenhagen artists. But if one employs the results of the small but distinct number of contemporary artists working with a productive revisitation of 1960s strategies in the visual arts, it would surely enable an outlook untrammelled by geographic boundaries. There remain many stories left unexplored in the local and global histories of art's ramifications on the social.

The examples are presented in dialogue across history. These dialogues represent associated motifs and related engagements and ideas. As motifs they qualify each other by dint of uncovering mutually specific, historical references. A sort of historical double-exposure or cross-fertilization, if you like.

Playground action on Nørrebro, Model for a Qualitative Society **and** *N55/Spaceframe*

During one Sunday in the spring of 1968, the artist Palle Nielsen built a playground in the slum of Copenhagen's Northern Borough. Together with a group of left-wing students he planned to clear the court of a neglected housing scheme and erect new facilities for children. At seven o'clock in the morning the group went around to all the residents with a bag containing two rolls and a paper attached to it with an image of two children playing on the kerb. The text read:

> Do you have children yourself or do you just hear the children scream and shout in the stairwell and entrance when you come home? Do you remember your own

possibilities for playing as few? Why do the children still make noise in the entrances? So few things have changed since you were a child. You may now follow up the demands for more kindergartens and day nurseries, for better playgrounds and youth centres, and for greater investment in children's well-being by actively participating in a public debate. Have you asked your council or your local residents' association about investments in child-orientation? Do you know that the authorities are empowered to give grants and are willing to invest in children's well-being if you demand it? It is your attitude towards the needs of adolescent children that decides the size of investment that funds increased clearing of backyards, better play facilities in future developments and new designs of municipal playgrounds. Sensible facilities for play means that the children stop making noise in the entries and stairwells. They won't have time. They'll be playing.

So, the residents came down and participated in the action, and by four o'clock in the afternoon everything was changed.

In 1968, during a research stay in Stockholm, Palle Nielsen chose the Moderna Museet as a framework to explore what he had previously been practising as actionism. After a period of bargaining for an invitation, in October 1968 a playground in the museum, *Model for a Qualitative Society*, was built with the assistance of a group of local Vietnam activists. Facilities for continued creativity were at the children's disposal during the entire course of the manifestation, in the form of tools, paint, building materials and fabrics. The Royal Theatre donated period costumes from different epochs to be used for role play. To this day, the noise level of the pedagogical art project is surely unparalleled in art history: loudspeaker towers were placed in each corner of the exhibition space, and the young museum-goers operated the turntables with LPs from every genre, playing dance music from the Renaissance at an ear-splitting level. In the restaurant a number of TV screens with live transmission offered a panopticon for uneasy parents, and enabled more sedate visitors to take in the active study of children's contact language. The playground architecture made concrete the pedagogical aim: a protected but pedagogically empowering milieu, to be accessed freely by all of Stockholm's kids (adults had to pay 5 crowns to get in). During its three-week exhibition period the *Model* received over 33,000 visitors, 20,000 of whom were children.

The notion that a child's early social relations form the adult individual was investigated by way of the *Model*. Creativity and experiential contact were thus incited as ways of assigning new priorities to human needs and acknowledging the 'qualitative human being' as an individual of society. The value of group relations was made evident as well as the necessity to work collectively as an

alternative to authoritarian society. The *Model* accepted the white cube as a 'free' topological premise: free in the sense of public access, accentuated by the anti-elitist stance of the *Model;* free in the sense that what is inserted into art institutions automatically legitimates its existence (or that is what they tell us, anyhow). Hence the *Model* embraced the art institution as a vehicle positioned in such a way in culture that the statements it conveys are catapulted into society.

The Copenhagen artists' group N55 rethink the social dimensions from which we basically structure our everyday lives. In the summer of 1999, on a dock by Copenhagen harbour, they built *N55 Spaceframe:* a residential unit of transformable, lightweight construction in flexible steel modules designed in collaboration with an architect. It is a functional and inhabitable sculpture and constitutes a radical revision of the house as we know it, as an object stationary in its construction and placement. Being much more than merely a goal-oriented installation, the construction of the living unit suggests an organic process that people may enter in all possible ways. Musicians, artists, architects, writers and curators each contribute to the social ambience of the work with projects, labour force, and their mundane, sociable presence. *N55 Spaceframe* constitutes the frame for activities that the participants themselves will establish, without any institutional interference. *N55 Spaceframe* is, for that matter, a utopian project in as much as it is an initial gesture, a rediscovery of the world. But in contrast to the great utopia, each time it is erected, *N55 Spaceframe* is architecturally and socially connected with the social surplus that it provides in connection with the process of construction and the context within which it functions. The 'utopian' in the project is not like a master plan that analytically anticipates social change, but one that describes a determined attitude from people's actions in concrete situations.

Palle Nielsen's way of practising art as a critique of architecture and living conditions is aligned with N55's praxis as a social fantasy, so to speak. As a reconceptualization of the residence, the *N55 Spaceframe* stands, shimmering, in the middle of Copenhagen as a fantastic creature which has just landed, staring the demands of contemporary living right in the eyes. If the idea of settling in an *N55 Spaceframe* doesn't appeal to you, then the project, at least constructively, constitutes a way of reflecting on the opposition between the individual and the forms of habitual thinking that too often sneak their way in as a syntax for our lives. One could object that N55 is merely replacing the old habits and linguistic forms with new habits, but in the space between these two positions and in the movement away from that which already is ossified toward the new and self-conceived, room is being made for the formulation of new differences. N55 accommodates what is currently the dominant, neoliberal determination of freedom of choice and is displacing the market mechanisms' relational dynamics in the direction of postulating that there are things which must be done.

Palle Nielsen's projects for *Festival 200* and *Middelburg Summer 1996*

In his writing, Palle Nielsen addresses the notion of large-scale communication including collective production of significance and value, and modes of distribution. Proceeding from a collective discussion and praxis surrounding common intentions, and in contradistinction to 'consumption's constraint and the production apparatus's power over the people', one can have qualitative and quantitative goals and thereby push communication boundaries. This calls for a positive and outgoing revision of aesthetic expressions which have been overhauled and repeated, and a revision of traditional forms of art distribution. The art institution's resources are cast into public space.

Festival 200 in 1969 was the 200-year jubilee of Charlottenborg Udstillingsbygning, the exhibition building of the Royal Danish Art Academy. Art historian Troels Andersen was invited to curate the anniversary show, and in accordance with his orientation towards non-violent anarchism – and in response to a minimal budget – artists from all over Europe were given a train ticket and free exhibition space if they would show up and participate with some project or other. In the week before the opening of the exhibition, the invitation to participate was open to everybody.

Palle Nielsen participated in three projects: a shooting range, a roulette, and an offset-printing works, all functioning representations of mass communication with popular appeal, imbuing the exhibition with a theme park atmosphere. Placed as the first thing by the entrance, the roulette was provided by the child-welfare committee and functioned as a metaphor for the anarchistic freedom promised by the exhibition. The shooting range offered air guns with which you could shoot your dislikes, organized in the form of photographs of Danish and international politicians and public persons. The roulette, as well as the shooting range, stood unattended.

The offset-printing works consisted of state-of-the-art rotaprint equipment to be used freely by everybody, and its appurtenant photo lab enabled general access to artistic expression. The festival's daily paper, flyers, leaflets, and printed matter in all colours were produced here. Some of it was distributed in the city or in other contexts, while others were integrated into the exhibition.

Palle Nielsen's projects introduced a reflexivity between play and production which must have seemed somewhat frivolous in the light of the era's will to revolutionary upheaval. On the one hand, play qualified large-scale communication as a way of stating that political artistic engagement doesn't exist in terms of practical politics, but as reform work with the prospect of change. On the other hand, play had to be organized and set free, seeing that society no longer offered integrated possibilities for living in its regulated, specialized spheres. To introduce social processes in the art institution is,

according to Nielsen, socially irrational. Social processes should happen where people are, in direct relation to what they do. But since social reproduction is in dire straits, there is a strong need for the production of participation, and for accessible metaphors of freedom.

In 1995 and 1996, Jens Haaning produced a series of production lines, where a number of people engaged in symbolically charged but ultimately undefined activities. In *Weapon Production* (1995), part of the group show *RAM* held in a Copenhagen suburb, a handful of young immigrants with some previous experience (so to speak) assisted the artist in the production of illegal street weapons; in *Flag Production* (1996), shown at the *Traffic* show in Bordeaux, France, Asian pupils from the local art academy sewed flags for an unknown nation. *Middelburg Summer 1996* (1996), a solo show at De Vleeshal, in the Dutch city of Middelburg, was in a sense the culmination of these works, in that the activity of the workers wasn't art-related in the first place:

Haaning engaged the Turkish-owned clothing manufacturers, Maras Confectie, to relocate its production facilities to the Kunsthalle for the duration of the exhibition. The entire institution was transformed into an appropriate environment for Maras Confectie's twelve Muslim (Turkish, Iranian and Bosnian) employees, replete with an office and canteen, soccer banners and blaring *TÜRKÜ* (a form of Turkish blues). As a beholder, you had to adapt to a peripheral position, as opposed to laying claim to the visual control and leisurely regulated space that exhibition architecture usually offers. You were, in fact, trespassing in foreign territory: not only an alien workplace, but a place where 'aliens' work. *Middelburg Summer 1996* provided an episodic mobilization of the dynamics of the cultural other, or 'the world market as ready-made', as one critic put it.

The work's critical position could also be summed up in the words of sociologist John Foran, writing in the 1997 *Theorizing Revolutions:* 'Oppositional cultures are often elaborated in contradistinction to the state, but they are also always rooted in the actual experience of diverse social sectors, that is, they have an eminently practical dimension.' As Fordist artefacts, production lines embody the dimension of physical labour, which is rapidly becoming obsolete in the era of immaterial work. Apart from privileging cultural otherness in a collectively organized form, *Middelburg Summer 1996* rejected art's service relationship to information society. Its laconic, alienating stageplay resisted the communication-driven prescriptions of the agents of the digital age, along with their (our) continual innovation of forms and modalities for the commerce of ideas.

Nielsen and Haaning point to conflicts in social processes and come up with solutions which are formally alike; for both projects Nielsen aptly calls the printing works a 'production installation'. It could be said, however, that *Middelburg Summer 1996* is an aestheticized version of Nielsen's production

installation. Actual participation is one step removed, something that may make the two works seem to differ in their conception of aesthetics; what actually aligns them may be their political stance in terms of social irrationality. (As an aside to his work, Haaning quoted Arthur Schopenhauer's dictum for De Vleeshal's website: 'The world is my imagination'.) The printing works at *Festival 200* and *Middelburg Summer 1996* each delivered critiques of the different effects of the acceleration of modernity's displacements, which increasingly control us as social beings.

Public Bath and *N55 Hygiene System*
In a feature on Copenhagen called 'Bursting the Gates of Welfare Utopia', the *Village Voice's* David Gurin wrote in November 1969 about 'the energy and beauty of the young Danes involved' in Festival 200:

[Troels] Andersen and a committee of Danish artists offered a second-class train fare to artists from all over Europe. An adventurous group accepted his invitation and put together a fantastically relaxed and unpretentious show. On some days it included a rock band in the sedate Charlottenborg courtyard. Otherwise it began for the visitor on the wall above a grand staircase that leads to the main floor of the gallery – pictures of Albertslund [a working-class Copenhagen suburb] and old Copenhagen were flashed side by side by two slide projectors. They seemed to beckon the viewer to stand up for some kind of environmental choice. A third projector flashed abstract forms. In an anteroom on the main floor were pinball machines and a shooting range with the prime minister of Denmark and Richard Nixon among the bull's eyes. In the grand exhibition hall were drawing tables and two offset printing presses. Materials and paper were liberally provided and anyone could design and print his/her own poster with expert help. At the back was a primitive hut, like a succah,[1] with uneven slats of wood for walls, and branches and leaves for a roof. Inside lived a nude 'family', with varying numbers of adults and children. They ate, drank, played and talked. [...] Occasionally one man in the family would climb up a rope ladder from the hut to the high ceiling of the hall from where, perched nude on the rope-ladder, he would film all the spectators whose eyes were on him. [...] Another room had a Danish artist's love letters strewn on the floor – people stood around reading them. [...] In another grand exhibition hall were a ping-pong table and a functioning sauna and shower. Artists and visitors – and the genius of the festival was that the two were not very distinguishable – played ping-pong, saunaed, and showered in the openness of the hall. [...] One especially touching room had a single rose in water on each of eight pedestals. Each day one rose was removed and a new one added, so the roses were in a gradually withering away of life and death.

The public bath and sauna were installed by the artist Paul Gernes. He wanted the artwork to be inserted in situations where things are used and thus his practice became strongly oriented in the direction of public art. The everyday function is taken literally in his public bath for *Festival 200*, and 'transposed to a level where it affects our senses and our thinking anew'.[2] Troels Andersen continues:

> It was given in the ideas of Morris, Ruskin and Gropius that people's behaviour in a surrounding world which in such high degree as ours is determined by things, could be changed by a revaluation of the surrounding objects, aesthetically and functionally. But these fashioned objects let themselves become easily integrated in the existing situation without any significant changes in norms of behaviour. Our society is still built on the nuclear family, and our whole production of consumer items (also counting a number of 'art objects') is based on this structure. What the conception of the happening among many other things contained was the suggestion of a new type of social form. [...] It implied the establishing of a new situation, the construction of an offer – but didn't necessarily force people in a certain direction.[3]

Troels Andersen's revaluation of the object also applies to N55 and their catalogue of functional art objects, with which they aim to create a social surplus. So far, N55's production of functional art objects with ethical and aesthetic consequences include a home hydroponics unit (a device for the domestic growth of vegetables), a clean-air machine, a hygiene system (low-cost bathroom), new designs for chairs, and a table. Everything is of N55 own design, in some cases with the help of experts to solve technical problems. Compared to an ordinary, utilitarian logic, their objects have a twist in relation to formalistic design: N55's attitude to the object is characterized by a sensitivity towards its role as a social determinant, as a role maker. The object answers back to the activity that surrounds it, instead of being a design-like hypostasis of itself. Or, in other words, the human activity and the object factor meld into one another – ergo, socially generous and disarming gestures like a collective installation of the hygiene system in mirthful colours, or the projection of a bed serviceable for six persons instead of the customary one- or two-person model.

The Oslo Trip and *Travel Agency*
In May 1970 the artists Finn Thybo and Per Bille were invited as part of the Danish representation in the Young Nordic Biennial at Kunstnernes Hus (The Artists' House) in Oslo. They decided to spend their grant of DKK 8,000 on buying 50 return tickets for the Oslo ferry and distributing them to 50 youths, mostly artists, musicians and architects. The group was to be installed,

collectively, in the exhibition as an artwork on the opening night, together with musicians from Oslo invited to participate in a pickup concert with the Copenhagen band Furekåben. Thus the group itself comprised the work of art and no one was allowed to leave it at any point.

Arriving in Oslo in good spirits the group, despite its hippie appearance, made it successfully through customs (with Black Afghan disguised as Tom's Caramels), and moved in one long column up through the streets of the Norwegian capital. Then, to the amusement of local businessmen, the group occupied what later turned out to be the rear entrance of the Oslo bourse. Wearing red banners and red ribbons round the head, or dressed up as native Americans, the group documented itself in front of banks and the sights of the city with a banner reading 'PEOPLE OF THE WORLD UNITE'. The arrival of the artwork at Kunstnernes Hus occasioned great commotion in the management, and the entire board was called for, but in the end accepted to host the group. Next, flyers for the opening party were distributed in Oslo, and snapshots and film were quickly developed; the same evening the doors of Kunstnernes Hus were opened for a presentation of documentation of the trip and the concert, where the director was seen in the rhythm section playing the bongos. The group returned in good order to Copenhagen on the ferry the next morning.

In Jens Haaning's work *Travel Agency* (1997), airline tickets were sold at competitive prices as artworks at Galerie Mehdi Chouakri in Berlin, capitalizing on German tax laws which exempt art from an eight per cent VAT. Accompanying certificates stated that if used for their original purpose, these tickets ceased to exist as art. If art is taxed less than other goods, why not label those other goods 'art'? That is, the airline ticket had a double capacity, each of which could be respective to art logic and economic logic; but if you want to grasp the idea of the work and the conceptual itinerary of each 'artwork' you can not do without the supplement of the other logic. By refusing to valorize high culture, and instead concentrating on the exchange of artistic ideas with real-world economics, Haaning created the possibility for realizing certain financial gains while upsetting the market at a micro-level.

In the *Oslo Trip* and *Travel Agency*, subversive sensibilities and art institutional allegiances together instigate a set of mutual deformations of incompatible cultural logics. Ideally, cultural and economic significance are put on equal footing, each invested in the multifold processes of ideological and geographic exchange. For *Oslo Trip* participants Finn Thybo and Kirsten Dufour, however, the work itself described a break with the art world for fifteen years.

TTA Løgstør and Life is Sweet in Sweden
After the *Oslo Trip* the work of Dufour and Thybo moved further in the direction

of activism. They worked with squatters in Copenhagen, and experimented with alternative social structures in small, closed communities in Jutland. In the 'aesthetic and political void' of the early seventies, Dufour and Thybo were looking for a position from which the local population in a given place could participate actively in a social, humanistic and political action. Based in Løgstør in Northern Jutland they started a ragpicker group in 1975, for the benefit of liberation movements in the third world, among them Zimbabwe African National Union and Eritrean Peoples Liberation Front. During the 12 years the group TTA Løgstør (Clothes for Africa) managed to collect the following and send it off to Africa: 112 tons of clothes and shoes; 30 sewing machines; 1 dental clinic; 3 operating tables; 15 hospital beds; 17 wheelchairs; 27 packages of other hospital equipment; 39 packages of toys; 30 packages of educational material; and the sum of DKK 447,911.

These goods were obtained mainly by means of household collecting, flea markets, enquiries at hospitals etc., and clearing up of estates. TTA workers were voluntary and paid a membership fee. Thybo describes the aims of TTA Løgstør:

Interactivity within the ragpicking group:
By collecting the surplus [of consumer society] and recycling it for humanitarian purposes, we solved several problems at the same time: we could make people aware of the conditions in other parts of the world and get them involved in an action, in the project. Leaflets about the collection of clothes were handed out to new households, and press releases about the annual flea market were sent to newspapers and local radio stations that covered the whole province. Here we informed others about the local conditions in those countries where we supported the liberation movements. We also spoke about the fact that the clothes were given to the liberation movements who distributed them in the refugee camps over which they had taken responsibility.

Last but not least, essential because of their tremendous contribution, the core of the group, 'the activists', who actively took part in the daily work, were recruited from the local community. It was our basis that Clothes for Africa should be both a local/social and a political/global project [...][4]

The last flea market was held in 1986. There was a steady reduction of activism, membership flow ebbed out, there was a split in the group, and the eventual conclusion was that it looked like solidarity work belonged to a certain generation.

In August 1995, Gothenburg was turned upside down. Sweden's second-largest city was about to host the World Championships in athletics. In an atmosphere of self-conscious activity, the urban environment was transformed through a series of 'beautification' projects, ranging from the architectural

remodelling of the inner city to the injection of a host of new commercial venues – greenery, colourful advertising and 'fresh paint' signs were sprouting up everywhere. A new black market for apartment sublets appeared and restaurants were openly advertising for 'young blonde female' staff. The visitors arrived at a sparkling new Gothenburg, starting the for-all-tourists search for the authentic folk and local spirit. With gorgeous weather, the pride of the citizens was only slightly stained by the embarrassment of having invented the place and themselves specifically for the tourists, and embarrassed that this act of deception was larger than their own naïveté. More than that, the debate over the day-to-day adjustments to all the newness made clear that, for better or worse, the Gothenburgers were losing their sense of belonging to the place they were proud to represent. The staging of the host's role turned from being an abstraction, 'the city', towards involving every single citizen. The distinction between 'guests' and 'hosts' began to dissolve. Not even a guide's uniform guaranteed discretion: everybody was new to the place they found themselves in, and to each other.

In the middle of this turbulence Aleksandra Mir opened *Life is Sweet in Sweden: Guest Bureau*, an alternative tourist office in downtown Gothenburg. 150 square metres were made available from the public sector, and Mir renovated and decorated the premises in a half-official, half-private cosy atmosphere that should make everybody feel welcome. Equipped with comfortable sofas, plastic greenery, an aquarium, dim lights and soft muzak, electric footbaths, a television with shopping channels and even a fresh smelling lavatory, the tourist bureau was freely available for use by any and everybody. The host's role was personified by anybody who wore the hostess uniform for *Life is Sweet in Sweden;* a blue-yellow dress-suit in a stewardess-cum-cashier cut, with the company's logo embroidered in silver on the breast pocket. From the beginning, twelve uniforms were available and during the project, 46 persons assumed the role as hostess, regardless of whether they had any connection with Gothenburg or not. With several hundred guests every day during the ten days that the World Championships took place, the tourist bureau became a social limbo, taking shape according to the constellations of people interacting with one another on the spot. The entire process of the situation established itself as a public coefficient where the participants, guests as well as hosts, were involved in a mutual endeavour intrinsic to sociability.

TTA Løgstør was evaluated critically as art after the fact; Dufour and Thybo presented documentation of the project for their exhibition in the N55 spaceframe, opening it up to a new narrative removed from the terminology of its time. TTA Løgstør and *Life is Sweet…* can both be contained in the same sphere as the aims and characteristics of the 'happening' – as outlined above by

Troels Andersen – and together they have resonance for more recent notions of identity politics. Just as TTA Løgstør's working premise was that the local belongs in a global society and that identities are created across geography and nationality, so *Life is Sweet...* was concerned with the loss of what might normally be considered solid identities. It also refers to those who always come back as subjects in the postmodern debate of identity – nomads, hybrids, immigrants, tourists. The limbo of the Gothenburgers – as that of the privileged Western citizen – was the whole point here, a collective intervention and mobilization in the face of an ambivalent official economy.

Both projects, like the other examples, take place in real time and depend on the presence of the other, whether it be the cultural other or the people in local surroundings waiting to be activated. Not least of all, the projects depend on each other in order to live on as collective memories with the people who took part, and the ones to whom the stories are told.

1 [A succah is a type of hut like the one described, built during the Jewish festival of Succot, and
 based on the portable nomadic dwellings of Moses and his followers during their desert exile.]
2 [footnote 1 in source] Troels Andersen: *Paul Gernes, 1966*, 1970.
3 [2] *Ibid.*
4 [3] Dufour, Thybo, Sørensen: *TTA Løgstør* 1975–1988.

Lars Bang Larsen, 'Social Aesthetics: 11 examples to begin with, in the light of parallel history', *Afterall*, no. 1 (London: Central Saint Martins School of Art and Design, 1999) 77–87.

Molly Nesbit, Hans-Ulrich Obrist, Rirkrit Tiravanija
What is a Station?//2003

Utopia Station, presented at the Venice Biennale in 2003, contained work by over 150 artists. Like Documenta 11 (2002), it was preceded by a number of seminars and exhibitions through which the exhibition's theoretical position was formulated. The following text, written by its three curators, outlines their political and aesthetic aspirations for a re-examination of utopia.

During a debate with Theodor Adorno in 1964, Ernst Bloch, pushed to the wall to defend his position on utopia, stood firm. Adorno had begun things by reminding everyone present that certain utopian dreams had actually been fulfilled, that there was now television, the possibility of travelling to other planets and moving faster than sound. And yet these dreams had come shrouded, minds set in traction by a relentless positivism and then their own boredom. 'One could perhaps say in general', he noted, 'that the fulfilment of utopia consists largely only in a repetition of the continually same "today".'

Bloch countered. The word utopia had indeed been discredited, he noted, but utopian thinking had not. He pointed to other levels of mind, to removes that were less structured by Western capital. Utopia was passing less auspiciously under other names now, he remarked, for example, 'science fiction' and the beginnings of sentences starting with 'If only it were so…'

Adorno agreed with him there and went on. 'Whatever utopia is', he said, 'whatever can be imagined as utopia, this is the transformation of the totality. And the imagination of such a transformation of the totality is basically very different in all the so-called utopian accomplishments – which, incidentally, are all really like you say: very modest, very narrow. It seems to me that what people have lost subjectively in regard to consciousness is very simply the capability to imagine the totality as something that could be completely different.' How to think utopia then? Adorno saw the only possibility to reside in the notion of an unfettered life *freed from death*. All at once the discussion of utopia expanded; it became not merely old, but ancient. It seemed to shed ideologies as if they were skins. Adorno declared that there could be no picture of utopia cast in a positive manner, there could be no positive picture of it at all, nor could any picture be complete. He went very far. Bloch only followed him part way. He summoned up a sentence from Brecht. He let it stand as the nutshell that held the incentive for utopia. Brecht had written 'Something's missing.'

'What is this "something"?' Bloch asked. 'If it is not allowed to be cast in a

picture, then I shall portray it as in the process of being. But one should not be allowed to eliminate it as if it really did not exist so that one could say the following about it: "It's about the sausage". I believe utopia cannot be removed from the world in spite of everything, and even the technological, which must definitely emerge and will be in the great realm of the utopian, will form only small sectors. That is a geometrical picture, which does not have any place here, but another picture can be found in the old peasant saying, there is no dance before the meal. People must first fill their stomachs, and then they can dance.'

'Something is Missing', the statement from Brecht. Typically when searching for utopia, one relies on the steps taken by others, for ever since its first formulation in 1516 in the book by Sir Thomas More, ever since its invention as the island of good social order, utopia has been a proposition to be debated, several speakers often pitching in at once. They bring thoughts, experience, the fruits of the past. For utopia is in many ways an ancient search for happiness, for freedom, for paradise. Sir Thomas More had had Plato's *Republic* in mind as he wrote. By now however utopia itself has lost its much of its fire. The work done in the name of utopia has soured the concept, left it strangled by internal, seemingly fixed perspectives, the skeletons of old efforts which leave their bones on the surface of the body as if they belonged there. Has utopia been strung up? Or obscured by bad eyesight? Certainly *it* has gone missing. Utopia itself has become a conceptual no-place, empty rhetoric at best, more often than not an exotic vacation, the desert pleasure island of cliché. Abbas Kiarostami, when asked recently if he had any unrealized or utopian projects, refused the long perspectives of utopia altogether. He preferred to fix matters in the present, taking each day one hill at a time. We in turn have set our sights on the middle ground between the island and the hill. We will build a Station there and name it Utopia Station.

The Utopia Station is a way-station. As a conceptual structure it is flexible; the particular Station planned for the Venice Biennale is physical too. It will rise as a set of contributions by more than sixty artists and architects, writers and performers, the ensemble being coordinated into a flexible plan by Rirkrit Tiravanija and Liam Gillick. It has been important to all concerned that the plan not present itself as a finished picture. Let us therefore conjure up the Station by means of a few figures. It begins with a long low platform, part dance-floor, part stage, part quay. Along one side of this platform is a row of large circular benches so that you can watch the movement on the platform or silently turn your back or treat the circle as a generous conversation pit. Each seats ten people. The circular benches are portable; as an option one could line them up like a row of big wheels. Along the other side of the platform a long wall with many doors rises up. Some of the doors take you to the other side of the wall. Some open into

small rooms in which you will see installations and projections. The wall wraps around the rooms and binds the ensemble into a long irregular structure. Over it floats a roof suspended on cables from the ceiling of the cavernous room in the old warehouse at the far end of the Arsenale where the Station sits. Outside the warehouse lies a rough garden. Work from the Station will spill into it.

The Station itself will be filled with objects, part-objects, paintings, images, screens. Around them a variety of benches, tables and small structures take their place. It will be possible to bathe in the Station and powder one's nose. The Station in other words becomes a place to stop, to contemplate, to listen and see, to rest and refresh, to talk and exchange. For it will be completed by the presence of people and a programme of events. Performances, concerts, lectures, readings, film programmes, parties, the events will multiply. They define the Station as much as its solid objects do. But all kinds of things will continue to be added to the Station over the course of the summer and fall. People will leave things behind, take some things with them, come back or never return again. There will always be people who want to leave too much and others who don't know what to leave behind or what to say. These are the challenges for a Utopia Station being set up in the heart of an art exhibition. But in addition, there are the unpredictable effects, which Carsten Höller has been anticipating, the points where something missing turns to something that becomes too much. The doubt produced between these two somethings is just as meaningful as any idea of utopia, he believes. These tensions will be welcomed like a guest.

What does a Station produce? What might a Station produce *in real time*? In this *produce* lies an activity rather more complex than pure exhibition, for it contains many cycles of use, a mixing of use. It incorporates aesthetic material, aesthetic matters too, into another economy which does not regard art as fatally separate.

But what is its place? The discussion of this question has been opened again by Jacques Rancière, in his book *Le partage du sensible*, which in French has the advantage of having a partition and a sharing occupy the same word. What is sectioned off and exchanged? It is more than an idea. Rancière takes his departure from Plato, pointedly, in order to remind us of the inevitable relation between the arts and the rest of social activity, the inevitable relations, it should be said, that together distribute value and give hierarchy, that govern, that both materially and conceptually establish their politics. This theatre of relations wraps itself around visions of worlds, each of them islands, each of them forms, but all of them concrete realities replete with matter and force. This is a philosophical understanding of aesthetic activity; it extends materialist aesthetics into the conditions of our present; it is a book to bring to a Station. As we have. But, once released, a book too leaves its island.

The Utopia Station in Venice, the city of islands, is part of a larger project. Utopia Stations do not require architecture for their existence, only a meeting, a gathering. We have already had several in Paris, in Venice, in Frankfurt, in Poughkeepsie, in Berlin. As such the Stations can be large or small. There is no hierarchy of importance between the gatherings, meetings, seminars, exhibitions and books; all of them become equally good ways of working. There is no desire to formalize the Stations into an institution of any kind. For now we meet. Many ideas about utopia circulate. Once when we met with Jacques Rancière, it was in Paris last June, he spoke to the difficulties involved in putting the idea of utopia forward. He pointed to the line that says 'There must be utopia', meaning that there must not only be calculations but an elevation, a supplement rising in the soul, and said that this line of thought has never interested him. Indeed he has always found it unnerving, even irritating. That which does interest him, he explained, is the *dissensus*, the manner in which ruptures are concretely created – ruptures in speech, in perception, in sensibility. He turned to contemplate the means by which utopias can be used to produce these ruptures. Will it begin and end in talk?

On another occasion, in Poughkeepsie last winter, just as a blizzard was about to blow in, Lawrence Weiner reminded everyone present that the artist's reality is no different from any other reality. Liam Gillick asked that we avoid utopian mirage, instead asking for utopia to become a functional step moving beyond itself. Martha Rosler told the story of going to see the space in Venice, arriving however as night fell to see only an interior of darkness, there being no lights. But utopia, she said, is what moves. Jonas Mekas warned of obsessions with ideas, since the dream, he said, could only succeed if we forget them. Leon Golub was apocalyptic. Allan Sekula, at our urging, showed the first five minutes of the tape he had made the day before during the peace demonstration in New York. Anri Sala showed us a tape of Tirana, where the mayor had painted apartment block walls into a geometric vision, a concrete hope. Édouard Glissant came. He spoke of the desire for the perfect shape, he spoke his language of landscapes. Only by passing through the *inextricable* of the world, he told us, can we save our *imaginaire*. In that passing there would come the *tremblement*, the tremor being fundamental to the passage.

Nancy Spero sent a morphine dream. Agnès Varda sent us the song of the Cadet Rousselle. Together we read an article Étienne Balibar had written six years ago for *Le Monde* which proposed to take complete leave of utopia now, in order to return to the heart of the matter – to let the imagination free to accept the sudden emergence of subjectivity in the social field. Let us make a sudden rush, a place for the imagination to expand, a place of fiction, fiction in its fullest sense. Balibar sees fiction to be the production of the real, something stemming

from experience itself, knowledge and action brought together so that they become indistinguishable, insurrection emptying into constitution. He used these thoughts to preface his *Droit de cité*. Another book for the Station.

It is simple. We use utopia as a catalyst, a concept most useful as fuel. We leave the complete definition of utopia to others. We meet to pool our efforts, motivated by a need to change the landscape outside and inside, a need to think, a need to integrate the work of the artist, the intellectual and manual labourers that we are into a larger kind of community, another kind of economy, a bigger conversation, another state of being. You could call this need a hunger.

Dare one rewrite a sentence by Brecht? Something *we need* is missing. The man who, seventy years ago, wrote 'Art follows reality' would surely not mind. Let us then take these words and press on. We need the words, old words and new words, we need the dance, we need the sausage, and still we need more. We have started, we meet in the Utopia Station, we start out again. The Station becomes a place to gather our starting points temporarily. It is primarily for this reason it resists capture and summary as a single image. Or is it the image of open possibility? The image of mixed use? Many things will happen there. And they will spark others.

Think of the Station as a field of starting points, many starting points being brought and offered by many different people. Some will bring objects now, others later. Each present and future contributor to the Station is being asked to do a poster for use in the Station and beyond: wherever it can hang, it can go. A paper trail for once goes forward. New posters continue to be added. In this way the Utopia Station produces images, even as it does not start with one. And a loose community assembles. It develops its own internal points of coherence, which shift with the times, as conversations and debates do.

Each person making a poster has been asked to make a statement of at least one and up to two hundred words. Independent of one another the statements collect. Stuart Hall and Zeigam Azizov elaborate upon a proposition: the world has to be *made to mean*. The bittersweet baked into hope, writes Nancy Spero. Pash Buzari sent a poem where darkness is dialled. The Raqs Media Collective calls utopia a hearing aid. Jimmie Durham cites the Cherokee, and adds that the 'probably' keeps people active. There will be hundreds of statements like these in the end. They will branch out. As they do certain figures begin to repeat. Ships and songs and flags, two times potatoes, two times Sisyphus, figures familiar from the discussion of utopia forty years ago, but they have been assimilated rather than cited. Utopia becomes the secret garden whose doors can be opened again. Utopia becomes the catalyst that burns and returns. None of us can say we begin from scratch.

These actitivities imply an activism. For many who come to the Station, its

invitation to self-organize speaks a political language already known to them and already being practised. The proposal to build non-profit de-centralized units and make them become the underlying mode of production, fitting together through the real market (not the monopolistically controlled world market of the present system), has been made by Immanuel Wallerstein in his book *Utopistics*. It would eliminate the priority given to the endless accumulation of capital. Still another book for the Station.

As the catalyst burns, it fumes. For ours is not a time of continually same todays. When we met in Poughkeepsie in mid-February, around the world vast crowds marched for peace. Seven weeks later, when we met in Frankfurt, the Coalition forces were entering Baghdad. The days come like Kiarostami's hills. It is not the continually same utopia. In the speech to the graduating West Point cadets in June 2002, President George Bush announced his policy of pre-emptive strikes and wars with the reassurance that 'America has no empire to extend or utopia to establish.' The idea of empire has been receiving much scrutiny. But what about the other idea here, the refusal of utopia, the concept that presumes forward social vision? Is it not this refusal that gives us reason enough to revive the question of utopia now? Whether it comes as catalyst or fume, the word should be pronounced. And so we start.

Molly Nesbit, Hans-Ulrich Obrist, Rirkrit Tiravanija, *Utopia Station* (Venice: 50th Venice Biennale, 2003).

Hal Foster
Chat Rooms//2004

The Anglophone reception of relational art has been relatively belated. In the following text, originally written as a book review of Bourriaud's Relational Aesthetics *and* Postproduction, *and Hans Ulrich Obrist's* Interviews, *Hal Foster expresses reservations about the optimistic rhetoric accompanying collaboration and participation.*

In an art gallery over the last decade you might have happened on one of the following. A room empty except for a stack of identical sheets of paper – white, sky-blue, or printed with a simple image of an unmade bed or birds in flight – or a mound of identical sweets wrapped in brilliant coloured foil, the sweets, like the paper, free for the taking. Or a space where office contents were dumped in the exhibition area, and a couple of pots of Thai food were on offer to visitors puzzled enough to linger, eat and talk. Or a scattering of bulletin boards, drawing tables and discussion platforms, some dotted with information about a famous person from the past (Erasmus Darwin or Robert McNamara), as though a documentary script were in the making or a history seminar had just finished. Or, finally, a kiosk cobbled together from plastic and plywood, and filled, like a homemade study-shrine, with images and texts devoted to a particular artist, writer or philosopher (Fernand Léger, Raymond Carver or Gilles Deleuze). Such works, which fall somewhere between a public installation, an obscure performance and a private archive, can also be found outside art galleries, rendering them even more difficult to decipher in aesthetic terms. They can nonetheless be taken to indicate a distinctive turn in recent art. In play in the first two examples – works by Felix Gonzalez-Torres and by Rirkrit Tiravanija – is a notion of art as an ephemeral offering, a precarious gift (as opposed to an accredited painting or sculpture); and in the second two instances (by Liam Gillick and by Thomas Hirschhorn), a notion of art as an informal probing into a specific figure or event in history or politics, fiction or philosophy. Although each type of work can be tagged with a theoretical pedigree (in the first case, 'the gift' as seen by Marcel Mauss, say, or in the second 'discursive practice' according to Michel Foucault), the abstract concept is transformed into a literal space of operations, a pragmatic way of making and showing, talking and being.

The prominent practitioners of this art draw on a wide range of precedents: the everyday objects of Nouveau Réalisme, the humble materials of Arte Povera, the participatory strategies of Lygia Clark and Hélio Oiticica and the 'institution-

critical' devices of Marcel Broodthaers and Hans Haacke. But these artists have also transformed the familiar devices of the readymade object, the collaborative project and the installation format. For example, some now treat entire TV shows and Hollywood films as found images: Pierre Huyghe has reshot parts of the Al Pacino movie *Dog Day Afternoon* with the real-life protagonist (a reluctant bank robber) returned to the lead role, and Douglas Gordon has adapted a couple of Hitchcock films in drastic ways (his *24 Hour Psycho* slows down the original to a near-catatonic running time). For Gordon, such pieces are 'time readymades'– that is, given narratives to be sampled in large image-projections (a pervasive medium in art today) – while Nicolas Bourriaud, a co-director of the Palais de Tokyo, a Paris museum devoted to contemporary art, champions such work under the rubric of 'postproduction'. This term underscores secondary manipulations (editing, effects and the like) that are almost as pronounced in such art as in film; it also suggests a changed status of the 'work' of art in the age of information which has succeeded the age of production. That we are now in such a new era is an ideological assumption; nonetheless, in a world of shareware, information can appear as the ultimate readymade, as data to be reprocessed and sent on, and some of these artists do work, as Bourriaud says, 'to inventory and select, to use and download', to revise not only found images and texts but also given forms of exhibition and distribution.

One upshot of this way of working is a 'promiscuity of collaborations' (Gordon), in which the Postmodernist complications of originality and authorship are pushed beyond the pale. Take a collaborative work-in-progress such as *No Ghost Just a Shell*, led by Huyghe and Philippe Parreno. A few years ago they found out that a Japanese animation company wanted to sell some of its minor characters; they bought one such person-sign, a girl named Annlee, and invited other artists to use her in their work. Here the artwork becomes a 'chain' of pieces: for Huyghe and Parreno, *No Ghost Just a Shell* is 'a dynamic structure that produces forms that are part of it'; it is also 'the story of a community that finds itself in an image'. If this collaboration doesn't make you a little nervous (is the buying of Annlee a gesture of liberation or of serial bondage?), consider another group project that adapts a readymade product to unusual ends: in this work, Joe Scanlan, Dominique Gonzalez-Foerster, Gillick, Tiravanija and others show you how to customize your own coffin from Ikea furniture; its title is *DIY, or How to Kill Yourself Anywhere in the World for under $399*.

The tradition of readymade objects, from Duchamp to Damien Hirst, is often mocking of high and/or mass culture or both; in these examples it is mordant about global capitalism as well. Yet the prevalent sensibility of the new work tends to be innocent and expansive, even ludic – again an offering to other people and/or an opening to other discourses. At times a benign image of

globalization is advanced (it is a precondition for this very international group of artists), and there are utopian moments, too: Tiravanija, for example, has organized a 'massive-scale artist-run space' called 'The Land' in rural Thailand, designed as a collective 'for social engagement'. More modestly, these artists aim to turn passive viewers into a temporary community of active interlocutors. In this regard Hirschhorn, who once worked in a Communist collective of graphic designers, sees his makeshift monuments to artists and philosophers as a species of passionate pedagogy – they evoke the agit-prop kiosks of the Russian Constructivists as well as the obsessive constructions of Kurt Schwitters. Hirschhorn seeks to 'distribute ideas', 'radiate energy' and 'liberate activity' all at once: he wants not only to familiarize his audience with an alternative public culture but to libidinize this relationship as well. Other artists, some of whom were trained as scientists (such as Carsten Höller) or architects (Stefano Boeri), adapt a model of collaborative research and experiment closer to the laboratory or the design firm than the studio. 'I take the word "studio" literally', Gabriel Orozco remarks, 'not as a space of production but as a time of knowledge.'

'A promiscuity of collaborations' has also meant a promiscuity of installations: installation is the default format, and exhibition the common medium, of much art today. (In part this tendency is driven by the increased importance of huge shows: there are biennials not only in Venice but in São Paulo, Istanbul, Johannesburg and Gwangju.) Entire exhibitions are often given over to messy juxtapositions of projects – photos and texts, images and objects, videos and screens – and occasionally the effects are more chaotic than communicative. Nonetheless, discursivity and sociability are central concerns of the new work, both in its making and in its viewing. 'Discussion has become an important moment in the constitution of a project', Huyghe comments, and Tiravanija aligns his art, as 'a place of socialization', with a village market or a dance floor. 'I make art', Gordon says, 'so that I can go to the bar and talk about it'. Apparently, if one model of the old avant-garde was the Party à la Lenin, today the equivalent is a party à la Lennon.

In this time of mega-exhibitions the artist often doubles as curator. 'I am the head of a team, a coach, a producer, an organizer, a representative, a cheerleader, a host of the party, a captain of the boat', Orozco says, 'in short, an activist, an activator, an incubator'. The rise of the artist-as-curator has been complemented by that of the curator-as-artist; maestros of large shows have become very prominent over the last decade. Often the two groups share models of working as well as terms of description. Several years ago, for example, Tiravanija, Orozco and other artists began to speak of projects as 'platforms' and 'stations', as 'places that gather and then disperse', in order to underscore the casual communities they sought to create. Last year Documenta 11, curated by an

international team led by Okwui Enwezor, was also conceived in terms of 'platforms' of discussion, scattered around the world, on such topics as 'Democracy Unrealized', 'Processes of Truth and Reconciliation', 'Creolité and Creolization' and 'Four African Cities'; the exhibition held in Kassel, Germany, was only the final such 'platform'. And this year the Venice Biennale, curated by another international group headed by Francesco Bonami, featured sections called 'Utopia Station' and 'Zone of Urgency', both of which exemplified the informal discursivity of much art-making and curating today. Like 'kiosk', 'platform' and 'station' call up the Modernist ambition to modernise culture in accordance with industrial society (El Lissitzky spoke of his Constructivist designs as 'way-stations between art and architecture'). Yet today these terms evoke the electronic network, and many artists and curators fall for the Internet rhetoric of 'interactivity', though the means applied to this end are usually far more funky and face-to-face than any chat room on the Web.

The forms of these books by Bourriaud [*Relational Aesthetics*; *Postproduction*] and Obrist, the chief curator at the Musée d'art moderne de la Ville de Paris, are as telling as the contents. The Bourriaud texts are sketchy – brief glosses of projects that use 'postproduction' techniques and seek 'relational' effects, while the Obrist tome is diffuse, with nearly a thousand pages of conversation with figures such as Jean Rouch and J.G. Ballard as well as the artists in question – and this is only volume I. (Ballard lets fly with a sharp aperçu; 'The psychological test is the only function of today's art shows', he says, with the Young British Artists in mind, 'and the aesthetic elements have been reduced almost to zero.' He means it as a compliment.) The conceptual artist Douglas Huebler once proposed to photograph everyone in the world; the peripatetic Obrist seems to want to talk to everyone (many of his interviews take place on planes). As with some of the art discussed in the book, the result oscillates between an exemplary work of interdisciplinarity and a Babelesque confusion of tongues. Along with the emphasis on discursivity and sociability, there is a concern with the ethical and the everyday: art is 'a way to explore other possibilities of exchange' (Huyghe), a model of 'living well' (Tiravanija), a means of being 'together in the everyday' (Orozco). 'Henceforth', Bourriaud declares, 'the group is pitted against the mass, neighbourliness against propaganda, low tech against high tech, and the tactile against the visual. And above all, the everyday now turns out to be a much more fertile terrain than pop culture.'

These possibilities of 'relational aesthetics' seem clear enough, but there are problems, too. Sometimes politics are ascribed to such art on the basis of a shaky analogy between an open work and an inclusive society, as if a desultory form might evoke a democratic community, or a non-hierarchical installation predict an egalitarian world. Hirschhorn sees his projects as 'never-ending construction

sites', while Tiravanija rejects 'the need to fix a moment where everything is complete'. But surely one thing art can still do is to take a stand, and to do this in a concrete register that brings together the aesthetic, the cognitive and the critical. And formlessness in society might be a condition to contest rather than to celebrate in art – a condition to make over into form for the purposes of reflection and resistance (as some modernist painters attempted to do). The artists in question frequently cite the Situationists but they, as T.J. Clark has stressed, valued precise intervention and rigorous organization above all things.

'The question', Huyghe argues, 'is less "what?" than "to whom?" It becomes a question of address'. Bourriaud also sees art as 'an ensemble of units to be reactivated by the beholder-manipulator'. In many ways this approach is another legacy of the Duchampian provocation, but when is such 'reactivation' too great a burden to place on the viewer, too ambiguous a test? As with previous attempts to involve the audience directly (in some abstract painting or some conceptual art), there is a risk of illegibility here, which might reintroduce the artist as the principal figure and the primary exegete of the work. At times, 'the death of the author' has meant not 'the birth of the reader', as Roland Barthes speculated, so much as the befuddlement of the viewer.

Furthermore, when has art, at least since the Renaissance, not involved discursivity and sociability? It is a matter of degree, of course, but might this emphasis be redundant? It also seems to risk a weird formalism of discursivity and sociability pursued for their own sakes. Collaboration, too, is often regarded as a good in itself: 'Collaboration is the answer', Obrist remarks at one point, 'but what is the question?' Art collectives in the recent past, such as those formed around AIDS activism, were political projects; today simply getting together sometimes seems to be enough. Here we might not be too far from an artworld version of 'flash mobs' – of 'people meeting people', in Tiravanija's words, as an end in itself. This is where I side with Sartre on a bad day: often in galleries and museums, hell is other people.

Perhaps discursivity and sociability are in the foreground of art today because they are scarce elsewhere. The same goes for the ethical and the everyday, as the briefest glance at our craven politicians and hectic lives might suggest. It is as though the very idea of community has taken on a utopian tinge. Even an art audience cannot be taken for granted but must be conjured up every time, which might be why contemporary exhibitions often feel like remedial work in socialization: come and play, talk, learn with me. If participation appears threatened in other spheres, its privileging in art might be compensatory – a pale, part-time substitute. Bourriaud almost suggests as much: 'Through little services rendered, the artists fill in the cracks in the social bond.' And only when he is at his most grim does he hit home: 'The society of spectacle is thus followed by the

society of extras, where everyone finds the illusion of an interactive democracy in more or less truncated channels of communication.'

For the most part these artists and curators see discursivity and sociability in rosy terms. As the critic Claire Bishop suggests, this tends to drop contradiction out of dialogue, and conflict out of democracy; it is also to advance a version of the subject free of the unconscious (even the gift is charged with ambivalence, according to Mauss). At times everything seems to be happy interactivity: among 'aesthetic objects' Bourriaud counts 'meetings, encounters, events, various types of collaboration between people, games, festivals and places of conviviality, in a word all manner of encounter and relational invention'. To some readers such 'relational aesthetics' will sound like a truly final end of art, to be celebrated or decried. For others it will seem to aestheticize the nicer procedures of our service economy ('invitations, casting sessions, meetings, convivial and user-friendly areas, appointments'). There is the further suspicion that, for all its discursivity, 'relational aesthetics' might be sucked up in the general movement for a 'post-critical' culture – an art and architecture, cinema and literature 'after theory'.

Hal Foster, 'Chat Rooms' (2004), published as 'Arty Party', *London Review of Books* (London, 4 December 2004) 21–2.

Biographical Notes

Roland Barthes (1915–80), the French literary theorist, critic and innovative exponent of structuralism and semiology, influenced visual theory and practice through his *Eléments de sémiologie* (1964; *Elements of Semiology*, 1967); his analyses of signifying systems in popular culture, collected in *Mythologies* (1957; trans. 1972) and *La Tour Eiffel* (1964; *The Eiffel Tower*, 1979); and his writings on the visual image in *Image–Music–Text* (1977), *La chambre claire* (1980; *Camera Lucida*, 1981) and *The Responsibility of Forms* (1985).

Joseph Beuys (1921–86) was a German artist, initially a sculptor, who after collaborating in the Fluxus movement (1962–63) developed his system of synthesizing artistic practice with political ideals and lived experience. In the early 1970s he founded organizations such as the Free International School of Creativity and Interdisciplinary Research. The largest holdings of his work are at the Joseph Beuys Archiv (http://www.moyland.de/pages/josephbeuysarchiv/), the Hessisches Landesmusum in Darmstadt, the Busch-Reisinger Museum at Harvard University, and the Kunstmuseum Bonn.

Nicolas Bourriaud is a French art theorist and curator who introduced the term 'relational aesthetics' in texts such as his catalogue introduction to the *Traffic* group exhibition at capcMusée d'art contemporain, Bordeaux (1995). From 1999 to 2005 he was co-director, with Jérome Sans, of the Palais de Tokyo, Paris. Projects he has curated include *Aperto*, the Venice Biennale (1993) and the Moscow Biennale (co-curator, 2005). His essays are collected in *Esthétique relationelle* (1998; *Relational Aesthetics*, 2002) and *Postproduction* (2002).

Peter Bürger is Professor of French and Comparative Literature at the University of Bremen. His detailed analysis of the institutions of art has provided a theoretical framework for studying the social context of art's production and reception. His works include *Theorie der Avantgarde* (1974; *Theory of the Avant-Garde*, 1984) and *The Decline of Modernism* (1992).

Graciela Carnevale is an Argentinian artist who was instrumental in forming the Grupo de Artistas de Vanguarda in the late 1960s, a coalition of artists, joined by sociologists, filmmakers, theorists, photographers and others who staged participatory politicized actions. Based in Rosario, Argentina, their projects included *Tucumán Arde* (*Tucumán Burns*) in 1968, a collaboration with sugar plant workers protesting against government oppression.

Lygia Clark (1920–88) was a Brazilian artist who worked in Rio de Janeiro and Paris. Out of a neo-concretist sculptural practice her work evolved in the late 1960s to encompass participatory works involving 'sensorial' experiences of objects and encounters, informed by her concurrent practice as a psychoanalyst. Her ideas were also closely affiliated with those of the artist Hélio Oiticica (see below) and the Brazilian Tropicália movement, in which they had a central role. Retrospectives include Fundació Antoni Tàpies, Barcelona (1997).

Collective Actions (*Kollektivnye deistviya*) was founded in Moscow in 1976 by Andrei Monastyrsky, Nikolai Panitkov, Georgii Kizevalter and Nikita Alekseev. Elena Elagina, Igor Makarevich and Sergei Romashko joined the group later, and its composition frequently changed. They are best known for their collaborative, conceptually based actions in rural spaces outside the city. Their

work was included in *Global Conceptualism: Points of Origin, 1950s–1980s*, Queens Museum of Art, New York (2000) and *Collective and Interactive Works in Russian Art 1960–2000*, State Tretyakov Gallery, Moscow (2005).

Eda Cufer is a Slovenian artist, theorist and theatre director who since 1984 has worked with the arts collective NSK (Neue Slowenische Kunst), and since 1989 has been a female collaborator with its subgroup of five male artists, IRWIN (Dusan Mandic, Miran Mohar, Andrej Savski, Roman Uranjek, Borut Vogelnik). In 1992 they joined with other groups from Eastern Europe and Russia in the project *NSK Embassy Moscow* (at an apartment, Leninsky Prospekt 12, Moscow), a month of events investigating 'how the East sees the East' – also the title of their book documenting the project.

Guy Debord (1931–94), the French writer, theorist and filmmaker, formed the Situationist International with the artist Asger Jorn and others in 1957. His books include *La Société du spectacle* (1967; *Society of the Spectacle*, 1970), his influential critique of the social alienation engendered by the primacy of the image as mediator and regulator of capitalist society; *Commentaires sur la société du spectacle* (1988; *Comments on the Society of the Spectacle*, 1990); and the edited collections *Guy Debord and the Situationist International* (ed. Tom McDonough, 2002) and *Complete Cinematic Works* (ed. and trans. Ken Knabb, 2003).

Jeremy Deller is a British artist whose practice has some parallels with ethnographic and sociological research, leading to participatory works based on shared cultural experiences. His projects include *Unconvention* (with Bruce Haines, 1999), *Folk Archive* (with Alan Kane, 1999 to the present), *The Battle of Orgreave* (2001) and *Social Parade* (2004).

Umberto Eco is a semiotician, medievalist and novelist who since 1999 has been President of the Scuola Superiore di Studi Umanistici, University of Bologna. His books include *Opera Aperta* (1962; *The Open Work*, 1989), *La Struttura assente* (1968; *A Theory of Semiotics*, 1977), *The Role of the Reader* (translated collection of key essays 1962–76, 1979) and *Incontro–Encounter–Rencontre* (1996).

Hal Foster is Townsend Martin Professor of Art and Archaeology at Princeton University, an editor of *October* and a contributor to *Artforum* and the *London Review of Books*. His books include *Recodings: Art, Spectacle, Cultural Politics* (1985), *Compulsive Beauty* (1993), *The Return of the Real* (1996) and *Prosthetic Gods* (2004).

Édouard Glissant is Distinguished Professor of French at the City University of New York and a Martiniquan writer, poet and essayist whose work on Frantz Fanon and around the ideas of 'creolisation' and Caribbean identity has been widely influential. His books include *Le Discours antillais* (1981), *Poétique de la Relation* (1990; *Poetics of Relation*, 1997) and *Traité du Tout-Monde* (1997).

Group Material was founded in 1979 as an artists' collaborative group in New York which significantly broke down the barriers between art and social and political practice. Attracting temporary members, its core artists became Julie Ault and Tim Rollins (founders), Doug Ashford (from 1982), Felix Gonzalez-Torres (1957–96; from 1987) and Karen Ramspacher (from 1989). Projects include *The People's Choice* (1980), *Americana* (1985), *Democracy* (1988), and *Aids Timeline* (1989-92).

Félix Guattari (1930–92) was a French psychoanalyst and political activist who was a central figure in the events of May 1968. Best known for his collaborations with the philosopher Gilles Deleuze, *Capitalisme et schizophrénie*. 1. *L'anti-Oedipe* (1972; *Anti-Oedipus*, 1983); II. *Mille plâteaux* (1980; *A Thousand Plateaus*, 1987), and *Qu'est-ce que la philosophie?*, 1991; What is Philosophy?, 1996), he developed his own social, psychoanalytic and ecologically based theories published in *Chaosmose* (1992; *Chaosmosis*, 1995), *Chaosophy* (1995) and *Soft Subversions* (1996).

Thomas Hirschhorn is a Swiss-born artist based in Paris, whose anti-aesthetic assemblages, monuments, altars and kiosks, using low-grade everyday materials, invite a questioning of the place of art in community and the contemporary status of the monument. Major projects include *Bataille Monument*, Documenta 11, Kassel (2002), *Musée Précaire Albinet*, Laboratoires d'Aubervilliers (2004), and *Utopia, Utopia*, Institute of Contemporary Art, Boston (2005).

Carsten Höller is a Belgian-born artist based in Sweden. With a doctorate in phytopathology, he uses his scientific training to make investigatory installations and artworks that actively engage viewers' perceptions and physiological reactions to environments and stimuli. Major solo exhibitions include *Sanatorium*, Kunst-Werke, Berlin (1999), *New World*, Moderna Museet, Stockholm (1999), Fondazione Prada, Milan (2000) and *One Day One Day*, Fargfabriken, Stockholm (2003).

Allan Kaprow (1927–2006) was an American artist best known as the inventor of the Happening in 1959, a term he abandoned in 1967, after which he explored other participatory models. The range of his early 1960s works is documented in his *Assemblages, Environments and Happenings* (1966); his writings are collected in *Essays on the Blurring of Art and Life* (1993). An important early group show was *Environments, Situations, Spaces*, Martha Jackson Gallery, New York (1961). Retrospectives include Haus der Kunst, Munich (2006).

Lars Bang Larsen is a Danish critic and curator based in Frankfurt am Main and Copenhagen. A contributor to journals such as *Documents sur l'art, frieze* and *Artforum*, he co-curated *Momentum – Nordic Festival of Contemporary Art* (1998), *Fundamentalisms of the New Order* (Charlottenberg, 2002), *The Invisible Insurrection of a Million Minds* (Bilbao, 2005) and *Populism* (Vilnius, Oslo, Amsterdam, Frankfurt, 2005).

Jean-Luc Nancy is a French philosopher among whose central reference points are the ideas of Georges Bataille, Maurice Blanchot, Jacques Derrida and Friedrich Nietzsche. His key works include *Le Titre de la Lettre* (with Philippe Lacoue-Labarthe, 1973; *The Title of the Letter: A Reading of Lacan*, 1992), *Le communauté désoeuvrée* (1986; *The Inoperative Community*, 1991), *Le retrait du politique* (with Philippe Lacoue-Labarthe, 1997; *Retreating the Political*, 1997) and *Être singulier pluriel* (2000; *Being Singular Plural*, 2000).

Molly Nesbit is Professor of Art at Vassar College, Poughkeepsie, New York, and has also taught at the University of California, Berkeley, and Barnard College, Columbia University. A contributing editor of *Artforum*, she is the author of *Atget's Seven Albums* (1992) and *Their Common Sense* (2000). She was a co-curator of *Utopia Station*, Venice Biennale (2003).

Hans Ulrich Obrist is a Swiss curator who is Co-Director of Exhibitions and Programmes at the Serpentine Gallery, London. From 1993 to 2005 he ran the 'Migrateurs' programme at the Musée

d'art moderne de la Ville de Paris. Among the many exhibitions and events he has co-curated are Manifesta I, Rotterdam (1996), *Cities on the Move*, Secession, Vienna (1997, and touring), the Berlin Biennale (1998), *Utopia Station*, Venice Biennale (2003), and the Moscow Biennale (2005). Volume 1 of his collected interviews was published in 2003.

Hélio Oiticica (1937–80) was a Brazilian artist who worked in Rio de Janeiro and New York. Like Lygia Clark, he moved from neo-concretism in the 1950s to participatory works in the late 1960s involving 'sensorial' objects and installation structures, *parangolé* capes worn by samba dancers, and environments which placed gallery visitors in material conditions evoking Latin American shanty town existence. Retrospectives include Witte de With, Rotterdam (1992, and touring).

Adrian Piper is a New York-based artist and philosopher. After participating in the beginnings of New York conceptualism in the 1960s, from 1970 she developed a 'catalytic' form of intervention in public or group situations to involve others in the questioning of perceptions derived from unchallenged notions of race, gender or class. Retrospectives include the New Museum of Contemporary Art, New York (2000).

Jacques Rancière is a French philosopher who first came to prominence as a co-author, with Louis Althusser and others, of *Lire* Le Capital (1965; *Reading* Capital, 1979). In the early 1970s he abandoned Althusser's form of Marxism and began to reflect upon the social and historical constitution of knowledges. Since the late 1990s he has investigated the political and its relationship to aesthetics within western culture. His books include *Le Maître ignorant* (1982; *The Ignorant Schoolmaster*, 1991), *Disagreement* (1998) and *The Politics of Aesthetics* (2004).

Dirk Schwarze is a German art critic who has been closely associated with Documenta since the early 1970s. His books include *Meilensteine: 50 Jahre documenta* (2005).

Rirkrit Tiravanija is an Argentinian-born Thai artist based in Chiang Mai, Berlin and New York, who since the early 1990s has been a leading figure in the development of relational art. Solo exhibitions and projects include Cologne Kunstverein (1996), The Museum of Modern Art, New York (1997), Secession, Vienna (2002), Museum Boijmans Van Beuningen (2005) and *The Land*, Chiang Mai, Thailand (ongoing from 1998).

Bibliography

Agamben, Giorgio, *The Coming Community*, University of Minnesota Press, 1993

Araeen, Rasheed, et al., *Remarks on Interventive Tendencies*, Danish Contemporary Art Foundation, Bergen, 2000

'Art and Collaboration', special issue of *Third Text*, vol. 18, no. 6, November 2004

Baker, George, 'Relations and Counter-Relations: An Open Letter to Nicolas Bourriaud', *Contextualise/Zusammenhänge herstellen*, Kunstverein Hamburg/Dumont Verlag, Cologne, 2002, 134–6

Barthes, Roland, 'The Death of the Author' ('La mort de l'auteur', *Mantéia*, V, 1968) and 'From Work to Text' ('De l'oeuvre au texte', *Revue d'esthétique*, 3, 1971), in Roland Barthes, ed. and trans. Stephen Heath, *Image–Music–Text*, Hill & Wang, New York/Fontana, London, 1977, 142–8; 155–64

Basualdo, Carlos, and Reinaldo Laddaga, 'Rules of Engagement', *Artforum*, March 2004, 166–9

Benjamin, Walter, 'The Author as Producer' (1934), in *Understanding Brecht*, Verso, London, 1998, 85–103

Beuys, Joseph, and Dirk Schwarze, 'Report on a day's proceedings, Informationsbüros der Organisation für direkte Demokratie durch Volksabstimmung', Documenta 5, Kassel, 1972; translated in Adriani Götz, *et al.*, *Joseph Beuys: Life and Work*, Barron's, New York, 1979, 244–9

Beuys, Joseph, 'I am searching for field character' (1973), in Carin Kuoni, ed., *Energy Plan for the Western Man: Joseph Beuys in America*, Four Walls Eight Windows Press, New York, 1990, 21–3

Bishop, Claire, 'Antagonism and Relational Aesthetics', *October*, no. 110, Fall 2004, 51–79

Bishop, Claire, 'Social Collaboration and Its Discontents', *Artforum*, February 2006, 178–183

Bourriaud, Nicolas, *Esthétique relationelle*, Les presses du réel, Dijon, 1998; English edition, *Relational Aesthetics*, 2002

Bourriaud, Nicolas, 'Berlin Letter about Relational Aesthetics', in Annie Fletcher and Saskia Bos, eds, *Berlin Biennale 2001*, Oktagon Verlag, Cologne, 2001, 40–41; reprinted in Claire Doherty, ed., *Contemporary Art: From Studio to Situation* (see below), Black Dog, London, 2004 43–9

Brecht, Bertolt, trans. and ed. John Willett, *Brecht On Theatre: The Development of an Aesthetic*, Methuen, London, 1964

Bürger, Peter, *Theorie der Avantgarde*, Suhrkamp Verlag, Frankfurt am Main, 1974; trans. Michael Shaw, *Theory of the Avant-garde*, University of Minnesota Press, Minneapolis, 1984, 47–54

Carnevale, Graciela, 'Project for the Experimental Art Series, Rosario', statement originally published as part of a series of brochures accompanying the 'Cido de Me Experimental', Rosario, Argentina, 7–19 October 1968; trans. Marguerite Feitlowitz, in Andrea Jiunta and Ines Katzenstein, eds, *Listen, Here, Now! Argentine Art of the 1960s*, The Museum of Modern Art, New York, 2004, 299–301

Collective Actions, *Ten Appearances*, 'Kievi-Gorky', Savel, Moscow Province, February 1981; translated in David A. Ross, *et al.*, eds, *Between Spring and Summer – Soviet Conceptual Art in the Era of Late Communism*, Institute of Contemporary Art, Boston/ The MIT Press, Cambridge, Massachusetts,

1990, 157–8

Collective Actions, *Kollektivnye deistviya: Poezdki za gorod* (*Collective Actions: Trips to the Country*), Ad Marginem, Moscow (1998), English edition forthcoming

Collective and Interactive Works in Russian Art 1960–2000, State Tretyakov Gallery, Moscow, 2005

Cufer, Eda, 'Transnacionala: A Journey from the East to the West', unpublished text. A variant of this essay was published in Jacob, *Conversations at the Castle* (see below)

Cufer, Eda and Viktor Misiano, eds, *Interpol: The Art Show Which Divided East and West*, IRWIN, Ljubjliana/Moscow Art Magazine, 2000, 43–58

De Certeau, Michel, *L'Invention du quotidien*, vol. 1, Christian Bourgeois, Paris, 1980; trans. Steven Rendall, *The Practice of Everyday Life*, University of California Press, Berkeley and Los Angeles, 1984

Debord, Guy, 'Separation Perfected' and 'Ideology in Material Form', in *Society of the Spectacle* (*La Société du spectacle*, Buchet-Chastel, Paris, 1967), trans. Donald Nicholson-Smith, Zone Books, New York, 1995

Debord, Guy, *Rapport sur la construction des situations et sur les conditions de l'organisation et de l'action de la tendence situationniste internationale*, Internationale lettriste, Paris, July 1957; trans. 'Towards a Situationist International', in *Guy Debord and the Situationist International: Texts and Documents*, ed. Tom McDonough, The MIT Press, Cambridge, Massachusetts, 2002, 44–50

Deller, Jeremy, 'The Battle of Orgreave', in Gerrie van Noord, ed, *Off-Limits: 40 Artangel Projects*, Merrell Publishers, London, 2002

Anna Dezeuze, 'Tactile dematerialization, sensory politics: Hélio Oiticica's Parangolés', *Art Journal*, vol. 63, pt. 2, Summer 2004, 58–71

Documenta 5: Befragung der Realität – Bildwelten Heute, ed. Harald Szeemann, Bertelsmann verlag/Documenta, Kassel, 1972

Doherty, Claire, ed., *Contemporary Art: From Studio to Situation*, Black Dog, London, 2004

Duchamp, Marcel, 'The Creative Act', lecture, American Federation of Arts, Houston, Texas, April 1957, published in *Art News*, Summer, 1957; reprinted in Robert Lebel, *Marcel Duchamp*, Trianon Press, London, 1959, 77–8

Eco, Umberto, *Opera aperta*, Bompiano, Milan, 1962; trans. Anna Cancogni, *The Open Work*, Harvard University Press, Cambridge, Massachusetts, 1989

Figueiredo, Luciano, ed., *Lygia Clark–Hélio Oiticica: Cartas (1964–74)*, Editora UFRJ, Rio de Janeiro, 1996

Foster, Hal, 'Arty Party' (author's original title: 'Chat Rooms'), *London Review of Books*, 4 December 2004, 21–2

Freire, Paolo, *Pedagogy of the Oppressed*, Continuum, New York, 1970

Gablik, Suzi, 'Deconstructing Aesthetics: toward a responsible art', *New Art Examiner*, January 1989, 32–5

Gablik, Suzi, *The Re-enchantment of Art*, Thames and Hudson, London, 1991

Glissant, Édouard, *Poétique de la Relation*, Éditions Gallimard, Paris, 1990; trans. Betsy Wing, *Poetics of Relation*, University of Michigan Press, Ann Arbor, 1997

Gonzales-Torres, Felix, interview by Tim Rollins, in *Felix Gonzalez-Torres*, A.R.T. Press, New York, 1993

Graham, Dan, *Two-Way Mirror Power*, ed. Jeff Wall, The MIT Press, Cambridge, Massachusetts, 1999

Group Material, *Democracy: A Project by Group Material*, Bay Press, Seattle, 1990

Guattari, Félix, 'The Postmodern Impasse', in Gary Genosko, ed., *The Guattari Reader*, Blackwell, Oxford, 1996, 109–13

Guattari, Félix, *Chaosmose*, Éditions Galilée, Paris, 1992; trans. Paul Bains and Julian Pefanis, *Chaosmosis: An Ethico-Aesthetic Paradigm*, Indiana University Press, Indianapolis, 1995

Hagoort, Erik, *Good Intentions: Judging the Art of Encounter*, Netherlands Foundation for Visual Arts, Design and Architecture (Fonds BKVB), Amsterdam, 2005

Hantelmann, Dorothea Von, and Marjorie Jongbloed, *I promise it's political*, Theater der Welt/Museum Ludwig, Cologne, 2002

Hardt, Michael, and Antonio Negri, *Empire*, Harvard University Press, Cambridge, Massachusetts, 2000; accessible on internet http://www.angelfire.com/cantina/negri/

Heeswijk, Jeanne van, 'Fleeting Images of Community', http://www.jeanneworks.net

Hirschhorn, Thomas, *Thomas Hirschhorn Musée Précaire Albinet*, Éditions Xavier Barral, Paris, 2005

Hirschhorn, Thomas, *24h Foucault*, artist's proposal, in *24h Foucault Journal*, Palais de Tokyo, Paris, 2–3 October 2004

Höller, Carsten, *The Baudouin/Boudewijn Experiment: A Deliberate, Non-Fatalistic, Large-Scale Group Experiment in Deviation* (2000), Project description as published in *De Witte Raaf*, no. 9, Brussels, May–June 2001

Holmes, Brian, 'Interaction in Contemporary Art' and 'Hieroglyphics of the Future: Jacques Rancière and the Aesthetics of Equality', in *Hieroglyphs of the Future*, What, How and for Whom, Zagreb, 2002–3, 8–16; 88–105.

Hunt, Ronald, *Transform the World! Poetry must be made by all!*, Moderna Museet, Stockholm, 1969

Inventory, 'On Art, Politics and Relational Aesthetics', *Inventory*, vol. 5, no. 2–3, 2005, 166–181

Jacob, Mary-Jane, *Conversations in the Castle: Changing Audiences and Contemporary Art*, The MIT Press, Cambridge, Massachusetts, 1998

Kaprow, Allan, *Assemblages, Environments and Happenings*, Harry N. Abrams, New York, 1966

Kaprow, Allan, *Essays on the Blurring of Art and Life*, University of California Press, Berkeley and Los Angeles, 1993

Kester, Grant, *Conversation Pieces: Community and Communication in Modern Art*, University of California Press, Berkeley and Los Angeles, 2004

Kollektive Kreativität/Collective Creativity, Revolver, Frankfurt am Main/Kunsthalle Fridericianum, Kassel, 2005

Kravagna, Christian, 'Working on the Community: Models of Participatory Practice', http://republicart.net/disc/aap/kravagna01_en.htm

Kwon, Miwon, *One Place After Another: Site-Specific Art and Locational Identity*, The MIT Press, Cambridge, Massachusetts, 2002

Laddaga, Reinaldo, 'Mundos comunes. Metamorfosis de las artes del presente', *Otra Parte* (Argentina), issue 6, Winter 2005, 171–3

Laddaga, Reinaldo, *Estética de la emergencia – La formación de otra cultura de las artes*, Adriana Hidalgo, Buenos Aires, 2006

Larsen, Lars Bang, 'Social Aesthetics: 11 examples to begin with, in the light of parallel history', *Afterall*, issue 1, Central Saint Martin's School of Art, London, 1999, 76–87

Larsen, Lars Bang, and Chus Martinez, Carles Guerra, *The Invisible Insurrection of a Million Minds: Twenty Proposals for Imagining the Future*, Sala Rekalde, Bilbao, 2005

Lee, Pamela M., *Object to be Destroyed: The Work of Gordon Matta-Clark*, The MIT Press, Cambridge, Massachusetts, 2000, chapter 4, 162–209

Lind, Maria, *et al.*, *Gesammelte Drucksache/Collected Newsletters*, Revolver, Frankfurt am Main/Kunstverein München, Munich, 2005

Lippard, Lucy, 'Entering the Bigger Picture', in Lippard, *The Lure of the Local*, The New Press, New York, 1997, 286–90

Morgan, Jessica, *Common Wealth*, Tate, London, 2004

Nancy, Jean-Luc, *La Communauté désoeuvrée*, Christian Bourgeois, Paris, 1986; ed. and trans. Peter Connor, *The Inoperative Community*, University of Minnesota Press, Minneapolis, 1991, chapter 1

Nesbit, Molly, and Hans Ulrich Obrist, Rirkrit Tiravanija, 'What is a Station?' (edited version accessible on internet) http://www.e-flux.com/projects/utopia/about.html

Nothing: A Retrospective by Rirkrit Tiravanija and Kamin Lerdchaiprasert, Chiang Mai Art Museum/Plan b, Bangkok, 2004

Obrist, Hans Ulrich, 'Introduction', *Take Me I'm Yours*, Serpentine Gallery, London, 1995

Obrist, Hans Ulrich, ed., *Do It*, Revolver and eflux, Frankfurt am Main, 2005

Oiticica, Hélio, 'Notes on the Parangolé' (1966), 'Position and Program' (1966), 'Eden' (1969), in Guy Brett, *et al.*, *Hélio Oiticica*, Witte de With, Rotterdam, 1992

Piper, Adrian, 'Notes on Funk I–IV', in Piper, *Out of Order, Out of Sight*, vol. 1, The MIT Press, Cambridge, Massachusetts, 1996

Purves, Ted, (ed.), *What we want is free: generosity and exchange in recent art*, State University of New York Press, Albany, 2005

Rancière, Jacques, 'Problems and Transformations in Critical Art', in Rancière, *Malaise dans l'esthétique*, Éditions Galilée, Paris, 2004

Rosler, Martha, 'Travelling Garage Sale', in Catherine de Zegher, ed., *Martha Rosler: Positions in the Life World*, The MIT Press, Cambridge, Massachusetts, 1998, n.p.

Allen Ruppersberg: Where's Al?, Magasin/Centre national d'art contemporain de Grenoble, 1996

Sartre, Jean-Paul, 'Why Write?' (1948) in *What is Literature?*, Routledge Classics, London, 1993, 26–48

Steiner, Barbara (ed), *Superflex: Tools*, Verlag der Buchhandlung Walter König, Cologne, 2003

Tiravanija, Rirkrit, 'No Ghosts in the Wall', in *Rirkrit Tiravanija: A Retrospective*, Museum Boijmans Van Beuningen, Rotterdam, 2004

Nothing: A Retrospective by Rirkrit Tiravanija and Kamin Lertchaiprasert, Chiang Mai Art Museum, 2004

Vilensky, Dmitri, and Chto Delat Group, 'What is to be done?' (2003), *Moscow Art Magazine Digest 1993–2005*, 121

Index

ACKNOWLEDGEMENTS

Editor's acknowledgements

Many thanks to Michael Asbury, Carlos Basualdo, Anna Dezeuze, Pablo Lafuente, Francesco Manacorda and Viktor Misiano. Research for this publication was funded by the Leverhulme Trust, with additional support from the Royal College of Art, London.

Publisher's acknowledgements

Whitechapel Gallery is grateful to all those who gave their generous permission to reproduce the listed material. Every effort has been made to secure all permissions and we apologize for any inadvertent errors or ommissions. If notified, we will endeavour to correct these at the earliest opportunity.

We would like to express our thanks to all who contributed to the making of this volume, especially: Julie Ault, Nicolas Bourriaud, Graciela Carnevale, Eda Cufer, Jeremy Deller, Umberto Eco, Hal Foster, Thomas Hirschhorn, Carsten Höller, Lars Bang Larsen, David Macey, Molly Nesbit, Hans Ulrich Obrist, Adrian Piper, Jacques Rancière, Rirkrit Tiravanija. We also gratefully acknowledge the cooperation of: *Afterall*, London; Artangel, London; Éditions Galilée, Paris; Farrar, Straus & Giroux, New York; Indiana University Press, Bloomington, Indiana; Kaprow Studio, Encinitas, California; University of Michigan Press, Ann Arbor; University of Minnesota Press, Minneapolis; The MIT Press, Cambridge, Massachusetts; Projeto Hélio Oiticica, Rio de Janeiro; The World of Lygia Clark Cultural Association, Rio de Janeiro.

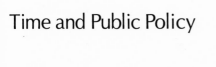

Time and Public Policy

T. Alexander Smith

Time and Public Policy

The University of Tennessee Press
Knoxville

Copyright © 1988 by The University of Tennessee Press / Knoxville.
All Rights Reserved. Manufactured in the United States of America.
First Edition.

The paper in this book meets the minimum requirements of the
American National Standard for Permanence of Paper for Printed
Library Materials. ∞ The binding materials have been chosen
for strength and durability.

Library of Congress Cataloging-in-Publication Data

Smith, T. Alexander, 1936–
 Time and public policy / T. Alexander Smith.
 p. cm.
 Bibliography: p.
 Includes index.
 ISBN 0–87049–574–7 (cloth : alk. paper)
 1. Policy sciences. 2. Time. 3. Middle classes. I. Title.
H97.S6 1988
361.6′1 – dc19 87–36554 CIP

For my mother

Contents

Preface

Over the years I have come to depend upon many colleagues in political science, but the special debt I owe to Theodore J. Lowi of Cornell University can never be adequately repaid. Not only has he been a constant source of support and encouragement, but his academic writings have exercised a profound impact upon my own thought. More than anyone else he has impressed upon me the value of theory in the social research enterprise; and in an era when social and political theory are increasingly subordinated to the demands of technique, he has steadfastly reminded us of the important things. It is a safe prediction that his scholarly output in the fields of policy process theory and the problem of interest group liberalism will long occupy a major place in our discipline.

I must also express my gratitude to various members of the Austrian School of economics. Indeed, a purpose in writing this book was to introduce more of my colleagues in political science to Austrian insights regarding scientific methodology and economic theory. In this respect Murray N. Rothbard of the University of Nevada at Las Vegas and Ludwig M. Lachmann of New York University, both major Austrian scholars, offered suggestions that were eventually incorporated into Chapters 4 and 5. John B. Egger of the Institute for Research on the Economics of Taxation carefully read the entire manuscript and tirelessly sought to help me avoid many minefields in economic theory. To these and other Austrians with whom I have enjoyed fruitful conversations at meetings of the Institute for Humane Studies I shall always be grateful.

In addition to Professor Lowi, other political science colleagues around the country have given generously of their valuable time in order to make this a better book. Aaron Wildavsky of the University of California at Berkeley, John W. Danford of the University of Houston, and Philip Abbott of Wayne State University read the entire manuscript and offered invaluable advice. Portions were also read by Alvin Abbott of New York City. Here at the University of Tennessee, Dan D. Nimmo, now of the Uni-

versity of Oklahoma, and Thomas D. Ungs read various chapters, and David M. Welborn read the complete manuscript. The latter, especially, accorded me both tolerance and kindness for a protracted period of time during which I ceaselessly burdened him with arguments about the role of temporality in social thought. I thank him for his patient understanding — and endurance. Similarly, Jon Manchip White, a Renaissance man if there ever was one, and Edward Francisco kindly read and commented upon the entire manuscript.

Cynthia Maude-Gembler and the staff of the University of Tennessee Press have been extremely patient and considerate. An author could not ask for a better working relationship. Finally I must thank Sandra Ransier and Larry Hall for providing me with crucial research assistance as well as Naina Pinkston, Irene Carney, Marie Horton, and Debra Pierce of the Department of Political Science for typing several versions of the manuscript.

Time and Public Policy

Chapter 1

Time in Human Action

An Introductory Analysis

Time both pervades our activities and makes of us its prisoners, its chains invariably constraining our actions. True liberation from its bonds is a hopeless endeavor, since opposition merely binds its subject ever more tightly. We must therefore obey its commands; indeed, social progress is to a large extent dependent upon the manner in which we adjust ourselves to time's demands. To disobey is in the long run hopeless. It is the purpose of this book to show why this is the case.

There is, of course, a substantial difficulty for any student who wishes to discuss time. Because so little agreement exists as to just what it is, much less how it is to be defined, the entire subject is fraught with conceptual difficulties. A biologist, physicist, and psychologist are each likely to view the problem in quite different ways. One writer, a psychologist by profession, identified some ten varieties of time.[1] The great sociologist Pitirim A. Sorokin gives us at least four types of time: metaphysical, physicomathematical, biological, and psychological. Each of these varieties, he believed, is explained by "sociocultural" time. For instance, we could hardly make our way in daily life without concepts of duration (such as weeks, months, years) or without certain events and rituals. Social life would become problematical, to put it mildly.[2]

The task we have set before us in this book is hardly so broad or encyclopedic as defining time. It is a more modest one of understanding the

manner by which time impinges upon public policy and the sociopolitical order. Yet, this focus does not permit us to sweep the social floor with a small disciplinary broom. Quite the contrary: The time dimension is so pervasive and penetrates the social fabric so deeply that the findings of many disciplines in the human sciences must be utilized. Accordingly, temporality will be considered as an intimate, inevitable, and indispensable element of human action. From this perspective individual action is always an intellectual thrust outward into a future stormy and unpredictable. Human choice is nothing less than an imagined point of resolution on a distant horizon. Expected as well as uncertain features form the core of our decisions, for the past is important mainly as a reference point from which the future may be grasped and made manifest. Traditional norms and values play a part in this book mainly as they influence human action geared to an imagined future. Consequently, this is a general inquiry into peoples' time horizons, about the ambiguous scarcity of time in their lives, the manner in which they allocate their time according to their "time preferences" in society, and the way the mere passage of time impinges upon their worlds.[3]

The close connection between time and human action derives from two fundamental facts of our existence: (1) we think before we act, and (2) all of our actions must take place *through* time.[4] By thinking about some desired end to be achieved, we imagine our acts as accomplished prior to their actual completion. Thus, actions are propelled by fantasized futures as yet incomplete; imagination about an unknown future is our fate. Whatever we choose to designate as the period in which our imagined projects and plans take place — the "moment-in-being," the "extended present," or the "specious present" — there can be no doubt that some period of time must of necessity elapse between the given act imagined as already accomplished and the actual completion of that particular act.

Seen from a slightly different angle, lived time in the lives of individuals is not an unduly complicated matter; indeed, we experience "lived" time as a present and fleeting instant, or succession of instants, in what G. L. S. Shackle calls the "moment-in-being." This is as true for the historian who writes of the rich past of his civilization as for the trader on the stock exchange who bets for or against a future rise in prices. Each thinks in the present but imagines the future-to-come, since choices at heart must be present thoughts about future events. This fact of existence complicates our lives, because the decisions we make in the course of elapsed time are carried out in the absence of knowledge about the decisions of others. The

temporal calendar ultimately confirms some choices while disconfirming others.[5] It is for these reasons that the concepts of *expectations* and *uncertainty* are essential tools for the social scientist. Let us therefore briefly consider these two concepts.

The mind's intellectual thrust into the future is an act of imagination, since the mind cannot know with sureness what unfolding events will bring. Action in the real world is therefore predicated upon expectations. In imagining a future act as having already been accomplished, we are guided by nothing less than "expectational time."[6] But what determines our expectations? In general, they are a product of previous experiences, but since each of us experiences the past differently, we also filter data in special and divergent ways. It is hardly surprising that divergent "biographies" among individuals lead to contrary expectations. In the real world each of our plans must be continually altered when faced with changed circumstance, and in the process of changing plans, new expectations are forever being formed.[7]

In stressing imagination, however, we must not exaggerate the volatility of expectations. Our social worlds, as Alfred Schutz argues, are by no means continually in flux. We take our surroundings mainly for granted, since "society" has previously structured the environment for us. Consequently, our projects, plans, and, of course, our expectations are based upon typical occurrences: We anticipate that such-and-such event will recur since it has occurred with some regularity in the past. Particular experiences which previously proved successful—whether carried out by us as individuals or communicated to us by others (either directly or indirectly)—become a vital part of our commonsense thinking about the everyday world. There is naturally far less assurance of typicality in the buying of equities on a stock exchange than in the posting of a letter, but in both instances we expect the recurrence of a typical constellation of facts or events. To a participant on a stock exchange the relevant facts of the situation are far less apparent, more contradictory, and in fact subject to sudden change, but the dependence of our expectations upon typical modes of thought is apparent in each case.[8]

Implied in the haziness of expectations is the notion of uncertainty. Between a period when an elaborate plan or a single projection of intent as the imagined accomplished act is first advanced and the time of actual completion of the plans or project reside any number of obstacles to success. Uncertainty is therefore inherent in social life, itself created by the passage of time and by diverse and changing values. As we previously ob-

served, in developing our plans we cannot know the choices others are even then making or are likely to make in the future. Time is a tyrant: Unfolding events may completely contradict our initial expectations. Unexpected change, ignorance, faulty knowledge, and the decisions of others over time become decisive elements in the social world. The elapse of time forces alterations in knowledge, but as knowledge is altered, the world is also changed.[9]

Conversely, we by no means flounder in complete uncertainty. As we have just seen in the case of expectations, recurrent typicality informs our experiences as commonsense thinking about the everyday world. Moreover, social institutions reduce uncertainty by providing signposts to which we may orient our actions. They may be utilized as either means by which we accomplish our ends or obstacles which must be avoided or somehow got around. At any rate, they increase predictability in human events. Indeed, a major theme in this book is that by neglecting the limitations inherent in time we have needlessly weakened support for institutions which would otherwise facilitate predictability in our lives.[10]

So far we have considered time in terms of individual actions. Thus, decisions and choices are seen as creations in the solitary moment and as being made under conditions of stark uncertainty. The expectations upon which decisions are based depend upon contradictory, changing, and multiple data. Indeed, that actions occur "over time" or "through time" is sufficient in itself to create a highly unpredictable world. This brings us to a second approach to temporality which we shall employ in this book. Decisions are made not only in relative darkness, but likewise are determined under conditions of inherent *scarcity*. Thus, temporal existence places the individual decision-maker in a double bind: in one case, bound by ignorance; in the other, not so much by a lack of knowledge as by the scarcity of a "product." From this perspective time is like any other good which must be economized. If we aim at certain ends or values, we must perforce abstain from the attainment of others. If we devote our energies to some activities, we obviously cannot give time to others. Think of the most mundane examples: There are only so many hours in a day; we all eventually die; and even if we lived in a paradise of unlimited consumption, we should still be faced with a fundamental problem of which goods to consume as well as the order in which to consume them.[11]

This second feature of time from the standpoint of individual choice—its inherent scarcity—plays a pivotal role in this book under the designation of "time preference." Time preference (or time allocation) involves

choosing to satisfy desires in the more immediate as opposed to the more distant future. In terms of duration it is the preference for the "sooner" as opposed to the "later." Other things being equal, we wish to have our wants satisfied in the present rather than in the more distant future. If this were not so, we should not have expressed the particular preference we did in fact express. Thus, in a formal sense the glutton and saint alike demonstrate time preference, albeit of a very different kind, since in the process of acting, each orders his or her own ends and values.[12]

What determines our time preferences? In the everyday world, as opposed to the formalism of economics, these preferences are governed by such forces as habit, self-control, length and certainty of life, regard for offspring and posterity, and even the nature of fashion. They may be altered in various ways: the growth of habits which encourage us to prepare for the rainy day; an educational emphasis upon self-control; the formation of habits supporting frugality; an increase in life expectancy; incentives, tax or otherwise, to provide for offspring and for future generations; and modifications in fashions. These and other factors act upon one another in complex ways and hence influence the ratio between present to future goods in the community. For example, in a nation where thrift is highly valued, time preferences may be said to be relatively "low." Where consumption is clearly evident, however, they may be said to be "high."[13]

Where markets are free and unhampered, the time preferences of a community reflect what is called "originary interest" or the "pure rate of interest."[14] According to Ludwig von Mises, originary interest is "the ratio of the value assigned to want-satisfaction in the immediate future and value assigned to want-satisfaction in remote periods of the future. It manifests itself in the market economy in the discount of future as against present goods." Indeed, originary interest determines the demand for and supply of capital and capital goods. In the long run we do not save and accumulate because there is a rate of money interest to be paid on the loan market; rather, we save because we value future goods more highly than present goods. Therefore, if the originary rate of interest is "high," relatively more people prefer present goods to future goods, but if it is "low," future goods are valued more highly than are present ones.

This view of time preference and its offshoot, originary interest, as developed chiefly by the "Austrian School" of economics, would at first glance seem to hold no special interest for noneconomists—indeed, this notion has been ignored by the vast body of social scientists. The method is highly formal, lending itself in the main to the study of "mere" eco-

nomic phenomena. By telling us that time preference is embodied in every action—that in the process of acting we automatically display its existence—the Austrians simultaneously seem to give us too much and too little, a theory logically tight but so formal and truistic that it has little applicability in the "real" world.

Undoubtedly, Austrian time preference theory gives little attention to the nature or "content" of time preferences. When it boldly states the universality of time preferences, Austrian theory does not explain why people in fact value and choose different temporal "lengths" or horizons. It does not tell us why, in the process of acting, different individuals select plans that require different waiting periods of time in order to bring such plans to fruition. To select a course of action is to display time preference, but the quality of a particular action is subject to personal norms and values.

It is at this point that other social scientists may find the Austrian theory quite pertinent to their own concerns, above and beyond the discipline of economics. For as a psychologist recently pointed out, the ability to defer gratification is probably influenced most strongly by a secure family environment, interpersonal trust, and the feeling that waiting indeed has payoffs.[15] Why, in the course of our lives, will some among us display preferences which involve waiting, patience, persistence, and delay, whereas others will display contrary sentiments and insist upon instant gratification? Why will one person value frugality and abstinence, another profligacy and concupiscence? Why will one value self-reliance, another government support? In short, why are some of us characterized by "long" time horizons whereas others display "short" ones? If, as the Austrians claim, time preference is a universal phenomenon inherent in each action, it surely behooves us to follow their lead but also to go another step, namely, to analyze the causes and consequences of our time horizons as they exist in our social and political worlds.

It is therefore obvious that the manner in which we allocate time is strongly conditioned by our social and cultural milieu. As should be apparent from subsequent chapters, our orientation toward time influences our views about ideology and policy, ultimately affecting both the quality of our lives and the material prosperity of society. Let us reflect a moment. Can it not be argued that our time horizons make us more or less impatient with the circumstances in which we find ourselves? Do they not determine the manner in which we allocate our time resource between immaterial and material "goods," between the spiritual and the physical? Do not time horizons influence the kinds of work we choose to do? Are they not

conducive to our abilities to initiate, continue, and finally complete our projects? More broadly, are not many of our more noble attainments dependent upon the ability and willingness to wait, to postpone, and to persevere in our endeavors? Are not economic and social policies, legal systems, and even political ideologies influenced by the way in which we approach and "handle" time?

Let us give two political examples. Suppose the political order is overwhelmingly dominated either by zealous reformers of the political left or by provincial reactionaries. The one promises and may seek to deliver immediate benefits, whereas the other denies its people any benefits of "modernity." It does not take much imagination to predict unfortunate social, economic, or political consequences in each instance. Or suppose, secondly, that political demagogues seek immediate amelioration of economic conditions through wholesale alterations in income and inheritance laws. Since the ability of large numbers in the community to save and accumulate the necessary capital goods *over time* is threatened, it is to be expected that a short-run redistribution of resources will lead to long-run deprivation. This is a problem with which developing nations are constantly faced, for as a rule short-run attempts to redistribute resources result in delayed economic growth.[16]

Time, Diversity, and Political Institutions

Since it was necessary to flesh out the basic facts of time and its relation to action, our analysis has been rather formal and abstract. Some readers may be inclined to find the "atomistic" individual of classical economics lurking just beneath the surface, while others may charge that human diversity and change have received too much attention at the expense of consensus and stability. Such misunderstandings may arise because we have so far said little with regard to government and social structure. In order to remedy this deficiency we shall turn our attention to the role that institutions, particularly politically related ones, play in human action and time. Thus, constitutional and legal systems as well as public policies make a great deal of difference in the way the diversity of ends and values is managed within the political community.

Let us not exaggerate individualism or diversity in society. Human action is varied but not completely random by any means. Most of the members of a society are hardly aware of, much less exist in, a state of "rugged

individualism" or "atomism." Ours is a world taken largely for granted. We did not create it but were simply born into an environment previously structured for us. It is, in many ways, a commonsense world in which typicality reigns. Our personal histories, "our stock of knowledge at hand," are indeed different, but experience nonetheless leads us to ascribe a typicality to things and events. Our anticipation of the future encourages us to believe that certain kinds of behavior we have observed or believe to have occurred in the past will repeat themselves in the future. Habit and tradition make us rule-following creatures no less than rule-creating ones. Reciprocal expectations among individuals are as a consequence built upon *typically performed prior acts*: Because I have observed that individuals and role occupants have previously behaved in rather predictable ways, I may reasonably anticipate that they will behave in a familiar way in the future when faced with similar situations. It is out of reciprocal relationships based upon typicality that most social institutions arise.[17]

Let us consider the general relationship which obtains between individual plans and purposes, on the one hand, and institutions, on the other. Institutions, as L. M. Lachmann has argued, are relatively permanent structures to which we orient our personal plans in a more or less unpredictable environment. They are means by which we realize our ends, or, conversely, they provide obstacles to our goals. Either way, our plans must take them into account. Institutions are therefore *signposts* guiding the way for us. It is for this reason that constitutional forms in particular, but also many political or economic structures, are so resistant to change. Such change, after all, produces too much uncertainty for too many people.[18]

This raises a question which lies at the heart of this book: What kinds of institutions are most compatible with the demands of time and human diversity? Or, how can the inevitability of diversity in ends and values be reconciled with the need for predictability in our everyday lives and simultaneously favor the creation of lengthened time horizons? This problem may not exist so much in mundane activities, but the manner in which it is tackled in the more public arenas may have a profound impact. We shall argue that since special kinds of structures mesh best with particular kinds of time orientations and human activity, how key elites answer these questions goes far in determining the health of the social order.

A basic theme running through this book is that a congruence between the demands of temporality, diversity of values, and institutional arrangements is most likely achieved (1) when social norms and values are oriented more strongly to future ends than to present gratification; (2) when

free markets predominate in economic life; and (3) when the "rule of law" and clearly defined policy rules govern the political community. To put it another way, socio-cultural, economic, and legal-policy realms must dovetail in special ways if individual freedom and prosperity are to be preserved.[19] Let us consider briefly each of these areas of human activity.

Sociocultural values and norms which stress future rewards over present wants are basic elements in economic dynamism and capitalism, although at a superficial glance they seem to have little to do with economic activity *per se*. Yet, what we may call the "Bourgeois Ethic" traditionally placed much store in such virtues as patience, abstinence, and thrift. Furthermore, in stressing the necessity for hard work and devotion to task as means to augment one's capital and the position of one's family, the traditional bourgeois inadvertently assumed a significant role in the economic development of the West. Many scholars believe that these values have now been gravely eroded by secular changes within the bourgeoisie and by temptations of material prosperity; that is, that capitalism has sown the seeds of its own destruction.[20] We, too, shall address these well-known factors which have contributed to the loss of bourgeois cultural and political hegemony as they related to family, class, and morals. However, we shall go further and accord special attention to certain ideological tendencies which have received less interest in the scholarly literature, for these, too, have undermined bourgeois individualism and the role of the entrepreneur-capitalist.

Thus, the almost universal disparagement of the "Economic Man" of classical political economy as a short-sighted, selfish creature at war with the common good is an intellectual error which must be combated. To the contrary, the failure to appreciate the overall tendency for Economic Man, *when left to his own devices,* to orient his activities to long-run activities ultimately valuable to the community-at-large is misunderstood on the left as well as on much of the right of the political spectrum. Thus, both left and right often sanctify the moral position of political roles at the expense of economic ones, assuming that the former are somehow more noble, uplifting, and conducive to the general welfare. This myth so pervades the discourse of historical, political, and economic studies that it is today accepted as a fact of life.

Similarly, not only intellectuals but also ordinary citizens wish to believe that they possess special insight into the future. They extol even as they sometimes fear the advent of what is known as "postindustrial society," a social order characterized by continual social change and tech-

nological innovation. In effect, they perceive that ideas, morality, and property relationships are the slaves of technology. But given their obsession with modernity, the postindustrialists often neglect older values which have brought unexcelled prosperity to the West and without which "modernity" itself would soon end. They consequently advocate policies calculated to undermine the very type of socioeconomic order they expect to evolve. We speak in this connection of their misunderstanding of free markets, private property, savings, and capital accumulation.

This same point may be made with regard to what we designate as the "age of promissory politics." This term aptly describes an era in which demands upon the state by its citizens—or upon "society," as people conventionally say—have grown all out of proportion to the ability of economic and political institutions to meet those demands. Expectations for immediate gratification derive not only from the more traditional interest groups hoping for subsidization and protection, but also from a citizenry which repeatedly finds its sense of justice offended when a more equitable distribution of material resources is not forthcoming. As a consequence, intellectual opinion today is less concerned with the extension of liberty *from* government than with redistribution of resources toward those who can claim relative deprivation. Not surprisingly, political power becomes the means to effect this end, so "freedom" in this context generally means the defense of political rather than economic liberties. Thus, the denial of any "right" to opinion, assembly, or press is met with universal condemnation from elite opinion, whereas infringements upon freedom of contract and rights to property are routinely denied by legislative bodies and courts. When one combines the "preferred" political rights with an ideological deification of political participation ("participatory democracy"), the way is open to politicize areas of life traditionally outside politics.[21] And the link which binds center and periphery is the modern political party in which government and opposition parties vigorously compete in outpromising one another that the "just society" is immediately around the corner. It is hardly surprising that so many critics are to be found defending party "reform" and "responsibility."

As we shall see in later chapters, the decline of the Bourgeois Ethic and the rise of ideologies which disparage economic roles, the tendency to treat technology as if it were an independent force in its own right, and the efforts to place promissory politics and the institutions which support it at the center of political life are attempts to circumvent the demands of temporality. Free markets play an equally important part in rounding out

our picture of the social order congruent in terms of temporality, diversity of values and ends, and institutional forms. Thus, in the economic realm unhampered markets provide the best means for coping with the diversity of producer and consumer tastes and knowledge. Pricing systems coordinate consumer preferences by directing land, labor, and capital toward our more urgent needs. Market institutions give us another significant benefit: Prosperity and relatively free markets are closely related, as a quick glance around the globe ought to suggest. Similarly, free markets provide a necessary, if not sufficient, condition for political freedom and diversity. Thus, a close correspondence also may be observed to exist between political and economic liberty. Over the long run each tends to reinforce the other. In this sense the various forms of "interventionism," so prominent in "liberal" and social democratic circles, do not really address the problem of diversity. In fact, they assume in the main that the two freedoms are not all that closely connected, that the public is best protected when markets are either closely regulated or in certain instances eliminated altogether. Whereas many interventionists are staunch defenders of "human" rights—or, rather, "political" rights—they remain indifferent to the protection of "economic" liberties.

Consequently, free markets contribute to congruence in the social order because they facilitate coordination of diverse tastes and values and harmonize well with noneconomic, political freedoms. It is hard to see how political freedoms could long exist in a world in which the liberty to offer one's services for hire as well as to buy and sell property is seriously impeded. This brings us to our last element of congruence, namely, that political and economic freedoms function best within a legal system which adheres to the rule of law. Within this tradition, according to Friedrich A. von Hayek, Michael Oakeshott, and others, good law possesses, among other things, the qualities of generality, certainty, equality. Moreover, it is indifferent to the specific purpose for individuals and groups. It is fundamentally a negative concept, since its "general" rules tell citizens what they *cannot* do, not what they *must* do; so long as they obey general rules, people are free to pursue their own ends and values.[22]

On the other hand, policy rules appear to contradict the rule of law notion on its face, since policies almost automatically allocate resources of various kinds among *selected* groups, thereby presumably violating the principles of "generality" and "equality" alike. Yet, as we shall argue, policies properly constructed in their essentials may partake of rule of law qualities, both in the ideological and statutory sense. That is, norms and

values which characterize the rule of law may in varying degrees carry over into the realm of policy. That welfare or educational policies, for example, can be framed so as to reflect the rule of law ideal may at first be difficult to accept; but, as Theodore J. Lowi has argued, the rule of law properly belongs to the realms of legislatures and bureaucracies no less than to judicial bodies.[23] This is not to deny, of course, that policy rules differ in function from legal rules, since the former usually apply to groups instead of individual cases, are of necessity more flexible, and are obviously more subject to shifting social and political currents than is the "judge-made" or "lawyer's" law developed in common law courts. Nonetheless, we hope to show that policy rules, properly developed, differ profoundly in ideal and practice from the "discretionary law" and "flexible" policy practices of the interventionist age. Indeed, without discretionary rules the modern socialist and welfare state could hardly otherwise accomplish its purposes.[24]

How does temporality enter our discussion of congruence? To put it simply, long time horizons are part of the sociological glue which holds together the various "subsystems" we have been discussing. Since we may call upon a rich social science tradition, it is easier to perceive the effects of time horizons in the sociocultural sphere than in the other areas. Thus, social values and behaviors which encourage us to look favorably upon future gains as opposed to present gratification have been subjected to analysis by such giants as Weber and Freud. Trust in the future, the desire to perpetuate one's family, frugality, and a belief in hard work, for example, are just a few of the values oriented toward the future with which we shall be concerned. Even the propensity to save and invest, while admittedly subject to pecuniary incentives found in the marketplace, is strongly influenced by sociocultural conditions.[25]

However, it is when the roles played by free market institutions *per se* and by rule of law and policy rule norms and values are considered that we find ourselves on less well-trodden ground. Nonetheless, it seems clear that these institutions implicitly reward certain kinds of temporal behaviors while punishing others. Rules almost by definition reproach individuals, ideologies, and policies wedded to the quick social "fix," since rules *ordinarily* stand in the way of people who would bend the system to their own individual ends. It is for this reason that claims for "equity" and cries for redistribution are hurled at them. Institutional devices and procedures which support individual freedoms in the marketplace with stable, clear-cut rules tend to work against immediate gratification by telling us implicitly not to expect too much for the moment from the larger society.

It is only when one cleaves consistently and ideologically to the image of the greedy speculator or business predator that this argument appears to lose plausibility.

Once we focus upon the demands of groups, not individual market participants, a quite different picture emerges. It is therefore mainly the *group* claims of trade associations, industrial unions, and public employees, for example, which are opposed to inflexible rules and the outcomes of market allocations. It is these interest groups which in overwhelming numbers pressure public authorities to change the rules in their favor—and now. Unhampered markets work their will slowly, affecting individuals and groups unpredictably, diffusely, and at different speeds as consumer needs change and relative prices rise and fall. It is of course the task of interventionist ideologies to thwart this process; and since the benefits unhampered markets generally bestow upon the public cannot be gauged in terms of their *immediate* effects, they offer little social support or reassurance to us in the short run.

To the extent that people are equipped with short-run lenses and due to the universal fact of time preference, it does not take much insight to see that a government-created occupation or subsidy carries more moral weight with us than do impersonal market allocations. Benefits to consumers come slowly and quietly, not as chunks of goods delivered with fanfare and derivable from a specific source. On the other hand, we by no means always take intellectual positions according to whether or not a reward is to follow. Interventionists are not necessarily egoists or hedonists, but they can more easily marshal arguments which juxtapose short-run solutions to social problems with a call to "common sense" against opponents who are stuck with appeals to the long run and to "reason."

This point may be made in the case of a public works project enacted by government for the purpose of reducing unemployment. In this instance citizens are immediately put to work, and unemployment figures may quickly fall. Cause-and-effect is there for all to see—or to think they see. Conversely, what is *not* seen are the more important data, since market defenders cannot rely upon hard "empirical" data to defend their position. Their arguments are essentially the following: A public works program diverts resources from more urgent needs, since new taxes may be required to put additional people to work; the project is to be financed by borrowing from a limited pool of capital, so investment in plants and equipment cannot be directed to other, more urgent areas of the economy; inflation will ensue if the program is funded by dollars run off on government print-

ing presses; and, overall, the program misallocates labor and capital since it does not reflect the wishes of consumers. These arguments are grasped by a process of economic reasoning; they cannot be proved empirically in the way one proves an increase in employment by pointing to increased payrolls.

A high regard for the virtues of waiting time and the presence of well-functioning markets, we shall argue, are best suited to a legal system strongly influenced by rule of law norms and values. Short time horizons and interventionist policies, on the other hand, accord most easily with a more flexible, discretionary system of rules. To say that a given system is based either upon "rules" or "discretion" is a rather gross generalization, or what Max Weber first called "ideal types." "Rules" and "discretion" are polar opposites which existing legal systems more or less approximate. In fact, legal systems in liberal democracies display mixtures of rules and discretion by adhering in varying degrees to rules. After all, a system based completely upon discretion would in no way protect democratic liberties. In general, conservative governments in Great Britain or in the United States are arrayed — or rather, are arrayed in lip service — on the side of fixed rules to a greater extent than are "socialists" France and Sweden. However, the most we may say from an empirical standpoint is that each political order possesses certain general features in terms of its attitudes toward time, its levels of economic and social intervention, and its legal norms and values.

It has been observed that preference either for fixed rules or for discretionary authority in the law carries along with it powerful ideological baggage. Thus, to stress individual rights and to denigrate the power of the state leads one to advocate fixed rules, whereas a concern with equality of condition and social justice induces support for more flexible and "pragmatic" forms. What is less well understood is that these divergent norms and values in the law also suggest divergent notions about time. The tension is particularly evident in the charges leveled at the common law by modern jurisprudence. The common law, that most faithful concrete embodiment of the rule of law ideal, is ridiculed by opponents as "static" or "rigid," unable to "change with the times." Furthermore, they say it is class-based, consistently serving the interests of business. As a result, it has proved inadequate to the task of ordering complex industrial societies, so, not surprisingly, it has been progressively supplanted in the course of the past hundred years by "law" made in legislative bodies and administrative agencies.[26]

These criticisms of the rule of law are themselves influenced by particu-

lar temporal notions. In one way or another it is the static and timeless quality of the common law which so irritates our modern jurists and politicians; and because the older law possesses this timeless quality, it naturally stands in the way of what many consider "progress." As a consequence, a major function of the common law is to *slow the tempo of social and group-directed political change.* If progress is to come, it must be within the context of individual actions rather than state or group actions.[27] This function to reduce the pace of change may be seen in just two of the major characteristics of the rule of law: namely, "equality" and "certainty." First, to treat each person equally before the law prohibits the law from treating each person unequally in the present in order to gain a desirable equal result at some future date, as is today done with regularity, for example, in cases of economic redistribution and "affirmative action" quotas based upon race or sex. Secondly, the concept of certainty implies *long-run* certainty; that is, that the law must be known. But knowledge of the law will be minimal, if the law cannot last for relatively long periods of time. It is hardly surprising, therefore, that rule of law advocates look with dismay upon the modern proliferation of statutes and administrative rulings, since an outpouring of "laws" and regulations makes a mockery of certainty. Finally, if the output the "laws" produced by legislatures and agencies grows over time, it is quite likely that the principle of equality will be violated, since legislators and bureaucrats necessarily exercise discretionary power in allocating economic and other resources.

The belief system which inspires a defense of the rule of law also predisposes one to adopt a similar outlook in public policy. Unfortunately, public policy must inevitably be a rather pale copy of the rule of law, since it can never be free of coercion in the same way legal rules are said to be noncoercive. One cannot speak of "equality before policy measures" in the same way one speaks of "equality before the law," since policies aim at given ends and involve purposes which necessarily help some groups and individuals at the expense of others.[28] Yet, the coercive elements in the political order may not only be minimized by reawakening once again a respect for the rule of law as traditionally understood and by limiting the functions of the state, but by bringing policy more into line with the rule of law norm, discretionary authority may be eliminated from many areas of political life. It is by considering sociocultural, economic, and legal policy areas that we hope to contribute to the ongoing debate about the kinds of institutions most likely to support a free and prosperous community.

The Uneasy Alliance of Social Science,
Social Philosophy, and Public Policy

The concepts of time and human action as presented above give us a somewhat messy social universe, one much less manageable and cohesive than many social scientists like to admit. We open a window on human action which is inherently expectational and oriented to an uncertain future by suspending man uneasily between past and future. Although the future can be imagined, it is kaleidic and therefore cannot be predicted with much accuracy. What keeps the elements of uncertainty in bounds and satisfies our need for order are the various institutions to which we orient our individual plans. Obviously there must be some congruence between the diversity, unpredictability, and uncertainty of human action, on the one hand, and the institutional roles, values, and norms on the other. Institutions which do not allow for human diversity and also limit individual planning to utilize permanent structures as a means for achieving some predictability lead to both political and economic instability. It is the proper "mix," no less than politically glamorous policy reforms, which must draw the attention of social scientists.

The approach to social phenomena utilized in this study is heavily dependent upon both that tradition associated with the so-called Austrian School of economics and the phenomenology of Alfred Schutz. As a result, it deviates from dominant trends in the social sciences. Whereas we have no desire to write a general critique of social science methodologies, it is necessary to observe that approaches ostensibly neutral may nevertheless have important policy consequences, several of which we shall encounter in later chapters. Thus, we must adumbrate briefly the manner in which our approach differs from the more orthodox schools of social philosophy and social science.

First, by conceptualizing time as inherent in all human action, we force the problem of temporality to the center of understanding in the social sciences. Most models, however, are essentially static thought-constructs which appear to make "reality" stand still. There is nothing in itself wrong with assuming a static world for research purposes, but when the notion is reified, it can lead both to group intellectual distortions of reality and to bad policy. Even in some instances in which given models may lay claim to "dynamism," it is quite common to find the changing elements upon which they are based moving in a rather uniform manner. This is particularly true for certain "longitudinal" studies.[29]

Although the charge of neglecting time applies with special force to certain approaches popular in sociology and political science, notably so-called "systems" and "structural-functional" orientations, it is made with increasing frequency about the queen of the social sciences, economics. Thus, the imposing "equilibrium" model of neoclassical economics has recently received scathing criticism. Critics allege that to ignore the market as one of process and change is to impose unrealistic assumptions about economic life upon the data; and that to view events as departures from an imaginary equilibrium where all economic forces are in perfect balance places the proverbial cart before the horse. How one gets to a state of equilibrium (if one ever does) is the real point at issue, not how one departs from a state of imaginary rest. Such assumptions, it is argued, lead to bad policy prescriptions, antitrust action being a most notable case in point.[30]

In general, the highly formalized style of neoclassical economics with its questionable assumptions has often left other social scientists rather cold, although its foundations have been attacked with great vigor in the profession itself. It is significant that some of the most severe critics of modern economics are precisely those economists who make change and time central to their approaches.[31] Thus, the assumption that knowledge, resources, and tastes are somehow given to "rational" individuals who in turn seek to "maximize" income or some other aspect of economic life, has been increasingly called into question; or, the utilization of probability theory in decisions which are in fact made in vast uncertainty has drawn its share of criticism; or, finally, the vast technical literature which seeks scientific truth through the employment of statistical aggregates and functional relationships, it is contended, assumes a timeless world in which variables are, as it were, collapsed into a formal mold.

Several popular versions of social thought have reached significant sections of opinion untouched by more orthodox models. They have therefore played a larger role in ideology and policy. One thinks especially of the "postindustrial" or "technological" theories of society.[32] In one sense the view of time in these popular theories is hardly novel or sophisticated, since the future unfolds inexorably into an age of technological marvels and material abundance. On the other hand, their notion of change is interesting: Time is forever being "shortened" in our lives as we seek to anchor our thoughts in events and objects subject in fact to ceaseless alteration. The political importance of the postindustrialists comes from two major sources: their influence upon large numbers of intellectuals rather

than upon social scientists alone, and the ideological and policy implica-
tions inherent in their vision of the future. Weaving various Marxist and
Keynesian threads ever so delicately into its conclusions, the postindus-
trialist's ideal is now so much a part of influential opinion that its ideologi-
cal impact is scarcely noticed; its assumptions are so much a part of ordin-
ary discourse that its radical policy implications go undetected and are
consequently acceptable to various shades of political opinion. Moreover,
postindustrial theory relies upon statistical aggregates as do the more "scien-
tific" theories, but never so lavishly as to threaten its influence with broad
sectors of intellectual opinion. On the other hand, not only is its idea of
temporality at odds with that previously offered, but its methodological
holism makes it antagonistic to the necessary role markets must play in
emitting pricing signals in complex social orders. Indeed, not individual
actors, but technological forces (here we see a Marxist impulse) move
across the social stage as if they were actual living organisms: "technostruc-
tures," "postmaterialist," "society," "classes." Therefore, people bound by
uncertainty and time scarcity are nowhere to be found.

It ought to be clear by now that an approach which makes of time and
uncertainty a basic social problem would find little in common with politi-
cal ideologies based upon collectivism on the far right or left. That is, our
stress upon diversity and unpredictability, upon the relatively low levels
of knowledge available to individuals, at face value implies a rejection of
massive government planning and/or nationalization of the means of pro-
duction. Planning from the top assumes that future events will unfold more
or less as they have done in the past and that sufficient information clearly
exists at the political center to coordinate individual units in the public
interest. That the elapse of time causes knowledge to change and that "one
mind" can process sufficient information to make centralized decisions is
highly problematical.[33]

But neither does our model coexist easily with the moderate interven-
tionist ideologies and policies found today in most Western democracies.
Interventionists seldom support massive planning of economies but in fact
take what they consider "pragmatic" approaches to issues of policy. For
example, moderate socialists at present generally resort to transfer pay-
ment schemes rather than to nationlizations in order to effect their ends.
They are, nevertheless, generally on the side of "income policies," wage-
price controls, "guidelines," "indicative" planning, controls over agricultural
production and other subsidies and regulations. Interventionism assumes
that governments possess sufficient knowledge to control the direction and

pace of change, but the failures of price supports and production quotas in agriculture, of income policies, of minimum wages, and so forth demonstrate their failure to perceive the importance of *secondary consequences* of social programs.[34]

The sharp line social scientists like to draw between the social sciences and "normative" studies may not be so simple a matter as many of them suppose. Scholars naturally prefer to think that their work rests on its own merits, far removed from ideological or partisan policy considerations. It often leads them to the conclusion that "facts" and "values" are clearly distinguishable. In fact, particular types of political philosophies and social science methodologies may grow out of ideological perspectives, lending themselves to certain kinds of policy values; or, conversely, social science and public policy naturally possesses an element of arbitrariness, as Marxists have long known and as their opponents have increasingly come to recognize.[35]

Let us look at an example. Holistic methodologies have much more in common with ideologies and policies based upon interventionism or collectivism than does our approach. Thus, if one takes an holistic view and conceptualizes, say, "technology" or "classes" as independent forces in their own rights—as standing somehow outside and above the activities of mere individuals—or if one looks not to the subjective preference of individuals but to such economic concepts as "aggregate demand" or "aggregate income," it is hardly surprising that the resulting policy prescriptions will differ from those of one who supposes individuals and their idiosyncrasies to be the basic reality in social analyzing. Whereas the latter finds diversity and unpredictability in social life, the former is more prone to discover order and predictability. On one side generally reside the defenders of markets and "rules," on the other side, market interventionism and "discretion." In either case the implications for policy are rather apparent.

The Plan of the Book

In the following chapters we shall have occasion to note the tendency for social philosophy, social science, methods and techniques, and public policies to overlap in significant ways. Although this tendency is too seldom admitted by its practitioners, there is little doubt that ideologies and policy prescriptions often lurk in the background of social science concerns. In this instance it is all too easy a trick to make good social science

become good public policy. This in itself is not necessarily a bad thing, but when the ideological or policy biases of the social scientist go unseen, or when they are based upon a misunderstanding of social and economic "facts," the result has too often been one of foolish social engineering. An aim of this book is to call attention to tendencies which often masquerade as "objective" science.

We shall draw generously from the various social science disciplines. Time and human action, it goes without saying, accept no disciplinary boundaries. Sociocultural, legal, economic, and political spheres are interdependent, acting and reacting upon one another in complex ways. Thus, one cannot be a political scientist, a sociologist, or an economist alone; for better or worse one must be all three. There are, of course, dangers in this approach, since all forest and few trees can lead to gross distortions in reality.

In subsequent chapters we shall address the following problems. Chapter 2 underlines the association between the loss of bourgeois hegemony in this century and growth of ever-higher time preferences in family, class, and culture. In Chapter 3 we assess the most fundamental facts of economic existence as they relate to the allocation of time. We accord special attention to errors in policy which result from the failure to comprehend these basic facts.

The next three chapters delve into the roles played by various ideological orientations in temporal derangement. Thus, in Chapter 4 we attack the myth of "Economic Man," a concept clung to with tenacity by political philosophers, social scientists, and historians alike. We seriously question their assumption that economic roles are somehow characterized by shorter time horizons than are political ones. Chapter 5 assails the ideal of "postindustrial society," a conceptualization whose basic attributes are widely accepted by sophisticated intellectual opinion but which is actually rent by contradiction. Chapter 6 lays much of the blame for the rapid growth of shortened time horizons on the phenomenon of "promissory politics." The argument is put forth that, paradoxical as it may at first appear, a major source for short time horizons derives from what are usually considered virtues in democracies: Increases (quantitatively and/or qualitatively) in political participation and the existence of highly competitive party systems, legitimated by the ideals of government and party "responsibility."

Chapter 7 offers some reforms which, we hope, point the way to a "policy culture" more attuned to the demands of time. We shall concentrate

especially upon the roles played by free markets and fixed rules in these matters.

In Chapter 8, finally, we suggest various possibilities for future research relating to the part played by time in various fields of human endeavor. In addition, we assess the basic problems encountered by modern people inherently torn between the contradictory demands made upon them by their roles as producers and consumers.

Chapter 2

The Bourgeoisie at Bay

Some Nonpolitical Sources for Time Horizons

This study is devoted mainly to the role time plays in the more public domains of economy and polity. It is primarily a study in public policy. But we must remember that experiences closer home probably have the stronger influence upon our conceptions of time. Our daily lives are much more under the sway of family, peer group, church, or class than under the impact of public questions. it is the agents of socialization which are most likely to form our attitudes and values regarding the extent to which we practice restraint, delay gratification, and in general value future as opposed to present goods. True, the literature about the impact of various agents of socialization upon time preferences is at best sketchy. Nonetheless, indirect evidence and various clues provided by diverse scholars point to family, class, and cultural values as primary sources for our time horizons. In this chapter we shall discuss the role played by these primary structures.

The theme which pervades this book is that our time horizons have changed radically in the modern era. If this is true, this higher time preference ought to be reflected in family, class, and cultural values and norms. Perhaps a useful but somewhat crude way to grasp the nature of this change is to contrast the present era with the heyday of capitalism, notably the nineteenth century (give or take a few years in the preceding and succeeding centuries). The earlier period was under the dominance of what is

known as the "bourgeoisie" or "older middle classes." Today that class and its ethics are in full retreat. As a social force it no longer dominates nor sets the tone for Western societies. It can no longer impose its values, including its conception of time, upon other groups and classes.

Admittedly, the concept of "bourgeoisie" or "older middle class" is an "ideal type," a mental construct of the kind utilized by social scientists to comprehend complex phenomena. In reality, ideal types are seldom found anywhere in pure form, but as mental constructs they give us a useful standard by which to comprehend differences between groups. What, then, were some salient characteristics of the "bourgeois"?

First, ownership and control of property were closely intertwined. The successful bourgeois, unlike their present-day counterparts, were both owners and managers of their firms; indeed, the separation of ownership and management within the modern corporation, which is so characteristic of our age, was largely absent from their world. Independent and often self-made, the older bourgeois controlled their own fate. Within their firms their word was law, their authority not in doubt. They ran their businesses according to their own desires, subject only to the changing demands of compromises in the market. Not inherited rank and status, but sheer ability and perseverance gave them their place in society, or so they believed. Their modes of operation within their firms or offices were therefore highly individualistic. The same could be said for the source of their income and the nature of their profession. They were financiers, merchants, brokers, rentiers, or lawyers, not white-collar managers, technocrats, or professionals employed in the large legal, medical, accounting, or educational factories of today.

Second, financial independence gave them mastery of their environment in other ways. They were, in David Riesman's words, "inner-directed," unlike the "tradition-directed" way of the peasant or the "other-directed" modern. They themselves reared their children with a strong sense of purpose and direction toward work and family. Their "internal gyroscope" told them, if necessary, to defy peers and in some instances traditional norms, so determined were they to succeed and behave according to their own rigid standards.[1]

Thirdly, and especially important for our purposes, the culture which the older bourgeoisie dominated and the values it forged within the social order were particularly favorable to lengthy time horizons. It is thus not surprising that the ascendancy of the bourgeoisie coincided with a marked growth in capital accumulation. It thus idealized and to a great extent

lived by values and norms which have been described in terms of thriftiness, hard work, diligence, self-reliance, independence, and restraint. Moreover, this culture was family-centered. Sexual continence, if not always followed, was nonetheless regarded as an ideal, and the family in general was well protected by custom and law. Not surprisingly, much consideration and care were given to the future generations. Indeed, to a large extent property was devoted to perpetuating the fortunes of children and grandchildren, and to effect these ends, saving and capital accumulation, rather than consumption, were duly idealized. These values were in turn sanctioned in religious theory and practice.

Finally, the bourgeois ideal was one of balance and moderation—of the golden mean. Extremism and excess were to be avoided. Change was possible, but only within the context of law and order. Both for religious and practical reasons, the senses were closely controlled, not given free rein. On the other hand, some degree of mastery over nature was deemed perfectly acceptable, so progress within the limits of this world was valued. These virtues were not so likely to elevate one to great deeds—these more often belonged to aristocrats or intellectuals—since they placed restraints upon innovation and the passions, but neither were they calculated to lead to stagnation.

It must be emphasized once again that the bourgeois model has never existed anywhere in pure form. Yet, individuals who possess many of those attributes we characterize as "bourgeois" have played a most important part in Western social life over the last two or more centuries. Their beliefs, values, and norms and their temporal outlooks have profoundly influenced other individuals and groups in the general population. Not surprisingly, the decline of the bourgeoisie, on the other hand, has coincided with an alteration in the temporal ideal. Our changing time horizons may be readily observed from recent and rather staggering changes in family, class, and cultural life. In each of these areas we observe a marked decline in the power and influence of people and ideals who, in our opinion, have contributed so much to our present prosperity and freedom.[2] Thus, a brief comparison of the bourgeois model with our present social structures and ideas suggests that the road we have traveled for the past century has taken us a long distance from bourgeois temporal notions and ethics.

Family Influence

The family undoubtedly plays a key role in the development of time horizons. As the primary agent of socialization, it is the chief mediator between the individual and the outside world, so none of us escapes its pervasive influence. For example, in politics alone it can be said that the party one supports, the interest in political matters, the degree of interpersonal trust, and trust for leaders and institutions are largely learned within a family context.

In the eighteenth and nineteenth centuries it was the bourgeois model of family life which came to dominate the Western world. The family in that period was a rather tightly knit unit. Roles were sharply defined between mother and father, between home manager and breadwinner. The somewhat aloof father, while authoritarian in manner and a strict disciplinarian by today's standards, deferred to his wife in her own area of expertise and in general intervened only intermittently. Middle-class children were certainly not disciplined so harshly or indifferently as in the working classes, nor were they treated with so much emotional distance as was the case with the aristocracy. In matters of economy the bourgeois family stressed savings and thrift—hence property—primarily as a method to protect the family unit in an inhospitable world: "For the aristocrat, ownership of property is not crucial; an aristocrat ruined is still an aristocrat. But a bourgeois without property is no longer a bourgeois."[3] In its desire to preserve and enhance the family, the bourgeoisie was sometimes prone to financial timidity. In France, for example, it had a special proclivity for investments in gold, state bonds, and land, but little taste for the more speculative, but often socially necessary, ventures. Although an element of fear was surely involved, the tendency itself suggests a propensity to delay present gratification in favor of future generations.[4] Joseph A. Schumpeter's observations, as usual, are apt: "The capitalist order entrusts the long-run interests of society to the upper strata of the bourgeoisie. The bourgeoisie work primarily in order to invest, and it was not *so much a standard of consumption as a standard of accumulation* that the bourgeoisie struggled for and tried to defend against governments that took the short-run view. *With the decline of the driving power supplied by the family motive, the businessman's time-horizon shrinks, roughly, to the life expectation.*"[5]

The bourgeois family as a model worthy of emulation has been called into question throughout this century, but in recent years the opposition

has come on like an avalanche. Indeed, opponents of bourgeois norms and values have severely shaken the confidence of parents, for the traditional belief that parents can and ought to assert their own authority over their children has been severely tested. The peer group, of course, has long posed a threat, but never more so than in our age. Moreover, parents are no longer the only "experts" to be found regarding the rearing of children: Medical and welfare professionals have to a large extent come forward, placing a strain upon parental confidence.[6]

The decline of the bourgeois family, we suggest, is strongly associated with the altered temporal horizons of our era. Thus, those values which encourage us to lay aside present "goods" for the future are located in the initial instance in the healthy family. In the first place, the manner in which we come to view authority in general and ultimately our respect for law and order within the larger community are strongly conditioned by familial factors. It is the family which provides children with limits against which they first test the world. In this respect it is initially the father as authority figure who plays a dominant role. But when, as at present, family and father are weakened and held up for ridicule—i.e., when their authority becomes problematical—children are thrust back upon their own resources. Cast adrift in a sea of normless "law," they fail to develop a healthy respect for authority. Consequently, in later life they are likely to evolve in one of two directions: Law and authority are either felt to be illegitimate chains deserving of every contempt or, conversely, feared and hence phantasized as all-powerful.[7]

One need go no further than the rebellious students of the 1960s for confirmation of such attitudes towards authority. Massive demonstrations were conducted against leading university authorities and political figures. Nothing seemed to stand in the way of student radicals. At the same time the most elaborate conspiracy theories were hatched to explain the oppressive nature of "Amerika" and its political regime, as rebellion and fear grew side by side.[8] *Yet systems of authority, whether personal and informal or whether established in law, function as restraints upon immediate gratification.* They encourage us to respect the needs and rights of others; they teach us about "society's" rights; they systematically refuse to treat us as the indulgent parent treats the spoiled child by giving in to the youngster's temporary whims. In a word, they guide and color our temporal horizons.

One may adduce various long-term and secular explanations for the erosion of parental authority, including industrialization, technology, or

"capitalism." Undoubtedly, with the shift from agriculture to urban life, with a growth of the division of labor and an extension of markets, and with an increase in social and geographical mobility, the bourgeois family was bound to undergo changes. Add to these pressures the continuation of inflation and, to a lesser extent, unemployment and one has the combustible elements for institutional upheaval. The dominant position of the father, the traditional role of the wife and mother, and the importance of children all come under increasing scrutiny as the settled life of rural communities is exchanged for a turbulent urban existence.

The decline of rural populations is a fact of momentous importance, since it raises the costs of child rearing to the family unit. Rural children traditionally begin to work on the farm at an early age. Furthermore, their food, clothing, and shelter as a rule are produced on the farm itself. It is therefore not surprising that birth rates tend to fall when societies undergo transformations from rural to urban settings.[9] Children in urban communities, however, are far more costly to rear. Not only are food, shelter, and clothing more expensive, but longer schooling and a more limited number of available jobs mean that children are unable to supplement family income. It is therefore not surprising that families would have fewer children.

Finally, we live in an era when life expectancy extends into the seventies or eighties and beyond. Given the costs of medical and old-age insurance, elderly parents, unable to care for themselves, may well impose a staggering burden upon the family incomes of their own children. For their part children may find their own savings depleted for their own twilight years. From their standpoint the time and the expense necessary to devote to parents may inhibit their own desire to have more children. "By the mid-twentieth century," Marvin Harris has concluded, "the costs and benefits of rearing children showed a lifetime deficit, a deficit that has become increasingly severe."[10]

Thus, if children become financial burdens to parents, the latter will in all likelihood have fewer children. In the United States, especially, this trend has accelerated in recent decades as rising prices and the temptations of the "consumer society" have placed severe pressures upon the family breadwinner. Thus, in order to supplement family income, wives, usually encouraged by their husbands, began to enter the work place. Whereas many women at first took part-time positions, it was not long before they sought full-time employment. As a consequence, two-income families multiplied.

The entry of women into the workplace in large numbers has impor-

tant consequences. Predictably, the population growth in Western nations has declined as women either delay or abjure childbirth altogether. Thus, in the West we are no longer reproducing ourselves. Indeed, the problem is serious enough in the United States, but it has assumed alarming proportions in such nations as West Germany, Sweden, and France. Obviously, the economic implications of these demographic factors are frightening. For one thing, through their payroll taxes and other transfer payments, younger workers will be increasingly called upon to assume a much larger share of the cost in support of retirees in particular and of an older population in general. This projected growth in transfer payments in turn may well force a reduction in savings and capital accumulation and, as a result, encourage an increase in social tensions. If one adds to this problem the continuation of inflation and the natural desire of couples to augment their present standards of living, then children may be seen by married people as an even greater burden in the future than at the present.

Moreover, as women increasingly left the home for the workplace, either on a part-time or full-time basis, it was to be expected that the family unit would undergo strain. Husbands, ever eager to have the family finances supplemented by another income but not always ready to participate in the housework and other duties at home, were resented by wives who themselves contributed heavily to the monthly check but were nonetheless expected to shoulder the major burden in caring for children and house. Similarly, in the workplace women found themselves being paid far less by male employers than men received for similar kinds of work. Such discrepancies in pay undoubtedly contributed to those seething resentments which subsequently led to the feminist revolution. It is significant that this revolt began little more than a decade following the end of the postwar baby boom (1957), at a time when large numbers of women had begun to enter the work force.[11]

Several factors may therefore be linked to the "revolution of rising expectations" found among women in the 1970s and beyond. We must take special note of those financial pressures which first led wives to enter the workplace. Such pressures were bound to undermine the role of the husband as authoritative head of the family. After all, he was no longer the sole breadwinner, his financial dominance was no longer complete, and his wife's horizons were not so likely to be restricted to the home itself. Growing financial independence and decisions about whether to have children thus made women less likely to endure unhappy marriages. As their professionalism and expertise grew, increasing numbers of them were less

willing to accept subordination to males on or off the job. Husband and children came to be seen not so much as a necessity but as an alternative to a professional career. Values and norms likewise now underwent changes regarding premarital sex, abortion, contraception, and living together without benefit of clergy. Finally, we must remember that discontent in the areas of social and political life affected the quality and tone of the demands of both feminists and less ideologically committed women for redress of their grievances. Thus the Civil Rights Revolution and the war in Vietnam influenced the thought and behavior of women.

Unfortunately, the growth of personal choice and freedom has its negative side as well. If women are less willing to tolerate disagreeable husbands, it appears that the latter have themselves come to desert their spouses in unprecedented numbers. Divorce increases in the Western world at an alarming rate. In the United States alone, every other marriage now ends in divorce, and one-parent families grow apace. One-third of all stepfamilies will also separate. The social and financial effects upon mothers and children are particularly alarming. "On the average," Lenore Weitzman observes, "divorced women and the minor children in their households experience a 73 percent decline in their standard of living in the first year after divorce."[12] It is estimated that as of March 1984, the mean annual income for intact households with children was $30,615 but only $12,290 for homes headed by divorced mothers.[13] If these trends continue it is obvious that more mothers and their children will fall into poverty.

The incidence of poverty among children themselves poses an especially serious problem. Children in poverty at present form an even larger group than do adults similarly situated. For more than a decade now inflation and declining rates of productivity have struck with particular force at the incomes of families in which breadwinners are young or middle-aged adults. The incomes of these parents have grown far more rapidly in recent years than have the incomes of older adults dependent primarily upon transfer payments, notably social security as well as interest or private pensions.[14] If such trends continue, it is altogether possible the time horizons of growing numbers of children will be adversely affected.

Which brings us to the nub of the temporal difficulty. The problem is that the erosion of parental authority in general and the authority of the father in particular play a strong part in the way children come to regard the future. More than three decades ago, David C. McClelland concluded that both the need for achievement and long time horizons were most often found among children in middle-class and upper–middle-class house-

holds in which a father was present.[15] More recent studies confirm his observation. Thus, those families where the father is present, where the interpersonal environment is trusting, and where the family is not locked into poverty tend to produce children who display a willingness to defer present gratification for future gratification. On the other hand, a willingness to defer gratification may be strengthened or attenuated by subsequent socialization experiences. Not only is the peer group an important agent, but it is important that the child or adolescent believe that waiting is likely to prove beneficial in the future. Not unexpectedly, middle- and upper–middle-class children are more optimistic about future possibilities. Schlomo Maitel has summarized these findings:

Apparently a time-preference rate is psychological baggage each of us carries through life, which varies with age and circumstances, differs widely from one person to another, and has enormous influence on our life-cycle decisions. Ability to wait is, according to recent empirical findings from psychology, learned in childhood, is part of the process of socialization and can be permanently altered.[16]

We have already mentioned some of the implications of reduced population growth in major Western democracies. Does this trend not possibly reflect a pessimism with regard to the future? This is, after all, an age of atomic weaponry and economic insecurity. The observation that a people simply loses faith in the future has been made more than once, especially in France between the wars. But there is something more involved: A conscious decision to rear children is a commitment to subsequent generations. It is a stake in the distant future, a desire to work for the maintenance of others who come after you. Conversely, a decision against children most likely reflects a turning inward upon the self. It is an ego-centered attitude linked with the present. Unencumbered by children, the childless couple is free to devote itself to the pursuit of present goods.

Writing in 1979, Gail Sheehy noted that young professionals in their twenties were postponing a decision to marry and to rear families: "While older men assume immediate responsibility and postponed gratification, young men want it turned around: gratification now and responsibility later."[17] Themselves children of the Affluent Age, they take prosperity for granted, yet paradoxically feel it may elude them in the end. They are permeated with "self-absorption." They are in the main unhappy, although one would expect the freedom they profess to desire would have given them happiness. As Sheehy puts it: "If the full strength of the postponing generation's brain- and will-power remains harnessed always and exclu-

sively in the service of self, what becomes of our social contract? How far will we . . . deteriorate into fractious fights over securing our own place in the sun so that we can drift off into fantasies of self-fulfillment?"[18]

The forces which led to the erosion of family strength also apparently affect sexual behavior. Indeed, given not only the tendency to delay marriage but the decline of religion, rampant divorce, contraceptive methods, and the high numbers of unmarried people in general, we should expect to find important changes in sexual mores. As a general rule, the relaxation of sexual codes may have marked effects upon total cultures. Sigmund Freud himself argued that the basis of civilized behavior is dependent upon limitations being placed upon sexual behavior. Some years later, in his study of preliterate peoples, J. D. Unwin similarly observed a close connection between sexual continence and cultural creativity. He noted that prenuptial freedom decreases as one moves from the most primitive or "zoistic" orders to the most "rationalistic" ones. In the more advanced societies, marked relaxations in sexual codes are followed in about three generations by a decline in creativity and expansion.[19]

Pitirim Sorokin, himself an admirer of Unwin's work, argues that throughout history the more creative and dynamic cultures have been characterized by strong family life and sexual continence. In general, sexual continence coincides in ancient and modern societies alike with creativity in the arts, literature, religion, philosophy, and law. He qualifies his argument, however, by asserting that the highest levels of creativity seem to occur in periods immediately following some relaxation of strict prohibitions against sexual freedom.[20] Finally, he explicitly points to a strong correlation between sexual continence and future "goods," between controls over sexual desires and time allocation. A community which makes of sex an "easy" thing misallocates its time resources: "Any notable achievement requires long training, persistent labor, and concentration. . . . The result is that little time and energy can be spent in pursuit of sexual thrills."[21]

Although the relation between class position and temporal horizons is discussed in the next section, it should be noted here that the breakdown of the family not only alters class positions of present and future family members, but also plays a vital part in class temporality. For example, whether the family is strong or weak can influence the income, occupation, and hence the class to which one belongs. Family and class, of course, may be separated for analytical purposes by the scholar, but both in reality are woven into the social fabric. Thus, when we study poverty in the midst of affluence we learn something about classes, but we also discover that

various family attributes correlate with certain class or economic characteristics. In general, disorganized families—that is, those in which the father is absent—are more likely to produce children who are prone to short-sighted demands for immediate gratification. Similarly, such children are more likely to be subject to narcissistic and criminal behavior. Can it be doubted, therefore, that disorganized families contribute to reduced life-chances for their members, both in the present and in the future, since broken families are less likely than intact ones to perpetuate values conducive to lengthened time horizons? In all likelihood members of the lower class will remain where they are, the middle-class offspring will remain static or, more probably, experience downward mobility, and the society as a whole will display a less dynamic material and cultural development.[22]

It appears that family disorganization and hence short time horizons are especially prevalent in areas where poverty exists. But we must be careful, for the problems of impoverished inner-city neighborhoods exist not only because income is low—in fact, it has increased—but also because so many fathers have deserted the home. Violence, drugs, and lawlessness—all attributes of short time horizons—are mainly a consequence of broken homes and of the failure of "male socialization" into family and organizational life. Just as the youth who commits crime is violent, performs poorly in school, and drops out of the educational system cannot control his present-oriented impulses, so his adult counterpart—often his father or the male who spends time with his mother—cannot alter his own time preferences. The latter leaves home, deals in drugs, remains unemployed, or shifts from job to job. Both father and children, bereft of the bourgeois ideals of drive and hard work, will as a result tend to work less on the job than will people from other classes.[23]

In modern America, unfortunately, family breakdowns seem to be spreading into the more prosperous and comfortable areas of social life, albeit in less volatile forms. Although the evidence for white middle-class juvenile delinquency is probably understated, there is little doubt that suburban crimes are increasing at an alarming rate. As many writers have noted, because their incomes are lower and because they lack the authority of a male, such families are responsible for a large percentage of deviant behavior. For, as Christopher Lasch has observed, the rest of American society has come to resemble a "pale copy of the black ghetto."[24] The failure of middle-class youth to internalize parental authority, to test itself against parental authority (especially that of the father), leads to situations in which immediate gratification takes precedence over future satis-

faction. To such youngsters the future becomes fearful and unpredictable. Not surprisingly, they place a large value upon toughness and noncommitment. Indeed, this "attraction of black culture for disaffected whites suggests that is now speaks to a general condition, the most striking of which is a *widespread loss of confidence in the future.*"[25]

Public officials and academics located at various points along the political spectrum are aware that something must be done to put the family aright. Strangely, students of political theory have devoted precious little thought to this problem. "Rational individualism," that variant of liberalism propounded by such giants of the modern Western tradition as Hobbes and Locke, offers us little help in our endeavors to relate the family to the political life of the community.[26] As an individualistic ideology, "liberalism" has been mostly indifferent to values which lend strength to the family unit (affection, emotion, etc.). Indeed, one commentator has concluded that the socioeconomic inequalities which grow out of the different educational, class, and status benefits provided by families are simply incompatible with liberal notions of "justice" and "equal opportunity."[27]

Thus, we perforce muddle along, caught between so-called "traditionalists," on the one hand, who would brook no state interference with family rights and who readily accept those inequalities which derive from differences in family resources, and between those social democrats and modern liberals, on the other hand, who support efforts by the social service state to assume a variety of traditional family functions as the only way to overcome our more egregious social and economic inequalities. Indeed, the former conclude that such undertakings as aid to dependent children, food stamps, housing, medical, and other benefits have sapped family vitality and contributed to that very poverty they aim to eliminate.[28] On the whole, however, these arguments have failed to convince political elites in Western democracies that meaningful alternatives to present welfare systems exist. In general, they would prefer to keep the present system, albeit improving its administration and effectiveness.

As it is, family reform is not easily placed at the top of the public agenda. One searches in vain in the Tax Reform Act of 1986 in the United States for support to raise the standard deduction for dependents by appreciable amounts. It is possible, however, that our tendency to stress concrete reforms may sometimes blind us to social complexity. We must remember, after all, that the family is heavily influenced by other human and institutional relationships. For instance, educational problems, neighborhood decay, and local government policies impinge strongly upon the family. A

wise policy would seek to relate reforms in these areas to their likely effects upon family vitality itself.[29]

In sum, political, attitudinal, and financial forces are arrayed against the bourgeois middle-class family as we have known it. The demands of the "consumer society," feminist values, altered notions regarding who works and who stays home, and a reluctance to have children increasingly lead both spouses to enter the workforce. Thus, the division of responsibilities within the family in which the husband works outside the home and the wife cares for the children is seen today with less frequency. Beset by inflation, high taxes, and often looked upon as an oddity in an age of divorced and single-parent families, the traditional family finds itself under siege. No doubt where parents jointly contribute to the family income, we may find children well-provided for, in at least the material sense. But whether such children and those from divorced and single-parent homes can readily adapt to modern life is more problematical.

In the United States, especially, we see that since 1965 the middle-income groups have shrunk as the two extremes of the income levels siphon off individuals in the middle. At the top one sees a growing number of families in which both spouses are employed in full-time and well-paid positions; at the bottom are families headed by unwed and divorced mothers. Hanging on tenuously to middle-class life-styles or skirting the fringes of poverty are many young and married couples with two or more children whose sole family provider is the father. Unfortunately, high payroll taxes, inflation, and declining productivity strike at these families at the moment when they most need financial help in support of their children.[30] This is hardly the social matter from which values conducive to the formation of long time horizons are fashioned.

The New Middle Classes

An approximation of the bourgeois class model described in the opening paragraphs of this chapter no longer exists as a force either valued or emulated widely in the modern West; it has been progressively replaced by different models. Frugality, self-reliance, moderation, independence, and devotion to family and future generations are more frequently questioned or ignored in daily life by large elements of the population. An occupational life oriented to hard work, long-term saving, and production

rather than immediate consumption is increasingly derided. Modernity has therefore undermined the bourgeois economic and social base, that is, the family structure which functioned to preserve other aspects of bourgeois existence. The changed social and cultural atmosphere is nowhere more apparent than are alterations within the middle class itself.

But what is class? It has been defined in various ways, such as by amount and source of income, type of education, kind of occupation, patterns of consumption, or patterns of deference. Sociologists as a result have divided and subdivided classes or "status" groups in many ways in their attempts to make sense of that world which Marx simply separated into bourgeoisie, proletariat, and aristocracy. Marx's world was, of course, an oversimplified one even for his own time, but class divisions and gradations are far more complex today. Our century alone has witnessed the disappearance or decline of many groups since the nineteenth century: an entrepreneurial class based upon relatively small firms, great landholders replete with titles, a downtrodden and very large industrial proletariat, a large peasantry, and a significant rentier class.

Although "classes" have by no means completely disappeared, they have progressively yielded to a large and rather amorphous "middle." Usually referred to as the "white-collar class" or the "new middle class," this middle includes everything from clerks, technicians, salesmen, and middle-level managers to upper-level executives. Of course, the income, status, and deference the new middle-class people receive vary enormously. Indeed, many in the new middle classes are hardly as well off as industrial workers. Moreover, unlike the past, income, occupational prestige, and education often show less correspondence than in the past. In this respect, one need only think of a rich car salesman, a relatively low-paid professor, or an impoverished member of an old and distinguished family. Money, occupational prestige, and status may in these cases diverge sharply. What does give a degree of unity to the new middle class is its connection through salaried positions with large organizations in the private and public sectors. Unlike the old bourgeois entrepreneur, merchant, professional, or artisan, this middle class works for someone else.

Implied in the notion of the new middle class is the view that attitudes, opinions, and beliefs have somehow become more homogeneous in Western societies. Distinct upper, middle, or lower classes blend into many and relatively fluid layers of social stratification. This observation is hardly a novel one. The decline in basic industries with their large blue-collar

working forces looking suspiciously upon their bourgeois "betters" and the sharp rise of a white-collar dominated "tertiary" sector in the West have attenuated class tensions.

Similarly, the rapid growth of mass consumer goods industries has made products available to ordinary people which were once reserved for the rich alone. And just as blue-collar and white-collar groups are no longer quite so distinctive as in the past, so rural and city worlds come to resemble each other more closely in attitudes and behavior. Modern transportation not only brings the farmer or peasant into contact with the city, but of even greater significance, the rural population itself has diminished. In general, then, the development of modern industries and salaried positions have reduced the size, role, and importance of "old" class groupings. Furthermore, national television, geographical mobility, and the breakdown of regional values have made their contribution to this state of affairs by reducing local distinctions. Finally, mass education, itself a powerful leveler of differences based upon class or status, is no longer the exclusive preserve of the privileged, even in Western Europe.

Although it is readily apparent that inferences regarding temporality are to be discovered in the numerous studies of class, it is also clear that the relationship between the two has hardly been an overriding concern among scholars.[31] For example, Schumpeter, Mills, and Hacker, while writing at different times and from diverse perspectives, referred only in passing to the temporal characteristics of the new middle classes. Each, however, clearly recognized that their time horizons had changed over the years. Indeed, a theme has recently emerged to the effect that the white-collar group of the "new middle class" is less willing to save and invest, is less pious and religious, is less devoted to family continuity, and in general is more concerned with immediate consumption.[32]

Thus, from Schumpeter's perspective this change is likely to end in socialism and economic stagnation. For Mill, on the other hand, the rise of the white-collar group means a lowered quality of life and culture as well as the dominance by those who occupied the more powerful positions in the government and corporate life. In Hacker's opinion we today witness an end of the "American era" of leadership in the world: Self-centeredness is triumphant; we are a nation of "200 million egos" (at least in the United States). "More" is continually being demanded from government and economy; affluence is taken for granted in a society where economic hardship is thought to be a thing of the past. Indeed, affluence and economic se-

curity are now perceived almost as an inalienable right, every bit as inviolable as guarantees of worship or privacy.

The government supports these new rights by protecting citizens from the vicissitudes of the marketplace. Since it draws a salary, the new middle class, unlike outdated classes of merchants, artisans, and businessmen, has little appreciation for the swings of the business cycle. Its position gives it little personal knowledge of profits *and* losses (the same may also be said of the modern working class). Salaries thus go up, but seldom, if ever, down; and merit—which everyone "knows" but seldom defines—not consumer satisfaction and preference, is felt to be the proper determinant of wealth and income. Like the traditional state bureaucrats, it values credentials and "rational" criteria as opposed to market rewards.[33] We must not forget for a moment that the salaried position of the modern middle classes creates a whole different set of incentives, attitudes and beliefs. The traditional bourgeoisie, on the other hand, was much more dependent upon land, relatively secure stocks and bonds, and independent ownership of property. Thus, the *type* of property and the *source* of income reinforced support for the family and future generations. Property can be left to heirs; salary cannot. Family continuity and stable property in turn required frugality and high rates of saving as opposed to lax habits of consumption.

Yet the temporal horizons of both old and new middle classes have received far too little attention from scholars.[34] Probably the most systematic effort in political science to analyze classes from the standpoint of time preference is that of Edward Banfield.[35] Banfield distinguished four classes in the United States—upper, middle, working, and lower—each of which is defined in terms of its ability to lay aside present gratification for future goals. Thus, to take the polar extremes, Banfield's lower class is present-oriented, living for the moment and forever indulging itself in crime, violence, and sex. Conversely, the upper class is more prone to interest itself in the provision for future generations. Unlike the lower class, which lives from moment to moment, the upper class quite willingly sacrifices its present desires for its children or grandchildren, its profession, its community, and even such abstractions as "mankind." Self-confident and independent, the typical member of the upper class is given to a high degree of self-expression.

The middle-class individual, on the other hand, is not so future-oriented as is the member of the upper class. Less devoted to future generations

or to community affairs and less favorable to unconventional modes of self-expression, the middle-class individual is primarily concerned with "getting ahead" in a profession. The working-class individual, in contrast, expects little from the future, and very likely expects to be old by the age of fifty. Unlike either the upper- or middle-class individual, the member of the working class has scant expectation of college-educated offspring. Moreover, the worker is little disposed to self-expression or unconventional behavior and, indeed, may be hostile to others who display such conduct.

Banfield is particularly concerned with "lower class culture" and what he sees as its strong devotion to immediate gratification. He argues that the sources of poverty in the United States derive not so much from racism as from an inability on the part of many poor people to plan their futures. For instance, schooling and preparation for a meaningful occupation require a postponement of thrills and leisure pursuits in favor of sustained concentration, work, and abstinence. But high time preferences are by no means always found among lower income groups alone. Some of our more privileged individuals and groups — at least in terms of status and income — themselves possess very high time preferences. In fact, Banfield is at pains to explain that *income* is not the sole determinant of our temporal horizons. Indeed we observed in the previous section that modern middle-class life to some extent has come to resemble ghetto existence in terms of family breakdown, sexual promiscuity, drug dependence, violence, and crime. Banfield confirms this observation from a somewhat different perspective. He notes that large numbers of present-oriented individuals are found in the one place we might least expect to discover its existence: in upper-class groups.

But does this argument not contradict his initial definition of "upper-classness"? Not if we take into account that individualism so characteristic of Banfield's upper class. Thus, many upper-class individuals show a strong propensity for self-expression and nonconventional behavior. Taken to extremes, self-expression and nonconventionality can easily lead to self-centeredness and self-indulgence. Highly individualistic and/or hedonistic pursuits may replace those internal restraints necessary for the attainment of long-term goals. Turning inward upon themselves, many upper-class individuals may become extremely present-oriented. Upper-class individualism thus takes on many of the attributes of lower-class behavior. From this point only a short step in reasoning is required to conclude that extremes — here, of class — may indeed find some common ground in their temporal

horizons. So different in income, status, and taste from the upper class, the deprived and downtrodden nonetheless find a commonality of attitudes with the inhabitants of the richly furnished homes of modern suburbia.

Alterations in Culture

As the Bourgeois Ethic has declined, a lower estimation of values associated with waiting time has come to pervade modern family life and class behavior. In the case of culture we note similar temporal trends. Religion, ideology, art, and literature today express quite different notions of time than in the periods of bourgeois dominance. We now discover a stress upon "change" and novelty instead of continuity, the short run instead of the long run, an impatience with "things as they are" in political and social life, and, overall, a much higher valuation upon present "goods" than upon future "goods."

The decline of religion in our lives has undoubtedly played a role in altering our time horizons. The structure of values we possess, the manner in which we look to the future, the respect which we accord various institutions, the way we treat others, our willingness to accept authority, and the degree of impatience we express regarding the ups and downs of daily existence are all strongly affected by religious tradition. Indeed, the impact of religion can hardly be exaggerated, for as one writer has aptly remarked: "In a secular epoch we sometimes overlook the ways in which our ancestors' entire culture . . . was expressed in religious terms.[36]

We might best comprehend the role of time in the religious practices of the traditional bourgeoisie by comparing them to potential extremes. That is, if certain highly traditional cultures and religions think only of tomorrow, whereas we moderns increasingly live only for today, the traditional bourgeoisie may be said to have sought a meaningful balance between the needs of both worlds, the one of today and the one to come. This tension, of course, has long led aristocratic Tory and socialist alike to deride bourgeois culture as hypocritical and to delight in the apparent contradictions of orthodox middle-class life styles. This criticism derives in part from bourgeois fence-straddling between the demands of religion and those of making a living and getting ahead in the everyday world. On the other hand, the bourgeoisie did achieve a reconciliation of sorts: It stressed God and Eternity but did not deny itself the benefits of the material world. It was necessary to renounce—but not too much!

In this respect the idea of the "Protestant ethic" compels attention. As developed mainly by Max Weber, this historical interpretation claims that Calvinism and other Protestant sects provided the necessary impetus for the development of modern capitalism. Thus, for the Calvinist, one's "calling," trade, or profession carried religious significance. Since one's occupation was religiously meaningful, it required diligence, attention to detail, and devotion to task. But how was one to be sure that one's efforts lived up to the requirements of God? Worldly success provided powerful evidence. Not surprisingly, under such circumstances thrift came to be stressed. Thrift was, of course, favorable to the growth of one's personal enterprise, but it had as well the unintended effect of facilitating the formation of capital in the larger community.

The extent to which the Protestant ethic "caused" capitalism or the degree to which Catholics themselves possessed similar values has been a subject of sharp debate. H. R. Trevor-Roper persuasively argues that Catholics forced out of their homelands by the Counter-Reformation were also imbued with the "Protestant" ideal of the calling. Catholics from Italy and Flanders found their way into Switzerland and Holland respectively, and there provided much of the impetus for Swiss and Dutch capitalism. If we see the impact of Dutch Calvinism upon Northern Germany, Denmark, Sweden, or America, we must not forget the initial role played by these Catholics and, indeed, by Jews and Catholics driven from Spain. "Although Weber was no doubt right to see in the idea of 'the calling' an essential ingredient in the creation of capitalism, he was undoubtedly wrong in assuming this idea was a purely Protestant idea," claims Trevor-Roper.[37]

This controversy need not detain us here; suffice it to say that the traditional bourgeoisie, whether Protestant or Catholic, attached great store in individual responsibility, diligence, thrift, and saving. Devotion to calling was more highly valued than leisure or play, and, as supported by religious sanctions, these values and norms, when internalized, were conducive to the sacrifice of present goods for the sake of future goods. Lord Keynes, whose own ideas did so much to undermine the bourgeois order, clearly perceived, if rather cynically, the relationship between religious principles and economic prosperity:

For a hundred years the system worked, throughout Europe, with an extraordinary success and facilitated the growth of wealth on an unprecedented scale. To save and to invest became at once the duty and the delight of a large class. The savings were seldom drawn on, and, accumulating at compound interest, made possible the material triumphs which we now all take for granted. The morals,

the politics, the literature, and the religion of the age joined in a grand conspiracy for the promotion of saving. God and Mammon were reconciled. Peace on earth to men of good means. A rich man could, after all, enter into the Kingdom of Heaven—if only he saved. A new harmony sounded from the celestial spheres.[38]

Despite its war against Church and priestly prerogatives and sometimes a sympathy for theories of the universe quite inimical to received doctrine, the traditional bourgeoisie on the whole retained a strong attachment to the churches and Christianity. The forces of pluralism and secularism, however, were not to be deterred indefinitely, and the uneasy alliance between the European middle class and established churches could not be sustained over the long haul. Even as bourgeois culture flowered in the eighteenth and nineteenth centuries, the churches slowly but surely lost their preeminent positions, and in some nations, notably France, anticlericalism was decidedly strong. Especially important causes of religious disintegration were the rise of science and scientific thought, industrialism, and mass education. In due course values were secularized, relativized, and pluralized.

Religious certainty thus crumbled. Indeed, the decline of the Judeo-Christian faith left in its wake an intellectual and spiritual void from which the West has not yet recovered. "I think it possible to suggest that the decline of the belief in personal immortality has been the most important political fact of the last hundred years," Irving Kristol has recently reminded us.[39] This erosion of religious foundations could not help but have a powerful impact upon family and associational life, and with the onslaught of mobility, industrialization, and urbanization, the individual was cast adrift in a diverse and normless world of change and competing values. Loneliness and alienation—truly modern themes in our literature—developed within the context of religious breakdown. Protestantism, it has been said, especially subjects us to chiliastic movements and often political extremism under appropriate social conditions. Moreover, our need for self-esteem—in Carl L. Becker's words, for the "heroic"—does not take easily to an age of growing cosmic uncertainty. After all, what could make us feel more insignificant than a realization that with the end of this life everything is snuffed out, meaningless? Christianity enabled Western mortals to deny their own mortality, but once science and change had rendered this view increasingly obsolete, something else had to be put in its place.[40]

The vacuum left by the erosion of faith has been filled mainly by politics and political ideologies. Religious grace was gradually exchanged for political grace, religious truth for political truth. "To go to the root of things,"

says Robert Nisbet of our era, "is to go to its politics."[41] Not surprisingly, in our day political ideologies have achieved a position of great moral weight. They may be either moderate or extremist. Both moderates and extremists are opposed to the old religious ways, but their tactics and strategies differ greatly. Thus, the moderates do not so much confront religious tradition directly as subtly undermine its role and legitimacy. The extremists, on the other hand, put themselves forward as clear alternatives, creating doctrines of salvation based upon class, race, or nation. The intent is to substitute the collective for the individual in social and economic affairs. The moderates, for their part are generally pragmatic interventionists in economic and social affairs, tolerant and mostly laissez-faire in the realms of morals and values. One seeks to replace the Judeo-Christian heritage with a secular religion, whereas the other favors flourishing diversity (at least in theory).

But who are the moderates? They include most of those we associate with the political center and left-of-center, people who refer to themselves as social democrats, liberals (in the modern sense), progressives, moderates, centrists, Christian socialists, and socialists. In a word, they make up the sociopolitical elites in Western democracies. Their doctrines are generally mild in tone, balanced in approach, often sophisticated in style. They do, of course, criticize bourgeois values, but ever so reasonably. As we said above, their opposition to the Bourgeois Ethic and the religious foundations upon which it rested are more like skirmishes than frontal assaults. If it were necessary to select a major representative of this policy culture style, one might well choose what are called the "Keynesians." When President Richard Nixon, a reputed "conservative," said in 1973 that we are all Keynesians now, he was simply giving expression to the conventional opinion. This is not to say that Keynes and his followers form the only moderate ideological "tradition." However, it would be difficult to imagine a single school of thought which has exerted a more profound impact upon administrators, politicians, and intellectuals in Western democracies over the past half century. If this choice seems surprising, it is only because the Keynesians had little interest in the great questions of life and death. But they did have strong opinions about the policy implications of a Bourgeois Ethic which itself rested upon religious and moral assumptions.

In their praise for theories based upon the short run and in their attack upon savings, the Keynesians have dealt a heavy blow to the bourgeois value system. Beneath their ostensible moderation has lurked a profound

antagonism to things bourgeois. In particular, they strike at the bourgeois attitude toward thrift. In this respect they are determined to turn old vice into new virtue. By calling repeatedly for the stimulation of "effective" and "aggregate" demand, by making a fetish of consumption, they seek to place spending on a higher moral plane than saving and the denial of present gratification. This helps us to understand why they have always been so contemptuous of Say's Law of Markets, the cornerstone of traditional economics. Say and his followers elevate supply—that is, saving and investment and, *implicitly,* the values behind them—to a superior moral and scientific position.[42] For the Keynesians, however, demand and consumption represent more socially useful values for scientific and policy reasons alike than does saving. It is an excessively narrow interpretation to view Keynes as concerned only with refuting Say's Law in the narrow sense; he likewise opposed in a general way the morality which issued from it.

Keynesian economics thus tends to undermine those values we associate in the broadest sense with "future goods." In their stress upon the short run, they have contributed to the dissolution of the bourgeois order. By advocating a general policy of interventionism, they deprive the bourgeoisie of its traditional role in saving and capital formation. The "euthanasia of the rentier," as Keynes put it, carries in its wake the rise of public sector officialdom and the social-service state whose aim is the short-run stimulation of demand and consumption.

Let us now turn to the ideological extremists. As proponents of alternative but secular religions, they openly attack Judeo-Christian values and norms. Christ offered his followers heavenly salvation in place of the tribulations of this world. But in order to gain entry into Heaven, Christian believers were expected to adhere to certain beliefs, values, and moral standards. As practiced in their family, social and business life, these beliefs, values, and norms gave them an incentive to lay aside present goods, material and immaterial, for those "goods" available in the future.

Competing secular religions, conversely, are devoted to an opposing ethic. Not only is their vision of truth and error diametrically opposed to Christianity (and to other religious systems, for that matter), but their view of the way the future unfolds is radically different. Salvation for Communists, militant socialists, and fascists takes place in this world, and is attained through politics and power.

The politics of salvation offers to its adherents a clear advantage over "bourgeois" systems or programs which concentrate upon individual effort and fate. As a general rule, the effects of government activities and ideolo-

gies which justify large-scale intervention in the marketplace are readily perceived by citizens, whereas market-oriented proposals and policies simply provide an impersonal framework of rules in which individuals may then seek their own ends. This situation poses a severe propaganda problem for individualism. For example, redistribution of income from rich to poor in the form either of an outright expropriation or of a transfer payment is immediately apparent to the beneficiaries, whereas the success of attempts to encourage individual activities may only be observed indirectly and over the long run, if at all. In the one case the public observes altruism and public-spiritedness, in the other, selfishness and privilege.

There can be little doubt in this respect that secular ideologies based upon collectivism possess tactical and strategic advantages in doctrinal and policy wars. Enemies are singled out; goods are transferred from this group or class to that group or class; concrete proposals are brought forth with the reasonable expectation that they can be implemented immediately—if not sooner; and, for the true believer, there is the enduring hope of paradise in this world.

The bourgeoisie can expect small success when issues are defined in this manner. The justification for patience and abstinence, not to mention the advocacy of individual effort and responsibility, is answered in the political arena with the cry for radical and rapid reform of state and society. A fascination with change and an impatience with "things as they are" are consequently legacies of the great secular religions. As such they embody a conception of time sharply at variance with Christianity, at least as expressed in the Bourgeois Ethic.

Therefore, it is not the loss of religious faith alone that turns us forcefully to the present. When their political supporters are in opposition, as is the case in present-day Western democracies, secular ideologies stimulate short time horizons by demanding *immediate* redistribution of economic and social benefits. They consequently reject the right and duty of the individuals of their own volition to lay aside present goods for the future in any meaningful sense, since that very process would call their collectivist ideologies into question. Not the individual but the collective achieves salvation—and in the short term.

Finally, the quest for political salvation through the immediate redistribution of resources acts as powerful stimulus to envy. Since religion frowns upon envy, there is undoubtedly some truth in the Marxist allegation that it is indeed an "opiate of the people." Envy is a motive which, if better understood, might well compete with money for first place in the

"mother's milk of politics" contest. According to Helmut Schoeck, the Protestant ethic prevented envy from achieving nearly as much social significance as it otherwise might have gained in the era of bourgeois dominance. Whereas success in one's profession implied that God was favorably disposed toward the individual, failure or misfortune implied His displeasure. Losers in the struggles of life, no less than the winners, served as examples of God's judgment. It is hardly surprising that in this cultural environment savings lay undisturbed and capital accumulated without undue pressure from would-be redistributionists. After all, repression of envy forces restraint and patience upon those who might otherwise clamor for immediate satisfaction through political action. By diverting interest from collectivist and redistributionist policies oriented to short-run satisfactions, religious belief, especially in Protestant nations, thus functioned as a means for the increase of capital accumulation.[43]

It is not only Communists and radical socialists who employ envy as a useful weapon against private property and free markets. As we shall see in Chapter 6, the same may be said to a lesser extent for the various political parties which compete for the votes of the masses by promising reform based upon the income redistribution within the context of the modern welfare state. They brush aside warnings with regard to capital decumulation and economic stagnation, all the while demanding greater transfer payments, progressive income taxes, and inheritance taxes in the belief that these reforms improve the conditions of the masses.

Even in normal periods envy penetrates into the guts of our political life. In the process it functions to speed up time for individuals by making them ever more impatient in their present circumstances. Proponents of political salvation tell us to seek first the political kingdom and the rest shall be given to us, so we not surprisingly lose the ability to distinguish between present and future needs. The present is the only "reality"— for "practical" people, at any rate. Conversely, for the more sensitive and well-meaning redistributionists, who witness so much evil in the world, ignorance of basic economics makes of them willing tools in support of policies detrimental to their own ends. Yet the effects upon the social order of the pragmatist and idealist are similar: Both in the private and public lives of modern people, presents and futures are increasingly merged into a timeless blob, and political judgments become progressively disoriented.

The secularization and politicization of society are not the only factors causing us to forsake the future. Similar changes have occurred in modern art and literature. Not surprisingly, intellectuals today strongly resist bour-

geois values. Indeed, what presently passes for the American bourgeoisie—
"middle America," artisans and merchants, white collar executives, inde-
pendent professionals, people in small towns—is under persistent attack
from significant portions of the media, foundations, presses, universities,
and political elites.

Among intellectuals systematic opposition to the Bourgeois Ethic and
culture has clearly emerged. Moderation, balance, and rationality in art
and literature have given way to extremes of subjectivity and to a brooding
self-consciousness. Imagination and will are now glorified at the expense
of tradition, and romanticism is tenaciously defended against the primacy
of reason. It may be said without exaggeration that the modern intelligent-
sia's major attributes are a belief in the unlimited freedom to innovate and
an exaggerated devotion to change for its own sake. Consequently, values
are constantly in flux as we face a ceaseless array of fads and "new" ideas.
Needless to say, this heightened self-awareness and hostility to bourgeois
culture has found its way into social thought. Intellectuals, so oriented to
"permanent revolution" in thought and fashion, find utopian ideologies
and collectivist doctrines especially appealing. Thought thereby takes leave
of responsibility.[44]

It is not only the slavish devotion to intellectual fashion, however short-
lived, which characterizes modern intellectuals; there is also a strong affin-
ity for equality. It is a version of equality, however, which is completely
antagonistic to the older, liberal ideal. On the contrary, today's intellec-
tuals accord a special status—labeled "equality"—to a succession of de-
prived minorities. Indeed, minorities in one period are given special status
only to lose it a short time later to still another minority. This ceaseless
substitution of passionate concern for a succession of deprived groups
could only take place in an age that is both obsessed with equality of so-
cial conditions and devoid of enduring ideologies based upon stable class
patterns. True, much of the appeal of Marxism resides in its equalitarian
thrust, but the newer version of equality only superficially resembles the
Marxist approach.

What are we to make of this "new" equality? Its foundations are prob-
ably supported by the motive of envy, but it draws upon, as it simultane-
ously distorts, modern ideals.[45] Thus, it is not a belief based upon *formal*
equality before the law. In fact, preferred tratement is given in the form
of "affirmative action" or hiring quotas in order to establish superior rights
for certain citizens.[46] Traditional legal equality is turned upside down.
"Equality" now means treating people unequally before the law in order

to achieve some equality of result.[47] Nor is this new equality, strictly speaking, a demand that heretofore deprived groups be given incomes equal to some national average. For instance, mere economic deprivation is not sufficient—poor Southern whites are routinely ignored. The same may be said for race, since Japanese and Chinese are seldom mentioned. Nor is it enough to have been subjected to a long history of discrimination, as in the case of Jews. No, it is an equality which is at once economic, psychological, and cultural in its thrust, since its intended beneficence is lavished upon targeted groups deemed *historically* deprived in each of these domains. But when racial minority status and low socioeconomic position are combined with cultural or subcultural distinctiveness, and when cultural distinctions are clearly drawn between the deprived group and the cultural values of dominant elites, the intelligentsia can be relied upon to accord the given group or race its unstinting support, deference, even admiration. Almost superhuman qualities may then be attributed to favored minorities, as their cultural values and beliefs are especially singled out for emulation and praise, and as their sufferings become a prime source of literary and political concern, often accompanied by no small amount of self-flagellation and guilt.[48]

This championing of oppressed and underprivileged minorities goes far beyond an otherwise admirable desire to aid the downtrodden. In fact it functions as a means by which bourgeois values may be opposed and finally undermined. It is at heart an attack upon "high" bourgeois culture by adversary intellectuals who first "endorse" unfortunate minorities left outside this culture and finally fling their values and behaviors at the citadels of bourgeois respectability. Sorokin long ago remarked upon the significance of this phenomenon. He believed that intellectual and upper-class obsession with primitive cultures and/or lower-class dress, behavior, and art signifies cultural decay. Just as opponents of high culture in the eighteenth-century intelligentsia and aristocracy could dote upon the virtues of rural *paysans* and "noble savages," so our modern intellectuals attribute special qualities to such groups as oppressed union workers, Blacks, Hispanics, and American Indians. It is as if the farther removed a given minority is from the tainted bourgeoisie in its values, behavior, and art, the higher its standing among the intellectuals.[49]

Anti-bourgeois romanticism, self-absorption, devotion to continual change, or rebellion may be observed from other perspectives. Daniel Bell has cogently argued that the modern intelligentsia is so intensely antagonistic to norms and values conducive to efficiency and rationality that our

culture is in the process of being liberated from the socioeconomic struc-
ture itself. To employ Marxian terminology, the superstructure increas-
ingly affects the basic forces of production as the culture becomes more and
more self-determining. Intellectuals, in their roles as artists and writers,
are ever more divorced from the world of modern corporations, public
bureaucracies, and scientific establishments. Our recent counterculture
of drugs, communes, dropouts, free sex, and primitive or working-class
dress is a clear reaction against older bourgeois structures and values —
against the high culture of the West — and, to Bell's chagrin, against mod-
ern social science and socialism. Since the modern intelligentsia is so much
larger than in previous historical periods, these trends take on special
significance.[50]

One may go beyond Bell to argue that this liberated and self-determining
culture is at work even within the middle- and upper-class citadels of
political, economic, and social power. Countercultural values are increas-
ingly accepted, transmitted, and sold by individuals whose occupations
have little in common with bohemian intellectuals. Foundations, media,
book publishers, universities, large corporations, civil service, and elected
officialdom have all in varying degrees absorbed antibourgeois values, per-
haps more than Bell himself is prepared to admit. Even ordinary merchants,
thought to be defenders of efficiency and rationality, often cater to such
values. In the desire to sell their products, they sometimes blatantly appeal
to values inimical to their own interests. One need only recall the ques-
tionable display of Pepsi and blue jean advertisements implying ever so
slightly that revolution is fun and the "in" thing to do. Indeed, according
to Irving Kristol, a broadly-based "knowledge class" competes with busi-
ness leaders for political and social power, whereas, in the opinion of
Kevin Phillips, a "mediacracy" presumably lends its support to countercul-
tural values at the expense of middle-class interests. This makes the anti-
bourgeois groups more respectable and less threatening than otherwise.[51]

Although Kristol and others place much of the blame upon intellec-
tuals, Bell himself takes his analysis further. He argues that "capitalism"
itself bears much responsibility. Mass production, after all, requires mass
markets, so demand must be whipped up so that we may consume the
goods produced. Under such conditions advertising is highly important.
But since it undermines the moral base of thrift and restraint, this need
to cater to mass consumption habits turns the bourgeois value system up-
side down. Intellectual opponents thus find it easy to picture the bourgeoi-
sie as hypocritical. They quickly sense a contradiction between ideals and

practice, and point out that business leaders utter pious platitudes in sermons, before children, or at chamber of commerce meetings, only to live in the real world of materialism and hedonism. Ideology and behavior bear little resemblance.

On the other hand, if this "cultural contradiction" in capitalism did not exist, many intellectuals would still find ample reason to call the market system into question and to reject the bourgeoisie. For instance, a major justification for capitalism lies in its ability to deliver material prosperity in the name of consumer democracy. However, both a sense of self-worth and an antagonism to a life based upon material comforts alone make intellectuals ill at ease with such notions, since the intellectual life is presumably devoted to more noble ends. Consequently, intellectuals, who can never truly justify their position in terms of adding up consumer votes, seldom coexist with the business community without tension in commercial society. It is hardly surprising that capitalism, standing as it does for consumer sovereignty, finds less than complete support within the ranks of the intelligentsia.[52]

No doubt there is much truth in such arguments. The role of mass production and mass advertising leads the business world to contribute unwittingly to the erosion of its own long-term interests.[53] The ceaseless quest for consumption does not accord very well with the restraining influence of saving and frugality. Nonetheless, the stress upon mass consumption results not only from structural aspects of modern capitalism. One must also understand the role of scientific Keynesianism in changing our values of saving and thrift. What other effects could be expected from the simultaneous denigration of saving, on the one hand, and an advocacy of every conceivable policy or program designed to stimulate aggregate demand, on the other hand? Do not Bell's modern mass-producing corporate leaders and Keynesian intellectuals unintentionally contribute to a similar end? Do not the academic economist and the advertising executive have more in common than either acknowledges? It is difficult to stimulate aggregate demand repeatedly without mass advertising and mass consumption. No matter what the complaints of Keynesian-oriented intellectuals about our lack of attention to the need of the public sector, their policy orientation regarding the role of consumption merges in significant ways with our corporate mass-producers.

In fact, there is nothing inherent in bourgeois capitalism which inevitably leads its elites to favor mass consumption at the expense of saving and the bourgeois virtues associated with it. The growth of mass consump-

tion industries and a corporate leadership devoted to the incessant stimulation of demand through pervasive advertising need not in themselves have taken us so far from the Bourgeois Ethic. It is entirely possible that prudent policies might have mitigated the force of Bell's "cultural contradictions." History is, after all, not predetermined. One can only speculate about the trend of Western capitalism had the Great Depression, for example, not taken place, or had our understanding of the modern banking system not be so deficient. At least from a theoretical point of view, high levels of saving—appropriately encouraged by prudent policy considerations—would *in themselves* place a damper upon excessive consumption. People might rediscover the truth that they must not live beyond their means, that investments must be financed out of real savings; i.e., out of restrictions upon current consumption. They would accordingly lengthen their time horizons by laying aside present goods for the future. By definition a society which rewards its more frugal members with appropriate incentives would at least place obstacles upon present-oriented desires as opposed to future needs.

Conclusions

The bourgeois have few defenders remaining among intellectuals. Left and right, radical and (often) conservative, regard them as pedestrian, philistine, or exploitative. They cannot evoke sympathy, since they lack sufficient poverty and often belong to groupings little inclined to deal with abstract symbols. They therefore possess few ideological weapons with which to conquer the world of ideas; their apologists cannot elevate the soul or win great victories. They are too cautious and patient for the more radical among us, too concerned with saving and capital accumulation, indeed too stingy, for the redistributionists. Conversely, for the traditional conservatives, especially those who stand in opposition to the modern industrial world, their devotion to commercial activities or private concerns as opposed to public service or philosophical contemplation mark them as insufficiently interested in the Good Life. Yet who can deny that despite tremendous increases in population, the period of bourgeois dominance brought forth unsurpassed political and material benefits, not to say a bounty in constitutional government and individual liberties? In no small way our present freedoms owe their impetus to bourgeois beliefs, norms and values.

In this chapter we have sketched the bourgeois decline by giving atten-
tion to the domains of family, class, and culture. In each of these areas
bourgeois ethical standards and conceptions of time have been placed un-
der severe strain. Consequently, the middle class has suffered a sharp loss
in power and influence. Intellectuals no longer lend it much ideological
support nor shore up interests which serve to maintain its role and func-
tion. There was, of course, nothing inevitable about this course of events;
indeed, despite oppressive taxation and misguided government policies,
entrepreneurs and owners of small businesses have steadily increased in
numbers. In the process they today employ more people than do our in-
dustrial giants.[54] In that these groups provide a sound social base for
middle-class strength and renewal, defenders may be encouraged that some
structural aspects of modern life are indeed compatible with bourgeois
traditions.

On the other hand, it cannot be denied that many secular trends point
in the other direction. These exogeneous forces must somehow be mas-
tered if middle-class growth is to continue and if its values are to be en-
hanced. Schumpeter was a pathfinder in this regard.[55] It was he who so
clearly perceived the part that bureaucratic structures—both private and
government—play in sapping middle-class individualism and entrepreneur-
ship. Individuals who draw salaries from large firms or work for public
organizations do not lend automatic support to values based upon con-
sumer sovereignty and the necessary disparities in profit-making and in-
comes growing out of diverse consumer preferences. Not that they by any
means oppose free choice for consumers; it is just that they do not com-
prehend the "excessive" incomes accruing to some capitalists and entrepre-
neurs, since the profits cannot be based upon "objective" criteria such as
degrees, length of service, and the like.

Market allocations thus seem "unfair" to a large body of intellectuals,
professionals, civil servants, and skilled and unskilled employees who draw
salaries or wages and who have attained their status according to educa-
tional training, credentials, seniority, or plain hard work. And since their
own incomes are usually somewhat insulated from rapid changes in prices,
at least in the short run, they can hardly be expected to support those in-
dividuals and groups who stand or fall in unpredictable markets where
sales and profits grow and decline with regularity. They consequently rail
against "conspicuous consumption" or "unearned" incomes, demanding
that accomplishments based upon "merit" be given recognition. However,
merit goes against the grain of entrepreneurial activities, since consumers

reward and punish their suppliers in quite impersonal ways. A decision to buy a particular good is in general unlikely to have anything to do with the merits of the management or employees who manufacture or sell that particular good.

In fact, the undoubted material benefits one sees in market societies by no means assure satisfaction with the existing order—quite the contrary. Mass production and rising incomes among the great majority prove mixed blessings when they lead to excessive expectations. Once basic comforts are provided, many of us become especially sensitive to what we do not yet possess in relation to others, a sort of "keeping up with the Joneses" mentality. When our stomachs are full, we may turn to what the late Fred Hirsch called "positional goods": the second house located beside a beautiful lake or on top of a mountain, the nice home in suburbia with plenty of space and few people, or the advanced education. But unlike refrigerators or automobiles, these objects become increasingly difficult to obtain as incomes rise and ever more of us gain the money or the leisure time to partake of them.

As is true of other goods, positional goods are also scarce, but it is not the kind of scarcity one encounters in the basic economic textbook; rather, it is what may be called "social scarcity." My enjoyment of a good characterized by social scarcity is dependent upon too many others not having access to it; indeed, as others acquire these goods, I find my own possession less satisfactory. For example, my university degree is useful to me only so long as the same advantage is not available to too many of my fellow citizens. Once it is mass-produced it no longer affords quite the prestige value nor guarantees the occupational rewards that I anticipated when I initially sought it. The same may be said for such positional goods as choice housing. As others pour into highly valued locations and utilize available services, the crowding process makes the area less attractive, certainly less enjoyable than I expected when I first acquired the house. It is as if one stands on tiptoe, catches a glimpse of something desirable, but is suddenly deprived of any benefits once others stretch upward to observe.[56]

These frustrations, Hirsch believed, encourage dissatisfaction with existing economic arrangements and distributions. An obsession with positional goods easily lends itself to claims upon government for services and entitlements which cannot possibly be met by the public sector. Paradoxically, it leads us into a "reluctant collectivism" by which we simultaneously demand more personal freedoms and regulation of economic life.

An obsession with the most ignoble private desires coexist, often in the same people, with the most noble public demands.

The triumph of the bourgeois system, therefore, gives birth to forces opposed to it, although not necessarily to those "contradictions" emphasized by Marxists and leftwing socialists. Rather, it is the success of the market order in which material development facilitates ever-rising demands for equality in various spheres of life—now. The "new" equality and "reluctant collectivism" erode the older notions of formal equality before the law and replace it with an ideal of equality (sometimes called "freedom") more oriented to result or material condition. This "new" equality, however, cannot truly be called radical, since it demands neither a major transfer of incomes nor major public ownership of the means of production. On the contrary, it is incremental and practical in nature, but always on the lookout for felt injuries, real or imagined, to status. Thus, it insists that the more privileged groups of society justify continually and unceasingly their own particular place in the social, economic, or political hierarchies. As capitalism breaks down existing class barriers, as large numbers of individuals experience class mobility (upward and downward), and as class, status, and income become blurred and diverge sharply among individuals, the demand for this elusive equality grows apace. Status insecurities created by "overchoice," fewer justifications for failure in life, and close proximity among those who diverge in talents and income but who reside in societies where rank and status discrepancies have diminished provide fertile ground for the making of invidious comparisons.

In fact, the new equality serves as the attendant of old-fashioned envy. It may be said without exaggeration that envy feeds best upon more "open" and objectively equalitarian social orders. The "social scarcity" theme may be interpreted as an aspect of envy-related phenomena. Frustrated by a desire for positional goods and increasingly resentful of those who have them, many otherwise affluent citizens call upon government to redress the imbalance in positional goods. Similar motivations probably afflict the growing numbers who work for large private and public bureaucracies and who depend as well upon merit criteria for their sense of self-worth but who nonetheless see "excessive" incomes going to stock jobbers, petty entrepreneurs, and car vendors. Since their own tastes may be highly developed and hence relatively expensive, they are likely to feel particularly deprived, certainly in the psychological sense.

At their best, bourgeois values and ethics counseled patience and claimed

to reward thrift and hard work. They deflected envy for some time and warded off the ideological forces born of bureaucratization. They therefore legitimated temporal actions oriented toward the future. But if it is true that our present predicaments derive in part from the material successes of the bourgeois system, the recent difficulties in Western economies suggest a new phenomenon for many of our generation. Indeed, our present economic stagnation is largely created by the failure to manage time properly and to develop institutions and values which reward waiting time in general, or at least raise the costs of present goods in relation to future goods. Admittedly, such secular forces as a consumer-oriented mass media, the "revolution in rising expectations," and ideologies calling for redistribution also serve to derange our temporal horizons by focusing our interests upon present desires.

A major source of our confusion, however, derives from simple ignorance and misunderstanding of economic problems. Basic economic reasoning is mostly absent not only in the public-at-large but, with rare exceptions, on university campuses as well. The neoclassical school with its arid and formal models, so dominant among professional economists, shares much of the blame for this state of affairs. In neglecting the time dimension it has impoverished public policy by failing to educate articulate citizens and policy-makers regarding the importance of temporality in socioeconomic affairs. It is to the role of time in economic life that we now turn.

Chapter 3

Time and Economic Fundamentals

or, What Robinson Crusoe Teaches Us about Public Policy

Time is closely woven into the fabric of economic decision-making and exchange relationships. Probably the most direct manner in which it impinges upon us as individuals is in the choices we must make between consumption in the present and consumption at various periods of the future. It is these choices which determine the amount of time and effort we devote to present consumption, to nonconsumption (saving), or to the production of capital goods. In allocating a scarce resource called time, we decide whether to consume now or whether to produce goods useful in the creation of consumer goods in the most distant future.

With a few significant exceptions, modern economists, whether "Keynesian" or "neoclassical," have expressed little interest in time. Their worlds consist primarily of more or less static relationships, of equilibrium models and statistical analyses of economic aggregates. But equilibrium models cannot easily handle problems of change and process, and statistical analyses necessarily collapse time into present lumps determined by the concerns of the scholar. But in the real world individuals constantly change their minds about the conditions of their existence, and act accordingly.

Alterations in knowledge, tastes, and technology force shifts in individual plans both now and in the future. Equilibrium models—and here we include even the more fashionable "dynamic growth models" of recent years—simply cannot deal very well with plans which, over time, conflict with one another. Similarly, one cannot "test" time by the more orthodox methods of today's social science. How can we treat time as a variable? Time is "everywhere," a function of nothing but itself! We certainly know that it exists "out there" and intuitively realize that it is important in exchange relationships, but as social scientists we cannot measure it. Under such conditions it is hardly surprising that modern economics would relegate it to the intellectual closet.[1]

In order to introduce the more salient features of time into economic relationships, we must develop a somewhat unorthodox approach to our subject matter. Fortunately, a methodology is indeed available, although it cannot yield the "facts" so dear to mainstream social science. This methodology—let us call it "Crusoe Methodology"—is in fact an old, indeed shopworn approach to the comprehension of economic life, but it has proved extremely useful for isolating and fleshing out phenomena all too easily hidden from direct observation and statistical manipulation.[2] This analysis begins by focusing upon an imaginary and solitary individual brought face-to-face with nature, having no other tools at his disposal on a deserted island but his labor, wits, and nature itself. This bare-bones approach temporarily seeks to eliminate all social, cultural, political, and interpersonal roles from consideration. By stripping our imaginary Robinson Crusoe of any social and cultural existence, we more readily perceive the factor of time in the lives of economic decision-makers. Once we have completed our analysis of the solitary individual, it is possible to recreate and to connect him with the larger cultural, social, and institutional arrangements of social beings.

We therefore grasp the immense complexity of time in economic relationships by focusing initially upon an isolated and imaginary individual. In this connection the notions of *time scarcity* and *elapsed time* enter our analysis. These "primordial" facts of time in the life of a solitary individual will then be related to more general aspects of social life. Finally, and most importantly, we shall consider some of the implications of Crusoe's story for public policy in the age of modern industrialism.

Crusoe, Crusonia, and the Tyranny of Time

We begin this chapter with an allegory about an imaginary Robinson Crusoe shipwrecked upon a deserted island. Although our Crusoe, like the traditional one, obviously possesses the bourgeois virtues, we shall nonetheless take liberties with the traditional Defoe account. Friday, for example, does not appear, but successors to the Crusoe "fortune" do enter our version. Moreover, we introduce a tribe from another island, although it plays a different role. Its members find his European features strange, even interesting, but keep their distance from Crusoe. They make only one demand: In return for use of the island, Crusoe will collect for them each month a certain portion of fruit and berries. In return, they will protect him from any hostile invaders of his island. Unlike the hapless American taxpayers of the 1980s who must labor approximately four-and-one-half months for their protectors, Crusoe need devote no more than a day of labor (spoilage is a problem!). Thus, a simple principle already emerges. Despite his solitary existence, Crusoe has time saved for him in a vital way: He can devote his energies to making goods for consumption rather than weapons for war.

Let us not, however, be insensitive to Crusoe's plight during his initial months on Crusonia. His existence is harsh and difficult, his problems staggering. Therefore, he must immediately store up a sufficient supply of food and water to get himself through the first days of privation. His store of provisions at the outset is necessarily small (and perishable), so he must resort to the crudest sorts of capital goods if he does not wish to perish from exposure and lack of nourishment. To put it simply, at this point, he lacks the necessary time to fashion those kinds of sophisticated capital goods which would otherwise give him a greater quantity of consumer goods.

Thus, from the outset Crusoe must content himself with making a long but crude stick (capital good) to knock the berries and fruit from the tall trees. Since he has no bow and arrows — "sophisticated" capital goods — he must for the present forego meat. He is too busy merely keeping himself alive to devote the necessary time and energy to work upon the tools which would enable him to kill a pig or bird. For similar reasons his living quarters are extremely rudimentary, slapped together with leaves, straw and vines. How he wishes he possessed a real house! But to realize that dream requires time, much time. Anyway, where would he get an axe to fell the logs? Or a domesticated ox or horse to transport them? Nails? And

so on. He must find a way to catch the rain, or else he will have to travel repeatedly some distance through the dense undergrowth to an underground spring, and it is a walk which consumes much time. For the present he must content himself with a crude bucket hollowed from a log; he cannot devote his energies at this time to the creation of a runnel hollowed from logs to carry his water from the forest to his clearing. Of course, the rain barrel, however crude, frees him for work on other capital goods. Finally, since fish are obviously a prime source for protein (he is mostly precluded from capturing fowl or beef), he must make a tool to spear the fish close to shore. Of course he would prefer a small boat, pole, and net, but such capital goods are beyond his reach *at this time.*

Crusoe at this stage of his "historical development" is therefore forced by existing circumstances to utilize less "capitalistic" methods of production; that is, he is prevented from engaging in what Eugen von Boehm-Bawerk first labeled the "more roundabout methods of production."[3] His immediate needs preclude the development of capital goods which otherwise would increase the quantity, quality and diversity of consumption goods at his disposal. No matter how much Crusoe desires a house, the lack of logs, nails, and other implements *previously created* thwarts his aims. He must severely *restrict his consumption in the short run in order to create capital goods useful in further production and consumption in the long run.* "History" restricts him, for were he to attempt "excessive" investment in time and energy at the expense of consumption, he would weaken, become less productive, and eventually die.

The years pass, and Crusoe's burdens ease. The fruit and berry tax is not increased by his neighbors, nor is his island threatened. More importantly for our purposes, the lapse of time has enabled him to "lengthen the period of production." Over the years he has accumulated a quantity of capital goods; hence, his creature comforts have grown. By this stage he has replaced his makeshift housing with a thatched hut. How? In the time elapsed he has accumulated the capital goods necessary for building a house (such as nails, hammer, axe, lumber, a domesticated animal). Not only have these capital goods given him the wherewithal to build a home, but many of these same implements have been and will be useful in the accumulation of still other capital goods. Building a boat, for example, required many of the same implements needed for constructing a house. Thus, his ability in some cases to *substitute* the same capital implements for different purposes—that is, to use capital goods for more than one project—contributes still further to the accumulation process. Substituta-

bility and the benefits of prior accumulation now quite literally save Crusoe time. In the future he may hope to reach his goals more quickly than he might otherwise.

Let us not forget that Crusoe's capital accumulation not only gives him a greater quantity of goods but in addition allows him to achieve both higher quality and diversity of consumption. In the process time is saved. For example, since he now has a boat and fishing net, he no longer has to run about the water's edge with a crudely formed spear in search of the occasional fish. His catch is thus quicker, greater, less taxing, more diverse, and more pleasing to his appetite. By now he has also made a bow and arrows, so beef and pork are part of his diet. This growing productivity and time and effort saved offer him *released time* for still other, highly diverse activities and pursuits. His released time for productive purposes enables him to create a wider range and variety of capital goods. In addition, he finds it possible to pursue leisure activities to a much greater extent than in previous years. He paints and even writes his memoirs, hoping that some European in the future will discover his work. Leisure is thus a highly valued good. Indeed, in terms of his "history," Crusoe is now part of the "leisured class," devoting many hours to "culture," much like the scholars and writers of our time or the aristocrats of an earlier age.

For the present we must briefly suspend our allegory in order to clarify certain theoretical problems.[4] In the first place, it was suggested above that Crusoe derives untold advantages from a lenghtened period of production. The meaning of this statement must be clearly understood. It does not refer to the actual period of time that it takes to produce a particular capital good but rather relates to the total amount of waiting as reflected in the various stages of production through which the good in question must pass until it ultimately becomes a consumer good. It is the time required in the creation of *all* goods that are finally utilized in the creation of a given consumption good. Thus, to place ourselves in Crusoe's world, we see that the stick which enabled him to knock down the berries from the tree took little time to produce. It is consequently a capital good in the "first stage of production," that is to say, one nearest the consumer (i.e., Crusoe himself).

But let us imagine for a moment the problems Crusoe encounters once he decides to build a house. In this case a lengthened process of production obviously comes into play. Think of all the capital goods which must be produced *before* Crusoe can begin to build his house — axe, hammer, nails, rope, logs, oxen, straw immediately come to mind. These capital

goods are obviously located at more distant stages of the production process—at least from the perspective of Crusoe. Until he has these goods he cannot have a house; but the creation of these very goods implies previous stages of production.

Perhaps a present-day distinction may help clarify this conceptualization. A traditional peasant and an American farmer may each harvest wheat, but their respective situations could hardly be more different. One uses a scythe, the other a tractor. Obviously the tractor is the more productive capital good since it embodies "the higher physical productivity of production processes requiring more time."[5] If we trace back through time all the various streams of labor, capital, and time which went into making this single tractor, we discover, for example, untold labor, coal, steel, rubber, office machines, buildings, wiring, and technical skills.

These considerations lead us to a related question. Why are the lengthened processes in fact more productive? First, they lead to a greater production of the same kind of good. Second, they lead to the production of goods which could not otherwise have been produced if shorter processes had been utilized. An enhanced accumulation of capital goods thus facilitates not only increased quantities but a greater variety of goods as well. Third, the lengthened structure of production "widens the ranges of economically relevant natural resources and human skills, making a finer division of labor advantageous."[6] Since "new capital investment always lengthens the overall structure of production," we may say that in his later years Crusoe's range of choices is therefore expanded. Why? The "waiting time" which is embodied in the previous "historical" accumulation of goods by Crusoe gives him more available time *in the present* to engage in projects which were previously unavailable alternatives or which, because of time constraints implied by his lower level of productivity, were simply impossible to get around to. Indeed, in his later years Crusoe may engage in leisure, developing weaving skills, painting, and in general investing in "human capital." In these ways his life is enriched, since the amount of time embodied in the production of capital goods has given him *released time* for other pursuits.[7]

The Heirs of Crusoe

Let us now carry our story beyond the life of Robinson Crusoe. Crusoe, we may suppose, is a lonely man. He has long since given up any hope

of returning to Europe. But he is nonetheless proud of his work on Crusonia. He wishes that he might perpetuate his accomplishments, since with his death the elements will soon lay waste all that he has created with hard work and ingenuity. That prospect is decidedly distasteful, for it destroys much of the meaning of his existence. In short, aside from any desire for companionship, Crusoe has need of progeny to carry on his work and to build upon his own achievements.

Crusoe therefore decides to adopt a son from the neighboring island. This he does, showering upon the child his wisdom and affection. In a few years, Crusoe dies, content in the knowledge that some part of his existence will endure through his adopted son. The heir, whom we shall call Crusoe II, has learned well from his father. Frugal, diligent, and moderate in habit, he possesses those quintessentially bourgeois characteristics we considered in the last chapter. Thus, goods bequeathed to him are kept in repair. Livestock, boat, house, and other implements and equipment remain in the condition his father left them. In addition, Crusoe II does not merely rest upon his father's laurels but proceeds in earnest with the further accumulation of capital goods. He obviously has an advantage unavailable to his father: He already possesses a stock of existing capital goods, so he need not go through the painful process of producing them himself. By having capital goods initially at his ready disposal, he may be said to have had time saved for him. For, unlike his father, he already has time in the material form of capital goods placed at his disposal.

Consequently, this *saved time* in the form of capital goods allows Crusoe II to turn his attention to the creation of additional capital goods and to the employment of his time resource in ways far removed from the possibilities open to his late father. He clears fields to grow food for himself and his livestock; he builds fences and pens for domesticated animals and fowl; and he adds to the size of his house. By father's standards he is a rich man.

Now let us suppose that Crusoe II takes a wife from the neighboring island. This would not be surprising. After all, he presumably speaks the language found on the other island, and he poses no threat to its inhabitants. Moreover, since the level of capital accumulation on Crusonia has reached an "advanced" stage, he can easily support a wife. In other words, the growth of capital makes it possible to support an increase in the population of Crusonia. In time the wife gives birth to a son, Crusoe III.

Our allegory now approaches its ending. With the death of his parents, Crusoe III assumes the task of nurturing and augmenting the Crusoe for-

tune. Unfortunately, he has few of his parents' qualities. He drinks heavily, spends much of the day swimming and hunting aimlessly, and makes frequent and prolonged visits to the neighboring island. It takes some period of time for the serious consequences to appear, but appear they do. The boat and roof spring a leak, with disastrous results; the crops rot in the fields; the livestock break through the fences; logging ceases; and many implements go unrepaired. In short, because his time horizons are distorted, Crusoe III's *capital is inevitably decumulated.*

At first his lapse into excessive consumption and leisure at the expense of saving and investment and work cause few problems for Crusoe III. To the outside observer nothing immediately appears amiss, since his "standard of living" seems the same as before. But eventually the squandering of his capital forces him to restrict his level of consumption. Soon he has fewer goods at his disposal than did his father, although his standard of living is not yet so low as was his grandfather's. It is certain, however, that his own children will be forced to restrict their own consumption much more seriously in order to further the process of saving and investment if they hope to enjoy a standard of living approaching that of their own grandfather (Crusoe II).

Crusonia and Modern Societies

The plight of the last Crusoe teaches that there is nothing automatic about capital accumulation, although certain modern schools of political thought seem to assume that there is.[8] Each generation must keep its capital stock watered, or its standard of living and that of its heirs will be reduced. We have underlined the failure of Crusoe III to save and invest, a failure indicated by his short time horizons. Of course a natural calamity such as a hurricane or tidal wave could play at least as significant a part. Our modern equivalent would presumably be war.

On the other hand, we moderns have other pressures far removed from those faced by the Crusoes but which nonetheless produce similar effects. Capital decumulation on Crusonia derives from natural forces or from individual shortcomings, but short-sighted policies have similar effects in modern industrial orders. Estate and inheritance taxes are excellent examples of this phenomenon, although they are taxes presumably enacted with the highest of motives. Thus, if heirs to large estates are forced to pay the government a high tax, it is obvious that what was previous capital

investment (e.g., bonds and stocks) is now turned over to the public treasury. It is highly unlikely that the taxed proceeds, which compose a minute amount of money in terms of public sector income, anyway, would then be directed by government into alternative investment rather than into present consumption. Much more likely candidates are social security, public servants and their programs, military procurement, or welfare groups. The consequences are capital decumulation since funds are removed from saving and investment channels. Again, if in order to pay their death tax, the heirs are induced to sell a part of their capital on the open market, the buyer must thereby spend a part of his or her own savings to make the purchase. The effect in this case is to slow down the rate of capital accumulation, hence to reduce the quota of capital per worker invested.[9] The society as a whole is that much poorer, although the public believes it is the rich alone who have paid the price.

Although the extent of their relationship has been the subject of fierce intellectual debate, there is little doubt that time and capital are intimately related.[10] On his little island Crusoe must economize his time resource if he is to increase his productive powers; hence, he puts aside a desire to consume as much as he might like in the present so that he may consume more abundantly and with greater variety at some future date. In the most profound sense, he must extend his horizons into the future, lowering his time preference along the way.

This same phenomenon characterizes modern societies, although the complexity of institutions and the division of labor easily hide this primordial fact from us. Crusoe simply exchanges with himself; he alone either consumes *or* saves. We, on the other hand, exchange with each other and as individuals save and consume in different degrees; some among us save more or consume more, others less. But the same fundamental principle holds for Crusonia and postindustrial society alike. In the latter those we call "capitalists" forego present consumption by lending a portion of their funds to others who in turn create enterprises and new products with the hope of reaping large rewards. It is therefore by restricting their present consumption that capitalists are able to make loans to entrepreneurs or farmers who in their turn hire workers to man machines or till fields. *Capitalists consequently give up present goods in order to receive goods with interest at some time in the future,* a role we all play by opening savings accounts, taking out IRAs, or purchasing annuities, corporate bonds, certificates of deposit, and commercial paper. Today we are all capitalists to some extent, including workers with their savings accounts, persons who

take out insurance policies, and contributors to a pension plan, no less than rich financiers who live entirely from interest on bonds.

Crusoe and modern man alike inhabit worlds in which the accumulation of capital depends upon prior saving and therefore relatively low time preferences. If we look retrospectively into the more or less distant past, we readily perceive that time was connected with the slow accumulation of capital goods. True, to save (nonconsume) does not automatically force one to strive to invest labor in creating goods from the material world. One may trust in the gods and be content with mere subsistence. But Crusoe and those who have oiled the engine of progress the last few centuries are in the best sense "bourgeois" types. Let us not lose sight of a simple truth: *It takes time to create capital goods, and it is the Bourgeois Ethic which is most conducive to the growth of the type of time horizons conducive to accumulation.* We, no less than Crusoe II and Crusoe III, owe much to the savings of our ancestors. It was they whose efforts allow us today to consume so much, to be so productive, and to possess the benefits of civilized life.

Similarly, as the amount of capital is increased, the groundwork is laid for still higher rates of saving. Recall the example of Crusoe II: Saving is far less costly, requiring less pain and sacrifice, since capital accumulation and productivity are so much higher. To put it somewhat differently: The growth of real incomes allows people to save more while simultaneously enjoying still higher levels of consumption. In this way the rich indeed get still richer—and with less difficulty! Whereas once only a small number of the privileged could afford to save, it is now possible for the great masses to do so—at least in the industrial nations. But we should note that in the postwar era it is the Japanese, the Swiss, and the West Germans—not the Anglo-Americans and the Scandinavians—who have experienced the least inflation and most productivity. It is significant that the former also value saving to a much greater extent.

Finally, the "history" of the Crusoes suggests that low time preferences within the social order contribute not only to material well-being, but to more civilized forms of life in general. By contributing to capital formation, extended time horizons facilitate those conditions which allow leisure time for cultural development. Crusoe, we saw, could turn to cultural and artistic pursuits only after he had created a sufficient supply of capital and consumer goods. Had he devoted himself to a consumer-oriented hand-to-mouth style of life instead of saving and investment, his life would have been less culturally enriched in the long run.

It is true that very poor societies with a small number of leisured elites have sometimes produced highly creative people, but this condition has hardly obtained over the past two centuries. Commerce, industry, and cultural development have been linked, to some degree. The creation of wealth by our bourgeois forebears laid the basis for cultural growth, although cultural and economic elites have by no means existed harmoniously. To the contrary, they have often been antagonists. But if we have benefited from the leisured interests of the aristocracy, including its willingness to "sponsor" culture, we also owe no small part to the sober strivings of the often rather uncultivated and unimaginative middle classes. It is they who are primarily responsible for the "released time" accorded intellectuals, artists, and writers and to the numerous universities, think tanks, and research organizations which house today's "leisured" classes.

Crusoe and Public Policy

What does the solitary Crusoe teach us about public policy? In this section we shall argue that, while we learn little from him about modern social science techniques, his lonely existence nevertheless reveals fundamental realities of life which can be transported across time and space. This observation is especially important so far as the role and function of saving and interest are concerned. Indeed, few areas of public policy are so fraught with misunderstanding and subject to such grievous social consequences for democratic orders. Particularistic interests, shopworn ideologies, and the worshippers of statistical aggregates have all combined forces to conspire against a few simple truths. As a consequence, the focus of our society is increasingly shifted from the necessity of capital accumulation to the tempting path of short-run demand and consumption.

In the next few pages we shall therefore argue that if we are to restore the dynamism of Western social orders, the present burdens being placed upon individual savings, corporate profits, interest on bonds, stock dividends, and the like must be eased and the emphasis upon present consumption discouraged. It is simply much easier to spend than to save, to put off the unpleasant future for the agreeable present, and to rationalize decisions in the name of full employment or social justice.

In addition to the role of savings, Crusoe can teach us much about the nature of interest. There is probably no area of public discourse where the followers of Keynes, party politicians, and well-intentioned social re-

formers have done more harm, so it is hardly surprising that confusion is rampant in the public-at-large. "Tight" money, after all, hurts, and sometimes hurts badly. That every economic and political pressure must be mobilized to bring interest rates down quickly, irrespective of the state of community savings, is so much a part of our folk wisdom that the defender of "high" rates is likely to be relegated to intellectual oblivion.

The Assault Upon Savings

Saving for Robinson Crusoe means, of course, nonconsumption. He saves in one of two ways: Either he renounces present goods for future goods of the *same* kind or quantity, or he chooses between immediate consumption of a quantity of goods or future consumption of a greater quantity or quality of goods.

Since it leads to investment and economic growth, saving is especially important for the growth and development of civilization. Individuals (households) are the most important source for the replenishment and enhancement of savings, but corporate saving ("self-financing") is also highly significant. Both types of saving, however, have been undermined in recent years by the decline of the Bourgeois Ethic, rampant inflation, and the tax collector. In particular, the treatment of interest and dividends, usually referred to by the loaded term "unearned income," as a proper subject for special taxation has undoubtedly had deleterious effects. In the United States, for instance, we see a form of double taxation, since a corporation not only pays a tax on its own profits, but its shareholders are themselves subsequently subject to a tax on the dividends they receive from the corporation. People typically save money for various reasons, only a few of which may be termed "economic" in the sense popularly understood: They may believe that it is fit and proper to do so; they may save out of sheer habit or because of custom; they may be miserly or highly pessimistic regarding the future; they may wish to avoid an appearance of "conspicuous consumption" or ostentatious behavior; they may be ill at ease with having to choose among sophisticated investment methods, since the time, energy and uncertainties ("information costs") may far outweigh expected future benefits; or they may perceive saving as simply the safest way to tuck away money while simultaneously receiving a security blanket in the form of fixed interest payments.

It ought to be noted that only the last point, strictly speaking, relates to commercial motives and "rationality." As the late Wilhelm Roepke noted:

"Interest is not something which is required to induce men to create capital. The supply of capital is more often than not inelastic, i.e., largely independent of the rate of interest. It is even possible that not a few individuals, in their desire to draw a given amount of interest-income, would save more where the interest is low than where it is high."[11]

Thus, the reasons people have for saving are as much a result of custom, habit, and tradition as of a pecuniary desire to "optimize."[12] Moreover, although it is difficult to measure precisely, let us not forget the imperatives of the modern social security state and its determination to reduce the risks inherent in economic life. The effect may have been to create an unrealistic faith in the future. Despite postwar inflation, large numbers of citizens in the West undoubtedly still believe that the guarantee by their governments to social insurance payments upon retirement will be honored.

If they ceased to believe these promises, they would surely put away more savings in preparation for old age. Similarly, by guaranteeing mortgage loans, by insuring bank deposits, and by assuring full employment and extended unemployment benefits, the modern state encourages us to borrow and spend in the present rather than to exercise restraint in deference to an unknown and risky future. To this extent a presumably risk-free society may also be a thriftless one as well.

In fact, saving has very much to do with the Bourgeois Ethic. That a predisposition to save goes far beyond a mere desire to receive the highest possible interest by lending money to others may be seen in the relative constancy of household savings over long periods of time. It has often been observed that sharp rises in prices usually leave savings relatively intact, and that even price upswings over the long haul hardly shake the habits of a lifetime. It is even typical for people to react "irrationally" to rising prices by *increasing* the amounts of money they save. For example, despite the severe inflationary pressures of the 1970s, Japanese, Britishers, and Canadians were saving at rather *higher* rates by the end of the decade than at the beginning. West Germans and Americans, on the other hand, behaved more "rationally," as their peoples devoted a smaller proportion of their incomes to savings. Nevertheless, it was only after 1975 that they finally got the message and their savings rates also began to drop sharply.[13]

The dangers to savings and hence capital accumulation are largely ignored in the capitals of Western democracies. True, at present "supply-side" economics has some vogue in Washington, and monetarists seemingly hold sway in Washington and London, but the *social* functions of saving and their central role in the economy often get lost in a swarm of

technical arguments. Whereas both "schools" lament the sad state of savings, they do not make it particularly central to their thought. It is not being too unfair, perhaps, to suggest that some of the more ardent supply-siders underestimate the *time* required for savings to be replenished, whereas monetarists give such overwhelming attention to money supply problems in the banking systems that they somewhat neglect the non-monetary factors which induce us to save.[14]

If supply-siders and monetarists currently have the ear of Anglo-American political leaders, it is safe to say that what might be called "demand-siders" hold the hearts and minds of most administrative, political, and educational elites—and never more securely than when the business cycle temporarily turns sour and unemployment figures show the slightest increase. Seldom at ease with attempts to control inflationary forces, the social and economic effects of which they notoriously underestimate, demand-siders display little inclination to cope with the withdrawal symptoms of inflation. Influenced profoundly by Keynes and the Revolution he spawned, they look to the stimulation of aggregate demand—that is, to "reflation"—as a panacea for economic troubles. Whether their policies favor "easy" money and credit, progressive income taxes, steep estate and inheritance levies, special tax reductions to stimulate demand at the slightest sign of cooling of the economy, large transfer payments, or public works, demand-siders, whatever their motives or the particular mix they stress, are in agreement in aiming their intellectual daggers at the heart of saving. Although the dagger is employed most openly in socialist Scandanavia or—until recently—France, it is only better hidden from our view by more "conservative" political authorities. When falling prices also lead to a temporary rise in unemployment, the latter are quick to join the chorus of demands to create public works and force interest rates down in order to stimulate demand.[15]

The pervasive influence of demand-side versions of reality has led commentators to support policies which siphon off savings into other, more questionable ventures. When these policies are wrapped up and sold as "social justice" or "social welfare" measures, any plea on behalf of the virtues of savings is likely to go unheard. An indifference or hostility to thrift may partly explain the reluctance to confront the basic problem of social insurance. Of course, one must not ignore what may only be described as intractable political problems inherent in any reformation of social security systems, for "gray power" is not something with which to trifle. Not surprisingly, legislatures have raised benefits on a regular basis, often in hopes of protecting retirees from inflation, while at the same time they

have been exceedingly reluctant to raise payroll taxes. Despite the wishes of those who must confront angry constituents, the problem does not go away. Smaller numbers of working adults are being asked to support with larger contributions ever-growing numbers of older, retired citizens. In 1940, a single retiree in the United States was supported by sixteen workers, but in the next few years it will fall on two workers to support one beneficiary. One sees similar trends in such countries as West Germany, Sweden, and Italy. Needless to say, if present trends continue, the burden upon the young will assume enormous proportions—and growing resistance, no doubt.

It is difficult to debate the merits of social security because of the ideological and political passions it excites. Few issues ignite so much controversy between intellectuals on the left and right. Most debate revolves around the redistributive effects of social security, its presumed limitations on personal freedoms, its inefficiencies, and its burdens upon this or that group. Seldom, however, do we consider its detrimental effects upon savings. It is a revealing statistic, for example, that in the United States government-coerced "savings" from social security are only slightly less than total household savings. Unfortunately these "savings" do not function as non-consumption funds which would otherwise find their way into investment channels.

By any meaningful standard, personal savings contributed to a social insurance fund for retirement years ought to provide a powerful stimulus to capital formation. Not only would interest accrue, thereby increasing the size of the retirement fund but, in addition, savings of such a magnitude would give a powerful impetus to capital accumulation. Unfortunately, social insurance funds do not work this way, since recipients far outnumber contributors. The consequence is that payroll deductions, ostensibly earmarked for retirement years, are diverted instead into present consumption mainly for retired and elderly citizens. Consequently, that which might have been invested in high-grade equities and interest-drawing bonds for new plant and equipment is utilized in consumption. The result is to diminish the capital stock of the entire community.[16]

Nevertheless, nothing seems to shake the public's belief that social security contributions offer meaningful protection for old age. This faith, however, may be difficult to sustain with ever-rising prices and shrinking numbers of younger workers. Moreover, it is quite likely that in the United States, for example, this faith in the integrity of social insurance contributes in no small way to the failure to save at higher rates. That is, a natural

tendency to worry about the rainy day may be blunted. It is an interesting fact that, when social security contributions are added to personal savings, Americans are as thrifty as West Germans, Canadians, or Britishers. Significantly, they rank far below the Japanese.[17]

Japan indeed presents an especially plausible confirmation of our hypothesis. Even with her present difficulties, Japan's economic productivity remains unsurpassed by other nations. Since her inflation rate has been less severe over the past sixteen years, it is to be expected that social scientists would seek an understanding of the "Japanese miracle." Unfortunately, scholars tend to attribute Japan's preeminence to consensual factors within the culture, to unique employee-employer relationships, to more or less guaranteed life employment with a single firm, to hard work, to a thirst for efficiency, and to a state machine characterized by forceful planned intervention in the economy. Seldom does the astounding Japanese propensity to save enter scholarly analyses.

The last argument, that government "planning" and intervention in economic life go far to explain Japan's postwar prosperity, may be disposed of quickly. In fact, the degree of intervention of "societal guidance" is quite small when compared with most industrial democracies. In general, tax incentives have been utilized by government to aid various industries thought to be crucial for economic development. This type of policy, of course, is an indirect means of support, and does not interfere with the market mechanism. Heavy and direct forms of support are far more difficult to discover in Japan. Thus, from the 1950s through the 1970s, only 10 to 15 percent of outstanding loans were financed by government. Furthermore, government's total share going for research and development in 1980 was far below that of the United States or West Germany, as was specified support for research and development grants to the private industrial sector. So-called "policy-implementation" funding in Japan has been far *more* generous to small businesses, homeowners, or farmers than to the large modern industries whose goods flood Europe and America. Indeed, funding for the hotel business, for example, has been much greater in postwar Japan than that for such industries as coal and steel. Finally, the Ministry of International Trade and Industry is much smaller, relatively speaking, than is the United States Department of Commerce. In sum, government expenditures as a percentage of the Gross National Product are far lower than in the United States or in the major European nations. To put the entire matter in a comparative context, it is therefore hard to see how

dirigisme is such a government success when the state has so much less with which to work.[18]

Typically, however, observers stress the social structure or culture as major explanations for Japan's astounding development. They point repeatedly to the harmonious and consensual nature of Japanese industrial relationships. They note, for example, how seldom the typical Japanese changes his or her occupation: One signs on for life, as it were. By gaining security of employment and some input into decisions affecting the firm, workers return loyalty and dedication to task. Hence, unlike their British, French, or American counterparts, Japanese do not face their employers as mutual antagonists.

If security of tenure and harmonious employer-employee relationships mitigate class tensions, they hardly explain the high Japanese savings rates. Interestingly, the accounts usually ignore the backward state of Japan's social welfare system. Indeed, Japan may be safely characterized as a "minimal welfare state." Thus, a comprehensive social insurance scheme is virtually nonexistent, and the "lifetime contract," so effusively praised in Western circles, comes to an end when one is about fifty-five. Perhaps it is this very "backwardness" which provides the powerful incentive to save. After all, can we doubt that saving will not be enhanced when one not only lacks state social insurance funds but also realizes that retirement will come at fifty-five?[19]

The necessity to prepare for an uncertain future and early retirement find special institutional outlets in Japan. For example, a government-run postal savings plan, various types of company plans, and generous bonuses (themselves mostly plowed back into savings) are at the disposal of the people.[20] Thus, it is tempting to conclude that Japanese prosperity derives, to a great extent, from pressures to prepare for an unknown future. One crucial fact cannot be denied: This phenomenon, which coincides with a significant lack of intervention in economic life, relatively low budgets and an "underdeveloped" welfare apparatus, makes us suspect that the much decried argument of the older economists that the modern welfare state saps the will of a community to save and invest has a great deal of truth to it. On the other hand, in recent years budget deficits and expenditures have steadily grown in Japan, and the savings rate, while still far above other nations, has fallen somewhat. Significantly, productivity has declined and inflation has increased.[21]

We may conclude that thrift is given special encouragement in Japan.

The limitations of a "minimal welfare state" which encourages citizens to prepare for their retirement years, highly developed thrift institutions, and a social insurance system which diverts large amounts of saved funds into investment channels all play a part in Japanese prosperity. Of course, one must not underestimate the role of cultural and social factors peculiar to Japanese life, but neither must one ignore the profound antidemand side of social and economic policy.

In this respect the American system represents, if not a polar opposite, at least a very different model. Whereas it may be claimed that the proconsumption bias built into the American social security system was an unintended by-product of political interests and normal desires by politicians for reelection, it is nonetheless arguable that its thrust is quite in harmony with demand-side ideology. It is only a particular instance of a more general tendency in American policy which accords priority to aggregate demand as the mainspring of economic prosperity. Thus, in America homeowners may deduct from their income tax interest on their mortgage payments and, until the Tax Reform Act of 1986, on their consumer credit cards and automobiles. But if a typical American places money in a savings account, receives a quarterly dividend from a corporation, or derives interest from a corporate bond, he or she must turn over a much larger portion to the tax collector than does a Japanese (or, for that matter, Swiss and German) counterpart. If one excludes envy of the "rich" as a motive, the intent of such tax legislation in the United States is rather clear: Punish thrift ("hoarding"?) and stimulate consumption by taxing the savings, the dividends, and interest on bonds, but not interest on automobile payments, credit cards, or homes.

For the present—and we stress "present"—the United States has belatedly begun to appreciate once again the virtues of saving. Whereas the benefits given to consumers and certain consumer-goods industries have hardly been eliminated, President Ronald Reagan in his first term did set in motion policies which alter the balance somewhat in favor of saving and investment. Whether Congress will allow these reforms to stay in place is, of course, open to question. Thus, the well-publicized "supply-side" reductions in marginal tax rates imply a significant increase in personal savings,[22] but probably of more importance in the long run were the efforts led by the Democratic opposition to slice taxes on interest and dividends, reduce the capital gains tax, create an investment tax credit, grant accelerated depreciation allowances, and reduce the levy upon estates. In their totality these proposals as enacted in 1981 and 1986 un-

doubtedly stress the future as opposed to the present, investment as opposed to consumption. At the same time pressures will continue to be strong to repeat them in whole or in part.

Moreover, the persistence well into the Reagan Administration of intermittent efforts by the Federal Reserve Board to contain sharply the staggering increases in the money supply are not merely efforts to control inflationary expectations and growth. They are likewise a salutary effort to restore a balance between debtors and creditors. The extent of the revolutionary (or counterrevolutionary?) purpose of these reforms has been grasped by one of the more politically astute and influential postwar economists, Walter Heller. He lamented in 1981 that "We are witnessing a transfer of risks of inflation from lender to borrower."[23] Seldom can one find such stark cynicism in a single statement. So what, one is tempted to say? Who does Heller think has borne these "risks" for so many years? Can he truly believe that it is the poor who compose the "debtor class" and the rich the "creditor class"? Is it not the rich who are usually the largest debtors and who probably hold most debt? Or is it that saving is just not *that* important from his economic and ideological perspective? In reality is it not primarily the small savers of modest means who have seen their nest eggs eaten away in the gathering inflationary storm as profligates and insiders reap huge rewards?

In fact, Heller had cause for lamentation. For once the creditor, the saver, was benefiting at the expense of powerful interests long dependent upon cheap credit and inflation. In 1980–1981, the "real interest rate"—the average quarterly rate on three-month treasury bills minus the average quarterly change in the Consumer Price Index—zoomed to unprecedented heights. Before 1980 thriftiness was, to put it mildly, not profitable. In the decade of the 1960s the real rate of interest reached 3 percent only one time (1966)! Mostly it hovered in the 1–1.5 percent range. In the decade of the 1970s it broke zero—that is, was positive—once (1976). In other words, throughout the decade savers were receiving negative returns, losing money; yet, their reaction to changes in the data was very slow in coming. This social phenomenon, of course, reflects that tendency we have repeatedly stressed; namely, that saving is a deeply entrenched cultural value as well as an economic one, not subject to rapid change, certainly not so rapid as some of the more ardent supply siders-believe.

Only in 1980 did the real interest rate finally begin to run up the scale, reaching a high of 5.5 percent.[24] With this sharp rise in nominal interest rates during the first term of the Reagan Administration, incentives grew

for citizens to place the savings in money market funds, IRAs, Keoghs, CDs, savings accounts, and other thrift instruments. Although their numbers are difficult to determine, many lenders, having achieved meaningful returns for the first time in memory, were never again to be so trusting of future price trends. Besides, most of us were now conditioned by years of rising prices to borrow and spend rather than to save. Fearful that the Reagan administration would behave like its predecessors and ease the money supply at the first sign of economic downturn, they tacked on an inflation "premium" to their interest charges. Nominal—that is, "observed"—rates rose to unprecedented heights, and saving became even more profitable. This increase in rates was initially abetted by the stubborn refusal of the Federal Reserve Board to keep interest rates at an artificially low (read "political") rate by fueling the money supply. Years of inflation, massive debt, and dissaving were joined in a serious attempt to control the money supply. Illusions for once were ripped away: The savings cupboard was far from full. The upshot of an October 1979 Federal Reserve Board decision to attempt to control the money aggregates but allow interest rates to reflect market conditions demonstrated how meager was the available pool of savings.[25]

For Congress, it was as always, a relatively easy matter to attack the favorable treatment given to savings. However, Congress, as all legislatures, generally neglects a fundamental truth: *The replenishment of savings takes time.* Thus, when the Reagan tax reform was greeted initially on Wall Street with a severe contraction on the stock market, House Speaker Thomas P. O'Neill and his colleagues pointed out that even Wall Street rejected this "Voodoo Economics." That this chorus of criticism began before the first tax cut was even in place and continued unabated before the reform could conceivably produce the intended changes is alarming evidence that economic rationality, which basically includes phenomena which can adjust to policy alterations only after *some elapse of time,* finds little favor in a political arena oriented to quick reform. On the other hand, some supply-side partisans themselves contributed to this definition of the issue as one to be resolved in the short run by claiming that the benefits of a tax cut would be instantaneous and painless.[26]

The immediate fall in stock and bond prices was in fact not particularly surprising. As Martin Feldstein has pointed out, the tax reforms bundle was intended to aid certain interests at the expense of others. Because the new tax rules allow accelerated depreciation rates for *new* plants and equipment, the value of *old* plants and equipment is reduced. Unless they buy

new plants and equipment, existing firms are consequently penalized in comparison to new enterprises in terms of the cuts they must bear. For similar reasons, new firms find it much easier to borrow money at the high interest rates than older, established corporations. Under such conditions it is only to be expected that share prices and bond prices would initially fall. "The fall in stock and bond prices," Feldstein has written, "is thus consistent with the new policy working properly and is not an indication that it is failing."[27]

For our purposes it is not so much the short-run fall of stock and bond markets in the face of altered tax depreciation allowances as it is the effects of these changes upon the volume of savings. In this respect the "Reagan Revolution" represented a sharp break with the past. In raising the costs of debt and equity funds, the new depreciation rules encourage a diversion of funds not only into new plants and equipment, but also into saving instruments. That is, money finds its way into savings which otherwise would have gone into the purchase of stocks and bonds. Money market funds, all-savers certificates, individual retirement accounts, and income retained from cuts in marginal tax rates represent powerful incentives to save.[28]

But let us not forget the most powerful *short-range* incentive to save, namely, the interest to be drawn from placing a portion of one's income in savings. It is small wonder that "high" interest rates are extremely distasteful. A rise chokes off less credit-worthy investors. Also, by definition, anyone who saves fails to consume by just that much. The result is a fall in consumption demand and prices, which in turn threatens output and employment—in the short run, it must be stressed. In this respect, the rise in savings engineered by the first Reagan administration and the Federal Reserve Board posed a special threat in the near term to a special kind of consumption good: higher priced consumer durables. Consumers are far less likely to buy automobiles, microwave ovens, furniture, boats, and other large items requiring significant outlays, as well as high-interest payments, when that same amount of money can draw double-digit, tax-free interest. For example, a strong negative correlation exists between the purchase of automobiles and the savings rate of the community.[29] For an administration portrayed by the popular press as composed of new and ostentatious wealth to support an older bourgeois frugality, to adopt a somewhat independent attitude toward consumer-goods industries, and to foster the growth of newer and probably more innovative industries is indeed ironic. By favoring simultaneously the saver and the dynamic entrepreneur, "Reaganomics" sought a reconciliation of stability and dyna-

mism. These changes were surely at the expense of interests which had dominated the corporate scene for a generation.

It is difficult at this point to draw major conclusions about Reaganomics. As this chapter is being written, the 1986 tax reforms have hardly taken effect. By the end of 1984 the administration could certainly argue that since it came to power prices and interest rates had finally begun to drop dramatically and that unemployment had been reduced. On the other hand, the continued growth of massive deficits into the forseeable future means that vital savings are diverted from the private sector and investment into the public sector and consumption. Indeed, the staggering American and world debt suggest that "real" interest rates would remain high even in the absence of fears of future inflation or efforts by the central bank to bring rates down through its open market purchases of government securities. After all, an expanding supply of debt implies low bond prices, which in turn mean high interest rates. Or, to put the matter somewhat differently, the pool of savings cannot keep up with the expansion of debt, so we may have already lost the battle.

It is also not easy to draw any major conclusions with regard to the major plank of the supply-side platform, namely, the reduction in marginal tax rates and their influence upon the rate of saving. After all, the tax reductions coincided both with large increases in social security taxes, originally enacted during the Carter administration, and with tax increases on gasoline, telephones, and travel initiated by supporters of President Reagan. Moreover, until quite recently inflation was still very high by historical standards and continued to push Americans into higher tax brackets. As for the general effects upon savings of the initial reforms embodied in the Economic Recovery Tax Act of 1981, the record is confusing. Experts were sharply divided as to whether we began to save more or less. The strong recovery in 1983 was led initially by *consumer* spending, and since that time household savings have continued their historical downward trend. To this extent the recovery had a Keynesian stamp. But if profits were included as a portion of savings, one got a rather different picture: "Gross private savings" were at historical highs.[30] Conversely, by 1987, individuals were saving less than ever.

The threat to a savings-oriented policy from demand-siders, however, is by no means completely dependent upon the state of the economy or scientific debate over economic theory. Popular prejudice regarding basic economic problems and the entry into the party debate of social science techniques reinforces demand-side ideology. Americans are, according to

many social critics, enamored of technology and science. Simply dress up the most slippery social theory in numbers and you gain support from laymen and experts alike. With their stress upon statistical aggregates, demand-siders are placed in a powerful position to take advantage of their attitudes and beliefs.[31] Accordingly, legislators and executives find statistics a useful tool on the way to electoral and political gain. They often obtain excellent results in the case of unemployment and consumer price figures, since the pictures the numbers present so graphically remind voters which political party is responsible for their fortunes, or misfortunes. The so-called "misery index," employed with such effectiveness by Jimmy Carter against Gerald Ford and subsequently by Reagan against Carter, gives testimony to the power of numbers in political campaigns. A rise in the Consumer Price Index (CPI) brings forth a chorus of jeers from the opposition, whereas a stable CPI refers to the government significant gains. An image of success or failure is thereby created by statistics, an image brought constantly to our attention each evening on the news. On the other hand, television has little to say about the role of savings. If any readers doubt this assertion, let them search their own memories for examples of media coverage regarding thrift and frugality. It is hardly an exaggeration to say that governments more often than not stand or fall according to the public's reading of employment and consumer price figures. When employment falls they find it exceedingly difficult to resist pressures to ease the supply of money and credit as a device to restore employment. Future inflation, it is assumed, can be taken care of by a future government. Since not only employment and consumer prices but the Gross National Product (GNP), another statistic widely advertised, are sensitive to home-building and automobile futures, it is to be expected that consumers would gain the right to deduct the interest costs of these durables from their tax returns. Similarly, governments always worry about high interest rates, but they are especially unsettled by prices and interest costs in such sectors as automobiles and housing, since tight money so quickly affects employment and productivity statistics. Therefore, keeping demand high becomes a major concern. For example, until recently interest on mortgages composed an important component of the CPI, so naturally every effort was made to keep interest costs as low as possible. Needless to say, leaders gave little thought to the possibility of capital wastage and malinvestment, since these elements cannot be readily translated into numbers. Even the Reagan administration testified to the power of the construction industry upon political images when, in an effort to ease its pain of high

interest rates, at a time when its own tax and interest policies were designed to favor quite different groups, it introduced the "all-savers" certificates in order to aid mortgage-lending institutions and the construction industry. Since the home building industry had been struck by the credit crunch with special intensity in the late 1970s and early 1980s, it seemed wise to offer relief. Unfortunately, despite its undeniable encouragement to savers (who could now receive up to $2,000 in interest, tax-free), the flow of saved funds was diverted at least temporarily from other, presumably more important areas of the economy. Yet, no industry whose well-being is defined by government, media, and the masses as a leading indicator of prosperity and economic health is likely to be denied preferential treatment.

Thus, saving receives few accolades from the public and political elites. To give it priority on moral and economic grounds is to open oneself to the spurious but effective charge of favoritism for the rich and powerful. And since savings lack statistical sex appeal and cannot be so easily explained to the laity, a policy favorable to thrift finds little political support. It is of particular significance that the benefits derived from a large supply of savings takes place over the long run and that their effects upon the public are largely unseen. Once again we are drawn back to the central problem of time horizons in sociopolitical life: A society oriented to speedy political and economic solutions is unlikely to look with favor upon public policies which take a long time to bear fruit. However, the quickened pace of production and employment, which may be encouraged by demand-side policies and abetted politically by glowing indices of production and employment, omits the *unseen* effects of malinvestment and capital decumulation. Thus, for every house built with tax relief, one may only speculate about new mills and equipment which remain unbuilt or, as in California, high-priced farmland that is employed for residential housing rather than for the growing of farm products. Scientific reality includes not only what can be seen but also what is unseen.

Envy and resentment also play a part in policy debate.[32] It is interesting that savings and capital gains are termed "unearned income." Somehow they are felt to be unfairly received, a boon for the rich, lazy, or unproductive. Whoever first defined this controversial issue as one of "unearned income" versus the "earned income" of a salary won a battle of no mean proportions, for thereafter any opponents were placed on the defensive.[33] Wealthier citizens save and invest to a greater extent than do people with

lower incomes, so if interest and dividends escape the tax collector's net, the charge can be made that the rich and influential do not pay their "fair share" of taxes. In the process the intellectual arguments based upon economic theory about the role of savings drop from sight.

Lofty intellectual arguments are, of course, available to the antisavers. Demand-side professional economists and politicians genuinely believe that the path to full employment and prosperity lies in the sustained stimulation of aggregate demand. Occasionally they will experience some worry over inflationary pressures, but the fear usually subsides at the first sign of rising unemployment. Beset by worries of insufficient demand, they believe that by making it easier for people to buy goods, one likewise increases employment, incomes, and profits. It is a good, commonsense appeal to the merchant, worker, consumer and, above all, to the legislator opposed to budgetary constraints and wedded to a policy of passing around largesse. And, in truth, demand-side policies often do achieve their aims *in the short run*, which is precisely what makes them so popular.

The Persistent Confusion over Interest

If a single issue unites various political factions, it is the proposition that high interest rates are a very bad thing. When disputes arise with regard to the wisdom of allowing rates to rise, to follow their "natural" bent, few defenders are to be found who argue that higher interest costs for borrowers may be necessary for a period of time in order to resupply a diminished savings pool. Rather, arguments are generally put forth to the effect that a policy of higher rates must be strictly a *temporary* expedient to cool off an overheated economy threatened by an upward drift in prices. One may safely predict, however, that once signs begin to mount that the rise in rates is having its intended effects, a chorus of groups will demand that interest rates be reduced forthwith by government fiat. Financial wizards, economists, and business and labor leaders all talk about interest as if it were a problem reducible to manipulation of money and credit rather than a fundamental reality traceable to the propensity of a population to consume in the present rather than the future. Politicians caught in a policy crossfire between the need to control inflation with tight money and the simultaneous demands by consumers and business for lower interest costs will opt for the latter for a simple reason: High interest rates hurt now, in the present, whereas inflation can be surmounted only with the passage

of time. In fact, the whole problem of interest produces more confusion, disagreement, and downright demagoguery than almost any other area of public discussion.

Let us imagine a typical cocktail party in the early 1980s attended by various individuals, each of whom has enjoyed some success in his or her occupational life. If, in the course of conversation, the subject of interest rates arises, one may be sure that those present—let us say a professor, lawyer, construction builder, furniture retailer, and a corporate executive— are of one mind with regard to the interest rate question. "High interest rates are killing this country," the professor remarks. Unlike the others in attendance, she is a political "liberal" (in the American sense), a defender of the "little guy" and highly committed to a "just" redistribution of the national pie. She is particularly concerned that the masses of people cannot presently obtain loans at prices they can afford and that employers who cannot easily borrow will be forced to lay off workers.

The professor is surprised, however, to discover that the other, more "conservative" individuals in the room agree with her assessment of the situation. The contractor cannot build homes because high interest rates prevent potential owners from taking out mortgages. Moreover, due to the high cost of borrowing, he cannot afford to fund a new building; and if this is not enough, he finds that he must lay off some of his workers. The lawyer in turn sees the demand for her services limited by a shrinking market for title searches and other activities. For his part, the furniture dealer points out that high interest rates in particular and slumping economic conditions in general make people more ready to put their money in savings accounts or money market funds than in bedroom suites. Furniture, after all, is a luxury item which may be postponed. The corporation executive, finally, laments shrinking profit margins and the difficulties of borrowing.

It is the same story wherever one hears such conversations: "Unreasonable" interest rates are a major cause of hard times. From the people at the cocktail party just described, to the homemaker who wants a new dishwasher, to the workers in the unemployment office, to the farmer who needs a new tractor, "high" interest rates are cursed. Lending institutions and the political parties in power come in for special blame, whereas the more imaginative minds find the culprit in a sinister "establishment" or "elite." These critics are not opposed to interest charges as such: They simply insist that lenders receive a "fair return," whatever that means.

Perhaps this hostility to interest which is "too high" derives from the

ancient and medieval belief, often sanctioned by religious authority, that receiving interest is somehow immoral; perhaps it is backed by the view that creditors are essentially rich or lazy people who receive money but do nothing productively to earn it, who avoid "real work"; or perhaps it is the frightened "little guy's" reaction against Wall Street, the banks and other established institutions. That opposition to creditors crops up continually in religious, farming, and small-business circles is ample testimony to its political salience. And since high interest rates *do* put a brake upon employment and production in the short run and place restraints upon consumer desires, the creditor obviously has few defenders upon whom to rely.

Unlike debtors, creditors cannot be readily organized as an important group or class for political mobilization of their interests. Most of us, after all, do not work for or own specific shares of stock in lending institutions. In truth, the interest payments most of us receive, while they may form a substantial portion of some incomes, are hardly as vital to our subsistence and status as is our occupation or profession. Loss of job is much more likely to land us on the front lines of political activity than is any loss of interest income. Moreover, many of our savings are *indirectly* received, and in fact are invested in interest-drawing instruments *for us,* as is the case with an insurance policy or a pension plan. These sources of wealth are no doubt highly important, but as a rule they do not impinge directly upon us with great force.[34]

Therefore, if lenders charge more than borrowers think is "fair," the creditors are immediately accused of "price-gouging" or "usury." If a central bank raises its discount rate or sells its bonds in "open market operations" (which allows it to mop up money), legislators and party leaders accuse it of harming the poor, throwing the deserving out of work, and bankrupting small business enterprises in order to aid the rich and powerful. Moreover, because so many consumer goods are bought on credit and because high interest rates restrict purchases of many goods, people with high expectations but modest incomes must delay their decision to buy the new television set, automobile, or kitchen appliance. Naturally their hostility is directed at visible credit-granting institutions. It does little good to point out to them that in modern times the beneficiaries of interest in general are themselves much more likely to be persons of modest means than are the debtors; that it is the rich who hold so much of the debt; that only the rich can *afford* to be large debtors. At this point one is likely to be met with a look of disbelief, since everyone simply *knows* what is

a "fair" rate of interest, and that this rate, unlike soap and bicycles, is somehow beyond the laws of supply and demand. It is their "commonsense" opinion that if so many of us are harmed by high borrowing costs, then political and monetary authorities must keep the rates sufficiently low so as to avoid pain.

But how "low" ought the rates to be? To that question harried legislators can hardly avoid becoming advocates of politically determined interest rates. Think about the forces with which they must reckon: Citizens who want to buy a house; businesspeople who find money "scarce"; farmers who must purchase feed and equipment; consumers who want new washers, automobiles, and other durables; laborers who are less likely to be laid off when business can borrow; dime store executives who depend upon a high volume of sales; the "little guys" who resent having to wait until they have made the money to purchase a particular good; large debtors who, anticipating inflation, wish to pay back with a cheapened currency; and national officials and "progressive" legislators who expect to receive a revenue windfall as inflation pushes citizens into higher income brackets and who wish the the government to borrow at cheap rates in order to finance government personnel and programs; that is, to all those groups or classes who do not wish to wait, who are impatient to spend, and who wish "a leg up" on those who in the past have exercised restraint and imposed thrifty habits upon themselves.[35]

Decrying, therefore, "unjust" interest, the public decrees that rates will be stabilized or reduced by a flood of additional currency and credit. No major class or powerful lobby can stand for long against this great "democratic" outcry. That market-determined interest rates are necessary to restrict demand for savings, to avoid capital wastage, to constrain the spendthrift inclinations of the community and to reduce inflation is too painful for a society oriented to immediate gratification and speedy industrial "progress."

Ordinary pecuniary, class, sectoral, and ideological interests are necessary but hardly sufficient explanations for sustained opposition to market-determined interest rates. As we have suggested previously, most of us, whatever the given socioeconomic or ideological category to which we belong, in principle oppose high interest rates as retrogressive and anti-social. Despite this "consensus" of opinion there exists among the majority of the public a profound misunderstanding with regard to the nature and functions of interest. This misunderstanding no doubt derives from the tendency to view the interest problem as merely one of the money and

credit available for loans. Based as it is upon everyday, commonsense experience, this "money" view of interest enjoys a wide following. In the opinion of money enthusiasts, interest rates are part and parcel of money creation institutions. From that point it takes only a short intellectual step to conclude that loans are easily come by, for, unlike physical goods such as typewriters, loans are reproducible pieces of paper.

If credit can be made available with so little effort and cost, few people in a position to influence events are likely to stand quietly aside when faced with a scarcity of money and high interest rates. Rationalizations under conditions of tight money will be found to assure steady access to a good (paper) so easily reproduced. True, by granting a right to a "reasonable" rate of interest, the advocates of credit manipulation display a tinge of doubt and realism; otherwise, one would expect them to support practically unlimited monetary injections. On the other hand, it cannot be doubted that many citizens are made happy—at least temporarily—by the process of money creation, since the usual effect is to force interest rates downward. Indeed, political and financial elites who favor easy money do have strong commonsense arguments at their disposal. Are interest prices not fundamentally different, say, from those of computers, pencils, or vegetables? The prices of these goods are presumably determined by the forces of supply and demand, but can the same be said for the price of pieces of paper? Is not a plentiful supply of these pieces of paper good policy? If not, then how do we explain rapid declines in interest rates once banks and governments systematically begin to inject money and credit into the economic system? Is the additional supply of money and credit not the cause for this change?[36] And, further, does not an expansionary monetary policy usually tend to restore employment and expand output? The overwhelming number of officials and members of the enlightened public would undoubtedly answer in the affirmative. And since lower interest rates, growing output, and increased employment are often associated with an increase in the money supply, easy money proponents seemingly would have the weight of experience, commonsense, and even empirical evidence on their side.

There are, of course, those in academia and the public who do not believe that interest can be reduced to money phenomena. They feel that it embodies a more fundamental reality and basic quality than quantities of paper can capture. They see interest rates as determined not so much by the amount of money in circulation as by the willingness to save and forego consumption, to practice thrift, and in general to abstain from present en-

joyments. If interest rates are low, it follows that many people have been frugal and abstemious; if they are high, too many spendthrifts abound. Like the money view, however, this notion too may be bought from economists in sophisticated packages.[37]

To comprehend the phenomenon of interest, therefore, requires us to modify in a most radical manner the natural inclination to view interest as the "supply of and demand for loans," the "price of money," or the "cost of borrowing." We must resist the commonsense tendency to associate it in our minds with the availability of money. The *essence* of interest encompasses, but is quite distinct from, what economists refer to as the "nominal" (observed) rate of interest. Indeed, interest possesses a stability over the long run somewhat independent of those ordinary loan rates whose figures are readily available to us from the financial pages of newspapers. Interest in our sense, however, is over the long run largely impervious to the whims of speculators, bankers, and political authorities. Presidents and prime ministers may try to ignore it and pretend that it does not exist by manipulating the money supply and central bank rediscount rates, but in the end they themselves are forced to bend to it. In one way or another it returns to haunt them, as we shall see, through its long-run determination of the interest rates we pay and receive in daily transactions. We shall henceforth designate this force as "basic interest."[38]

But how can we posit the existence of basic interest? It cannot be seen, felt, or touched, nor made the object of statistical analyses.[39] Nevertheless, there is powerful evidence that basic interest—or whatever one wishes to designate this phenomenon—does indeed exist. In the most fundamental sense, evidence for its existence is derived from the primordial facts of human action and time preference.[40] Thus, just as present actions are preferable to future actions, so present goods are likewise preferable to future goods.[41] And because we prefer present satisfactions to future satisfactions, it follows that future goods are discounted relative to present goods. It is this discount of future goods which may be termed the "basic rate" of interest.

Since it is embodied in action and time preference, nothing could be more "basic" than the basic rate of interest. Indeed, time preference and basic interest alike issue from the same source: human action. As a consequence, basic interest exists wherever human action exists, in Crusonia no less than in modern America or Europe. Contrary to what one might suppose, it did not arise with modern loan markets. "A rate of interest on money loans," Frank Fetter observed at the turn of the century, "would

be unthinkable if there were no differences relative to time in the estimates men place on some good available at different points in time. On the other hand, the use of money and the practice of borrowing and lending in terms of money are of comparatively recent origin."[42]

What part does basic interest play in the overall social order? In this connection time preferences are of fundamental importance since they influence the height of basic interest. Thus, "low" time preferences coincide with a "low" basic rate of interest; "high" time preferences with a "high" rate. If members of Nation A value present goods as opposed to future goods more highly than do citizens of Nation B, the basic interest rate in Nation A will be relatively higher. But, if for some reason time preferences in Nation A undergo a change and future goods come to be valued more highly, the basic rate will also drop. In the everyday world a fall in time preferences tends to increase the supply of savings in the community and, as a consequence, cause a decrease in nominal interest rates. Hence, high levels of saving coincide with a low basic rate of interest and ultimately lead to low rates on loan markets.

This last point—that a fall in the basic interest rate also forces nominal rates down in the long-run—may be dismissed as idle speculation by "realists" and "empiricists." In fact, however, one ought not be surprised that nominal rates are ultimately harnessed to time preference and basic interest. Time preferences denote the relative values of present and future goods, and decisions to save or consume express these respective values.

An abundant pool of savings is a commitment to the future and to future goods; and because the supply of such goods is relatively plentiful, government deficits produce less harmful side effects. A large supply of savings implies that government borrowing requirements are less likely to crowd out borrowers from the private sector. Interest rates are therefore lower than otherwise, so fewer pressures exist for government authorities to monetize deficits through the purchase of government securities. Inflation is less likely to be a problem for two reasons: Governments are under less pressure to inflate the money supply, and the greater tendency on the part of the public to save reduces consumption demand and hence pushes the prices of final goods in a downward direction. Consequently, nominal interest rates, while still higher than in the absence of government deficits, are less harmful and more politically acceptable to the public.[43] For example, Germany for much of the 1960s and 1970s and Japan for most of the postwar period suffered less from inflation and crowding out than did other industrial nations that were less thrifty.[44]

What factors encourage a large pool of savings over time? For an explanation we must now depart from the realm of economics and turn to sociocultural forces. Because our values and customs as embodied in our time preferences strongly influence the propensity to save, and because the desire to save or dissave changes slowly over time, it follows that the savings pool cannot grow rapidly in the short run. Therefore, it is apparent why the basic rate of interest lags behind changes in nominal rates. Only slowly and over an extended period do the fundamental forces which affect basic interest become the servant of politicians, central bankers, group interest wedded to inflationary policies. Only in the course of time, in other words, do their programs and interests impinge upon the sociocultural system.

Concluding Remarks

It is the failure to account for the basic nature of savings and interest which creates so much confusion among people such as those who were engaged in conversation at our imaginary cocktail party. They cannot fancy that we moderns face problems inherently similar to those which exist on the fictitious island of Crusonia. They see only absurdity in arguments that posit fundamental realities which no amount of cultural, social, technological, and political "modernity" can alter. They consequently fall into the trap of confusing the nature of interest with the availability of green paper. Rather, they believe that interest exists at the behest of politicians and central bankers, so they cannot conceive that it is a reflection of community time preferences and the ratio which exists between demands for present and future goods. Basic interest is in fact rather stable and subject to relatively little variation in the short run, rooted as it is in sociocultural values, norms, and customs, and consequently independent of political will. Unlike nonconsumptive savings which manifest true interest, banknotes denote something highly variable, fleeting and volatile, subject to sudden alteration.

The basic rate of interest, therefore, cannot be quickly charged by government fiat. Savings habits die slowly. For example, in the short run sudden increases in the money supply and sharp rises in consumer prices do not always lead to "rational" reductions in savings—indeed, precisely the opposite effect may ensue. The long run, however, is another matter. A determination by policymakers to stay on a noninflationary course can

eventually turn spenders into savers, debtors into creditors, so habits and opinion may indeed be altered. Excellent examples are Germany during the Adenauer era following World War II and France in the first years of General de Gaulle's government. Strong policy—indeed, authoritarian leadership—clearly altered behavior.

On the other hand, continual injections of paper money into the economic system and repeated attempts to maintain interest rates at artificially low levels over a sustained period exert a profound influence upon our time horizons. Credit-created inflation, if it persists for a sufficient period, shortens time horizons, as customs, values, and opinions begin to catch up with the growing money supply. Consequently, people turn increasingly to present goods and consumption. The basic rate then begins its inexorable rise. The authorities are eventually faced with an agonizing choice: Either they continue on an inflationary course and fuel each threatened downturn with new money and credit, or they resolutely place limits upon the money supply. To follow the first course eventually threatens the stability of the social order, but to go the second route has short-run ill effects in terms of high interest rates, reduced productivity, and greater unemployment. In democracies the second path also leads *more quickly* to the loss of government and legislative offices. It is not just that inflation encourages social and political conflict; in addition, prolonged price increases produce short time horizons within the public, making it ever less amenable to the necessary policy changes. To this extent the temptation by officials to buy short-run support with inflation is self-defeating. The resulting rise in time preferences and the basic interest rate make the public ever more inclined to lose patience with officialdom. It is hardly surprising that governments in the Age of Inflation are put out to pasture by their electorates with growing frequency. A public geared to short time horizons demands satisfaction—and quickly.

Chapter 4

Political Man
vs. Economic Man

The Enduring Antagonism

In previous chapters we noted how time horizons affect or are affected by economic activity. We also considered how public policy influences time preferences. In this chapter we shall focus upon the types of time horizons one encounters in economic and political roles respectively. For example, are we more likely to display high (or low) time preferences in political or economic roles? It is when we relate these roles to the temporal dimension that some interesting hypotheses opposed to conventional wisdom emerge. To understand this problem and the confusion it engenders in so much modern social thought, however, requires that we return at least to the eighteenth-century work of Adam Smith. After all, it was he more than any other thinker who set the tone for subsequent debate.

Smith's monumental *Wealth of Nations* was undoubtedly one of the most important books ever written. Its powerful defense of free enterprise became in future years a source of inspiration for the admirers of capitalism no less than the object of ridicule for its socialist opponents. In his massive work Smith penned various statements which since have outraged the detractors of capitalism, partly because many of his intellectual descendants sometimes pushed his conclusions to extreme limits. Neverthe-

less, many of his admirers were also somewhat unenthusiastic with certain of his arguments regarding human motivation. "It is not from the benevolence of the butcher, the brewer or the baker that we expect our dinner," he wrote, "but from their regard to their own interest." This "system of natural liberty" (laissez-faire) leads to prosperity for the community. An "invisible hand" therefore guides each of us, despite our self-interest, to contribute to the general good. That selfishness unwittingly produces the public good has long been denounced as naive at best and base or stupid at worst. To turn private vice into public virtue, Smith's detractors insist, is to open the way to public corruption. As a result, our moral sensibilities will be dulled.[1]

Adam Smith's conclusions regarding the unintended consequences of self-interest did not go unchallenged on many political fronts, both progressive and traditional; indeed, for the past two centuries his "invisible hand" explanation has assumed a prominent place in political and intellectual debate. After all, the implications are simply too revolutionary to ignore. In support of Smith two quite different but also complementary strands of thought came to dominate the intellectual landscape. One is primarily moral in tone, whereas the other takes a rigorously scientific stance. To a large extent, however, both strands eventually merged in the polemics of our age, providing a ready-made arena for political combat. In the moral sphere "Social Darwinism"—the survival of the fittest in economic competition—and the Horatio Alger myth—anyone with sufficient aptitude and work may make it to the top of the ladder of success—grew out of Smith's self-interested seller and were offered as an explanation for progress and a justification for capitalism. Needless to say, people have generally found little difficulty in choosing sides.

The second strand of thought, the scientific realm, is in some ways more intriguing for the student of ideas. In this case Smith's self-interested economic actor was refined by successive generations of professional economists. But, contrary to the intentions of these supposedly value-free scholars, their creation of a "rational" economic man, a construct at once highly abstract and totally devoid of moral content, not only became the tool of scientists but, paradoxically, entered the realm of partisan political debate. As a political weapon rational Economic Man became synonymous with greed, a lack of feeling, cultural insensitivity, and a paucity of public spirit. He thus emerges as a ruthless individualist bent upon keeping his workers on subsistence wages, determined to pay no public taxes, and a

staunch opponent of social reform. For the professional economist he may be merely a mental construct, but for many others he symbolizes a social and political *reality* they despise — capitalism and its culture.

It is not difficult to understand why the political left would find in the self-interested actor an object of ridicule, since he is so clearly antagonistic to its historical ideals. The left's devotion to managed or nationalized economies, emphasis upon income redistribution, and hostility to economic individualism are readily apparent. Communist, socialist, social democrat, Christian democrat, and "liberal," no matter what their other differences — and they are substantial — are in agreement that Economic Man must be carefully controlled or at least watched, since by fostering values devoted to economic greed and self-aggrandizement economic individualism readily destroys social harmony.

The traditional conservative's rejection of Economic Man is especially interesting, however, since it is popularly believed that conservativism and economic individualism somehow go together. Yet many conservatives can bring themselves to give only "two cheers for capitalism."[2] They, too, fear the triumph of Economic Man. Decrying the laissez-faire attitude implied in Smith's metaphor of the "invisible hand," they lament the loss of tradition and authority, holding what they see as commercial, material, and inattention to civic responsibility as destructive of social order. They believe that religion, good education, breeding, and "natural" class leadership are undermined when citizens concentrate too readily upon material achievement and when status and reward systems pay high respect to commercial achievement. Joining the moderate left, these conservatives defend much of the modern welfare state, differing from their opposition in the belief that public officials with their views are capable of administering the state more efficiently and humanely than are their opponents on the left.

One thinks in this respect of the early postwar "neo-conservatives," certain of the followers of the late Leo Strauss, and various recent "neo-conservatives."[3] With notable exceptions, members of these various "schools" of conservatism in general accept to some degree the left-wing indictment of economic individualism.[4] Economic Man simply produces undesirable social consequences, and as a result must be strictly constrained by government. Thus, most of the early postwar neo-conservatives lent their support to the managed economy and in their social philosophies were strong admirers of British Toryism. Important Straussians also take a rather dim view of commercial society, and in fact hold Smith, with Thomas Hobbes,

responsible for ushering in many of the ills of modernity.[5] And, finally, the recent neo-conservatives, who for the most part are much more friendly to free markets than were their predecessors, nevertheless have strong reservations about Economic Man. For instance, one of their most fertile minds who is also highly sympathetic to free markets, Irving Kristol, has repeatedly called attention to the weak moral underpinnings of capitalist society.[6]

We may conclude, therefore, that an underlying assumption by the left and by a substantial portion of the right is that economic individualism is antithetical to social harmony and civilization.[7] The farther one moves to the left, of course, the more extreme the antagonism, but the intellectual right also tends to see an ever-looming threat of greed, commercialism, the erosion of intellectual graces, and a decline in public spiritedness and patriotism. Economic Man, they tell us, plays havoc with those norms and values which serve to temper human behavior.

Because Economic Man (even when he is not so designated) forms so much a part of the everyday working assumptions of social theorists, historians, and politicians, a fundamental question goes unasked: If Economic Man has such undesirable traits, does not some other "type" of "man" in our midst obviously possess much more desirable ones?[8] None of us can reasonably deny that the less admirable traits of narrow economic individualism must be controlled by social and cultural values — an avowed aim of many staunch defenders of competitive markets — but the opponents of Economic Man usually have more concrete constraints in mind. They are more concerned with specific limitations by government calculated to limit the effects of Economic Man than with the influence of diffuse but physically noncoercive cultural and social norms and values.

Opponents of Economic Man, therefore, have a yardstick against which to judge his inadequacies. Although the standard is seldom explicitly stated, there is little doubt that it encompasses political roles involved in the making of public policy. In a word, "Political Man" is the standard against which Economic Man is judged, and found wanting. After all, they seem to say, is Economic Man not guided primarily by self-interest and the demand for immediate gratification, whereas Political Man is much more attuned to altruism and the public interest?

One response given by defenders of Economic Man is to question the moral fitness of Political Man. Hence, the best defense seems to be a good offense. In this respect a most important supporter of Economic Man on scientific and moral grounds alike for several years now has been the so-

called "public choice" school. This school recently gained public attention when its leader, James M. Buchanan, was awarded the Nobel prize in economics. In their approach, public choice advocates apply the basic assumptions and techniques of neoclassical economics to the assessment of public sector officials by arguing that politicians and bureaucrats, no less than market participants, respond to self-interest and incentives. Whereas their analyses may have somewhat undermined the more simplistic view of the public servant as disinterested statesman, they hardly raise the moral position of Economic Man; indeed, they make Political Man and Economic Man largely indistinguishable. As such, the impact of public choice scholarship upon the general tone of ideological debate is likely to be minimal, possibly even nihilistic, since its major conclusions implicitly extend the notion of the greedy, acquisitive, and self-interested individual into political life as well.[9]

This "yes but so what" attitude of public choice theory, however, is hardly a typical one. A more common response to the relationship of Economic Man to Political Man may be found in the pronouncements of George Will. A perceptive columnist and self-proclaimed Tory who is intensely hostile to liberalism, Will probably speaks for a large majority of intellectuals of all opinions when he states: "Capitalism means the liberation and incessant inflaming of appetites. But neo-conservatives deplore the *predictable* consequences of capitalism which include the sorts of social disintegration which *should be expected when a culture celebrates instant gratification.*"[10] As we shall presently see, this statement embodies the enduring confusion regarding the respective time horizons of political and economic roles. It confuses self-interested activities with short-run gratification. Or, similarly, as Karl Popper suggests, it confuses individualism with egosim: Only social or collectivist types of activities are seen as altruistic.[11] This stance, which is taken for granted in so much political thought, readily lends itself to the notion that political or, in Popper's words, "collectivist" decisions are essentially other-regarding.

Moreover, nothing said ought to be taken to imply that economic roles in some manner are consistently characterized by long time horizons. Values and institutions play a significant part in channeling behavior into socially useful endeavors linked to the future. As we employ the term, "typical" behavior is not synonymous with uniform behavior; it simply excludes that which is "atypical." It encompasses neither the aberrant, the distinctive, nor the uniform. Of course, in their quest for the "quick buck," business people often manipulate the political and legal machinery to achieve

their ends. For instance, this state of affairs has long obtained in the con-
servation field in the United States. But this has less to do with Economic
Man than with defects in property law or with regulatory policies which
have encouraged economic actors to call upon the state for sustenance.
We merely argue that, other things being equal, it is far easier to devise
incentives for Economic Man than for Political Man in the development
of policies beneficial to the overwhelming majority of citizens.[12]

But, it may be protested, is not a "typical" entrepreneur, so much a part
of the economic landscape, prone to risky speculation and hence the cease-
less drive for immediate satisfaction? Do not entrepreneurs often gamble
their fortunes in a drive for immediate gain? Whatever the time horizons
of the individual entrepreneur, however, we must remember that the en-
trepreneurial role is intimately bound to individuals and groups whose
time preferences are of necessity relatively low: Savers and capitalists. With-
out prior savings, entrepreneurs can hardly perform their function—un-
less they themselves have previously saved out of current income or un-
less they receive a windfall in the form of fiat money (a condition which
of course must invariably end to the detriment of the great majority of
entrepreneurs).

Due to such confusions Economic Man for too many generations has
received a bad press, much of which is undeserved. We shall therefore
stand conventional wisdom on its head and argue that it is Political Man
who possesses many of the less endearing qualities usually attributed to
Economic Man. This conclusion is especially warranted in the case of
time horizons, since, contrary to what is usually supposed, time horizons
are more likely to be short when we occupy political instead of economic
roles. Hence, as Political Man assumes added weight in the modern world,
time preferences also rise. For example, inflation, as we have argued, has
its roots in high time preferences, and it is the ascendency of Political Man
in democratic orders which contributes in no small way to the growth of
inflationary pressures. Contrary to the views of those who see in Eco-
nomic Man the source of our inability to put aside present desires and
to "plan" over the long run, it is in fact the degradation and decline of
economic roles and the concomitant growth of political ones which have
shortened time horizons.

Political Man versus Economic Man

In our various roles—political, economic, or social—we cannot escape the consequences of temporality. Other things being equal, we prefer want-satisfaction in the present rather than at sometime in the future. In the willingness to wait, to save and invest, however, we calculate that the "pain" of waiting will be subsequently compensated when at some period in the future we receive a greater amount of goods or other rewards.

Economic Man, if left to his own devices, is much more likely to defer gratification than is Political Man. This phenomenon may be observed in various ways. When we participate in economic activities, the future and its uncertainties are usually powerful forces calling for caution, abstinence, and frugality. We must save and accumulate if we are to be prepared for the rainy day, catastrophe, or old age. In traditional societies the most ig-norant peasants know that they cannot allow their cattle to disappear gradually nor leave their plowing unattended. Fishers realize that they must keep their nets in repair or lose their catch. The complexity of mod-ern conditions in no way alters these fundamentals. Modern business leaders, no less than peasants, must turn their gaze toward the future and take care that their capital remains intact. In their ownership of shares of stock and other resources they are vitally concerned that the future value of their investments be maintained, even augmented. Economic Man con-sequently has every incentive to protect the "capital value" of his invest-ment. Unlike the legislator, political executive, or administrative official, the investor is the owner of resources, not a "manager" of them. This func-tional distinction between officialdom and private owner—between Politi-cal Man and Economic Man—helps to explain their respective differences in time preferences.[13]

Let us discuss this distinction, for example, from the standpoint of natural resource conservation. Surely, one might argue, if there is any arena from which self-interested Economic Man ought to be excluded it is in policies relating to the preservation of our minerals and forests. Nonethe-less, even in the case of conservation policy, Political Man stands upon shifting intellectual grounds. If selfish private interests have often wasted our natural resources (and they have), we still may not conclude that cen-tral governments are as well equipped as private entrepreneurship to pro-tect future generations. Whether the natural resource is copper, timber, oil, or natural gas, self-interested Economic Man—assuming he is unen-

cumbered in his ownership of the given resource—generally strives to increase the capital value of his investment. However, in order to accomplish his ends, he is forced by circumstances to take the long view or else risk an erosion in the value of his capital. Once again we observe that self-interest and regard for the future are not antagonistic notions by any means. Economic Man can indeed become the wellspring of conservation.

Let us take the following example. If the owners, say, of a copper mine or an oil well expect the price to rise in the future, they will simply increase the present price at which they sell their product and/or reduce production by closing down the mine or well. Copper or oil is as a result conserved. Why? By raising their price or reducing output the owners force buyers to economize by using less or to turn to cheaper substitutes. Ordinary consumers or producers who had previously depended upon these products are now forced to make do with smaller amounts. Consequently, more copper or oil is made available for "humankind" and "future generations."

Economic Man, however, does not conserve merely for the sake of conserving. Let us suppose that the copper owners expect copper to become quite plentiful in the more or less distant future, either because they believe demand will fall due to cheaper methods of extraction or because they anticipate competition from lower-priced substitutes. In that case, they find it expedient to place more copper than otherwise on the market for sale in the present. As a result, the price falls and its consumption is increased.

One more illustration demonstrates only too well the part played by special circumstances and also calls our attention to the distinction between nonrenewable and renewable resources. A most obvious example is forest preservation and reclamation. Conservationists have repeatedly warned us that forests will be in short supply by the end of this century. Not only will a shortage of pulpwood and sawtimber exist but with the devastation of our forests, we shall face additional soil erosion. Yet although it is undeniable that many public lands have been laid waste by timber companies in the United States over the past two centuries, it is incorrect to place the blame upon Economic Man per se. Such criticism does not acknowledge that timber companies often work for private gain in the *public* sector. Since Political Man leases public lands to private owners, Economic Man loses his essential character. He does not own the timberlands. Timber companies make profits from felling and selling trees,

but government sets the terms upon which the forests are harvested, opening the way to manipulation for private gain at the expense of public-supported interests.

Cross-national comparisons help us to understand this phenomenon. Since the United States government owns vast tracts of public lands which are then leased to private firms, usually on a short-term basis, the timber companies have a strong incentive, as it were, to "cut and run." After all, they themselves do not own or rent the right to harvest forests from *private* owners, so they are under little pressure to replenish the forests with hopes for future gains. On the other hand, in much of Europe, where until recently a tradition of private ownership of the forests long existed, the private owners of lands and estates had a much stronger incentive to restock their forests. Indeed, despite denser populations, Europe long remained in little danger of forest depletion.

It must not be concluded that saving and investment activities alone lead Economic Man to extend his horizons into the future. Even our consumption habits—surely the most present-oriented of economic activities—are restrained by future uncertainty. The more we project a given portion of our household budget into the future, the less our ability to earmark our expenditures for specific goods. For instance, a lump sum may be put aside at a time in the fall or winter for next summer's vacation. At that point we cannot know our specific needs, such as our manner of travel or the exact location for our vacation, but because we lack concrete details we relegate some expenditures to an imaginary "sundries account." Uncertainty therefore forces itself upon us even in the case of consumer goods.[14]

The long-run personal and social consequences of continual consumption or spending at the expense of saving and capital accumulation may be more easily perceived by the individual in his role as Economic Man than as Political Man. In politics fewer signposts exist which are favorable to the deferral of gratification. On the contrary, there are very strong incentives in political life to prefer want-satisfaction in the present rather than in the future. That "traditional" or "classical" economists, whether by intuition or reason, have grasped this connection can hardly be doubted; otherwise why do their policy preferences attempt to divorce economic policy from political considerations? Or, to put the matter the other way, why do those who place their faith in government action continually demean the importance of economic individualism? Indeed, the classical economists' emphasis upon Economic Man has led their detractors to ac-

cuse them of one-sided explanations of human behavior, although this one-sidedness was motivated in part by a desire to ward off poorly conceived economic policies.

Most policy disputes over the proper role of government in the economy are in reality disagreements over the long run or the short run. They revolve around the time required for policies put in place to take effect. And since most policy changes which are designed to utilize free markets as means for economic growth and productivity can make themselves felt only with some lapse of time, it is to be expected that pro-market advocates would continually find themselves on the ideological defensive. The "give the system time to work" attitude of the traditionalists and the "in the long run we are all dead" of various interventionists express these orientations quite well. Keynes, whose name was first attached to the latter phrase, was of course referring to what he believed were inadequate classical responses by pro-market advocates to an economic system in dire need of government direction.

On the other hand, since Economic Man, other things being equal, can more easily perceive the utility of waiting time, a sudden rise in time preference, we hypothesize, is more likely to derive from noneconomic settings than from economic ones. After all, personal costs to individuals in their household budgets are far more easily understood than are indirect losses stemming from government extravagance. Mental connections between individual actions and economic effects upon family or business are much more readily made than are linkages between private interests and public expenditures. In the role of Political Man, citizens can proclaim the priority and necessity of larger welfare budgets, redistribution of income, and other goals, secure in the false belief that their own pocketbooks are not unduly threatened. They see the concrete effects of a public outlay in a way they can never see the consequences of individual market activities. Whereas the market works slowly and imperceptibly as consumers' most urgent needs are met, a specific government program creates a much stronger impression that positive, forceful, and large-scale solutions to problems are at hand.

These differences between Economic Man and Political Man derive not only from their divergent time perspectives. They also derive from an inherent bias of public policy against long-run solutions to issues, as some recent theories of the policy process have contended.[15] This bias may be readily observed in the following contexts: (1) The different manner by which we apprehend the present and future; (2) whether the expected im-

pact of a given public policy takes place in the short run or long run; and (3) whether the effects of a given public policy are direct or indirect in their impacts.

We are biased against the future since, as noted previously, the present or "moment-in-being" is experienced and thus easily understood (enjoyed or found distasteful).[16] The impact of present decisions is therefore "real." The future, however, must be "imaginatively created." Unlike a present which is experienced, it must to some extent be intellectualized; hence, it is clouded with uncertainty, less susceptible to prediction. To put it simply, future knowledge is deficient knowledge. For example, under the threat of inflation, a decision to raise taxes or cut government expenditures is likely to meet resistance from politicians and voters since it causes a marked discomfort in the experienced present. Benefits can only come at some point in the future; they can only be promised; and they can only be imagined. Who can say that the expected future gains will compensate for the more immediate deprivation? In the absence of strong political, philosophical, and institutional restraints to counter present experiences, the tendency in political life is surely to eschew the future good for the present and more agreeable moment-in-being.

Policies are put into effect either in the short run or over the long run. If the expected impact of a program or law is perceived soon after its enactment, citizens and activists alike find it relatively easy to apportion praise or blame. Conversely, if the perceived effects take place gradually over time or occur at some more remote date, the praise or blame is not so readily fixed by voters, allies, or opposition. It is partly for this reason that presidents gain their reputations as "good" or "bad" chief executives. If they appear to be "on top of things" and change course with some frequency, their place in history seems more assured. Because inflation is so intractable and because the usual programs require such lengthy periods to achieve their results, government efforts to limit inflation's deleterious effects are unlikely to be well understood and appreciated. Conversely, most endeavors to decrease unemployment through job-creation programs, transfer payments, subsidies, and low-interest loans may be carried out quickly, if not always successfully, and their impact is observed in the immediate period. Thus, government creates the impression that it is "doing something." It is seen as our protector from powerful and sinister monopolies, unions, and the like.[17] From this perspective the most useful anti-inflationary devices for a government under siege by the electorate or the opposition party are wage-price controls and "incomes policies," since these programs

create an impression of positive action, concern, and resolution in the present moment.

Closely related to the short-run/long-run dichotomy is another one, namely, whether the actual impacts of a program are direct or indirect in terms of the costs or benefits they bestow. The impact of a tax increase or decrease, for example, is surely direct. Positive or negative assessments are easily made by voters and politicians, since these taxes are experienced in the present and their effect is felt in the immediate future. The same point may also be made with regard to the unusual plethora of subsidies, cash grants, tariffs, quotas, and licenses. Again, with respect to our previous example of inflation, attempts to control its excesses by direct means such as wage-price controls are much more likely to be applauded than are the indirect means of monetary policy.

It follows that policies whose benefits can only be imagined creatively, whose expected impacts are indirect, and which occur in the long run will receive far less support than those policies which are experienced in the present, whose expected impacts are direct, and which take place in the present. What can one expect in the everyday world of political reality, other than individuals with shortened time horizons who formulate and administer policy? It is this short-run view which goes so far as to explain why Western democracies are plagued with inflation and ever-larger budget deficits.[18] Public policy bows to political time and Political Man, not to economic time and Economic Man.

One may conclude, therefore, that a rise in time preference is inevitable as economic decisions become more politicized, as decision-making is carried from the more personal and private realms into the more political ones. After all, the incentives to defer gratification are generally weak in political decision-making. Why should Political Man wait? He has every inducement to orient his actions to the present, so he makes many demands upon political institutions with authority and power to grant economic and other rewards. Most rewards take the form of what has been described elsewhere as "distributive policy making." It is a process by which political favors are granted by legislative, executive, and judicial committees amid little conflict and public debate.[19] This policy process can lead to explosions in government deficits and debt as more and more individuals and groups become aware of the methods by which direct cash grants, subsidies, low-interest loans, licenses, contracts, purchases, and the like are made. As government grows in size, controls directly or indirectly a greater share of the national income, and regulates greater areas of private

life, these demands will increase. Those previously ignorant of the role of government are made increasingly aware of its impact and the profits to be garnered from it.

Governments find it increasingly imprudent to resist demands from various groups in the population. Support initially given with the view that it was to be a temporary grant from the state is quickly converted into an "entitlement," a God-given right to public support. Of course, key elites have long dipped into the public trough—"welfare for the rich" or the "middle-class pork barrel," it has been called—but massive increase in public aid is a relatively recent phenomenon. As the political claimants to economic largesse grow in numbers, the line between the political and economic realms of life is progressively blurred: Each feeds upon the other.

The tendency for the political to submerge the private in a sea of public rhetoric may be seen in our changing ideas about budget deficits and government debt. Many generations before, Keynes regarded private debt and public debt as essentially similar phenomena. A deficit was no more acceptable in governments than in one's own home. To argue that the public debt was unimportant because "we owe it to ourselves" would have been regarded as little short of madness by most Americans prior to the Great Depression. But as James M. Buchanan and Richard E. Wagner conclude in an important study of political Keynesianism, once the public ceased to perceive the Federal budget in much the same manner that it viewed household budgets, the way was prepared for sharp increases in annual public expenditures. The door was now open for the time preferences of politically-oriented individuals to supplant those of economically-oriented ones.[20]

In general, the massive growth of the welfare state, staggering transfer payments, military expenditures, innumerable subsidies, and increases in personal and corporate taxes are made at the expense of saving and capital accumulation. It is hardly surprising that time preferences and basic interest rise steadily in Western democracies.

But these changed conditions present public officials with unpleasant prospects. To perpetuate prosperity they constantly seek stimulative remedies. A rise in time preference and, hence, basic interest ultimately forces a rise in nominal interest rates. The result is short-run unemployment and reduced production. In the world of politics, however, this state of affairs is intolerable. Political Man cannot wait for the structure of production to adjust to altered time preferences but must instead restore employment levels and stimulate production—now.[21] In the name of "justice," the "work-

ing class," or simply general prosperity, he utilizes the central banking system to ease the supply of credit and money. These moves are applauded by demanding debtors, many small businesses, corporation leaders, real estate speculators, contractors, unions, or anyone else in need of quick and easy credit. In the long run, of course, this artificial stimulation can only be inflationary, but a short-run effect is, one hopes, prosperity.

The time preferences of Political Man in his role as voter or official determine this response. A recession and unemployment are far more threatening politically than is a prolonged rise in prices and a gradual erosion of purchasing power. Unemployment hits hard in the immediate future, whereas inflation strikes with more subtlety and stealth over longer periods. Not surprisingly, anti-inflationary policies have proven more difficult to develop in the industrial West. After all, if the conceivable remedies implied in a controversial policy can only be imagined, if the expected impact takes place over a long period, and if the effects are indirect, the policy will unlikely be acceptable to strategic political elites.

The Time Preference of Democratic Policies

Our era has rightly been defined as one of "rising expectations." In previous periods relatively small numbers of citizens demanded services from government because rigid class systems, poor communication, low levels of education, and restricted voting effectively limited demands upon political institutions. But with the rise of the mass media, the intensification of party conflict, the development of ideologies committed to social and economic equality, and the growth of the welfare state, expectations increased and demands consequently grew among the citizenry.[22] Redress of social and economic ills was more and more perceived in political rather than economic terms. Our age, Jacques Ellul argues, is increasingly a politicized one; hence, the most personal problems and solutions are increasingly given a public dimension.[23]

This growing politicization of problems traditionally thought to be non-political can only shorten time horizons. In Chapter 2, we delved into the relationship between class and time preference. It is necessary, however, to amend somewhat the argument that middle- and upper-class individuals are more likely to possess extended time horizons than are lower-class persons. Whereas this is true in the aggregate, we must remember that role — especially political role — can become an intervening variable. Most

studies focus upon the attitudes of classes, not upon elites who advocate and influence policies oriented toward the *short run*: ministers who become experts in social welfare; altruistic businessmen, union leaders, civil servants and other enlightened elites who ceaselessly call for "social responsibility"; and intellectuals and educators who advocate on theoretical grounds various forms of interventionism in the economic field. No matter how wedded these elites may be to low time preferences in their personal lives and household budgets, their public positions place them at the other extreme. They therefore prepare the way and lead the battalions who develop high time preferences. They likewise display a faith in the efficacy of political action as the source of economic justice and social reform. By demanding large transfer payments and the redistribution of income as the chief means for resolving social ills, they facilitate the growth of high time preferences and consequently mobilize the support of individuals and groups who might otherwise remain politically quiescent.

Under these circumstances the democratic state becomes a battleground of preferential treatment where more is both expected and demanded by elites and ordinary citizens alike. The competition for economic and social status increasingly focuses upon the short run, and because of the promises given by parties and politicians, claimants are encouraged to believe that their needs may be met with little real cost. Thus, it is believed that greater equality, justice, and economic growth may be simultaneously achieved by redistributing income, increasing welfare, granting subsidies, and regulating business and labor relationships. It is only normal under these circumstances that a multitude of individuals and groups would turn to the state in order to achieve their ends. This highly instrumental view of public life coincides with the tendency to look to government to resolve many problems heretofore perceived as essentially private in nature.

These changes in attitudes and expectations can only bring about a rise in time preferences. Since the populace tends to consume more than it saves and produces, its economic advance begins to slow down. Real growth, as we have seen, can only come from prior savings, but inflation, a growing public sector, and increased taxes reduce capital accumulation. A reduction in living standards which coincides with inflated expectations can only alienate citizens from the present economic order. In short, the economic time preferences in the community are overwhelmed by its political time preferences. Political Man increasingly dominates Economic Man. Thus, most of the ideologies presently held by the various political and social elites in Western democracies extol the efficacy of political action

at the expense of individual action. Running the gamut from Marxism to milder forms of interventionism, these social and political philosophies are in agreement that the "public" role ought to be enhanced at the expense of individual economic action; hence, government "planning" receives especially favorable attention. The irony is that in democratic orders planning seldom achieves its purposes simply because Political Man is in essence characterized by high time preferences. True planning, after all, requires patience, forebearance, and waiting time, but political actors in democracies lack precisely those qualities. If this were not the case, present inflationary forces would not be so severe. In the most profound sense, inflation derives from altered time preferences, although many scholars will continue to place the blame upon unions, corporations, and energy shortages. Such explanations, however, merely scratch at surfaces, confusing cause and effect.

Time Preferences and Political Philosophy

Systematic political philosophizing may be traced at least to ancient Greece, but the giants of the Western tradition have for the most part given scant attention to time preferences. For example, relatively little concern is evident in the political writings of Plato, Aristotle, Machiavelli, Hobbes, Locke, Rousseau, Marx, and others who have exerted such a profound influence upon our culture. After all, as a theoretical construct the idea is hardly a century old, coming as it does to us mainly through such economists as Menger, Boehm-Bawark, Fetter, and Fisher.

The chief reason that time preference — or some facsimile — does not enter the calculations of political philosophers probably derives from the types of questions they normally pose: What is justice? Why ought one to obey the state? How ought powers to be dispersed? These questions do not necessarily obviate the need to incorporate time horizons, but they hardly make of them a crucial concern.

On the other hand, one might expect recent students of political philosophy to have incorporated the concept of time preference into their work. However, we are doomed to disappointment. Perhaps it is simply not central to the interests of political philosophy, but one suspects that the Adam Smith bogeyman is also a causal agent. That individual self-interest might produce public benefits is an alien, if not distasteful, notion to most present-day students of political philosophy. Many of them, at any

rate, have decidedly socialist or aristocratic values rather than bourgeois and free market ideals.

Nonetheless, an absence of theory about time preference does not mean that the great political thinkers were unaware of time's importance in the lives of the members of the political community; far from it. Many writers undoubtedly believed that important benefits accrue to the community from delayed gratification. This position is especially apparent among those who wrote mainly from a religious or idealist perspective. Accordingly, they sharply censured sensual, class, or commercial interests which were not subordinated to the interests of one's soul or for the good of the state. In this respect, education received special attention since it could be utilized to inculcate civic virtue or knowledge of God. But because most of the classics were written prior to the development of modern economic theory, and because, moreover, the major thinkers gave paramount attention to the nature of citizenship, authority, or power, they tended to view the problem of time horizons more as a "public" question than as a "private" or personal one. Thus, if deferral of gratification or abstinence from certain activities was seen as beneficial to the community, the major means for achieving that end lay with public authority and leadership. Morality was imposed from the top, as it were. Private-directed actions, unless closely scrutinized, were inadequate at best and at worst were likely to be detrimental to public morals.

If a single notion of time can in general characterize political philosophy, it is that of *elapsed time*. The great thinkers were concerned with the consequences of present and future events upon the life of the community. These events in turn were evaluated positively or negatively; hence, the effects of *individual* time horizons upon economic, social, and political life hardly entered their calculations. In their view time had more to do with the unfolding of important historical events, wanted or unwanted, than with discrete, individual orientations and values about time.[24]

In the modern world it is the different expectations with regard to unfolding future events which generally distinguish liberal political thinkers from conservative ones. Conservatives and, for that matter, "reactionaries" wish time to stand still, or they hope to eradicate the disagreeable present and carry time backward to a previous state of affairs, either real or imagined. This was the extreme position of Plato and the more moderate stance of Burke, but it also characterizes the nineteenth- and twentieth-century reactionaries who romanticize the Middle Ages and find modern industrial society highly distasteful (Bonald, de Maistre, Maurras).[25]

Conversely, the liberal tradition eagerly anticipates the unfolding of future events; it is optimistic about the possibilities of progress over time. This was in general the attitude of writers during the Enlightenment. For example, no matter what their other differences, Rousseau, Condorcet, and Voltaire voiced a faith in the spirit of progress. Utilitarianism, of course, was a natural outgrowth of this spirit, and gave a powerful stimulus to majoritarianism — an impulse, as we shall have occasion to repeat, which in the course of the following centuries led to a severe shortening of individual time horizons. Thus, certain of the *philosophes* on the continent, notably Helvétius and Holbach, advocated social utility, but it was in England that the "greatest happiness for the greatest number" gained its strongest hold upon opinion. There, Jeremy Bentham, James Mill, John Stuart Mill, and the legalist John Austin helped to disseminate ideas relating to legislation and legal theory which have carried over into our era. By placing political institutions, legislation, and the common law under the firm scrutiny of utility, they not only encouraged a propensity to question existing property rights and the common law, but also helped to elevate statutory law and social legislation to the heights of respectability. Consequently, utilitarianism could not help but quicken the demand for, and pace of, social change. To this extent there was a short step from utilitarianism to modern socialism, although the strong commitment to individualism for some period masked this growing commitment to collectivism.[26]

It is probably accurate to say that our most widely studied political philosophers in the Western tradition have little in common with that individualistic liberalism which derives from the eighteenth and nineteenth centuries. It is not Montesquieu, Condorcet, Hume, and Adam Smith who receive the most attention from modern students so much as Plato, Rousseau, Hegel, and Marx. If one excludes certain individualistic aspects of Rousseau's work, it cannot be denied that the latter group is profoundly antiliberal and indeed collectivist in orientation. Whereas the eighteenth- and nineteenth-century liberal thinkers stress moderation, balance, and faith in gradual progress,[27] many of the interpreters of Plato's Utopia, Hegelian Idealism, and Rousseau's General Will are led by their *political* convictions to demean individualism and exalt the state, nation, race, class, or the masses. If students of the Scottish Enlightenment or admirers of de Tocqueville or Burke are frightened by the democratic collectivism of a Rousseau, the Will to Power of Hegel, or the class antagonism of Marx, they ought to keep in mind that ancient Greece not only gave the West Socrates, but it also provided inspiration for subsequent thinkers

determined to draw analogies between the Greek city-state and modern nation-states. As Popper and others have pointed out with much conviction, Plato's dissatisfaction with the pluralism of his time led him to idealize an older tribalism. Caste, cohesion, and order in his Utopia would subsequently be transformed by others into democratic collectivism and glorification of the state.[28]

Although the radical democrat and the worshiper of state power are strongly opposed to each other in principle, they are nevertheless united in the belief that a collectivity—either the "people" or the state—must manage individual time horizons in the public interest. Rousseau and Hegel, who with Marx have probably exercised the most profound influence on modern thought, represent two very dissimilar political philosophies which take similar positions with regard to time horizons. For Rousseau "true" freedom takes place within the framework of the General Will, whereas for Hegel liberty is found by subjecting one's personal will to the ends of the state. Both philosophers, however, believe that virtue resides in the ability to merge one's own will with a larger collective. Obviously the time horizons of individuals must themselves be transformed into *public* time preferences. The logical outcome is state management and manipulation of individual time horizons through government planning.

Many of the intellectual followers of Rousseau and Hegel may be traced to schools of thought which either glorified the state outright or for practical reasons utilized its powers ro oppress individuals in the name of the people. Apologists for the state and radical democracy alike are united in opposition to individualism and pluralism. Prussia, Mussolini's New Rome, and Hitler's Third Reich each claimed an affinity with Hegel, whereas Robespierre and the "democratic" French Revolution looked to Rousseau. The modern admirers of Hegel justify the state as the "march of God on earth," and the heirs of Rousseau institute reigns of terror in the name of the "masses." Marxism, of course, joins Hegel and Rousseau, taking something from each system. Hegel's dialectic, "stood on its head" by Marx, provides the historical explanation for class conflict and the coming Revolution, whereas the communist Utopia, standing at the end of the historical process, makes us free and truly equal in our natural goodness. In the meantime, of course, the dictatorship of the proletariat is necessary, say the descendants of Marx. In this period political roles must be all-controlling, and time horizons must be determined by the Leninist state. To save or consume, and to what degree, become for Lenin's successors a decision of party and state.

For radical collectivists, therefore, the management of time is mainly a function of political leadership rather than individual preference. Conversely, the heirs of Bentham and the moderate socialists, whether Marxist or Christian, are not so eager to hand over time management to the state as are the totalitarian statists and radical democrats. But moderate and extremist alike represent the triumph of political roles; and since the common good and virtue are linked with either *public* activity or majorities, a state may with a good conscience restrict consumption, siphon off "excess" income, limit profits, enact usury laws, establish exchange controls and tariffs, decree fixed wages and prices, and in general coerce citizens in the name of the general welfare. Can one therefore be surprised that most modern political thinkers find self-interest and the marketplace repugnant to their values? After all, social justice, the common good, or the rule of majorities is diminished by an adherence to mere "bourgeois" values.

Conclusion

In this chapter we have argued that the Economic Man of classical economics has received much unjustified criticism. In fact, his critics often merely assume that Political Man possesses virtues far superior to those of Economic Man, although the assumption remains for the most part unstated. The presumed moral superiority of Political Man is so much a part of our intellectual tradition that for one to stress the *social* benefits of self-interested economic activities is to invite ridicule. Perhaps the decision would be less strong if political roles were specifically examined more closely in relation to economic ones. Indeed, once we consider time preference, there arise strong reasons to question the conventional wisdom, for a powerful case may be made for the proposition that people are more likely to defer present gratification for future ends in the pursuit of economic rather than political activities. This argument, of course, has powerful implications for those who profess a faith in the ability of governments to engage in long-run planning. Nevertheless, the belief persists on the part of overwhleming numbers in the intellectual community that competitive markets and "excessive" individualism unleash short-run forces of hedonism, dissensus, and cultural degeneration.

Chapter 5

The Illusions of "Postindustrial Society"

Ours is an age of ideology, although we often go to great pains to deny that it is. We observed in the last chapter that ideological assumptions regarding the world creep with relative ease into our political and scientific discourse. It is now appropriate to consider an explanatory view of society which specifically denies any connection with ideology. In the name of hardheaded realism and science it purports both to explain the present and to be in harmony with the forces of the future. Unlike the concepts of Economic Man and Political Man, which are to a great extent implicit in our ideas of social reality but which may nonetheless incline us toward specific ideologies and policies, the arguments from this perspective form a fairly explicit explanation of social order as it exists at present, or will exist at a date in the near future. We speak in this regard about what is called the theory of "postindustrial society."[1]

Despite its pretense to scientific neutrality, postindustrial theory nevertheless carries within itself an implied commitment to high time preferences. Postindustrialists may diverge markedly on this or that point, but on the nature of time horizons they are remarkably silent; hence, the critic for the most part is forced to rely upon indirect evidence. Yet, it cannot be denied that the "carriers" of the postindustrial morality come down solidly in favor of behaviors, values, and public policies at one with high time

preferences. Moreover, it does not really matter whether the given post-industrialists are philosophers, social scientists, political administrators, or ordinary, well-educated citizens. If they are philosophers or social scientists they are likely to find themselves involved in blatant contradictions, whereas if they are practitioners their programs and policies will favor the growth of shortened time horizons. Therefore, the theory and practice of postindustrial society, we shall see, provide good soil for high time preferences.

A critique of postindustrial theory and the assumptions upon which it rests involves far more than mere intellectual exercise. It is at heart both a challenge to the way many of us comprehend, explain, and justify present policies as well as an anticipation of the manner in which we expect the future to unfold. Thus, it is not quite accurate to say, as has a leading scholar, that postindustrialism has little to say about politics, since the posture it adopts inevitably favors particular interests and policies.[2] One must not suppose that those who find postindustrial society congenial to their tastes and intellects are small in number; indeed, its tenets pervade the thinking of professors, intellectuals, politicians, media people, and others *au courant* in the world. Moreover, an acceptance of the basic ideas of postindustrial society is to be found on all sides of the political spectrum. One quickly discovers that liberal individualists and traditional conservatives alike speak the language of postindustrial theory once they shed their specific ideological garments for those of ordinary conversation and scientific discussion. In short, the postindustrialist operates in the world of everyday discourse, standing somewhere between the realm of "pure" ideology and actual practice. For this reason the assumptions postindustrialism brings to bear upon public policy have important social and political consequences.

The massive alterations in communications and technology as well as profound changes in life-styles have led many to conclude that we have entered or are on the threshold of a new postindustrial age. "Postbourgeois" or "postmaterial" values, themselves created by material abundance, mass education, and unparalleled possibilities of leisure, stress "self-actualization," and other non-material aspects of life.[3] On the other hand, this postindustrialism may bring along a whole new array of problems. Change may be so rapid as to make "future shock" our lot, so we had better prepare for its coming.[4] Similarly, older class ideologies, resting upon the politics of a simple industrialism, may be supplanted by new conflicts such as, for

example, those between the generations. Hence, while material progress reaches unparalleled heights, new divisions over cultural values become a distinct possibility.[5]

What are the major attributes of "postindustrial society?" Samuel P. Huntington lists some five which, he argues, are common to most studies of this genre: (1) the economic predominance of the service sector; (2) a widespread and critical role for professional, managerial, and technical workers; (3) a central role for knowledge, technology, and research rather than physical capital—hence, the dominance of universities, think tanks, and media devoted to the transmission of knowledge; (4) high standards of affluence; (5) high levels of and access to education; and (6) "postbourgeois" values as opposed to older ones like the "protestant ethic."[6] Whereas various theorists choose to emphasize one or more of these five characteristics, or even certain particulars implied in various ones—e.g., technology, equality, leisure, change, or communications—few scholars are likely to quibble very much with Huntington's summary list.

There have been some excellent critiques of the postindustrial idea, including, for example, Victor Ferkiss's devastating criticism.[7] In this chapter, however, we take a rather different tack, resting our case upon three propositions. First, and most importantly, we discuss postindustrial theory and the kind of society it posits in terms of time preference. A discussion of temporality leaves much doubt with regard to its viability, at least in the form promoted by its admirers. Secondly, we attack an assumption which lies behind most arguments for the emergence of postindustrial society: that technological growth is an operative force in its own right, moving more or less under its own steam. Finally, even if one accepts the attributes assigned to the "emerging order," it is still true that the various characteristics commonly attributed to post-industrialism cancel out one another in significant ways. Thus, "post-material" and self-actualizing values not only contradict the probability of material advancement but call into question any age of "postscarcity."

In order to support our argument regarding the tenuous quality of postindustrial society, we shall address three problems: (1) the tendency for postindustrialists to ignore or denigrate the role of savings and capital accumulation; (2) their reification of technology; and (3) their failure to recognize the effects of inflation on technological development and inflation's consequence for postindustrialism in general. Whereas individual proponents of the postindustrial thesis have sometimes addressed one or more of these issues, there can be little doubt that the overwhelming number

among them have either ignored them altogether, as in (1) and (3), or exaggerated the importance of particular phenomena, as in (2).

The Erosion of Savings and Capital Accumulation

The energy crisis of the 1970s undoubtedly dampened some of their fervor, but the theorists of postindustrial society subscribe to the view that we are moving into an era of "postscarcity." To the extent that we are not, the chief causes are generally attributed to the lack of public funds directed toward the "knowledge" sectors, failures in the tax system, niggardly transfer payments, and a reluctance to control price-administering "oligopolies." Once such obstacles are removed, it is said, the progressive trends in socioeconomic life will reassert themselves more strongly than ever, although admittedly one must still allow for unforeseen cultural, ethnic, and political conflicts.

It is recognized, however, that this analysis is conceptually flawed. In fact, postindustrial society is threatened mainly for the following reason: *High time preferences weaken support for saving and hence the accumulation of capital goods.* As such, the material means upon which any postindustrial society rests are gravely endangered. Without this structure there can be relatively fewer knowledge industries and postmaterial values based upon leisure assumptions, since economic stagnation would then carry in its wake stagnation in other areas of social, political, and cultural life.

Perhaps these points may be made more clearly if we quote directly from a study of postindustrialization in Sweden. It is a work which both takes the postindustrial society idea seriously and summarizes the views of its theorists:

As modern industrial systems continue to sustain economic growth and achieve mass affluence, postindustrial modernization becomes an historic possibility. Used by numerous social scientists to describe the emerging era of economic and social relations in the United States and much of Western Europe, a postindustrial society can be defined as one in which the primacy of capital accumulation and industrial production yields to the primacy of redistribution of wealth, material goods, political influence, and social status. As an important corollary of postindustrial modernization, the inherent contradiction between collective and individual claims for control has accordingly assumed new dimensions.[8]

This paragraph in fact is an excellent illustration of how complex societies do *not* work. The notion of "technology as independent force" liter-

ally permeates it: "Modern industrial systems," presumably postindustrial ones, "sustain economic growth and achieve mass affluence." The causal sequence is incorrect. Technology and economic efficiency are two entirely different concepts: It is the available supply of capital goods which *determines* the range of techniques to be utilized. Actually, less advanced techniques in many instances may be economically more efficient.[9]

Moreover, we are informed that capital accumulation "yields" to "redistribution." This conclusion may well be an empirical statement about changes taking place in major Western democracies at this juncture, but the consequences are unlikely to portend the scenario postindustrialists have in mind. Redistribution and economic stagnation may occur simultaneously, since redistributive policies on a large scale would affect incentives to save and invest.[10] Indeed, "redistribution" and a decline in capital accumulation are unlikely to be associated *in any way* with the emergence of a postindustrial society. Without capital accumulation there can be no postindustrial society. As the statistics come in each year, individual savings rates continue to stagnate or fall in Western democracies. If this trend continues, one may say with some confidence that the postindustrial prediction will be replaced with another, less glamorous one.

A more serious objection in this context relates to the proposition that postindustrial society is linked both with the redistribution of wealth and the stability or decline in the accumulation of capital goods. If this means that a more affluent order is capable of reallocating more resources through transfer payments and "public" goods, then one finds little with which to quarrel. This is merely another way of saying that rich nations, unlike poor ones, can afford the welfare state. But if it means that the "primacy" of capital accumulation levels off or declines in the emerging or existing postindustrial societies, then the argument is quite controversial. No modern society can materially thrive without a growth in the accumulation of capital goods over time (assuming present population trends); and the more such goods are accumulated, the greater the wherewithal for still further growth. As we saw in Chapter 3, these accumulated goods offer "released time" from the production of consumer goods and capital goods relatively near the consumer in order to create other capital goods which, while more productive over the long run, nevertheless take more time to come to fruition. In general, they also offer a wider choice for specialization and differentiation in skills and goals. It is for this reason that rich nations tend to grow ever richer while poor nations have much more difficulty "taking off."[11]

Because postindustrialists misunderstand the fundamental dependency of the emerging order upon rising levels of capital accumulation and of the latter upon the supply of savings, they naturally fail to comprehend the decisive importance of time preferences upon savings. Let us be clear on this point: In certain short-run cases all savings may not equal all investment, since the two functions may be performed by different individuals. Moreover, one can even conceive of investments as prior to savings.[12] But nonconsumptive genuine savings, as opposed to the mere *appearance* of savings when money creation finances investment, are dependent upon our time preferences. By saving, we restrict our consumption, and this restriction in turn leads to investment and the accumulation of capital goods. We give up present goods for future goods, present consumption for consumption at a more remote date.[13]

Postindustrial theory, however, begins at the opposite end of the intellectual chain: It ignores time preference, demeans savings, and implies that technology causes or can dispense with capital accumulation. Postindustrial technology simply spews forth material goods and leisure time.[14] Once this outlook is accepted, it is easy to see how "postbourgeois values" and notions of "future shock" based upon short time horizons find ready support among theorists. We live for the moment. Affluence turns our heads from the difficulties of everyday existence to leisure and self-expression. Political conflicts may threaten the social order, but changing and experimental life-styles based upon both non-material and sensual modes of behavior are, if not inevitable, at least something to be lived with.

Unfortunately, the values and norms which technological society supposedly creates (see Ch. 2) are incompatible over the long run with capital accumulation. The Bourgeois Ethic, the "work ethic," "inner-direction," frugality, self-control, forebearance, abstinence, and other such words and phrases express values conducive to capital accumulation, since they are favorable to low time preferences and high rates of saving. They also connote values conducive to the creation of technology and innovation. One cannot have capital accumulation without saving; and one cannot have continual technological innovation without the accumulation of capital goods. In brief, our civilization, both material and spiritual alike, is ultimately dependent upon certain values instrumental in the deferral of short-run gratification.[15]

We therefore emerge with a glaring contradiction: *Postindustrial material prosperity is incompatible with postindustrial values.* Its believers must give up one or the other.[16] How do we explain this contradiction?

Indeed, how do we explain the stress upon technological holism in general? Perhaps it is the ideological hostility to the role and function of markets and a sympathy for large-scale planning, for "societal guidance."[17] Or is it the assertiveness of a "new class?" This point has been made more than once by sociologists and political scientists.

While not denying the importance of these explanations, we should like to focus upon a different argument altogether, one which, incidentally, is quite compatible with other extant explanations. For both scientific and ideological reasons, postindustrial theory tends to assume that economies operate according to the demand of technological forces and advanced knowledge as found in governments, think tanks, and certain types of corporations. Thus, it assumes that markets play at best only a limited role in economic growth and prosperity. It likewise assumes that the economic order churns out goods automatically at an almost unbelievable rate. It is not surprising, therefore, that *the* economic problem in a system of "postscarcity" is the proper distribution of abundant resources and the associated problem of *demand management*. A superabundance of goods of necessity precludes an obsession with supply (production) problems. The trick is merely to slice a large pie equitably and to keep demand for vast quantities of goods sufficiently high for full employment.

The great shadow of Marx, of course, looms in the background—his holism, his stress upon the inexorable forces of production, and his grand vision of the future—but it is more likely that Lord Keynes and his followers have had a more direct impact upon postindustrial theorists. Keynesianism merges nicely with the technological orientation: It observes glut in the midst of depression, whereas postindustrialists see superabundance in the midst of *mere* prosperity. Keynesianism thus provides the general outlook and many of the working assumptions upon which theorists (the more well-known of whom are sociologists and political scientists) build their postindustrial explanations about status, class, life-styles, and the like.

Keynes and his supporters were (and are) in a real sense depression economists, generally perceiving the economic problem as one of effective demand or, to put it crudely, "underconsumption." The Great Depression demonstrated that large quantities of goods could pile up and remain unsold. Poverty and mass unemployment in the midst of plenty seemed to violate "orthodox" economics.

Say's Law, the cornerstone of the older schools, was finally laid to rest. "Supply"—that is, production—no longer creates—that is, constitutes—

demand for other goods.[18] To paraphrase Keynes's paraphrasing of Say: "Demand creates its own supply." Once one admits that a lack of effective demand threatens the growth of income and employment, the neglect of the time dimension is all but inevitable—other than in a short-run garb. Lengthy time horizons have thus become both bad economics and bad policy. Through its stimulation of aggregate demand, government becomes the major means by which employment and production are sustained. Public works, large transfer payments, low interest rates, redistributive income taxes, and the like fill the gap created by "excess" savings. Since the propaganda accompanying such programs and policies, normal in any democratic society, fosters high expectations for success, and since some effects of the stimulus to aggregate demand are indeed apparent in the near future, government intervention both creates and reinforces short time horizons at elite and mass levels. Not surprisingly, this brief readily coincides also with "knowledge class" beliefs of civil servants, educators, and technicians who look to central administrators, not to individuals and corporations, to press the accelerator of progress. They also presumably reap the credit for any short-term success.

An overriding concern with aggregate demand makes little room for the function of savings; and since savings implies that present goods be renounced for future goods, it likewise makes little place for time. Thus, whereas the role of time finds much of its meaning in a society dominated by the older, future-oriented bourgeois notions of thrift and frugality, a stress upon spending and consumption—upon aggregate demand—finds a ready reception in our modern consumer-oriented, affluent society. This "hydraulic Keynesianism," as Alan Coddington has designated that brand of Keynesianism which found its way into nontechnical writings and into policy prescription, places itself on an entirely different plane from the older economics. Not individual choices and messy markets, but government manipulation of large aggregates such as total income, expenditure, and output now plays the central role.[19]

Obviously hydraulic Keynesianism grew out of conditions quite distinct from those of postindustrialism. Slack demand, unemployment, and reduced output at first glance seemingly have little in common with postscarcity and technological innovation. Yet, a similar mind-set unites both eras. Each is fascinated with state direction by experts of economic life; each also sees social reality in holistic terms. Governments, statistical aggregates, and underlying forces, but not individuals move the world.

Little in postwar economics fundamentally undermined the hold of

hydraulic Keynesianism upon the public. One might have expected the dominant neoclassical school, which sought to marry Walras to Keynes, to offer some resistance, especially in its stress upon individual rationality. In fact, its influence has been mixed. The assumption in neoclassical theory that tastes, resources, and knowledge are somehow already "given" to individuals or firms and that the latter in turn maximize income (or other values) easily lends itself to other interpretations. Moreover, "equilibrium" notions govern neoclassicism, not the ceaseless change, diverse tastes and expectations, and the lack of knowledge found in real markets. In this highly rational view of economics, market competition is thus seen as a static "state" of affairs, not a "process" through which ceaseless change occurs. "Perfect competition," when put in lay hands, becomes the standard by which the world is judged—and found wanting. Since no system can ever reach this perfect state of affairs, the plausibility of competition itself is called into question. The public is taught that competition exists only on paper, so it naturally wonders if market economics can ever really work.[20]

Technology in the Driver's Seat

Postindustrial theory therefore ignores the crucial role of savings and capital accumulation and the dependence of each upon long time horizons. Similar intellectual blind spots are to be found in another component of postindustrial theory, namely, the tendency to treat technology as if it were an "independent variable," as if it had a life of its own. "Technology," says Bell, "is the foundation of industrial society. Economic innovation and change are directly dependent upon the new technology."[21] Moreover, this technology leads to an era of "postscarcity." As John Kenneth Galbraith tells us, modern industry is composed of a "technostructure" of price-administering corporations whose planning needs and oligopolistic market positions enable them to produce the innovations so necessary for growth and prosperity.[22]

Although such scholars as Bell and Galbraith are important sources of the technological mentality, the most important influence, according to Nathan Rosenberg, may ironically be Schumpeter. The wide scope Schumpeter allowed for technological innovation and its consequences for the ups and downs of the trade cycle, the virtues he attributes to economics of scale, and the decisive role he gives to "monopolies" in innovation

offer a strong appeal to technologists. Especially important is his stress upon the "innovation" function of technology; unfortunate, however, is his neglect of the "invention" and "imitation" stages. Technology is thus perceived as a great exogeneous force bursting upon the scene in the form of a major invention or cluster of inventions carried out by entrepreneurs of vision.[23]

Reality, however, is rather more complex. The time lag between an invention and its technical feasibility may vary enormously. Indeed, many inventions never approach feasibility, and even if technical workability is established, it does not necessarily follow that a given invention is *economically superior* to existing techniques. For example, synthetic rubber was technically feasible prior to World War I, but so long as costs of natural rubber were low, it had small chance for success. Again, there is the problem of different factor combinations. For instance, building houses with wood makes more sense in the United States than in Great Britain. Or, techniques useful for agriculture in a developing nation may be completely inappropriate for a Western country. In other words, economic prosperity and development ought not to be confused with either the concept or growth of technology.[24]

Furthermore, the diffusion and innovation stages must not be confused. Innovations are unlikely to emerge full-blown on the market. Their diffusion requires continual adaptability and modifications to the needs of various submarkets as well as change in various inputs affecting the economic usefulness of an innovation. Just try to imagine, for example, cars without roads! Small incremental alterations, redesigning, and routine changes may turn out to be decisive influences governing an invention. These alterations may be small, but they may well determine the fate of innovations.

At bottom, confusion arises because the postindustrial mentality adopts what might be called an "engineering" as opposed to an "economic" view of socioeconomic progress. Hence, it confuses cause and effect by treating technology as the "independent" variable. It fails to apprehend that time preferences and savings are *prior* to technology.[25] As Murray N. Rothbard has so cogently argued, there will always be a shelf of available and superior inventions and productive techniques which nonetheless remain unused by entrepreneurs. Why? Because the supply of capital is far more limited than is the number of inventions and techniques. To put it another way: The demand for saved funds outstrips the demand for new knowledge.

This observation may be shown in a comparison of rich and poor nations. Information is transmitted rather quickly between countries among

technological and entrepreneurial elites, but capital, due to its inherently limited supply, travels much more slowly, if at all. What, therefore, is a poor nation to do if it lacks capital? It can borrow capital and hence the capital goods from more affluent nations; or, conversely, it can severely restrict its own consumption and increase its own pool of savings, pulling itself up, as it were, by its own bootstraps. To take the first route is far easier, of course, since others have previously saved time for the poorer nation, enabling the latter to avoid the painful and slow process of capital accumulation.

In addition to the role played by saved capital, there is also the problem of capital goods. To repeat, it is the available supply of capital goods which determines which of the various techniques are likely to prove more feasible. A superior technique may well not be utilized because plants and equipment *created in the past* are already available. It is thus the relatively higher expected costs of new capital goods which prevents entrepreneurs and investors from removing inventions and more productive goods from the "knowledge shelf." On the other hand, expectations of high profits to be derived from new plant equipment or even changed location may indeed increase the demand for inventions and techniques. "An old machine will be scrapped for a new and better substitute," says Rothbard, "if the superiority of the new machine or method is great enough to compensate for the additional expenditure necessary to purchase the machine."[26]

Finally, when we observe the structure of capital goods, we note that it is in the capital goods sectors, not the consumer goods sectors, that newer technologies are most often developed. The stimulation for new capital goods—the thirst for inventions and new techniques—is highly dependent upon the number and kind of goods which have been previously accumulated. Generally speaking, the greater the accumulation, the higher the technological innovation. Thus, if postindustrial growth and prosperity are to be more than a dream, citizens must constantly add to the pool of savings.[27]

True, the causal sequence may appear to go in the other direction: That is, technology seems to influence the nature and form of capital accumulation. A new technology can create new demands, making some skills redundant. For example, a new railroad may encourage new technologies as population and cities grow in relation to the transportation system. But even in this instance the rails become feasible only because the previous accumulation had already reached a certain stage; after all, sufficient goods had to be available for transport.

However, there is a more fundamental difficulty for the theorists of post-

industrialism. Because technology is treated as an independent, exoge-
neous, and singularly creative force, they are led to misunderstand, first,
the nature and functions of markets and, second, the immense complexity
of modern capital structures. In the first case, market competition is treated
as insignificant at best and unworkable at worst. Accordingly, the tech-
nologists attach relatively little importance to profits and price systems.
Changing profits and prices are, nonetheless, *generators of knowledge.*
They allocate resources to the more preferred wants of consumers by di-
recting savings and investment toward those goods and services where
prices are rising, where profits are high, and/or where prospects are glow-
ing. When relatively open, market systems provide an institutionalized out-
let for the supply of available savings. They likewise distribute resources
among the various kinds and orders of capital goods.

Time preferences are important because they ultimately determine the
ratio of savings to consumption in a given community. Depending upon
the degree of interference and obstacles placed in the way of individuals,
their time preferences are reflected in the rate of interest. Relatively high
time preferences would encourage more investment in goods nearer to the
consumer, for interest rates would be higher, whereas relatively lower time
preferences would presumably encourage lower interest rates and thereby
direct savings and investment towards those capital goods more remote
from consumers. A close link, therefore, exists between time preferences,
savings, and the ordering of capital goods.

Let us now turn to the complexity of the capital structure itself. Imag-
ine a universe of tools, equipment, buildings, land, furnaces, machines,
wire, typewriters, and other multiple goods. Numerous planning minds
combine, alter, and discard these capital goods. Small alterations in con-
sumer preferences bring forth new data and combinations. Market knowl-
edge, as determined by prices, profits, and expectations about the future,
each day leads to new capital combinations and to the reshuffling of ex-
isting capital goods. Some capital goods are high specific in terms of the
purposes to which they must be put; once that purpose disappears, they
must be discarded. Others may be substituted for other capital goods.
And still others are — and sometimes have to be — complementary to cer-
tain capital goods. Hence, it is quite naive to perceive this reality of capital
as a "lump," as homogeneous, or as a "flow."[28] By underestimating capital
complexity, we give rise to the false idea that the capital structure may be
easily manipulated by central planning agencies. This misunderstanding
of capital complexity also paves the way for the technological mentality.

The problem of complexity may be gleaned from still another angle.

Modern production structures are characterized by what Boehm-Bawerk first called the "more roundabout methods of production." In progressive societies the period between the initial input of various productive factors and the output of final consumer goods takes longer, but it is also more productive. Thus, *over time* ever greater amounts of labor, materials, and existing capital goods enter into the processing of final goods. Let us give a simple example. We might employ three methods for harvesting wheat: we might simply pick it; we might use a scythe to cut it; or we might buy a tractor to harvest it. It is readily apparent that the last method is the more roundabout, since far more time and resources went into the building of a tractor than in the mere utilization of field labor. Think of the long period of time for all the steps involved in creating the tractor—e.g., iron ore, blast furnaces, steel plants, skilled labor, sophisticated tools.

Whereas Boehm-Bawerk's notion is probably a safe generalization about modern Western societies, it is not always true that progress is solely a function of the time it takes for consumer goods to ripen. As Lachmann has argued, the more roundabout methods of production insight may be understood more realistically as a growth in the *division of capital.* Just as the division of labor implies more specialization among workers, so the division of capital suggests a growing specialization and differentiation among capital goods. Thus, layers upon layers of capital goods are piled upon one another in complex ways, spreading, we might imagine, both outward and downward, widening and deepening the structure of production. Not only are similar sorts of goods continually being multiplied but, more importantly, wholly different kinds of capital goods are being developed, enabling societies to resist the Law of Diminishing Returns.[29]

It ought to be clear by this time that the view of the capital structure offered above—i.e., one stressing the knowledge-generating functions of markets and the intricate linkages between capital goods—is quite incompatible with the technological vision in postindustrial theory. By assuming central sources of information, postindustrial theory generally ignores capital complexity. It gives us the "knowledge class" of concentrated information producers and recipients. This "new class" of scientists, technicians, doctors, managers and other experts requires more think tanks, massive outlays for R & D, and public sector funding. It gives us "system" controls, "societal guidance," and "planning," all the while claiming to represent the "public interest" and the "future."

But does this small number of individuals know the amount and kinds of capital goods which are to be produced in the face of millions of daily

producer and consumer decisions? Do those skilled in "societal guidance" aid us? In the absence of knowledge generated by markets, can any amount of technological wisdom give us an answer? Answers to such questions are difficult to come by, since postindustrial theory is so reticent about the functions of markets. On the other hand, a stress upon central guidance and planning in economic matters is not seen as incompatible with cultural and political freedoms. In fact, postindustrialists generally expect other freedoms to grow.

Inflation and Technological Stagnation: Some Clues from Trade Cycle Theory

For some time now most western nations have periodically experienced "stagflation" and reduced rates of productivity. Inflation especially, by encouraging present gratification, wild speculation, and in general an emphasis upon the short run, distorts the manner in which we perceive time. It discourages saving and thrift as it simultaneously encourages spending and debt.

Inflation, however, assumes little importance in postindustrial theory, although the longer it endures and grows, the greater the threat it poses to affluence and productivity—that is, to postindustrialism itself. In this respect, nothing is more crucial for postindustrial society than technological innovation. However, in recent years various writers have pointed ominously to figures relating to drops in R & D expenditures, declines in inventions and patent applications, and sluggishness in productivity. These warnings, ironically, coexist with opinion apparently favorable to postindustrial arguments. It is not accidental that recent expressions of concern in some circles for our technological future coincide with the fact of accelerating inflation.[30]

Many economists, after all, have long pointed out that inflation encourages malinvestment, distorts markets, and wastes capital. Constant changes in prices make it difficult for business executives to anticipate future consumer demands. Similarly, the "paper profits" made during inflationary periods distort business decision-making. For example, equipment is bought "at cost" in one period, but at a later date rising prices make very high profits possible. Unfortunately, the profits are eaten up when subsequently the new equipment must be replaced at the higher price levels. Likewise, when old equipment is utilized for extended periods during

an era of rising prices, the owners of such durable assets may reap huge profits. Their very success, however, draws investment into these markets; not only are rewards for newcomers highly problematical, since they must purchase *new* equipment at *higher* prices than otherwise, but due to the limited supply of capital, investments in other areas of the economy are correspondingly reduced. Finally, inflation generates income for certain kinds of activities at the expense of others. Thus, new scientific techniques may not prove as profitable as, say, forecasting price trends or understanding tax liabilities.[31]

These more or less traditional accounts of the ravages of inflation undoubtedly imply serious consequences for innovation, but they fail to focus upon the specific relationship between innovation and inflation. Under what conditions is innovation most likely to occur? In what cases is innovation most likely to be discouraged? We suggest that a clue is to be found in a literature which has fallen from grace in recent decades, namely, trade cycle theory.[32] It is by observing extreme inflationary situations and by asking in general which periods of the upswings and downswings of the cycle are more congenial to innovation that we may gain some insight into those environments most conducive to technological innovations. Such a picture, of course, must be somewhat distorted, since it imposes more order on the capital structure than actually exists and since it extrapolates from rather extreme economic conditions.

Two additional points should be kept in mind. The first is the obvious but neglected truth that the supply of capital is limited: By definition, capital devoted to certain areas cannot be allocated to other areas. The second point is more on the order of a "realistic assumption" about the structure of capital goods. As "produced means of production," capital goods may be mentally arranged from those of a higher order most remote from consumers to those which ultimately turn out consumer goods. At the obvious risk of being simplistic, we might conceptualize the capital goods structure in terms of the following types of industries:

1. those which produce consumer goods,
2. those which produce equipment for the production of consumer goods,
3. those which produce raw materials, and
4. those involved in innovative goods.[33]

Note that the first three industries (1–3) are located in ascending order, running all the way from final consumer goods to raw material producers,

whereas the innovative goods—e.g., so-called "growth industries"—cannot be so easily placed. Indeed, innovative goods exist in *various* industries, especially in our modern world with its large "service sector." They need no longer derive from such basic industries as railroads or steel; they may also be found in computer and automobile markets.

Yet innovations do seem to flourish in a particular kind of economic climate. First, since an innovative good is best described as a "future good," it "depends thus largely on expectations regarding a distant, unknown and uncertain future."[34] Demand for it is only loosely connected with present consumer goods; indeed, it may even represent the production of a wholly new industry. Consequently, the desire to invest is likely to be affected by the relationship which exists between costs—including interest costs—and future expected yields. To put it another way, if we assume bright prospects for a particular innovative good, then low and/or stable costs (including low interest rates) and expectations of continued stable costs will create an inducement to invest in that good. Conversely, a rise in costs checks inducements.

Secondly, a desire to invest is also likely to be influenced by the level of real wages, that is, by the "ratio between the money wages and price of the product of a given industry."[35] Thus, the higher the real wage, the greater the likelihood that labor-saving machinery will be substituted for workers. Traditional boom periods in their late stages are characterized by a rise in real wages, causing not only the replacement of old machinery but the introduction of new equipment to replace expensive labor. In other words, these periods are normally those of capital expansion—expansions whose limits are subsequently reflected both in the liquidation of malinvestments and in increases in unemployment. During the boom itself, however, the glow of prosperity is felt with rising wages, high demands, and favorable business prospects.

One might suppose that the rise in product prices and profits would encourage innovative forces, at least with regard to the substitution of machines and equipment for labor. In fact, entrepreneurs may find it more profitable to hire cheap labor than to convert to expensive machinery.[36] Hence, an inflationary boom with its hectic business activity at relatively full employment may easily lend itself to the *false* impression of technological progress.[37] Similarly, rising consumer demand and incomes at full employment levels may simply encourage short-term investment and speculative ventures at the expense of long-term capital formation. Boom conditions, therefore, by no means necessarily assure genuine innovation.

An important question remains unanswered: Since only a *limited* supply of capital is available to be distributed among the various orders of capital goods, how are the "innovative industries," which stand somewhat aloof, to realize their fair share? For example, increased investment in higher-order goods draws labor, land, money, and goods away from lower-order industries relatively nearer the consumer. This situation cannot last indefinitely, however. A reversal of the process must eventually take place when demand for higher-order goods drops off. Resources are then withdrawn from the latter toward lower-order goods where demand and prices in the meantime have risen relative to higher-order goods. This entire process may be conceptualized as one in which a limited supply of capital resources is being ceaselessly redistributed along the rungs of an imaginary ladder of structured goods.[38]

As creators of "future goods," innovative industries are highly sensitive to changes in the demand for capital and labor. In fact, they are rather quickly put at a disadvantage. Thus, a strong rise in "aggregate demand" at relatively full employment stimulates consumption goods industries and those which produce equipment for these industries. This demand in these areas for new machinery and replacement, as well as rising incomes and demand for raw materials, has several effects. Higher incomes mean greater consumer demand (assuming saving does not absorb the new income), whereas a quick rise in profits encourages short-term investment and speculation to meet the growth in consumer demands. Capital flows into the consumer, equipment, and raw material goods industries, not into those firms which merely *promise* future profits. At any rate, capital and labor are diverted from future-oriented industries into those which are nearer to the consumer, away from "capital-intensification" and the "more roundabout methods of production" into short-term investments and speculation.

In boom periods intense pressures are placed upon raw material industries. As their prices rise, innovative industries, whose profits lie in the distant future, are forced to compete with economic sectors whose products are already in high demand. Thus, innovations are struck from two directions: Their borrowing costs and their need for raw materials and equipment made with raw materials make it unprofitable to invest in the creation of long-range products. Because consumer demand is high and rising, industries which supply consumer goods and/or supply equipment to consumer goods industries become more profitable. Moreover, the profits to

be made with rising prices draw capital into more speculative ventures and away from future-oriented firms.

Under boom conditions the demand for labor also increases. The consequent growth in incomes and the diversion of capital from stages nearer the consumer, however, eventually force a rise in consumer goods prices and a consequent fall in "real wages." This situation the unions find increasingly unacceptable. Industries with higher profit margins at the lower stages may bear increased labor demands or substitute new machinery, and those at the higher stages may find their borrowing costs favorable because of "easy money" policies or because they have high profit margins. But those industries dependent upon low costs may have much difficulty in absorbing high-priced labor.

The boom is deceptive for analysts since it is so tempting to equate glowing productivity and employment figures with technological progress. The perspective presented here suggests a contrary interpretation. A most pertinent example is Constantino Bresciani-Turroni's detailed assessment of the Great German Inflation following World War I. Precisely because the German inflation was so extreme in its impact, we learn something about the effects of inflation upon social and economic structures in less extreme circumstances. In Germany between 1919 and 1923 was a conjunction of intense economic activity and a reduction in living standards. Indeed, complaints were heard that German business was not buying enough improved machines because labor was so plentiful, although there was ample evidence at the time that a powerful stimulation of capital markets was indeed taking place. At the end of the boom, however, the shortage of capital in certain sectors became painfully evident. Interest rates were steep, capital had gone into hiding, projects were stillborn, and workers were no longer willing to accept reductions in real wages. In these inflationary years there was a feverish development of coal mining, steel, and the growth of shipyards, whereas lower order goods nearer consumers such as shoes, textile products, housing, and agriculture were relatively neglected. The so-called "shortage of capital" was in fact a distortion within the productive structure. With the subsequent fall of prices in 1924, the beginning of a slow return to balanced growth between the various stages of production began to take place. Between 1926 and 1928, new industries were created, productive equipment reorganized, and technical changes introduced. Significantly, the latter period also was one of price *stability.*[39]

What do we learn from this excursion into trade cycle theory? First, a noninflationary climate is essential for sustained technological development. High levels of saving, low interest rates, slack consumer demand, relatively cheap labor, and low raw material costs seem especially conducive to innovation. Needless to say, at this juncture these conditions are nonexistent in major Western democracies. These conditions also suggest an adherence to government policies which repudiate notions of "aggregate demand." After all, the artificial stimulation of demand is likely to foster those industries least in need of stimulation, namely, the consumption goods industries and those industries complementary to them. Similarly, attempts to maintain low interest rates through "easy money" policies are likely to cause malinvestment in higher order goods, to divert resources from innovative firms, and in the long run to reinforce inflationary pressures. Capital is therefore wasted, destroyed.

Conclusions

As an ideological tendency postindustrialism has profound policy consequences in terms of the roles it legitimates and the structures it supports. It in effect legitimates the positions and functions of a "new class" of technocrats who are indifferent, if not hostile, to the Bourgeois Ethic and the more traditional middle classes. Postindustrialism therefore underestimates the contributions of savers, small business, and entrepreneurs while it extols the work of scientists, professional managers, and other "experts" in the "knowledge class" who work for large organizations in both private and public sectors. Not surprisingly, such experts are often less than enthusiastic with regard to the functions performed by competitive markets in the allocation of scarce resources, nor are they likely to be found among those intellectuals who stress the efficacy of competitive markets.

Similarly, the postindustrial mentality provides a favorable ideological climate for the growth of "neocorporatism." Neocorporatism, of course, implies a working relationship between associations of business, labor, and professions, on the one hand, and government agencies, on the other hand. Governments do not so much keep private organizations at a respectful distance as establish working partnerships with particular elements in the private sector. They accordingly give subsidies, award licenses, and impose quotas and tariffs against imports in return for some degree of control over business and union decision-making. The establishment of for-

mal consultation channels between government and private sector interests invariably leaves many groups to fend for themselves. Hence, policy is skewed in favor of those sectoral interests deemed most representative of the "national interest."[40] Postindustrial intellectuals tend to see such changes as either inevitable or worthy of support. We must therefore scrap the concept of postindustrial society since it expounds an inadequate social theory and ultimately leads to bad social policy. It is inadequate social theory because its defining characteristics contradict and cancel one another: because of its holistic view of technology, its naiveté regarding the function of saving, its misunderstanding of market complexity and the role knowledge plays, and its ignoring of the time dimension. Similarly, poor theory easily embraces poor policy. Postindustrialists too often assume that the knowledge possessed by central authorities and scientific elites, if properly cultivated, provides a sufficient basis for the growth of postindustrial society. Like Political Man, postindustrialists in general display more faith in political organizations and in centrally directed structures of experts than in the outcomes of impersonal market allocations. Economic Man, increasingly replaced by technocrats, has a much smaller role to play in the new postindustrial order, belonging as he does to a bygone era.

Chapter 6

An Age of
Promissory Politics

Ours is not just an age of inflation; it is also an age of Promissory Politics, hardly a surprising observation given the ascendancy of Political Man. Citizens have always demanded that their governments defend their lives and property, but it is the explosion in demands for material benefits and protection from the vagaries of economic change which give our era its peculiar coloration. Politicians for their part have not only responded to the public's insistence upon largesse and protection, but, if anything, have pushed more strongly than citizens themselves for policies and programs designed to extend privilege. Indeed, the source for these initiatives derives as much, if not more, from political leadership than from the public-at-large. We previously examined the social, economic, and ideological manifestations of this state of affairs, but have so far merely touched upon the role played by political structures in shortening our time horizons. It is clear in this regard, however, that one political institution is of special importance, namely, the modern political party.

In the present chapter we argue that it is through political parties and the functions they perform that promissory politics receives its chief stimulus. But if party activities are the chief means by which promissory politics grows, there are also certain ideological and constitutional contexts that help to sustain it. We cannot isolate parties, therefore, from those ideologies and institutions which reinforce party functions and legitimate their

activities. To this end we consider three beliefs or values in relation to party role which people in Western democracies support with varying degrees of enthusiasm and which sustain legitimacy.

First, we address the popular proposition that extensive participation in modern democracies is both a right and a duty. The question raised is seldom about whether mass sentiments ought to be restrained in some manner but is rather about how best to tap citizens' desires. Since in any democracy the wishes of the people must be ascertained in some fashion and leaders must be chosen to represent them, the political party has naturally evolved as the chief instrument for accomplishing the vital functions of representation and leadership recruitment.

Second, parties are the major means through which government power is to be exercised in the name of the people. The outcome of party competition in elections is therefore a "mandate" to govern. But a mandate is not unlimited; parties and governments must also be held "responsible" (or accountable) on a continuing basis. In many nations and among many elites there is the strong belief that political systems in which party and government "responsibility" are assured through clear lines of authority running from the government to the peoples' representatives and on to the masses not only enable leaders to ascertain mass desires more clearly but also assure "good" policy. Conversely, those systems which divide government authority among branches of government or possess weak party organizations, as in the United States, are criticized by sophisticated opinion on the grounds that their structures produce indecisive, divisive, and unrepresentative leadership.

Third, although seldom stated in any explicit manner, there is a marked tendency for those who believe in strong party organization and intense inter-party competition to place their faith also in what is known as the political "center." This attitude is understandable. The center functions to reassure those of us who revere strong party competition for the peoples' vote while simultaneously reducing our fear that powerful parties and extreme debate may undermine democratic stability. A faith in broad participation, mandates, accountability, and a moderate center compose the basic structure of the democratic myth we profess to believe. Political parties give meaning to these values: They are the instruments through which democratic ideals are realized. But they are also the major source of promissory politics; as such, they are an important factor in rising time preferences within modern societies.

As we shall see below, in its somewhat halting and intuitive way, con-

servatism has sought constitutional reform and moral persuasion, usually with little success, as means by which the level of promissory politics may be contained or reduced. We give some attention to the conservative position — at least as implied in its theory. Finally, we suggest that one nation, Switzerland, more than any other democracy, has slowed the advance of short time horizons within her population. It is hypothesized that, partly because of constitutional factors and political practice, the Swiss have restrained the more baneful effects of promissory politics.

A warning is in order at this point. The criticisms we shall make about voting and parties ought not to be taken as a brief for their elimination. Our intention in this chapter is merely to introduce an element of caution with regard to the effects of parties upon time horizons. Unfortunately, there is a widely held assumption that party competition is under almost any conceivable conditions conducive to democratic stability and good policy. This conventional wisdom needs some revision, although a determination of the exact point that competitive parties become dysfunctional for the system would require separate treatment.

Democracy without political parties is hardly imaginable among large populations, and without a wide franchise it is meaningless. Yet, because so much faith is placed in voters and political parties by philosophers, social scientists, and politicians bent upon "perfecting" democracy, a desire for perfection may in the process turn our politics into antidemocratic, antiliberal channels. By concentrating so much effort upon making democracy more "real" and parties more accountable, we set the stage for rises in time preferences and the growth of forces opposed to democracy; or, to put the matter bluntly, in bowing before the altar of Political Man, the trumpeters for a more nearly perfect democracy in the end bring the whole process down around themselves.

Democracy and Political Parties

What is democracy? In the minimal sense it is simply a system by which electors may change elites through periodic elections.[1] Democratic philosophers and political scientists have given much attention to the means by which the franchise may be extended to ever-large numbers of citizens; they have suggested how democracy may be made more meaningful for the individual elector; and they have considered the methods by which parties as mobiliziers of electorates may be made more "responsible." It is usu-

ally taken as axiomatic that the more aware, educated, and active an electorate, as well as the more efficient the party system in mobilizing voters and transposing their wishes into policy, then the more humane and efficient the entire democratic system will be.[2]

There can be no doubt that as constituted at present the fortunes of democratic governments and political parties are intimately joined. Political parties compete for the peoples' vote; hence, by simplifying alternatives and offering electorates a choice, parties serve as transmission belts between the populace and its rulers. They presumably discover what the sovereign people wishes while simultaneously governing in its name. Successful candidates of winning parties are therefore able to base their claims to leadership upon the Democratic Will. As a result, parties perform functions which are indispensable to democratic government.

Unfortunately, the dysfunctions of parties go mostly unrecognized. In the following pages we argue that the dynamics of party competition created by the drive for government power play an especially strong part in the rising time preferences so characteristic of our age. By making slavish and sustained appeals to the short-run interests of various groups—indeed, by performing their democratic functions all too effectively—parties plant the seeds of instability in the body politic. They create the belief that more demands can be satisfied by government than in fact can be met.

One must not conclude, however, that political parties and their immediate political environs are the only causal agents of temporal derangement. After all, parties exist in societies where the ceaseless drive for equality of condition occurs, where a faith in continual progress is assumed, and where it is believed that the state ought to distribute benefits to increasing numbers of citizens. Such are the widely held values and beliefs in Western political cultures; therefore as organizations whose business it is to win elections and capture control of government, parties naturally respond to and reinforce these beliefs and values within the public. If public attitudes were to shift, one may be sure the parties would quickly follow suit.

Since party systems are embedded in democratic ideals of popular sovereignty and individual rights, and since party militants, candidates for office, and political leaders are among the chief propagandists of these ideals, it is important that in the first instance we accord some attention to democratic philosophy. If parties indeed encourage short time horizons, it seems logical that the government philosophies upon which they legitimate their rule must themselves imply similar temporal assumptions

and ideals. It is doubtful that belief and practice would radically diverge indefinitely. The various myths of democratic philosophy are propagated by the more interested, active, and aware citizens, and it is these elites who likewise support, finance, and lead political parties.

It does not follow, however, that we need to consider here in great detail the rich varieties of democratic theory. Those ideals which have moved us to great deeds, or great evil, have not only drawn upon many systems of thought, but in the process of political debate have been vulgarized and simplified. This is especially true when one turns to the problem of participation.

Democracy and Participation

One difficulty with any definition of democracy is that the values and interests of particular theorists may differ strongly. Most studies, however, stress either the extent or the quality of participation as the critical factor. Those thinkers who look upon the extent of participation in democracy as the more important value usually emphasize that democracy is in essence the rule of the majority. In their view, rules and procedures which increase turnout at elections or enable voters to be consulted by the most direct route possible and in the greatest number of instances are most appropriate. Thus, they wish to limit the ability of minorities to thwart majorities, so they have little admiration for the checks-and-balances or "mixed" government dear to those who fear concentrations of power. Most of them undoubtedly believe in individual rights, but one has the feeling that, if pushed to choose, they would invariably side with the rights of the majority.[3]

There are also democratic thinkers for whom mere majoritarianism is hardly a sufficient basis for democracy. It is not that they wrap themselves in individual rights; far from it. They seek, however, a more *refined* participation by the majority. Following in the tradition of Rousseau, and often Marx, it is the "general will," not the "particular will," that truly matters. Mere majorities are insufficient if people are ignorant of their "true" interests. In the opinion of these thinkers, the quality of participation is all too easily dulled and distorted by ideologies of the ruling class, a lack of access by the masses to the levers of power, and the presence of a culture suffused with capitalist "possessive individualism."[4] Only when the social structure is radically transformed can the interests of individual and polity be reconciled.[5]

Most thinkers who reflect upon democracy, however, probably come down somewhere between these two extremes. They agree that the majority principle is supremely important but go on to aver that both minority and individual rights must be vigilantly guarded. Thus, in their opinion majority and minority require each other. After all, these theorists ask, how can one discover what a majority wants in the absence of free speech, a vigorous press, the right to assembly, and competitive political parties? Democracy and individual rights go together; one without the other makes no sense. It is only by exercising our individual freedoms that we discover what the majority in fact wills.[6]

Finally, there are democratic theorists, usually political scientists or political sociologists, who are more empirical, less philosophical, in their approaches to social thought. They are aware of but less disturbed by the fact that political activity is dominated almost invariably by the more affluent, educated, and interested—i.e., by the upper classes. Their studies confirm that mass participation is limited, perfunctory, and often irrational. As a consequence, they set their sights for democracy somewhat lower than do the more abstract political philosophers. Although less uneasy with the rule of elite groups than are the more radical democrats, they hold that elites may nonetheless be held accountable so long as leaders are forced to compete with one another. Thus, democracy in their view is essentially competition among elites for the people's vote. And it is political party competition which keeps the democratic wheels moving along. Parties are vital to democracy in that they simultaneously supply alternatives and seek to ingratiate themselves with electorates.[7]

Of course, party competition in itself tells us little about the quality of the choices offered, that is, about the meaningfulness and significance of the vote for the masses. This more limited and empirical approach accepts the probability that the masses may be manipulated by elites; indeed, the notion of democracy as essentially competition for the electorate's vote is quite compatible with what the more radical thinkers would consider oligarchy and a restricted franchise. For their part the radicals, who wish for a "real" democracy based upon a major transformation in individual behavior and property relationships, find these views far too timid, hence inadequate to the task of democratic construction. On the other hand, because the belief in strong party competition is so strongly held both by political activists and by orthodox social scientists, and because its prescriptions are widely accepted on all fronts of the left-right political spectrum, it is particularly appropriate to give this more moderate and popular approach special attention.

From the standpoint of time preferences, almost any democratic theory, whether of the moderate or extreme variety, displays a fatal flaw: It exposes the social order to high time preferences. A society characterized both by large-scale political activity and low time preferences is difficult to imagine. Democratic enthusiasts repeatedly remind us of the duty to vote and to join with others (groups) to influence officialdom; they praise our knowledge of candidates and issues; they encourage us to believe in the beneficial effects of political solutions to socioeconomic problems; and in good egalitarian fashion, they make us very aware of economic, class, status, and elite distinctions. They aim, in a word, at the politicization of social-cultural life. When defenders of democratic ideologies attribute special virtues to achieve citizens and public officials but ridicule the less active ones among us, they tend either to demean or deemphasize the ordinary, mundane spheres of daily existence. In its quest for *the primacy of the political,* democratic theory therefore unwittingly unleashes all those natural propensities crying out for immediate gratification.[8] With much help from the Marxists and no small amount of aid from aristocratic conservatives, it wittingly or unwittingly calls into question the meaning of bourgeois existence.

One aspect of daily life involves the use and disposal of property and income. Because they are essentially private in nature, property relationships pose a special difficulty for democratic theorists. Many, accordingly, treat property rights at best with cold indifference and at worst with outright contempt, considering them as strictly subsidiary to participation and the political life. Thus, they subordinate property to politics. The intellectual process by which this feat is usually accomplished involves distinguishing "property rights" from "human rights." The American Supreme Court has been especially adroit in this regard by elevating the First Amendment guarantees of religion, expression, and assembly to the status of "preferred" rights. On the other hand, it has relegated the "due process" clause of the Fifth and Fourteenth Amendments concerning property to the fringes of individual rights; it has looked benignly upon the seizure of property by the state under the "eminent domain" and "police power" clauses; and it has given wide latitude to Congress to regulate private business under the interstate commerce clause.[9]

By attributing to "human" rights a special status, democratic theorists are able to reconcile the individual with the majority. After all, the exercise of "preferred" freedoms of the First Amendment type *presupposes* institutions, procedures, and values designed to discover what a given ma-

jority may will at any particular time. It is true that intellectuals occasion-
ally run afoul of majority prejudice, but the tension between individual
and majority in no way compares with the sharp divisions and perpetual
war existing between the rights of property and the majority principle.
Whereas majorities may often be at odds with the holders of property (in-
deed, they may confiscate it in the name of democracy), the majority prin-
ciple itself is much more easily joined to the political ("human") right of
speech, press, assembly—and to competitive parties.

"Human" rights are certainly not necessarily more private than are prop-
erty rights, but in a manner foreign to property rights they are more sym-
metrical with and function more easily in the political sphere. As a result,
property rights are more easily walled off from the wishes of majorities—
indeed, property holders are antagonistic to majorities bent upon trans-
fers of their rights—whereas human rights embrace a public and political
dimension harmoniously linked with majoritarianism. Because both hu-
man rights and the majority possess this public and political dimension,
critics of property rights hold a decisive moral and logical advantage:
They may simultaneously defend individual political freedoms, the ma-
jority principle, and the public welfare. As a consequence, the staunch
defender of property is placed on the defensive in the moral and political
arenas alike and is often regarded as a propagandist for "selfish" interests.

Yet property rights per se play a highly significant part in our ordinary
lives which democratic theorists too often ignore.[10] For just as political
rights are critical to public servants, politicians, newspeople, artists, writ-
ers, and intellectuals, so property "rights" are particularly crucial in the
more mundane affairs of ordinary citizens. As Brian Crozier has pointed
out, democratic theory places far more stock in the former than in the
freedom of employers to hire anyone they wish or to fire employees who
have performed unsatisfactorily, in the right to join or not join a union,
in the right not to pay an income tax that is steeply progressive, in the
right to invest one's capital without restriction, in the right to save in the
secure knowledge that government will not erode the value of the cur-
rency, and in the right to bequeath property to one's heirs free of state
confiscation. Whereas democratic theory may undoubtedly be sympathetic
to any one or even two of these rights, one may be sure that on average
they take second place to the "preferred" types.[11]

Participation, Political Parties, and
Government Responsibility

Democratic philosophies are mainly of interest to the high priests of theory, but the abstract ideas developed by the theorists are often vulgarized and gradually seep into the assumptions of larger publics. Social scientists, not to mention journalists and politicians, are important transmission agents for these ideals. And political scientists in particular are important because they so often graft the assumptions of democratic philosophy to empirical theories of more practical relevance. Thus, the long-standing demand among political scientists that political parties be made "responsible" is a practical way by which the ideals of democracy may be reconciled with strong and effective government leadership. It is the theorist's way to have an impact upon the world of affairs.

For the responsible party advocates, the reconciliation of democracy and authority is most easily attainable in a parliamentary system of government in which only one of two parties can secure an absolute majority of seats in the legislature. With this absolute (as opposed to a relative) majority assured, a single winner claims a "mandate" to put its program into effect. The single-party cabinet (in Great Britain) or government (on the Continent), unencumbered with coalition partners, may then form a strong and effective government, since it is presumably composed of the leaders of the majority itself. Consequently, in parliamentary systems the party-as-government is responsible before the legislature and, through the latter, to the people (electorate). Accountability running all the way from the government through the legislature to the people is thereby assured. Needless to say, in the case of the United States this notion of "responsibility" is devoid of meaning, since President, Senate, and House of Representatives are constitutionally independent of one another and often represented by different parties.

Despite this absence of coherent parties and party government in the United States, a "responsibility party school" can lay claim to a distinguished intellectual heritage.[12] Its beginnings may be traced at least to Woodrow Wilson's classic, *Congressional Government,* published in 1885. In that work a future president deplored the powers exercised by congressional committees at the expense of party leadership. An unabashed admirer of the British parliamentary system (at least until he became president), Wilson perceived the potentialities inherent in that peculiarly American institution. Therefore, he voiced a position proclaimed by subsequent gen-

erations of American political scientists firmly convinced that divided au-
thority and undisciplined parties prevented the development of coherent
policy-making. The elevation of the "responsible parties" idea to profes-
sional norm probably reached its highest level in 1950 with the issuance
of a report by the American Political Science Association's "Committee for
a Responsible Party System." The report, of course, had its share of critics
at the time, and they have undoubtedly grown in the past three decades.
Few political scientsts have believed it possible, or even desirable, to im-
port major British institutions outright into the United States.[13]

On the other hand, the concept of the responsible party has permeated
the intellectual world to such an extent that almost no political scientist
or respectable journalist in the United States would be so bold as to take
the opposite position by making a case for *weak* parties; indeed, we are
regularly regaled with pleas to make our parties stronger and more viable.
Conventional wisdom therefore lays many political, budgetary, and social
problems at the doorstep of party weakness; so when political events seem
about to overwhelm us, admirers of the British system appear, even if Brit-
ish institutions receive no *explicit* acknowledgment or endorsement in
their writings. Any disagreement among these admirers of strong parties
takes place over the feasibility of certain reforms and the extent to which
particular changes might unsettle the political system as a whole. The
more daring call for such constitutional requirements as forcing President,
House, and Senate to stand simultaneously for election (usually every four
years) or for allowing members of Congress to sit in the Cabinet. Others,
less bold, concentrate upon such internal party reforms as greater finan-
cial support for the national parties or for alterations in the nomination
process in order to give party leaders more influence.[14]

It takes little imagination to see why a belief in strong parties exercises
a powerful hold upon knowledgeable people. An ostensibly nonpartisan
and nonideological argument for a strong party system, clothed as it is
in scientific neutrality, in reality conceals naked ideological and policy-
related concerns. It may sound perfectly neutral to make a plea, say, for
tighter organizational controls over party nominations, disciplined legisla-
tive voting, and programmatic coherence as means for assuring more re-
sponsibility in government and for giving voters clearer alternatives, but
these arguments may also be interpreted more cynically as ideological
weapons in the service of democratic majoritarianism and national eco-
nomic interventionism.[15] It is the "cadre"-type American parties in particu-
lar and right-wing "bourgeois" parties with their loyalty to locality and

provincial notables which therefore draw criticism from the more intense partisans of party responsibility.[16] Not only do these cadre parties adhere to parochial rather than "national," interests, but especially in the United States, they also tend to favor the stalemated constitutional barriers of divided government, checks-and-balances, and federalism. Moreover, they make it possible for legislative committees and legislators to thwart the will of national party, executive, and legislative leaders. Whether these reforms go whole hog and call outright for responsible parties along British lines, or whether they merely wish to tinker here and there, with few exceptions they almost invariably glow with "liberal" and social democratic ideals. So, despite vital differences in their approaches to the possibilities of reform, the gap between a Burns and a Polsby is not so vast as one might at first suppose: Both agree on the end for which parties function; it is the means to strengthen their roles in society which divide them.[17]

The advocates of reformed parties do not favor strong organization only because they advocate the strong positive state in social and economic affairs. In most cases they genuinely believe that reform makes democracy more meaningful. They think that voter participation, when high, usually reinforces support for democratic values, since to their view parties function as transmission belts between leaders and followers. Furthermore, they believe that democratic leadership is more effective when it is recruited through strong party organizations. Since they must compromise and unify diverse points of view, these leaders are more likely to be moderate and to produce good policies than are those leaders who are recruited from weak ones. Consequently, unlike the factional and often demagogic leadership so prevalent in weak parties, leaders from strong party organizations more easily overcome particularistic and parochial interests. Whereas a generation ago strong party leadership was favorably associated with advancing social welfare, economic intervention, and an indifference to deficits, it is today sometimes linked with containment of runaway budgets. The road traveled by party reformers from Schattschneider to Polsby has been a curvy one indeed.[18]

It is ironic that American admirers of "responsible" party systems look longingly across the Atlantic to British parliamentarianism as worthy of some degree of emulation. They admire a system in which either the Conservative or the Labour party possesses a majority in its own right and thus organizes government power. They likewise praise the manner in which the cabinet is held "responsible" before the House of Commons. "Mandates" deriving from the electorate and ratified in the House are pre-

sumably clear since the British prime minister, unlike an American president, is not forced to cope with a legislature under the command of the opposition. After all, in Great Britain—indeed, in parliamentary systems generally—executive and legislative powers are "buckled" or merged, since cabinet members are also mostly leaders of the party majority in the House of Commons, or, to put it another way, the cabinet is a committee of the House. Thus, responsibility is assured: Voters know whom to blame— that is, whom to hold responsible—and they presumably understand who has the proper "mandate" to govern. Consequently, the British need worry little about any "two majorities,"[19] one of which camps in the legislature, the other in the executive; nor, so far, do they need concern themselves about governments composed of several parties, as has been the case historically with, say, France, Italy, or Germany.

The neatness and form of British cabinet government and the assurance of responsibility it evokes have appealed to intellectuals on both sides of the American political spectrum, although, as we previously noted, enthusiasm has been far stronger on the left than on the right. But it is especially during periods of constitutional or economic crisis that at least implicit support for it surfaces. The argument for change in the United States, however, seems somewhat strange, since the reformers seldom ask a fundamental question: If the British system is so worthy of emulation, why has that nation experienced so many social and economic problems in the course of this century? Why has Great Britain been known in the postwar period as the "sick man of Europe"? Her class tensions have been persistent, her productivity has been stagnant, and her pound, at least until recently, has been steadily eroding. Perhaps her American admirers might argue that, without the benefits of a superior political and party system, she would be worse off, but this hypothesis is hardly testable.

In fact, since World War II, democracies having less admired political systems have consistently outperformed Great Britain by almost any measurement of social and economic well-being one may choose to employ. The responsible party school on this side of the Atlantic may contend that political forms and processes are more important than price levels, employment figures, work stoppages, or output statistics. One can imagine the response of the typical citizen to this position. Or, our anglophiles may depreciate the effects of public policy in Great Britain by placing the blame for any "sickness" upon other, nonpolitical "sub-systems." This approach, of course, is one which characterizes those obsessed with "the political"; hence, either nonpolitical phenomena are underplayed (for instance, eco-

nomic phenomena connected with unhampered markets) or are ignored altogether. In addition, they might argue that without her superior political system British social and economic problems would have been even more serious than otherwise. This hypothesis, of course, like those claims made for the parties, is unfalsifiable, and, besides, at least until recently, major American specialists on British political life for much of the post-war period gave us glowing accounts of the successes of British "neocorporatism" and the welfare system.[20]

Political Parties and the Virtues of Competition

Perhaps the whole idea of responsibility has long been overworked. Perhaps many political scientists are incorrect, that strong and, yes, "responsible" parties often contribute less to community consensus than to community dissensus, less to good policy than to bad. For whatever their necessary functions in a democracy, by contributing to high time preferences, parties threaten social and political stability. But what is it specifically about political parties which leads us to this disquieting conclusion?

It is basically through the dynamics of party competition that our temporal vision is distorted. In order to win government power, each party seeks to convince the electorate that it best meets the needs of voters. The government-of-the-day maintains that, if only given sufficient time and support, it will enact programs in the public interest, while the opposition, just as sincerely, castigates the party-in-power for any real or imagined failures and assures the public that it, not the majority, can do much more for the people. Consequently, government and opposition alike seek to define their opponents as Scrooges determined at all costs to deny social justice to the people. Significantly, each promises solutions to this or that problem now, or soon, not in some distant future. In this competitive bidding process, appeals are invariably made to the demons of envy, class hatred and ethnic or racial resentment, not to mention the more concrete interests of subsidization, licensure, and public projects.

Strong party competition, political scientists often argue, is absolutely essential to good and responsible government. For example, the late E. E. Schattschneider saw in what he called the "socialization of conflict" a primary means for bringing people previously deprived into the political system.[21] The driving force behind this socialization of conflict in a democracy, he believed, is the political party. Indeed, he valued party conflict

as the major contributor to the extension of democracy in the United States.[22] In the process of seeking power, parties are necessarily on the lookout for new voters. It is the socialization of conflict brought about by this party competition which encourages participation by less fortunate citizens and, as a result, reduces alienation and produces socioeconomic benefits for those previously left outside the "system."

Not only does a wide scope and intensity of conflict generate voter participation and, supposedly, support for democratic values, but, as Lowi suggests in his highly acclaimed study, under conditions of sharp conflict, legislators are placed under pressure to formulate clear-cut rules (statutes) for which they may be more easily held accountable.[23] Broad conflict is not generally welcomed by legislators; they much prefer the low-key politics of pork barrel and casework to staking out positions on controversial issues. After all, many constituents may find their individual representative's vote on affirmative action or tax hikes objectionable, but these same voters offer little objection and possibly much praise for the new office building or for intervention on behalf of constituents before a Housing and Urban Development official. Representatives, therefore, prefer the closed doors of committee rooms where special interests can work their will unimpeded and where favors and support may be traded among members without public scrutiny. On the other hand, by eroding clear lines of communication between the legislature and the public, nonconflict or low conflict reduces the probability of open, democratic, and coherent policy.[24]

Similarly, since they are more open to public scrutiny and involve questions of outright indulgence or deprivations to large numbers of people, legislative battles place strong pressures upon individual legislators to spell out clearly their intentions regarding pending legislation. Not only do these pressures increase the likelihood that "public" rather than "private" interests will prevail, but of equal importance are their implications for good law. Legislators typically prefer to write vaguely worded statutes replete with promises of future benefits. These legislative proposals are more often statements embodying vague hopes and noble intentions than of laws clearly defined. For example, an injunction to "clean up the air" is an ideal which we all presumably share, but the difficulties of implementation and administration impose serious and unforeseen costs upon many members of the public.

Lawmakers, of course, have aims other than merely good law. In particular, they wish to keep conflict to a minimum and to avoid the hostility

of powerful constituency interests, all the while forging a coalition suffi-
ciently broad and popular to pass the given proposal. Unfortunately, stat-
utes poorly written often result in a de facto delegation of power to non-
elected officials unaccompanied by clear standards of implementation.
Many ambitious laws are nominally enacted by legislative bodies only to
be "filled in" in the field by administrators required by circumstances to
interpret the meaning of ill-defined statutes. The effect is "lawmaking" by
nonlegislative administrators forced to create their own rules on a case-by-
case basis.[25]

From Lowi's perspective, party and legislative conflicts have many salu-
tary consequences: They encourage legislative accountability to electors;
they lead to genuine (i.e., democratic-institutional) policy-making as op-
posed to the informal politics of the pork barrel; they place particularistic
and status quo interests on the defensive and foster innovative ones;[26] and,
finally and perhaps most importantly, because clearly written statutes en-
courage the delegation of legislative power accompanied by strict stan-
dards of implementation, the "rule of law" rather than the discretionary
rule-making of informal administrative and interest-group legislation is
favored. In so far as legislative rule-making is characterized by broad and
open conflict, therefore, responsibility, democracy, and the rule of law are
accordingly facilitated.[27]

Schattschneider and Lowi have exercised a profound influence upon
political scientists, especially in the United States. Many of their colleagues
may display a more guarded enthusiasm about party competition, giving
it less prominence and attention, but in reality most of them take it for
granted that broad conflicts organized around responsible parties and
party leadership are essential elements in the public welfare. Their beliefs
in this matter are guided not so much by principled reflection as by as-
sumptions about what is "obvious to anybody." True, some political scien-
tists see a threat to democratic institutions from certain types of electoral
participation. Comparative government specialists in particular have noted
that sudden increases in voting or heavy turnouts over longer periods im-
ply potential opposition to regimes from antidemocratic forces. Still oth-
ers have noted that "working class authoritarianism," which shows a pro-
pensity to turn out more heavily in times of economic dislocation, or the
growth of traditional nonvoting and uneducated electorates may under-
mine the influence of the more educated and tolerant ones, thus preparing
the way for demagogic political leadership.[28]

Much more typical, however, are the American state and local govern-

ment experts who, under the influence of the late V. O. Key, Jr., have for many years praised strong party competition. By employing sophisticated statistical techniques, they presumably demonstrate strong "empirical" support for the belief that intense party competition and democratic health are closely intertwined. Their studies conclude that the interplay of competition at state and county levels correlates positively with such variables as per capita income, urbanization, industrialization, and welfare policies. So, if competitive party systems cannot be said to *cause* good democratic government, they are at least intimately bound up with the prosperity and progress of democracy (itself a necessary if not sufficient cause of democracy). Or, to put it graphically, states dominated by one party tend to be backward, states with two-party competition tend to be progressive (a cynic might say "liberal"). These findings can only reinforce a generalized belief among scholars who study the politics and history of whole nations that strong competitive parties which "get out the vote" are indeed the macebearers of "real" democracy, prosperity, and individual rights.[29]

With regard to subject-matter, cross-national, American national government, and American state experts all extol strong competitive parties. So far as one can tell, the same may be said for various social science methodologies, including those which are supposedly static in approach and which are so often accused by radicals of letting "conservative ideology" in the methodological back door. One thinks in this connection of the "structural functional" and "systems" approaches to social science. Indeed, by focusing more upon the cohesive than the conflictual aspects of social life, scholars who expouse these methodologies have received reams of abuse from Marxists, conflict theorists, and others. This body of literature, as developed by sociologist Talcott Parsons and his colleagues and as carried over into political science, principally by Gabriel Almond and David Easton, asks how certain "sub-systems," structures, processes, or norms and values, function to contribute to the maintenance of other structures and values as well as to the social system as a whole. Political scientists argue that the most important function performed by political parties is "interest aggregation," although other functions such as "socialization" (learning about politics) and "recruitment" of leaders do not go unnoticed. Nevertheless, the major function parties perform is to "aggregate"—i.e., to reconcile and compromise—"demands" of diverse individuals and groups.[30]

Despite their emphasis upon those forces making for social and political cohesion, the structural-functionalists and others apparently take party

conflict for granted and indeed find it quite "functional," particularly when only two parties are involved. One looks in vain for the "dysfunctional" part played by competition. Almond in particular has nothing but praise for the Anglo-American parties, although he is naturally more guarded about certain continental multi-parties. It is not the dynamics of party competition and promissory politics which create much dissensus but rather divergent ideologies and special interests (regional, ethnic, or religious) which divide the parties. Consequently, the function of interest aggregation is much more difficult to perform in multi-party systems such as Italy and France where single interests or a small number of pressure groups coincide neatly with the various parties. Conversely, in Great Britain or the United States, where the two-party system serves as a loose umbrella for diverse interests, the aggregative function is performed well by the parties. In the latter, pragmatic bargaining and openness are stressed rather than noncompromise and flights into ideological purity.

Yet the structural-functionalists, ever mindful of cohesion, fail to see that in their need to satisfy so many groups in order to build coalitions, the aggregative parties themselves may be dysfunctional for the political system. Indeed, as we shall presently see, the necessity for such parties to attract the "center" voters and groups poses grave difficulties for the larger order. At any rate, in reading the more influential studies by structural-functionalists, one has the distinct impression that "modernization," including economic growth and widespread education, is a panacea for basic problems relating to "demand overload" in Western democracies.[31] In fact, the "overload" may derive from promissory politics. Or perhaps these scholars simply assume that system "supports" (love of flag, national pride, reverence for constitutions, etc.), which a balanced system demands, can somehow compensate for the pressures of parties and interest groups, for they certainly reject the notion that party-generated expectations in two-party systems may undermine consensual elements uniting the polity. They do not perceive—possibly because their major works appeared in the 1950s and 1960s when deficits were less staggering and inflation less pronounced—that "aggregation," when combined with easy access to public resources, itself becomes increasingly dysfunctional as current raids upon public treasuries enlist coalition support for present gratification at the expense of future growth.

Therefore, although ostensibly devoted to consensual or static approaches, the so-called "conservative" model-builders are in agreement with their colleagues about the role of party competition. For "conservative" and "lib-

eral" social scientists alike strong party combat is viewed in favorable terms. Once one strips away the jargon of systems analysis, it is plain that the function of "interest aggregation" is essentially a euphemism for old-fashioned "coalition-building." The sorts of conflict which arouse suspicion are those based upon extremist ideologies, regional disputes, or ethnic conflicts as found, say, in France, Italy, Ireland, or Belgium. To this extent the Anglo-American two-party system receives only plaudits.

Why have so many experts disregarded the dangers to political and social order which are created by promissory politics? One reason is obvious: To criticize strong party competition is to risk the appellation of "antidemocratic," or even "fascist." A second reason is paradoxically due to the strengths of the comparative method in the social sciences. A good comparativist thinks relatively. To take an example, Italy has been more unstable than Great Britain, France has been more unstable than Switzerland, and so on. In this way we explain *relative* differences among national entities.[32] However, there is also some risk to this method in that we tend to overlook long-run trends within *particular* nations. We may underestimate or overlook altogether important changes in specific polities. Thus, to group together particular countries with specific kinds of problems and/or to try to discern where individual nations are trending (as, say, the United States or Great Britain) suggests more disturbing conclusions than the cross-sectional methods we generally employ in comparative studies.

A third reason is the related tendency sometimes to single out political structures alone as the decisive elements but simultaneously to ignore basic social and economic structures. For example, we may observe that in nation A a coherent majority with a moderate opposition ("Loyal Opposition") governs but note that in nation B a coalition of several parties rules which is continually threatened by resignations from its own ministerial ranks by opposition parties who refuse to "play the game." We conclue quite rightly that nation A is the more successful democracy of the two. However, by exaggerating the role of political phenomena, we may also miss those underlying but extrapolitical trends which threaten future stability in what today appear as quite successful polities.

Promissory Politics in and at the Center

This brief excursion reveals social science values and norms highly disposed to a special kind of party politics, namely, to that politics which

is practiced at the "center" of the political spectrum. We even give centrist parties special titles which surely imply a high regard for their ability to govern and to maintain regime stability: "catchall," "aggressive," and "coalition," for example. It is these parties and the politics they practice which enable political observers to support strong political competition with little fear of its adverse consequences for the system. In short, the "center" is where the politics of success resides. It is where voters and groups are forever moderate and pragmatic, yet ever ready and willing to swing at a moment's notice to another centrist party if the present favorite strays too far left or right in ideology or policy. Since extremist parties by definition lack the qualities of the center, they presumably have little hope for winning government power.

Seldom has a comforting recipe been written for political strategists, politicians benefiting from the status quo, and social thinkers wedded to democracy but fearful of its excesses. Seldom has a better rationalization been found to redirect resources quietly and circuitously from the masses of voters to targeted groups and electorates. Everyone covets the center, no one so much as those organizations which wish to utilize it for their own particular ends.

The failure to appreciate the dangers inherent in the promissory politics of political parties no doubt originates in part from the weight and meaning we attach to the political center, a place where fickle and demanding electorates will, if aroused shift their loyalties suddenly from one center group to another one. So secure are we in the belief that party competition does little harm but much good in a democracy that our uncritical acceptance of the "moderate" center makes us indifferent to the dysfunctional aspects of intense party struggles. After all, how can careful attention to the needs of voters and groups possessed of "moderate" traits in any way be harmful to the public welfare?

In fact, the less welcome effects of centrism are indirect and occur over a protracted period of time. They arise mainly from fears by party leaders of losing marginal votes in the next election; hence, the parties indulge various swing groups (or those who have the reputation as swing groups) far out of proportion to their actual numbers in the population. The political parties therefore compete feverishly with one another but simultaneously make every effort to play down excess in ideology for fear of being labeled "extremist." Promissory politics squares the circle: Fierce struggles ensue while philosophical distinctions are reduced to the most banal abstractions.

The center is the place where loyalties occur at the margin, where voters and groups shift from one party to the other with little hesitation. Indeed, it is easier to say what the center is not than what it is. For instance, centrist voters do not locate themselves with conviction on the left or right of the political spectrum; they are not rigidly committed to a particular party or ideology; and they do not call themselves strong liberals, conservatives, socialists, or communists. If we cannot define center voters, we nevertheless feel we know something about them, since we are unable to do without them once political discussions arise. The center may be an amorphous, elusive concept, but we seemingly require its existence as an organizing principle of political interpretation of strategy. Neither ideologues nor tough-minded political advisers can do without it as a way of making sense of political events.

It is particularly difficult to break down the concept of the center into various components which express the behaviors of individuals, although good social science obviously demands that we do so. Actually, when we think of the center as a "center vote," we usually perceive it as the place where "independents," "floating voters," and "ticket-splitters" reside. Indeed, the so-called "independents" have received much attention in the American political science literature. Much like their French counterparts, who have been given the rather unflattering designation of *marais* (swamp) voters, American independents have traditionally been more ignorant about politics, relatively less interested, less intense, more tardy in making up their minds as voting time approaches, and even less likely to vote. Their mere presence and the fact that their ballots so often determine the outcome of elections give elections a special tone they might otherwise lack, namely, vague policy pronouncements and ideological fuzziness.[33]

Nevertheless, even the concept of the independent voter presents many difficulties. At least since the Johnson-Goldwater presidential election of 1964, there is strong evidence that independent voters increasingly find themselves with growing numbers of active, aware, and ideologically committed electors. Whereas the more traditional independents were essentially "apolitical," many of the newer ones are what may be called "apartisan," that is, essentially unattached to parties but nonetheless much involved in politics. Such voters are found disproportionately among the newer white-collar groups rather than among the older self-employed and professional classes; and these white-collar groups increase in modern industrial societies. There are additional difficulties. The various concepts which we employ to refer to the center may contradict one another. For instance, the

"ticket-splitters" and "independents" are somewhat different. They by no means always demonstrate the same intensity of commitment to political parties, nor do they represent similar educational, religious, age, or occupational strata. Similarly, the "floating voters" of Great Britain are far more likely to be *strong* party identifiers than are their American and French counterparts. We may therefore rather arbitrarily place floaters, *marais,* and independents in the center if we wish, but we must remember that substantial differences exist within the center of the spectrum.[34]

Once one tacitly assumes or mentally slips into the notion of an enduring center of fickle voters as concrete reality, a process of reification of the center may now be said to have already begun. The mental notion of center *votes* is thus gradually and imperceptibly replaced by that of the center as *group.* The group concept, however, need not include electorates alone, but may be stretched to encompass pressure groups as well. Strange as it may seem, voters and organized groups are often considered as if they were similar conceptual animals; hence, in public awareness the group idea need not just describe individual voters but, in addition, may be extended to include what are thought of as "pressure groups." The political effect is to alter our conceptual notions and the way we act upon the world. Attention to electorates per se is mostly confined to pollsters and statisticians, but because it helps us organize the world meaningfully, the group assumption characterizes far larger numbers in the public. On the other hand, let us not think of these two notions as airtight compartments; in fact, they may be readily merged or separated in our minds according to the given problem at hand.

We are generally more comfortable with the group notion than with the voter concept, for concrete knowledge of electorates is an esoteric enterprise requiring some study and thought. On the other hand, to shift our focus to the idea of a *center group* allows us to interpret the political world far more comfortably, since it reinforces our faith in the durability of the moderate, democratic elements which generally contest elections. Thus, the "center group" becomes so much a part of our understanding of the political world that the distinction between voter and group becomes hopelessly blurred in most minds. One consequence is that the typical "marginal" or "swing" group bandied about in ordinary political conversation seldom takes on those unfavorable attributes with which we routinely condemn similar kinds of groups in other political contexts. Indeed, in the course of election campaigns the typical member of the various farm, business, or labor organizations usually escapes the condemna-

tion we customarily heap upon these same organizations when they engage in legislative and bureaucratic politics. In other words, as the context in which we evaluate the center *shifts with the problem at hand,* the negative or positive evaluation of the given group is likewise easily altered. Conversations referring to the "farm vote," the "working class vote," the "little guy," or the "moderate" vote, which supposedly compose a "center" in the course of elections, may in other contexts become highly negative assessments in relation to the "tobacco interest," "Big Labor," "Big Business," or the "extremist." In our minds the latter are essentially special interests with a degree of illegitimacy—at least until they are associated once again with the center vote of election campaigns.

Groups perceived by public opinion as in the center therefore achieve a degree of power and legitimacy denied to noncentrist ones. Their legitimacy is especially secure when assessments are made of them in terms of election campaigns, as they more readily escape public criticism of being narrow and selfish organizations arrayed against the public interest. At the same time they create a fear among party leaders that, unless their demands are met, they will shift their loyalties from their present favorite to one of the other parties somewhere in the center. Consequently, good strategy, commonsense, and high principles all demand that the major parties court them assiduously.

Group spokesmen, moreover, are increasingly associated in the public mind with the particular group. This blurring of distinction creates an additional process of reification: Specific individuals speaking for specific swing groups, as it were, appropriate the organization and portions of the electorate as their own *personae.* In the public mind each of these three elements is joined to create a more or less real, acting, and thinking being. "It"—the swing element thought to be of the center—is therefore reified and anthropomorphized. Voters, interest groups, and group leaders are simultaneously rolled into one common image at the center of the political stage. Unfortunately, the benefits "it" seeks are not always so much symbolic as concrete and material.

Neither perceptions nor ideologies are sufficient in themselves to explain the widespread acceptance and legitimacy accorded center-oriented, swing groups in Western democracies. Institutional practice and the concrete needs of political elites undoubtedly reinforce their importance. Thus, the particular manner in which elections are contested may be significant. In Great Britain, for example, the system of electoral representation—a single-member constituency, one in which a mere simple majority is re-

quired for election—overrepresents the winning party in the House of Commons but underrepresents the minority party. It has often been observed in this respect that a 50 percent vote enables one party to gain roughly 65 percent of the seats, whereas the minority party is severely underrepresented. Under these circumstances it is possible to form a government composed solely of members of the winning party.[35]

Conversely, majority government is not necessarily *strong* government, if by strong government we mean one which at a minimum protects its citizens from domestic threat, foreign enemies, and devaluation of its currency.[36] In fact, as we have previously argued, the British record in the postwar period has hardly been a salutary one when compared with that of Switzerland, West Germany, Gaullist France, or Sweden. Contrary to the assertions of many political scientists, the single-member, simple majority, first-past-the-post system has brought to Great Britain a stability based more on form than on substance. For if her electoral system has generally produced a majority government, it has also allowed swing groups to dictate much public policy, since a small, incremental change in the vote can lead to much more substantial alterations in parliamentary representation. And since, moreover, a simple majority suffices to elect members of Parliament in some 635 separate constituencies, a strong tendency exists for both major parties to move toward the "center" by appealing to its specific marginal groups within the voting population.

The electoral system receives much praise from observers since it presumably encourages a strong and moderate government under the control of a majority party. To this extent it is universally regarded as an important factor in democratic stability. Unfortunately, because well-placed swing elements are a key to winning elections, small, fickle, often vocal, and highly organized groups are rewarded with all manner of support, far out of proportion to their numbers. Thus, the need to aggregate interests becomes a means by which benefits are taken from the less vocal and less organized and bestowed upon center groups.

This type of electoral system, moreover, encourages the worst form of conservatism among government leaders. To repeat, elections are won or lost at the margin, so every effort must be expended to gain the marginal vote; and because incremental shifts in elections portend much larger changes in the House of Commons, the swing groups assume special importance in high ministerial circles. Cabinet members indeed have every incentive to placate these groups: The fall in power and prestige from minister to opposition is a very long one. Everything is therefore done in

normal circumstances to placate these centrist interests. For this reason, among others, British leaders are usually "pragmatic," "moderate," and "wet," whereas those who refuse to play the game are derided as "ideological," "extreme," or "dry." Mrs. Thatcher, for instance, has often enraged and bewildered the Labour and Social Democratic opposition because she has periodically been such a "dry," but old-fashioned Tories with their sense of *noblesse oblige* have also been rather bemused at her reluctance to make U-turns in policy.[37]

Of course, most electoral systems in Western democracies do not resemble the British one (the United States, Canada, and New Zealand are significant exceptions), but are rather based upon some variant of proportional representation. For its part proportional representation usually facilitates the creation or maintenance of multi-party systems. Since no single party is likely to gain an absolute majority of seats in the legislatures, it also leads to coalition government. Moreover, with the existence of several parties, one not surprisingly discovers a considerable overlap between one particular interest and a given political party. The function of "aggregation," described by Almond, therefore occurs at the uppermost level of the government coalition rather than within one of the major parties.[38] In that case, what we might designate as a "pressure-group party" achieves the swing role at the very top in the cabinet itself. Unlike the marginal groups in two-party-systems, a pressure-group party does not show its influence so forcefully in the politics of electioneering. For example, in France during the Third and Fourth Republics and in Australia, political parties with an agricultural base often made entry into, or withdrawal from, coalition governments dependent upon satisfaction of their rather narrow desires. At the highest levels the power of swing interests within coalitions sometimes weakened those coalition governments to such an extent that the state became a football for major sectional groups. In general, in both two-party and multi-party systems, the social environment as a whole is increasingly politicized. In both kinds of systems one observes roughly a two-stage policy process: A privilege initially granted by the state is rapidly converted into an entitlement; if subsequently called into question by the state or other interests, that privilege is defended with all the weapons, both political and moral, at the disposal of the threatened pressure group.

By promising center groups support in order to protect them from the vagaries of the market, governing parties soon discover the recipients of largesse are in essence ingrates, who constantly wish to know what the

politicians have done for them lately. In their eyes, benefits are not favors rendered to tide them over until better days arrive but are instead entitlements. Indeed, they tend to see their benefits as "rights" coequal with the enshrined ones of "life, liberty, and estate." And once subsidies and other benefits are frozen into entitlements, the state finds it almost impossible to withdraw them. "Every Frenchman wants a privilege or two," a cynical Charles de Gaulle once remarked; that "is how he expresses his passion for equality."[39]

The General's observation has applicability elsewhere. If potential beneficiaries of "a privilege or two" are viewed by political elites as centrist and "moderate" in ideology, if they are also thought to be part of the "marginal," swing vote in elections, and if they are believed to have a strong moral claim upon the larger society, then it is well-nigh impossible for governments to resist their demands. If the first two conditions apply, the governing parties generally seek to spread the costs widely and diffusely among the general public as they target support for specific interests. In addition, if demands are based upon High Principle and Right, the groups are placed in a most advantageous position. The farming community, for example, has traditionally called upon symbols lauding the "agricultural way of life" in order to win subsidies, price supports, and low interest loans. At present, civil rights organizations in the name of "social justice" and "equality" lay special claim to the moral high ground, although their demands are today often motivated less with a concern for equal treatment under law than by a desire for *material* benefits. For instance, what was seen in the 1960s as an equal right to a nonsegregated education or to service in a hotel without regard to race is progressively regarded as a right to specific numbers of jobs and to welfare benefits. Since these new material "rights" are defended as a form of equality before the law, the governing and opposition parties not surprisingly have vied with one another to accommodate those groups which speak in the name of "civil rights."[40]

Promissory Politics and the Politicization of Demands

Let us not exaggerate the part played by political parties in temporal illusion. Very high time preferences existed long before party competition or democracy. In various nations at different times throughout recorded history, peoples have lost sight of the fact that they must lay aside present

goods for future goods. Relatively speaking, the nineteenth century was characterized by low time preferences. In Great Britain, the most productive nation of that period, the drive for present gratification was long held in check by religious authority, strong family life, economic individualism, and absolutist conceptions of morality. It was a culture in which the Bourgeois Ethic was supreme. But even then the way was being prepared for the short time horizons of subsequent decades. The growth of scientific knowledge, the popularity of all-encompassing ideologies, and general economic advancement gave rise to an exaggerated faith in Progress. With these advances people became more complacent and less disposed to prepare for an uncertain future, either spiritually or materially, although they simultaneously became more impatient with existing conditions.

Political influences received powerful stimulation. Substantial increases in the franchise, of course, encouraged political awareness and, as a result, increased demands for public largesse. Areas of life previously thought reserved for individual action were therefore politicized, and, not surprisingly, the modern social service state received growing ideological and moral support. This was especially the case after 1867 when the electorate was suddenly and broadly expanded. The seeds of promissory politics were planted.[41]

In this, as in so many other areas of social and political life, Alexis de Tocqueville was among the first to grasp the significance of the emerging order. After visiting England in the 1830s, he advanced the hypothesis that nations which possess affluence and relative material equality are prone to exaggerated expectations that poverty may be quickly eradicated.[42] In these societies, elites and masses alike find poverty more and more unacceptable and demand immediate remedies. Spokesmen for the poor, especially, play upon the guilt feelings of the rich, while political and social elites, with little danger to their own status or possessions, plead for an expansion of social services.

Tocqueville, moreover, observed that general wealth and pauperism existed simultaneously in England but not on the Continent. On the contrary, in Spain and France one found much poverty but few paupers. He ascribed this contradiction mainly to the effects of greater affluence upon the values of England. Unlike poverty in France and Spain, that in England was not believed to be an inevitable part of daily existence; rather, it was thought to be due more to special circumstances, corrected by government aid. After all, was not wealth increasing? Were not the destitute becoming far less numerous? Thus, special conditions peculiar to the unfortunate

individual must be taken into account. Alter the environment, provide an opportunity, and a productive citizen will come forth. Is this not the optimism and faith so characteristic of our twentieth-century democracies? That the "poor will always be with us" is less self-evident when so many among us are indeed not poor and when general affluence is so apparent. In order for this optimism to translate into policy, all that was required was the subsequent growth of party organization, competition for the vote, and an extension of the suffrage.[43]

In our age, far more affluent than the England of Tocqueville's day, we more openly lay the cause of pauperism at the door of that abstraction called "society." We, too, think it possible to end poverty quickly and expect our politicians to respond promptly with solutions to this blight upon the social environment. Moreover — and here we also owe much to Tocqueville's insights — the spread of social equality and mobility enhances our awareness of status distinctions and "relative deprivations." Let us not be too cynical: Genuine fellow-feeling is undoubtedly at work when we demand a better life for our more unfortunate neighbors, but the less noble drive to envy, to take from others perceived as more fortunate than we often plays a role. Modern communication unfortunately reinforces these tendencies. Television not only displays the fortunes of those better placed then ourselves, but brings a vivid picture into the home of the individual or family struck by poverty, unemployment, or plain bad luck. The TV picture seems so "real," an expression of things as they are, not as they in fact are in a special time and place, but as they exist everywhere. It is thus a major intellectual source for generalizations about society. But to this extent it also dulls our ability to grasp the true interconnections of abstract phenomena. At any rate, these instant pictures, feeding at once upon envy and empathy, explain an apparent contradiction of modern life: The simultaneous growth both of general affluence and the centralized, service-providing state.

Political parties do not so much create this situation as exploit it for their own ends. Ceaselessly reminding the average citizen about the plight of this or that unfortunate neighbor, parties and political leaders reinforce the "reality" of the television set with claims that they can change the picture to a more pleasant one if only given the opportunity to govern. By reinforcing a bias against the status quo, however, they foster support for policies geared to the quick fix.[44]

Rising demands and inflated expectations about the possibilities for

rapid alleviation of social problems increase the role of the state but also undermine its ability to perform a primordial function of authority, namely, that of reassurance. It has long been recognized that government does more than respond to demands from its citizens: "In their obsession with the state, men are of course obsessed with themselves. Political forms thus come to symbolize what large masses need to believe about the state to reassure themselves."[45] Government, it is said, lends psychic and emotional stability in the face of changing events. Regulatory agencies, controls over wages and prices, or antitrust actions are efforts at symbolic reassurance. Indeed, there is no small amount of scapegoating as government agencies ceaselessly ferret out "monopolists" and "price gougers." It has been observed, for instance, that antitrust indictments sharply increase during periods of inflation. The idea, of course, is to deflect blame for price rises from government and monetary authorities, the real culprits, to unions and corporations. Similarly, wage-and-price controls seldom if ever work but are nonetheless continually trotted out as a panacea for inflation.[46]

Undoubtedly, opposition parties, goaded on in part by a media obsessed with government social and political shortcomings, undermine reassurance within the public. But as the opposition prepares for its own elevation to power, it just as surely also paves the way for its own eventual fall from political grace. This is not to say that opposition arguments are necessarily untrue, but one outcome of intense competition is constant change in policy, seldom giving one policy time to take effect before putting another one in its place.[47] It is policy by fits and starts, as governments continually strive to reassure publics in a less reassuring world.

Parties in power can promise much, but in the end they cannot outpromise an opposition with no responsibility for governing. As opposition forces dwell upon goverment inadequacies, the public itself grows more cynical and ever more inclined to discharge incumbent administrations. Consequently, demands for policy changes occur at a faster clip, but the public has no clear idea of the direction in which it wishes to go. In these circumstances the "political business cycle" flourishes: Repeated money injections and public spending grow prior to elections, only to alternate with restraint in monetary growth and spending following electoral battles. Now unemployment, now inflation compete for the public's attention, all within the space of a few months. But government's ability to reassure is eroded by these shifting policies, and the loss of legitimacy further spreads with the failure of policy. Antiestablishment politics and chili-

astic ideologies become alternative, if largely fruitless, forms of action, as cynicism and alienation compete with conventional but unconvincing symbols of reassurance.[48]

Quite clearly, the modern components of culture and technology have an electoral dimension. Due to the high costs of gaining information, election campaigns are more like games in which consumers (voters) register their preferences for a product rather than serious discussions of issues and policy alternatives. Candidates exposed to the pressures of television and fully aware that positions strongly held probably stand to lose more voters than they can gain accordingly merchandise their programs like so much soap and lipstick. As a result they win more support because of "image" and personality criteria than because of philosophy or leadership. Survey analysis has long demonstrated that, relatively speaking, not just the "independents" we considered above, but voters in general possess little interest, awareness, or knowledge of issues. Indeed, in some instances they vote for candidates and parties with whom they disagree over important issues. They resolve this obvious contradiction by attributing positions to their favorite parties or candidates which the latter do not in fact hold. For example, majorities in both the United States and Great Britain have given the left-of-center Democratic and Labour parties more credit for controlling inflation than their right-of-center Republican and Conservative counterparts! At any rate, to focus upon policy is to reflect upon larger political and economic problems, which hardly serves the short-run needs of legislators up for reelection. In the United States, for example, legislators are kept in office less for the policies they pursue than for their constituency casework and for their success in obtaining pork barrel.[49]

As a rule, electorates are influenced more by partisan considerations, a diffuse sense as to the party best equipped to lead the nation, constituency services rendered by incumbents, and general economic conditions than by programs and policies. To get a grip upon issues, after all, implies an "opportunity" cost in terms of time spent upon personal education instead of time devoted to job, leisure, or interpersonal relationships. It is a *time cost* unlikely to be borne by many of us, since to all but a small number of people, income, family, and friends are vastly more important than are politics and parties. Hence, unless an immediate financial or other incentive is at stake, we usually remove parties and politics from our daily concerns. The vacuum created by public indifference and mental laziness is filled rather easily by the simplistic slogans of party propaganda. By playing upon basic emotions and prejudices, the parties therefore make

every effort to overcome public indifference. In other words, seeking government power and the consent of indifferent and ignorant voters inevitably leads parties to support policies oriented to the short run.

These phenomena may be observed in any number of cases. For example, when staggering increases in interest rates and prices held put Ronald Reagan in the White House in 1980, the subsequent drop in each failed to earn his administration many plaudits.[50] The public, taking the good news in stride, simply shifted its interest and concern to the unemployment level. Hence, the resolution of one "crisis" was immediately replaced by another "crisis." In its sudden shift in focus the public was undoubtedly influenced by a media in search of exciting news. But such is the nature of our modern, crisis-oriented reporting.[51]

Electoral impatience, of course, is incompatible with meaningful economic reform, and in particular with a consistent anti-inflation policy. Political leaders who seek to apply policy in a consistent manner invariably lose out to "reflationists" and price controllers. Thus, anti-inflationary efforts are undermined at every turn over the long haul when its initially determined supporters within a government party become first hesitant, next lose confidence, and finally cave in as the opposition unloads its reflationary guns once employment and productivity figures begin to appear.

An instructive example in this regard is found in the comments of disappointed Republican leaders following the 1982 congressional elections when, despite a salutary fall in inflation and interest rates throughout 1980–1981, the unemployment level actually grew. The retrospective comments of GOP leaders speak volumes about the temporal values of "conservative" political leaders. As Michael S. Johnson, press aide to the Republican Minority Leader in the House of Representatives put it: "We went at our programs and our goals with such fervor in 1981 that we got too far in front of the people who gave us our mandate. As we moved toward recession and high unemployment, we maintained too much self-confidence *in the long-term impact* of our program. We believed our own rhetoric, and *we forgot to be shortsighted*." Or, to quote Richard Richards, Chairman of the Republican National Committee: "There is a tendency to think that *when we made a decision certain things would happen.* If we cut taxes and social spending the results would occur as an exact science. That just ain't so. Everyone who runs for office oversimplifies what he can and will do, and we did that. But things didn't follow as easily and routinely as we thought they would, and we've jeopardized our credentials and our right to lead."[52]

These typical conceptions of political reality, recorded so approving by Steven V. Roberts of the *New York Times,* are in fact excellent examples of the temporal illusion. Mr. Johnson's prescription is simple: Forget the long run and concentrate exclusively upon the short term. Mr. Richards, however, is more sophisticated, and we are almost tempted to say that he has absorbed secondhand the static, timeless models of modern economics only to reject them when they conflict with the more important business of winning elections. But it is more likely that he was influenced at the time by some of the more optimistic projections of Arthur Laffer and other supply-side theorists. During the presidential election of 1980, they had been interpreted as saying that large reductions in marginal tax rates for individuals would *quickly* lead to increased productively, more employment, lower prices, and reduced deficits. When for various reasons the subsequent tax reduction failed to show immediate results, many GOP officeholders lost their nerve, retreated into "realism," and labeled their more consistent colleagues "ideologues." It is a position as old as politics.

To conclude our argument to this point, democratic theories and a majoritarianism enamored of political parties box themselves into the corner of quickened temporality. Consequently, in their efforts to make democracy more meaningful, theorists and the practitioners who absorb their teachings secondhand merely encourage rises in the level of demands made upon the policy and inadvertently strengthen those social forces predisposed to immediate gratification. Party reformers for their part are seldom political extremists. Unlike the radical democrats, they accept the necessity of elites but insist that elites be "responsible." That responsible and competitive parties, however, contribute to high time preferences is ignored or misunderstood. In the end, like the adherents of "participatory democracy," the hard-headed realists also cater to the short-run "needs" of active, aware, and informed citizens.

The Antimajoritarian Impulse of Conservatism

It might be supposed that conservatism excapes the temporal pitfalls of radical democracy and the various forms of majoritarianism. From Burke to Kirk, conservatives have insisted that sound moral and institutional restraints guide the passions. Duty and deference, not egoistic rights and equality, form the core of major conservative value systems. The crucial roles of family, church, and school in moral training are continually

emphasized as are *noblesse oblige,* honor, and respect for property. Indeed, reverence for the past, loyalty to social institutions, and religiosity would seemingly pit conservatives against those individuals and policies out to encourage short time horizons.

Conservatives as a rule certainly do fear the potential evils which inhere in unrestrained majorities out to gain short-run satisfactions. Indeed, the idea that good public policy takes time to develop and implement is surely implied in their constitutional thought. The belief in "balanced" or "mixed" government in which legislative, executive, and judicial branches check and overlap one another in the functions they perform is a case in point.[53] Gains by the masses are to be orderly and limited, tempered by constitutional roadblocks favorable to waiting time. The American Founding Fathers clearly intended to place roadblocks in the way of temporary majorities, but they were not opposed to "deliberate" majorities carefully forged over a period of time.[54] Their chief fear was that extreme opinions might sweep suddenly and massively across the many constituencies and therefore threaten life and property. Accordingly, they hoped that constitutional devices designed to pit legislature, executive and judicial branches against one another would guarantee fundamental liberties. As children of the eighteenth century, they valued balance and limits, believing that power divided against itself would be rendered harmless.[55]

For the most part, modern American conservatives extend this tradition by adhering steadfastly to constitutional antimajoritarianism; indeed, in their opposition to mass democracy they champion ideals and institutions calculated to enhance the role of minorities. Thus, there are certain constitutional safeguards to be defended, such as judicial review, federalism and states' rights, the advice and consent of the senate, the presidential veto, and staggered elections. On the other hand, there are also practices and institutions of a nonconstitutional nature which have grown more or less in harmony with the ideals of divided government: for example, the Senate filibuster, legislative committee powers, and decentralized and fragmented parties. It is conservatives, not liberals, who for much of our history have been in the forefront in support of these practices and institutions.

It is hardly surprising that antimajoritarianism finds ready support among prominent conservatives in other nations as well. Thus, in Great Britain, where Parliament is sovereign and its acts therefore legally not subject to judicial review by the courts, conservative spokesmen show a strong inclination to reduce the powers of the legislature. In so doing they some-

times question the hallowed British concept of cabinet responsibility before the House of Commons. In fact, in their constitutional speculations, British conservatives often lean toward American-type conceptions of government and seek to divide and check the powers of the central government. They make suggestions to strengthen the House of Lords in relation to the House of Commons, to weaken the parties, to increase the powers of parliamentary committees, to allow the judiciary the right to review acts of parliament, to introduce a Swiss-type referendum in the British Isles, and, in general, to reduce the powers of a cabinet and House of Commons held tightly in two by party discipline.[56]

Appeals for reform have recently been given a special urgency as their sponsors note the growing radicalization of the Labour party and of the major trades unions. They doubt that a radicalized Labour party will be a stickler for the protection of "human," much less property, rights, especially if doctrinaire Marxists win positions of leadership. Let us take the following scary scenario: First, assume key trades unions come under the domination of radicals who then employ their considerable influence through the National Executive Committee of the Labour party. Assume, furthermore, that the Parliamentary Labour party is radicalized. Finally, given the fact that Parliamentary Law is supreme, under present British constitutional conditions a one-party dictatorship becomes a distinct possibility.

On the other hand, it must be admitted that the various conservative proposals for reform would also fundamentally alter the present British constitutional system. Proposals for checks-and-balances along American lines strike at the heart of British Constitutional democracy as it has been practiced in this century. Not only the Sovereignty of Parliament but collective and ministerial responsibility would have to be eliminated! To this extent, the proposals have an air of unreality about them. Unlike their American counterparts, however, conservatives in Great Britain have no tradition of divided government to buttress their arguments.

Across the Channel, continental conservative theorists have shown a similar concern with limiting and dividing power in the state. They, too, propose constitutional and institutional reforms whose function it is to slow down political time and to deny instant gratification to majorities in league with powerful chief executives. Because the state has absorbed so many functions traditionally thought to be the prerogative of local governments and intermediate associations, European conservatives (and reactionaries) have generally sought to limit the powers of central governments. Thus, they have supported the privileges of local communities against the

encroachments of the state. And given the absolutist traditions of the state in most of Europe, it is not surprising that at the national level conservatives generally champion the rights of legislatures against executive power.

If this position presently holds for Christian Democratic conservatives in West Germany or Italy, for "Independent Republicans" and "Centrists" in France, and in general for what are designated "liberals" and "republicans" in other European nations, the same cannot be said for Gaullism in France. There one discovers mixed ingredients in the ideological brew, since Bonapartist elements advocate a strong presidency and the national referendum. French conservatism shows a rather distinctive profile, although its Fifth Republic founders also end by displaying the typical conservative fear of rampaging majorities. Undoubtedly General Charles de Gaulle envisioned the presidency as superior to the legislative power, and his generous utilization of the national referendum to consult the populace directly was calculated to bypass parliament altogether. In addition to the power to submit bills to referenda, the president in France dismisses the government and calls for new elections to the National Assembly, presides over the council of ministers, rules by decree (Article 16) in the event of a national emergency, makes significant diplomatic and judicial appointments, and exercises important powers in foreign policy and diplomacy. The Gaullist Constitution is therefore a plebiscitary one in which final authority rests with a chief executive in constant, if not mystical, communion with the people. From General de Gaulle's perspective, parliament and the political parties were essentially illegitimate institutions, especially when they attempted to stand or mediate between the leader and the masses. Needless to say, any conception of constitutional authority which places intermediate bodies in such a subsidiary position is bound to be suspect to most British, European, and American conservatives.[57]

On the other hand, Michel Debré, the major author of the fifth Republic Constitution and a Gaullist diehard, originally envisioned a more or less *passive* President, one who in essence said, "Hey, let's stop a minute and think about this policy again." The president's role in domestic affairs is accordingly conceived as one in which delay and reconsideration are major values to be employed against that rambunctious, often irresponsible tribune of the masses, the National Assembly. Thus, Debré claimed the president's major functions are those of making "appeals" to other institutions. The president may ask for a reconsideration of the laws within two weeks, may refer laws to the Constitutional Council if their constitutionality is in doubt, may dissolve the lower house and call for a new election,

and may call for a referendum on proposed legislation or policies. This conception of the presidency was hardly the Bonapartist type of institution which was to evolve in practice under de Gaulle. Whereas the constitution of 1958 called for the *indirect* election of the president, the amended version of 1962 allows for the direct election of the chief executive.

A stress upon checks-and-balances and a lack of trust in mass democracy are eminently conservative themes, which may be seen elsewhere in the constitution of the Fifth Republic. In particular, president and prime minister (with the government) were expected by most of the Fifth Republic founders to share executive authority. It was forgotten until recently that Article 20 instructs the government, not the president, to "direct the policy of the nation." Thus, we see that the constitution initially created a hydra-headed executive, partly presidential and partly parliamentary. It is a presidential system in that the chief executive has powers separate from and above those exercised by the legislature. The National Assembly, for example, cannot vote the chief executive out of office. Nevertheless, in true parliamentary fashion, the cabinet members are themselves also "responsible" before the legislature and may be voted out of office by the lower house.

In addition, the founders demonstrated a conservative concern for equilibrium and balance among the institutions by creating an upper house, the Senate, to legislate on an equal footing with the popularly elected National Assembly. The Senate is elected indirectly by a college of local notables and parliamentarians, its members are given a rather long term of nine years, and the election of its membership is staggered. Finally, the government itself is accorded substantial weapons to fight an assertive legislative branch. In case of disagreement between the National Assembly and Senate over a legislative draft, the government's proposal automatically becomes law; restraints are placed upon the legislative role in the amending process by the so-called "package vote," a constitutional device by which the government may restrict amendments and demand a vote up or down immediately on the text of its own proposal; restrictions are placed upon the motion of no-confidence; and members of the government are no longer allowed to serve simultaneously as members of Parliament and ministers of government. In these and other ways the government is given a clear advantage over the legislative branch. If the "people" gain the referendum in the Fifth Republic, their legislative representatives after 1958 are much weaker than in the past.

In the course of his years in power, de Gaulle made every effort to

strengthen the plebiscitary elements of his regime. He liberally utilized the referendum, and so far as was possible he ignored the parties and parliament altogether, ruling instead in splendid isolation. He made grand tours of the provinces to communicate directly with his people, he remained sternly aloof from the political parties, and he demonstrated his capacity to bypass parliament altogether by employing the referendum to ratify policies previously decided upon. In general, the prime minister and government served more as a conduit for proposals decided upon by de Gaulle in the Elysée Palace than as a government legitimately "responsible" to the legislature. Yet by far the most important change in the evolution of the presidency was the 1962 amendment to the constitution which allowed for the direct election of the president of the Republic. This reform had a profound impact upon the subsequent growth of political institutions, for it gave future presidents a legitimacy, if anything, greater than parliament itself. Here we see clear evidence of a Bonapartist as opposed to a conservative impulse.

Yet, as time passed, the more conservative forces reasserted themselves. Most Gaullists were never happy with the General's inclination to keep "his" party at a distance. The Gaullist party from the beginning seemingly existed to vote for de Gaulle's programs rather than to participate as a partner in policy formation. Many Gaullists resented this situation, and it did not extend beyond de Gaulle's tenure of office. Future Gaullist presidents were therefore obliged to consult on a more regular basis with the majority in the National Assembly. Thus, the rubber stamp role to which de Gaulle relegated the party was progressively modified. Similarly, many Gaullists were hostile to de Gaulle's employment of the referendum as a device to ratify decisions previously made in isolation from party and parliament, as the effect was to bypass parliament altogether. Not surprisingly, following de Gaulle's loss of power, in 1969, the referendum fell into general disuse as an important instrument of policy ratification.

Through these diverse national strains of conservatism runs a common thread of thought: Conservatives in various national contexts display an abiding faith in institutional "equilibrium." Even when they wish to stress elements foreign to the conservative core, as is the case with French Gaullism, some force seems to pull them back toward their roots. To put it simply, they wish to divide powers both vertically and horizontally, for the fear of concentrated power is never far from their speculations. As we have seen, it has long been a prominent theme of American political thinkers; it has influenced French conservatives in a political climate where statist

ideologies have long found nourishment and where Bonapartism and re-
actionary ideologies have sometimes confused the issue;[58] and it has re-
cently found special expression in a British conservatism whose general
tradition is steeped in the ideals of Parliamentary Sovereignty, unitary gov-
ernment, and disciplined party majorities. These are three very different
traditions, but their fears and concerns are remarkably similar.

But if we penetrate beneath the surface of conservative thought we dis-
cover another dimension which has escaped consideration: Conservatives
wish to revamp constitutional practices in order to decelerate change. It
is divided and restrained power which they hope will accomplish that
purpose. Indeed, their eager embrace of mixed institutions and balanced
government implies a persisting fear that transient and unscrupulous ma-
jorities bent upon immediate gratification and social change will threaten
ancient, mainly nonpolitical liberties. Efforts to strengthen local autonomy
(as in the United States), to question Parliamentary Sovereignty (as in Great
Britain), and to ward off growing executive and bureaucratic centraliza-
tion (as in most countries) are therefore attempts to slow the pace of politi-
cal change. To conservatives, Power is in essence the marriage of central
authority and mass democracy in order to accelerate the tempo of socio-
political change.[59]

If a major end of conservatism is to tame Power—whether deriving
from the top (central administration) or the bottom (masses)—in order to
reduce the speed of political change, then conservatives must somehow
come to terms with two problems: (1) the role for what is often designated
the "natural aristocracy" and (2) the role for legislatures. Some conserva-
tives have addressed these issues forthrightly, but many have unfortunately
glossed over the intellectual and political difficulties.

The Role for the "Natural Aristocracy"

We need spend little time with "rule of the best" arguments. Indeed,
modern liberals and social democrats have subjected them to devastating
criticism.[60] In the modern era, conservatives are obviously wary about sup-
porting the concept of a natural aristocracy, although many with a special
affinity for Greek thought and for the older British Toryism apparently
believe in the possibility of training and gaining recognition for an elite
educated to prize virtue and the public welfare. The intellectual difficulties
are staggering. How does one find such an elite and then keep it insulated
from the particularistic demands of groups or from the irresistible politi-

cal urge to pander to electorates? How can virtue itself be defined, agreed upon, and finally inculcated in the elite? Why should we expect to find the necessary deference in an age increasingly wedded to populism in culture, the arts, and intellect? Proper education may offer possibilities for the growth of a "natural aristocracy," but to find agreement as to the proper type of education is a monumental task. Or, if one places the elite in an upper class based upon ascriptive qualities, is there not the danger that many less intelligent or morally unfit individuals will be awarded high rank and political position for no other reason than their membership in a special social category? Whether thinking of the landed families in Great Britain or of the Eastern seaboard elite here in the United States, surely one must have some doubt about the policies these elites have bequeathed their respective nations.[61] And would today's masses, smothered with egalitarian norms and values, give deference for very long (if at all) to highly educated and socially privileged individuals? Finally, to reiterate in his context an argument put forth throughout this book: Conservative elitists tend to assume the "best" ought to be found in positions of "public responsibility," but is it not clear by now political roles themselves more often corrupt rather than elevate the sensibilities of leaders, that political busybodies with vast resources at their command regularly go about offering programs which make the lives of most of us less fulfilling and more difficult over the long run?

Indeed, it may be argued that that types of elites favored by conservatives in an era when citizens are obsessed with "rights" to material comforts and status equality have little opportunity to emerge—especially in political life. Nor have populations in less democratic eras of the past readily taken to such leaders when the point of elite rule was brought forcefully to their attention. For example, in as fine a defense of conservative elitism as has ever been put forth in the public arena, Edmund Burke in a speech before his Bristol electors argued that the member of Parliament must be a trustee for his constituency rather than a mere delegate of their temporary interests. Not only did the Bristol electorate fail to appreciate Burke's position—they threw him out of office—but his modern followers, when engaged in politics, show scant inclination to follow his advice. Thus, in the United States, senators and representatives from the *more* secure constituencies are also more likely to vote in harmony with the wishes of their electorates than are legislators who derive from marginal and more competitive districts. Burke himself had justified the "rotten borough" system of his time on the grounds that it helped insulate the MP from the momen-

tary desires of his constituents; today, however, extended service in Congress apparently enhances one's ability to discern the wishes of electorates and hence one's willingness to follow popular dictates.

Across the Atlantic, where the ideal of Tory *noblesse oblige* still carries some weight, there is more adherence than ever to the trustee model, although cabinet members in the Conservative party have long come in great numbers from a social class anchored in the landed aristocracy, gentry, or older commercial interests admired by many conservative intellectuals on the right. Yet, democracy and egalitarian norms have steadily invaded the Conservative party. For instance, the Troy tradition called for the party leaders to "emerge" spontaneously rather than be subjected to election by caucus. However, in 1965 the Conservative party changed its collective mind and thereafter elected the leader by ballot. Moreover, the party's leaders have long ridiculed "ideology" in the name of "pragmatism"—at least until the rise of Margaret Thatcher. This opposition to fixed principle, of course, rationalized the Tory acceptance of nationalization, the huge welfare state, and, more recently in the case of resistance to Mrs. Thatcher, to what is euphemistically called "reflation." In general, those Tories who make it to the top rungs of party and government tend to derive from highly partisan Conservative families, occupy safe seats, and conform closely to party dictates in Parliament. Apparently, background and safety of tenure dispose one to conformity and, as a result, pave the way to political power, but at the same time they do not encourage independence of thought and action.[62] Certainly they do not incline one to Burke's Bristol position, since loyalty to party is apparently perceived as a higher duty than any abstract ideals or "general interest." In this respect, Mrs. Thatcher diverges from her immediate predecessors in more ways than her sex. To their chagrin—one thinks of Harold Macmillan and Edward Heath—this "ideologue" has often resisted a Tory tradition which links political reality with a "middle course" in British politics. It is interesting that "moderate" Labour party leaders have themselves shown alarm at her emphasis upon principle and her repudiation of welfare state notions so long associated with aristocratic Toryism. One can only be amused when her Socialist opposition offers presumably disinterested advice that she return her party to its aristocratic traditions!

The Role for Legislatures

Conservatives are normally more philosophically committed to legislative power than to executive authority. As defenders of the former they believe that executive power has become so dominant in this century that a dire need exists to restore equilibrium between the major branches. Let us recall in this connection that it is "mixed" government and balance-of-power deals which have traditionally inspired conservative thought. Thus, the Greek and Roman classics, the "country" ideology in seventeenth-century England which found its way subsequently into American pre- and post-Revolutionary thought, the Whig ideals in nineteenth-century England and America, and twentieth-century conservatism among Republicans and Southern Democrats have all fiercely resisted king or president.

It is true in revolutionary periods, when order is unduly threatened, that conservatives tend to side with the executive against what is seen as a weak and divisive legislature. Thus, in France, where the principles of constitutional government have never been entirely secure, conservatives joined Napoleon I, Napoleon III, Marshal Pétain, and General de Gaulle in protest against growing threats to law and order. But these lapses seldom last for very long, and conservatives soon return to their traditional defense of balanced government and legislative rights. This was as true for the Orleanists of the nineteenth century as it is for the *modérés* of the twentieth century.[63]

In the United States during this century, conservatives have placed a special trust in Congressional power. Recognizing this state of affairs, liberals have supported a strong presidency against what they see as a naysaying Congress.[64] Congress has indeed been particularly well placed to foster conservative ends. For example, the legislative branch has supported procedures in internal organization and often policies which contradict a basic liberal belief in majoritarianism.[65] Whatever else there is to be said about the American Congress, it is clear that in most cases it has the necessary resources to resist a quick march by presidential majorities across the political terrain. Thus, powerful legislative committees and chairman armed with institutional privileges and long tenure, legislative oversight of administration, controls over the budget, the legislative "veto" (recently declared unconstitutional), and, above all, the right to investigate the administration probably make Congress the envy of power-seeking legislators throughout the Western world.[66] From a conservative perspective, the appeal of Congress lies with the substantial power of delay by which the

legislative branch supposedly forces majorities to temper their demands for immediate gratification. In its efforts to slow down the pace of programmatic change for much of this century, Congress has consistently frustrated liberals determined to utilize a plebiscitary presidency for social and economic reconstruction.

Actually, research strongly implies that Congress is today a heavy contributor to our temporal derangement; that it has done little, if anything, to foster "waiting time." According to Morris P. Fiorina, Capitol Hill, not the president or his much maligned bureaucracy, is chiefly responsible for the enormous growth of public employment, expenditure, and costly regulation.[67] This is not to say that departments and agencies of government have steadfastly resisted new programs and expenditures dispensed by Congress; to the contrary, they have welcomed them. Nevertheless, runaway deficits, massive outlays, and regulatory "reform" were primarily created by a Congress determined to insulate incumbents from reelection pressures. Thus, seniority and service on major committees with clout has brought untold rewards to many congressional districts and continual reelection for representatives and senators. Congressional committees, whose members enjoy mutually beneficial relations with the bureaus and agencies they regulate, therefore strongly support, often in the face of presidential resistance, the expansion of costly programs. It is these tight, cozy, mutually beneficial relationships among congressional committees and subcommittees, regulatory agencies or executive departments and bureaus, and clientele groups which are aptly designated as policy "triangles."

It was long the opinion of many conservatives (and some liberals) that congressional weakness in the face of executive initiative derives from a paucity of staff and expertise available to the legislature. If only Congress were given its own experts, this argument goes, it would develop its own agenda and ward off executive dominance. Yet, although staff and budget on Capitol Hill have grown enormously in the past two decades and field offices and staff in the constituencies have multiplied, legislators continue to spend far more time on casework and pork barrel than on policy formation. A strong policy position, we have previously observed, often makes enemies of previous friends and indifferent constituents, whereas sewage treatment plants and agriculture subsidies usually make strong friends (who also supply campaign funds) and few enemies. Furthermore, power within Congress is now so decentralized that the legislative branch is even more unwieldly. The trend toward decentralization was accelerated with enactment of the Subcommittee Bill of Rights (1973) by which standing

committee chairmen lost power to subcommittees and subcommittee chairmen. The former were no longer able to appoint subcommittee chairmen and members nor determine subcommittee jurisdictions, staff, and budgets. The consequence was the creation of ever more little triangles within the policy arena.

As a result, Congress is today more insulated than at any time in memory from the larger forces in American society. It plays its games of distributing largesse and performing small chores for the deserving. It demands to govern, it hamstrings presidents, but it cannot rule on its own. Like the National Assembly of French Fourth Republic, which kept turnover of premiers at a maximum and legislative elections at a minimum, Congress increasingly functions as a "house without windows," impervious to external forces welling up in the American community.

Accordingly, we see that the traditional conservative bias in favor of legislatures is somewhat misplaced in the modern era. In their hostility to the executive, conservatives often fail to heed sufficiently the warning of Walter Lippmann some thirty years ago that our politics suffers from a "derangement of powers."[68] On the other hand, the bias is understandable, if for no other reason than that their opponents in America and Europe alike have championed for so long the centralized state in order to effect massive transfers to income, property, and power.[69]

Is There a Way Out?:
An Uneasy Case for Swiss Institutions

By this time the reader must wonder if any type of political system is today productive of good public policy. The American polity with its system of checks-and-balances and separation-of-powers threatens to drift into a stalemate in which Congress can prevent executive action but cannot develop its own policies. Cabinet government, if anything, displays even more serious liabilities, although the concept of government responsibility before the legislature would in theory make it responsive to more inclusive interests. In fact, all of the more important democracies, whether presidential or parliamentary, suffer from increased social tensions, inflation, unemployment, lower rates of productivity, and overgovernment.

We have argued that a major source of political and economic failure is the growth of a promissory politics, fanned by competitive party organizations and democratic ideology. One consequence is to shorten indi-

vidual time horizons and to weaken support for institutions, norms, and values usually resistant to instant gratification. Thus, until members of Western political communities lower their expectations with regard to the gains to be made from political activity, promissory politics will continue to thrive. And social scientists will also continue to regard "nonparticipation" and "depolitisation" as greater threats to liberal democracy than an overactive political thyroid.[70]

Comparative studies of political institutions may provide some insight into these problems. Who cannot think of various liberal democracies whose intelligentsia at some time did not reject its political leadership as excessively "authoritarian," whose opposition leaders and social scientists did not condemn them for allowing the rot of "depolitisation" to set in, and whose sophisticates did not mourn the supposed atrophying of democratic institutions? Konrad Adenauer's West Germany following World War II and Charles de Gaulle's France are examples which immediately come to mind. Although criticism seldom abated that both leaders had seriously weakened democratic institutions by "authoritarian" rule, our gift of hindsight suggests a far different picture. In both nations, of course, the oppositions were generally weak, the major parties deferential, and the legislatures thoroughly dominated by forceful leadership. Yet, in less than a decade following World War II, West Germany became the chief economic power of Europe, second only to the United States in the West, and regained her respectability among the nations of the world. Under de Gaulle, France reformed its Constitution, which in turn has survived the General, created a continuity of leadership by ending the musical-chairs governments of the two previous republics, and established economic reforms which led to rapid growth and price stability for several years.

On the other hand, France and Germany were saddled with historical traditions which strong and forceful leadership alone could not alter. Marxist influences were particularly powerful on the opposition benches, class antagonisms ran deep, the welfare state was firmly entrenched, and anti-statist individualistic philosophies of economy and society were widely embraced at that time. In short, Adenauer and de Gaulle were themselves accidents of time and place, thrust into leadership by crisis and national humiliation. In one case Germany lay prostate, her powerful institutions shattered and compromised; in the other, a frightened political elite, finding both communist and military rule intolerable, turned to the only democratic alternative available during the Algerian crisis in 1958. In each coun-

try, therefore, leadership was decisively exercised within the context of compromised institutions and a power vacuum.

Fortunately, a better case study may exist to lend our hypothesis plausibility: Switzerland. Small in size, well situated by geography, and possessor of a unique citizen army and a firm tradition of neutrality in foreign affairs, she hardly qualifies as a "typical" democracy. Nevertheless, Switzerland raises some interesting hypotheses for consideration. Unlike the Adenauer and de Gaulle governments, which arose out of crisis, the Swiss regime calls upon an unbroken tradition of democratic stability, social harmony and economic order; indeed, by any standard of measurement she must be considered a successful democracy. Her democracy is long-lived, her rulers clearly legitimate, and her constitution enduring.[71] The Swiss crime rate is far lower than that in such advanced welfare states as Great Britain or Sweden. Her economy, moreover, is the envy of the world, having long supported high rates of employment without having simultaneously stimulated the fires of inflation. Among industrial nations her per capita income is the highest in the world. Her labor-management relationships have been relatively peaceful, so extremists have wielded little influence. Her savings level has been among the highest in the world throughout this century, and at present she takes second place in frugality only to Japan. Savers are repeatedly reassured that their nest eggs will retain fundamental value. Not surprisingly, central bankers have made a fetish of stable money, a task made easier since Swiss governments have generally balanced their budgets. Despite periodic threats of "imported" inflation from abroad, the Swiss franc remains consistently among the strongest currencies in existence.[72]

Which brings us to a basic Swiss characteristic: the bourgeois style of life. To a greater extent than other countries, the Swiss people and elites are permeated with middle-class values. One finds in that small nation a large merchant, capitalist, and professional class. Ownership of property is relatively widespread, although world competition and escalating land values in recent years have kept the peasantry smaller in size than might have otherwise been the case. The Swiss rank far behind other European nations in terms of deviant behavior: Illigitimacy as well as crimes against property and person are far less prevalent.[73] Pride in family and occupational tradition, often noted by foreign observers, may explain the Swiss obsession with saving and stable money as opposed to the mass consumption habits so characteristic of other societies. Moreover, foreigners have repeatedly referred to the general sobriety, sturdiness, privacy, indepen-

dence and frugality of the population, albeit sometimes with no small degree of contempt.[74] This pervasive dominance of bourgeois traits has consequently proved to be infertile soil for redistributionist schemes and for massive outlays of public monies; hence, the politics of compassion is less evident among the Swiss than in other political systems.

If it is correct to say that the cultural and economic spheres in Western nations have become increasingly impotent as political activities, parties, and participatory ideologies have grown, it may also be said that Swiss political ideologies and institutions have been relatively less successful "colonizers" than have their counterparts elsewhere. For example, as compared with other peoples, the Swiss display an astounding lack of interest in national political activities and institutions. It is well known in this respect that their knowledge of federal political figures is notoriously low. This ignorance may result from any number of factors, including the short legislative sessions and the limited functions carried out by the central government. Similarly, the level of participation in elections is exceeding low for a Western nation; indeed, it ranks with the United States. Whether this high degree of apathy derives from sheer contentment, the relatively small role of the federal government, or the exorbitant number of times the citizen is called upon to vote is not entirely clear.[75]

On the other hand, the outcomes of various referenda in recent years testify to the endurance of bourgeois resistance to government regulation as well as social and economic equalitarianism. Among the more important votes favorable to work, frugality, economic freedom, and traditional authority structures are the following: The populace refused to shorten the work week from 44 hours; it resisted efforts to mandate worker participation in management decision-making; it set back attempts to lower the age for citizens to become eligible to receive their national pension payments; it opposed special taxes upon higher incomes; and it steadfastly continued to support the secrecy provisions of Swiss banking laws. Needless to say, these referenda must appear as aberrant behavior to their European neighbors who steadily reduce the work week and lower the retirement age, extend "codetermination" in industry, enact higher taxes upon "unearned" income, and nationalize or increase state regulation of the banking systems.

It is to be noted that from a comparative standpoint, political parties in Switzerland are much less pivotal in political life than elsewhere in Europe or in America. It may be for this reason that Swiss socioeconomic values and structures seem relatively less politicized. True, the Federal

Council (cabinet) is composed of a coalition of parties, so it superficially resembles the multi-party governments typically found throughout Europe. Nevertheless, Swiss parties play a less decisive role in political leadership, policy-making, and recruitment of government ministers at the national level.

In the first place, government coalitions in multi-party systems are generally represented roughly according to the proportion of seats the particular parties occupy, although typically a center-left or center-right government is unlikely to choose either a party on the extreme or a large but moderate party from the other side of the aisle (so-called "Grand Coalitions" are an exception). This situation has by no means always been typical of the makeup of the Swiss Federal Council. For instance, the large body of Catholic conservatives were excluded from various governments for much of the postwar period. Nevertheless, the usual practice is for government coalitions to be very broadly based, indeed, to be rather nonpartisan in coloration. Thus, parties are co-opted into coalitions which in other systems would normally find themselves in opposition. For example, the dominant "bourgeois" and "liberal" parties (Christian Democrats, Free Democrats, and Swiss People's party) have often ruled with the Marxist Social Democrats. Since all the major parties are included in governing coalitions anyway, it is hardly surprising to discover political practices which deemphasize competition and partisanship among groups which elsewhere would be more clearly divided into Government and Opposition.[76] It is therefore less simple for victors in the electoral struggle to divide the spoils among themselves—or at least there is less incentive to do so. Once chosen, a minister is, in fact, expected to renounce all formal ties to party and to interest groups. Needless to say, these practices would seem strange to the Britisher in search of a Loyal Opposition, to the American used to fierce party combat, and to the French citizen expecting fierce ideological partisanship and party competition.

The emphasis upon nonpartisan criteria in the choice of ministers is only one reason to believe that political parties are less crucial in Swiss political life than in other nations. Secondly, it may be of particular importance that language and canton considerations play a major role in ministerial recruitment. Of the seven members of the Federal Council, Zurich and Bern are reserved for German-language individuals, whereas Vaud belongs to a French-speaking one. Indeed, the practice is for non–German-speaking cantons to control two of the seven seats of the Federal Council, whereas the remainder are German preserves.

Thirdly, it is significant that the Swiss parliament meets but some forty-two days a year, about one-quarter the number of days their American, British, or Canadian counterparts, for example, devote to legislative work. The Swiss legislative environment, therefore, is hardly one to nourish party professionalism, since parliamentarians in a rush must devote relatively more time to specific lawmaking and approving government regulations made in their long absence than to constituency casework and the pork barrel. Because less is at stake, because less time is available, and, let us not forget, because the communes and cantons have so many powers, ministerial recruitment of parliamentarians takes on a more nonpartisan hue than otherwise.[77]

Fourthly, the Swiss place a high value upon expertise as an essential requirement for ministerial service. Once again, the obvious effect is to reduce the importance of party service and loyalty.

Finally, these four criteria are reinforced by the tradition of long tenure accorded Federal Council ministers. As we previously observed, once ministers are chosen by the Federal Assembly, they may serve as long as they wish. Similarly, Swiss practice reinforces the popular contention that ministers are "above politics." Not only is their departmental authority thereby enhanced, but they are also relieved from the obsessive concern with re-election or cabinet advancement so typical of their counterparts in other democracies. Consequently, their values are likely to reflect closely those of the experts within the ministries over which they preside rather than the values of typical party leaders.[78]

The ministerial portfolio is therefore removed for the most part from narrow patronage and partisan considerations. Quite simply, there are a limited number of seats at any given time over which to fight; so with a low turnover rate, competition for office and party pressures for extracting promises are severely limited. Needless to say, this style of politics is almost unimaginable in other democracies where party loyalty and years of service are the chief factors in recruitment. On a few occasions, it must be added, a minister who displeases Parliament may be quietly told to resign or risk public embarrassment, but this state of affairs is rare.

In sum, if party criteria play a role in initial selection to the Cabinet, they are by no means the only consideration, since party interests must compete with nonpartisan values which legitimate broadly based coalitions as well as with place of residence, with language, with expertise, and, above all, with the fact that long service on the seven-person Federal

Council leaves so little to distribute anyway. James A. Dunn has well summarized this situation:

The fact is . . . Switzerland does not really have a national party system, but only a very loosely linked congeries of cantonal parties. Party considerations do play some part in establishing the *proporz* in the seven-member Federal Council . . . but so do considerations of language, religion, size of canton, and so on. And once a man is elected to the Council, he is expected to be able to rise above partisan politics and seek the common good according to the dictates of his conscience. He does not take orders from the party that he previously belonged to.[79]

In this chapter we have emphasized the part played by legislatures in the stimulation of short time horizons. We have noted that this problem may be exacerbated by a derangement of legislative-executive relations, by the weakness of executive authority; and that conservatism, in its traditional hostility to executive power, sometimes overlooks the manner in which legislatures foster values inimical to conservatism. This is especially apparent in the United States, where a Congress through its powerful standing committees and subcommittees provides the principal means by which government regulation and the indiscriminate provision of largesse have grown to unprecedented heights. The problem is somewhat different in European parliamentary systems. In Great Britain, for example, since disciplined parliamentary majorities, backed by the myth of the mandate won at the polls, have ample resources, both material and moral, at their disposal, executive weakness per se has not been so much the problem. But government fear that any refusal to gratify marginal groups risks electoral disaster has led to fiscal and monetary irresponsibility. On the Continent, however, where coalitions are a fact of political life, governments are readily threatened by a potential withdrawal of support. This situation, of course, renders government authority weak and indecisive, unable to withstand the pressures of major interest groups.

The constitutional and political system of Switzerland has to a great extent avoided these pitfalls of modern democracy. The executive cannot be said to be weak, for the cabinet clearly dominates the Federal Assembly. Drafts of laws are initiated mainly within the ministries, then guided through the National Council and Council of States by the minister concerned. The seven Federal Counselors control their own departments relatively free of pressures from parliament and ministerial colleagues alike. This is due in part, no doubt, to prevailing values and norms, previously discussed, which insulate the cabinet from intense party and ideological

pressures. Moreover, in Switzerland there is a clear separation of powers between legislative and executive branches. Hence, the ministerial portfolio is constitutionally incompatible with service in parliament, since appointment to the Federal Council requires prior resignation from parliament. Indeed, "collective responsibility" of the cabinet before the House is nonexistent, and the "interpellation"—the bans of French Third and Fourth Republic governments—while utilized in legislative debate, is not followed up by a motion of no-confidence. Other than to pass a "motion" or "postulate," there is little that the legislature can do to force a reluctant cabinet to accede to its dictates. The motion *commands* action but must receive support in both houses of the legislature, whereas the postulate *invites* action but needs gain the favor of one house alone. Obviously, a motion would be taken seriously by the Federal Council, but its use cannot actually force action by the executive.

We cannot leave this subject without making reference to that unique Swiss institution of direct democracy, the referendum. As is well known, the constitutional "initiative" and "referendum" are both utilized to alter their constitution. Yet perhaps the more significant type of referendum from the standpoint of legislative-executive balance is the "legislative challenge." Under this system any law or regulation may be repealed if contested within ninety days by a petition of 50,000 citizens or by eight cantons and subsequently struck down by a popular majority. It is likely that the legislative challenge makes the parliament far less beholden to special interests than its absence would suggest. The fear of a *potential* referendum undoubtedly makes legislators think twice before supporting *new* legislation likely to stir resentment among significant numbers of citizens. In this case, and contrary to the conventional conservative wisdom which generally fears direct democracy, the referendum probably functions as a bulwark against legislative innovation.

On the other hand, the legislative challenge may also be employed as a method to void laws opposed by majorities but nonetheless supported by entrenched minorities or elites. Thus, whatever one's particular ideas about the wisdom of prayer in the schools, abortion, or busing of school children to achieve racial balance in the United States, it is likely that with a national referendum at least some of these policies by now would have been altered in the United States. A similar argument may also be made with regard to taxing and spending policies, as cries for reduced taxes and balanced budgets today grow ever more strident. It ought to be observed in passing that in the United States a staggering rise in the number of state

initiatives has taken place. This multiplication of referenda in the past ten or fifteen years suggests that the separation of powers as practiced in American state and national government will come under growing pressure since legislatures and courts seem determined in many instances to invalidate petitions supported by popular majorities. Although this problem has received scant attention, burgeoning referenda surely imply a derangement of powers in the United States.

In the final analysis it may not be so much presence of norms and values supportive of nonparty criteria in ministerial recruitment and behavior, short legislative sessions, cabinet dominance of the legislature, or even restrictions imposed upon parliament by the referendum as the power of the Swiss cantons to limit the power of Political Man. Indeed, the special position of the cantons relegates many conflicts to local levels which might otherwise find their way into the national arena. The reverse observation, of course, has long been made about France, where a centralized state, monopolization of political life by Paris, and a highly nationalized and regulated economy presumably make policy "overload" a constant barrier to political stability. To take an example, any significant proposal to reform the university system in France finds its way almost at once to the Ministry of Education in Paris and to parliament.

In Switzerland, on the other hand, not only education, but health, policy, and public works are primarily cantonal matters. The same is true of the judiciary, since unlike the United States, there is only one federal tribunal and federal law itself is administered by local courts. Not surprisingly, the cantons have the major fiscal clout, for the lion's share of taxes paid by Swiss citizens is claimed by local governments. Moreover, the cantons share a piece of national power through their representation in the Council of States (upper house), but unlike the United States Senate, the method of election is determined by the individual cantons.

Finally, language, nationality, and religion tend to mitigate the nationalizing political effects of raw class conflict. For example, the working class, small by European standards anyway, is confined neither to a single language group nor to a particular region. Indeed, the phenomenon of "cross-pressures" observed by sociologists is much more relevant in Switzerland than in such class-ridden societies as Italy and France or in Canada or Belgium, where class and language correspond more closely. Thus, German-speaking Swiss include numerous Protestants and Catholics in their midst as do their French-language compatriots.

The questions raised by the success of Switzerland as a stable democracy

deserve much more attention than we can devote to them in this work. Although there are indications, for example, that excessive spending by the various levels of Swiss government (federal, cantonal, communal) are beginning to pose problems, that the transportation system needs a thorough overhaul, and that outrageous subsidies to farmers must be reduced, basic problems in Switzerland appear less severe than in other industrial nations. Nevertheless, almost alone among the Western democracies, little Switzerland for the past twenty years has most successfully resisted for a longer period and with more consistency the twin evils of inflation and unemployment. Indeed, her social cohesion over the past two decades has seemed more secure than the better-known systems, including those of Great Britain, Sweden, and the United States. Who reads about ever-changing governments, high rates of unemployment and inflation, or major labor stoppages, tax revolts, and massive deficits in Switzerland?

Yet, the more important theories of stable democracy advanced by such outstanding political scientists as Eckstein, Lipset, Beer, Dahl, Lijphart, Almond, Nordlinger, Lowi, and Budge, while highly plausible, cannot entirely do justice to the Swiss case. For example: Whether democratic stability is seen to result from a congruence of authority patterns between government and other authority patterns of the society, from a diffuse sense of deference in the community, from the existence of a particular form of pluralism, from relatively even rates of economic development, from mass communications and high rates of literacy, or from dominance by a large middle class and a lack of class awareness on the part of workers. It is possible, of course, to utilize any number of these ideas to explain the Swiss phenomenon. What is more difficult to fathom, however, is why Switzerland has experienced so much less social turmoil recently than have other stable democracies. Not that these democracies are in danger of imminent collapse; but it is hard to avoid the conclusion that unstable elements have progressively undermined their public authority.

We conclude that Switzerland is somehow "less political" than other major democracies; that is, her citizens are less trusting or hopeful about what political leadership and institutions, especially at the national level, can accomplish. Her political system has been a less pervasive influence in family, group, and economic life; in short, nonpolitical values and structures are less politicized. Since the Swiss *national* political leadership has fewer resources to transfer and redistribute, there likewise exist fewer ideological, institutional, and policy incentives for short time horizons. No doubt, the Swiss public is subject to the usual "modern" sociocultural in-

fluences arrayed against low time preferences. For example, mass advertising, instant communication through television, a reduction in parental authority, and the decline of religious tradition have also made themselves felt in Switzerland.

Nevertheless, Political Man has been kept more in abeyance in Switzerland than in other nations. "Because of the nature of Swiss institutions," says Dunn, "parties, politicians, bargaining, and so on are not very salient in the mind of the Swiss citizen."[80] We have seen in this chapter that competitive party systems are a primary means by which ideologies and values favorable to instant gratification are transmitted between elites and masses. To this extent, therefore, party competition softens resistance to the politicization of the larger community. It is indeed ironic that political institutions in Switzerland, so "inadequate" for the achievement of "social reform" or democratic leadership based upon clear lines of accountability, may actually be less detrimental to social cohesion than are the systems of our more "advanced" polities.

Chapter 7

Toward a Coherent Policy Culture

Bourgeois Time, Say's Law, and the Quest for Abstract Rules

The preceding chapters have addressed our conceptions of time in several contexts. We have adumbrated the effects of time horizons upon family, class, and culture; we have considered their influence upon economic thought in general and upon the more mundane decisions of saving and investment in particular; we have noted how political activities and values have been elevated to the loftiest heights in the public imagination to the detriment of the welfare of all and have examined their place in important ideological systems; and we have explored their connection with democratic ideals relating to participation, to government responsibility, and to the role of political parties. In one way or another, we have seen how various ideologies, values, and political institutions have conspired against the necessity of waiting time.

In this chapter we offer various suggestions for reform in order to reorient our flawed conception of temporality. It is largely a reform within the context of policy culture, hardly a laundry list of concrete proposals for change. However, we must be under no illusion. In the absence of sociocultural change and institutional reforms in the economies of the

Western world, it is probably unrealistic to expect meaningful reform else-where. Consequently, an alteration in policy values may well have insig-nificant effects unless the sociocultural and economic spheres are also changed. As we stated at the outset of this work, society, economy, and polity require relatively congruent structures if social and political stabil-ity are to be achieved. These three subsystems are not sustainable by just any kind of temporal glue. If, for example, a reduction in the role of Politi-cal Man is essential to the growth of more lengthy time horizons within the sociocultural and economic spheres, government must likewise pursue policies which reinforce, or at least do not discourage, the necessary sym-metrical relationship between the subsystems. We therefore contend that a policy culture oriented to "rules" instead of commands and discretion-ary authority is most congenial to waiting time in the political and eco-nomic areas of social life. This orientation involves nothing less than a re-turn to and reinstitution of those values and norms favorable to a social order based upon the authority of rules rather than discretion. In the most general sense, we speak of a return to those values and liberties encap-sulated in the notion of the "rule of law." Nevertheless, our chief interest is less in the rule of law per se than in the means by which policy may be made to conform to this noble ideal. The rule of law becomes a yard-stick against which major policies may be measured. In the long run, we hope, policy developed according to the criteria will influence the law itself.

It is routinely assumed by various shades of political opinion that the growth of regulation, welfare, and the ideologies which sustain the social service state preclude a return to the rule of law as it was traditionally understood. We submit, however, that a more fundamental force under-pins the modern state and the ideologies which sustain its growth. It is a powerful brake to any reform of policy or law otherwise calculated to strengthen the role of individuals against the state. It is largely oblivious to reasoned discourse. It is seemingly a problem endemic to modernity but achieves a special importance in democratic societies as it casts its threaten-ing pall over every policymaker in a position to effect reform. It thrives on all the conventions of modern politics—e.g., participatory democracy, government responsibility before the legislature, party competition—and in conditions of material prosperity and affluence. At bottom, however, it feeds less upon physical surroundings and public life than upon the psyche itself.

What is this great force which holds the modern imagination? It is

nothing less than the contradiction, or antagonism, within most of us in the course of our daily lives as simultaneous producers and consumers. This duality of roles breeds a contradiction which, unless resolved or at least mitigated, precludes reforms based upon the rule of law. Thus, we must address this problem before we consider the optional role of policy rules in a free society.

The Policymaker's Dilemma:
The Tension between Consumer and Producer Roles

Man's dilemma in reconciling simultaneously the twin roles of producer and consumer is a very old one. It begins with the eviction of Adam and Eve from the Garden of Eden but assumes virulent sociopathological dimensions in modern orders. Once Adam and Eve faced scarcity, once they no longer could depend upon unlimited consumption, they were confronted with the stark choices about how much time to devote to consumption and how much time to devote to production.

For good reason, the contradiction between occupational and consumer roles long remained mostly beneath the surface of political concerns. Lacking the necessary tools and technological knowledge, continually subject to starvation and disease, forever being exploited and deprived of basic property rights by "betters," the great majority for much of history barely subsisted. The Biblical injunction that one must work in order to eat was at best a problematical choice, since one might well work much but eat little. Consumption was therefore mainly devoted to the attainment of food, drink, and shelter—of basic needs. Indeed, "conspicuous consumption" and leisure belonged to the very few.

Under these conditions any antagonism between economic, social or status needs attached to one's role as a producer and the demands of consumption could hardly reach the stage of political awareness. In Europe, for instance, the overwhelming bulk of the population was peasant, tied to the soil by tradition, if not law. The aim of the peasantry was to be self-sufficient enough to eke out a living over and above what their lords expropriated as tribute.

Industrialization, the growth of technology, the extension of markets, the slow but steady accumulation of capital, and an enhanced division of labor gradually created the necessary conditions by which poverty and misery were largely eradicated in Western nations. Interpretation of cause

for these trends, of course, was far from unanimous among the learned. Many critics on Right and Left alike found only misery, crowdedness, abject living conditions, unemployment, and alienation well into the twentieth century. Indeed, it was during the nineteenth century, at the very time an explosion of population coincided with a strong elevation in living standards, that some of the more imaginative critiques of industrialization were penned. Neither the reactionary, who took a cue from the Middle Ages, nor the Marxist, who looked to a communism freed from want and alienation, found much to praise; yet, what was halting, uneven progress in the seventeenth and eighteenth centuries laid the foundations for the unparalleled rise in living standards in parts of Europe and America in the following centuries. This unprecedented increase in material standards, when combined with the erosion of inherited status and the rise of political liberty and constitutional democracy, planted the seeds which we might term the "policymaker's dilemma."

To make this point we might briefly compare the traditional and modern eras. In the traditional, hierarchical societies of Europe and England, there was little tension apparent within individuals between their simultaneous roles as both producer and consumer. Within an environment of great scarcity, sharp distinctions in class and status likewise made for clear distinctions in the way people consumed. Aristocracy and gentry, bourgeoisie, peasants, and workers all consumed in quite different ways from one another, their life-styles were sharply differentiated, and their respective ranks were clearly separated by education, behavior, speech, symbolic usage, and material conditions. The leveling effects of mass-produced goods, therefore, had little place in such societies; indeed, even by the middle of the twentieth century, these distinctions had not entirely disappeared in parts of Europe. Pollsters discovered that respondents had rather clear conceptions about "peasant" and "bourgeois" life-styles, despite the rise of mass living standards and the growth of a "middle class."[1]

In traditional Europe people meekly accepted these distinctions (except on rare occasions) and consumed according to rank. It must be stressed, however, that these graduations in class and status were not so fixed and immutable in medieval Europe as to prevent a level of economic growth sufficient to leave the rest of the world far behind. One reason for the rapid growth in the rate of capital accumulation was that the process crept up on the population. Thus, in those cases where religious sanctions were insufficient to elicit acceptance of large fortunes, a belief that "that is just the way things are" was sufficient. It was within this social context

that nascent capitalism could take root in the sixteenth and seventeenth centuries.

Today the situation is far different. A breakdown of important status and class distinctions coincides with what is somewhat inappropriately termed "overchoice" in consumption habits. These changes are a consequence of the extension of markets, mass production, an extensive division of labor, and, in general, rising affluence.[2] People now consume at breakneck speeds in "throwaway" societies, while entrepreneurs, when unrestricted by the constraints of government and society, spring up everywhere to meet demands for a variety of consumer goods. Although differences in amounts and kinds of consumption may also be large in modern societies, the growth of mass production and rising incomes makes standards seem egalitarian when compared with previous societies. In this age we prize our strong positions as consumers, our "right" to pick and choose with abandon among a bewildering multitude of goods and services. Although all of us cannot own large homes in the most affluent neighborhoods, untold numbers can nevertheless lay claim to television sets, washing machines, dishwashers, and the like. As compared with the eras of our grandfathers and great-grandfathers, ours is surely the age of the consumer.

"Overconsumption," however, carries with it a pronounced psychological burden: The more power we have to consume in the present, the higher our expectations for even higher consumption in the future; and the more elevated our expectations become as a result of ever-growing levels of consumption, the greater our tendency to regard overchoice as the natural, permanent state of affairs. To have our consumption restricted, either through reductions in nominal wages or being forced to pay higher prices for various kinds of goods (e.g., oil, natural gas, rent), is regarded as the fault of "someone" in particular or as an unnatural state of affairs at best.[3] It is more than ever seen as a denial of basic rights.

Thus, we find it difficult to make a mental connection between demand for our own particular product or service, which may fluctuate widely in certain periods, and our "right" to consume abundantly, preferably at a higher rate over time. When a fall in demand for our product or service occurs and our consumption must be restricted, we place the blame upon the government, foreigners, and others to whom unfair advantage is attributed; hence, we demand protection from what are in fact more likely to be impersonal market forces brought about by our consumer fickleness. This phenomenon appears most readily among those of us who are em-

ployees in large organizations and have come to expect our wages to rise each year, so the necessary linkage between consumption and production is perceived in the most indirect manner, if at all. Unlike the merchant or retailer whose fortunes rise and fall with trade, salaried individuals are not so subject to sudden shifts in product or service demand, nor are they as likely to find their consumption habits wrenched sharply downward. But because they are not so obviously influenced by the trade cycle, they likewise react strongly not only to a threat to their position as producer but also to any reduction in their consumption. This failure to comprehend the function of markets in general and of consumer preference and its effects upon the demand for one's specific good or service in particular leads to demands for protection of producer privilege. Conversely, these same individuals would be horrified if any restrictions were placed upon them as consumers.

We moderns do not easily comprehend that high living standards and mass consumption require a constant diversion of land, labor, capital, and time into ever-changing channels of production and exchange if the ceaseless, shifting demands of consumption and the maintenance of incomes we have come to expect are to be retained and augmented. We fail to see a link between the freedom to consume in great abundance and the need for the prices of goods and labor to reflect the ceaseless and fickle preferences of consumers. We bask in overchoice but refuse to come to terms with the consequences for producer roles of accelerating and increasingly unstable alterations in consumption. To put the matter bluntly, we do not draw the necessary connection between a desire to consume a large array of goods and the inescapable decline of certain incomes or outright loss of occupation for ourselves as producers and as owners of capital, and as entrepreneurs, merchants, retailers, salespeople, industrial workers, and so on. We do not perceive any contradiction in our drive simultaneously for ever-rising levels of consumption and for the protection of production roles. Unfortunately, if we could assure the latter, the former would inevitably diminish.

Because, relatively speaking, in middle-class societies we thrive as consumers, because we perceive so much affluence around us, because our choices seem to grow endlessly, and because changes in our decisions as individual consumers in discrete cases have no obvious effects upon the fortunes of those who serve our needs (strictly speaking, ourselves), we come to believe a similar trajectory invariably propels production upward. We cannot imagine that our devotion as consumers to fads and to bewil-

dering variety in our choices necessarily dictates wrenching effects upon the volume and demand for the *particular* goods and services we purchase. We recoil at the thought that our fickleness would hurt anyone else, or deprive virtuous citizens of their incomes. On the other hand, a basic reality intrudes: We are producers and sellers of goods and services no less than consumers of goods and services. The result is that we quite literally threaten ourselves, our own livelihoods, for our fickleness and "instability" as consumers make our own positions as suppliers and producers forever tenuous and insecure.

Therefore, "conspicuous consumption" in particular and mass consumption in general are basic causes of insecurity of occupation, income, and status. It is as if we are at war with our own beings, with our dual roles in society. But why is this the case? Because to a large extent our status and self-worth are powerfully defined by the kind of work we do. Consumption, we have previously stressed, was traditionally tied, however tenuously, to class, life-style, and occupational position. If production was rigidly determined by birth and guild, so to a great extent was consumption. Amount and type of consumption were rather specific to rank and class. True, at the margins the sharp distinctions in consumption began to blur even in precapitalistic societies. For example, a prominent bourgeois often sought to adopt the life-style of the aristocrat, and members of the rural upper class whose members often possessed ancient lineage sometimes lived quite rustic, even rather impoverished, lives.

But with mass consumption, the growing homogenization of tastes, and the eradication of the more blatant distinctions between classes, the more intimate connections among individuals between their production and consumption roles were progressively severed. The freedom and wherewithal to consume on a broad scale, obvious facts of modern life, have exacted a high cost. Since we are stimulated by mass advertising and exposed to vast numbers of goods and services, we also have a powerful desire to keep up with the Joneses. But this ceaseless drive to consume simultaneously deals us a harsh blow as producers: We revel in mass goods but become forever more insecure in our work. The temptation is to escape this dilemma by calling upon the state for sustenance in the form of subsidies, regulatory controls over our competitors, and tariffs and quotas against outsiders. It is as if we are intent to return to an earlier age on the production side while clinging tenaciously to modernity on the consumption side. Our roles are hopelessly antagonistic, as we forever hang between retrenchment and progress, between protection and freedom.[4]

Herein may reside a prime cause for much of our present-day mental and social sickness. Many among us seek to resolve this role conflict in the embrace of the huge state and private bureaucracies in which income security may be combined with decent pay. Unfortunately, the outcome in our inflationary times is more often relative security but average, often declining real incomes. But if present occupational trends in America, for example, are any indication, these attempts at self-protection are likely to prove fruitless. Thus, at present, doors close on applicants for local, state, and Federal jobs and become relatively scarce at the *Fortune 1000* level, but open more widely to entrepreneurial skills in the insecure "middle-tech" and "low-tech" areas of the economy.[5] However, due to the producer-consumer role conflict, this trend may well portend even greater psychic and social tensions.

The incessant struggle in the middle class for college degrees and other credentials may be taken in this light as a protective device against our role contradictions. Upper classes have long sought to exclude the par-venu by selective criteria governing language, dress, education, and taste; hence, money by itself is usually deemed insufficient for access to privileged positions. On the other hand, credentialism has important stabilizing functions both for those who have previously met its criteria and for new applicants who wish a degree of protection from the vicissitudes of the market. After all, credentials supposedly reflect "true" merit and worth as defined in societies dominated by "achievement" as opposed to "ascriptive" criteria. Since much prestige is attached to large corporations and public service bureaucracies, degrees and passing tests represent "success" according to the principle of "rationality," a trait which Max Weber attributed to modern bureaucratic orders.

Credentialism accordingly squares the circle of contradiction modernity thrusts upon us. It offers the hope of protection in our producer roles while steadfastly refusing to acknowledge the possible effects upon general consumption. Modern bureaucracy thus has the unintended function of reconciling the warring consumer and producer roles within many of us, at least for those who work for such organizations. It represents the endeavor to have it all.

Of course, in the long run we cannot have it all; something must give. If carried to extremes, the effects of efforts to protect incomes from market pressures by stabilizing occupations through the use of state power and monopoly at the expense of those incomes determined by consumer preference will be the retardation of entrepreneurial efforts to determine con-

sumer wishes and to allocate land, labor, and capital in the most efficient manner. So long as we demand high levels of consumption we must likewise tolerate insecurity in occuational roles. Socialism in its various shades is undoubtedly an indication by powerful segments within the population that the antagonism between roles is intolerable. It is not surprising that these socialists, however independent in their daily lives, idealize the role of large state-run organizations. On the other hand, let us not despair, for our knowledge of social ideas provides at least a partial reconciliation of the producer-consumer roles. It derives from a simple idea which grew out of the eighteenth century but which has been sadly neglected in our own era.

Enter Say's Law of Markets[6]

Put forth by Frenchman Jean-Baptiste Say in 1825,[7] Say's Law of Markets is hardly a complete social cure for alienation, envy, resentment, and the pressures for special interest legislation. Nor can it ward off the various ideological illusions of those who are unable to perceive much benefit in free markets. Although its employment as a cornerstone of public policy might arrest social decay, it can offer only limited consolation for us in our present sociocultural plight. Say cannot reconcile the basic antagonistic roles of consumer and producer within the individual, for while that antagonism may be understood, it can never be entirely eliminated. At the same time, if its true meaning could be grasped by large numbers in the public, many serious errors in policy might be avoided. Let us see why this is the case.

Say contended that it is only by supplying goods and services to others that we may in turn demand goods and services from them. Exchange, therefore, takes place between people who supply one another.

But what happens to "demand"? Demands are simply supplies as seen from a different angle. That is, we can demand only if we can first supply; only as suppliers do we possess the power to become demanders. Therefore, *supplies are the source of demands.* The metaphor of two blades of a pair of scissors is sometimes used to explain the relationship between supply and demand. The idea is that both are equally necessary but in some sense are dissimilar. In fact, it is more accurate to refer to each blade as a "supply blade," which is to say that the blades are in essence similar.[8]

Until the 1930s, Say's Law was taken for granted by most educated people. In part, this consensus derived from social conditions. Consump-

tion was limited to far smaller numbers of people; few citizens had the means to save; since the educated middle classes were suspicious of state power and generally supportive of free markets and free trade, governments were restricted in their functions; and, finally, religion and ethics (not to mention necessity) riveted attention upon the creation of wealth rather than upon spending and consuming it. Say's Law, that basic building block of the classical economics of Adam Smith, David Hume, David Ricardo, and the two Mills, stood supreme. Such names as Malthus, Sismondi, Marx, and Hobson were for the most part hardly taken seriously by enlightened opinion. Indeed, Say was not so much widely debated as taken for granted.[9] A nation which failed to supply, it was widely believed, could hardly consume. Or, as the moral and religious outlook of an ascendant bourgeoisie would have understood it, one who did not work could hardly expect to eat.[10]

In previous chapters we considered in passing the role played by notions of demand and consumption within the context of certain ideologies. Specifically, we mentioned their importance for devotees of the "technological society" and for the followers of Keynes. Each approach is profoundly opposed to Say's Law; and in the case of Keynes, the opposition is vocal and pointed. Abba Lerner and Paul Sweezy, for example, went so far as to attribute the endurance of Keynes's work to its presumed intellectual destruction of Say. Unlike Say, Keynes certainly believed that insufficient demand for goods and services, inadequate investment opportunities, and persistent unemployment posed the enduring problem for modern economic systems. His solution was therefore for the state to engage in public works, shift the tax burden to higher income groups who were otherwise predisposed to "oversave," manipulate the interest rate through easy money, and in general expand the role of government in the economy. To this extent he displayed little fear of deficits, much less dissaving, but great faith in the ability of public servants to act for the general interest.[11]

Although hardly a political radical, Keynes was joined by Marxism in a common belief that high unemployment was an integral part of modern capitalism. Both Marxism and Keynesianism were highly contemptuous of Say's alleged naiveté regarding employment levels. And, it must be admitted, modern economic conditions sometimes lent commonsense support to those demand-side advocates who stressed oversaving, "excess" production, and underconsumption. Thus, in its trough phase the business cycle of the nineteenth and early twentieth centuries gave the impres-

sion of insufficient demand, since workers would often lose their jobs even as prices dropped sharply. Similarly, the inability of the masses to buy overstocked goods lent credence to notions of insufficient demand and underconsumption. Marxists observing these social and economic conditions found the causes of crisis in the dynamics of capitalism itself. As capitalism matured into its monopoly phase, they argued, the resulting concentration of wealth and income in fewer and fewer hands led to the growing pauperization of the masses. Simultaneously, however, the productive powers of capitalism became ever more formidable, so the ability on the part of the population to purchase the goods produced by the capitalist machine steadily declined. In this Marxist version it was a case of overproduction at the top, underconsumption at the bottom; therefore, capitalism must inevitably dig its own grave. In the hands of J. A. Hobson and V. I. Lenin, the "underconsumption" theme had both a political and an intellectual impact as an explanation for economic crises in general and for British imperialism in particular.

On the whole, if Say's views have been misinterpreted, if not distorted, by his opponents, it is the Keynesians who share no small portion of the blame, for, unlike the Marxists, they appeal to a much wider spectrum of moderate and democratic opinion.[12] They ridicule Say's Law by attributing to it a simple faith in full employment. In their opinion, unemployment may well occur when economies are in "equilibrium." Consequently, public intervention is an important ingredient in the restoration of full employment.

Say did not deny that a *partial* unemployment was a distinct possibility in the short run. What he did deny, however, was the possibility of *general* unemployment over the long run. In the long run it is the institutional and economic barriers that thwart supply which create unemployment in the real world. Let us take an example provided by Say in this running dispute with Thomas Malthus, namely, the case of woolen merchants in England during the eighteenth century. The merchants assuredly wished to sell their goods in the south of Italy, but found it difficult to do so. Why? Although they surely wished to "supply" (to sell to) the Italians, the latter were unable to supply the English in return. Whereas her inhabitants obviously needed the woolen goods, Italy was unfortunately a poor country, her resources meager; hence, from her side she lacked the means to supply the English. The effect upon the English woolen industry, therefore, was a loss of potential sales, profits, and employment. In other words, one may be quite willing to supply another individual, but if the other person can-

not in turn supply, it is impossible to make an exchange (other than as a gift or by force). This fundamental truth lies at the heart of Say's Law of Markets.

How do the opponents of Say respond to this argument? In brief, they usually assert that the problem is one of a lack of "effective" demand. Stimulate demand by increasing purchasing power, they conclude, and the woolen goods would have cleared the market. Consequently, a fall in profits, sales, and employment required the stimulation of demand and consumption in Italy.

Say, however, would claim that the stress upon demand is radically misplaced. It is true that British woolen merchants or anyone else may overshoot the market; that is, they may well produce at any specific time an excessive number of goods, hardly an unusual occurrence in a world where information among individuals and firms is highly imperfect. Unemployment in this or that industry may derive from an excess of production of goods and services. However, one may also be sure that somewhere else in the economy an inadequate utilization of land, labor, or capital exists. It follows, therefore, that a general overproduction of all goods and services is impossible. Indeed, governments can do little in the way of demand stimulation to restore production and employment in the long run, for if they divert resources to the woolen industry, they by definition reduce resources available to other parts of the economy.

There is another, if not more profound implication for public policy implied by Say's Law. It is the proposition that supply is the driving force behind "demand."[13] A reduction in demand implies nothing less than the *withholding* of supply, but, because one observes unemployed people, machines, and reduced sales, the fact of withholding superficially resembles the withering of demand. It is the appearance of slack demand for output which then leads to the incorrect inference that insufficient demand rather than insufficient supply is the cause for unemployed resources. For example, if the output of Widget's Inc. is unable to clear the market, the company as a result must reduce its purchase of capital equipment, labor services, and inventories. Consequently, potential customers themselves have insufficient supply (specifically, money) to buy widgets and other products or services—the means by which they originally derived their own ability to supply goods and services to still others; or, because there exist inferior merchandise, overpricing, or relatively greater demand for other products, widget product sales are too "low." Withheld output (supply) of widgets therefore reduces Widget's own ability to demand inputs

of services in such forms as equipment, workers, and capital. To put it another way, product manufacturers, laborers, and salespeople cannot supply Widget because Widget finds its own ability to supply reduced.

In addition to market rigidities produced by faulty knowledge and ignorance, public policy and the legal system play a crucial role in the withholding or release of supply. For instance, tariffs and import quotas withhold supply between nations; agricultural quotas withhold supply of farm produce; by raising the costs of production many government regulations inadvertently encourage withholding of supply; and business monopolies withhold supply by reducing production but simultaneously raising prices. When sales slacken, such restrictions of supply become especially injurious to the public.

Similarly, labor unions withhold supply of labor through the use of the picket line and the closed or union shop. The consequences are to raise wages of protected workers but to throw others into nonprotected sectors, thus reducing the wages of workers in nonunionized areas.[14] Or, unions may prevent the adjustment of labor costs downward in the face of lower sales. This resulting rigidity of wages leads to more layoffs than would otherwise take place in bad times, whereas in better times it encourages less than optimal employment of all workers. After all, workers, as well as employers, who cannot supply others cannot demand in their own turn from still others. Accordingly, they can purchase fewer automobiles, washing machines, shirts and suits, and television sets; and the sellers of these goods find their own positions as suppliers precarious. In other words, what we observe is a process of withholding which spreads like ripples on a pond throughout an economy and social order, restricting at increasing rates the ability of people to supply one another.

Fortunately, Say's Law enables us to resolve a difficulty which appears paradoxical at first sight. Thus, to follow Say, supply may be defined as the "creation of value," whereas consumption, its opposite, may be defined as the "extermination of value."[15] Consequently, *consumption implied an extermination of the power to demand*: One can demand only if one can likewise supply; but one can supply only to the extent that one has not previously consumed. As a result, that which may appear in "bad times" as the lack of "effective" demand is on close inspection merely an inadequacy of supply. Needless to say, the policy implications of this insight are enormous. They require that we do nothing less than reflect not only upon the relative economic effects of "supply" and "demand" (and consumption), but that we also consider their consequences for the larger society.

In this regard Say's Law has often been the subject of economic discourse, but hardly ever is it considered by political scientists and sociologists. Indeed, if, as we have suggested, the Law is so difficult to grasp, how can such esoterica arise in the course of political and social controversy? Yet, despite appearances, the Law is very much a part of present-day policy debate. On one side are Say and his classical descendents; on the other, Keynes and his followers. Not surprisingly, the dispute in the course of political battle has been vulgarized by the various combatants and intellectuals. Commentators sometimes refer to the dispute as one between "trickle-down" and "trickle-up" theories of political economy. On the trickle-down side are "conservatives" and "supply-side" supporters of "Reaganomics"; on the trickle-up side "liberals" and social democrats of various hues. The former support policies which stress supply: slashes in taxes on interest, dividends, and inheritance as well as reductions in corporate levies. In general, they oppose programs which transfer income and property allocated by the market to government agencies and the "nonproductive" citizens. They are therefore unwilling to "punish" the "rich," since they believe that higher incomes play a crucial role in capital accumulation.

The trickle-up believers, on the other hand, deprecate the effects of supply-side policies and lay stress instead upon "demand" and consumption. They tend to view tax reductions for business and higher income groups as giveaways to "special interests" at the expense of the poor. They picture the descendants of Say as compassionless theoreticians of a defective political economy. Conversely, progressive taxes upon business and the upper classes are lauded as good social policy, since they presumably transfer money to the less privileged. But this policy is likewise good economics: "Demand," after all, "creates its own supply," so demand must not be allowed to falter. If demand happens to slacken, then unemployment will surely emerge in the near future. From this perspective suppliers generally tend to overproduce and demanders to underconsume. Since the rich tend to "oversave," even hoard, rather than to consume and demand, an appropriate social policy stimulates the demand side. Hence, taxes upon "hoarders," the creation of public service work for the unemployed, increased welfare and social insurance benefits, and transfer payments for lower income groups are viewed not only as compassionate acts but as necessary stimulants of economic activity. Trickle-up economics is not only good economics but good social policy as well.

Of course, as political strategists, trickle-up supporters are prone to appeal to the politics of class envy. They ceaselessly condemn tax "loopholes" and "welfare for the rich." In general, demand-side theories, whether

Keynesian or Marxist, tend to assume that the economic pie is fixed in size; hence, the remaining question is how best to cut it. The more moderate demand-siders obviously do not want social strife to stray beyond the bounds of civil discourse, but most probably believe with Keynes that their programs, while somewhat class-oriented, nonetheless ward off the more unfortunate aspects of class warfare and so protect the democratic polity. Like those political scientists who look to the benefits of party conflict, the demand-side political economists are unopposed to economic conflict among groups so long as the struggle does not get out of hand.

Say's Law, in contrast, abounds with optimism. It has no use for the metaphor of the fixed pie but rather argues that supply may be expanded infinitely. If people shed the shopworn ideologies wedded to conflict and redistribution, if they orient their actions more to supply and less to short-run consumption, and if they resist temptations to employ the state as a means for withholding supply, there is no reason to suppose most economic problems cannot be solved. In this respect, the recent supply-side theorists are true heirs of Say.[16] They, too, hold fast to the idea that by unleasing the forces of supply in the form of reduced rates, by the elimination of tariffs and quotas, and by the abolishment of government regulations which inhibit supply, a natural harmony is created between groups and classes within society. Like Say, they also underline the role of individual incentives as opposed to government direction in economic life.

Class conflict therefore has no place in policy debate conducted within the context of Sayist principles, since it is self-defeating in terms of the ends it seeks, namely, material abundance. Its results can only prove disappointing for those radicals and moderates who speak in the name of the masses. Actually, only individuals, or groups of individuals, in their varied efforts to supply one another have the necessary means over the long run to expand output for the welfare of the masses. This is one reason why revolutions seldom, if ever, bear fruit for the masses and why hopes, not to say heads, are so often dashed. Revolutions fracture the natural harmony of exchange relationships by placing government between people who wish to supply and be supplied. Class revolution may indeed work for the benefit of political elites, but it invariably results in a lowering of living standards for the people as a whole.

Say's Law not only rejects class conflict, but, in addition, reposes a special trust in the individual. This stance is implied in the supply function itself. When we seek to supply others, we are confined mostly to the realm of hopes and anticipations. In the absence of state intervention on our be-

half, we have no guarantees that our particular supply will in fact be acceptable to others in the form of actual prices paid on the market. Knowledge of the future and the ability to supply at a profit are seldom available in a world of changing expectations, tastes, and technology. We supply in order to demand and consume, but we cannot rest assured that our supply will find ready acceptance. Such personal insecurities, which are often enough an expression of reality, are all too easily projected upon public institutions, as Harold Lasswell pointed out long ago.[17] State intervention undoubtedly protects certain incomes from market-created insecurities at the expense of still other incomes, although the diversion of resources may go unnoticed if the cost is spread widely among the citizenry as a whole. For instance, farmers, secure in the knowledge that their produce will be purchased by a government agency at a guaranteed price above the market price, are in truth not so much suppliers as expropriators of the incomes of their fellow citizens. They thus escape the social obligation to supply.

The free market, anti-interventionist bias of Say is well known to historians of economic thought. As a result, the sociocultural attacks upon Say's Law, more implicit than explicit in focus, have been neglected in debates over economic theory. In fact, Say's Law and the Bourgeois Ethic are symmetrical. It is not merely that Say's Law is an admirable defense of the vitality of unhampered markets. In addition, the ongoing debate between the Law's classical defenders and their Keynesian opponents crucially depends upon the moral weight one attaches to supplying and saving as opposed to demanding and consuming. Thus the struggle is over values, norms, and life-styles as well as about high theory.

Say's great contemporary antagonists, especially Sismondi and Malthus, were too much the children of their age to mount a full-scale attack upon the Bourgeois Ethic. By criticizing Say for failing to see that the accumulation of capital goods may be so large that the resulting glut will fail to clear the market, they merely chipped away at the edges of the moral underpinnings of his theory. Since they feared overproduction, they concluded that a loosening of the saving bias and a reduction of the moral importance attached to thrift were necessary for the general welfare. They believed, consequently, that demand would be outpaced by a mounting accumulation of capital goods. Subsequently, Marx also stressed overproduction, but unlike Say's contemporaries, he had nothing but contempt for the Bourgeois Ethic. His attack was thus sociocultural in intention no less than economic in its thrust. But it was the "crank" J. A. Hobson who made the primacy of consumption central to his theory. Thus, the road

from a fear of inadequate supply, to oversupply, and, finally, to under-
consumption was less than a century in the making, but at the intellectual
level it symbolized a major decline in bourgeois power. Sismondi, Malthus,
Marx, and Hobson may have wounded Say, but it was John Maynard
Keynes who would almost finish him off.

Keynes wrapped his economic thought in a single antibourgeois pack-
age, doffing his hat to the overproduction theories, smiling tolerantly upon
the underconsumption "cranks" (as he called them), and adding a dash
of oversaving and underinvestment to his own anti-Say recipe. He began
his famous *General Theory of Employment, Interest and Money* with an
attack upon the "classical" Say and ended with a salute to interventionist
policies based upon consumption and demand.[18] He mercilessly ridiculed
thrift and perceived saving as fundamentally antisocial in its consequences.
He praised expenditure upon luxury items and thought meritorious the
efforts of mercantilism to limit the rise in interest rates through arbitrary
"custom" and outright usury laws. It was not that overproduction and
underconsumption theories as explanations for unemployment were merely
incorrect; it was that they failed to account satisfactorily for society's ex-
cessive tendency to save. The effects of oversaving, in his opinion, were
to limit the inducement to invest, so a fall in effective demand and con-
sumption threatened employment and productivity. In the end he had only
contempt for the "moralists and economists who felt much more virtuous
in possession of their austere doctrine that no sound remedy was discov-
ered except in the utmost of thrift and economy by the individual and by
the state." His was an astounding combination of cynicism and icono-
clasm in league with an implicit advocacy of inflation as a way of life.

But was Keynes correct? We think not. Let us repeat the essence of Say's
Law by recalling that supplies *are* demands looked at from a different per-
spective. One offers supplies in order to gain other supplies, or, to put it
differently, to be able to make demands upon others. To supply therefore
provides for us the source of our power to demand. Further, let us remem-
ber that "production" creates value, but that "consumption" exterminates
it. These definitions, hardly a subject of controversy in themselves, none-
theless have important implications for our argument: *If consumption is
the extermination of value, it is in the last analysis also the extermination
of the power to demand.* In short, any decision to consume limits by just
that much at that moment the power to demand! Why? Because by ex-
terminating value we to that extent limit our power to demand (or to be
supplied, if one prefers).

We conclude, therefore, that proconsumption policies based upon Keynesian "effective" demand are bound to be self-defeating in the long run, since any weakening of the power to demand is nothing more or less than a forced reduction in the level of *future* consumption. It is to rationalize present gratification and selfishness at the expense of the future. It is a society where the destabilizing forces of political and social disorder coexist with an obsession with the self and its liberation. It is for this reason that the most intense forms of politicization are found beside the most extreme forms of political apathy. In terms of its policy implications, it is an open invitation to group or class warfare. After all, a society whose elites rail against the Bourgeois Ethic is surely one doomed to low productivity and high unemployment—to social conflict.

Proconsumption policies give vent to desires conducive to the short run by weakening those moral restraints which encourage individual responsibility, devotion to duty, and productivity. Indeed, given the natural wish for the "right" to consume instead of the "duty" to produce, it is hardly surprising that our present obsession with "equality" and our hostility toward the authority of major institutions and elites is joined to Promissory Politics. The desires for immediate gratification are always likely to be strong in democracies, and the party regimes willingly reinforce these pressures. It is ironic indeed that many intellectuals who criticize self-interested economic behavior with such intensity are often the same individuals who support policies based upon proconsumption, demand-side policies and who lament remaining pockets of the Bourgeois Ethic in our culture.

Although Say's Law cannot necessarily reconcile the warring elements of production and consumption within each individual, an understanding of its imperatives can make the tension more manageable in a way Keynesianism and its offshoots can never hope to do. By enhancing the probabilities of material welfare, it reduces social tensions, and by stressing production and the values and norms associated with productive activities—e.g., thrift and frugality, lack of ostentation, hard work, and individual responsibility—a philosophy based upon the insights of Say's Law may stimulate attitudes which look more to the future and less to the present.[19]

A mere change in the structures of incentives and values, however, is probably insufficient to bridge the chasm between our consumer and producer roles. In addition, socioeconomic norms and values must reckon with the pressures of political life; indeed, the supply side cannot stand by itself for very long against a demand side working through Political

Man. As we have seen, the essence of democratic politics is unfortunately demand-oriented to the short-run. Consequently, if they are to achieve an influence which persists through time, supply-side interests must work their way into the heart of the political system. They must affect policy and legal norms and values.

We shall therefore argue in the following pages that *fixed* rules are conducive to this end. Rules place limits upon our desires; they refuse to indulge our every wish and encourage us to lean upon our own resources; and in our political lives they roughly set the permissible boundaries of political action. Just as government interventionism in the social services is the servant of policies based upon demand and consumption, so rules in policy and law are the servants of supply and production. The remainder of this chapter attempts to show why such is necessarily the case.

The Case for Rules in Public Policy

We hypothesize that unless policy cultures in modern states are sharply altered, the tendency exists for Political Man to encroach increasingly upon the nonpolitical domains in society. But what sort of policy culture is most congruent with vital nonpolitical areas and with lowered time preferences? In other words, which type provides the necessary framework conducive to values of responsibility, independence, thrift, and productivity instead of those values and institutions linked with Promissory Politics and pressures for instant gratification? In general it must be a policy culture based broadly upon fixed, static rules rather than upon "commands" or "discretion." This does not mean that policy can be guided in every instance by rules rather than discretionary elements. Such an attempt would be self-defeating, indeed unrealistic, and impossible to achieve in practice.

Actually, every political order is composed of complex *mixtures* of rules and discretion.[20] A police officer on the beat or a social worker, for example, utilizes a combination of rules and discretion. In general, fixed rules are far more essential to the workings of systems based upon private property and free markets, whereas commands are more pervasive in socialist and interventionist orders. Thus, in the modern democratic welfare state based upon a strong drive for social regulation and property transfers according to widespread norms of "social justice," administrative rule-making and legislative statutes increasingly crowd out common law decision-making.[21]

The Distinction between Rules and Commands[22]

Although in practice they often overlap, rules and commands, analytically speaking, reside at opposite ends of a continuum, differing profoundly in scope and function. Commands are more limited in extent, bound to particular time and place. Moreover, they demand the performance of specific tasks and pursue specific purposes. Thus, they are addressed to assignable agents; they are applied to specific actions to be performed on particular occasions; and they require the performance of a substantive action. Commands, in sum, are aimed at the carrying out of concrete tasks and are addressed to *known* persons who are required to perform substantive acts.

Rules could hardly be more different in function and purpose. To understand their essential attributes, it is helpful to think in terms of a game of football or tennis. Such rules do not in themselves award a substantive satisfaction or impose a specific detriment; rather, they achieve legitimacy because of their authenticity. Individuals engage in self-chosen actions, often seeking diverse and incompatible ends, but always accept the rules themselves as authentic in terms of the procedures they prescribe. As Oakeshott has observed, they involve what may be designated a "moral practice," a way of behaving which is difficult to express verbally but which is nonetheless readily understood by participants. The obligations that rules impose are therefore not a consequence of utility or expected results so much as of accepted belief. Finally, since rules assume that actions are self-chosen, they do not demand specific kinds of performance; rather, they merely stipulate the "adverbial conditions" or procedural requirements by which individuals are otherwise left free to carry out their purposes.

Whereas commands and discretionary authority in the form of administrative law and legislative statutes compose the bulk of "law" in modern states, the rule of law ideally poses an enduring resistance to power exercised by governments. For our purposes the rule of law may be defined as a mode of moral association in which laws are known in advance, are noninstrumental, and impose obligations to subscribe to "adverbial conditions" in the performance of personal acts.[23]

This definition of the rule of law is simply an extension of the previous definition of rules in general. Nor is it a particular law itself, but instead a description of the attributes a good law ought to possess. Thus, when we speak of "equality" before the law we have in mind a type of justice

blindly applied and irrespective of race, color, religion, or material condition. Or, when we speak of "certainty" we mean not so much a clearly worded and unambiguous legislative statute, as it has come to mean nowadays, but an obligation to follow known rules which have been in existence for a long time.[24] And when we assert that the rule of law must possess a "general" applicability, we imply not only the principle of equality but also that it must not treat people differently according to the presumed demands of distributive justice, class, or status; rather, the rule of law assumes that each of us adheres to procedures embodied in the rules themselves. Its generality is confirmed by its conformity with "means" and "procedures," not to "ends" and "content."

Since they seek to achieve specific purposes and are based upon command elements, the countless "laws" enacted by legislatures are, for the most part, clear violations of the principle of the rule of law. Not surprisingly, it is in the private and judge-made law of torts, contracts, and property, that the rule of law has traditionally resided, not in the hurly-burly world of interest group politics, party programs, and statutory and administrative decisions.

Rules governing commerce and exchange have usually emerged gradually as individual participants find ways to establish stable and governing relationships among themselves. Thus, rules seem to arise spontaneously as participants in commercial relations, often unknown to one another, strive for a degree of certainty and order as the scope of their varied transactions broadens and as market situations become more uncertain. The attempt to stabilize reciprocal relationships with rules in an uncertain world is a process which has often occurred less as a result of specific state intervention than as a ratification after the fact by the state of customary forms previously routinized.

For example, the Law Merchant of medieval Europe arose initially because rules were needed to regularize commercial relations among peoples of diverse language and customs. It is significant that the Law Merchant was originally administered by the merchants themselves rather than by trained jurists. It is also significant that the Law Merchant was eventually integrated into the Common Law of the English realm. If not actually prior to legislative "law," much of this private law clearly antedates the rise of democracy and parliamentary sovereignty.[25] Yet when we moderns think of "law," it is to commands enacted by legislatures that we mainly attribute the status of real law.

It is understandable that social reformers are lukewarm at best to the

rule of law as the term was traditionally understood. The rule of law belongs to the private affairs of individuals, to the procedural means or protective devices they utilize as they carry out their otherwise self-chosen ends. It resists the will of those who would bend the law to the achievement of concrete social ends of "social reform." Indeed, it offers scant incentive for political actions. Statutes, hotly debated and widely publicized, bring forth immediate payoffs (or losses) to various political factions and their clients, whereas the beneficiaries of rules are mostly unaware of the benefits they themselves derive from a rule-oriented social order. Rules consequently conspire against those who would place their hopes for reform upon legislators and administrative officials.

It is undeniable that the modern ideological shift in favor of discretionary authority fits well with our changed temporal vision. Generality, certainty, formality, and equality as found in the rule of law tend to thrust individuals back upon their own powers, and they thus find it difficult to seize the resources of others through the employment of state coercion. General rules, after all, give little substance to most of us, but are merely features of the social landscape in which individuals carry out their own plans. Where stable rules exist, expectations are not unduly inflated within the public, and anticipations of the rapid alleviation of social problems are more readily managed. Thus, the role of law functions to foster waiting time and, accordingly, raises a barrier to the claims of political parties and interest groups standing to benefit from the politics of redistribution.

Of course, the supporters of discretionary rules are usually loath to admit the rule that ideology plays in their arguments. If they do admit its relevance, they nonetheless consider ideology the servant of more fundamental forces in history. According to Guido Calabresi, the "golden age" of the common law was undermined by "statutorification"—by the modern proliferation of legislative and administrative "rules." A basic cause for this change was the steady growth in demands made upon the state for relief and protection from the traumas of modern industrial life. As democratic rights were extended and as people came to expect more from their governments, citizens were no longer willing to accept their fate. Moreover, there was the growth of technical legislation, of which tax law is a particularly appropriate example, whose numerous regulations and procedures proved extremely difficult to integrate into the body of common law rule-making. Similarly, the common law was not readily adapted to the pressures of rapid technological change; hence, legislatures were increasingly pressured to intervene and to adjust the law to modern social

conditions. In the process, however, they delegated responsibilities to administrative agencies presumably better prepared to adjust to ever-changing circumstances. Finally, the demands for preferential treatment by major interest groups altered the role of law in society. Unlike common law judges, legislative bodies are uniquely equipped to facilitate the bargaining process and reconcile group differences. Thus, labor law, for instance, was created not so much by the courts as by legislatures in whose halls the outcomes were a result of the group struggle.[26]

Therefore, it is argued, we must tidy up the statutory mess by reconciling the common law with the "age of statutes."[27] However, the former must give way to the latter. History, new ideas of "rights," and the development of the welfare state are in essence incompatible with the old-fashioned ideal of the rule of law. On the other hand, many scholars view the death of the rule of law with indifference, if not pleasure. In this respect, Calabresi, for example, apparently has few qualms about discretionary authority:

> There is nothing wrong with inconsistent, unprincipled, or preferential treatment—within the bounds of constitutional requirements. Most lawmaking involves just such preferences, and these must be respected as long as they represent the wishes of current majorities or coalitions of minorities or even past compromises among groups that retain current majoritarian support. It is for this reason that government by directly majoritarian bodies, or by representative bodies, or by representative bodies unhampered by checks and balances does not present pressing problems of obsolescence. Such bodies "know" the distinctions that are currently desired.[28]

If we are to believe modern jurisprudential scholarship, it is apparently somewhat naive to suppose that men and women may be guided within the social order by fixed rules rather than by legislative coercion and administrative commands. But must we resign ourselves to ever more discretion in the laws ordering our existence? There is one argument which lends itself to some degree of optimism in this regard. It is that a strong ideological component underlies the arguments of those who advocate discretionary authority. On the other hand, ideologies can be changed. Whereas discretionary authority is undoubtedly unavoidable in vast areas of human existence, it may nevertheless be rolled back in many domains.

There is no doubt that economic interventionism requires a judicial system ideologically amenable to discretionary authority. There is also not much doubt that fixed rules are necessary in a society based mostly upon free markets and private property. Many serious critics believe that the judicial system is itself an important link in the growth of interventionism

in society. As some recent scholarship suggests, support for economic in-
terventionism among judges and politicians has far less to do with the
complexities of modern life than with plain old-fashioned ideological
preferences. If this is true, one may question seriously the proposition that
the present system was somehow inevitable.[29]

Social democrats and liberals, in the first place, often assume that the
imperatives of a complex society require a law sufficiently "flexible" and
"pragmatic" to meet the accelerating pace of modern change. "Static" com-
mon law rules are regarded as an inadequate response to new needs. But,
as Richard Epstein has argued, common law rules were progressively un-
dermined in the course of this century less because of their presumed in-
ability to adapt to the needs of modern industry and technology than be-
cause of ideological shifts in the judicial temperament. To take examples
in the law of property, contracts, and torts from two quite different peri-
ods, that of nineteenth-century England and Classical Rome, it may be
observed that judges in each era were required to decide upon quite similar
kinds of problems. Whether a merchant makes a contract involving malt
and tobacco or one including sophisticated multinational transactions,
whether one commits fraud with a sword or a telephone, or whether one
trespasses with hay or electronic gadgetry, what is at stake for participants
in each age are questions regarding the substantive principles of common
law. Despite differences across centuries, the basic intellectual problems
regarding justice are remarkably similar.[30]

Consequently, in many instances the violence done to traditional norms
of law by ideology may be seen for what they are, and no amount of talk
about "creative decision-making" or modern complexity can hide that
fact. One thinks in this respect of certain cases involving landlord-tenant
obligations where ideological predispositions of judges are clearly dressed
in the modern language of "social justice." But let us not rest our doubts re-
garding modern trends in judicial decision-making upon the easier cases.
To the sceptic the argument that an ideological bias exists which is wed-
ded to discretionary rules in the service of the "social justice" may claim
with some persuasion that the deck has been stacked. After all, contrac-
tual rights of tenants and landlords may well be expected to undergo rela-
tively less technological change in the course of centuries than would
change in other areas of the law. As a consequence we merely present a
straw man, a rather restricted example less affected by modernity than
other parts of the law of contracts. But, we may ask, is not the case of
a giant manufacturer of sophisticated machinery and the consumer who

bought the particular manufactured product from a retailer a different matter altogether? Thus, in the traditional law of contracts only those who were directly party to a contract (in "privity") could sue for breach of a contract. But in the modern era, when manufacturers and the consumers who buy their products are remote from one another—that is, when retailers, not manufacturers, are ultimate sellers of goods which they themselves did not produce—is the law of contract not in need of radical amendment? Is it not clear that manufacturers and consumers can no longer stand in privity to one another? And if this is so, how can manufacturers and consumers possibly be connected in terms of a contractual relationship? Not surprisingly, the traditional law of contracts has been amended. For example, manufacturers of defective steering mechanisms on automobiles are now held liable even though they themselves are not direct parties to the sales. In this sharp break with precedent the courts said that there exists an "implied warranty" between remote manufacturer and distant consumer. Such cases have fundamentally altered the nature of contractual rights and duties.[31]

We must remember that buyers of manufactured goods who in turn sold to consumers were hardly unusual in the last century. Yet the courts then felt constrained to defend the privity doctrine. For example, as in the case of *Huset v. J. I. Case Threshing Machine Co.* (1903), the privity doctrine was supported to the effect that there "must be a fixed and definite limitation to the liability of the manufacturers and vendors for negligence in the construction and sale of complicated machines and structures which are operated or used by the intelligent and the ignorant, the skillful and the incompetent, the watchful and the careless, parties that cannot be known to the manufacturers or vendors, and who use the articles all over the country."[32] As Epstein pointedly remarks, if some tools and machines in our age are far more complex and are also far safer to operate, and if some machines are more complex in design and engineering, they are likewise more easily manipulated. Thus, the abrogation of older contractual relationships as we move from strict rules to more diffuse "standards" apparently is more dependent upon the ideas of social philosophy than upon technology.[33] "In particular," notes Epstein, "the greater technology and complexity of modern life cannot account for the abandonment of traditional legal rules."[34]

We have no wish to belabor these points of law, but only to suggest that the dismissal of common law rules as outdated relics is misplaced.

In reality, it appears that common law was undermined less because of any inherent defects than because it stood in the path of politicized legal relationships. A system which functioned to prevent the politicization of so much of social life gave way in the face of ideological onslaught to statutorification and administration. Of course, its abandonment in the law of contracts, property, and torts was often justified in the name of technological necessity, social justice, democracy, or some other political ideology, but the effects of its decline were at the expense of the economic freedom of the individual.

Therefore, the decline in support for abstract rules, of which the common law was so much a part, may have been due not so much to historical forces as to the rise of new ideologies. But this conclusion suggests that the hold of statist ideologies upon the public may also be more tenuous than is commonly thought, for ideas and ideologies may be altered by superior ideas and ideologies. However, one need not advocate judicial reform alone as the only method by which to restore the role of the rule of law in modern societies; indeed, we may carry reform deep into the camp of collective ideologies, that is, into public policy.

Two Types of Policy Culture

No doubt the idea that one may logically demonstrate a useful connection between rules and policy must appear strange to students of the rule of law. Outstanding scholars, including Hayek and Oakeshott, have made it abundantly clear that they consider the two concepts antithetical, since rules in their pure sense have nothing in common with ends and purposes, that is, with the essential attributes of public policy. Rules at common law, for instance, are generally opposed to the statutes of legislatures and the rulings of administrative agencies. Rules and policy are therefore at polar extremes, each the possessor of distinctive attributes.

Nevertheless, policies and, by extension, policy cultures may be composed of various elements of rules. If a policy of necessity discriminates among various individuals, groups, or classes, the discrimination may be radically minimized through the introduction of important rule elements into policy. In short, those who seek to restore the rule of law in the affairs of citizens may focus their attention not only upon legal system but upon policy culture as well. Since public policies in the past have generally un-

dermined the role of rules in law, perhaps the introduction of rule-based policies in nonlegal areas would eventually result in a rebirth of the rule of law as well.

What is meant by the term "policy culture"? Both noun and adjective require some elaboration. The concept of culture, though widespread, is exceedingly difficult to define.[35] We are not helped very much by knowing that it is all "of a people's shared customs, beliefs, values, and artifacts," as a sociology textbook defines it.[36] For our own purposes, we rely upon the work of Pitirim Sorokin, whose definition is so helpful because it grounds culture in the actual world of human behavior and so gives to it empirical referents.[37]

Sorokin argues that "meaning" (that is, a sign which stands for something else), is basic in determining whether or not any phenomenon is cultural. Without meaning, a great book, for instance, is a mere sheaf of papers and a religious totem is only a piece of wood. It is his contention that we must analyze culture in three ways: in its ideological (meanings, values, norms), behavioral, and material aspects. These attributes of culture, in turn, may be studied from the standpoint of the individual, the group, or the intergroup. Similarly, the ideological, behavioral, and material cultures of individuals and groups may be integrated, nonintegrated, or indeed quite contradictory to one another. From this perspective it is obvious that ideological, behavioral, and material integration are much more likely to occur at the individual than at the group or intergroup levels. Therefore, "culture" may be defined as the meanings, values, and norms of individuals and groups as these components are objictified in their actions and reactions and in their material vehicles.

Let us take an example. An individual may believe in the tenets of communism (his or her "ideological culture"); this person may or may not, however, behave as a communist; and that behavior may or may not be externalized through material vehicles such as parties, organizations, posters, pamphlets, and the like. It is therefore the degree of integration in our ideological, behavioral, and material cultures which determines how strongly rooted a particular cultural phenomenon is. One may believe in the tenets of communism, but its rootedness and importance depend upon whether one actually behaves as a Communist and utilizes various materials by which to put one's belief into practice.

What about "policy"? It, too, is difficult to define precisely, although we can agree that it displays at least two attributes. First, it surely includes more than individual, discrete decision-making; indeed, any useful con-

ceptualization requires a grouping or merging of certain types of decisions.[38] Secondly, policy includes actions by government actors. Hence, for our purposes it may be defined as the purposive actions of government actors dealing with matters of concern.[39]

We are now in a position to define "policy culture." It may accordingly be thought of as the *meanings, values, and norms regarding the purposive actions of government as these mental phenomena are externalized in the overt behaviors and material vehicles of individuals and groups.* It follows that if cultures are so seldom highly integrated, then that slice of the general culture—the policy culture—will also be nonintegrated. Any society will likely be composed of various types of policy culture. Indeed, societies are characterized by diverse policy cultures because the assumptions and orientations of policy elites—the very way in which basic reality is viewed—tend to vary when they consider what course of government activity is proper and what the consequences of such activity are likely to entail. For more sophisticated citizens such considerations may relate to basic political philosophies; for the less sophisticated ones, they may not be *expressly* articulated, but they are usually there if we only look for them. Since so few citizens think much about policy questions, however, it is probably more fruitful to delve into elite rather than mass attitudes.[40]

Thus, the number of policy cultures is diverse because we have differing expectations regarding what government ought to do and what the effects of its actions are likely to occasion. Our basic assumptions with regard to any policy to be enacted by government typically revolve around four fundamental questions: (1) To whose end or benefit ought policy to be directed? (2) Which primary value, "liberty" or "equality," ought to be advanced more strongly? (3) Who ought to control the enactment of policies? That is, where ought the locus of power to be? and (4) What ought to be the nature of the controls? That is, what kinds of legal or other controls ("discretion" or "rules") make more sense? Since government is inherently a matter of coercion and control, the answers to each of these questions determine which of us ought to be indulged or deprived, and to what degree.

When we reflect upon the "purposive actions of government," therefore, we make assumptions about the proper beneficiaries of governmental activity, the outcomes we hope to advance, the locus of power, and the proper sorts of controls to be utilized. Although these assumptions—or conceptual frameworks—may be highly developed and logically consistent in the hands of the social scientist or philosopher, they are for most

of us rule-of-thumb, working assumptions by which we find it possible to organize a confusing and often contradictory world. Even among less well-trained people, however, the manner in which the four questions are answered tends to carry a certain logical consistency too seldom recognized. Let us therefore discuss each of these questions in some detail and the relationships which exist between them.

On the ends of policy. Most will readily agree that the proper end of public policy ought to be the welfare of the whole society. But at any given moment, we usually link the welfare of *specific* individuals or groups with the welfare of the great majority when we consider the proper beneficiaries of public policy. By advocating support for certain segments of society, we easily suppose that we are actually staking out a position which is best for the entire society. Nonetheless, a concern with policy paradoxically directs our intellects away from more generalized ends toward more specific ones. The result is that the beneficiaries of our concerns become means no less than ends! It may be observed in this regard that the proponent of the market economy who calls for an incentive tax for business is no less public-spirited than the socialist who demands a prompt redistribution of property for the masses.

Therefore, to support the "public welfare" requires that policy orientations be directed towards one of three units, each of which is generalized as a reasonable facsimile of the public good: individuals, groups, or masses. The communist or radical socialist calls for proposals to alleviate the condition of the proletariat; the moderate Labourite, Social Democrat, or "liberal" demands aid for particular groups perceived as receiving less than their fair share of the national pie; most "conservatives," at least on economic issues, perceive individual incentives as the prime motive for advancing the welfare of all. However, as all claim to speak for policies which benefit the whole society, each in fact concentrates attention upon the individual, group, or class while speaking simultaneously of the "welfare of all."

On the value to be enhanced. "Liberty" and "equality" are loaded terms, the subject of much debate but little enlightenment. Often the terms are even used interchangeably. In modern democracies, for example, no political party with any chance for attaining power can expressly repudiate either value. Equality, especially, is a value presumably inherent in the democratic experience to which totalitarians find it prudent to profess allegiance. Over time the two values have come to delineate different ideals of the good society. To the liberals of the nineteenth century equality

meant formal equality before the law, equal political rights for all citizens, and equal rights to dispose of one's property, whereas to the socialists of the following century it meant not only political and legal equality but a high degree of social and economic equality as well.

However, those who profess a firm belief in what is variously designated "liberty," "equality of opportunity," and "freedom," on the one hand, and those who express an absolute devotion to equality of result and to social and economic equality, on the other hand, are rarely found in the real world. It does not follow that in our primary allegiance to one of these basic values we thereby expect the other to disappear; indeed, the lesser value is generally expected to be enhanced as well. It is a question of emphasis. For example, in modern democracies many of the proponents of equality of opportunity and liberty assume that the free interplay of individuals in competitive markets will itself lead more or less to social and economic equality in the long run. As Aaron Wildavsky has observed in a most important work, political cultures which make different assumptions about equality may nevertheless not come into conflict because each mistakenly believes that the other has its notion of equality. This happened in early nineteenth-century America when a "sectarian" political culture—one suspicious of authority, hostile to class and status distinctions, and favorable to equality of condition—aligned itself with an "individualistic" or "market" political culture wedded to capitalistic competition and commercialism against a national "hierarchy" represented by the Federalists. Sectarians and individualists alike assumed that equality of opportunity would itself lead to a rough equality of condition. Political cultures may therefore be joined at certain historical junctures only to become bitter antagonists in other eras.[41]

On the question of controls. Government is inherently a question of coercion and control, so when we consider the policy alternatives available and their consequences we tend to regard with approval or suspicion a particular locus of power—local or national. Laissez-faireists will reject the proposition that the national government is especially important anyway, relying instead upon a belief that the less government, the better. Conversely, radical Marxists, if their supporters are in power, will believe that the best place to gain their ends is in the centralized state machine. From their perspective the machinery itself is dominated by a particular class, so it is right that the majority class control this instrument of coercion. Between the laissez-faire position which would keep government at a minimum and a collectivist one which would allow coercive national controls

are situated various socialists, liberals, and social democrats who fear the unlimited state, who wish to circumscribe government power through law, but who nevertheless are highly disposed to the use of state power for promoting moderate social welfare goals.

On the nature of controls. Just as we differ from one another in terms of the value and meaning we attach to the proper locus of governmental power, we also disagree according to the manner by which we wish the controls to be exercised. What we have here is a question of the proper legal controls. Some of us undoubtedly wish to keep law clearly defined and far removed from human intervention. Good law removes most human activities from government supervision and hence from discretionary authority. This, of course, is the rule of law ideal we considered above. Exclamations in America not only about the "rule of law," but calls for a "republic of laws, not men," and the repeated denunciations of administrative tyranny excite the emotions of such people. In their view, government, not poverty, illiteracy, or any other social condition is the prime threat to the good life.

This dislike of big government in general and government arbitrariness in particular is often carried over into questions of social welfare and political economy. In general, those who worry much about the need for strict rules also value the free market for the obvious reason that economic bargaining presumably takes place outside the domain of government. In this sense they lay stress upon the importance of various impersonal mechanisms as the best method to reduce the possibility of improper intervention by politicians and civil servants alike.

The effort to subordinate political, administrative, and economic activity to rules is, of course, hardly an acceptable position among most current Western leaders and intellectuals. On the other hand, those who would subordinate legal and quasi-legal rules to such abstractions as the nation-state, the "people," or a class are even less prominent. In between are the great majority of elites, namely, those who would prefer clear-cut rules if possible but who also in a contradictory manner desire to make them adaptable to changing conditions. From their perspective, law must be adjusted to the needs of changing society; it must be the servant of social justice. Since "social justice" is more easily enhanced through government intervention, they have little objection to "positive" government, to administrative and legal discretion.

The four basic assumptions not only guide our policy preferences along rather clearly defined lines, but also bear close relationship to each other

in logical and meaningful ways. We may express this idea in terms of two major types of policy culture presently dominant in Western democracies.[42] One we shall call "ameliorative," the other "individualistic." The former grows out of the asumptions, ideals, needs, and interests of social democratic philosophies, whereas the latter owes its major inspiration to eighteenth- and nineteenth-century liberal ideals of individualism. Neither, it must be emphasized, is a "pure" type, but in fact represents a central tendency, since few organizations, much less total societies, are perfect examples of either type of policy culture. Each type overlaps various organizations; indeed, particular organizations are seldom entirely integrated at the ideological level. Nevertheless, some kinds of organizational structures are much more integrated than others. Due to similarity in mission, in backgrounds of members, in training, and in ideology as well as in organizational cohesion, a central banking system is likely to be far more coherent ideologically than, for example, a welfare system.

There is little doubt that ameliorist values are dominant today in most major government agencies, in the media, and among intellectuals. In recent years, however, ameliorism has come under increasing attack from individualistic sources. And unless a dramatic shift occurs in the economic fortunes of those nations where individualistic policy cultures have supplanted ameliorist ones in the hot seats of the "bully pulpits" of presidential and prime ministerial leadership, there is good reason to expect individualistic impulses to increase in influence. Indeed, Reaganism and Thatcherism, no doubt aided by the dramatic failures of interventionism in Mitterrand's France, are obvious manifestations of this new mood. The election of politicians who because of their policy preferences were thought by sophisticated opinion only a few years ago to be incapable of winning national elections testifies to major shifts in intellectual and political climates. Let us also not forget the intense interest in such theories as supply-side economics, monetarism, Austrianism, and all the various shades of "neoconservatism." All display a common outlook in one crucial respect: a desire to enhance the role of the individual in his or her economic and social life at the expense of government and state.

The Policy Culture of Ameliorism

In this type of policy culture, individuals are strongly disposed to the amelioration of the conditions of *specific* groups in the population, such as migrant workers, the poverty-stricken, the aged, and ethnic minorities.

Ameliorists are easily the most numerous, influential, and active among key policy-makers in Western societies. They are commonly found among intellectuals on university campuses and elsewhere, among civil servants, and among "liberal" and "social democratic" politicians. Even old-fashioned Tories, who refuse to imitate the more democratic and "open" style of governing characteristic of their opponents, are nonetheless often forced to adopt ameliorative policies if they wish to rule.[44]

On the other hand, proponents of ameliorism are unwilling to utilize fully the coercive powers of the state to accomplish their ends. Ameliorism is hardly extremism in its aims; indeed, it is strongly supportive of the democratic ideal, pragmatic and reformist in intent, and geared to moderate change. Typical ameliorists therefore display a profound attachment for equality as a principle, but rather than applying it broadly to "classes" or "masses," as collectivists of the left or right are wont to do, they look approvingly upon specific groups in the population. In this way the attainment of equality can rest more easily upon short-run, pragmatic, and somewhat limited ends in policy. Their beliefs in the possibilities of moderate reform carried out by government and the fact that their aims are directed toward specific groups thus lend to ameliorism a *short-run outlook* with regard to policy—not surprising given the faith in government's ability to increase equality.

In general an ameliorative policy culture wishes to *level upward,* whereas radicals seek to *level downward.* The distinction is an important one, for it places policy limitations upon the statist propensities of ameliorism. The ameliorist concentrates upon selected groups, whereas more radical reformers hope to dethrone governing elites and place in authority the presumed representatives of the "masses" or "classes." Even when as the latter, like ameliorists, champion specific interests, their arguments are usually couched in terms of class-related criteria. Ethnic minorities, for instance, are said to be a part of the general masses or proletariat, not a specifically deprived group in an otherwise affluent society. Thus, an ameliorative policy culture is directed more toward the *specifically downtrodden* (e.g., blacks, farm workers, the unemployed), less toward the *downtrodden in general.*[44]

This basic policy preference for the specifically downtrodden[45] resembles what James Tobin, a former member of President John F. Kennedy's Council of Economic Advisers, refers to as "specific egalitarianism."[46] When the basic necessities of life, health, and citizenship are involved, Tobin argues in a well-reasoned essay, modern societies stand ready to in-

tervene in market allocations by rationing resources in order to achieve a more equitable distribution. It is his contention that our entire society is characterized by this "strain of thought," and that an overwhelming number among us are quite willing to legislate specific egalitarianism in such areas as health care, housing, food stamps, and education.

However, Tobin cannot entirely shed his ameliorist skin. He himself demonstrates an adherence to specific egalitarianism—to ameliorism— even as he proposes a form of market policy which we shall describe presently as an "individualistic policy culture." Thus, he supports a voucher system for housing but then immediately demands various regulations which would in fact facilitate that specific egalitarianism he had previously rejected. He would eliminate certain subsidies for homeowners, alter building codes and zoning ordinances, and press hard against racial discrimination. While such regulations, of course, may conceivably be morally sound social policy, it is difficult to see how Tobin has rejected specific egalitarianism. To put it another way, most people, no matter how learned and scientifically "neutral," do not readily liberate themselves from their ideological policy cultures.

Ameliorists frequently express a preference for rules over commands, and they undoubtedly believe in the rule of law as an abstract concept. But when confronted with the practical problems of policy preference, they usually come down on the side of flexibility and discretion in the legal, economic, and social policy arenas.[47] This stance is only natural, for in order to achieve their ends, ameliorists have need of a kind of law adaptable to changing conditions. The static view is not easily made compatible with policy preferences designed to effect changes through collective action. If a purpose of good social policy is to reward specific groups in the population which have previously been deprived, then discretionary rule-making is clearly preferable. Clear and permanent rules cannot be so easily adapted to the short-run problem of enhancing equality. Since they are applied mainly to individual behavior rather than to group advancement, rules thwart efforts to achieve rapid and general distributive justice. To the argument that increased regulation of the private sector may threaten individual freedoms over the long run, the ameliorist answers that public intervention and discretionary rule-making by public agencies may actually expand liberties. For example, a law which restricts the activities of some elements in the population may actually free other citizens to do those things they were previously prevented from doing under existing law. A traffic light on a busy street restricts the rights of motorists, but

it expands the liberties of the pedestrian to get to the other side without fear. From this perspective the basic question is Which rights are to be preferred? and the answer to that question is mainly dependent upon the relative emphasis one places upon the leveling-up process intended to benefit specifically deprived groups in our population.[48]

Similarly, the stress upon specific egalitarianism leads ameliorists to view the central government as the most appropriate vehicle for managing the economy. Calls for greater reliance upon market forces rather than the "mixed economy" in the allocation of scarce resources usually leave them cold — and a little perplexed at the naiveté of their opponents.[49] They may, of course, express some fear in the growing role of government in economic life, but such worries are seldom translated into policy proposals. As moderate interventionists they are responsive to "planning," to "incomes policies," to "guidelines," and to compulsory arbitration of labor-management disputes (unless they happen to speak for unions). They likewise believe in the utility of "fine tuning" in fiscal policy, since the continual manipulation of aggregate demand, they feel, is necessary for enduring prosperity.

A fear of weak "aggregate" demand has a special role in the ameliorative policy culture. Here the canons of social science and everyday values meet and reinforce one another in policy. Stripped of the usual language of economics, weak aggregate demands threaten specifically deprived groups. Without demand management, individuals and firms may "oversave" so unemployment and reduced output are a constant threat to such groups. Liberal economist Arthur Okun observed that he never found a political conservative among those economists who regard the growth of final demand as the *key* determinant of investment (that is, who believe that a change in demand for consumer goods has a disproportionate effect upon producer goods).[50] This insight is not surprising. An emphasis upon final demand concentrates our thoughts upon a need for greater spending by increasing our worries about the spectre of "oversaving." To ward off an excess or thrift requires a strong government role in taxing "excessive" incomes and in stimulating general demand through public spending on public works and social services. This perspective in turn neatly meshes with the felt need to achieve greater equality for specifically deprived groups, as the proposed programs themselves usually assert anyway. One focuses upon group interests but equates these interests with those of the general populace, while at the same time it can be asserted that the needs of the specifically deprived are also met.

This point may also be made with reference to the well-known "Phillips

curve." Accepted by many economists, political leaders, and laity alike as a basis for good social policy for most of the postwar period, this conceptualization asserts that there is a necessary trade-off between unemployment and inflation. That the Phillips curve does or does not reflect empirical reality is not our concern, but there can be little doubt that it has a strong policy culture bias, namely, an ameliorist one. First, the trade-off between inflation and employment focuses our attention upon short-run policy considerations. If unemployment is rising, then appropriate measures are readily available to stimulate demand and to put more people to work in a *short* period of time. Secondly, the Phillips curve rationalizes an aggressive fiscal and monetary role for government management of aggregate demand. Lastly, most supporters of the Phillips perspective focus especially upon the level of employment instead of inflationary forces. This is hardly surprising—the destructive quality of inflation is much more *general* in its impact, whereas unemployment strikes most cruelly at *specific* groups championed by ameliorists.

It is to be expected that opponents of economic planning are given short shrift where ameliorative policy cultures predominate. To the ameliorists the question is not one of planning or not planning. The real question is the proper degree of planning, and that is a problem of trial and error.[51]

The Policy Culture of Individualism

Barring major economic upheavals for which "conservatives" are held responsible, we believe the next several years will see a growth throughout the West of policy cultures linked to individualistic norms and values. Consequently, decision-makers will probably seek solutions to complex economic and social issues which are based upon quite different assumptions than are those to be found in the ameliorative policy cultures so prevalent at present. Policies once denigrated as "reactionary," condemned as "laissez-faire," and deemed inadequate to a "complex" industrial society may now wend their way to the legislative and government agendas in various industrial nations, if for no other reason than the manifest failures of ameliorism.

An essential attribute of these policies will be to link rules to individualism. Because this type of policy culture stresses individual action, it perforce emphasizes the crucial role of rules. Individualism and rules simply cannot be dissociated within the social order; one without the other is self-defeating, unimaginable over the long run. Just as an ameliorative pol-

icy culture requires a legal system based upon discretionary law for policy implementation, so an individualistic policy culture requires rule of law assumptions and values. We have already made this point within the context of the legal system and its connection with economic freedom, but this linkage may be discerned also within the context of total cultures. For example, in his influential study of French authority relationships, Michel Crozier found that just as the French value personal autonomy highly, so they likewise value impersonal and negative rules within organizational settings as the principal means to circumscribe and limit arbitrary authority. That rules so pervasive throughout French society have often made people resistant to change, including technological change, ought not to obscure the truth continued in Crozier's important study that "nondependence" norms and values are preserved precisely because the static rules function to formalize, limit, and restrict power over individuals.[52]

What distinguishes the policy culture based upon individualism? Basically, such a policy culture begins with the assumption of individuality and diversity in tastes, values, and interests. Individual motives, incentives, and ideals are therefore at odds with the *group* assumptions so prevalent within ameliorative policy cultures. As might be expected, terms such as "private property," "free economy," "capitalism," and the "marketplace of ideas" capture its basic ethos. Because they crown individual freedom as the true sovereign, free markets in goods or ideas are preferred to the decisions of political authorities. As we have argued throughout this book, the impersonal nature of markets tends to reduce the impact of politics and exclude administrative officials from many areas of economy and society.

The desire to increase individual autonomy at the expense of the state, of course, also explains why individualists extol the "rule of law": Clear rules aim at removing individuals from government discretion. They reduce the means for the exercise of power by Political Man. But in their advocacy of "rules" rather than "authorities,"[53] individualists sometimes place much hope upon legislative rule-making and as a result oppose the legislative tendency to delegate its authority to administrative agencies:

The older strictures about the rule of law should be interpreted more and more severely as one moves up through the governmental hierarchy. Extensive delegations of power to executive or administrative officers should be largely confined to local bodies. At higher levels such delegations of legislative discretion should be severely economized and, when invoked, should be regarded as a temporary or transitional expedient. National government should be government by law, by

legislative rules, and by legislation which follows clear, announced rules of policy. A national legislature should bind administration by closely confining rules, enforceable by an independent judiciary.[54]

Let us issue a warning at this point. We must not exaggerate the consistency within policy cultures. The ideological, behavioral, and material realms of individuals and groups more often than not diverge sharply from one another in the real world. By moving from one policy arena to another, a given individual sometimes alters his or her orientation from that of individualism to ameliorism (or vice versa).

The part played by individual rights in the ameliorative policy culture is instructive in this regard. In general the ameliorist maintains some degree of ideological consistency so long as policies devoted to the protection of civil rights carry an economic dimension. "Affirmative action" (including racial and sexual quotas and timetables) and comparable worth, for example, pose no major difficulty. Since these rights refer ultimately to questions of occupation and income, they harmonize well with the basic assumptions of the ameliorative policy culture. But in the case of nonmaterial rights such as the First Amendment freedoms, a logical difficulty arises. Ameliorists favor the basic right to religion, speech and assembly, but the underlying justification for their support depends upon rather a different set of attitudes and values than one sees in other policy areas. Thus the basic attitudinal structure of ameliorism bears little relationship to the ideological and legal positions taken by ameliorists on most other issues. In short, where personal rights are concerned, ameliorists adopt the outlook of the individualistic policy culture. Although one might dismiss the problem as endemic to all policy cultures, the extent of the inconsistency calls for comment.

We know that all policy cultures are somewhat inconsistent, but the question remains: Why is the inconsistency so apparent in the ameliorative policy culture? One simple explanation is that, since our basic political and cultural freedoms are deeply embedded in Western political cultures, no political party at the present time with any hope for power dares to oppose these fundamental rights; that is, they are taken for granted and are highly valued in the society as a whole. Similarly, as we previously observed, ameliorists are well represented in intellectual and artistic circles, so their occupational interests make them particularly sensitive to violations of the freedom of speech and pen. Finally, their typical defense of the "preferred freedoms" does not in reality contradict the structural re-

quirements of their basic assumptions to the extent one might suppose. With rare exceptions, basic rights are unlikely to incite those political antagonisms which compel us to choose forthrightly between the different values of liberty and equality. For, unlike disputes which focus primarily upon economic and property rights, the First Amendment liberties do not fundamentally contradict the ameliorist value that the most appropriate method for achieving meaningful equality within the democratic order is to direct one's support to specifically deprived groups. Unlike economic liberties, which are designed mainly to strengthen property rights to ownership and exchange (rights which ameliorists generally wish to limit), these noneconomic liberties seldom call into question the value of equality itself. To put it another way, liberty and equality do not confront one another. In short, the noneconomic rights will likely be perceived as costless in their effects; or at least they are not scarce in the sense that one person's demand for them will deny their use to other individuals. They are thus free goods to be enjoyed by all, irrespective of social and economic position. The fact remains, however, that since these rights are highly individualistic in terms of the ends they seek to promote, they strike in a logico-meaningful manner at an ameliorist *Weltanschauung* dedicated to an equalitarianism brought about by the leveling-up process.

The individualistic policy culture, to the contrary, shows more ideological coherence with regard to individual liberties across an array of economic, social, and welfare issues than does the ameliorative one. The ideological assumptions which undergird this policy culture—the idealization of the individual, the greater value placed upon liberty than equality, the fear of central government, and a preference for static rules—readily apply to political and economic liberties alike. In this regard, consistency is more apparent among "libertarians" than "conservatives." For example, in "hierarchical" political cultures where the state is strong, national institutions are well developed, and class and status distinctions remain sharply defined, one finds that conservatives may well be as attuned to traditional interests as to individual rights.[55] In general, whatever the agreement over economics, conservatives and libertarians often display sharp differences over social and cultural freedoms. Again, many radicals join conservatives on the question of economic collectivism but support libertarians on the question of cultural permissiveness. For many of us, therefore, the free market in ideas need not coincide with the free market in goods.[56]

Toward Policy Reform: Some Examples

If, as we have seen, policy is inherently coercive in major respects, its discretionary qualities may nevertheless be softened. It is the introduction of rules into policy which places brakes upon coercion. Since rules open the way to individual freedom and diversity, they also reduce the likelihood of large-scale error and systematic inefficiencies. Information in society is incomplete, highly dispersed throughout the social order. When individuals are allowed to use their knowledge as they see fit and to respond to changes in data (such as costs and prices), the magnitude of errors is sharply curtailed and mistakes tend to be self-correcting. But when individuals and groups in official positions strive to impose their own ideas upon social and economic situations where information is necessarily incomplete, one not surprisingly discovers inefficiencies, bottlenecks, overproduction, and underproduction. Where prices are not free to reflect changes in demand and supply, coordination is problematical. Fixed rules to a great extent provide a social framework within which systematic coordination can occur.[57]

Whereas this function of rules has been recognized for some time in the case of economic systems, it has for the most part gone unnoticed that rules provide an effective antidote to the temporal illusion. That is to say, they provide some incentive for individuals to take the longer view into consideration when they make their plans. It applies not only to rules in legal systems but also to policy rules. By limiting the scope of means at the disposal of political actors to manipulate material resources, predetermined rules in policy likewise tend to frustrate those who would employ the political system for the achievement of *group* ends.[58]

Consequently, the incentive to utilize political institutions for the accomplishment of econmoic and political ends is less likely to be present. Other things being equal, a taller basketball team will dominate the boards and win the game when it plays a smaller squad. On the other hand, if the latter is able to change the rules to its advantage by, say, limiting the number of shots at the basket one may take on the offensive board, the ultimate outcome may well be altered. And, for instance, if a maximum of three shots at the basket does not do the job, then the short team may demand a "law" for four shots. In this situation rules obviously lose their authenticity. The assertion of "rights" by short players puts the rules up for grabs, since the taller team will unlikely accept the new balance. Consequently, an atmosphere develops in which anticipations for rule change

grow exponentially as defenders of a present status quo tirelessly contest advocates of innovation. Social life is increasingly politicized as teams focus their interests upon alterations in the rules rather than upon the game itself.

To stress the role played by rules in knowledge and temporality suggests that much of the debate over political reform of executive and, especially, legislative institutions may be sorely misplaced; indeed, that much reform will likely prove less than satisfactory for achieving its stated ends. For example, let us return to the problem of legislative delegation. Delegations unaccompanied by clear standards for implementation are felt to be particularly illegitimate, as they enable nonelected officials to make policy supposedly reserved for the peoples' representatives. Law may be formally framed by Congress, but the real creators are officials in the field building up their own rules and regulations on a case-by-case basis. This drainage of power from legislative bodies to executive administrators not only erodes government legitimacy in general, but increases the likelihood of access to influence of powerful, if regulated, "interests." It encourages that unfortunate combination of arbitrariness and weakness on the part of officialdom we see in the modern, overgoverned state.

On the other hand, it is not at all clear that reform in this area would affect the fundamental problem of high time preferences in modern societies. In fact, if one accepts the interpretation put forth in the previous chapter, there is every reason to suppose that a coherent legislative majoritarianism would serve the interests of the possessors of short time horizons. To establish clearly the locus of sovereignty would no doubt encourage "responsibility," but it would in all probability also politicize culture and society to a far greater extent—with unfortunate consequences.

In this respect, we may turn to one of the most interesting attempts at political reconstruction, namely, to that of Lowi.[59] Referring specifically to the American situation, he argues that many of our present ailments would be manageable if Congress, with the help and assistance of the courts, would only write coherent statutes. He is highly critical of Congress for failing to spell out its intentions with language which places strict limits upon the delegation of power to administrative officials. He maintains that regulatory legislation in the late nineteenth century possessed the attributes of good legislation to a much higher degree than does more recent legislation. For example, in the case of the regulation of the railroads, as contained in the Interstate Commerce Act of 1887, the language

was "concrete" and "specific" in terms of the object (railroads) to be regulated. As a result, the congressional intent is clearly understood.

Lowi observes that over time administrative discretion grows in extent and power as Congress progressively abdicates its responsibility with the issuance of ill-defined, vaguely worded legislation. Thus, the "specific" regulation as found in railroad regulation and broadened somewhat in legislation governing "the trusts" is now broadly extended in its coverage to more or less "universal" concerns. For example, with the creation of such agencies as the Consumer Product Safety Commission (CPSC) and the Occupational Safety and Health Agency (OSHA) in our day, we find that instructions to administrators from Congress are highly abstract and diffuse. Thus, minimum and maximum rates allowed by the ICC regulators diverge sharply from the potential regulation of *anything* having to do with consumer safety or the workplace environment. What has therefore evolved is the progressive abdication of power by Congress. The legislative body finds a problem and simply instructs officialdom to somehow take care of it. It is a historical change of major proportions from representative democracy to the Administrative State, a form of governance in which the scope of control is defined ever more broadly and the objects of regulation are defined ever more loosely. "The move from concreteness to abstractness in the definition of public policy," concludes Lowi, "was probably the most important single change in the entire history of public control in the United States. Certainly it is the most important step to those concerned for the rule of law.[60]

Nevertheless, it is hard to see how mere restrictions upon legislative delegation in themselves can have a major effect upon those forces which have placed Political Man so firmly in control of large areas of socioeconomic life. In the absence of a reduction in the scope and size of government power, smaller budgets, the restoration of more competitive markets, and a return to the rule of law *as traditionally understood,* change is difficult to envisage. As our case study of Switzerland suggests, a depoliticization of socioeconomic values and structures, including a reduction in the scope of government power *and* legislative activity, is more likely to facilitate legitimacy.

But let us look at the problem of delegation of legislation from a different angle. Suppose Congress as a collective body at some time in the near future recaptures power from its committees and subcommittees; suppose it can indeed make "good" law. The experience of other nations such as

Great Britain suggests little reason for optimism if one depends upon reforms designed merely to clarify responsibility. In Great Britain legislative committees are constrained by the practice of cabinet and ministerial responsibility before the House of Commons and by disciplined parties, but little impact has been made upon runaway budget deficits, excessive welfare state expenditures, and administrative overregulation. Indeed, one might expect a more combative Congress, impelled by strong and competitive parties, to engage in ever more protracted efforts at redistribution and regulation at the expense of individual and property rights—a fact which Lowi himself implicitly acknowledges.[61] The increase in redistribution and regulation necessarily leads to a growth in legal coercion, since interest groups that demand protection from competitors or income support will seek legal redress from a hospitable legislature.[62]

From a rule-oriented perspective it is difficult to visualize congressional statutes which are clearly worded but simultaneously unrelated to specific ends and purposes. Indeed, such statutes generally violate the rule of law principle. Command edicts issued in America by the legislative sovereign in 1887 differ in no fundamental way from those issued in the 1970s. Because temporary majorities are able to write statutes which impose clear means for implementation but are also designated to accomplish specific ends, there is little assurance that state coercion will be contained. It only means that citizens may get a better understanding as to their true oppressors.

At first blush one might reasonably argue, for instance, that while policies in antitrust or in the regulation of trucking, airlines, or rails lend themselves to rule-based criteria, the same argument is less easily made in the area of social welfare. Thus, where basic market forces are operative, as in industrial competition, the aim of the reformer is to remove impediments to competition such as restrictions upon entry into markets in the form of tariffs, import quotas, licenses, patents, and the like. Moreover, in this area it goes without saying that common law rules prohibiting contract violation, fraud, and deception would be enforced. On the whole, we have a situation in which the older notions of government as night watchman apply, so we find ready legal congruence with free market principles.[63] In these instances the problem of transfer payments—namely, the expropriation of some citizens at the expense of other citizens—is hardly a matter of concern.

Social welfare policies are certainly less manageable (at least in theory) than are industrial policies. Rules for industrial policy are more amenable

to the rule of law principle. It is obviously less difficult to frame rules which prohibit certain behaviors for everybody than to frame rules whose avowed aim must of necessity give specific kinds of help to specific categories of people. A prohibition against particular actions calculated to restrict entry into a given field of commerce or a prohibition against legalized monopoly—e.g., cartel agreements, horizontal mergers, or railroad debates and predatory business practices as mentioned in the Sherman Act—may avoid discretionary application much more easily than can decisions about which of us is to receive subsidized housing or free lunches.[64] In the industrial field, therefore, the state may in theory withdraw to a remote perch and act as enforcer of abstract rules. However, in the area of welfare or poverty, an uninvolved citizen—the "affluent" taxpayer—pays the price. In this policy area, therefore, the problem of discretionary transfers of income intrudes. As a consequence, the principle of static and abstract rulemaking is automatically violated, since costs are disproportionately borne almost invariably by *selected* groups within the population.

Nevertheless, *if it can be said that social policy usually requires the imposition of commands at the outset, it is possible at other points on the policy process continuum to invoke rule-related criteria.* It is this possibility which lies at the heart of policies in social welfare areas as diverse as family assistance, the negative income tax, vouchers in housing and education, and enterprise zones, to name a few of the more salient ones.[65] As is true of other, more traditional policies whose intent is to eliminate poverty, increase equality of opportunity, or raise incomes, they also aim at the welfare of specific groups within the population. However, if they are initially founded upon commands, they likewise soften coercion with general rules allowing a relatively wide range of choice. In Samuel Brittan's felicitous words, "A selective social policy discriminates among *people* by the non-discretionary general criteria in income, wealth, and need."[66] And he proceeds to make a distinction we have been trying to draw between industrial and commercial politics, on the one hand, and social welfare policies, on the other hand. A "selective" industrial policy discriminates among firms, products, or locations and calls for discretionary decision-making by officialdom, whereas a "selective" social policy has the opposite effect: It eliminates discretionary decision-making by politicians and administrators.[67]

For example, voucher systems in education and housing, by which recipients are given vouchers worth so much money to be spent upon schooling or housing, and the negative income tax express what we have

designated the individualistic policy culture: They seek the elimination of discretionary authority; they utilize indirect controls; they concentrate upon individuals (or families); and the support they dispose of occurs *automatically* once certain needs are established, consequently eliminating the need for large numbers of administers. These programs are discretionary in that they often involve transfer payments, at least initially, and are intended to help selected types of citizens. But they are rather different from existing programs since they are governed by rules announced in advance and are activated according to general criteria of wealth, income, or need. Because these policies abridge the influence and effective controls of legislators, civil servants, and welfare workers, one may be sure that any efforts to implement them will not only meet stiff resistance but redistribute political power at the expense of officialdom. We do not imply that vouchers are the only means by which the rule of law principle may be applied to welfare and poverty policy. The family allowance system, so widespread in Europe (and Canada), is a case in point. Some governments limit payment both in terms of family income and of the number and age of children, but the typical pattern is to grant payment to each family irrespective of need.[68] But perhaps the most widely publicized of the various programs is the negative income tax. As proposed by Milton Friedman and others, it would pay money to citizens in the lowest income tax brackets while preserving incentives for those at higher levels who earn additional money. Nevertheless, it has come in for scathing criticism. Pilot studies in the United States, according to Charles Murray, lead to the conclusion that its enactment in the nation would be detrimental to family stability and employment.[69] In fact, it must be stated that the negative income tax was originally conceived as a *replacement,* not a supplement to other forms of welfare.[70]

That a major purpose of these policies is not only efficiency but a desire to make them rule-based may be observed in the case of a proposal made in Great Britain by a group of experts with Conservative connections. In listing the advantages of a negative income tax — or "Reverse Income Tax," as the British call it — the experts demonstrated a strong preference for rules as a principle means by which to assure a reduction in discretionary authority in welfare:

> 1. Compared with the Supplementary Benefit payments a RIT (Reverse Income Tax) system has the outstanding advantage that there is no need to apply for help in the sense of going to an office distributing payments and proving need. Payment

is automatic and given 'as of right' to anyone whose income is below the prescribed level.

2. Again . . . a RIT has the advantage that it is based in the objective test of a family's income and not (at least partly) on discretionary judgment of officials about whether or not a person is in need.

3. The need to apply for help and to submit to the partly discretionary decisions of officials are important reasons for the reluctance among some people to apply for supplementary benefit.

4. A further consequence of the generality of the help given by a RIT is that people of full-time employment will receive help on the same basis as those not in work.

5. RIT offers the possibility of major reductions in the amount of state expenditure and taxation.

6. RIT uses a test of need that is financial and not defined in terms of categories of need (old people, large families, widows, etc.) RIT is truly universal in its approach to the poor, because it helps everyone whose income is below the minimum level regardless of whether they fall within specified categories of need.[71]

Note the thrust of this proposal: The elimination of official discretion; the reduction in government personnel and other costs; the reduction of controls by civil servants over citizens' lives; and last, but far from least, the establishment of general and "negative" rules which would come into being *automatically* once a need covered by the general criteria arises.

One final and pertinent, if less publicized, case to be drawn from the poverty area is the idea of Enterprise Zones. Unlike other policies we have mentioned, the thrust of EZ legislation is more indirect in its subsidization of needy individuals, and aid, further, does not come to the individual as a matter of course according to income, wealth, or need. Its benefits, in fact, go to entrepreneurs willing to invest their own incomes and skills in selected geographical areas. Support, therefore, does not come to selective categories of citizens in a direct manner as a matter of course, although its ultimate effects are expected to have large-scale consequences in terms of increased standards of living in poverty-ridden areas. Whether its ultimate beneficiaries will indeed gain rather depends upon the initiatives of entrepreneurs responding to money incentives.

The idea of EZ originated in Great Britain in 1977 and by 1980 became part of the legislative agenda of the government of Mrs. Thatcher. However, it was quickly watered down by various ministerial committees, and when it was finally presented to Parliament its original purpose had been all but lost.[72] In the United States, the EZ idea, as originally sponsored

in the House by Representatives Jack Kemp and Robert Garcia of New York, is at present very much alive. Since that time it has passed the Senate on two occasions but has suffered defeat in the House. On the other hand, President Reagan supported it strongly in his Budget Message on February 6, 1985, and considering his November 1984 landslide reelection, some form of EZ will probably pass in his second term. Many in opposition, however, fear that the benefits will accrue to service industries and higher income groups rather than to lesser-skilled individuals.[73]

The Enterprise Zone bill, as embodied in Kemp-Garcia, is relatively simple in conception. "Depressed" rural and urban areas, selected initially by state legislatures, confirmed by the state and the given locality, and approved in Washington by the Housing and Urban Development Agency (HUD), are designated as Enterprise Zones. Each zone is afforded an array of tax benefits and regulatory exclusions denied to other localities in state and nation. Investment tax credits, depreciation allowances, and the elimination of capital gains taxes figure among the more significant benefits granted to entrepreneurs and sellers of property within the zones.[74] Although the initial investors in EZ can hardly be termed poor, it is anticipated that their own and subsequent investment will ultimately benefit the immense majority of poor citizens as well. In the long run, of course, assuming they do not fail, EZs will presumably generate income under their own steam, thereby providing a larger tax base from which various levels of government may draw sustenance. In that event the tax burden will be altered.

Therefore, Enterprise Zones discriminate, at least in the short run, against taxpayers and regions not fortunate enough to gain the endorsement of state legislatures and HUD. They favor entrepreneurs (hardly a poor group!) and workers within the zones. Nevertheless, the Sabre Foundation report, which appeared in late 1984, claims an initial success for a large majority of the Enterprise Zones set up so far. On the other hand, if the prior British experience is any indication of future reaction, we may find strong opposition among sellers of goods outside the zones who must compete with lower-priced goods manufactured in the targeted areas.[75]

The innovative aspect of EZ may be observed by comparing it with the "urban renewal" programs so prevalent in postwar America. The essential distinction between them is to be found in the amounts of coercion employed in each program. Whereas EZ relies principally upon incentives and keeps commands at a minimum, urban renewal at least in its effects is coercive at specific points in the unfolding policy process. The access

points to discretionary authority in any given urban renewal program are therefore greater both in number and extent of control. Whereas both programs depend ostensibly upon private sector entrepreneurship, EZ relies mainly upon rules announced in advance. If EZ discriminates against citizens outside its areas of jurisdiction through transfers of public tax resources into favored locations, and if its beneficiaries are perhaps placed at an advantage against competing producers and retail establishments, the command elements it calls forth are surely negligible when compared with the discretionary powers applied by government to citizens within urban renewal districts. Because EZ offers incentives to entrepreneurs in the form of individual tax reductions, rather than government-induced expropriation of property and special access to low-interest government loans from Washington, the effects of any failure in policy in urban renewal are likely to be far more pervasive and costly to the society as a whole.

As conceived and developed over time, urban renewal displays a curious ideological blend of private initiative, local control, democratic participation, and national responsibility.[76] At the time of its creation the program stressed "free enterprise," but it was soon evident that governments, local and national alike, would steer urban policy. Hence, Washington set the general standards for implementation and cities filled in the details. Major costs were borne by Washington, since most of the income lost by cities was made up by the federal government. Accordingly, Washington was to be assured by local governments that broad citizen participation had been made available in the development of proposals worked out in city halls. This overall control at the national level and wide delegation of authority to local governments made urban renewal an excellent example of what Lowi calls "interest group liberalism," that ongoing process by which Congress enacts a law defined loosely and lacking in clear instructions to local officials regarding programmatic implementation.[77]

The urban renewal process typically occurred in the following sequence. Once a plan for urban renewal was found acceptable by HUD in Washington, land, business establishments, and houses were expropriated for "public use" by city governments. Merchants, tenants, and landlords were as a consequence forced to sell or evacuate, willingly or not, unless they met the specifications established by the local planning authority. The "fair market value" supposedly paid for expropriated property presumably eased the anguish of expropriation. Next, buildings were torn down or revitalized, and sewage, lighting, and water "improvements" were made at government expense. Finally, the redeveloped area was sold to private

developers. The developers not only purchased the property at bargain prices but were also given access to low-cost government loans. According to Martin Anderson, "Land was usually sold to private developers for almost 30 percent of what it cost the city to acquire, clear, and improve it."[78]

Many criticisms, of course, have been levelled at urban renewal over the years, the most common one at its exploitative qualities. For example, although popular prejudice perceived urban renewal as a housing program for low income inner-city dwellers, it often functioned more as a program to remove the poor from their homes. This charge is verified by the appearance in many cities of high-rent apartments in the middle of areas previously poor and now redeveloped. Thus, social engineering schemes in the name of the "public good" which forcibly removed less influential people from their homes and businesses became distasteful to many in the public, and the realization that many developers bought property at relatively cheap prices undermined the moral authority of the program. Finally, that the highest court in the land, the United States Supreme Court, could endorse an expropriation of private property by legislative fiat indeed tells us that there is little the state cannot seize for public use under its "police power." In short, here was a public policy unsettling to various ideological persuasions, if for different reasons.

By now it should be abundantly clear that urban renewal policy comprises *several access points to discretionary authority.* Discretion and coercion dominate this process—and not merely at its initial stages, as is true of EZ. The entire program suggests a large transfer of resources and power directly from the federal government to particular cities. Most important, by removing people forcibly from their homes and businesses, albeit in the name of progress, and by transferring sizable funds to developers, it abridged property rights in fundamental ways. Of course, the democratic myth was often invoked: Did not urban renewal legislation by Congress specifically call for "citizen participation"? Yet, given the quality of activity and numbers involved in participation as well as the "interest group liberal" bias in implementation, one may doubt that urban renewal is in any meaningful sense "democratic."

What cannot be doubted is that urban renewal makes significant inroads into the ideal of property rights. Storeowners, renters, landlords, and homeowners may be simply evicted by government under its rules. What also cannot be doubted is that the property of expropriated citizens may be awarded by government to other citizens. The state's power of eminent domain may thus be utilized as a means to transfer property not

only from the individual to the state but, in addition, from individual to individual, with the state acting as a middleman.[79] Consequently, as points of access to discretion, these two phases in the urban renewal programs are on the opposite pole from a policy rule of law. Compared with urban renewal, EZ is a model of equal rights under the law.

We have considered the role of general rules in welfare and poverty policies because it is often supposed that programs in this area are particularly resistant to the imposition of rule-related criteria. So, if discretion can be reduced in these cases, there is every reason to believe other areas may also be susceptible to rules. In fact, there are indeed other areas of policy where discretion, in theory at least, may be eliminated entirely. A most obvious case is that of monetary policy. Whatever their technical disagreements, and they are substantial, the Chicago School of Milton Friedman and the advocates of a classical gold standard are at one with regard to the importance of rules for monetary policy.[80] Both agree that a strict rule ought to temper the actions of central bankers; that left to their own devices, bankers are too often prone to mistakes. Either central bankers succumb to inflationary pressures placed upon them by powerful interest groups and the blandishments of legislative and party leaders, who hardly see beyond the next election, or they misread the economic data over the short run, then overreact and overstimulate business cycle peaks or troughs. A money rule, however, enables economic units to make their plans for the long run, more secure in the belief that signposts are clear and relatively permanent in a world of perpetual change.

Quite apart from any technical arguments, the advocates of a "pure," "orthodox," or "classical" gold standard are the more consistent defenders of a strict rule. In the first place, the monetarist defenders of a "money rule" have been so far unable to provide us with a convincing definition of money; but if money cannot be defined, we have good reason to suspect that it likewise cannot be measured. Thus, the various Ms (M_1, M_2, M_3, etc.) put forth by economists have proved less than successful until now as predictors for policy. Upon which of the Ms must central bankers depend? To what degree? Moreover, with the advent of banking deregulation and the growth of negotiable order of withdrawal (NOW) accounts, money market funds, and other recent innovations in the United States, for example, the possibilities for measurement have become even more hazardous. Similarly, assuming that one can measure in a reasonably meaningful way the various Ms, that knowledge may be of limited use to the policymaker. For instance, suppose interest rates fall and people shift their savings tem-

porarily to checking accounts, leading to a rise in M_1. Are central banks correct to conclude that a restriction of M_1 is necessary? The answer is far from clear, as Alan Reynolds argued in a devastating attack upon monetarism.[81] At any rate, the growing comlexity of money instruments has made problems of measurement and control much more difficult than in the past.

In a more fundamental way, the monetarists overstress the demand for money as opposed to the supply of it. In certain cases prices may fall with a rising supply of money and credit if people simultaneously desire to increase their cash holdings at an even higher rate. This problem poses a great difficulty for those who believe in the ability of central banks to control the money supply, since the possibility exists that control bankers may restrict the money supply at a time when consumer spending, for example, is dropping. Instead of leaning against the wind, as they are said to do, central banks may add a puff of their own.

Secondly, the monetarist money is not "real" money but rather fiat money. In other words, it is not gold or silver. Fiat money, unlike gold or silver, may be manufactured at negligible cost. And since monetarists accord central government bankers a monopoly over the note issue of an irredeemable paper, there is every expectation that abuses of power will occur. Not surprisingly, some thoughtful scholars in recent years have sought to resolve the monopoly problem by radical means. Either "denationalize" money and let currencies compete against one another and against other forms of money (e.g., gold and silver)—that is, change the legal tender laws—or establish a system of private banking on the lines of Scotland in the eighteenth and early nineteenth centuries.[82] Nevertheless, leading monetarists, who in other areas are staunch critics of monopoly power, willingly give monopoly power to central banks to control the supply of money in the belief that bankers can be equipped with a "rule" for money.

In the absence of meaningful technical requirements for control over the money supply—far better than we presently possess—it is hard to see how central bank monopolists will not continually err, or worse, abuse their authority; and even if they do not wish to abuse their awesome powers, it is unlikely that they can long resist pressures from executive officials, parliamentarians, and party leaders. Thus, the problems associated with the definition and measurement of money, political pressures, and monopoly power make the imposition of a policy rule of law under the monetarist regime at best problematical. Concentrated power plus inadequate

information provides a powerful incentive for the politicians to fill a power and informational vacuum. In short, the monetarists may get the one thing they of all people least want: persistent inflation.

The gold standard advocates offer a rather different solution. From their perspective money is easily defined. It is currency defined in terms of such-and-such a unit of weight in fine gold. Banks therefore need only exchange dollars, francs, marks, or whatever for gold on demand. Consequently, if governments inflate the money supply, causing prices to rise, citizens and foreigners find it expedient to exchange, say, dollars for gold. The drain of gold from the banks and nation of the inflating country cannot go on forever. Since either by law or for reasons of prudence banks must maintain a certain ratio of money (gold and silver) to money-substitutes, they find it necessary to limit the issuing of credit and to restore previous ratios. The effects of credit restraint are a fall in profits and prices and employment. However, with the fall in prices, citizens soon find it expedient to hold dollars, so they once again return gold to the banks. The increase in gold enables banks to ease credit and lower their interest charges. These changes prepare the way for a new boom. And so on. . . .

The gold standard may be found in various kinds of banking systems; indeed, it worked relatively well under free banking and central banking alike.[83] In its heyday, however, the typical case was generally one in which central banks possessed a legal monopoly over note-issue and functioned as lenders of last resort. This "classical" gold standard existed among nations whose currencies were set in terms of a fixed price of gold and who allowed free movement of specie within and between the nations. Consequently, although central banks such as the Bank of England enjoyed a certain monopoly position, they in no way could claim as much discretion under the gold standard of their day as their twentieth-century successors have gained under both the "gold exchange system" and under freely fluctuating exchange rates.

Thus, under the orthodox gold standard, central banks and commercial banks were under constant pressure to keep their houses in order, lest a fear for the solvency of commercial banks or a belief that the currency was depreciating would soon lead citizens to exchange their dollars or francs for gold. If central banks enjoyed a monopoly from the state, they were nevertheless subject to the discipline of gold: Excessive losses of gold led to attempts to coax reserves back to the banks by raising interests rates and by reducing loans. It was precisely this freedom on the part of the in-

dividual to drain banks of specie and so force them to mend their infla-
tionary ways which led Mises to place the gold standard on a par with
political constitutions as a bulwark in the defense of individual rights.[84]

If there is a better case of the policy rule of law principle we do not
know of one. The classical gold standard, whatever its demerits (and schol-
ars are deeply divided on this question), provides an admirable case study
of fixed rules. It reduces the power of officialdom and legislators to inter-
vene in the interests of short-term employment and profits. To put it more
directly, it was resistant to pressures from those who would adopt short-
run palliatives at the expense of long-run price stability. It supported the
interests of the savers, those on fixed incomes, the retired, and the unosten-
tatious at the expense of economic interests tied closely to governments
and to inflation. And it had the strength to force compliance with its im-
personal will: If governments sought to inflate, citizens withdrew their in-
vestments and savings by exchanging money-substitutes for real money (i.e.,
gold), a defense against currency debasement. Finally, people could pre-
pare for the future relatively secure in the knowledge that if prices rose
for a time they would also subsequently fall. Conversely, if the rise in
prices was expected to continue unabated, there was always the right to
withdraw one's support from the dollar, pound, mark, or other national
currency. In short, the gold coin standard has all the advantages of a money
rule but in theory few of its disadvantages.

We have no intention here of joining the ongoing debates between advo-
cates of a commodity standard, freely fluctuating fiat money, gold exchange
standard, gold coin standard, competing but denationalized currencies,
and so on. These debates have been addressed by some of the most influen-
tial scholars in the social sciences.[85] Rather, our concern is with the rising
disquiet in diverse schools over a need for fixed rules in monetary policy.
Growing numbers of social scientists and political elites have apparently
lost faith in our discretionary ability to fine-tune economies and have
therefore favored reforms in policy based upon rule-oriented criteria rather
than upon the commands of officials. "Chicago" and "Vienna" are, so to
speak, again taken seriously in Washington and London, even Paris!

It is clear that the gold standard agrees most fully with the policy rule
of law norm. Thus, from the standpoint of rules it carries few of the tech-
nical flaws associated with irredeemable money. Moreover, as we have
observed, since domestic currencies under the orthodox gold standard are
defined in terms of gold, a growth in fiat money soon leads to a restoration
of equilibrium as currencies are increasingly exchanged for gold to the det-

riment of the banks. Unless public officials decide they will no longer be dominated by the proverbial "cross of gold," their power to issue commands is sharply circumscribed.

On the other hand, a money "rule" dependent upon fiat money has need of a proper definition of money in order to control its growth. But when techniques are not buttressed by consensus and when definitions are hazy or controversial, the "rule" is likely to be bent and changed on grounds of efficiency. Like sailors steering in treacherous waters, so policymakers must react to constant shifts in economic data. Hence, the admirable attempt to elaborate a static rule for money which leads to a stabilization of the "price level" is likely to prove an elusive goal. Similarly, under a system in which fiat currencies of various nations exchange against one another, the money rules are ultimately subject to the wishes of institutionalized monopolists, namely, central banks invested with power to produce cheap pieces of paper declared to be legal tender. An institutional monopoly armed with discretionary authority in terms of rule application is a tempting target for pressure groups; and when disagreements persist over the proper rate of growth in the money supply and over how best to manipulate the supply for the public good, the money rule quickly becomes an important part of political struggles between bank officials, elected officials, and major groups. Policy is then subject to sharp twists and turns in which inflationary interests more often than not emerge victorious. So unless monetarism can find an acceptable definition and measurement of money, and unless it can develop a money rule sufficiently acceptable to public opinion to keep monopolistic central banks in line with stated policy, the "monetary sin of the West" will persist.[86]

The recent crop of supply-siders, among the more hostile critics of monetarism, are especially contemptuous of monetarist attempts to control the money supply with any degree of success.[87] Of course, they, too, call for a rule in monetary policy but advocate a return to one based upon gold. Yet they show little enthusiasm for the orthodox gold standard of the previous century. To the contrary, they favor a restoration of the system established in 1944 at Bretton Woods and later sacrificed on the altar of monetarist freely fluctuating exchange rates when in 1973 the United States went "off gold."

As is true of the monetarist rule, the gold exchange standard rule is largely a theory in search of a rule, as a reading of the tortured history of central bank interventions from World War II until 1971 surely teaches us.[88] From the standpoint of the political scientist concerned with power

relationships, the supply-siders are much closer to the monetarists than they wish to admit. Both display a high confidence in central banks and both believe that proper techniques properly administered are compatible with good rules.

The supply-side system calls for currencies to be set in terms of a fixed price for gold, but at that point its resemblance to the traditional gold standard mostly disappears. Thus, central bankers in the major industrial nations, having once agreed upon a fixed price of gold, are to enter the foreign market when necessary to prevent individual currencies from rising above or falling below certain fixed points (values). For instance, if the French franc threatens to become excessively undervalued in terms of the pound or dollar, central banks will step in and buy francs and/or sell pounds and dollars. Thus, the worth of currencies is placed at the disposal of the wisdom of central bankers who, it is *assumed,* actually possess the power to maintain the value of currencies within stated bounds. If the bankers' forecasts are correct, and if one indeed assumes they possess the power to stem fearful flights from currencies under pressure, one might conclude that, even in the absence of a fixed money unit of account, this kind of policy is unobjectionable from the standpoint of results obtained.

History, however, is far from encouraging. Under the gold exchange standard, as it operated in the latter half of the 1920s and in the quarter century following World War II, certain currencies were accorded the status of "key currencies." After World War II this honor belonged to the American dollar. This meant that dollars held in foreign banks served along with gold as reserves against which other nations' currencies could be expanded. The effects upon Europeans of a dollar expansion were similar to an expansion of their gold supply: a growth in the money supply and subsequently in inflation in the countries receiving the "excess" dollars. It led to what was called "imported" inflation, especially in West Germany, where a strong mark invited an influx of dollars.[89]

Although the United States was supposed to play the role of a banker's banker, it continually ran a balance-of-payments deficit and inflated its own economy, causing resentment throughout the Western world. But attempts by nervous foreigners to exchange their excess dollars for gold were resisted by less than subtle political pressures from Washington. Thus, in 1971, the Nixon Administration, after placing much pressure upon reluctant foreigners, finally gave up and closed the gold window in an effort to head off a hemorrhage of gold from American shores. In 1973, the final link to gold was officially severed, and the establishment of free competi-

tion among national currencies, strongly favored by monetarists and much of academic opinion, replaced the gold exchange standard.

Despite the rather mixed performance by the gold exchange standard, the doyen of supply-siders, Robert Mundell, has only high praise for the Bretton Woods system. "Except for the great devaluations of 1949," he writes, "the quarter century of this regime was exemplary in its stability, growth, and world economic development, perhaps unmatched at any-time outside an imperium, such as the Roman Empire.[90] High praise indeed! But then why did the system come to such an untimely end? Mundell concludes that an obstinate adherence to gold at $35 an ounce and a loss of political leadership by the United States during the Vietnam War years were primary causes for its demise. Unlike those economists who predicted that a gold exchange standard must fail due to its inherent flaws,[91] prominent supply-siders therefore defend the system in its broad essentials. However, given the steady rise of inflation throughout the postwar period, this reading of economic history appears rather strange. Moreover, just why a reform which allows central banks the power to readjust the "fixed" price of gold at irregular intervals would prove beneficial is not at all clear. One suspects that such flexibility would encourage inflationary interests to exert pressure upon governments for continual adjustments in the price of gold. On the other hand, if a policy were established which adhered consistently to past practice, the gold price would remain rigidly fixed. But would the nation, or nations, who were designated key currency countries resist the temptation to inflate their own money supply? The lessons of the 1950s and 1960s are hardly encouraging—or they are encouraging only if one uses the 1970s as a point of comparison.

One point therefore seems clear. The orthodox gold standard conforms most closely to a policy rule of law standard. In their advocacy of a gold exchange standard, it is true that such supply-siders as Mundell and Jude Winneski ostensibly favor a fixed price for gold, but their solution as a whole would necessarily undermine a consistent rule-oriented public policy. Aside from narrow technical arguments, they are no more consistent in their defense of rules than are the monetarist defenders of our present system of freely fluctuating exchange rates.[92] That their defense of fixed rules in any true sense is tenuous at best may be observed in the discretionary powers they willingly grant to central bankers. Central banks are charged with the duty of maintaining national currencies within their specific "par value" ranges, which requires them to buy and sell foreign exchange in order to calm markets and maintain equilibrium. In more serious cases,

however, nations may find it necessary to revalue their currencies upward or downward in terms of the price of gold. To accomplish such tasks obviously demands government elites who are armed with a high degree of discretionary authority.[93]

Thus, only the traditional gold standard can truly place governments and government policy under the discipline of a rule. Unlike our present system of freely fluctuating fiat money and its predecessor, the gold exchange standard, the traditional gold standard did not conform to the dictates of central governments and their banks but rather required both to bend to its stern rule. To the traditional defenders of this order, gold offered security to citizens against loss of income due to debasement of the currency by their governments. In the long run the value of their savings was protected from politicians determined to support policies and groups enriched by inflation. It is not accidental that the age of the gold standard coincides with an unprecedented expansion of economic growth and population in the West. It also goes hand-in-hand with the rule of law, since, indeed, as public policy, it most fully basks in the rule of law.

Conclusion

We have argued in this chapter that policy in various areas might be much improved if the insights of Say's Law were joined to abstract rules. In a general way certain scholars have observed that basic freedoms in the market and elsewhere cannot exist indefinitely in the absence of the rule of law. Although what we have said throughout this book would confirm this observation, we supply an additional reason to support this proposition. We have seen that there is far more to the concept of "supply" in Say's Law than a consideration of its economic truths taken in isolation would imply. Indeed, once we relate supply to noneconomic phenomena, various hypotheses compel our attention. Thus, it is apparent that supply bears a close relationship to the Bourgeois Ethic. As a major component of classical economic thought, however, Say's Law is normally associated with an egoistic individualism which social democratic thought and practice ostensibly temper in the interest of the public. It is the Keynesians, those dedicated opponents of Say, who employ anti-Say conclusions to justify a large "public" role for the state; hence, by putting self-interest in its proper place, capitalism will be saved from its excesses.

Yet the Keynesians must be asked a fundamental question. Will not a

political economy based upon assumptions about demand and consumption prove a more fertile ground for the excesses of egoism than one based upon the need to supply? In the process of supplying others is one not much more likely to call forth values and norms conducive to industry, thrift, devotion to task, unostentatiousness, and even (to follow Gilder) altruism instead of an ethic linked to demanding and consuming? Rather, are demand and consumption values not much more prone to breed an obsession with the self and its aggrandizement? We are led to the paradoxical conclusion that a social and economic policy based upon anti-supply principles inadvertently facilitates the growth of values Keynesians claim to abhor. It is a paradox not unlike the one we considered in Chapter 4, where we saw that Political Man was much more likely to possess those unattractive qualities regularly attributed to Economic Man.[94]

Similarly, quite apart from the role they play in the growth of economic, political, and cultural freedoms, abstract rules have various consequences for our temporal vision. By removing the legal system from the clutches of Political Man they function to foist waiting time upon us. More generally they reduce dependence upon the state. When abstract rules are applied to many public policy areas, they reinforce individual freedoms and simultaneously reduce the likelihood of large-scale error so characteristic of many policies. Finally, if "measures" of public policy are inevitably violations of the rule of law principle, it may nevertheless be said that policy rules do less violence to that ideal than do those policies based upon discretionary elements. To this extent they provide hope that we may reconstruct the social order upon more secure foundations.

Chapter 8

Reform and Its Limits

Most of the great eighteenth- and nineteenth-century liberal thinkers were dedicated to limited government under the rule of law, political liberty, and economic freedom. Their twentieth century successors sought, on the whole, to retain the first two elements but added a strong feature of social and economic equality. Unfortunately, since they progressively sacrificed much in the way of economic freedom, the ideals of limited government and the rule of law were themselves increasingly attenuated. It is a story of ideological decline which has been told many times by various scholars offering diverse opinions.

In this book we have argued that unless some restoration of the older ideal of liberalism is effected, the result is likely to prove ruinous both to our liberty and prosperity over the long run. Rather than addressing those themes most common to liberalism, however, we have sought to demonstrate that major elements of the traditional liberalism, such as the rule of law and economic freedom, are themselves closely attuned to the persistent demands which temporality imposes upon all human action. Thus, a major reason why liberalism in its traditional guise has brought so many benefits to the human race is that its central notions are congruent with the demands of time. It was especially from the work of Carl Menger, Eugen von Boehm-Bawerk, and the Austrian School of economics that social science finally began to make the connection between temporality and various human activities.

We ignore the constraints which time places upon us at our collective

peril. Human beings necessarily act through time, so its mere passage has important consequences for individuals and societies alike. In particular, our plans for the more or less distant future are likely to go awry, since we perforce make choices without prior knowledge and current information about what others have done, are doing, and will do. Our social worlds are accordingly uncertain and unpredictable. Moreover, since each of us possesses a different stock of knowledge accumulated through earlier experiences, our imagined futures will likewise diverge. Were any two individuals to call somehow upon similar experiences, it by no means follows that their interpretations of the future would lead each to form similar expectations about the course of subsequent events. We are thus doomed to live with uncertainty and unpredictability.

Furthermore, the farther events extend into the unknown future, the more tentative our plans are likely to become and the more likely they are to call for revision. There is accordingly a need for institutions, rules, and norms which, at a minimum, contribute to the stabilization and harmonization of expectations among otherwise diverse human beings. After all, any number of problems that we face daily occur under uncertain conditions in which institutional integrity makes a great deal of difference: Families must decide whether they can afford children in the future; homemakers and other consumers as well as savers and entrepreneurs must contemplate whether prices will rise or fall in the future; farmers must worry about livestock and crop production levels, not to mention land prices and interest rates; business must anticipate consumer needs; officials must invariably speculate about the effects of their programs and policy directives upon economy and society. In these and a myriad of other ways, each of us must form our expectations in contexts of uncertainty. The trick, of course, is to make reforms which facilitate the coordination of individual plans and yet bend with the realities of human diversity and the demands of time. Since there is little evidence thus far that we have begun to learn this lesson, it is hardly surprising that the feeling grows in the general public that we are losing control of our institutions.

In addition to the problems humans invariably encounter with the march of time, there is another aspect of temporality which ought to be emphasized. It is that time is a scarce resource to be allocated among competing ends; various alternatives of necessity must be sacrificed if other, more desired aims are to be achieved. The creation of industrial society required the utilization of human effort, physical resources, and capital. In addition, the capital growth which characterizes its high development took

time in the sense that its present state embodies a lengthy process of capital accumulation. It is obvious that scarcer resources, including time, went into, say, the building of a tractor than into the production of a scythe. At bottom the comparative economic wealth of societies results from many decisions being made over time which stress saving and investment at the expense of consumption and leisure. "Lack of capital," said Mises, "is dearth of time."[1]

Time, to be sure, is allocated among competing ends in a more fundamental way than are other scarce resources. It is scarce in a way that capital and consumption goods are not. Time's importance as a scarce resource is related not only to the need to allocate it between such activities as basketball games or movies but also to what may be designated as "existential scarcity."[2] First, we have only so many years on this earth. Secondly, we have only so much energy to expend. Finally, some choices are so crucial to the course of our lives that, having once made them, we find it almost impossible to reverse in any meaningful way our previous commitments. In this case we effectively eliminate other potential aims in life. The decision to become a lawyer or a doctor, for instance, effectively precludes other options. And once we introduce the barriers of intellect, money, status, class, and residence into our discussion, we can see that the fact of time imposes many severe restrictions upon our lives. To this extent the argument by Marxists and others that one's potentialities may be actualized cannot carry us very far; indeed, the concept of self-actualization is mostly a chimera. "Under no circumstance," Walter A. Weisskopf has written, "can man accomplish an existence in which he can actualize all of his potentialities." To deny the fact of existential scarcity, he goes on to say, is to "raise hopes which can never be fulfilled and lead only to disillusion, despair, and self-destruction."[3] He might have added that its denial leads to inflated expectations, dashed career hopes, false utopias, and "demand overload" in modern societies.

In general, it may be hypothesized that those who are predisposed to save for the future and invest their labor (mental and physical) in market economies whose functions and limits they likewise comprehend are less likely to have problems with existential scarcity than do those who are addicted to leisure, who are enamored with consumption, and who resent the role played by free markets. Few postindustrial societies possess to a large degree the former traits, especially that of saving. Only Switzerland, Japan, and West Germany cling to the older habits, often in the face of fierce criticism from a more "advanced" American government which

feverishly consumes the savings of others and insists that Japan and West Germany in particular inflate their economies in order that American exports may be increased. Apparently, worldwide inflation is the recipe for prosperity.

Our effort to find our way through temporal thickets leads us to conclude that students of public policy must make time an important component of their work. If this is true, then a basic problem is to discover how public policy best conforms to temporal demands. Our view is that a new balance must be struck between Political Man and Economic Man. We have argued that the public places far too much faith in the ability of public officials to remedy social and economic maladies. On the contrary, political executives, civil servants, legislators, and party leaders are as a rule far more responsive to short-run pressures than are individuals who are situated in private economic roles. It follows, therefore, that policies calculated to reduce the influence of the public sector in various areas of social and economic life would have beneficial effects upon our time horizons. Indeed, in recent years various students of public policy have put forward ideas which are intended to reduce the dominant position of the public sector, although, with few exceptions, the problem of time has played little part in their studies. For example, the "public choice" school and its major spokesman, James M. Buchanan, have for some time sought to undermine the prevalent view that public officials are somehow less oriented to "self-interested" incentives than are ordinary economic actors in the private sector.[4] We accept this conclusion, adding to it the proposition that political actors are also more likely to be characterized by short time horizons than are economic actors.

Thus, we would agree with those who make this case for a public policy oriented to privatization, rules, and free markets. The road to reform would likely include at least the following: (1) reductions in the size and scope of government; (2) the introduction or extension of the idea of rules rather than commands, wherever appropriate, into the legal, economic, and social welfare area; and (3) the creation of various constitutional rules and procedures which would affect the tempo of political life and conflict.

Size and Scope of Government

With regard to the size and scope of government, there is an increased awareness in many quarters that the modern social-service state has almost reached its limits. It indeed acts as a brake upon employment and

productivity. As a consequence, its excessive growth makes the provision of vital services in future years all the more problematical since the economic pie expands insufficiently to cover the costs of the welfare state. In this work, we have given only fleeting attention to the problem of government size as such, mainly because the effects of this trend have been discussed so often in other places. Nonetheless, as our own short study of Switzerland surely suggests, there is every reason to believe that shrinking the size of government, in terms of cost and functions performed, would alter temporal horizons favorably.

It is therefore not surprising that privatization has recently come in vogue as governments seek to shed unprofitable operations by selling their nationalized assets to private individuals. France, Great Britain, Japan, Austria, and the United States, for example, have all embarked upon such adventures.[5] There is, moreover, a growing realization that government regulation of the private sector is itself often responsible for both the rising costs of consumer goods and reduced employment and productivity. Policies which license, subsidize, or otherwise protect particular business and professional groups are coming under strong attack from various quarters. If such policies finally gain widespread support in the public, the effects would be to shift more capital and labor into the private sector, where competitive market principles prevail, and where, barring irresponsible inflationary policies, time preferences are less likely to be distorted. No doubt the inclination of the "no-risk society"[6] is to demand complete security of occupation, income, workplace, old age, and medical care, not to mention government protection from natural disasters. Policies which attempt to eliminate all risk are, of course, self-defeating and detrimental to economic growth in many cases. Again, the tendency for the middle classes to take advantage of programs designed originally for the more unfortunate members of society has created privileges which will be fiercely defended.[7] The winner in this continuing struggle between freedom and security will dictate to a great extent the direction of temporal values in the foreseeable future.

Rules rather than Commands

The implementation by policymakers of programs, statutes, and common laws based upon the authority of rules rather than upon discretionary commands is to be applauded. In this study we suggested that a more consistent application of rules would enhance efficiency and/or liberty in

such areas as education, housing, urban renewal, and monetary policy. Rules provide indispensable signposts for individuals who seek their own specific ends but who are likewise confronted with a world of uncertainty and divergent expectations. As a major element in the private law, they provide a semblance of systemic order, yet also allow individuals to utilize their own resources as they see fit. When they are well drawn, rules reconcile the need for stability with change.

Rules, moreover, are particularly crucial to the operations of free markets where property and individual rights are common. Competition under market conditions is essentially a "discovery procedure" in which participants need an umpire who guarantees protection against theft and fraud but at the same times does not prevent the exchange of information and goods. Recent events make this point clear. As deregulation proceeds, as products penetrate national boundaries with increasing frequency, as branches of major corporations settle in foreign countries, and as capital flows abroad have major impacts upon domestic policies and groups in other nations, a legal and monetary order based upon abstract rules is more essential than ever to political stability. "Pragmatic" flexibility as a response to change will probably become even less satisfactory, as our present intervention in world currency markets makes all too clear.

On the other hand, a system based upon large-scale interventions or, worse, collectivist economic planning will create even greater uncertainty among economic participants. The constant imposition of new regulations and the granting of subsidies which prevent entrepreneurs from determining the more urgent wants of consumers will prove counterproductive as national economies grow increasingly interdependent. Likewise, efforts to prevent changes in the direction of economic freedom will produce greater instability not only in economic but also in other policy areas, as we have observed throughout this study. In other words, a legal order based upon rules rather than discretionary authority is most congruent with freedom, efficiency, and the ultimate reality of human action. And because such an order is compatible with the fundamentals of human action, it is likewise most congruent with the demands of time.

As stable features of the social landscape, rules play an indispensable role in the structure of our time horizons. They are thus an obstacle to those political interests which seek to manipulate political processes for their own short-run satisfaction. To put it another way, rules thwart interest groups and public officials who would otherwise be encouraged to believe that the public treasury and regulatory system are up for grabs.

Indeed, from the standpoint of officials themselves, rules to a great extent provide a protective cover from group pressures, since the former are denied from the outset a "flexible" or "practical" response to the claims of those with political or financial clout. Generally, rules securely in place tend to inhibit that incessant mobilization and countermobilization among contending factions which socializes conflict and hence politicizes society. This process, unless contained, leads social orders relentlessly to "demand overload" in government and dashed expectations among the citizenry.

Constitutional Reform

Still another area in which an understanding of the role of time in human affairs might prove enlightening to students of public policy is constitutional reform. It would not be an exaggeration to say that our knowledge of the temporal role in constitutional matters, however, is in its infancy. In our brief study of the Swiss political system, we suggested that various temporally-related factors may have contributed to the strength of its constitutional democracy. In one way or another, those constitutional and political factors which otherwise might have stimulated the growth of short time horizons and consequently the politicization of life in that nation, have clearly been undermined. For example, the conservative effects of the legislative challenge, the short parliamentary sessions, the limited power of the political parties in government recruitment, the secure tenure given to ministers, the high value placed upon administrative expertise, the collegiality and secretiveness of cabinet decisionmaking, the cabinet and ministerial domination of the legislative process, and the limited fiscal powers of the central government have all played an important part in this vital process. The constitutional and political factors in conjunction with a strong market economy and Bourgeois Ethic have kept politicization of the society to a minimum.

Although one nowhere finds experts in constitutional law making a fetish of time, it is arguable that temporal assumptions indeed sometimes lie at the heart of their arguments. For example, it was well perceived by the Founders of the American Republic. They were clearly aware that "a continual change of government measures (laws) is inconsistent with every rule of prudence, and every prospect of success."[8] Furthermore:

It will be of little avail to the people that the laws are made by men of their own choice, if the laws be so voluminous that they cannot be understood; if they be

repealed or revised before they are promulgated, or undergo such incessant changes that no man who knows what the law is to-day can guess what it will be tomorrow.

Another effect of public instability is the unreasonable advantage it gives to the sagacious, the enterprising and the moneyed few, over the industrious and un-informed mass of people. Every new regulation concerning commerce or revenue, or in any manner affecting the value of the different species of property, presents a new harvest to those who watch the change, and can trace its consequences; a harvest, reaped not by themselves, but by the toils and cares of the great body of their fellow citizens.[9]

In general, they believed that a refined "deliberative sense" of the commu-nity is a basic ingredient in a prosperous and stable republic. According to Kendall and Carey, the founders in no way sought to thwart democracy, but wished instead to temper the pace and sheer force of its movement across the nation.[10] As chief agent of the democratic principle, the House of Representa-tives was awarded a first-among-equals position vis-à-vis the other major in-stitutions, but the Founders nonetheless thought it expedient to put constitu-tional roadblocks in the way of the major democratic branch of government. They were determined to prevent those massive swings in opinion which might be put to demagogic ends detrimental to republican stability. Thus, the separation of powers, checks-and-balances, federalism, and other con-stitutional procedures were erected in order to slow the tempo of political change. Unlike so many modern political scientists, the Founders perceived that little good comes from a widespread political socialization of conflict. It was subsequent generations who came to a contrary opinion.

One may read a similar interpretation into the constitution of the French Fifth Republic. Here, too, temporal assumptions apparently guided the creators of the new Republic in 1958. It may also be argued that the French system includes institutions and processes which also seek to refine the "deliberative sense" of the community. Since fear of an unfettered Assem-bly was of paramount concern to leading Gaullists, it is not surprising that the founders of the Fifth Republic would award equal power to a Senate indirectly elected; that they would insist upon drawing a distinction be-tween separate domains for "law" and "regulations" which confines the legislature to specified law-making areas and also denies it residual pow-ers; that they would place limits upon the right of the National Assembly to vote no-confidence in the Government; and, as spelled out in various articles of the constitution, that they would award the government pro-cedural advantages over parliament so far as the agenda, debate, and bud-get are concerned. Although the American Founders mostly feared mass

pressures, whereas the French constitutionalists in 1958 were especially wary of a rambunctious Assembly, each perceived the basic threat to stability in the form of rapid, widespread onslaughts upon the seats of authority by demagogues and their followers. The Americans, after all, were making a democratic experiment in an age of monarchy; given the prejudices of their era, they were naturally concerned about the behavior of the general populace. On the other hand, the source of potential instability in 1958 in France, the Gaullists believed, derived from a "political class" corrupted by weak institutions. The early Americans feared "factions" which might merge into one mighty force, the other a "regime of parties" intent upon bringing the state to its knees. In each case, however, there was fear that ill-considered policies based upon short-run actions and demands would undermine order and stability.

It is obvious that constitutional reform based upon temporal notions would necessarily accord rules an important place. With the present positivist predispositions of jurists in this country and across the Atlantic, however, the prospects for a return to the rule of law as traditionally understood are not encouraging. Reform would be much more likely if judges began to attend to property rights with as much fervor and devotion as they presently apply to "human rights." Thus, if property were given equal respect, the extension of rules into many areas of society where discretionary justice now runs rampant would become a real possibility. This is certainly the conclusion to be drawn from important works by Rothbard and Epstein.[11] Since such a reorientation would reduce the power of Political Man, it is entirely conceivable that, other things being equal, the general pattern of time preferences in Western societies would also be altered.

With the notable exceptions of government taxing and spending, reform in these areas would mainly require a consensus among political elites. A reform from the top down, as it were, would affect behavior at the mass level only indirectly and then over a protracted period, although in the case of monetary reform, for example, the benefits ought to become evident in the relatively near future. It is at the sociocultural level, however, that traditional interests would prove most resistant to reform. Good public policy, after all, can take one only so far in the reformation of religious and ethical norms and values. The Bourgeois Ethic, or some facsimile, might well be encouraged if proper fiscal and monetary incentives were accorded savings and thrift, but when the social position of the older bourgeoisie has been undermined by the growth of a large bureaucratized and essentially nonpropertied white-collar class, when religiosity has been

weakened by relativism and pluralism, and when secular ideologies based upon collectivist premises promise an earthly paradise, the prospects for renewal do not appear particularly propitious at this time. In other words, any efforts to alter the status quo must compete with all the forces of mass society and mass culture.

In this respect capitalism plays a rather mixed role in its own defense. Surely in this age the material and political benefits it has bestowed upon the masses cannot be doubted. That it continues to evoke opposition, both from a populace which pressures its representatives to place obstacles in the way of efficient market allocations and from intellectuals who despise it as a system, is an interesting topic in itself. In this book we have had occasion more than once to mention the various sources for this opposition; and in order to throw some light upon this problem, we have drawn heavily upon the thought of such diverse writers as Schumpeter, Hayek, Schoeck, Lipset, Polanyi, Bell and Kristol, to mention only a few of the more important ones.

We would like to stress again a somewhat different perspective, one which is basically compatible with other interpretations. If we consider capitalism as a system of socioeconomic organization, we see that it is often feared, disliked, or even rejected because its very dynamism stimulates a diffuse sense of apprehension about the future. It offers rewards and punishments according to the value of one's services to anonymous consumers. Consumer preferences, however, often change to the detriment of many suppliers of goods and services. For their part, intellectuals, whose stock-in-trade is opposition to the values of mass consumption, indict capitalism because it presumably ranks quantity over quality in the allocation of status and worth. It thus refuses to regard people according to intrinsic merit as defined by intellectuals themselves. And, in those instances in which intellectuals are especially dependent upon mass tastes for their income, their alienation from society may be acute. But among most categories of people there exists the uneasy feeling that their status or income is never quite secure. Furthermore, even if particular individuals are relatively comfortable with their circumstances, they daily note the shifting fortunes of those neighbors who, for whatever reason, fail to respond appropriately to impersonal market signals and to the anonymous consumers who propel capitalism. This fear of the unknown future is driven underground in times of general prosperity, but at the first sign of economic or social dislocation, it again springs forth into the public consciousness. The demand for government protection from competition and for income

support becomes well-nigh impossible to contain politically. The cost, of course, is ultimately borne by the politically weak citizens and by those who practice the bourgeois virtues.

But even if this diffuse sense of apprehension and foreboding can never be entirely eliminated from the human psyche, it can nevertheless be managed once the basic functions and overall benefits of competitive markets are understood. As we argued in the last chapter, a proper understanding of Say's Law provides a means by which we may comprehend and, we hope, manage our divided selves. Strictly speaking, Say teaches that, depending upon how one wishes to look at the problem, supplies are demands. But one cannot demand (and consume) unless one can in fact supply others. It may therefore be more accurate to say that people supply one another. To supply, in turn, connotes values other than merely supplying goods and services. In a sociocultural sense it implies such values as thrift, patience, forebearance, and work. In other words, in ordinary *usage* a supplier of goods and services is much more likely to be oriented to long-run activities and behavior than is a demander and consumer of goods and services.

At this point Say offers us an insight into the basic human condition in an era of social mobility and material affluence. Economic change has stimulated a division within the self which gives rise to a simultaneous demand for the unimpeded "right" to consume with abandon and for the "right" to an assured status or class position within the social hierarchy.[12] Neither our supply side nor our demand side is to be denied full rein. Unfortunately for those of us in modern societies, these two "rights" often turn out to be incompatible with each other, since in the aggregate we consumers punish and reward *specific* suppliers of goods and services who may or may not be ourselves.

Throughout most of history the divided self has been reconciled mainly through restrictions on the consumption side according to the position one held within a somewhat rigid status or class hierarchy. Aristocrat, bourgeois, peasant, and urban worker were characterized by distinctive life-styles and consumption patterns. The fact that productivity was rather low for our ancestors meant that choices were severely limited for the bulk of the population. But if consumption was restricted for the great mass of mankind and the range of choices sharply defined, the supply side of life was also relatively stable. Indeed, the insistence by the classical economists that consumption was the end of production must have seemed a revolutionary concept to most people in the eighteenth and nineteenth cen-

turies. Production and consumption were therefore regulated through legal and customary barriers to entry into markets and occupations, but the existence of this system had the effect of creating a greater degree of psychological security and a resignation to existing conditions than is possible in modern societies.

The modern Industrial Revolution impinged strongly upon attitudes and values with regard to the future. Optimism gradually increased, but in many quarters so did pessimism. In the one hundred and twenty-odd years before our century, one finds the optimism of a Condorcet, Helvétius, Mill, or Spencer existing beside the dark forebodings of a Burke, de Maistre, or Bonald. It is significant that in the nineteenth century the theme of alienation first enters our vocabulary, for the forces unleashed by industrialism increasingly estranged our producer selves from our consumer selves. Thus, with the rapid expansion of choice, a growing population grew ever richer and greater numbers began to enter the middling classes. Wealth and freedom increased; privilege retreated.

On the other hand, a cost was to be paid from the standpoint of psychic security. Indeed, our twentieth-century prosperity has exacerbated that diffuse, gnawing sense of apprehension regarding future events and one's place in the community. It is a condition undoubtedly made more severe by the extension of the division of labor and market competition; and despite the clear benefits of these changes, they are nevertheless often resented as contrary to mass welfare. Anne Mayhew's study of American farmers in the nineteenth century, for example, is instructive in this respect. Despite a general rise in the agricultural terms of trade and declines in interest and freight rates, farmers became ever more convinced that they were mere tools in the hands of Eastern bankers and railroad barons. "Even though the prices he received were falling less rapidly than the prices he paid," she writes, "the farmer protested about his 'deteriorating' economic position because he was locked into a system where his success or failure now depended on prices—a system where, even if he was a 'good farmer' in pre-1800 terms, he might fail because he was a 'bad businessman' in late nineteenth-century terms."[13]

It is this form of estrangement from the world that afflicts modern societies and ultimately drives people into the arms of the protective, service-providing state. In a perverse Hegelian sense, the state unites and reconciles in a higher synthesis our divided producer and consumer selves. Yet in free and democratic societies the state must invariably fail in the task which is thrust upon it. It cannot, after all, openly restrict consumption

without causing a rebellion at the polls. For this reason it seeks to effect changes on the supply side of life. Consumption preferences, however, vary enormously and change rapidly, so the value of most products and the psychic security of those who are dependent upon them is necessarily somewhat tenuous. Since consumption in mass-production societies cannot be sufficiently stabilized and thus made more or less specific over time to status and class, as in rigid class and status hierarchies, the state's only realistic option is to shore up specific producer interests and hope that living standards do not suffer.

Thus, the separation of our producer and consumer selves encourages public officials to favor the panopoly of subsidies and regulations common to modern democracies. It is as if citizens in industrial societies wish somehow to return to a feudal and traditional order on the supply side of life while maintaining the "demand" side of the modern world. The state is viewed as our status or class protector, but its intermittent support can seldom ease the sense of fear and loneliness. These fears derive in essence from a nonguarantee of security in status, income, and occupation which exists with a wide array of consumptive choice propelled by capitalism.

State officials and political parties unintentionally aggravate both those tensions created by the division within the self and temporal disorder: Through one set of public policies the political system encourages private and public consumption and demand, yet simultaneously through the impediments it places upon production and employment, it unintentionally exacerbates insecurity and alienation among the governed. A point is necessarily reached at which the system of subsidies, quotas, tariffs, taxes, licenses, and business regulations begins to have serious effects upon production. In times of crisis an Adenauer or a de Gaulle may enter the democratic political arena and impose reforms. More often, however, the impulse to grant privileges to specific groups merely stimulates rival demands. A process of "intervention entropy" then ensues by which each new tax or regulatory burden calls forth a strong effort to resist on the part of those who are harmed by the latest intervention. Thus, in the public sphere political parties attempt to socialize conflict in order to win support for aggrieved interests, whereas in the private sector tax lawyers, financial advisers, accountants, and others whose function it is to aid citizens in their efforts to escape taxes and regulations proliferate.[14]

Western societies are therefore suspended uneasily between an intense desire for material comforts and an unwillingness or inability to give in-

tellectual sustenance to those impersonal market allocations and formal rules which have sustained the prosperity and liberty their citizens have by now come to regard as normal. Indeed, these institutions are more tolerated than esteemed. Since legal and economic systems based upon abstract rules and impersonal markets can seldom command a strong and persistent public loyalty, they are undermined by ideologies and political party programs which promise quick solutions to complex social and economic ills. At the same time those traditional social and cultural habits, opinions, and attitudes which lend legitimacy to productive activities are progressively overwhelmed by powerful interests which take prosperity for granted, demand such an array of "rights" that the term itself is almost bereft of meaning, and insist that any number of incomes and occupations be protected from market competition. Consequently, the internal restraints which must necessarily be placed upon the drive for immediate gratification are steadily eroded, while the social-service and regulatory state itself assumes the duty to protect the citizenry from a growing number of perceived "risks" to income, occupation, and status. Unless the people of Western democracies come to terms with these contradictory pressures, one can only conclude that the prospects for stable democracy are indeed problematical.

On the other hand, there are grounds for optimism. The past decade has seen a resurgence of interest in those values and policies bequeathed to us by the older liberalism, whereas the modern social democratic ("liberal") ideal of centralized government and income redistribution has been questioned on both sides of the political spectrum. True, the social democratic influence remains strong in intellectual circles, although the election of various governments from the Right in recent years suggests that its hold on the masses is no longer quite secure. What commentator at the beginning of the 1970s, after all, would have dared to predict the rise to power of such ideologists as Margaret Thatcher and Ronald Reagan? Similarly, in the area of economic policy, both Keynesians and neoclassicals have come under mounting criticism from a variety of monetarists, supply-siders, and Austrians. Finally, in the field of political theory, libertarians and conservatives command a much more respectful hearing than was possible only a few years ago. As a general rule the former stress private choice and economic freedom, whereas the latter emphasize those norms and values which give us moral order and unity. But no matter what their other differences, both are for the most part agreed on the proposition that excessive dependence upon the public sector and the weakening of

the private sector have been unfortunate from the standpoint of the public welfare. Thus, this growth of diversity in opinion on both sides of the political spectrum has made discussion of political, social, and economic problems possible to a degree few libertarians or conservatives would have predicted only a short time ago.

Notes

Chapter 1

1. Robert E. Ornstein, *On the Experience of Time* (New York: Penguin, 1970), 15–24.

2. Pitirim A. Sorokin, *Sociocultural Causality, Space, and Time: A Study of Referencial Principles of Sociology and Social Science* (New York: Russell & Russell, 1964), 159–225.

3. This book is the product of many sources, but it owes a special debt to G. L. S. Schackle, Ludwig M. Lachmann, Alfred Schutz, and, in general, the Austrian School of economics. G. L. S. Shackle takes what may be considered the most radical view of time in the policy sciences: *Imagination and the Nature of Choice* (Edinburgh: Edinburgh Univ. Press, 1979) and *Epistemics and Economics* (Cambridge: Cambridge Univ. Press, 1972). Lachmann, carrying on the great tradition of Max Weber and Alfred Schutz, employs a methodology that is a judicious blend of Weber, Schutz, and the founder of the Austrian School of economics, Carl Menger. See especially his *Capital, Expectations, and the Market Process: Essays on the Theory of the Market Economy,* ed. Walter E. Grinder (Kansas City, Mo.: Sheed, Andrews and McMeel, 1977). Schutz has exercised a strong influence in sociology. We found most useful his "Tiresias, or Our Knowledge of Future Events," in *Collected Papers II: Studies in Social Theory,* ed. Arid Brodersen (The Hague: Martinus Nijhoff, 1971), 277–93. Among the Austrians, see, in addition to Lachmann, particularly Ludwig von Mises, *Human Action: A Treatise on Economics,* 3rd rev. ed. (Chicago: Regnery, 1966), esp. 92–118; and Murray N. Rothbard, *Man, Economy, and State: A Treatise on Economic Principles* (Van Nostrand, 1962), 1–27. Other especially pertinent studies are Clifford Sharp, *The Economics of Time* (Oxford, Eng.: Martin Robertson, 1981); George Soule, *Time for Living* (New York: Viking, 1956), 86–101; Schlomo Maitel, *Minds, Markets, and Money* (New York: Basic Books, 1982), 54–81; Bernard P. Dauenhauer, "Making Plans and Lived Time," *Southern Journal of Philosophy* 7 (Spring 1969): 83–90; George Gurvitch, *The Spectrum of Social Time* (Dordrecht-Holland: D. Reidel, 1964); and John R. Hall, "The Time of History and the History of Times," *History and Theory* 20 (Feb. 1980): 113–31.

4. Mises, *Human Action,* 1–19; and Rothbard, *Man, Economy, and State,* 1–6. Although this study is written by a political scientist who is particularly indebted to economics, it must be stated that the approach in the next few pages is quite in line with some recent work in psychology. See M. A. Dapkus, "A Thematic

Analysis of the Experience of Time," paper presented at the 91st Annual Convention of the American Psychological Association at Anaheim, California, August 1983.

5. This is a basic theme in Shackle's work. For an analysis, see Lachmann, "Professor Shackle and the Significance of Time," in *Capital, Expectations, and the Market Process,* 81–93.

6. Shackle, *Imagination and the Nature of Choice,* 6ff.

7. Schutz, "Tiresias, or Our Knowledge of Future Events."

8. Alfred Schutz, *Collected Papers I: The Problem of Social Reality,* ed. Maurice Natanson, (The Hague: Martinus Nijhoff, 1962), 36, 66–96; Lachmann, *The Legacy of Max Weber* (London: Heinemann Educational Books, 1970), 26–34, and his *Capital, Expectations, and the Market Process,* 65–80.

9. This point has received special attention in Schackle's work. For a discussion of this point, and others, see Alan Coddington, "Creaking Semaphore and Beyond: A Consideration of Shackle's 'Epistemics and Economics,'" *British Journal of the Philosophy of Science* 26 (June 1975): 152–63.

10. See Lachmann, *The Legacy of Max Weber,* 49–91.

11. See Rothbard, *Man, Economy, and the State;* Sharp, *The Economics of Time,* 10–11; Soule, *Time for Living;* and P. N. Rosenstein-Rodan, "The Role of Time in Economic Theory," *Economica* 1 (1934): 77–97. Indeed, so important is time for some writers that it is included as a factor of production. This is true, for example, of Mises and Soule, who differ widely in other respects.

12. In the stress upon action we are especially indebted to the works, previously cited, of Mises and Rothbard.

13. This point of view, of course, is associated with the Austrian School of economics, but is also to be found in the work of other economists and noneconomists. See, for example, Irving Fisher, *The Theory of Interest* (New York: Kelley, 1965), 503–5; and Maitel, *Minds, Markets and Money.*

14. Mises, *Human Action,* pp. 525–37; and Rothbard, *America's Great Depression* (Kansas City, Mo.: Sheed and Ward, 1975), 17–18.

15. Maitel, *Minds, Money, and Markets.*

16. See, e.g., the work of P. T. Bauer, *Dissent on Development: Studies and Debates in Development Economics* (Cambridge: Harvard Univ. Press, 1972).

17. Schutz, *Collected Papers I;* Friedrich A. Hayek, *Law, Legislation, and Liberty: Rules and Order* (Chicago: Univ. of Chicago Press, 1973), 17–24; and T. Alexander Smith, "A Phenomonology of the Policy Process," *International Journal of Comparative Sociology* 23 (March–June 1982): 1–16.

18. Lachmann, *The Legacy of Max Weber,* 87–100.

19. For different reasons altogether we would agree with the Marxists, who stress for their own reasons that society, economy, and polity require congruent structures, and would disagree with the democratic socialists and liberals, who advocate interventionism in economic life but expect noneconomic freedoms to escape the clutches of government.

20. The classic is undoubtedly Joseph A. Schumpeter, *Capitalism, Socialism, and Democracy* (New York: Harper Torchbooks, 1950). See esp. 59–164.

21. See, e.g., the balanced account of William Letwin, "Economic Due Process

in the American Constitution and the Rule of Law," in Robert L. Cummingham, ed., *Liberty and the Rule of Law* (College Station: Texas A & M Univ. Press, 1979), 22–73.

22. Among the best studies of the rule of law are: Michael Oakeshott, *On History, and Other Essays* (Oxford: Basil Blackwell, 1983), 119–64; Hayek, *Law, Legislation, and Liberty: Rules and Order;* and Bruno Leoni, *Freedom and the Law,* (Los Angeles: Nash, 1972).

23. Theodore J. Lowi, *The End of Liberalism: The Second Republic of the United States,* 2nd ed. (New York: Norton, 1979). But cf. Hayek, *Law, Legislation, and Liberty: Rules and Order,* 55–71.

24. J. T. Winkler, "Law, State, and Economy: The Industry Act of 1975 in Context," *British Journal of Law and Society* 2 (Feb. 1975): 103–28.

25. In this regard, see the works, previously cited, of Maitel and Schumpeter as well as Sigmund Freud, *Civilization and Its Discontents* (New York: Norton, 1961); and Hans Gerth and C. Wright Mills, eds., *From Max Weber: Essays in Sociology* (New York: Galaxy, 1958), 267–359.

26. These trends are discussed in Hayek, *Law, Legislation, and Liberty: Rules and Order,* 55–93; for a most interesting recent account, see Shirley Robin Letwin, "Law Without Law: Politics in the Courtroom, *"Policy Review,* no. 26, (Fall 1983): 7–15.

27. This argument is quite in agreement with a recent study of Richard Epstein, "The Social Consequences of Common Law Rules," *Harvard Law Review* 95 (June 1982): 1717–51.

28. Hayek, *Law, Legislation, and Liberty: Rules and Order,* 139; also, Oakeshott, *On History.*

29. See, e.g., the remarks of Shackle, *Imagination and the Nature of Choice,* pp. 52–60; and Hall, "The Time of History and the History of Times."

30. D. T. Armentano, *The Myth of Anti-Trust* (New Rochelle, N.Y.: Arlington House, 1972); and Robert H. Bork, *The Anti-Trust Paradox: A Policy at War With Itself* (New York: Basic Books, 1978).

31. This is true for the Marxists and "Post-Keynesians" such as Mrs. Joan Robinson, Lord Kaldor, and Piero Sraffa and for the Austrians.

32. The most popular recent versions are surely those of Alvin Toffler, *Future Shock* (New York: Random House, 1970), and Daniel Bell, *The Coming of Post-Industrial Society: A Venture in Social Forecasting* (New York: Basic Books, 1973).

33. The classic argument in this regard is Friedrich A. Hayek, "The Use of Knowledge in Society," *American Economic Review* 35 (Sept. 1945): 519–30; for a recent use of Hayek's approach, see the stimulating study of Thomas Sowell, *Knowledge and Decisions* (New York: Basic Books, 1980).

34. This theme is neatly developed in Henry Hazlitt's book, *Economics in One Lesson* (New York: Manor Books, 1975).

35. See Norman Barry's fascinating account of this problem in "A Defense of Liberalism Against Politics," *Indian Journal of Political Science* 41 (June 1980): 171–97.

Chapter 2

1. David Riesman, with Nathan Glazer and Rewel Denney, *The Lonely Crowd* (Garden City, N. Y.: Doubleday Anchor Books, 1953).
2. This is a theme which pervades Wilhelm Roepke's work. See, e.g., *A Humane Economy: The Social Framework of the Free Market* (Chicago: Henry Regnery, 1960); and Schumpeter, *Capitalism, Socialism, and Democracy.*
3. See Jesse R. Pitts, "Continuity and Change in Bourgeois France," in Stanley Hoffmann et al., *In Search of France* (Cambridge: Harvard Univ. Press, 1963), 253.
4. Ibid., 250–59.
5. Schumpeter, *Capitalism, Socialism, and Democracy,* pp. 160–61. Our italics.
6. This is the theme of Christopher Lasch, *Haven in a Heartless World: The Family Besieged* (New York: Basic Books, 1977).
7. Ibid., 164–65, 178.
8. Ibid.
9. Marvin Harris, *America Now: The Anthropology of a Changing Culture* (New York: Simon and Schuster, 1981), 81.
10. Ibid., 82.
11. Ibid., 80ff.
12. Leonore J. Weitzman, *The Divorce Revolution: The Unexpected Social and Economic Consequences for Women and Children in America* (New York: Free Press, 1985), xii.
13. See *Insight,* Oct. 13, 1986, 8–17. For unmarried mothers the figures are even more disturbing: $5,665.
14. See Victor Fuchs, "What's Leaving Children Poor?", *Wall Street Journal,* Oct. 2, 1986.
15. David C. McClelland, *The Achieving Society* (Princeton: Van Nostrand, 1961), 333–38.
16. See Maitel, *Minds, Markets, and Money,* 59.
17. Gail Sheehy, "Introducing the Postponing Generation," *Esquire* 92 (Oct. 1979), 27.
18. Ibid., 33.
19. J. D. Unwin, *Sex and Culture* (Oxford: Oxford Univ. Press, 1934).
20. Sorokin, *The American Sex Revolution,* (Boston: Porter Sargent, 1972), 107–30.
21. Ibid., 71–72.
22. See Weitzman, *The Divorce Revolution;* and Office of Policy Planning and Research, United States Department of Labor, *The Negro Family: The Case for National Action,* March 1965, 38–41.
23. Ibid.
24. *Haven in a Heartless World,* 165.
25. Ibid. Emphasis ours.
26. On these matters, see Philip Abbott, *The Family On Trial: Special Relationships In Modern Political Thought* (University Park: Pennsylvania State Univ. Press, 1981), 5–6, 14–38; also, see Jane Bethke Elshtain, *Public Man, Private Woman: Women in Social and Political Thought* (Princeton: Princeton Univ. Press, 1981).

27. This is the theme of James S. Fishkin's *Justice, Equal Opportunity, and the Family* (New Haven: Yale Univ. Press, 1983).

28. See, e.g., Charles Murray, *Losing Ground: American Social Policy 1950–1980* (New York: Basic Books, 1984; and George Gilder, *Wealth and Poverty* (New York: Basic Books, 1981).

29. Abbott, *The Family On Trial*, esp. 199–208.

30. See Fuchs, "What's Leaving Children Poor?"

31. On this point we may agree with Edward Banfield, *The Unheavenly City Revisited* (Boston: Little, Brown, 1974), 30.

32. Schumpeter, *Capitalism, Socialism and Democracy*; C. Wright Mills, *White Collar: The American Middle Classes* (New York: Oxford Univ. Press, 1956); and Andrew Hacker, *The End of the American Era* (New York: Atheneum, 1971).

33. See, for example, Gilder, *Wealth and Poverty*, 145–52.

34. A significant exception is Georges Gurvitch, *The Spectrum of Social Time*, 92–96. However, there are significant difficulties with this account. It is not very useful to argue that the bourgeois conception of time is characterized by "Time alternating between advance and delay." This approach makes the whole process at once too calculating and rational. For that matter, the conceptualization could apply to any ascendant class—or group—concerned with its "rights." Gurvitch, whose methodology is completely holistic, consequently treats saving and accumulation as if they were mere rational devices for protecting privileged positions. In fact, they not only performed an economic function, but reflected notions of time, reinforced by religion and morals, which elevated denial of present gratification to an ideal.

35. *The Unheavenly City Revisited*; also his "Present-Orientedness and Crime," in Randy E. Barnett and John Hagel, eds., *Assessing the Criminal: Restitution, Retribution, and the Legal Process* (Cambridge, Mass.: Ballinger, 1977), 133–42.

36. Norman Birnbaum, *The Crisis of Industrial Society* (London: Oxford Univ. Press, 1969), 116.

37. See H. R. Trevor-Roper, "Religion, Reformation, and Social Change," in *The Crisis of the Seventeenth Century: Religion, the Reformation, and Social Change* (New York: Harper & Row, 1967), 1–45; see also, Kurt Samuelson, *Religion and Economic Action* (New York: Basic Books, 1961), 157; and, in general, H. M. Robertson, *Aspects of the Rise of Economic Individualism: A Critique of Max Weber and His School* (New York: Kelley and Millman, 1959).

38. John Maynard Keynes, 84–5.

39. Irving Kristol, *Two Cheers for Capitalism* (New York: Basic Books, 1978), 175.

40. Different aspects of these problems have been explored by Ernest Becker, *The Denial of Death* (New York: Free Press, 1973); also Erich Fromm, *Escape from Freedom* (New York: Holt, 1976); and Robert A. Nisbet, *The Sociological Tradition* (New York: Basic Books, 1966).

41. Robert A. Nisbet, *Tradition and Revolt: Historical and Sociological Essays* (New York: Vintage, 1970), 163; also, the work of Jacques Ellul should be consulted, especially *The Political Illusion* (New York: Knopf, 1967).

42. In fact, Say's Law stressed supply and demand equally, but unless one can

supply a product or labor, one can hardly demand in return. As we shall see, the doctrine itself is quite in harmony with the Bourgeois Ethic. This view could never accept a conception of social life which counsels the constant stimulation of consumption and fears "oversaving" and "hoarding." Among the few scholars who have actually attempted to deal with the moral implications of Say's Law, albeit somewhat unsatisfactorily, is George Gilder (*Wealth and Poverty,* 21–46).

43. Helmut Schoeck, *Envy.*

44. See Nisbet, *Tradition and Revolt,* 163–81.

45. This is the basic theme of Schoeck's *Envy,* previously cited.

46. One of the first major works to call attention to this problem, which has by this time called forth much comment, is Nathan Glazer, *Affirmative Discrimination: Ethnic Inequality and Public Policy* (New York: Basic Books, 1975).

47. These points have been made in general about the incompatibility of "social justice" and true equality before the law in Friedrich A. Hayek, *Law, Legislation, and Liberty,* vol. 2, *The Mirage of Social Justice* (Chicago: Univ. of Chicago Press, 1976).

48. See the pertinent remarks somewhat along these lines by Andrew Hacker, *The End of the American Era,* 150–51.

49. Pitirim A. Sorokin, *Social and Cultural Mobility* (New York: Free Press, 1959), 559–73.

50. Daniel Bell, *The Cultural Contradictions of Capitalism,* (New York: Basic Books, 1960).

51. Ibid., and Kevin P. Phillips, *Mediacracy: American Politics in the Communications Age* (Garden City, N. Y.: Doubleday, 1975).

52. Ernest van den Haag, "Confusion, Envy, Fear and Longing," in Ernest van den Haag, ed., *Capitalism: Sources of Hostility* (New Rochelle, N. Y.: Epoch Books, 1979, 19–43.

53. Few have perceived with greater vision the nefarious effects of mass advertising upon the bourgeois social and economic structure than did the late Wilhelm Roepke. See, e.g., *A Humane Economy,* 137–38.

54. This appears particularly true of the United States. See Peter F. Drucker, "Why America's Got So Many Jobs," *Wall Street Journal,* Jan. 24, 1984; and Gilder, *Wealth and Poverty,* 75–85.

55. See his *Capitalism, Socialism, and Democracy,* 59–164.

56. Fred Hirsch, *The Social Limits of Growth* (Cambridge: Harvard Univ. Press, 1976), 15–54, 102–14.

Chapter 3

1. See in particular the criticisms of mainstream economics in the previously cited works of Lachmann and Shackle.

2. See, e.g., Rothbard, *Man, Economy, and State,* 1–67.

3. See Eugen von Boehm-Bawenk, *The Positive Theory of Capital* (London: Macmillan, 1891), 17–23.

4. On the following points one can do no better than to consult the stimulat-

ing work of Rothbard. See *Man, Economy, and State,* vol. 1, 40–49; also, vol. 2, 486–91.

5. See Mises, *Human Action,* 481–82.

6. Leland B. Yeager, "Capital Paradoxes and the Concept of Waiting," in Mario J. Rizzo, ed., *Time, Uncertainty, and Disequilibrium* (Lexington, Mass.: Heath, 1979), 202.

7. Rothbard, *Man, Economy, and State,* vol. 2 (Van Nostrand, 1962), 488.

8. See Chapter 5, below, for a discussion of this point.

9. On these ideas, see Mises, *Human Action,* 807–8.

10. This issue was a source of contention between Mises and Frank H. Knight. See Mises, *Human Action,* 481–82; and Frank H. Knight, "Professor Mises and the Theory of Capital," *Economica* 8 (Nov. 1941): 409–27.

11. See Wilhelm Roepke, *Economics of the Free Society* (Chicago: Regnery, 1963), 205. The complex of reasons why people save has received far too little attention from sociologists and non-economists. Many economists, whether because of ideology or an obsession with statistical techniques, thoroughly misstate the problems. An excellent recent example may be gleaned from the following statement: "For there are only three reasons why anyone saves—you are a miser, you want to die rich or you want to buy something that you cannot afford without savings." See Lester C. Thurow, "Where Credit is not Due," *Newsweek* 102 (Nov. 21, 1983).

12. Ibid.; and Irving Fisher, *The Theory of Interest,* 503–05.

13. For example, see Allan Sloan and Christine Miles, "Slowdown at Capital Gap," *Forbes* 125 (Jan. 17, 1980), 38–42.

14. This is especially apparent when one observes their differences with the Austrian school. Unlike the monetarists and supply siders, Austrians make savings a major part of their theory of the business cycle. See the comparative study of Gerald O'Driscoll, Jr., and Sudha Shenoy, "Inflation, Recession, and Stagflation," in Edwin Dolan, ed., *The Foundations of Modern Austrian Economics* (Kansas City, Mo.: Sheed & Ward, 1976), 185–211. On the other hand, it must be remembered that we describe differences in emphasis rather than fundamental distinctions in theory among the three "schools." Many Austrians are also more likely to emphasize a cultural component in savings than are the other schools, which lay stress upon the role of "incentives" in particular and totally "rational" behavior in general.

15. A spirited defense of French policy in this respect may be found in Pierre Uri, "How to Lower Interest Rates," *Guardian* (Manchester) 125, Weekly Ed., July 26, 1981. These tendencies may be observed in the United States in the periodic and spirited battles between then Treasury Secretary Donald Regan and Federal Reserve Chairman Paul Volcker over the money supply. Similarly, one might often suppose that many in the Reagan Administration are closet demand-siders, as witnessed by their defense of tax reductions as a method to stimulate demand for final consumption goods. This apparent contradiction has not been lost on their detractors. See, for example, Walter W. Heller, "Mr. Reagan is a Keynesian Now," *Wall Street Journal,* March 23, 1983; and Lester C. Thurow, "The Ultimate Keynesian," *Newsweek* 103 (Jan. 23, 1984).

16. See the following articles of Martin Feldstein: "Facing the Social Security Crisis," *Public Interest,* no. 47 (Spring 1977): 88–100; and "Toward a Reform of Social Security," *Public Interest,* no. 40 (Summer 1975): 75–95. Also, see A. Lawrence Chickering and Jean-Jacques Roas, "The Social Security Problem: We've Got Company," *Wall Street Journal,* May 20, 1982.

17. See, e.g., Sloan and Miles, "Slowdown at Capital Gap."

18. Richard B. McKenzie, "Fashionable Myths of National Industrial Policy," *Policy Review,* no. 26 (Fall 1983): 75–87; also, Kent E. Calder, "Japan's 'Minimalist' Government," *Wall Street Journal,* Feb. 13, 1981. A major recent statement in favor of a "new industrial policy" is to be found in Robert B. Reich, *The Next American Frontier* (New York: Times Books, 1983).

19. On these points, see Ezra F. Vogel, *Japan as Number One: Lessons for America* (Cambridge: Harvard Univ. Press, 1979), 184–203.

20. Ibid.

21. Norman Gall, "Black Ships are Coming?", *Forbes* 131 (Jan. 31, 1983): 67–75.

22. In fact, the reduction in tax rates seemingly spurred consumer spending rather than saving, at least in the short run.

23. See Walter W. Heller, "Reaganomics: Is That All There Is?", *Wall Street Journal,* Oct. 6, 1981.

24. Alfred L. Malabre, Jr., "Interest Rates, Adjusted for Rising Prices, Show Unprecedented Minus-To-Plus Swing," *Wall Street Journal,* Oct. 2, 1981. We are quite aware of the harm done by high rates of interest! To lament the plight of savers is not to suggest that high interest rates are a good thing over the long run. For instance, they are highly detrimental to economic growth, innovation, and to smaller concerns. Similarly, because they encourage overvalued currencies, they are also harmful to export industries.

25. This simple point too often goes unrecognized with so much talk about "real" interest rates, the "inflation premium," etc. But see, for example, Ralph E. Winter, "Savings Shortage Keeps Rates High, Economy Slow, Some Experts Say," *Wall Street Journal,* Aug. 18, 1982.

26. See the famous interview of David Stockman by William Greider, which led to Mr. Stockman's being taken to the "woodshed" for scolding by President Reagan. William Greider, "The Education of David Stockman," *Atlantic Monthly* 248 (Dec. 1981): 27–54.

27. Martin Feldstein, "The Tax Cut: Why the Market Dropped," *Wall Street Journal,* Nov. 11, 1981.

28. Ibid.

29. See, e.g., the analysis of John Koten, *Wall Street Journal,* Nov. 11, 1981.

30. See, e.g., Peter T. Kilborn, "Americans Saving Less Now Than Before the '81 Tax Act," *New York Times,* Sept. 6, 1983; and Alan Murray, "Widely Disparate Savings Statistics Given by Fed, Commerce Officials," *Wall Street Journal,* Nov. 22, 1983. Gross private savings are composed of gross savings and gross business savings. For a study in disillusionment from inside of the Reagan Administration, see Paul Craig Roberts, *The Supply-Side Revolution* (Cambridge: Harvard Univ. Press, 1984).

31. There are, of course, exceptions on the demand side, such as the well-known economists John Kenneth Galbraith and Robert Heilbroner.

32. Shoeck, *Envy.*

33. A definition of issues based upon the resentment of a majority for the status, income, or wealth of a minority generally favors the political interests of the former at the expense of the latter if the issue is sufficiently contagious and widespread. Politics as the "socialization of conflict" has been given a powerful theoretical formulation in the work of E. E. Schattschneider, such as *The Semisovereign People: A Realist's View of Democracy in America* (New York: Holt, 1960). Conversely, widespread conflict need not be based only upon issues involving class interests. See, e.g., Keith Richmond, "Daylight Saving in New South Wales: A Case of Emotive Symbolic Politics?," *Australian Journal of Public Administration* 37 (Dec. 1978): 374–85.

34. That people seldom behave "rationally" in the textbook sense ought to be plain by this time. E. E. Schattschneider observed long ago in the case of protective tariffs that primary producers of domestic goods in competition with "cheap" foreign goods were much more likely to win support from Congress for import protection than would domestic secondary producers who were themselves highly dependent upon goods cheaply produced from the primary producers. It appears that the shoe must pinch directly and firmly to guarantee political activity from an affected "interest." See his *Politics, Pressures and the Tariff: A Study of Free Private Enterprise in Pressure Politics as Shown in the 1929–1930 Revision of the Tariff* (New York: Prentice-Hall, 1935); also, Raymond A. Bauer, Ithiel de Sola Pool, and Lewis Anthony Dexter, *American Business and Public Policy: The Politics of Foreign Trade* (New York: Atherton, 1963).

35. A classic and well-written discussion of the social consequences of inflation is that of Andrew Dickson White in a paper read before the Union League Club of New York in 1876 and published as *Fiat Money Inflation in France* (Irving-on-Hudson, N. Y.: Foundation for Economic Education, 1959).

36. Of course, the experience of the 1980s in which high rates of interest persist over time may have reduced the confidence and number of enthusiasts for this type of policy.

37. In fact, "interest" has both "monetary" and "real" components, as economists teach us. We stress here the manner in which it is perceived in the public as a whole, by most intellectuals, and within the financial community.

38. The basic rate of interest is essentially what Mises calls "originary" interest and Rothbard the "pure" rate of interest. We use the term "basic" to convey in the strongest possible language to nonspecialists the fundamental and permanent qualities inherent in interest. On these issues, see Mises, *Human Action,* 526–32; and Rothbard, *Man, Economy, and State,* vol. 1, 313–86.

39. On the other hand, Santoni and Stone believe that the "real" interest rate may be measured by getting the ratios of composites of present goods to future goods: the ratio of the Consumer Price Index to the Standard & Poor Index, the ratio of the price of lamb to the price of sheep, the ratio of the nondurable goods component of the CPI to the durable goods component, and the ratio of beef to

the price of cattle. Since there was little change found in these ratios over time but since nominal rates were quite volatile, they attribute little significance to their "real" rate. At the very least, they argue, the latter had little effect upon nominal rates. But do these measurements really get at the ratio of present goods to future goods component of basic interest? Are they not too limited in terms of the range of goods they consider? Cannot a "basket of goods," as measured in the CPI, be called into question by arbitrary decisions to include or exclude certain of them (e.g., rental housing)? At heart, do these measures get at the problem of savings in the community? Presumably a drop in savings in banks, in insurance companies, in pension funds, and in corporate profits might tell us more in this respect than a change in prices of durable goods and common stocks. Unfortunately, the authors deal only with the latter. Moreover, the existence of inflation over the long run is itself testimony to the growth of high time preferences in the community, which can be hidden for relatively long periods by injections of money and "incorrect" expectations. True, inflation may be initially produced by the machinations of central banks and politicians calculated to keep nominal rates low, but its continuation is linked with general forces in the population. Indeed, the persistence of inflation reflects a rise in time preferences and hence basic interest. Why? Because of the effects it has upon our values regarding present and future. Consequently, inflation is both cause and consequence of our altered horizons. Finally, although we cannot go into business cycle theory at this time, it may be noted in passing that the credit-creation machinations of banks, which was the traditional impetus for booms and inflation during the course of the business cycle, has been to an extent supplanted by the method of "simple inflation," that is, the process by which government treasury departments in order to pay bills issue bonds which are then bought and monetized by central banks. This recent change, historically speaking, would affect time preferences in general since it produces inflationary pressures but may have less effect upon higher order goods (e.g. the durable goods listed in the CPI). See G. J. Santoni and Courtenay C. Stone, "What Really Happened to Interest Rates?: A Longer-Run Analysis," *Review: Federal Reserve Bank of St. Louis* 63, no. 9 (Nov. 1981): 3–14. For considerations of "simple inflation," see the remarks of Mises, *Human Action,* 570; and Murray N. Rothbard, "Austrian Definitions of the Money Supply," in Louis M. Spadaro, ed., *New Directions in Austrian Economics* (Kansas City, Mo.: Sheed, Andrews and McMeel, 1978), 152–53.

40. The following arguments are derived mainly from Mises and Rothbard. Following their lead, we may say that the basic rate of interest excludes the uncertainty elements in contracts and rather short-run fluctuations in expectations regarding price trends.

41. To repeat, time preference is *always* positive since in the absence of action the organism is simply at rest, motionless. The basic interest rate cannot therefore be "negative" or "zero," for such ideas make sense only if human action is itself absent. It is indeed surprising that major economists, apparently oblivious to Mises' work, can write redundantly and with enthusiasm, no less, that the "case for positive time preference is compelling." See Mancur Olson and Martin J. Bailey, "Positive Time Preference," *Journal of Political Economy* 89 (Feb. 1981): 1–25; also,

Santoni and Stone, "What Really Happened to Interest Rates?". For a most stimulating response to Mises' critics on this issue, see Roger W. Garrison, "Reflections on Misesian Time Preference," 1975, unpublished ms.

42. Frank A. Fetter, *Capital, Interest, and Rent: Essays in the Theory of Distribution* (Kansas City, Mo.: Sheed, Andrews and McMeel, 1977), 234.

43. We assume in this regard that governments borrow mostly from the public-at-large rather than from the central banks. In case they resort to the latter policy, the effects will be inflationary, for the money supply will accelerate.

44. On the other hand, because the government borrowing requirement was so large in Germany, especially, the growth of productivity was less than it might have been in the absence of competition from the public and private sectors for the limited supply of capital.

Chapter 4

1. Adam Smith, *An Inquiry into the Nature and Causes of the Wealth of Nations* (New York: Modern Library, 1937), 42–23.

2. This is the title of one of Irving Kristol's books, previously cited.

3. The first group of postwar neo-conservatives would include such writers as Walter Lippmann, Russell Kirk, Peter Viereck, John Hallowell, Thomas I. Cook, Francis Wilson and Willmoore Kendall. The major Straussians include Harry Jaffa, Walter Berns, Herbert Storing, Martin Diamond, Joseph Corpsey, and Harvey Mansfield, Jr. Leading neo-conservatives of recent vintage include Irving Kristol, Daniel Bell, Robert Nisbet, Nathan Glazer, Daniel Patrick Moynihan, James Q. Wilson, Norman Podhoretz, and others who have lost their faith in the New and Fair Deals and write in such periodicals as the *Public Interest* and *Commentary*. Among the major writers who seek to keep a foot planted firmly in the conservative camp by indicting some aspects of economic individualism while adhering strongly to traditionalism in culture and society are Wilhelm Roepke, Robert Nisbet, George Gilder, those grouped around William F. Buckley's *National Review* and (yes!) Friedrich von Hayek. Anyone doubting Hayek's position in this regard should read the concluding chapter in the last volume, *The Political Order of a Free People*, of his trilogy *Law, Legislation, and Liberty* (Chicago: Univ. of Chicago Press, 1979), 153–76. As for those conservatives who display a fervent attachment simultaneously to religious-cultural elements and to free markets, one must pay special attention to the work of Roepke (see, e.g., his *Humane Economy*, 90–150).

4. Exceptions for the most part occur among economists, especially those in the Chicago and Austrian schools of thought.

5. This point has been made with special force by the Straussian, Joseph Cropsey, *Polity and Economy: An Interpretation of the Principles of Adam Smith* (The Hague: Martinus Nijohoff, 1957). A more recent study which adheres in general to this interpretation but softens it in notable ways is Stephen Miller, "Adam Smith and the Commercial Republic," *Public Interest*, no. 61, (Fall 1980): 106–22.

6. See, for example, his *Two Cheers for Capitalism*.

7. Indeed, conservatives have been attacked from the left on this point. See Morton Auerbach, *The Conservative Illusion* (New York: Columbia Univ. Press, 1959).

8. "Economic Man" and "Political Man" are, of course, ideal types. Ideal types vary from the most concrete and personal to the most abstract and formal. In the following pages we argue that a "typical" Economic Man has a greater incentive to lengthen his time horizons than does a "typical" Political Man. A congressman, president, civil servant, or mayor has less incentive to postpone want-satisfaction than does the head of a household, an entrepreneur, a corporation head, or the owner of a small business. Certain atypical cases, of course, exist: e.g., environmentalists in politics or spendthrifts consuming their capital. For a discussion of this rather thorny methodological problem, see Alfred Schutz, *The Phenomenology of the Social World* (Evanston, Ill.: Northwestern Univ. Press, 1967), 176–214.

9. A good discussion of the aims of public choice theory is to be found in James M. Buchanan, "Toward Analysis of Closed Behavioral System," in James M. Buchanan and R. D. Tollison, eds., *Theory of Public Choice* (Ann Arbor: Univ. of Michigan Press, 1972), 11–23.

10. George F. Will, *The Pursuit of Virtue and Other Tory Notions* (New York: Simon and Schuster, 1982), 40. Emphasis ours. Will's statement is an excellent example of the tendency to associate individualism in economics with short time horizons. It also demonstrates the extent to which one of our most astute critics on the right has been taken in by a myth of long-standing. Certainly it is not a myth confined to the anticapitalistic left.

11. Karl P. Popper, *The Open Society and its Enemies,* vol. 1 (New York: Harper Torchbooks, 1962), 101.

12. On the role of types as a device for scientific analysis, see footnote 8, above; for some interesting comments regarding the role of the American government in conservation, see the various essays in Phillip N. Truluck, ed., *Private Rights and Public Lands* (Washington, D.C.: Heritage Foundation, 1983).

13. The following examples may be found in Murray N. Rothbard, *For a New Liberty* (New York: Collier-Macmillan, 1973), 259–68.

14. P. N. Rosenstein-Rodan, "The Role of Time in Economic Theory," *Economica* 5 (1934): 77–97; also see Emil Kauder, *A History of Marginal Utility Theory* (Princeton: Princeton Univ. Press, 1965), 165–66.

15. See, e.g., T. Alexander Smith, *The Comparative Policy Process* (Santa Barbara, Calif.: ABC-Clio, 1975).

16. In addition to the work of G. L. S. Shackle, previously cited, see his *Time in Economics* (Amsterdam: North-Holland, 1958), 1–67; and *The Nature of Economic Thought: Selected Papers 1955–1964* (Cambridge: Cambridge Univ. Press, 1966), 71–84. One might also consult the penetrating analyses of Ludwig M. Lachmann, "Professor Shackle on the Economic Significance of Time," in *Capital, Expectations, and the Market Process,* 81–93; and "From Mises to Shackle: An essay on Austrian Economics and the Kaleidic Society," *Journal of Economic Literature* 14 (March 1976): 54–61.

17. See, e.g., Murray Edelman, *The Symbolic Uses of Politics.*

18. See the excellent study of James M. Buchanan and Richard E. Wagner, *Democracy in Deficit: The Political Legacy of Lord Keynes* (New York: Academic Press, 1977); also, Robert Nisbet, *Twilight of Authority* (New York: Oxford Univ. Press, 1975), 97–102; and Samuel Brittan, "The Economic Contradictions of Democracy," *British Journal of Political Science* 5 (April 1975): 129–59.

19. Smith, *The Comparative Policy Process,* 31–34.

20. Buchanan and Wagner, *Democracy in Deficit,* 100–1.

21. These comments are based upon, Mises, *Human Action,* 538–86; Friedrich von Hayek, *Prices and Production* (London: George Routledge, 1935); and Murray N. Rothbard, *America's Great Depression* (Kansas City, Mo.: Sheed & Ward, 1975. An excellent study of Hayek's theory as compared with the "monetarist" and "Keynesian" ones may be found in Gerald P. O'Driscoll, Jr., and Sudha R. Shenoy, "Inflation, Recession, and Stagflation," in *The Foundations of Modern Austrian Economics,* 185–211.

22. This is a theme common to many works. One of the best remains Schumpeter, *Capitalism, Socialism, and Democracy,* 131–63, 415–25; also, Brittan, "The Economic Contradictions of Democracy."

23. Jacques Ellul, *The Political Illusion* (New York: Knopf, 1967).

24. E.g., Francis Graham Wilson, *The Elements of Modern Politics* (New York: McGraw-Hill, 1936), 514–18.

25. This idea is discussed in the biting commentary of Auerbach, *The Conservative Illusion;* also Popper, *The Open Society and Its Enemies.*

26. This theme is to be found in J. L. Talmon, *The Origins of Totalitarian Democracy* (New York: Praeger, 1951); also, Hayek, *Law, Legislation, and Liberty: The Mirage of Social Justice,* 17–23.

27. See Carl L. Becker, *The Heavenly City of the Eighteenth-Century Philosophers* (New Haven: Yale Univ. Press, 1932); and Gladys Bryson, *Man and Society: The Scottish Inquiry of the 18th Century* (Princeton: Princeton Univ. Press, 1945).

28. See Popper, *The Open Society and its Enemies.*

Chapter 5

1. The term "postindustrial society" is, of course, most closely associated with Daniel Bell, *The Coming of Post-Industrial Society.* Other terms which have been utilized more or less interchangeably with "postindustrial society" are "technological society," "post-welfare," "advanced industrial," and "superindustrial." Highly popular works which might be mentioned in addition to Bell's are: Zbigniew Brzezinski, *Between Two Ages: America's Role in the Technetronic Era* (New York: Viking, 1971); Alvin Toffler, *Future Shock;* Herman Kahn and Anthony J. Wiener, *The Year 2000: A Framework for Speculation on the Next Thirty-Three Years* (New York: Macmillan, 1976); Alain Touraine, *The Post-Industrial Society* (New York: Random House, 1971).

2. Samual P. Huntington, "Postindustrial Politics: How Benign Will It be?", *Comparative Politics* 6 (Jan. 1974): 163–92. Huntington believes that postindustrial theorists have far too little to say about politics.

3. See, e.g., Ronald Inglehart, "The Silent Revolution in Europe: Intergenerational Change in Post-Industrial Societies," *American Political Science Review* 65 (Dec. 1971): 991–1017. Inglehart has employed such terms as "post-bourgeois" and "post-materialist" to describe these phenomena. See *The Silent Revolution: Changing Values and Political Styles Among Western Publics* (Princeton: Princeton Univ. Press, 1977), and for a more recent argument that "post-material" elements have penetrated the elite, his "Post-Materialism in an Environment of Insecurity," *American Political Science Review* 75 (Dec. 1981): 880–900.

4. This is, of course, the theme of Toffler's *Future Shock*.

5. Huntington, "Postindustrial Politics," 163–64.

6. Ibid.

7. Victor Ferkiss, "Post-Industrial Society: Theory, Ideology, Myth." Paper prepared for the Annual Meeting of the Midwest Political Science Association, Chicago, April 1979.

8. M. Donald Hancock, *Sweden: The Politics of Postindustrial Change* (Hinsdale, Ill.: Dryden Press, 1972), 7.

9. See, e.g., Mises, *Human Action*, 496, 507–8; Rothbard, *Man, Economy, and State*, vol. 2, 489–94; and Nathan Rosenberg, *Technology and American Economic Growth* (New York: Harper Torch Books, 1972), 25–38. Mises and Rothbard, on the one hand, and Rosenberg, on the other, stress different aspects of the problem, but are actually quite compatible with one another.

10. This theme may be found in Jude Wanniski, *The Way the World Works: How Economies Fail and Succeed* (New York: Basic Books, 1978).

11. One can still learn much in this respect by reading Eugen von Boehm-Bawerk's classic work, *The Positive Theory of Capital*, 7–125. Also, note the remarks by Leland B. Yeager, "Capital Paradoxes and the Concept of Waiting," in *Time, Uncertainty, and Disequilibrium*, 187–215.

12. C. Bresciani-Turroni, "The Theory of Saving," *Economica* 3 (May 1936): 162–81. It may be objected here that we are setting up a straw man; that in truth postindustrial theorists, as most social scientists, are surely aware of the necessity of savings. That may well be true, but if so, why do they remain so silent with regard to its role? Why do they not inform us how its functions relate to the emerging order?

13. See, e.g., the previously cited works of Mises, Fisher, and Boehm-Bawerk. The classic statement of the "pure" time preference theory is undoubtedly that of Frank A. Fetter, "Interest Theories, Old and New," in *Capital, Interest, and Rent*, 226–55.

14. Bell, *The Coming of Post-Industrial Society*, 189.

15. The view that capital accumulation is prior to technology will be considered in more detail below. For now we ask the reader to consult Mises, *Human Action*, 490–523; and note Friedrich A. von Hayek, *The Pure Theory of Capital* (London: Routledge & Kegan Paul, 1941), 48: "Which of the many known technological methods of production will be employed is assumed to be determined by the supply of capital available at each moment." With regard to the problem of deferral of gratification, see, e.g., in addition to Mises, Sigmund Freud,

Civilization and Its Discontents; Pitirim A. Sorokin, *The American Sex Revolution;* and *From Max Weber; Essays in Sociology* (New York: Galaxy, 1958), 267–359.

16. Nowhere does the failure to see that postindustrial values are largely inconsistent with economic prosperity loom larger than in the present author's own field of comparative politics.

17. See, e.g., Jeffrey D. Straussman, "Technocratic Counsel and Societal Guidance," in Leon N. Lindberg, ed., *Politics and the Future of Industrial Society* (New York: David McKay, 1976), 126–66.

18. The repudiation of Say's Law and its assumptions about the way the world works would in itself make a fascinating study if linked with larger, noneconomic ideas. For a careful reassessment, see W. H. Hutt, *A Rehabilitation of Say's Law* (Athens: Ohio Univ. Press, 1974).

19. See Alan Coddington, "Keynesian Economics: The Search for First Principles," *Journal of Economic Literature* 14 (Dec. 1976): 1258–73.

20. See John C. Moorhouse, "The Mechanistic Foundations of Economic Analysis," *Reason Papers* (Winter 1978): 49–67; Norman P. Barry, *Hayek's Social and Economic Philosophy* (London: Macmillan, 1979), 19; for the classic statement regarding competition and for a devastating attack upon "pure competition," see Hayek's *Individualism and The Economic Order* (Chicago: Univ. of Chicago Press, 1948), 92–106; also, Israel M. Kirzner, *Competition and Entrepreneurship* (Chicago: Univ. of Chicago Press, 1973); and for some interesting comments regarding the relationship of individual rationality models to collectivism, Lewis H. Haney, *History of Economic Thought* (New York: Macmillan, 1949), 784–85.

21. "Technology" is, of course, an ambiguous term. It may refer to the best means for achieving a given end; it may imply a mere change in techniques; or, more broadly, it may refer to economic "factor" shifts leading to increased productivity. In the larger sense, the concept includes inventions, innovation, and economic growth. These will be used interchangeably with technology, unless so stated. For an attempt to make the necessary distinctions, see, e.g., Edwin Mansfield, *Technological Change* (New York: Norton, 1971), 10.

22. See John Kenneth Galbraith, *The New Industrial State* (New York: Houghton Mifflin, 1967). This view and others which emphasize the linkage between concentration and collusion have been seriously questioned. See Harold Demsetz, "Industry Structure, Market Rivalry, and Public Policy," *Journal of Law and Economics* 16 (April 1973): 1–9; and Yale Brozen, "The Antitrust-Task Force Deconcentration Recommendation," *Journal of Law and Economics* 13 (Oct. 1970): 279–92; and, for an excellent analysis by a political scientist, see the stimulating work of Donald J. Devine, *Does Freedom Work?: Liberty and Justice in America* (Ottawa, Ill.: Caroline House, 1978).

23. Joseph A. Schumpeter, *Business Cycles: A Theoretical, Historical and Statistical Analysis of the Capitalist Process,* 2 vols. (New York: McGraw-Hill, 1939), esp. 84–102; and Nathan Rosenberg, "Problems in the Economist's Conceptualization of Technological Innovation," in *History of Political Economy* 7 (Winter 1975): 456–81.

24. Rothbard, *Man, Economy, and State,* 489–94.

25. Ibid., and Nathan Rosenberg, *Perspectives on Technology* (London: Cambridge Univ. Press, 1976), especially 141–50.

26. Rothbard, 492.

27. Rosenberg, *Perspectives on Technology*, 141–50.

28. The following analysis of capital owes much to Ludwig M. Lachmann, *Capital and Its Structure* (Kansas City, Mo.: Sheed, Andrews and McMeel, 1978). Lachmann observes that the study of capital in recent years has been less concerned with the structure of capital goods than with interest and the income accruing to various classes of the population. It is not surprising that this notion of capital would find little to resist in the technological mentality. After all, to view capital in terms of flows avoids conceptualizing the problem as one of differentiation and complexity (see vii). For a study from the interest perspective, see Robert M. Solow, *Capital Theory and the Rate of Return* (Amsterdam: North-Holland, 1963).

29. Lachmann, *Capital and Its Structure*, 78–85.

30. E.g., John A. Tatom, "The Productivity Problem," *Review: Federal Reserve Bank of St. Louis* 61, no. 9 (Sept. 1979): 3–16. It is interesting that "innovation" is increasingly becoming a topical issue in the popular press. In the last few years such semi-intellectual magazines as *Time* and *Newsweek* have devoted feature articles to the innovation and productivity problem. In the United States we note that during one of the greatest periods of innovation, namely, in the fifty years preceding World War I, "new technical or social inventions, almost immediately spawning new industries, emerged on average every 18 months." This was likewise a period in which the general level of prices was stable or declining. See Peter F. Drucker, "The Innovative Company," *Wall Street Journal*, February 26, 1982.

31. James Buchanan and Richard Wagner, *Democracy in Deficit;* Robert Nisbet, *Twilight of Authority*, 97–102; Samuel Brittan, "The Economic Contradictions of Democracy," 129–159. Although political scientists and sociologists have had much to say about unemployment over the years, it is safe to say that they have neglected the social consequences of inflation. An honorable exception is sociologist John H. Goldthorpe, "The Current Inflation: Towards a Sociological Account," in Fred Hirsch and John H. Goldthorpe, eds., *The Political Economy of Inflation* (Cambridge: Harvard Univ. Press, 1978), 186–214. Among the clearer explanations of the nature of inflation remains Graham Hutton, *What Killed Prosperity, In Every State from Ancient Rome to the Present* (New York: Chilton, 1960).

32. The following paragraphs rely heavily upon the Austrian theory of the Trade Cycle as developed by Mises and Hayek. See Mises, *Human Action*, 538–86; and Hayek, *Prices and Production* (London: Routledge, 1935). A comparison of Hayek's theory with the monetarist and Keynesian ones may be found in Gerald O'Driscoll, Jr., and Sudha Shenoy, "Inflation, Recession, and Stagflation," in *The Foundations of Modern Austrian Economics*, 185–211.

33. The following discussion of the relation of innovation and growth to rhythms in the trade cycle is mainly based upon Ludwig M. Lachmann, "A Reconsideration of the Austrian Theory of Industrial Fluctuations," in his *Capital, Expectations, and the Market Process*, 267–88.

34. Ibid., 273; also Rosenberg, *Technology and American Economic Growth*, 56–57.

35. Ibid., 273–74.

36. Thus, rising prices of goods need not in themselves lead to the substitution of machines for labor, to what Hayek labelled the "Ricardo Effect." See his "Three Elucidations of the Ricardo Effect," *Journal of Political Economy* 77 (Jan./Feb. 1969): 274–85.

37. One may observe this phenomenon with special clarity in the Germany of the 1920s, when the appearance of intense capital development coincided with increased use of hand labor. Only with the fall in prices was German technological backwardness stunningly revealed, although many observers at the time were completely misled. See Bresciani-Turroni, "The Theory of Saving," 171–81; also, his classic study of the German inflation, *The Economics of Inflation* (London: George Allen & Unwin, 1937). Bresciani-Turroni's work has received far less attention than it deserves.

38. The banking system with its ability to create credit and money plays an especially important role in this respect. Unfortunately space does not permit discussion of this aspect of trade cycle theory. See, however, the previously cited work (note 32) of Mises, Hayek, and O'Driscoll and Shenoy; also, Murray N. Rothbard, *America's Great Depression*.

39. Bresciani-Turroni, *The Economis of Inflation,* especially 364–67, 392–93, 409–11. Aspects of the problem of waste, distortion, and malinvestment in boom periods may be found in the stimulating study of the Great Depression by Rothbard, *America's Great Depression,* 154ff; also Gottfried Haberler, "Money and the Business Cycle," in Quincy Wright, ed., *Gold and Monetary Stabilization* (Chicago: Univ. of Chicago Press, 43–73); and Andrew Dickson White, *Fiat Money Inflation in France.*

40. See, among others, Winkler, "Law, State, and Economy," 103–28.

Chapter 6

1. This minimal definition obviously says nothing about the extent of the franchise or about the rights of speech, press, and assembly, although their protection is surely implied in the statement itself. A classical confrontation on this and other points may be found in the spirited debate between Herbert McClosky, "The Fallacy of Absolute Majority Rule," *Journal of Politics* 11 (Nov. 1949): 637–54, and Willmoore Kendall, "Prolegomena to Any Future Work on Majority Rule," *Journal of Politics* 12 (Nov. 1950): 694–713.

2. On the other hand, it goes without saying that election experts have been quite aware of the intellectual limitations of the electorate. For example, see the enduring comments of Bernard Berelson, "Democratic Theory and Public Opinion," *Public Opinion Quarterly* 15 (Fall 1952): 313–30.

3. Kendall's equation of democracy with majority rule (see note 1 above) seems somewhat tongue-in-cheek, but it is a serious effort to paint majority rule with an anti-individualist brush.

4. This term is drawn from C. B. Macpherson, *The Life and Times of Liberal Democracy* (London: Oxford Univ. Press, 1977).

5. Ibid; see also Michael Margolis, *Viable Democracy* (New York: Penguin, 1979); and John Gaventa, *Power and Powerlessness: Quiescence and Rebellion in an Appalachian Valley* (Urbana: Univ. of Illinois Press, 1980), esp. 3–20.

6. Also, David Spitz, *Patterns of Anti-Democratic Thought* (New York: Free Press, 1965), 29–32; and McCloskey, "The Fallacy of Absolute Majority Rule."

7. This view has been widely accepted among the most diverse kinds of social scientists. Joseph Schumpeter, Raymond Aron, Maurice Duverger, E. E. Schattschneider, James MacGregor Burns, Nelson Polsby, Walter Dean Burnham, and Samuel Beer, for example, not only differ in ideology but also employ diverse methods in their observation of political phenomena.

8. For instance, see Jacques Ellul, *The Political Illusion.*

9. E.g., William Letwin, "Economic Due Process in the Constitution and in the Rule of Law," in *Liberty and the Rule of Law.*

10. The distinction between human rights and property rights is, of course, no real problem, if by property we include ownership of one's self and that which we have "mixed with our labor." See the fascinating account of Murray N. Rothbard, *The Ethics of Liberty* (Atlantic Highlands, N. J.: Humanities Press, 1982), 29–34.

11. Brian Crozier, *The Minimum State: Beyond Party Politics* (London: Hamish Hamilton, 1979), 44–63.

12. A recent assessment of this problem may be found in Leon D. Epstein, "What Happened to the British Party Model?," *American Political Science Review* 74 (March 1980): 23–37.

13. See APSA Committee on Political Parties, "Toward A More Responsible Two-Party Party System," *American Political Science Review* 44 (Sept. 1950); for an early criticism of the committee's conclusions, see Julius Turner, "Responsible Parties: A Dissent from the Floor," *American Political Science Review* 45 (March 1951): 143–52; for an assessment of these and other views with regard to parties among American political scientists, see Leon D. Epstein, "The Scholarly Commitment to Parties," in Ada W. Finifter, ed., *Political Science: The State of the Discipline* (Washington, D.C.: American Political Science Association, 1983), 1227–54. The APSA report has received no small amount of attention over the years. E. E. Schattschneider, instrumental in its writing, was a consistent advocate of "responsible" parties in the United States, as is the well-known political historian, James MacGregor Burns. Not surprisingly, both men are political "liberals," whereas those who have opposed their reforms not only on party matters but on issues as well are usually somewhat more traditional in orientation (e.g., Clinton Rossiter, Malcolm Moos, James Burnham, Harry Jaffa, Edward Banfield, Aaron Wildavsky, and Austin Ranney).

14. "Conservative" political scientists have generally opposed these reforms. For example, see Willmoore Kendall, *Contra Mundum* (New Rochelle, N. Y.: Arlington House, 1971), e.g., 266–87; and Walter Berns, "Reform of the American Party System" in Robert A. Goldwin, ed., *Political Parties, U.S.A.* (Chicago: Rand McNally, 1961), 40–58. On the other hand, let us emphasize that many American

political scientists and other commentators see in our weakened party system the principal cause of many social and political problems. They are not necessarily anglophiles, but they do argue that party reform in the 1970s and the decline of party organization over the past generation or more have gravely weakened the forces of democratic stability. It is precisely this "group" of scholars, however, who reinforce so strongly the conventional wisdom. See, especially, Nelson W. Polsby, *Consequences of Party Reform* (New York: Oxford Univ. Press, 1983); and Walter Dean Burnham, *The Current Crisis in American Politics* (New York: Oxford Univ. Press, 1982).

15. See Berns, "Reform of the American Party System"; and Kendall, "The Two Majorities in *Contra Mundum,* 202–27.

16. Certainly this stress was to be found in the works of V. O. Key, Jr., perhaps the outstanding scholar of political parties in America; Key was surely no political conservative so far as economic interventionism was concerned. The concept of "cadre" party is developed in Maurice Durverger, *Political Parties* (New York: Wiley, 1954).

17. Seldom does one find a prominent conservative among such writers. Notable exceptions are the well-known journalists Henry Hazlitt and Kevin Phillips.

18. See, e.g., Polsby, *The Consequences of Party Reform;* and E. E. Schattschneider, *Party Government* (New York: Holt, 1960).

19. The classic study of the British system, first published in 1867, is Walter Bagehot, *The English Constitution* (Garden City, N.Y.: Doubleday, 1972). For a concept of the "two majorities," see Kendall's essay, previously cited. The aim of Kendall was to deny special legitimacy for the presidential majority as established by national plebiscites; indeed, he believed that, if anything, the Founding Fathers intended to make Congress the true representative of the majority, since the chief executive as originally created was elected indirectly. Kendall's argument was primarily directed at such writers as James MacGregor Burns and Robert A. Dahl. See Burns, *The Deadlock of Democracy: Four-Party Politics in America* (Englewood Cliffs, N. J.: Prentice-Hall, 1963); and Dahl, *A Preface to Democratic Theory* (Chicago: Univ. of Chicago Press, 1956).

20. Perhaps the best-known is Samuel H. Beer. See his *British Politics in the Collectivist Age* (New York: Knopf, 1966) and his *Britain Against Itself: The Contradictions of Collectivism* (New York: Norton, 1982); also, Harry Eckstein, *Pressure Group Politics: The Case of the British Medical Association* (London: George Allen & Unwin, 1960), 1–64.

21. E. E. Schattschneider, *The Semisovereign People: A Realist's View of Democracy in America* (New York: Holt, 1960).

22. E. E. Schattschneider, *Party Government* (New York: Holt, 1942).

23. Lowi, *The End of Liberalism,* esp. 92–126, 295–314.

24. See, e.g., Lowi, "Decision Making vs. Policy Making: Toward an Antidote for Technocracy," *Public Administration Review* 30 (May/June 1970): 314–25.

25. See Lowi, *End of Liberalism,* 68–78, 198–236; and Morris P. Fiorina, *Congress—Keystone of the Washington Establishment* (New Haven: Yale Univ. Press, 1977); and Michael T. Hayes, "The Semi-Sovereign Pressure Groups: A Current Theory and an Alternative Typology," *Journal of Politics* 40 (Feb. 1978): 134–61.

26. Sometimes Lowi comes close to suggesting that conflict is good in and for itself. See *The Politics of Disorder* (New York: Basic Books, 1971), 3–61.

27. Lowi's rule of law differs significantly from the older view (see Ch. 7 below).

28. This theme has been around sociology circles for a long time. See, e.g., Seymour Martin Lipset, "Working-class Authoritarianism" in his *Political Man: The Social Bases of Politics* (Garden City, N.Y.: Doubleday, 1960), 97–130. The tendency for the masses to engage in extremist politics has been recognized by writers as diverse as Tocqueville, Le Bon, Ortega y Gasset, Lederer, and Heberle. An excellent discussion of mass society theory is found in William Kornhauser, *The Politics of Mass Society* (Glencoe, Ill.: Free Press, 1959), 21–38, 227–38.

29. This literature is voluminous. See, for instance, the pathfinding work of V. O. Key, Jr., *American State Politics: An Introduction* (New York: Knopf, 1956). On the other hand, it has been argued that party competition may be less important than certain socioeconomic variables. On this point, see Richard E. Dawson and James A. Robinson, "Inter-Party Competition, Economic Variables, and Welfare Policies in the American States," *Journal of Politics* 25 (May 1963): 265–89.

30. The pioneers in this area are Gabriel A. Almond and David Easton. See Almond, *Political Development: Essays in Heuristic Theory* (Boston: Little, Brown, 1970), esp. Chs. 1, 3; and Easton, *A Framework for Political Analysis* (Englewood Cliffs, N.J.: Prentice-Hall, 1965) and *A Systems Analysis of Political Life* (New York: Wiley, 1965).

31. Gabriel A. Almond and Sidney Verba, *The Civic Culture* (Princeton: Princeton Univ. Press, 1963).

32. Arend Lijphart, "Comparative Politics and the Comparative Method," *American Political Science Review* 65 (Sept. 1971): 682–93.

33. For instance, see Arthur H. Miller and Martin P. Wattenberg, "Measuring Party Identification: Independent or Non-Partisan Preference?", *American Journal of Political Science* 27 (Feb. 1983), 106–21; David Butler and Donald Stokes, *Political Change in Britain* (New York: St. Martin's, 1976); Walter deVries and V. Lance Tarrance, *The Ticket-Splitter: A New Force in American Politics* (Grand Rapids, Mich.: William B. Eerdmans, 1972); Emeric Deutsch, Denis Lindon, and Pierre Weill, *Les Familles politiques en France* (Paris: Les Éditions de Minuit, 1966); and Russell J. Dalton, "Cognitive Mobilization and Partisan Dealignment in Advanced Industrial Societies," *Journal of Politics* 46 (Feb. 1984): 264–84. Such works owe much of their inspiration to voting studies growing out of the so-called "Columbia" and "Michigan" schools of thought following World War II.

34. See, e.g., Butler and Stokes, 22–28.

35. Political scientists have long considered this type of electoral system far preferable to one of proportional representation, since the latter presumably favors multi-partyism and coalition governments.

36. These minimum requirements for any government are discussed in Crozier, *The Minimum State.*

37. This "dogmatism" has been criticized not only by Labour and Social Democratic "moderates" but also by some old-line Tories. In a more scientific vein, Samuel Beer sees in Thatcherite "neoliberalism" a source of instability in British politics. See his *Britain Against Itself,* esp. 155–208.

38. The function of "aggregation" is developed in the work of Gabriel Almond. E.g., "A Functional Approach to Comparative Politics," in *Political Development*, 79–151. For a concrete study of the problems of aggregation within multi-party systems, see Charles E. Frye, "Parties and Pressure Groups in Weimar and Bonn," *World Politics* 18 (July 1965): 635–55.

39. As quoted in *Contra Mundum*, 347.

40. The dispute over "affirmative action" and "quotas" is a clear example. See Glazer, *Affirmative Discrimination*.

41. See, e.g., T. W. Hutchison, *The Politics and Philosophy of Economics: Marxians, Keynesians and Austrian* (New York: New York Univ. Press, 1981), 23–43; Alexander Rustow, *Freedom and Domination: A Historical Critique of Civilization* (Princeton: Princeton Univ. Press, 1980), 373–478; Christie Davies, "Crime, Bureaucracy, and Equality, *Policy Review*, no. 20 (Winter 1983): 89–105 and James Q. Wilson, "Crime and American Culture," *Public Interest* 70 (Winter 1983): 22–48.

42. Alexis de Tocqueville, "Memoir on Pauperism," *Public Interest* 70 (Winter 1983): 102–20.

43. Hutchison, *The Politics and Philosophy of Economics*.

44. This theme has long informed the work of Robert A. Nisbet, e.g., *The Twilight of Authority*.

45. Murray Edelman, *The Symbolic Uses of Politics*, 2.

46. E.g., Murray Edelman and R. W. Fleming, *The Politics of Wage-Price Decisions: A Four-Country Analysis* (Urbana: Univ. of Illinois Press, 1965); Yale Brozen, "The Antitrust Witch Hunt," *National Review* 33 (Nov. 24, 1978): 1470–71, 1476–77.

47. This propensity of political leaders to shift policy directions has been practically elevated to the heights of political wisdom by Richard E. Neustadt in his discussion of presidential power. For example, by shifting policy positions constantly, Franklin D. Roosevelt was able to keep his opponents and his supporters in the dark as to his true intentions, thus enhancing his ability to control them. Had he displayed ideological rigidity, his opposition and supporters alike, secure in their knowledge of his actions, would have adjusted accordingly. See, *Presidential Power: The Politics of Leadership with Reflections on Johnson and Nixon* (New York: Wiley, 1976), 229–31.

48. The function of reassurance is discussed in Edelman, *The Symbolic Uses of Politics*, 22–43.

49. See, for example, Fiorina, *Congress — Keystone of the Washington Establishment*, 1–55.

50. One need not claim that Reagan deserves full credit for the fall in prices. Indeed, more credit might go well to the Chairman of the Federal Reserve Board, Paul Volcker. After all, the latter had pursued a policy of monetary restraint since November 1979. On the other hand, it cannot be denied that the Reagan Administration lent the Fed support in those months.

51. On these points and the role of the media in general, see Dan Nimmo, *Political Communication and Public Opinion in America* (Santa Monica, Calif.: Goodyear, 1978); and Kevin P. Phillips, *Mediacracy*.

52. Steven V. Roberts, "The G.O.P.: A Party in Search of Itself," *New York Times Magazine* 135 (March 6, 1983): 31–40, 80. Emphasis ours.

53. This generalization does not necessarily hold for the traditional British Tories. In fact, as Beer has repeatedly pointed out, they have usually been advocates of centralized state power—with the proviso that they alone administer it! This is a theme of both his *British Politics in the Collectivist Age* and *Britain Against Itself.*

54. See *Contra Mundum,* 403–17.

55. This point applies more to the Scottish than to the French Enlightenment. But see Carl L. Becker, *The Heavenly City of the Eighteenth-Century Philosophers.*

56. See Crozier, *The Minimum State;* and Robert Moss, *The Collapse of Democracy* (New Rochelle, N. Y.: Arlington House, 1976).

57. The distinctions among French conservatives on these points is discussed in René Rémond, *The Right Wing in France from 1815 to de Gaulle* (Philadelphia: Univ. of Pennsylvania Press, 1966).

58. For example, a far right thinker such as Charles Maurras, who was the spiritual leader of *Action Française,* comes immediately to mind. Regional autonomy, intermediary associations, and hostility to the centralized state characterized reactionary thought, but its antidemocratic and antisemitic sentiments led many to Vichy and pro-Nazism.

59. See Bertrand de Jouvenel, *On Power: Its Nature and the History of its Growth* (New York: Viking, 1940); and Robert A. Nisbet, *The Quest for Community: A Study in the Ethics of Order and Freedom* (New York: Oxford Univ. Press, 1953).

60. David Spitz, *Patterns of Anti-Democratic Thought.*

61. Historically many conservatives have been hostile to commerce and capitalism. As a consequence, they have sometimes united with socialists against traditional liberalism in support of "progressive" legislation. This was true both of Prussian reactionaries in the time of Bismarck and of Tories in Great Britain. However, a case may be made that the conservative aristocrats did not come off badly in their compassion for the poor and their hostility for the bourgeoisie. The first comprehensive social security and unemployment insurance systems owe their creation to the junker aristocracy. On the other hand, these Prussian agricultural interests were granted high tariffs against the importation of grain, and their allies among the industrialists were given both protection from imports and the right to form legal cartels. Thus, in the end the workers paid more for their food. They also paid higher prices for other products. The revolution in welfare had raised costs of production for German manufacturers, thus making Germany less competitive in international markets. Cartellization, on the other hand, enabled many firms to dump goods abroad while selling them at higher prices in Germany itself. That the workers gained in the long run is highly doubtful.

Similarly, the famous Speenhamland system enacted in England in 1796 has also been praised as an example of upper-class compassion arrayed against a heartless industrial bourgeoisie. In this case the landed gentry, presumably shocked by the ravages of capitalism, joined forces with the proletariat against the urban middle classes (indeed, President Richard M. Nixon and Daniel P. Moynihan, his adviser, based their proposed Family Assistance Plan in part upon Speenhamland). In fact, the 1796 revision of the Elizabethan Poor Law led to such an explosion

in public assistance rolls that it was necessary to reform the system radically some thirty-six years later. Under the Poor Law, payments to the poor were based upon the number of dependents and the price of bread. One effect was to encourage the poor to increase the size of their families; another consequence was the growth of bastardy. Furthermore, since payment was based upon the price of bread, it led to a large rise in the cost of administering the program. Similarly, it encouraged people at the margin to go on relief, since their incomes would now be higher than if they remained employed. Finally, the reform enabled rural employers to pay lower wages than otherwise, since the state made up the difference if wages fell below the minimal point. But for a sympathetic treatment of the Elizabethan Poor law and of the efforts by conservatives to protect the poor and others against the cruelties of the market, see Karl Polanyi, *The Great Transformation* (New York: Farrar and Rinehart, 1944); and for an account which argues that welfare reforms are at heart efforts to buy off the poor in order to thwart their revolutionary aspirations, see Frances Fox Piven and Richard A. Cloward, *Regulating the Poor: The Functions of Public Welfare* (New York: Vintage, 1972).

62. See, e.g., James J. Lynsky, "The Role of British Backbenchers in the Modification of Government Policy," *Western Political Quarterly* 28 (June 1970): 333–47.

63. See Rémond, *The Right Wing in France;* T. Alexander Smith, "Algeria and the French *Modérés:* The Politics of Immoderation?", *Western Political Quarterly* 23 (March 1965): 116–34.

64. Such luminaries as James McGregor Burns, Robert A. Dahl, Henry Steele Commager, E. E. Schattschneider, Arthur Schlesinger, Jr., and Richard E. Neustadt immediately come to mind. Of course, the Vietnam War gave second thoughts to many American liberals about just what a strong presidency might do to their interests.

65. Willmoore Kendall, "The Two Majorities."

66. Joseph P. Harris, *Congressional Control of Administration* (Washington: Brookings Institute, 1964).

67. *Congress — Keystone of the Washington Establishment.*

68. Walter Lippmann, *Essays in the Public Philosophy* (Boston: Little, Brown, 1955).

69. This is in effect the theme of Paul Johnson, *Modern Times: The World the Eighties* (New York: Harper & Row, 1983); and Barry, "A Defense of Liberalism Against Politics."

70. See, for example, George Vedel, ed., *La Dépolitisation: mythe ou realité?* (Paris: A. Colin, 1962).

71. This definition is drawn mainly from Eckstein, *Division and Cohesion in a Democracy,* 11–17, 227–30.

72. For a basic understanding of Switzerland, one can do no better than to consult the work of Christopher Hughes. The following paragraphs rely heavily upon his studies, esp. *The Federal Constitution of Switzerland* (Oxford: Clarendon Press, 1954); *The Parliament of Switzerland* (London: Cassell, 1962); and *Switzerland* (London: Ernest Benn, 1975). See also the work of Jürg Steiner, *Amicable Agreement versus Majority Rule: Conflict Resolution in Switzerland* (Chapel Hill: Univ. of North Carolina Press, 1974); Jürg Steiner and Robert H. Dorff, *A*

Theory of Political Decision Modes: Intraparty Decision Making in Switzerland (Chapel Hill: Univ. of North Carolina Press, 1980).

73. See, e.g., Davies, "Crime, Bureaucracy, and Equality," 101–2.

74. As Orson Welles put it in the movie, *The Third Man*: "In Italy for thirty years under the Borgias, they had warfare, terror, murder, bloodshed—but they produced Michelangelo, Leonardo da Vinci, and the Renaissance. In Switzerland, they have brotherly love, five hundred years of democracy and peace, and what did that produce? The cuckoo clock." This is taken from John McPhee, *La Place de la Concorde Suisse* (New York: Farrar, 1984), 47; McPhee's book is a fascinating account of the Swiss army and its effects upon other spheres of society.

75. On these points, see, e.g., "Switzerland: A Survey," *Economist* 285 (Oct. 30, 1982): 3–18. It is interesting and revealing that this analysis makes no mention of the political parties!

76. These themes have been discussed from a comparative standpoint by Herbert J. Sprio, *Government by Constitution: The Political Systems of Democracy* (New York: Random House, 1959), 64; and Robert A. Dahl, "Patterns of Opposition," in Dahl, ed., *Political Oppositions in Western Democracies* (New Haven: Yale Univ. Press, 1966), 341; Steiner and Dorff, *A Theory of Political Decision Modes*, 10–11; James A. Dunn, Jr., "'Consociational Democracy' and Language Conflict: A Comparison of the Belgian and Swiss Experiences," *Comparative Political Studies* 5 (April 1972): 3–39; and Thomas A. Baylis, "Collegial Leadership in Advanced Industrial Societies: The Relevance of the Swiss Experience," *Polity* 13 (Fall 1980): 33–56.

77. Jean Blondel, *Comparative Legislatures* (Englewood Cliffs, N. J.: Prentice-Hall, 1973), 57–62, 91.

78. Bayliss, "Collegial Leadership in Advanced Industrial Societies," 46.

79. Dunn, "'Consociational Democracy' and Language Conflict," 18. Dunn, significantly, classified Switzerland as a "depoliticized democracy."

80. Ibid., 27.

Chapter 7

1. Natalie Rogoff, "Social Stratification in France and the United States," *American Journal of Sociology* 58 (1952–1953): 347–57.

2. These themes have long been important ones in sociology. For example, see Seymour Martin Lipset, *Political Man;* Daniel Bell, *The End of Ideology* (Glencoe, Ill.: Free Press, 1960) and *The Cultural Contradictions of Capitalism;* and, from a different perspective, John Kenneth Galbraith, *The Affluent Society* (Boston: Houghton Mifflin, 1958).

3. This idea is developed throughout Hayek's *Law, Legislation, and Liberty: The Mirage of Social Justice.*

4. For a somewhat different interpretation, but one which is fully compatible with the argument offered in this study, see Fred Hirsch, *The Social Limits of Growth*, 15–160.

5. Peter F. Drucker, "Europe's High-Tech Delusion," *Wall Street Journal,* Sept. 14, 1984.

6. This section owes a very strong debt to the work of William H. Hutt, *A Rehabilitation of Say's Law;* also, Thomas Sowell, *Say's Law: An Historical Analysis* (Princeton: Princeton Univ. Press, 1971).

7. Jean-Baptiste Say, *A Treatise on Political Economy,* 6th ed. (Philadelphia: Lippincott, Grambo, 1853); and *Letters to Thomas Robert Malthus on Political Economy and Stagnation of Commerce* (London: George Hardin's Bookshop, 1936).

8. It is easy to misunderstand this point. See, e.g., the remarks of Tyler Cowen, "Say's Law and Keynesian Economics," in Richard H. Fink, ed., *Supply-Side Economics: A Critical Appraisal* (Frederick, Md.: University Publications of America, 1982), 160–84.

9. On the other hand, his debate with Malthus did receive a good deal of attention from other leading economists.

10. 2 Thess. 3:10. A literate Scot, Frenchman, or Englishman in the time of Smith, Hume, or Ricardo, moreover, would have been amused to see a so-called "supply-side economics" become a point of contention (if one excludes the debate on budget deficits!), as was the case in America during the presidential election of 1980. On the other hand, in this century, notably since the publication of Keynes's *General Theory,* gathering intellectual forces, the Great Depression, and material conditions have undermined the moral power of Say's Law.

11. These ideas are to be found in his monumental *General Theory of Employment, Interest, and Money* (1936; London: Macmillan, 1957).

12. What first-year economics student cannot quote Keynes's interpretation of Say that "supply creates its own demand?" It is, unfortunately, a highly misleading statement.

13. See Hutt, *A Rehabilitation of Say's Law,* 13–14. For an extreme interpretation, see the works of George Gilder, e.g., *Wealth and Poverty,* 28–46. For a trenchant critique of Gilder, see Thomas W. Hazlett, "The Supply-Side's Weak Side: An Austrian Critique," in Fink, ed., *Supply-Side Economics,* 93–120.

14. See the explanation of Hutt, ibid., 103–9.

15. Ibid., 13–14.

16. One thinks in particular of Robert Mundell, Arthur Laffer, George Gilder, and Jude Winneski.

17. See Harold D. Lasswell, *Psychopathology and Politics* (Chicago: Univ. of Chicago Press, 1934).

18. See his *General Theory,* 3–22, 333–71.

19. On the other hand, no amount of material well-being can entirely eliminate disputes based upon race, religion, sex, and status. To some extent these conflicts are impervious to resolution in societies where the population is obsessed with entitlements and "rights."

20. See, e.g., G. Ganz, "Allocation of Decision-Making Functions," in *Public Law,* Autumn 1972: 215–311, and Winter 1972: 299–308. Also, Kenneth Culp Davis, *Discretionary Justice: A Preliminary Inquiry* (Urbana: Univ. of Illinois Press, 1971), 3–51.

21. This is the argument of Guido Calabresi, among others. See *A Common Law for the Age of Statutes* (Cambridge: Harvard Univ. Press, 1982), 1–7.

22. The next few paragraphs rely heavily upon Oakeshott, *On History, and Other Essays,* 119–64.

23. Ibid.

24. See, especially, Leoni, *Freedom and the Law,* 77–96; and Giovanni Sartori, *Democratic Theory* (New York: Praeger, 1965), 278–325.

25. Hayek, *Law, Legislation, and Liberty: Rules and Order,* 72–73.

26. Ellen Ash Peters, "Common Law Judging in a Statutory World: An Address," *University of Pittsburgh Law Review* 43 (1981–82): 995–1011; and Calabresi, *A Common Law for the Age of Statutes,* 77.

27. This is the basic argument found in the work of Calabresi and Peters.

28. *A Common Law for the Age of Statutes,* 55.

29. See the incisive remarks of Letwin, "Law Without Law: Politics in the Courtroom," 7–15; also, Richard A. Epstein, "Economic Liberties and the Judiciary: The Active Virtues," *Regulation* 9 (Jan.–Feb. 1985):14–18.

30. See Richard A. Epstein, The Static Conception of the Common Law," *Journal of Legal Studies* 9 (March 1980): 253–75.

31. For reference to various landmark cases, see ibid., 262–63.

32. Ibid., 261.

33. See Jethro K. Leiberman, *The Litigious Society* (New York: Basic Books, 1981), 18–32.

34. Epstein, "The Static Conception of the Common Law," 269.

35. For various definitions, see Leslie A. White, "Definitions and Conceptions of Culture," in Gordon J. DiRenzo, ed., *Concepts, Theory, and Explanation in the Behavioral Sciences* (New York: Random House, 1966), 93–110; A. L. Kroeber and Clyde Kluckhohn, *Culture: A Critical Review of Concepts and Definitions* (Cambridge: Harvard University Printing Office, 1952).

36. Donald Light, Jr. and Suzanne Keller, *Sociology* (New York: Knopf, 1975), 564.

37. Sorokin's output was staggering. For an understanding of the culture concept, one might begin with his *Society, Culture and Personality: Their Structure and Dynamics* (New York: Harper, 1947), 313–41; and *Modern Historical and Social Philosophies* (New York: Dove, 1963), 187–204.

38. This point is discussed in Smith, *The Comparative Policy Process,* 1–8, 164–69.

39. See, e.g., James E. Anderson, *Public Policy-Making* (New York: Praeger, 1975), 2–4.

40. See, e.g., David Butler and Donald Stokes, *Political Change in Britain* (New York: St. Martin's, 1976). Indeed, studies of mass attitudes show citizens generally display little consistency in their policy preferences.

41. Aaron Wildavsky, "Choosing Preferences by Constructing Institutions: A Cultural Theory of Preference Formation, *"American Political Science Review* 81 (March 1987): 3–21; also Carolyn Webber and Aaron Wildavsky, *A History of Taxation and Expenditure in the Western World* (New York: Simon and Schuster, 1986), 584–614.

42. A third type not considered in this work may be designated "reallocative." This type is represented by the "totalist" or totalitarian ideologies as found in Communism and Fascism.

43. An instructive case may be found in Martin Meyer's *The Bankers,* in which he discusses the Federal Reserve Board in the United States: "There is a camaraderie about the federal reserve system, a sense of a secret society working together in the bowels of the economy, keeping confidences with a tenacity quite extraordinary in America, manipulating mysteries the outside world (which includes bankers and monetary economists) does not begin to understand. . . . Shortly before he left the St. Louis Fed (because he wanted to teach), Gerald Dunne said, 'There are twenty-five or twenty-six thousand people in this outfit, nationwide, but it has resisted the pathology of bigness. I really know most of my colleagues, their weaknesses and strengths, and I think they know mine.' Increasingly, their jobs are going to economists rather than to former bankers—but they are economists trained at the Fed." *Bankers* (New York: Weybright and Talley, 1974), p. 395. For other interesting studies of the FRB, see Michael D. Reagan, "The Political Structure of the Federal Reserve System," *American Political Science Review* 55 (March 1961): 64–75; Sanford F. Borins, "The Political Economy of 'The Fed,'" *Public Policy* 66 (Spring 1972): 175–98; Sherman J. Maisel, *Managing the Dollar* (New York: Norton, 1973). For a study of the British Treasury and its relationship with the Bank of England, see Samuel Brittan, *Steering the Economy: The Role of the Treasury* (Harmondsworth, Middlesex, Eng.: Penguin, 1970), 69–70, 75–87. Instructive works in the welfare area are Gaston V. Rimlinger, *Welfare Policy and Industrialization in Europe, America, and Russia* (New York: Wiley, 1971), 1–5, 341–43; Frederic L. Pryor, *Public Expenditures in Communist and Capitalist Nations* (Homewood, Ill.: Irwin, 1968), 128–81, 281–312; Arnold J. Heidenheimer, Hugh Heclo, and Carolyn Teich Adams, *Comparative Public Policy: The Politics of Social Choice in Europe and America* (New York: St. Martin's, 1975), 187–226; and Robert J. Myers, *Expansionism in Social Insurance* (London: Institute of Economic Affairs, 1970), 15–16, 26–30.

44. This was said to be true for the British Conservatives. A great deal of the hostility for Mrs. Thatcher's Government derives from her eagerness to break with a "consensus" established by both major parties, Conservative and Labour. See, e.g., Geoffrey Smith, "Mrs. Thatcher Has Turned the Tories Upside Down," *Wall Street Journal,* Feb. 13, 1985; and Edward Pearce, "A Prime Minister Under Siege," *National Review* 37 (April 19, 1985). For a pessimistic account of the breakdown of consensus, see the work, previously cited, of Samuel H. Beer, *Britain Against Itself.*

45. This point may be made with regard to race relations. Nathan Glazer has observed the moral authority of equality as a key force in the area of affirmative action programs in employment and school integration. Despite the opposition of much of the general public, periodic presidential hostility, and the presence in Congress of a majority which refused to write affirmative action into law, the utilization of statistically imposed quotas became public policy. A moral appeal which stresses the historical oppression of a minority and simultaneously calls for greater equality in the short run gave affirmative action proponents the upper hand in the

fray. Against such forces the opponents of employment and racial quotas found it very difficult to mobilize support for their position. In other words, an ameliorative policy culture was dominant. Power rested with the federal courts and especially with certain agencies of the government bureaucracy: the Equal Employment Opportunity Commission; the office of Civil Rights of the Department of Health, Education and Welfare; the Civil Rights Division of the Department of Justice; and the Office of the Federal Contract Compliance of the Department of Labor. See Nathan Glazer, *Affirmative Discrimination*, 207–13.

46. James Tobin, "On Limiting the Domain of Inequality," *Journal of Law and Economics* 13 (Oct. 1970): 263–77. In this connection Andrew Hacker has remarked: "Now that most members of the working class are no longer poor and powerless, the liberal [read "ameliorist"] must find a new historical vanguard. Hence the burst of compassion for the black. While there is concern over endemic poverty, it is noteworthy that impoverished white Americans fail to rouse liberal emotions to nearly the same degree as the plight of poor blacks. Liberal sentiment has always been *selective,* choosing their objects of compassion with a careful eye for the tenor of the times. Racial minorities will occupy this special position only so long as they qualify as society's *downtrodden classes," The End of the American Era,* 150–51. Emphasis ours.

47. On the other hand, the reader should keep in mind the inconsistency of ideological policy cultures. Many economic and social ameliorists display quite different attitudes so far as free speech, the right to assemble, etc. are concerned.

48. The accuracy of these statements is confirmed by the comments of Arthur M. Okun, a former member and Chairman of the Council of Economic Advisers in the Democratic Administrations of the 1960s. Okun's description of the ideological positions of professional economists concerned with policy comes very close to the one utilized in this study. See *The Political Economy of Prosperity* (Washington: Brookings Institution, 1970), pp. 19–21. For a strong argument in favor of discretionary justice, see Kenneth Culp Davis, *Discretionary Justice;* and for a study of the liberating aspects of "coercive" law, see David Spitz, *Democracy and the Challenge of Power* (New York: Columbia Univ. Press, 1958).

49. Or, as one critic of the Chicago School of economics put it: "Chicago proposals occasionally overvalue marginal increments of economic freedom as compared with other values. . . . This choice need not . . . lead inevitably, camelnosedly, to the concentration camps and the gas chamber." See Martin Bronfenbrenner, "Observations on the 'Chicago School'(s)," *Journal of Political Economy* 70 (Feb. 1962): 74.

50. Okun, *The Political Economy of Prosperity,* 19.

51. See, for example, the argument against Hayek as found in Herman Finer, *The Road to Reaction* (Boston: Little, Brown, 1945), 25.

52. Michel Crozier, *The Bureaucratic Phenomenon* (Chicago: Univ. of Chicago Press, 1964).

53. Henry C. Simons, *Economic Policy for a Free Society* (Chicago: Univ. of Chicago Press, 1948), 18.

54. Ibid.

55. Wildavsky, "Choosing Preferences by Constructing Institutions," 19n.

56. "Conservatives" who draw upon English Tory sources often criticize modern "libertarians" and apologists for eighteenth- and nineteenth-century "radicals" for failing to realize that an emphasis upon egoistic individualism will tear society apart.

57. This position is associated with Hayek in particular, but is characteristic of the entire Austrian School of Economics. On these points, see S. C. Littlechild, *The Fallacy of the Mixed Economy: An "Austrian" Critique of Economic Thinking and Policy* (London: Institute of Economic Affairs, 1978), 38–50, 60–66.

58. See, e.g., Richard A. Epstein, "The Social Consequences of Common Law Rules," 1717–51.

59. Lowi, *The End of Liberalism.*

60. Ibid., 100.

61. This view not only permeates *The End of Liberalism,* but may be found in various places where Lowi deals with theories of the policy process, e.g., "American Business, Public Policy, Case Studies and Political Theory," *World Politics* 17 (July 1964): 677–715; "Four Systems of Policy, Politics, and Choice," *Public Administration Review* 32 (July–Aug. 1972): 298–310; and *The Politics of Disorder,* esp. 3–61.

62. Again, this is implicit in Lowi's theory of the policy process. But compare with Epstein, who approaches the subject from a different perspective. See Richard A. Epstein, "The Social Consequence of Common Law Rules."

63. See, e.g., Littlechild, *The Fallacy of the Mixed Economy,* 27–50.

64. Robert H. Bork, *The Antitrust Paradox: A Policy at War With Itself* (New York: Basic Books, 1978), 20–21. One may well wonder if the subsequent tangled life of antitrust would have been far different, less confusing, and more effective if Sherman's own understanding of monopoly had been consistently followed. In his opinion, monopolists are simply those who simultaneously raise prices and restrict output — period.

65. Of course, one may have doubts about the practical application of any one of these programs on any number of grounds. See Charles Murray, *Losing Ground,* 147–53. On the other hand, the major defenders of NIT insisted that it must *replace* other forms of welfare if it were to prove successful. See Milton and Rose Friedman, *Free to Choose* (New York: Avon, 1979), 110–115.

66. Samuel Brittan, *Government and the Market Economy: An Appraisal of Economic Policy Since the 1970 General Election* (London: Institute of Economic Affairs, 1971), 31. Original emphasis.

67. Ibid.

68. John B. Williamson, et al., *Strategies Against Poverty in America* (Cambridge, Mass.: Schenkman, 1975), 77–85.

69. See his *Losing Ground,* 147–53, for these and related problems of poverty policy.

70. See footnote 63, above.

71. Anthony Christopher et al., *Policy for Poverty* (London: Institute of Economic Affairs, 1970), 33–36.

72. See Madsen Pirie, "A Short History of Enterprise Zones," *National Review* 33 (Jan. 23, 1981): 26–29.

73. L. Bemen, "Reorganizing the Inner Cities," *Fortune* 104 (Dec. 14, 1981): 98–100; and Jack Kemp, "A Case for Enterprise Zones," *Nation's Business* 70 (Nov. 1982): 54–56.

74. Ibid.; and for a less enthusiastic view about the future of EZ, see John Sloan, "Enterprise Zones May Not Be the Bargain That's Advertised," *Wall Street Journal,* March 26, 1985.

75. In Great Britain union regulations and safety and health restrictions are very strict, and change in the law was fiercely resisted. Thus, support for the EZ concept was undermined almost from the beginning by ministers, civil servants, and union interests. See Pirie, "A Short History of Enterprise Zones."

76. For a thorough study of urban renewal, see Martin Anderson, *The Federal Bulldozer: A Critical Analysis of Urban Renewal, 1949–1962* (Cambridge: M.I.T. Press, 1964). The following paragraphs draw heavily upon Anderson's study.

77. Lowi, *The End of Liberalism,* 237–68.

78. *The Federal Bulldozer,* 2–3.

79. Sadly enough, it is a process recently reaffirmed by a so-called "conservative" Supreme Court in *Hawaii Housing Authority v. Midkiff* (1984).

80. Examples may be found in Leland B. Yeager, ed., *In Search of a Monetary Constitution* (Cambridge: Harvard Univ. Press, 1962). The articles by Milton Friedman and Murray Rothbard are especially pertinent in this regard. For a recent discussion, see Joseph T. Salerno, "The 100 Percent Gold Standard: A Proposal for Monetary Reform," in Fink, ed., *Supply-Side Economics,* 454–88.

81. See his "The Trouble with Monetarism," *Policy Review* no. 21 (Summer 1982): 19–42. A recent debate in the *Economist* 295 (April 27–May 3, 1985: 23–25; and May 4–10, 1985: 23–25) in which Sir Alan Walters, chief economic adviser to Mrs. Thatcher, and James Tobin, a member of past American Democratic Administrations, argue the case for and against monetarism is a clear example of the ongoing debate over rules in economic policy.

82. See, e.g., F. A. Hayek, *Denationalization of Money—The Argument Refined: An Analysis of the Theory and Practice of Concurrent Currencies* (London: Institute of Economic Affairs, 1978); and Lawrence H. White, *Free Banking in Britain: Theory, Experience, and Debate, 1800–1845* (Cambridge: Harvard Univ. Press, 1984).

83. White, *Free Banking in Britain;* High Rockoff, "The Free Banking Era: A Reexamination," *Journal of Money, Credit and Banking* 1 (May 1974): 41–67; and Richard H. Timberlake, *The Origins of Central Banking in the United States* (Cambridge: Harvard Univ. Press, 1978).

84. A recent summary of this debate may be found in Salerno, "The 100 Percent Gold Standard," 454–88.

85. Ibid.

86. See the devastating attack upon the gold exchange standard by one of the outstanding defenders of the classical gold standard: Jacques Rueff, *The Monetary Sin of the West* (New York: Macmillan, 1972).

87. E.g., Reynolds, "The Trouble with Monetarism." In fact, leading supply-siders such as Jude Winneski, George Gilder, and Robert Bartley have regularly

inveighed on the pages of the *Wall Street Journal* against monetarism and the present system of freely-fluctuating exchange rates.

88. Again, one can find no better account than in Jacques Rueff, previously cited. For a clear and concise history of this period, see Henry Hazlitt, "To Restore World Monetary Order," in Hans F. Sennholz, ed., *Gold is Money* (Westport, Conn.: Greenwood, 1975), 61–76.

89. This was a constant theme in the work of the German economist Wilhelm Roepke. Among his many works one might begin with a group of essays, edited by the political scientist Gottfried Dietze, entitled *Against the Tide* (Chicago: Regnery, 1969).

90. Robert A. Mundell, "Gold Would Serve Into the 21st Century," *Wall Street Journal*, Sept. 30, 1981.

91. In this respect, see the works, previously cited, of Rueff and Hazlitt. Also, see Arthur Kemp, *The Role of Gold* (Washington, D.C.: American Enterprise Institute for Public Policy Research, 1963).

92. From a technical point of view, of course, one may well conclude that the supply-side case is stronger than the one favored by monetarists and economists generally, but this conclusion does not affect our argument. We address the problems of rules per se; hence, our interest is only indirectly related to the problem of technique. On the other hand, our sympathies admittedly lie with the classical gold standard. For a strong case in favor of gold as opposed to fiat money, see Murray N. Rothbard, "Gold vs. Fluctuating Fiat Exchange Rates," in Sennholz, ed., *Gold is Money*, 25–40.

93. The founders of the post–World War II gold exchange standard, especially and including Lord Keynes, certainly envisioned their system as one in which enlightened public officials would necessarily guide the various nations to international economic stability. See Buchanan and Wagner, *Democracy in Deficit*, 77–85.

94. A social order based upon "capitalism" probably has less to do with the modern obsession with self than do such phenomena as rapid social mobility and its status insecurities, excessive expectations, and high living standards, which are for the most part by-products of material success.

Chapter 8

1. Mises, *Human Action*, p. 497.

2. Walter A. Weisskopf, *Alienation and Economics* (New York: Dutton, 1971), 22–26.

3. Ibid., 25.

4. See, e.g., James M. Buchanan, "Toward Analysis of Closed Behavioral Systems," 11–23.

5. See, e.g., "Privatization: Everybody's Doing it, Differently," *Economist* 297 (Dec. 1985): 71–86.

6. See the stimulating study of Yair Aharoni, *The No-Risk Society* (Chatham, N. J.: Chatham House, 1981).

7. Excellent examples may be found in John Logue, "Will Success Spoil the Welfare State?: Solidarity and Egoism in Social Democratic Scandinavia," *Dissent* 32 (Winter 1985): 96–104.

8. See *Federalist No. 62* in Alexander Hamilton, James Madison, and John Jay, *The Federalist Papers* (New York: Bantam, 1982), 316.

9. Ibid., 317. We wish to thank John W. Danford for bringing this passage to our attention.

10. Willmoore Kendall and George W. Carey, *The Basic Symbols of the American Political Tradition* (Baton Rouge: Louisiana State Univ. Press, 1970).

11. Murray N. Rothbard, *The Ethics of Liberty;* and Richard A. Epstein, *Takings* (Cambridge: Harvard Univ. Press, 1985).

12. The concept of the "self-divided" man has, of course, been used in a more traditional way. For an excellent discussion of this problem, see Shirley Robin Letwin, *The Gentleman in Trollope: Individuality and Moral Conduct* (Cambridge: Harvard Univ. Press, 1982), esp. 37–52.

13. Anne Mayhew, "A Reappraisal of the Causes of Farm Protest in the United States, 1870–1900," *Journal of Economic History* 62 (June 1972): 475.

14. John Burton, "The Instability of the 'Middle Way,'" in Norman Barry et al, *Hayek's 'Serfdom' Revisited* (London: Institute of Economic Affairs, 1984), 89–111.

Selected Bibliography

Abbott, Philip. *The Family on Trial: Special Relationships in Modern Political Thought*. University Park: Pennsylvania State Univ. Press., 1981.

Aharoni, Yair. *The No-Risk Society*. Chatham, N. J.: Chatham House, 1981.

Almond, Gabriel A. *Political Development: Essays in Heuristic Theory*. Boston: Little, Brown, 1970.

———, and Sidney Verba. *The Civic Culture*. Princeton: Princeton Univ. Press, 1963.

American Political Science Association Committee on Political Parties. *Toward a More Responsible Two-Party System*. New York: Rinehart, 1950.

Anderson, James E. *Public Policy-Making*. New York: Praeger, 1975.

Anderson, Martin. *The Federal Bulldozer: A Critical Analysis of Urban Renewal, 1949–1962*. Cambridge: M.I.T. Press, 1975.

Armentano, D. T. *The Myth of Anti-Trust*. New Rochelle, N. Y.: Arlington House, 1972.

Auerbach, Morton. *The Conservative Illusion*. New York: Columbia Univ. Press, 1959.

Bagehot, Walter. *The English Constitution*. Garden City, N. Y.: Doubleday, 1972.

Banfield, Edward. *The Unheavenly City Revisited*. Boston: Little, Brown, 1974.

Barnett, Randy E., and John E. Hagel, eds. *Assessing the Criminal: Restitution, Retribution, and the Legal Process*. Cambridge, Mass.: Ballinger, 1977.

Barry, Norman P. *Hayek's Social and Economic Philosophy*. London: Macmillan, 1979.

———. "A Defense of Liberalism Against Politics." *Indian Journal of Political Science* 41 (June 1980): 171–97.

———, et al. *Hayek's 'Serfdom' Revisited*. London: Institute of Economic Affairs, 1984.

Bauer, P. T. *Dissent on Development: Studies and Debates in Development Economics*. Cambridge: Harvard Univ. Press, 1972.

Bauer, Raymond A., Ithiel de Sola Pool, and Lewis Anthony Dexter. *American Business and Public Policy: The Politics of Foreign Trade*. New York: Atherton, 1963.

Baylis, Thomas. "Collegial Leadership in Advanced Industrial Societies: The Relevance of the Swiss Experience." *Polity* 13 (Fall 1980): 33–56.

Becker, Carl L. *The Heavenly City of the Eighteenth-Century Philosophers*. New Haven: Yale Univ. Press, 1932.

Becker, Ernest. *The Denial of Death*. New York: Free Press, 1973.

Beer, Samuel H. *Britain Against Itself: The Contradictions of Collectivism.* New York: Norton, 1982.

————. *British Politics in the Collectivist Age.* New York: Knopf, 1966.

Bell, Daniel. *The Coming of Post-Industrial Society: A Venture in Social Forecasting.* New York: Basic Books, 1973.

————. *The Cultural Contradictions of Capitalism.* New York: Basic Books, 1976.

————. The End of Ideology. Glencoe, Ill.: Free Press, 1960.

Berelson, Bernard. "Democratic Theory and Public Opinion." *Public Opinion Quarterly* 16 (Fall 1952): 313–30.

Birnbaum, Norman. *The Crisis of Industrial Society.* London: Oxford Univ. Press, 1969.

Blondel, Jean. *Comparative Legislatures.* Englewood Cliffs, N. J.: Prentice-Hall, 1973.

Boehm-Bawerk, Eugen von. *The Positive Theory of Capital.* London: Macmillan, 1891.

Bork, Robert H. *The Anti-Trust Paradox: A Policy at War with Itself.* New York: Basic Books, 1978.

Bresciani-Turoni, Constanino. "The Theory of Saving." *Economica* 3 (May 1936): 162–81.

————. *The Economics of Inflation.* London: George Allen & Unwin, 1937.

Brittan, Samuel. *Steering the Economy: The Role of the Treasury.* Harmondsworth, Middlesex, Eng.: Penguin, 1970.

————. *Government and the Market Economy: An Appraisal of Economic Policy Since the 1970 General Election.* London: Institute of Economic Affairs, 1971.

————. "The Economic Contradictions of Democracy." *British Journal of Political Science* 5 (April 1975): 129–59.

Bronfenbrenner, Martin. "Observations on the 'Chicago School'(s)." *Journal of Political Economy* 70 (Feb. 1962): 72–75.

Brozen, Yale. "The Antitrust-Task Force Deconcentration Recommendation." *Journal of Law and Economics* 13 (Oct. 1970): 279–92.

————. "The Antitrust Witch Hunt." *National Review* 33 (Nov. 24, 1978): 1470–71, 1476–77.

Bryson, Gladys. *Man and Society: The Scottish Inquiry of the 18th Century.* Princeton: Princeton Univ. Press, 1945.

Brzezinski, Zbigniew. *Between Two Ages: America's Role in the Technetronic Era.* New York: Viking, 1971.

Buchanan, James M., and Robert D. Tollison, eds. *Theory of Public Choice.* Ann Arbor: Univ. of Michigan Press, 1972.

————, and Richard E. Wagner. *Democracy in Deficit: The Political Legacy of Lord Keynes.* New York: Academic Press, 1977.

Burnham, Walter Dean. *The Current Crisis in American Politics.* New York: Oxford Univ. Press, 1982.

Burns, James MacGregor. *The Deadlock of Democracy: Four-Party Politics in America.* Englewood Cliffs, N. J.: Prentice-Hall, 1963.

Butler, David, and Donald Stokes. *Political Change in Britain.* New York: St. Martin's, 1976.

Calabresi, Guido. *A Common Law for the Age of Statutes.* Cambridge: Harvard Univ. Press, 1982.

Christopher, Anthony, et al. *Policy for Poverty.* London: Institute of Economic Affairs, 1970.

Coddington, Alan. "Creaking Semaphore and Beyond: A Consideration of Shackle's 'Epistemics and Economics.'" *British Journal of the Philosophy of Science* 26 (June 1975): 152–63.

———. "Keynesian Economics: The Search for First Principles." *Journal of Economic Literature* 14 (Dec. 1976): 1258–73.

Cropsey, Joseph. *Polity and Economy: An Interpretation of the Principles of Adam Smith.* The Hague: Martinus Nijhoff, 1957.

Crozier, Brian. *The Minimum State: Beyond Party Politics.* London: Hamish Hamilton, 1979.

Crozier, Michel. *The Bureaucratic Phenomenon.* Chicago: Univ. of Chicago Press, 1964.

Cunningham, Robert L., ed. *Liberty and the Rule of Law.* College Station: Texas A & M Univ. Press, 1979.

Dahl, Robert A. *A Preface to Democratic Theory.* Chicago: Univ. of Chicago Press, 1956.

———, ed. *Political Oppositions in Western Democracies.* New Haven: Yale Univ. Press, 1966.

Dalton, Russell J. "Cognitive Mobilization and Partisan Dealignment in Advanced Industrial Societies." *Journal of Politics* 46 (Feb. 1984): 264–84.

Dauenhauer, Bernard P. "Making Plans and Lived Time." *Southern Journal of Philosophy* 7 (Spring 1969): 83–90.

Davies, Christie. "Crime, Bureaucracy, and Equality." *Policy Review,* no. 20 (Winter 1983): 89–105.

Davis, Kenneth Culp. *Discretionary Justice: A Preliminary Inquiry.* Urbana: Univ. of Illinois Press, 1971.

Dawson, Richard E., and James A. Robinson. "Inter-Party Competition, Economic Variables, and Welfare Policies in the American States." *Journal of Politics* 25 (May 1963): 265–89.

Demsetz, Harold, "Industry Structure, Market Rivalry, and Public Policy." *Journal of Law and Economics* 16 (April 1973): 1–9.

Devine, Donald J. *Does Freedom Work? Liberty and Justice in America.* Ottawa, Ill.: Caroline House, 1978.

Deutsch, Emeric, Denis Lindon, and Pierre Weill. *Les Familles politiques en France.* Paris: Les Éditions de Minuit, 1966.

Devries, Walter, and V. Lance Tarrance. *The Ticket-Splitter: A New Force in American Politics.* Grand Rapids, Mich.: Eerdmans, 1972.

Dietze, Gottfried, ed. *Against the Tide.* Chicago: Regnery, 1969.

DiRenzo, Gordon J., ed. *Concepts, Theory, and Explanation in the Behavioral Sciences.* New York: Random House, 1966.

Dolan, Edwin, ed. *The Foundations of Modern Austrian Economics.* Kansas City, Mo.: Sheed & Ward, 1976.

Douglas, Mary, and Aaron Wildavsky. *Risk and Culture.* Berkeley: Univ. of California Press, 1982.

Dunn, James A., Jr. "'Consociational Democracy' and Language Conflict: A Comparison of Belgian and Swiss Experiences." *Comparative Political Studies* 5 (April 1972): 3–39.

Duverger, Maurice. *Political Parties.* New York: Wiley, 1954.

Easton, David. *A Framework for Political Analysis.* Englewood Cliffs, N. J.: Prentice-Hall, 1965.

———. *A Systems Analysis of Political Life.* New York: Wiley, 1965.

Eckstein, Harry. *Pressure Group Politics: The Case of the British Medical Association.* London: George Allen and Unwin, 1960.

Edelman, Murray. *The Symbolic Uses of Politics.* Urbana: Univ. of Illinois Press, 1967.

———, and R. W. Fleming. *The Politics of Wage-Price Decisions: A Four-Country Analysis.* Urbana: Univ. of Illinois Press, 1965.

Elshtain, Jane Bethke. *Public Man, Private Woman: Women in Social and Political Thought.* Princeton: Princeton Univ. Press, 1981.

Epstein, Leon D. "What Happened to the British Party Model?" *American Political Science Review* 9 (March 1980): 23–37.

Epstein, Richard A. "The Static Conception of the Common Law." *Journal of Legal Studies* 9 (March 1980): 253–75.

———. "The Social Consequences of Common Law Rules." *Harvard Law Review* 95 (June 1982): 1717–51.

———. *Takings.* Cambridge: Harvard Univ. Press, 1985.

Feldstein, Martin. "Toward a Reform of Social Security." *The Public Interest* 40 (Summer 1975): 75–95.

———. "Facing the Social Security Crisis." *The Public Interest* 47 (Spring 1977): 88–100.

Fetter, Frank A. *Capital, Interest, and Rent: Essays in the Theory of Distribution.* Kansas City, Mo.: Sheed Andrews and McMeel, 1977.

Finer, Herman. *The Road to Reaction.* Boston: Little, Brown, 1945.

Finifter, Ada W., ed. *Political Science: The State of the Discipline.* Washington, D.C.: American Political Science Association, 1983.

Fink, Richard H., ed. *Supply-Side Economics: A Critical Appraisal.* Frederick, Md.: University Publications of America, 1982.

Fiorina, Morris P. *Congress — Keystone of the Washington Establishment.* New Haven: Yale Univ. Press, 1977.

Fisher, Irving. *The Theory of Interest.* New York: Kelley, 1965.

Fishkin, James S. *Justice, Equal Opportunity, and the Family.* New Haven: Yale Univ. Press, 1983.

Freud, Sigmund. *Civilization and its Discontents.* New York: Norton, 1961.

Friedman, Milton, and Rose Friedman. *Free to Choose.* New York: Avon, 1979.

Fromm, Erich. *Escape from Freedom.* New york: Holt, 1976.

Frye, Charles E. "Parties and Pressure Groups in Weimar and Bonn." *World Politics* 18 (July 1965): 635–55.

Fiorina, Morris P. *Congress—Keystone of the Washington Establishment.* New Haven: Yale Univ. Press, 1977.

Galbraith, John Kenneth. *The Affluent Society.* Boston: Houghton Mifflin, 1958.

———. *The New Industrial State.* New York: Houghton Mifflin, 1967.

Garrison, Roger W. "Reflections on Misesian Time Preference." 1975, unpublished ms.

———. "Intertemporal Coordination and the Invisible Hand: An Austrian Perspective on the Keynesian Vision." *History of Political Economy* 17 (Summer 1985): 309–21.

Gerth, Hans, and C. Wright Mills, eds. *From Max Weber: Essays in Sociology.* New York: Galaxy, 1958.

Gilder, George. *Wealth and Poverty.* New York: Basic Books, 1981.

Glazer, Nathan. *Affirmative Discrimination: Ethnic Inequality and Public Policy.* New York: Basic Books, 1975.

Goldwin, Robert A., ed. *Political Parties, U.S.A.* Chicago: Rand McNally, 1961.

Gurvitch, Georges. *The Spectrum of Social Time.* Dordrecht-Holland: D. Reidel, 1964.

Hacker, Andrew. *The End of the American Era.* New York: Atheneum, 1971.

Hall, John R. "The Time of History and the History of Times." *History of Theory* 20 (Feb. 1980): 113–31.

Hancock, M. Donald. *Sweden: The Politics of Postindustrial Change.* Hinsdale, Ill.: Dryden, 1972.

Haney, Lewis H. *History of Economic Thought.* New York: Macmillan, 1949.

Harris, Joseph P. *Congressional Control of Administration.* Washington: Brookings Institution, 1964.

Harris, Marvin. *America Now: The Anthropology of a Changing Culture.* New York: Simon and Schuster, 1981.

Hayek, Friedrich A. von. *Prices and Production.* London: George Routledge, 1935.

———. *The Pure Theory of Capital.* London: Routledge & Kegan Paul, 1941.

———. "Time-Preference and Productivity: A Reconsideration." *Economica* 12 (Feb. 1945): 22–25.

———. *Individualism and Economic Order.* Chicago: Univ. of Chicago Press, 1948.

———. "Three Elucidations of the Ricardo Effect." *Journal of Political Economy* 77 (Jan./Feb. 1969): 274–85.

———. *Law, Legislation, and Liberty.* Vol. 1, *Rules and Order.* Chicago: Univ. of Chicago Press, 1973.

———. *Denationalization of Money—The Argument Refined: An Analysis of the Theory and Practice of Concurrent Currencies.* London: Institute of Economic Affairs, 1978.

———. *Law, Legislation, and Liberty.* Vol. 3, *The Political Order of a Free People.* Chicago: Univ. of Chicago Press, 1979.

Hayes, Michael T. "The Semi-Sovereign Pressure Groups: A Current Theory and an Alternative Typology." *Journal of Politics* 40 (Feb. 1978): 134–61.

Heidenheimer, Arnold J., Hugh Helco, and Carolyn Teich Adams. *Comparative*

Public Policy: The Politics of Social Choice in Europe and America. (New York: St. Martin's, 1975.

Hirsch, Fred. *The Social Limits of Growth.* Cambridge: Harvard Univ. Press, 1978.

Hughes, Christopher. *The Federal Constitution of Switzerland.* Oxford: Clarendon Press, 1954.

——. *The Parliament of Switzerland.* London: Cassell, 1962.

——. *Switzerland.* London: Ernest Benn, 1975.

Huntington, Samuel P. "Postindustrial Politics: How Benign Will It Be?" *Comparative Politics* 6 (Jan. 1974): 163–92.

Hutchison, T. W. *The Politics and Philosophy of Economics: Marxians, Keynesians, and Austrians.* New York: New York Univ. Press, 1981.

Hutt, W. H. *A Rehabilitation of Say's Law.* Athens: Ohio Univ. Press, 1974.

Hutton, Graham. *What Killed Prosperity, In Every State from Ancient Rome to the Present.* New York: Chilton, 1960.

Inglehart, Ronald. "The Silent Revolution in Europe: Intergenerational Change in Post-Industrial Societies." *American Political Science Review* 65 (Dec. 1971): 991–1017.

——. *The Silent Revolution: Changing Values and Political Styles Among Western Publics.* Princeton: Princeton Univ. Press, 1977.

——. "Post-Materialism in an Environment of Insecurity." *American Political Science Review* 75 (Dec. 1981): 880–900.

Johnson, Paul. *Modern Times: The World From the Twenties to the Eighties.* New York: Harper & Row, 1983.

Jouvenel, Bertrand de. *On Power: Its Nature and the History of Its Growth.* New York: Viking, 1949.

Kahn, Herman, and Anthony J. Wiener. *The Year 2000: A Framework for Speculation on the Next Thirty-Three Years.* New York: Macmillan, 1976.

Kauder, Emil. *A History of Marginal Utility Theory.* Princeton: Princeton Univ., 1965.

Kemp, Arthur. *The Role of Gold.* Washington, D.C.: American Enterprise Institute for Public Policy Research, 1963.

Kemp, Jack. "A Case for Enterprise Zones." *Nation's Business* 10 (Nov. 1982): 54–56.

Kendall, Willmoore. "Prolegomena to Any Future Work on Majority Rule." *Journal of Politics* 12 (Nov. 1950): 694–713.

——. *Contra Mundum.* New Rochelle, N. Y.: Arlington House, 1971.

——, and George W. Carey. *The Basic Symbols of the American Political Tradition.* Baton Rouge: Louisiana State Univ. Press, 1970.

Key, V. O. Jr. *American State Politics: An Introduction.* New York: Knopf, 1956.

Keynes, John Maynard. *The General Theory of Employment, Interest, and Money.* London: Macmillan, 1957.

Kirzner, Israel M. *Competition and Entrepreneurship.* Chicago: Univ. of Chicago Press, 1973.

——, ed. *Methods, Process, and Austrian Economics: Essays in Honor of Ludwig von Mises.* Lexington, Mass.: Heath, 1982.

————, ed. *Subjectivism, Intelligibility and Economic Understanding: Essays in Honor of Ludwig M. Lachmann on His Eightieth Birthday.* New York: New York Univ. Press, 1986.

Knight, Frank H. "Professor Mises and the Theory of Capital." *Economica* 8 (Nov. 1941): 409–27.

Kornhauser, William. *The Politics of Mass Society.* Glencoe, Ill.: Free Press, 1959.

Kristol, Irving. *Two Cheers for Capitalism.* New York: Basic Books, 1978.

Lachmann, Ludwig M. *The Legacy of Max Weber.* London: Heinemann Educational Books, 1970.

————. "From Mises to Shackle: An Essay on Austrian Economics and the Kaleidic Society." *Journal of Economic Literature* 14 (March 1976): 54–61.

————, and Introduction by Walter Grinder. *Capital, Expectations and the Market Process: Essays on the Theory of the Market Economy.* Kansas City, Mo.: Sheed Andrews and McMeel, 1977.

————. *Capital and Its Structure.* Kansas City, Mo.: Sheed Andrews and McMeel, 1978.

————. *The Market as an Economic Process.* Oxford: Basil Blackwell, 1986.

Lasch, Christopher. *Haven in a Heartless World: The Family Besieged.* New York: Basic Books, 1977.

Lasswell, Harold D. *Psychopathology and Politics.* Chicago: Univ. of Chicago Press, 1934.

Leiberman, Jethro K. *The Litigious Society.* New York: Basic Books, 1981.

Leoni, Bruno. *Freedom and the Law.* Los Angeles: Nash, 1972.

Letwin, Shirley Robin. *The Gentleman in Trollope: Individuality and Moral Conduct.* Cambridge: Harvard Univ. Press, 1982.

————. "Law Without Law: Politics in the Courtroom." *Policy Review,* no. 26 (Fall 1983): 7–15.

Lijphart, Arend. "Comparative Politics and the Comparative Method." *American Political Science Review* 65 (Sept. 1971): 682–93.

Lindberg, Leon N., ed. *Politics and the Future of Industrial Society.* New York: David McKay, 1976.

Lipset, Seymour Martin. *Political Man.* Garden City, N. J.: Doubleday, 1960.

Littlechild, S. C. *The Fallacy of the Mixed Economy: An "Austrian" Critique of Economic Thinking and Policy."* London: Institute of Economic Affairs, 1978.

Logue, John. "Will Success Spoil the Welfare?: Solidarity and Egoism in Social Democratic Scandinavia." *Dissent* 32 (Winter 1985): 96–104.

Lowi, Theodore J. "American Business, Public Policy, Case Studies and Political theory." *World Politics* 17 (July 1964): 677–715.

————. "Decision Making vs. Policy Making: Toward an Antidote for Technocracy." *Public Administration Review* 30 (May/June 1970): 314–25.

————. *The Politics of Disorder.* New York: Basic Books, 1971.

————. "Four Systems of Policy, Politics, and Choice." *Public Administration Review* 32 (July/Aug. 1972): 298–310.

————. *The End of Liberalism: The Second Republic of the United States.* New York: Norton, 1979.

Lynsky, James J. "The Role of British Backbenchers in the Modification of Government Policy." *Western Political Quarterly* 28 (June 1970): 333–47.

Macpherson, C. B. *The Life and Times of Liberal Democracy.* London: Oxford Univ. Press, 1977.

Maisel, Sherman J. *Managing the Dollar.* New York: Norton, 1973.

Maitel, Schlomo. *Minds, Markets, and Money.* New York: Basic Books, 1982.

Mansfield, Edwin. *Technological Change.* New York: Norton, 1971.

Margolis, Michael. *Viable Democracy.* New York: Penguin, 1979.

Mayhew, Anne. "A Reappraisal of the Causes of Farm Protest in the United States, 1870–1900." *Journal of Economic History* 62 (June 1972): 464–75.

McClosky, Herbert. "The Fallacy of Absolute Majority Rule." *Journal of Politics* 11 (Nov. 1949): 637–54.

McKenzie, Richard B. "Fashionable Myths of National Industrial Policy," *Policy Review,* no. 26 (Fall 1983): 75–87.

Miller, Arthur H., and Martin P. Wattenberg. "Measuring Party Identification: Independent or Non-Partisan Preference?" *American Journal of Political Science* 27 (Feb. 1983): 106–22.

Mills, C. Wright. *White Collar: The American Middle Classes.* New York: Oxford Univ. Press, 1956.

Mises, Ludwig von. *The Theory of Money and Credit.* New Haven: Yale Univ. Press, 1953.

———. *Human Action: A Treatise on Economics.* Chicago: Regnery, 1966.

Moorhouse, John C. "The Mechanistic Foundations of Economic Analysis." *Reason Papers* (Winter 1978): 49–67.

Moss, Robert. *The Collapse of Democracy.* New Rochelle, N. Y.: Arlington House, 1976.

Murray, Charles. *Losing Ground: American Social Policy 1950–1980.* New York: Basic Books, 1984.

Myers, Robert J. *Expansionism in Social Insurance.* London: Institute of Economic Affairs, 1970.

Neustadt, Richard E. *Presidential Power: The Politics of Leadership With Reflections on Johnson and Nixon.* New York: Wiley, 1976.

Nimmo, Dan. *Political Communication and Public Opinion in America.* Santa Monica, Calif.: Goodyear, 1978.

Nisbet, Robert A. *The Quest for Community: A Study in the Ethics of Order and Freedom.* New York: Oxford Univ. Press, 1953.

———. *The Sociological Tradition.* New York: Basic, 1966.

———. *Tradition and Revolt: Historical and Sociological Essays.* New York: Vintage, 1970.

———. *Twilight of Authority.* New York: Oxford Univ. Press, 1975.

Oakeshott, Michael. *On History, and Other Essays.* Oxford: Basil Blackwell, 1983.

Office of Policy Planning and Research, U.S. Department of Labor. *The Negro Family: The Case for National Action,* March 1965.

Okun, Arthur M. *The Political Economy of Prosperity.* Washington, D.C.: Brookings Institution, 1970.

Olson, Mancur, and Martin J. Bailey. "Positive Time Preference." *Journal of Political Economy* 89 (Feb. 1981): 1–25.

Ornstein, Robert E. *On the Experience of Time.* New York: Penguin, 1970.

Peters, Ellen Ash. "Common Law Judging in a Statutory World: An Address." *University of Pittsburgh Law Review* 43 (1981–82): 995–1011.

Phillips, Kevin P. *Mediacracy: American Politics in the Communications Age.* Garden City, N. Y.: Doubleday, 1975.

Piven, Frances Fox, and Richard A. Cloward. *Regulating the Poor: The Functions of Public Welfare.* New York: Vintage, 1972.

Polanyi, Karl. *The Great Transformation.* New York: Farrar and Rinehart, 1944.

Polsby, Nelson W. *Consequences of Party Reform.* New York: Oxford Univ. Press, 1983.

Popper, Karl P. *The Open Society and its Enemies.* Vol. 1. New York: Harper Torchbooks, 1962.

Prendergast, Christopher. "Alfred Schutz and the Austrian School of Economics." *American Journal of Sociology* 92 (July 1986): 1–26.

Pryor, Frederic L. *Public Expenditures in Communist and Capitalist Nations.* Homewood, Ill.: Irwin, 1968.

Reagan, Michael D. "The Political Structure of the Federal Reserve System." *American Political Science Review* 55 (March 1961): 64–75.

Reich, Robert B. *The Next American Frontier.* New York: Times Books, 1983.

Rémond, René. *The Right Wing in France from 1815 to de Gaulle.* Philadelphia: Univ. of Pennsylvania Press, 1966.

Reynolds, Alan. "The Trouble with Monetarism." *Policy Review,* no. 21 (Summer 1982): 19–42.

Richmond, Keith. "Daylight Saving in New South Wales: A Case of Emotive Symbolic Politics?" *Australian Journal of Public Administration* 37 (Dec. 1978): 374–85.

Riesman, David, with Nathan Glazer and Rewel Denney. *The Lonely Crowd.* Garden City, N. Y.: Doubleday Anchor Books, 1953.

Rimlinger, Gaston V. *Welfare Policy and Industrialization in Europe, America, and Russia.* New York: Wiley, 1971.

Rizzo, Mario J., ed. *Time, Uncertainty, and Disequilibrium.* Lexington, Mass.: Heath, 1979.

Roberts, Paul Craig. *The Supply Side Revolution.* Cambridge: Harvard Univ. Press, 1984.

Robertson, H. M. *Aspects of the Rise of Economic Individualism: A Critique of Max Weber and His School.* New York: Kelley and Millman, 1959.

Rockoff, Hugh. "The Free Banking Era: A Reexamination." *Journal of Money, Credit and Banking* 1 (May 1974): 41–67.

Roepke, Wilhelm. *A Humane Economy: The Social Framework of the Free Market.* Chicago: Regnery, 1960.

———. *Economics of the Free Society.* Chicago: Regnery, 1963.

Rogoff, Natalie. "Social Stratification in France and the United States." *American Journal of Sociology* 58 (1952–1953): 347–57.

Rosenberg, Nathan. *Technology and American Economic Growth*. New York: Harper Torch Books, 1972.

———. "Problems in the Economist's Conceptualization of Technological Innovation." *History of Political Economy* 7 (Winter 1975): 456–81.

———. *Perspectives on Technology*. London: Cambridge Univ. Press, 1976.

Rosenstein-Rodan, P. N. "The Role of Time in Economic Theory." *Economica* 1 (1934): 77–97.

Rothbard, Murray N. *Man, Economy, and State: A Treatise on Economic Principles*. 2 vols. Princeton: Van Nostrand, 1962.

———. *America's Great Depression*. Kansas City, Mo.: Sheed and Ward, 1975.

———. *The Ethics of Liberty*. Atlantic Highlands, N. J.: Humanities Press, 1982.

———. *Collected Papers II: Studies in Social Theory*. Ed. Maurice Natanson. The Hague: Martinus Nijhoff, 1971.

Rueff, Jacques. *The Monetary Sin of the West*. New York: Macmillan, 1972.

Rustow, Alexander. *Freedom and Domination: A Historical Critique of Civilization*. Princeton: Princeton Univ. Press, 1980.

Samuelson, Kurt. *Religion and Economic Action*. New York: Basic, 1961.

Santoni, G. J., and Courtenary C. Stone. "What Really Happened to Interest Rates?: A Longer-Run Analysis." *Review: Federal Reserve Bank of St. Louis* 63, no. 11, (Nov. 1981): 3–14.

Sartori, Giovanni. *Democratic Theory*. New York: Praeger, 1965.

Say, Jean-Baptiste. *A Treatise on Political Economy*. 6th ed. Philadelphia: Lippincott, Grambo, 1853.

———. *Letters to Thomas Robert Malthus on Political Economy and Stagnation of Commerce*. London: George Hardin's Bookshop, 1936.

Schattschneider, E. E. *Politics, Pressures and the Tariff: A Study of Free Private Enterprise in Pressure Politics as Shown in the 1929–1930 Revision of the Tariff*. New York: Prentice-Hall, 1935.

———. *Party Government*. New York: Holt, 1942.

———. *The Semisovereign People: A Realist's View of Democracy in America*. New York: Holt, 1960.

Schumpeter, Joseph A. *Business Cycles: A Theoretical, Historial and Statistical Analysis of the Capitalist Process*. 2 vols. New York: McGraw-Hill, 1939.

———. *Capitalism, Socialism, and Democracy*. New York: Harper Torchbooks, 1950.

Schutz, Alfred. *Collected Papers I: The Problem of Social Reality*. Ed. Maurice Natanson. The Hague: Martinus Nijhoff, 1962.

———. *The Phenomenology of the Social World*. Evanston, Ill.: Northwestern Univ. Press, 1967.

———. *Collected Papers II: Studies in Social Theory*. Ed. Maurice Natanson. The Hague: Martinus Nijhoff, 1971.

Sennholz, Hans F., ed. *Gold is Money*. Westport, Conn.: Greenwood, 1975.

Shackle, G. L. S. *Time In Economics*. Amsterdam: North-Holland, 1958.

———. *The Nature of Economic Thought: Selected papers 1955–1964*. Cambridge: Cambridge Univ. Press, 1966.

———. *Epistemics and Economics*. Cambridge: Cambridge Univ. Press, 1972.

————. *Imagination and the Nature of Choice.* Edinburgh: Edinburgh Univ. Press, 1979.

Sharp, Clifford. *The Economics of Time.* Oxford: Martin Robertson, 1981.

Sheehy, Gail. "Introducing the Postponing Generation." *Esquire* 92 (Oct. 1979): 25–33.

Simons, Henry C. *Economic Policy for a Free Society.* Chicago: Univ. of Chicago Press, 1948.

Smith, Adam. *An Inquiry Into the Nature and Causes of the Wealth of Nations.* New York: Modern Library, 1937.

Smith, T. Alexander. *The Comparative Policy Process.* Santa Barbara, Calif.: ABC-Clio, 1975.

————. "A Phenomenology of the Policy Process." *International Journal of Comparative Sociology* 23 (March–June 1982): 1–16.

Solow, Robert M. *Capital Theory and the Rate of Return.* Amsterdam: North-Holland, 1963.

Sorokin, Pitirim A., *Social and Cultural Mobility.* New York: Free Press, 1959.

————. *The American Sex Revolution.* Boston: Porter Sargent, 1972.

Soule, George. *Time for Living.* New York: Viking, 1956.

Sowell, Thomas. *Say's Law: An Historical Analysis.* Princeton: Princeton Univ. Press, 1971.

————. *Knowledge and Decisions.* New York: Basic Books, 1980.

Spadaro, Louis M., ed. *New Directions in Austrian Economics.* Kansas City, Mo.: Sheed Andrews and McMeel, 1978.

Spitz, David. *Democracy and the Challenge of Power.* New York: Columbia Univ. Press, 1958.

Spiro, Herbert J. *Government by Constitution: The Political Systems of Democracy.* New York: Random House, 1959.

Steiner, Jürg. *Amicable Agreement Versus Majority Rule: Conflict Resolution in Switzerland.* Chapel Hill: Univ. of North Carolina Press, 1974.

————, and Robert H. Dorff. *A Theory of Political Decision Modes: Intraparty Decision Making in Switzerland.* Chapel Hill: Univ. of North Carolina Press, 1980.

Tatom, John A. "The Productivity Problem." *Review: Federal Reserve Bank of St. Louis* 61, no. 9 (Sept. 1979): 3–16.

Timberlake, Richard H. *The Origins of Central Banking in the United States.* Cambridge: Harvard Univ. Press, 1978.

Tobin, James. "On Limiting the Domain of Inequality." *Journal of Law and Economics* 13 (Oct. 1970): 263–77.

Tocqueville, Alexis de. "Memoir on Pauperism." *The Public Interest* 70 (Winter 1983): 102–20.

Toffler, Alvin. *Future Shock.* New York: Random House, 1970.

Touraine, Alain. *The Post-Industrial Society.* New York: Random House, 1971.

Trevor-Roper, H. R. *The Crisis of the Seventeenth Century: Religion, the Reformation, and Social Change.* New York: Harper & Row, 1967.

Truluck, Phillip N., ed. *Private Rights and Public Lands.* Washington, D.C.: Heritage Foundation, 1983.

Turner, Julius. "Reponsible Parties: A Dissent from the Floor." *American Political Science Review* 45 (March 1951): 143–52.

Unwin, J.D. *Sex and Culture*. Oxford: Oxford Univ. Press, 1934.

Uri, Pierre. "How to Lower Interest Rates." *Guardian* (Manchester). Weekly ed. 125, July 26, 1981.

Van den Haag, Ernest, ed. *Capitalism Sources of Hostility*. New Rochelle, N. Y.: Epoch Books, 1979.

Vogel, Ezra F. *Japan as Number One: Lessons for America*. Cambridge: Harvard Univ. Press, 1979.

Wanniski, Jude. *The Way the World Works: How Economies Fail and Succeed*. New York: Basic Books, 1978.

Webber, Carolyn, and Aaron Wildavsky. *A History of Taxation and Expenditure in the Western World*. New York: Simon and Schuster, 1986.

Weisskopf, Walter A. *Alienation and Economics*. New York: Dutton, 1971.

Weitzman, Leonore J. *The Divorce Revolution: The Unexpected Social and Economic Consequences for Women and Children in America*. New York: Free Press, 1985.

Welborn, David M. *Governance of Federal Regulatory Agencies*. Knoxville: Univ. of Tennessee Press, 1977.

White, Andrew Dickson. *Fiat Money Inflation in France*. Irving-on-Hudson, N.Y.: The Foundation for Economic Education, 1959.

White, Lawrence H. *Free Banking in Britain*. Cambridge: Cambridge Univ. Press, 1984.

Wildavsky, Aaron. "Choosing Preferences by Constructing Institutions: A Cultural Theory of Preference Formation." *American Political Science Review* 81 (March 1987): 3–21.

Will, George F. *The Pursuit of Virtue and Other Tory Nations*. New York: Simon and Schuster, 1982.

Williamson, John B., et al. *Strategies Against Poverty in America*. Cambridge, Massachusetts: Schenkman, 1975.

Wilson, James Q. "Crime and American Culture." *The Public Interest* 70 (Winter 1983): 22–48.

Winkler, J. T. "Law, State, and Economy: The Industry Act of 1975 in Context." *British Journal of Law and Society* 2 (Winter 1975): 103–28.

Wonnell, Christopher T. "Contract Law and the Austrian School of Economics." *Fordham Law Review* 54 (April 1986): 507–43.

Wright, Quincy, ed. *Gold and Monetary Stabilization*. Chicago: Univ. of Chicago Press.

Yeager, Leland B., ed. *In Search of a Monetary Constitution*. Cambridge: Harvard Univ. Press, 1962.

Index

Time and Public Policy was designed by Kaelin Chappell, composed by Lithocraft, Inc., and printed and bound by Braun-Brumfield, Inc. The book is set in Sabon with Optima display. Text stock is 60–lb. Glatfelter Natural Smooth.